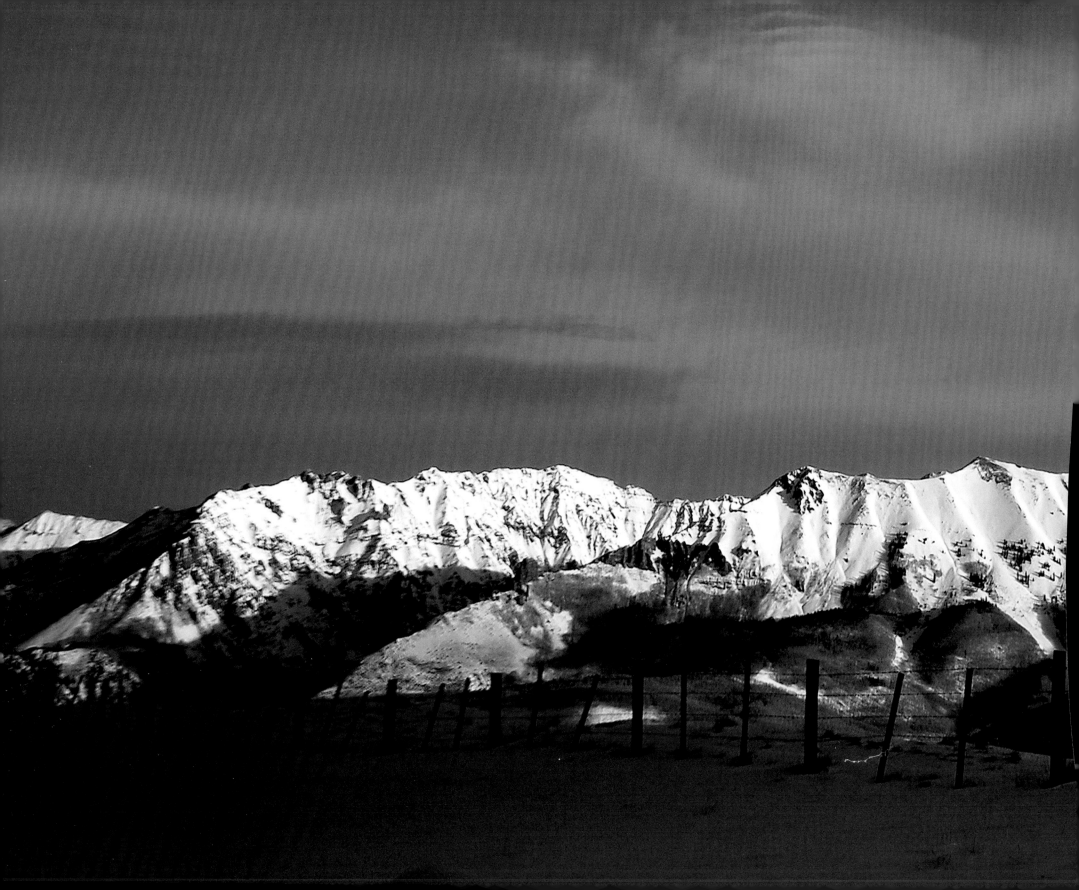

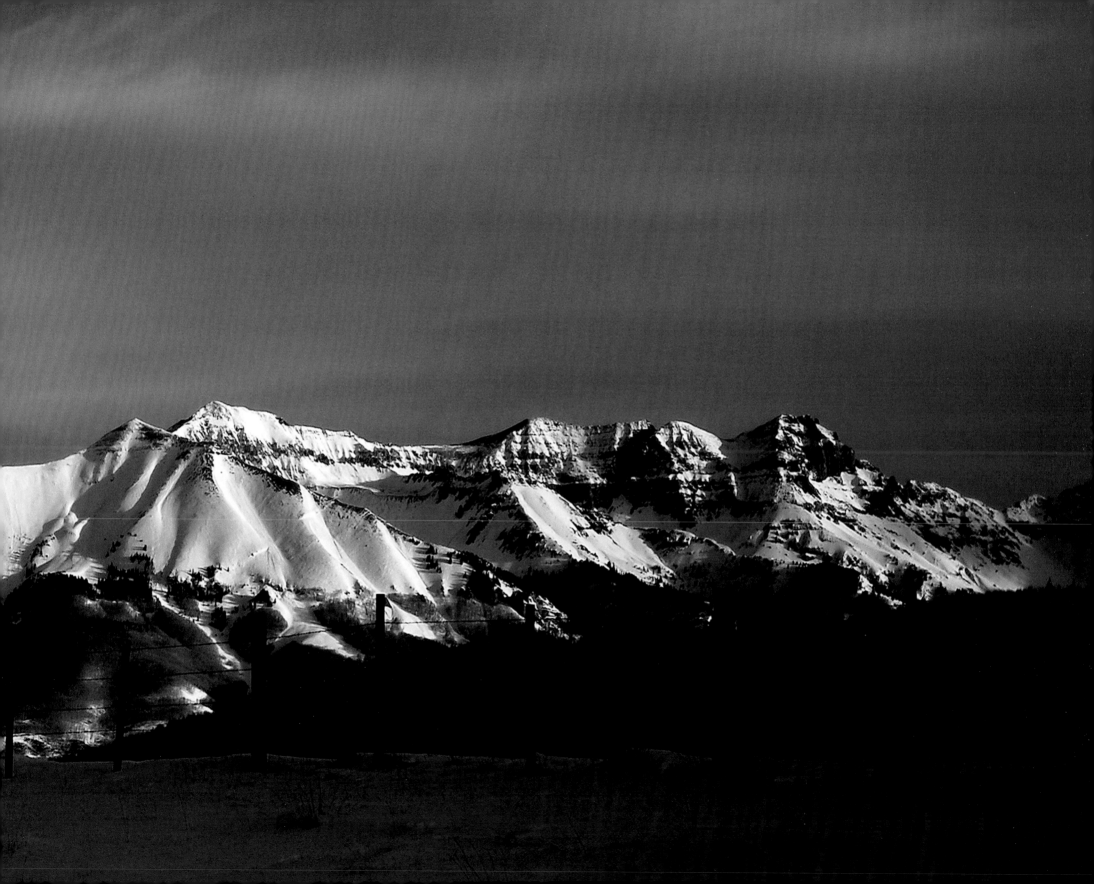

Roads Less Traveled

Photographs of a Traveling Salesman

Photography by Bill Hitz

Text by Rod Johnson

Bill Hitz ©

Foreword by General H. Norman Schwarzkopf

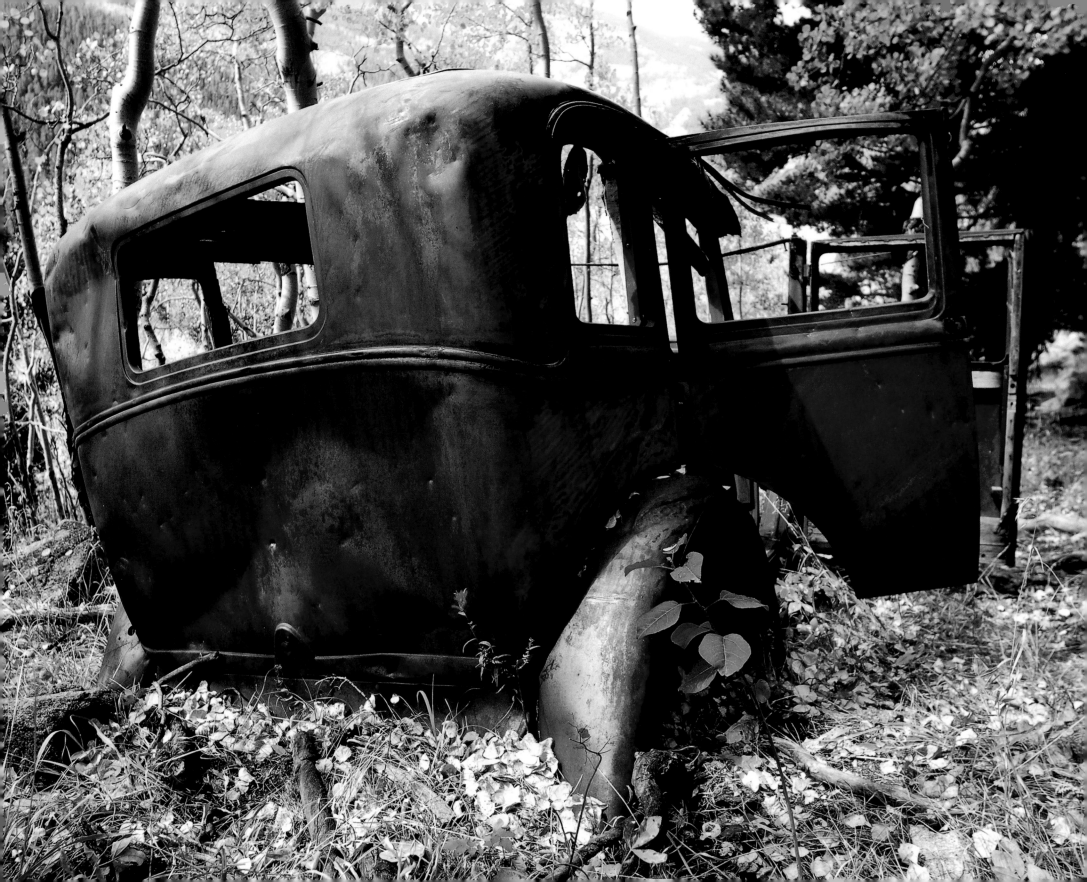

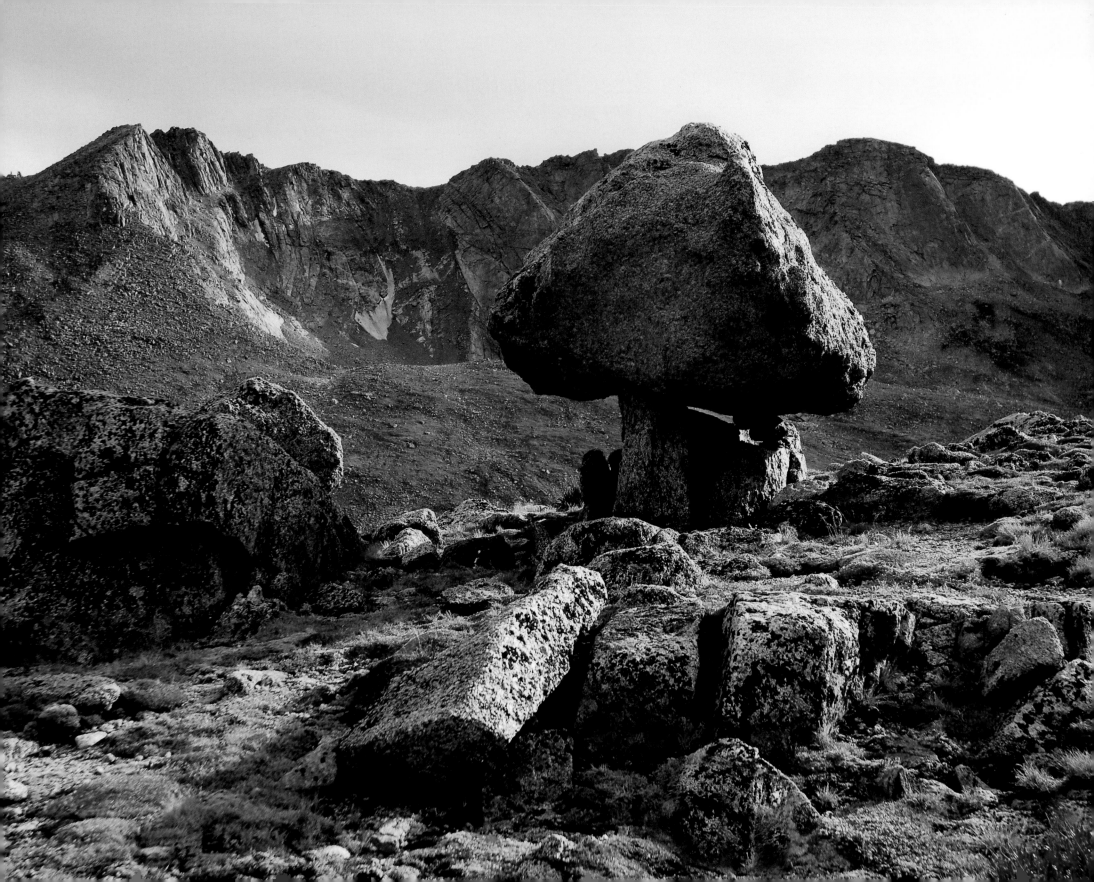

Cool River Productions

8403 Zephyr Street
Arvada, Colorado 80005

www.roadslesstraveledbook.com
www.coolriverproductions.com
www.mtevansphotography.com

Photography, Book Design and Art by Bill Hitz
Text by Rod Johnson

Library of Congress Catalog Card Number: TXu1694167

ISBN # 978-0-578-07639-3

Printed in Canada

Dedication

I dedicate this book to my Father and Mother, Brothers and Sisters,
and my sons, Cameron and Nicholas.
To Sheri, Nicole and Steven.

Rod Johnson and family

To all the men and women who wear the uniforms of our country,
and the ones who have given their lives to protect our freedoms.

To all those who cannot get out to see what I have seen.

And to General H. Norman Schwarzkopf and his wife Brenda,
who believed in me and my work and encouraged me to make this book.

Acknowledgements

*I would like to express my gratitude to some of the many people I have met
along the way without whose help this book would not have been possible.*

*To Brenda Van De Mije of East Meets West Gallery; Telluride, CO.
With out whose help and support this project would never have come alive*

*To Bryan, who taught me so much about photography. He was one
of the greatest photographers I have ever known.*

*To John Feeney and Marshall Monsell of Horizon Foods; Denver CO.
David Cammarata*

To Grizzly Creek Framing; Golden, CO.

To John Adams of www.bluetulipmusic.com

To Joe and Jim of Shadows Ranch; Georgetown, CO.

To Shauntel Hutchinson, Tater and the Hutchinson family of Perfect 10 Bison Ranch; Rose, NE.

To John and Lucinda Hazen.

To all my friends at Echo Lake Lodge.

To Sam and Alya Salter

To Nancy and Dwight

To Bill and Colleen of RealBooks Plus, Morrison, CO, for helping to bring this book from concept to reality.

*And to all the friends that I have met on my journeys who helped me along the high roads,
and the ones who shared my campfires.*

Preface

I have traveled many miles. The roads were rough at times, much like the roads we travel through life. But the rewards are worth it if you just push on and stay to the center of the roads. We all seek a path. My path to create this book was not easy. Just trying to make a living with the economy being so up and down was difficult at times. I had to make a living, but I wanted to photograph everything I saw each day; to capture a moment in time. A silent hike in the mountains, a walk along a stream to hear the water trickle. A bird singing in the forest, or the sound of a big bull elk calling in the distance. A campfire to keep you warm and light up the night. The moonlight nights, a falling star, the brilliant white snow on the mountaintops. It is all here; so much to share. America is truly a place to fulfill your dreams.

Always believe in what you are doing. Believe you already have it. Hold it true to your heart and it will happen. This book is of a journey that I have taken in my dreams for many years. A journey that I wanted to share with so many people who have touched my life. I have met so many wonderful people over the years and through the miles. Some have come and gone, but many have remained as cherished friends.

There are many photographers in the world. Each one sees something different. You capture your own image. You feel the excitement, the thrill of the hunt for that one perfect photo. A prize that you can feel deep in your soul. You wait and wait for that perfect moment. And then it happens. I remember sitting in the cold in a snow storm, the snow was falling heavily, but I knew that if I just waited a few more minutes I would get that photo. Then you just get some luck that one could only dream of. I look at some of the greatest photographers of the world like Ansell Adams. His work lives on. One can only imagine how many hours he sat in one place to capture a photo. You learn something every time you venture out into the field. The days always change. The weather plays a big part of an image. I find the best time to take photos is early morning or late afternoon. Photography can be so rewarding and so good for the heart; for stress relief. I see so many kids these days stuck in the house playing video games. If only they would get out and discover the great outdoors. I urge parents to take their kids camping or fishing. Enjoy life; get a camera. A photo tells a thousand words. —Bill Hitz

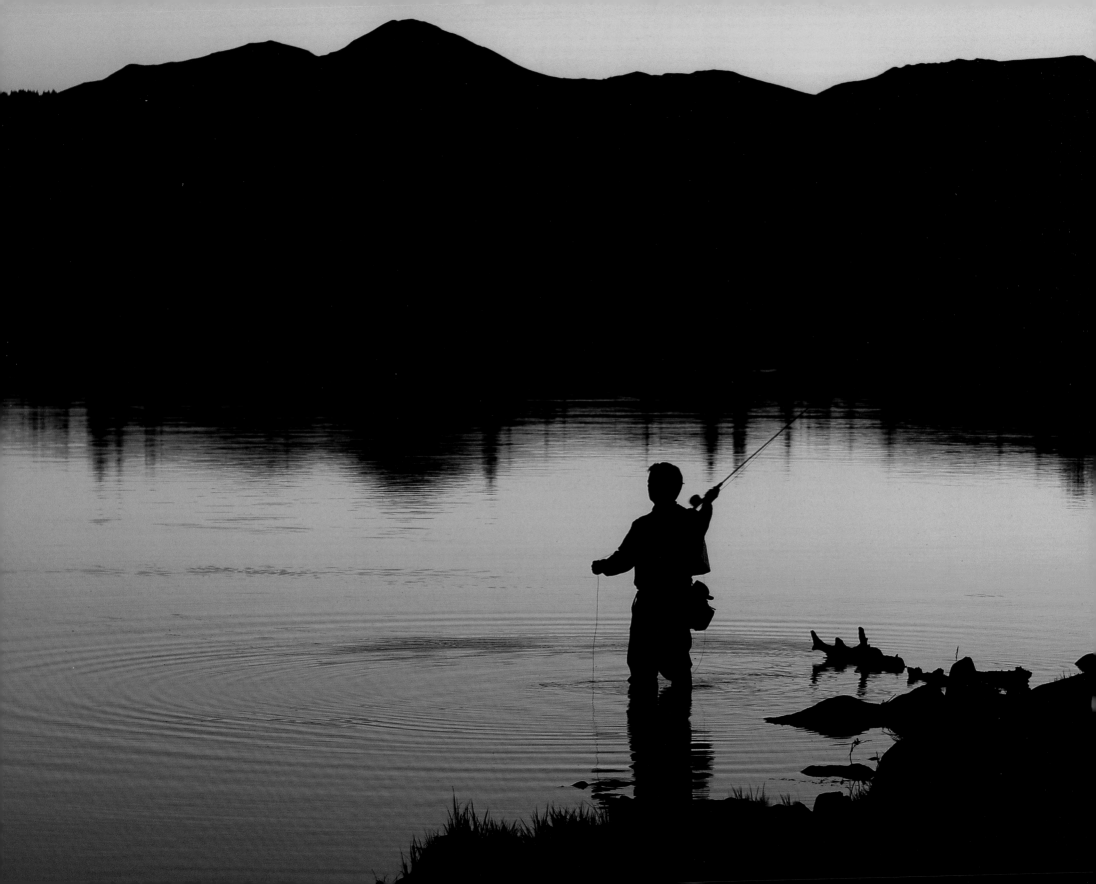

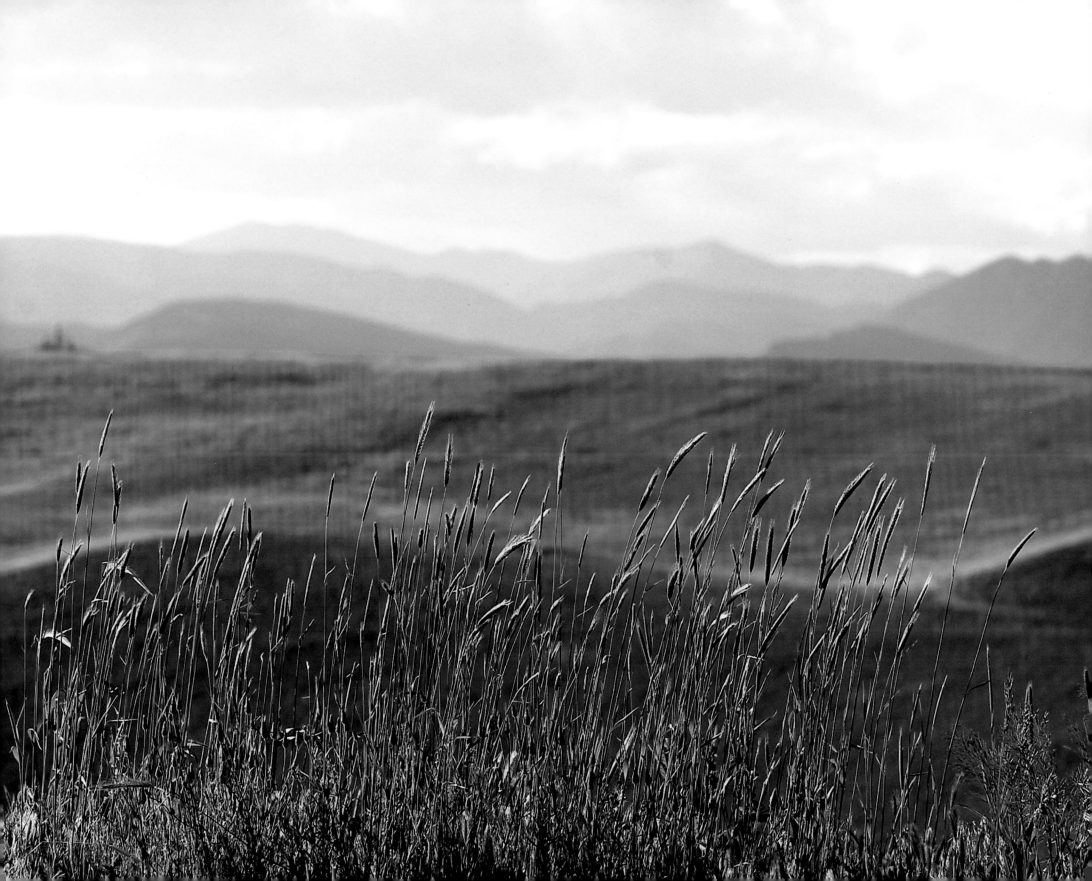

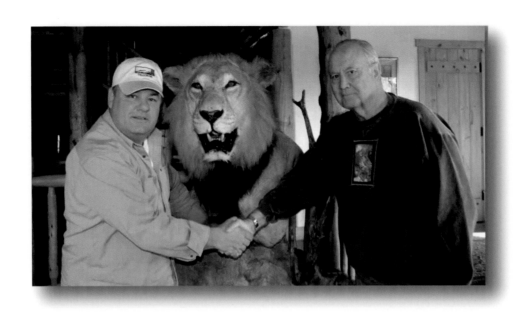

"Your photos are like a spirit; they speak to me..."

General H. Norman Schwarzkopf
U.S. Army, Retired

FOREWORD

I met Bill Hitz quite by accident. It was a beautiful sunny day in Colorado when a stranger appeared at my door. He introduced himself and explained that he was a traveling salesman, selling high-quality meat, seafood, and other frozen food items which he had available on his truck. He said he had been visiting some of his customers in the area and that he was just knocking on doors in the neighborhood trying to find potential customers for his products. Bill seemed like a nice, friendly, harmless traveling salesman, so I told him that I would have a look at some of his products.

Over the next few years, Bill would stop by our house every few months when he was in the area. My wife, Brenda, and I always enjoyed Bill's visits as well as many of his fine products. Eventually, we started inviting Bill to stay for a cup of coffee and conversation. We learned that Bill grew up in northern Wisconsin and that he was an avid outdoorsman, as am I, who enjoyed fishing, hiking and camping. We started sharing stories of our biggest catch, each of us embellishing just a little, as good fishermen will do. Soon Bill started showing us photos he had taken over the years from his travels over the highways and back roads of some of our nation's most beautiful countryside. We were impressed not only with the high quality of Bill's photos but, more importantly, with the unique composition and subject matter of his photos. I could tell that this traveling salesman had a genuine talent for "seeing" great pictures. That talent, combined with the opportunities Bill had to visit special places with his camera always poised next to him on the front seat of his truck, resulted in some of the most moving and inspiring photographs Brenda and I have ever seen. We could tell by Bill's spirited enthusiasm when he shared his photos with us that photography is indeed his real passion in life.

Each time Bill would stop by our house, Brenda and I found that we were more excited to see any new photos Bill had taken since his last visit than we were about restocking our freezer. One day Bill was showing us some photos he had recently taken of several beautiful horses running through freshly fallen snow. The photos were absolutely amazing. The sharpness and clarity of Bill's photographs were outstanding. We could see the horses' breath, count the hairs in their manes and tails and follow the path of each clump of snow through the air as the horses' hooves kicked up the white powder as they ran.

I looked at Bill and said, "Your photos inspire me…they are like a spirit…they speak to me. You should put your photographs in a book for everyone to enjoy. I would even be willing to endorse the book for you." Bill looked at me with a look of disbelief. He turned and looked at my wife. Brenda smiled and looked Bill in the eye and assured him, "Norman would do that for you, Bill."

So it is with great pride that I would like to introduce to the world, a treasure that I discovered by accident one afternoon when a traveling salesman showed up at my doorstep with a smile and a camera. Bill once told me that one of his goals was to make it possible for everyone to be able to see and enjoy the wondrous sights he has been privileged to see as he has ventured down back roads, byways and roads less traveled in this beautiful country of ours. He has made his goal a reality by capturing and sharing with us extraordinary moments in time that otherwise only he might have seen.

It is my hope that you will enjoy my friend Bill's 'Photographs of a Traveling Salesman' as much as Brenda and I have.

General H. Norman Schwarzkopf
U.S. Army, Retired

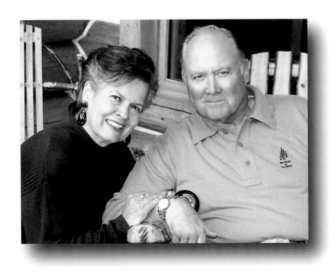

Brenda and Norman Schwarzkopf

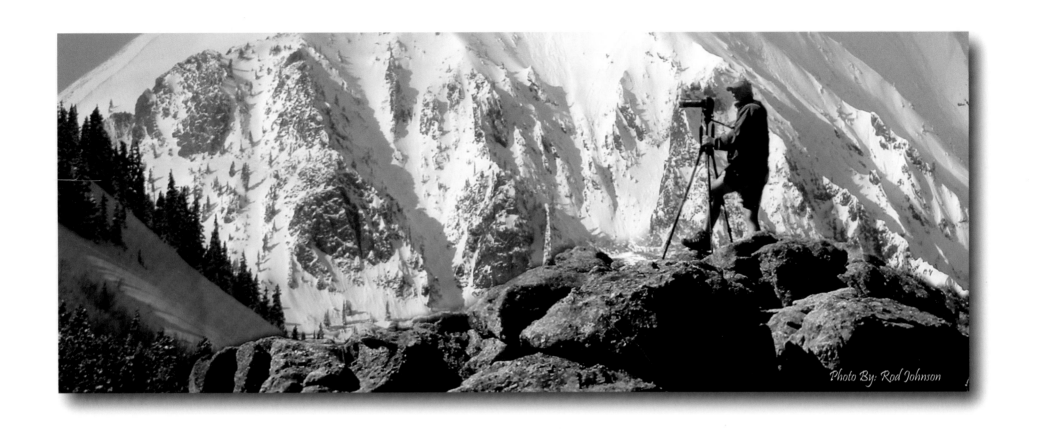

Photo By: Rod Johnson

"My camera is my pen and my photos tell the story..."

Photographer Bill Hitz

Bill Hitz ©
2010

Introduction

I had been crouching in the reeds next to a small lake in Park County, Colorado for what seemed like hours as I tried to work myself close enough to an enormous flock of pelicans sitting quietly on the water without startling them before I could get a few good photographs of them. Suddenly something spooked the wary birds as they seemed to move as one giant unit, rather than many individuals, frantically flapping their oversized wings as they attempted to become airborne. My camera was clicking rapidly as I captured frame after frame of majestic synchronized flight. "There's gonna be some great shots here," I thought as the birds approached my end of the pond. Suddenly, as the startled flock passed just overhead, for some unknown reason, it seemed like every one of those huge birds decided to relieve itself. I was caught in what seemed like a rainstorm of pelican poop. I was soon covered from head to toe. I did what I could to protect my camera from the onslaught, but my clothes, hat and hair were a dripping, smelly mess. I kid you not. I have the photos prove it.

Once I spotted a flock of wild turkeys run into the trees as I rounded a curve while driving in the Poudre Canyon in northern Colorado. I stopped the pickup truck I was driving along the side of the road and grabbed the camera I always keep on the front seat beside me and headed into the forest where I had seen the big birds disappear. Before long I came to an old abandoned cabin. I could hear sounds coming from the opposite side of the cabin. As I peeked around the corner of the cabin, there on the other side was a flock of about twenty turkeys scratching and pecking at the pine needles that covered the ground. I quietly raised my camera and started to click off frame after frame as the turkeys continued their busy search. "This is unbelievable," I thought as I continued to take advantage of my good fortune. "There's gonna be some awesome shots here." The longer I stayed the more comfortable the turkeys became with my presence. It must have been the quiet clicking of the camera that drew their attention, but soon I was surrounded by inquisitive gobblers. One bird was even so bold as to peck the lens of my camera as I tried to take his portrait. I kid you not. I have the photos to prove it.

Another time, as I was driving near Blue Mesa Reservoir near Gunnison, Colorado, I watched as a bald eagle gently glided on outstretched wings into the shadows near the water as the sun slowly sank in the west. I pulled off at the next turn and followed the dirt road as it wound its way toward the lake in hopes of catching another glimpse of the majestic bird. I parked the truck and grabbed my ever-ready camera off the front seat and headed quietly in the direction I thought the eagle had been going. It was quiet and serene. The lake was calm and smooth. No other people were around as I stalked closer and closer to the water's edge. Suddenly I found it. The big eagle was standing in the water taking a bath. It would dip its head into the water and bring it back up and stand there as the water dripped from its curved yellow beak, the drops coming off in increasingly spaced intervals. The sun was low, just catching the eagle's bright white head in its rays, making it stand out against the dark shaded background. "This is awesome. These are going to be some amazing shots," I thought as I clicked away, thankful that I had my biggest lens on my camera. I kid you not. I have the photos to prove it.

I could go on and on. One time I was head butted by an angry mother buffalo as I tried to get just one more shot of her calf as it grazed in the tall grass. Luckily there was a chain link fence between us that took most of the blow. Another time I was chased up a steep trail by two wild hybrid wolf-dogs as I struggled to get back to my truck parked far above. One of the animals even jumped on my back, my bulky backpack saving me as I fought them back with my fishing rod. I even ended up in the hospital after that ordeal.

There have been numerous times that I have slept in my truck or in a small tent near the top of a mountain or even under the stars, shivering in a sleeping bag, waiting to catch the first rays of sunlight on a snowcapped peak mirrored in a smooth mountain lake. I have spent hours at a time in one place waiting for the sun and the clouds and the wind to be absolutely perfect all at the same instant. There have also been times when I would come to the crest of a hill on a secluded back road somewhere and the most awesome sunset or rainbow or fly fisherman silhouetted in the golden rays of the setting sun reflecting in a glass-smooth lake would be waiting for me to just stop and grab my camera and capture one more once-in-a-lifetime photograph along some road less traveled. I kid you not. I have the photos to prove it.

As a boy growing up in northern Wisconsin, I learned to enjoy and appreciate nature and being outdoors. I had eight brothers and five sisters so sometimes I would go fishing or go for long hikes in the woods just to get away and enjoy the peace and serenity that come with being alone with nature. I started to carry a notebook and pencil with me. I would spend hours just sketching or drawing the trees and lakes and hills and animals I would encounter. In this way I learned to 'see' pictures; the composition, framing, depth and dimension so when I started to carry a camera and take photographs of what I saw, the artistry of making good photographs seemed to come naturally for me.

After high school I spent several years in the military, first in the army then the navy. I traveled all over the world and everywhere I went I was amazed at how much beauty and splendor awaited around the next corner or over the next hill. When I left the navy I lived in Australia for several years. It was during these years that I became serious about capturing the beauty of what I saw so that I could share it with others. When I returned to the United States and started working as a traveling salesman in Colorado and some of the surrounding states I was already in the habit of always carrying a good camera with me. The other thing I learned early on was to never be in too much of a hurry to stop and take the photo of that fleeting sunset or that moose standing in a rushing river or follow a flock of turkeys into the trees, because the opportunity to capture that specific moment in time, under those specific conditions will never be available again.

To me, life has always been like a journey, a series of choices. You take a turn here and climb a high mountain pass there. Around each corner or just over the next hill lies another life story waiting to be played out. My journey has taken me to many wonderful places and as I travel over the mountain roads, another turn on a winding pass tells another story. This journey I have taken through a lens and this book is my way of sharing a few of my stories through some of my photos; photographs of a traveling salesman driving some of the less traveled roads in some of the most beautiful states in the country, my only companion a Nikon camera sitting on the seat beside me. My hope is that each person who picks up this book will be able to experience at least a part of the joy, excitement and awe that I experienced as it happened.

I am grateful for the people God has put in my path as well, for without these people this book would never have become a reality. It is truly a gift to be able to share this book with so many wonderful people. I had the pleasure of sharing a campfire high in the San Juan Mountains of Colorado with a poet one time. He was somewhat of a hermit with long hair and a beard. He reminded me a lot of Grizzly Adams from the old television show about a mountain man and a bear. As we sat sharing stories beside the campfire, the poet told me that he likes to hike and spend time in the forest, mostly by himself. He then writes poems to capture his feelings and his thoughts so he can let others enjoy his experiences through his poetry. I realized at that moment that what I do is exactly what that poet does. My camera is my pen and my photos tell the stories. I kid you not. I have the photos to prove it.

Bill Hitz
Photographer

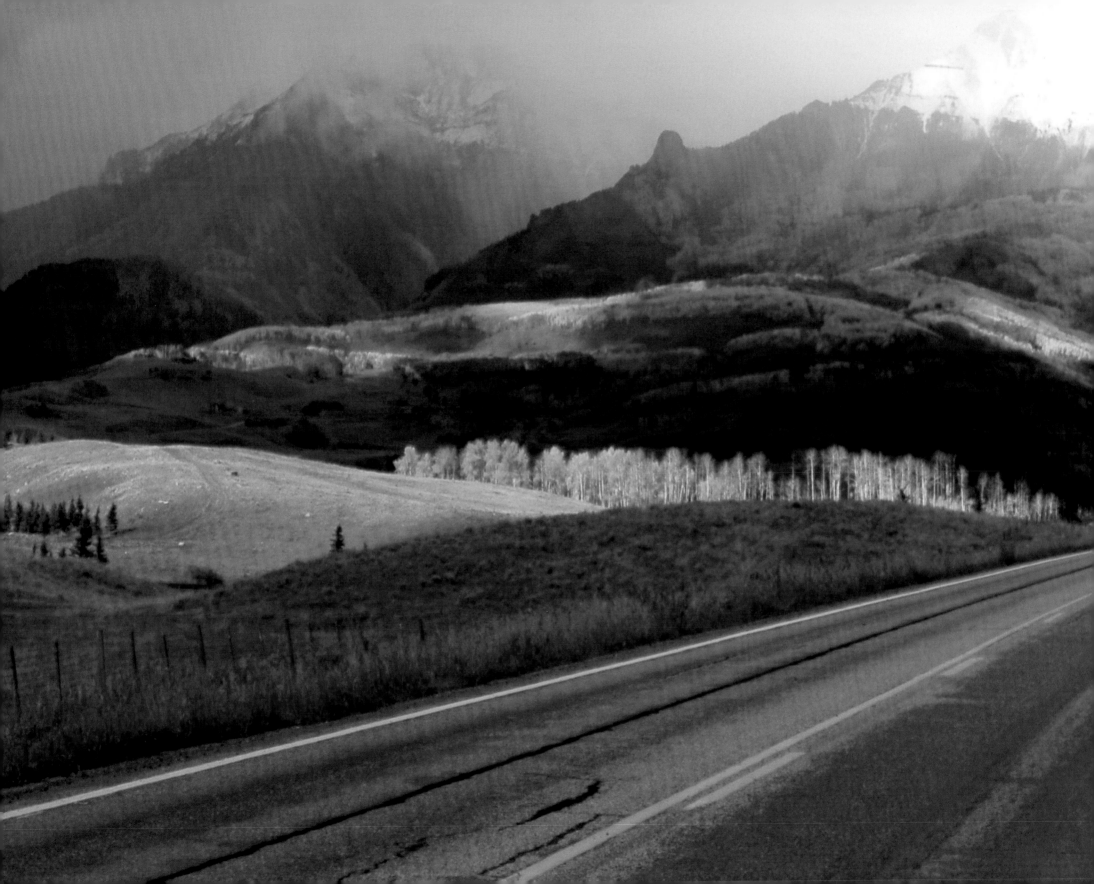

Roads Less Traveled

Photographs of a Traveling Salesman

Photography By: Bill Hitz

Contents

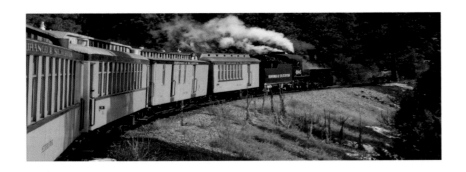

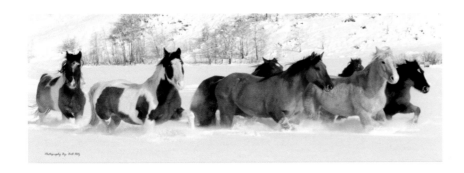

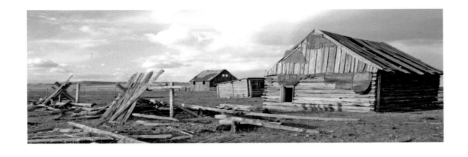

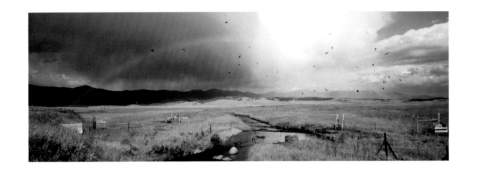

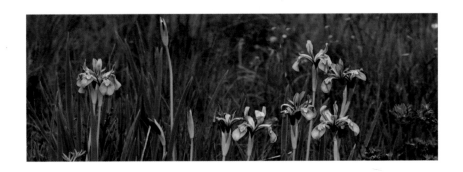

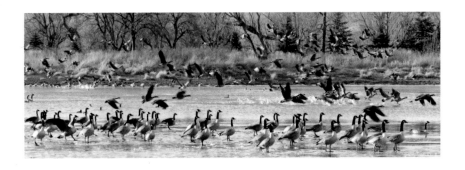

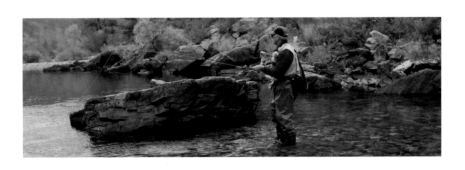

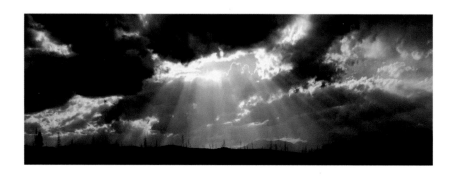

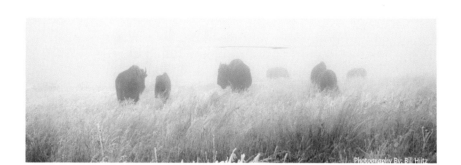

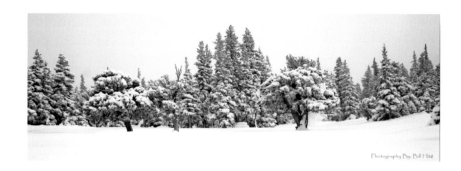

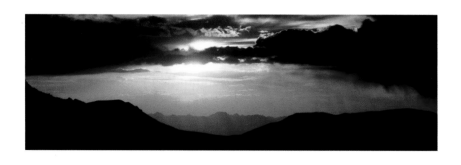

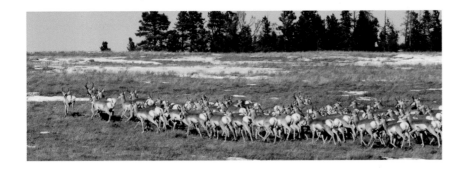

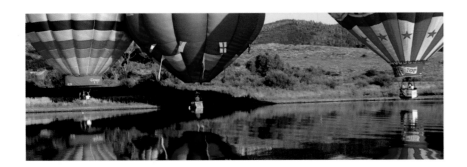

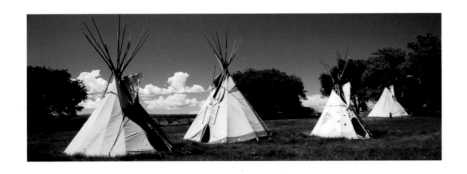

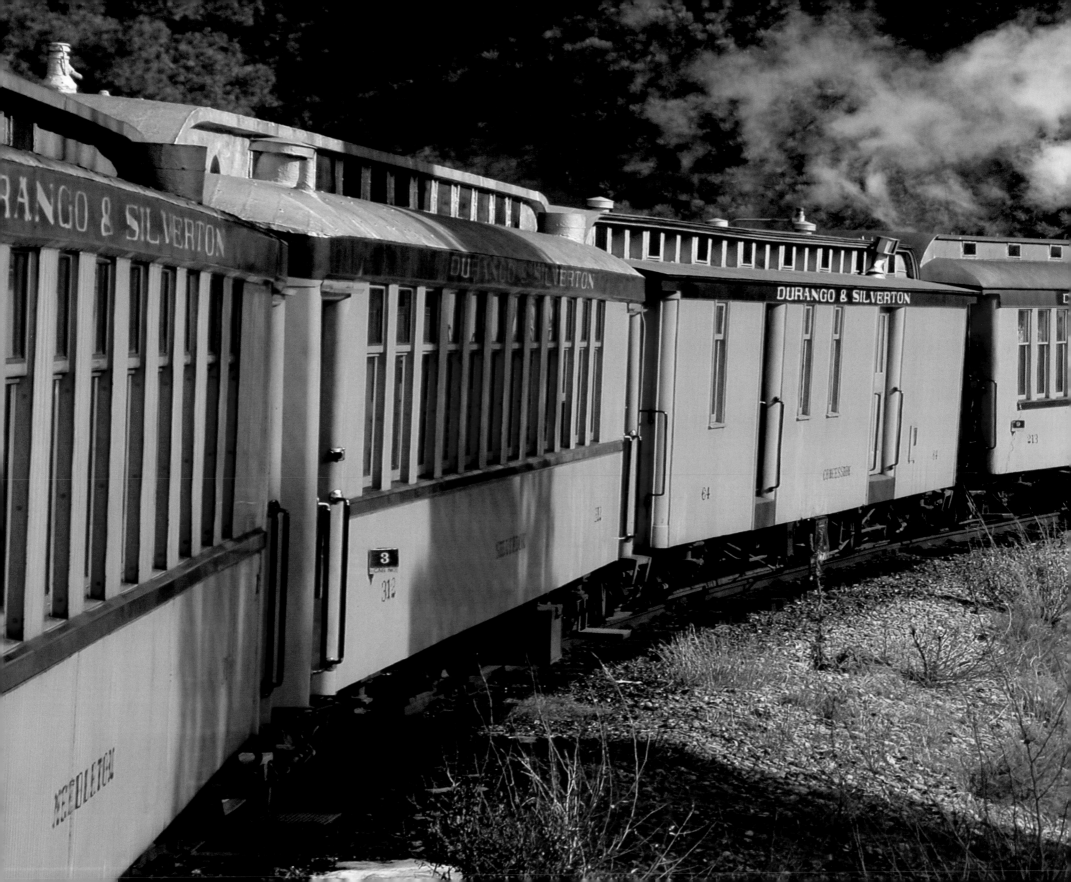

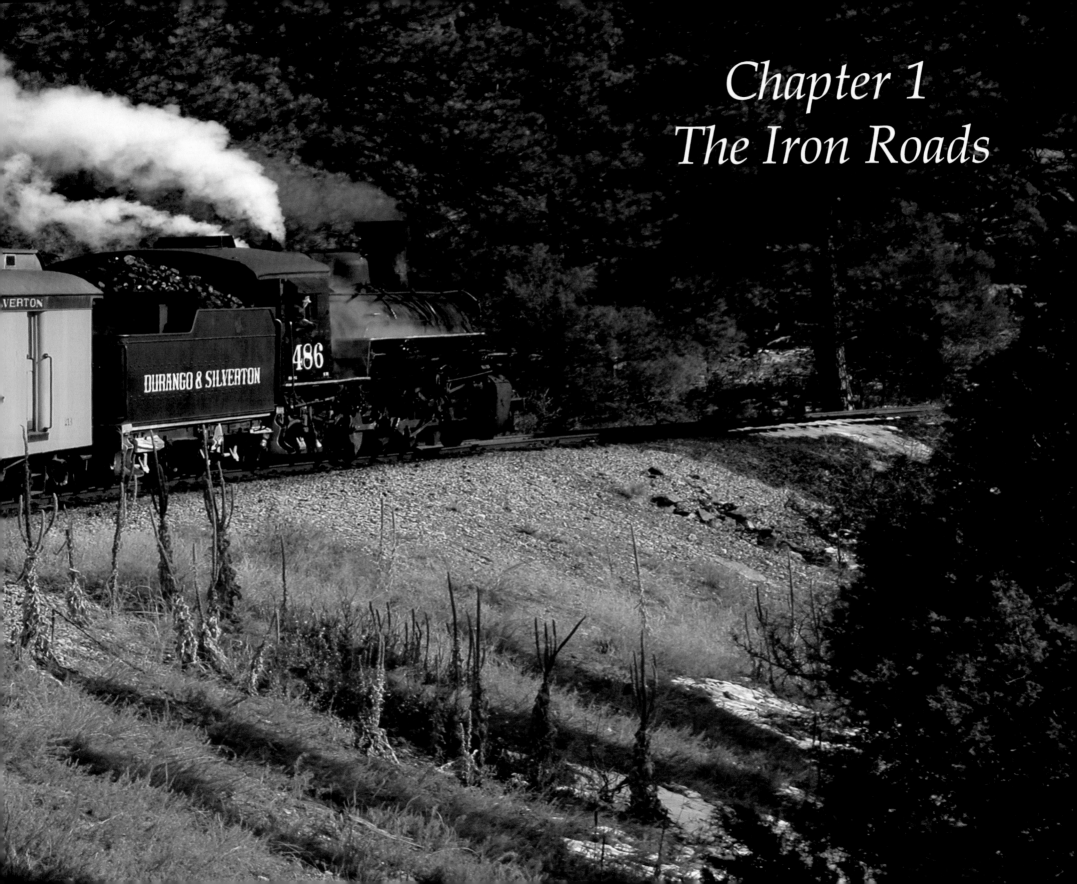

Chapter 1
The Iron Roads

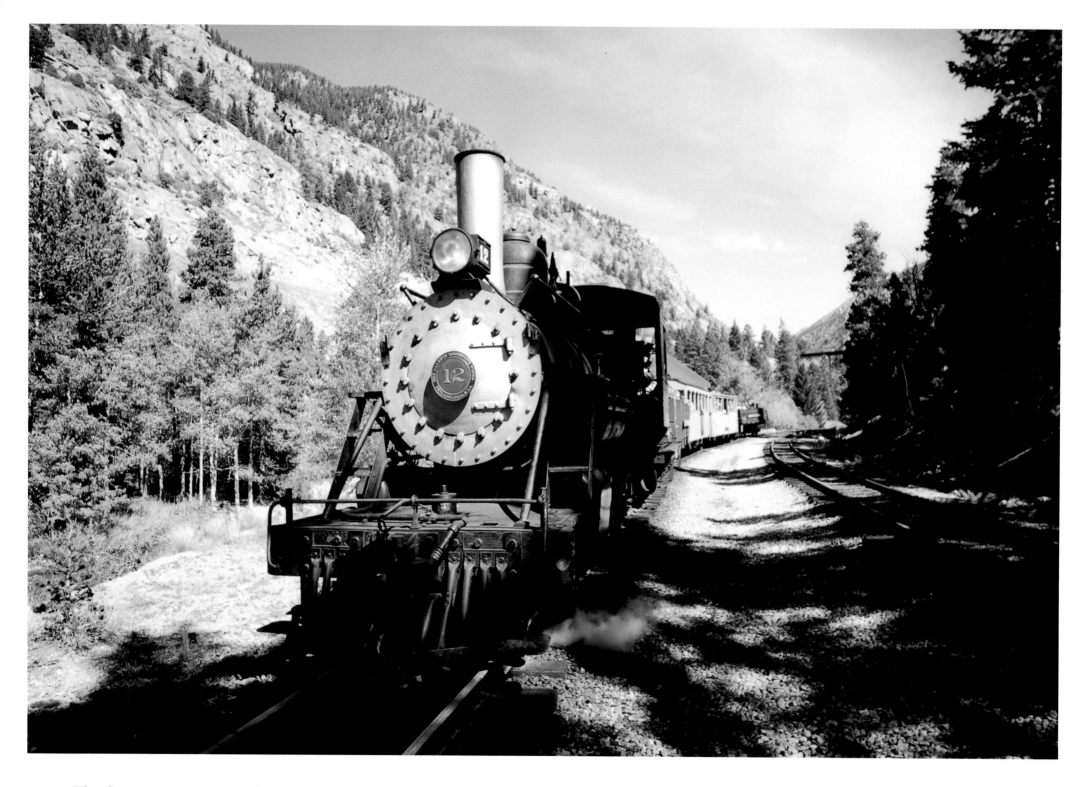

The Georgetown Loop Railroad was one of Colorado's first visitor attractions. Completed in 1884, this spectacular stretch of three-foot narrow gauge railroad was considered an engineering marvel for its time.

It was a beautiful fall day in the Rocky Mountains when I walked into the Georgetown Loop Railroad station, a popular tourist attraction that takes you between the old mining towns of Georgetown and Silver Plume, Colorado along the Clear Creek Valley. I was enthusiastically taking photos of everything I could capture. When one of the owners noticed what I was doing, he asked if they could get copies of what I was shooting. I told him that I was putting some photos together for a book I hoped to publish one day. I was given a tour through the workshops and met and even had lunch with the crew. When I was invited to ride up in the engine with the crew on the next run, I couldn't believe my good fortune. I jumped up into the engine and watched and photographed the crew as they got the train ready to go. The coal was shoveled in and the steam pushed the iron wheels around. It was a grand site to see all the fall colors with the sun coming through the trees as we climbed up the Clear Creek Valley toward Silver Plume. The two small mining towns lie only about two miles apart, yet the train must travel over three miles as it winds through the steep canyon. I kept clicking the camera. All along the narrow gauge tracks you can see history everywhere. As we headed over the bridge spanning Clear Creek the view down the valley toward old historic Georgetown with the sun behind us was awesome. As we made the turn over the loop shaped bridge, the engineer blew off some of the built-up steam. That created some magical photos as two rainbows appeared in the mist from the steam down on the river bend below. One thing that I did not plan for was getting so black from all the coal ash that flew out as we chugged along the iron tracks. The crew asked if I wanted a piece of toast. I said yes but asked how they were going to toast it, since I didn't see a toaster anywhere. Well, they cooked the toast right on the hot engine. They also made hot coffee and the whole nine yards. The crew really made you feel like you were at home. It is a lot of work to keep this piece of American history rolling along and this crew takes a lot of pride in the work they do. To see the smiles on the people who come from all over the world to ride the Old Iron Horse was a reward in and of itself. This was a great experience and I will always remember this crew and the professionalism they showed that wonderful fall day.

4

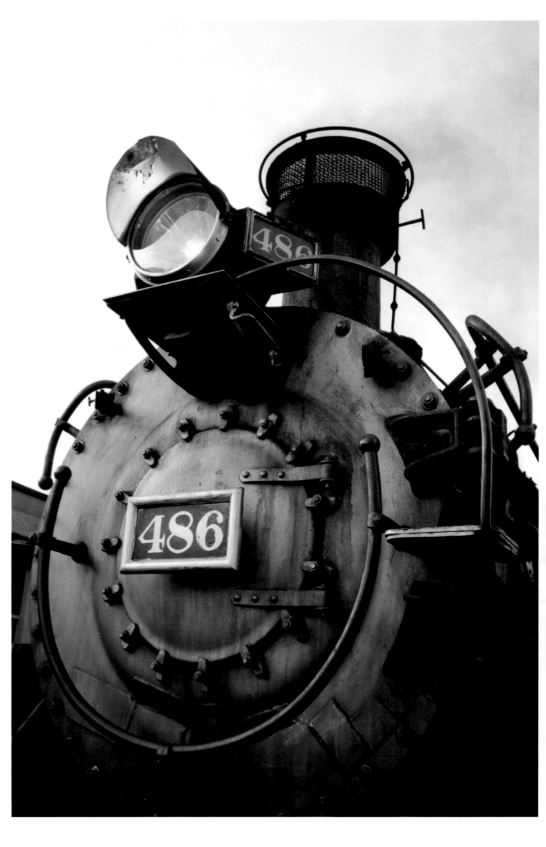

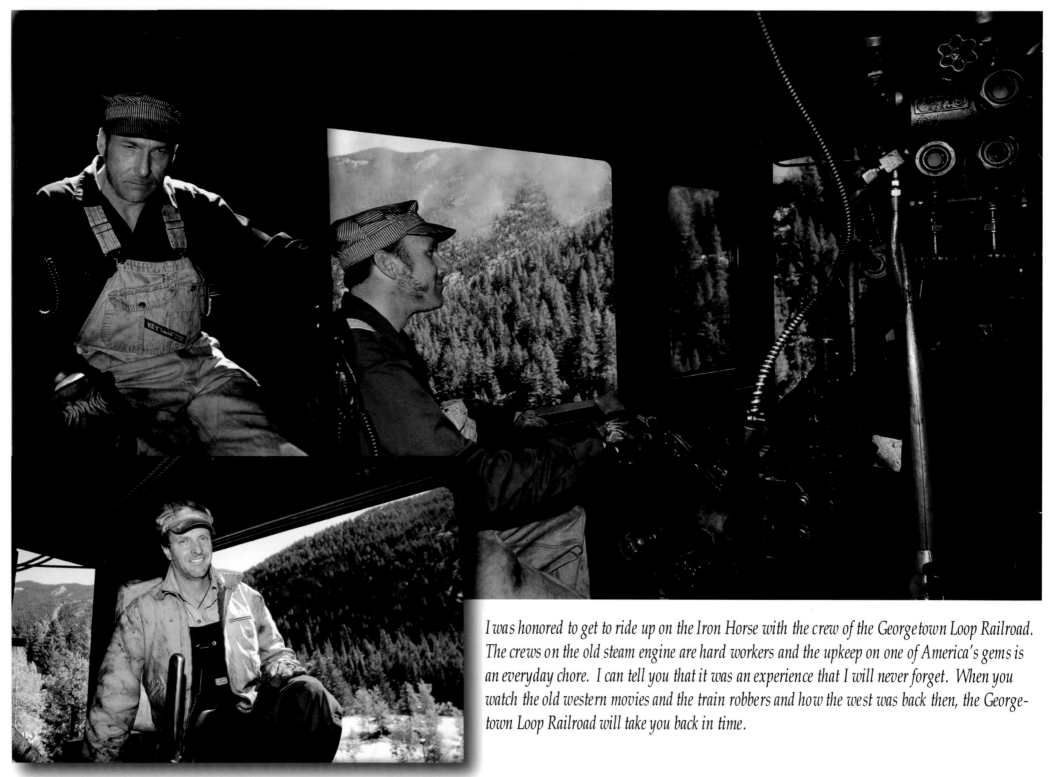

I was honored to get to ride up on the Iron Horse with the crew of the Georgetown Loop Railroad. The crews on the old steam engine are hard workers and the upkeep on one of America's gems is an everyday chore. I can tell you that it was an experience that I will never forget. When you watch the old western movies and the train robbers and how the west was back then, the Georgetown Loop Railroad will take you back in time.

5

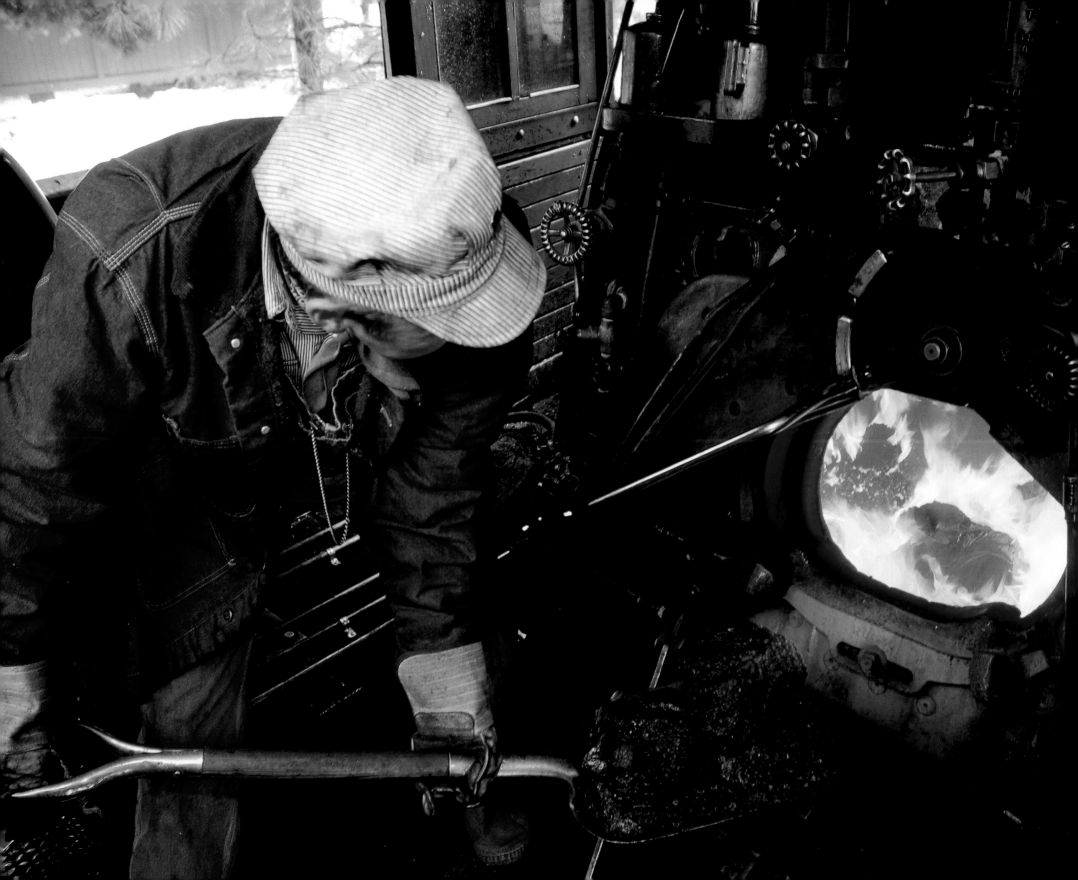

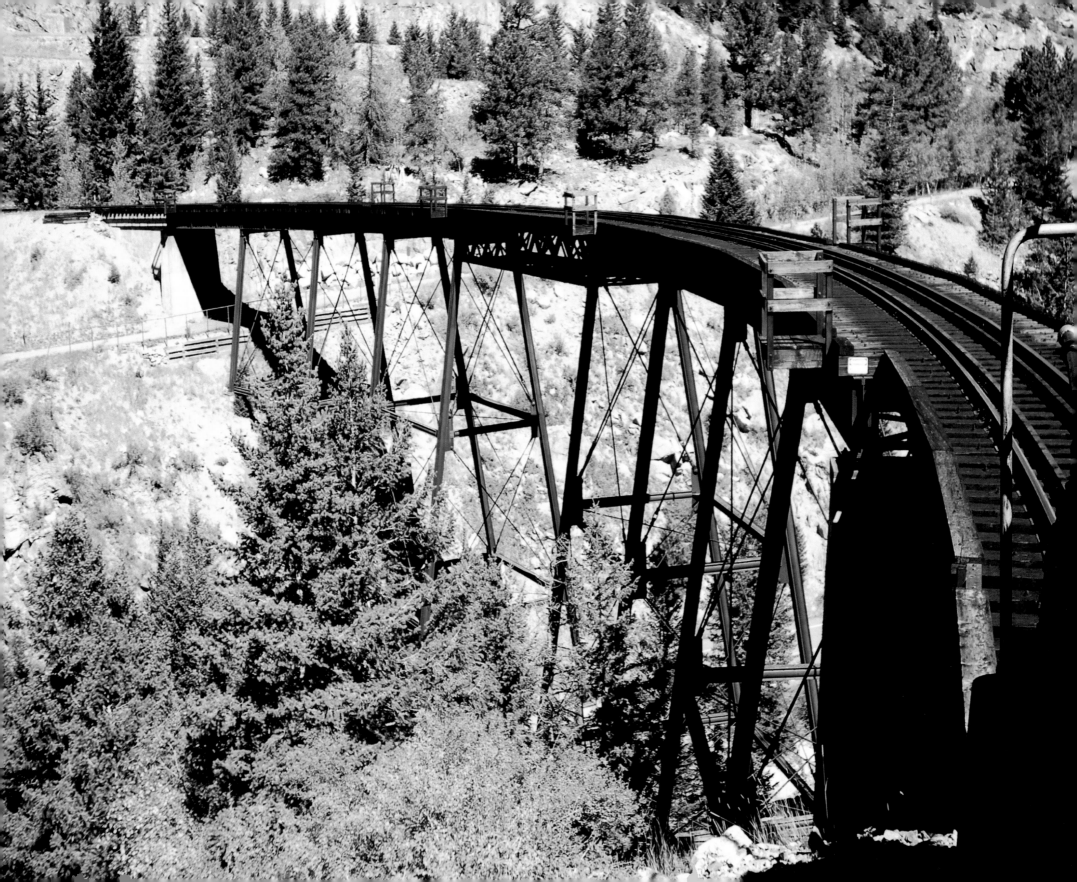

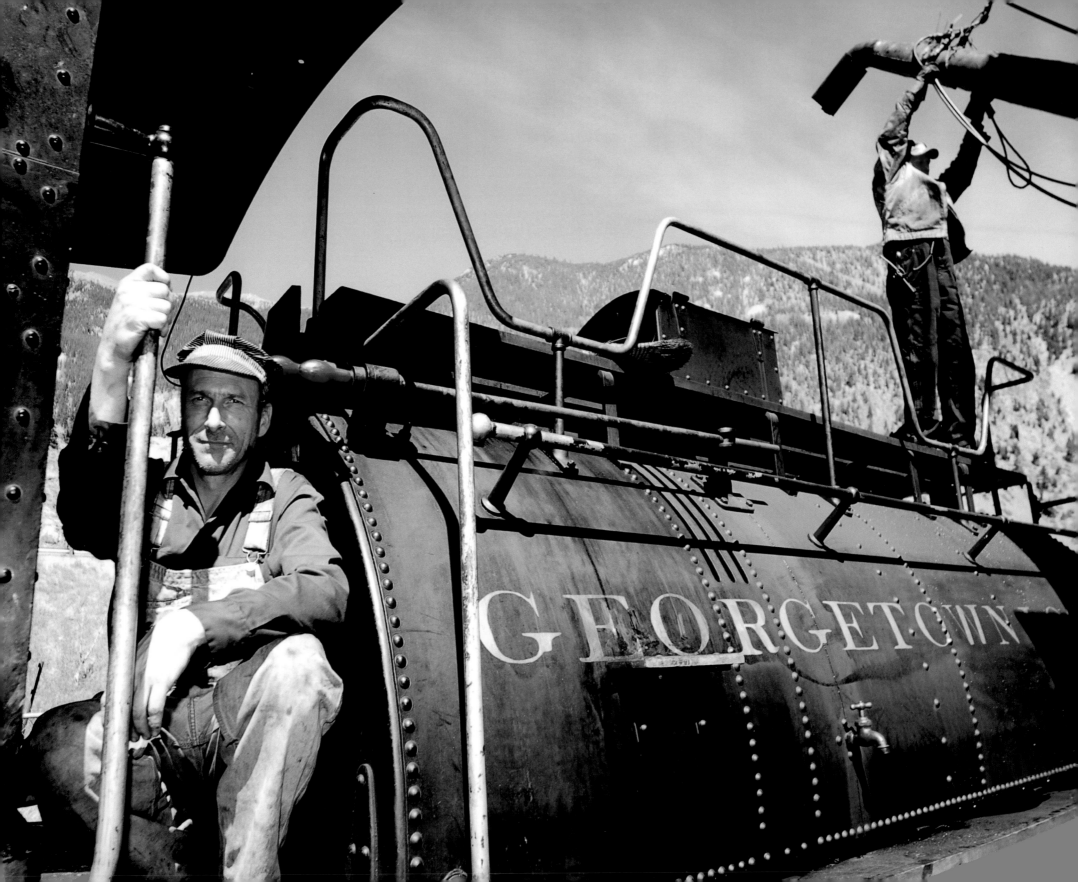

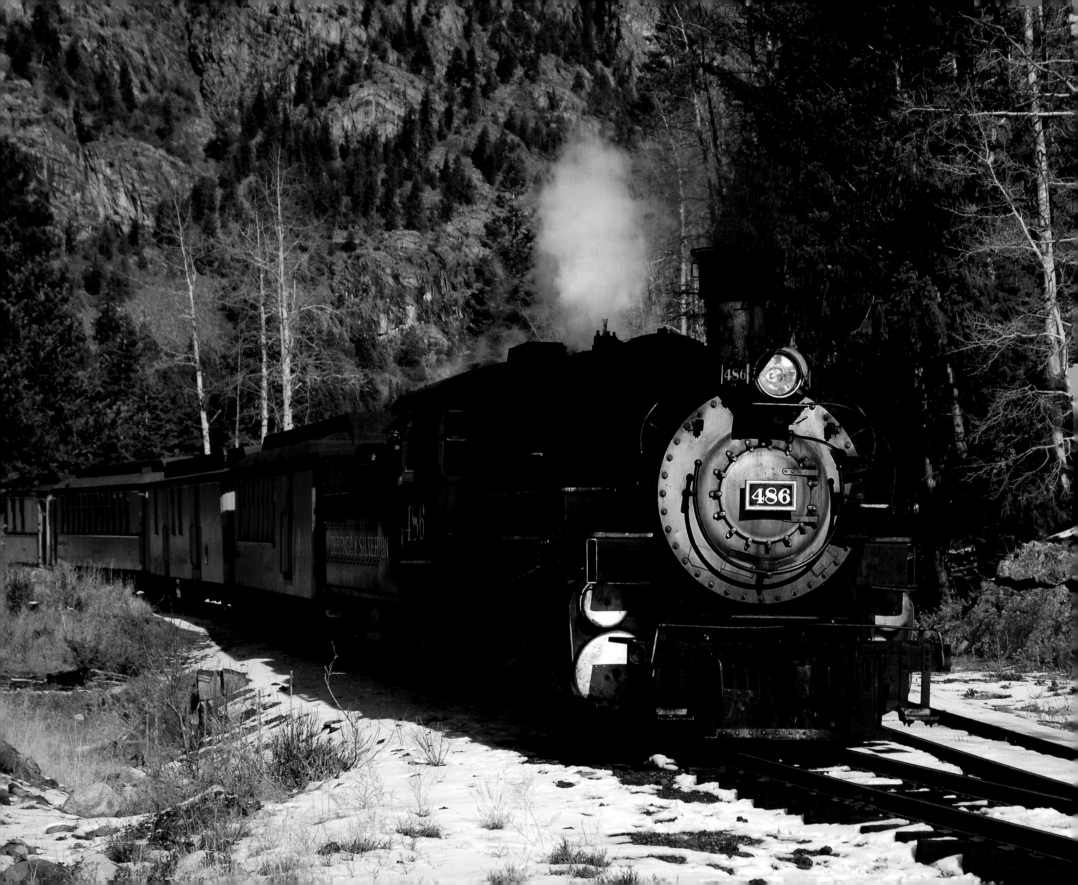

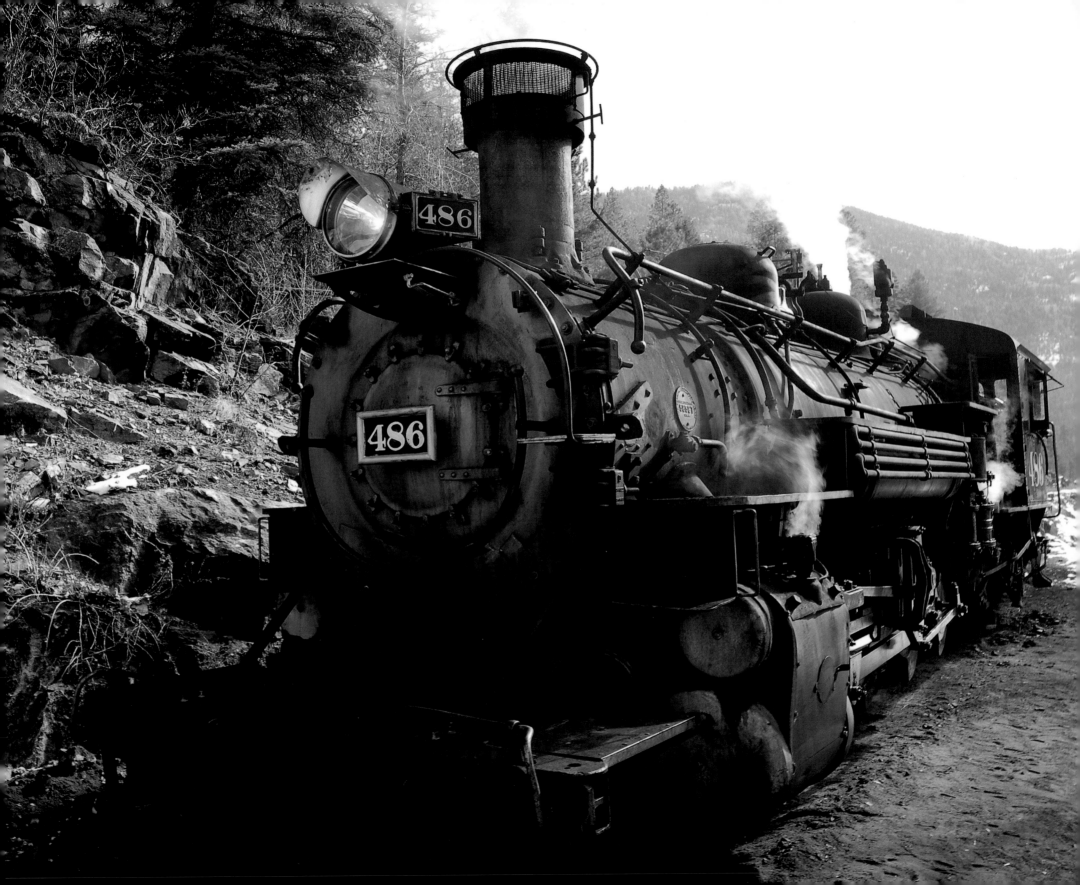

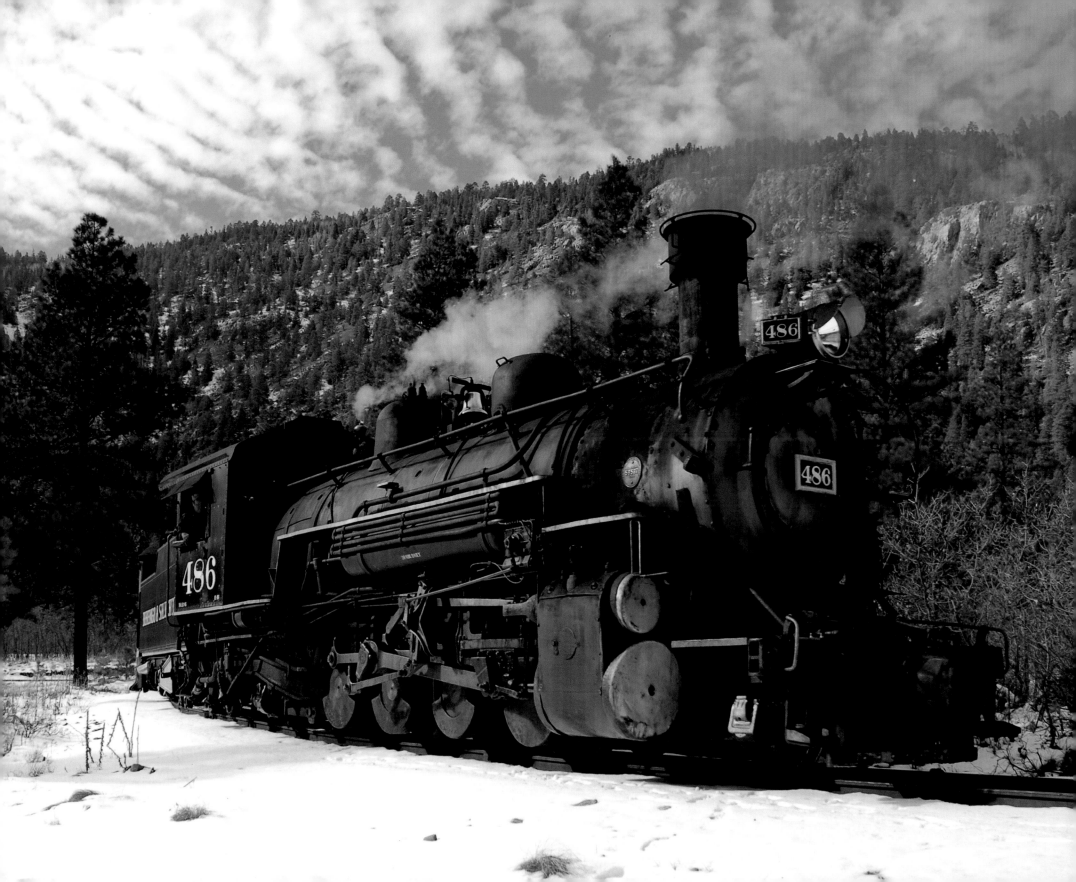

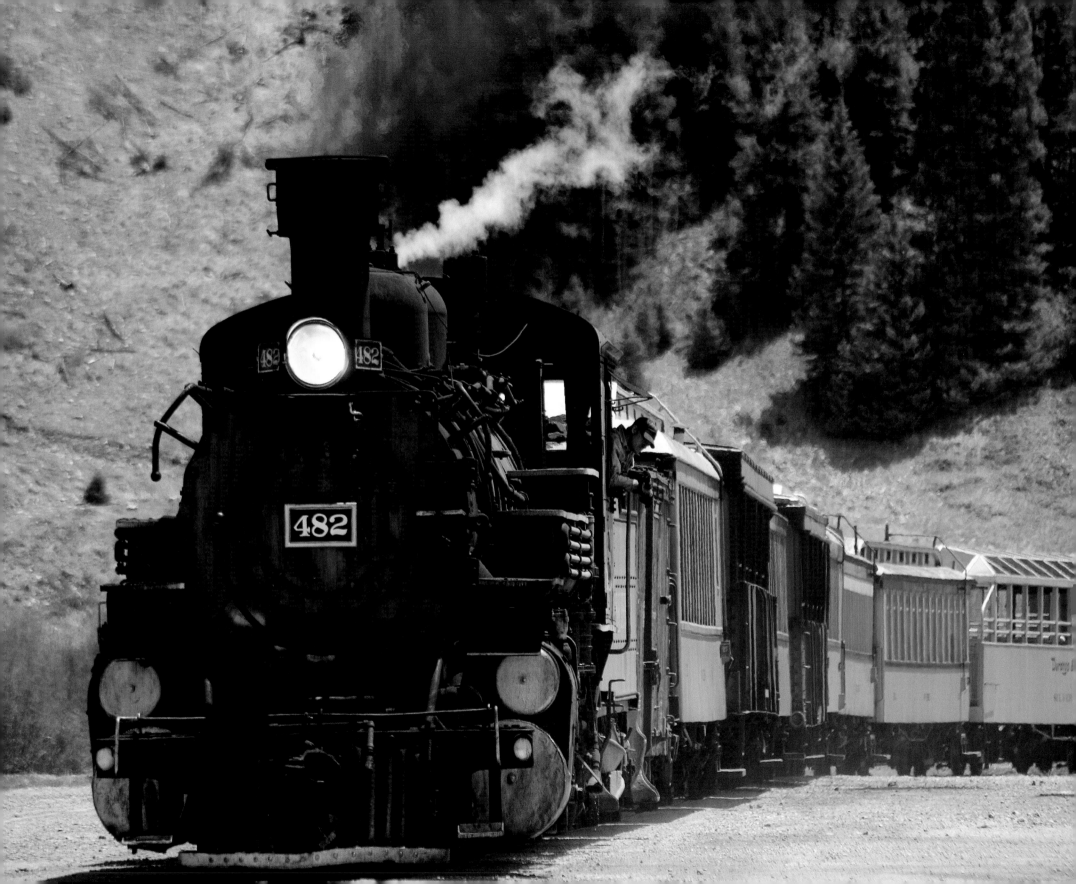

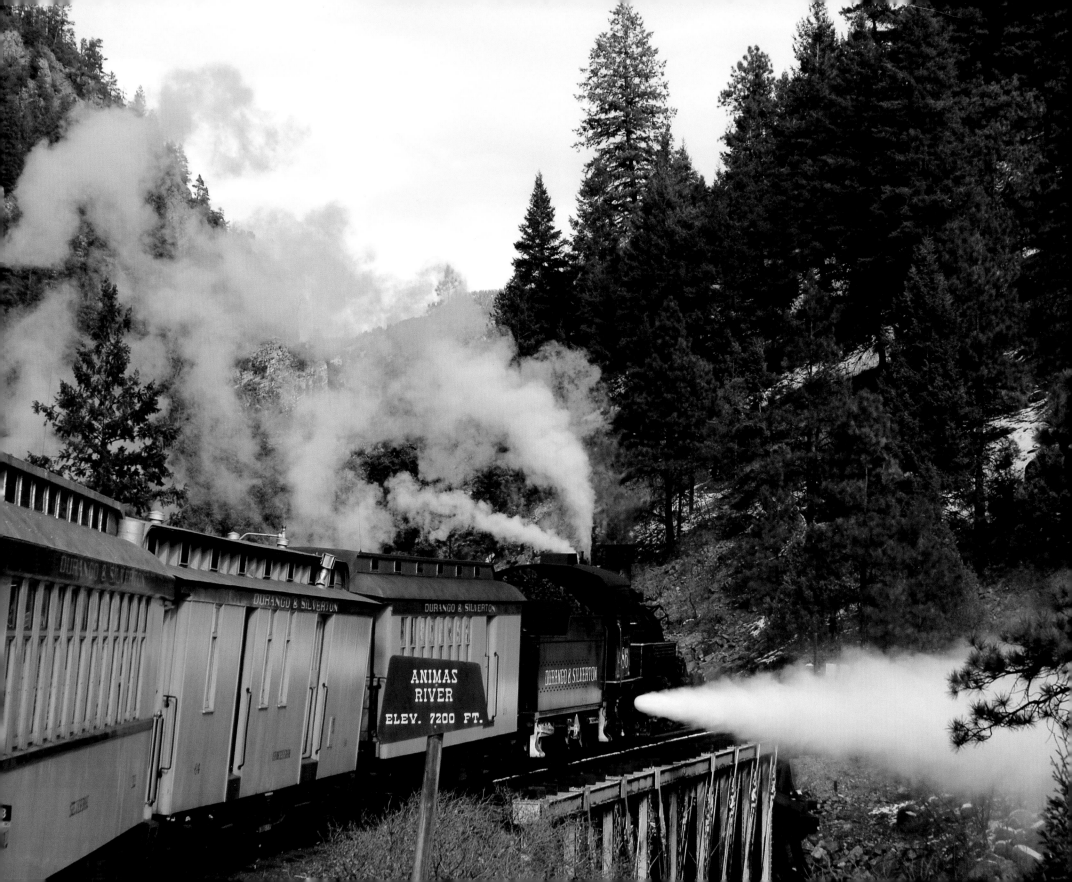

Chapter 2
Seen Their Better Days

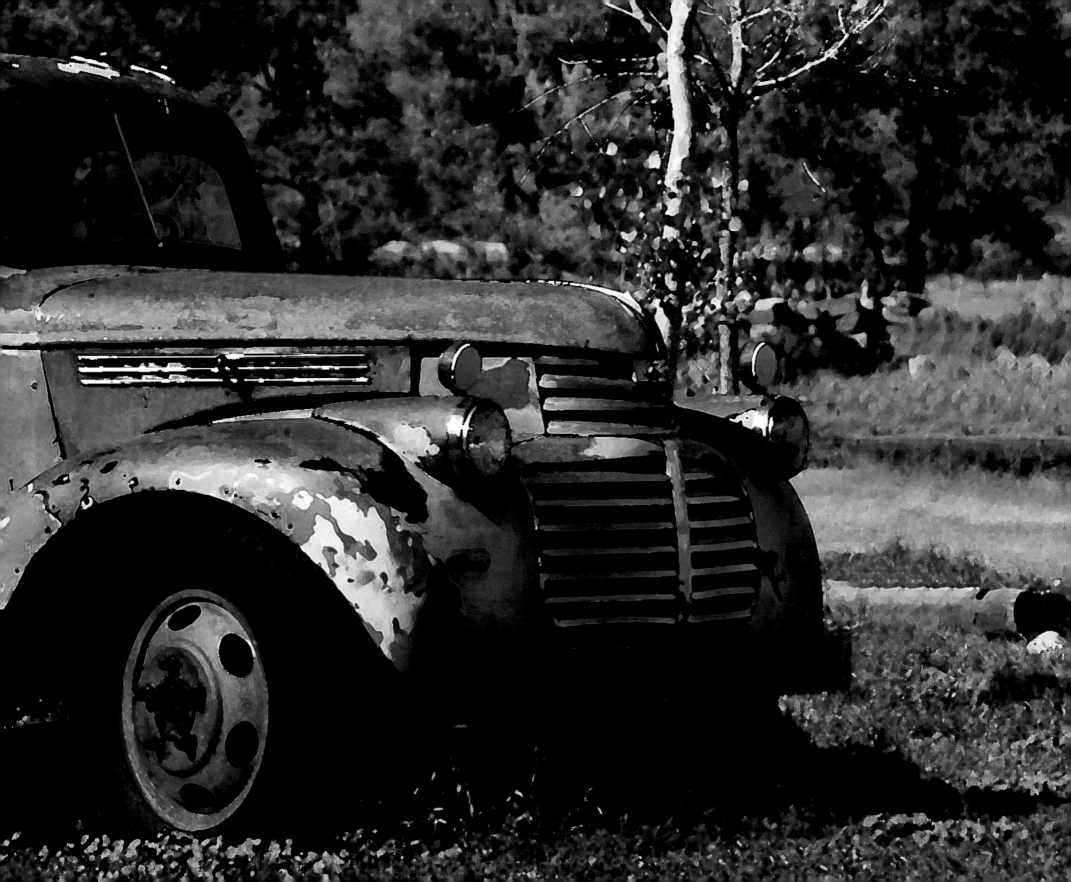

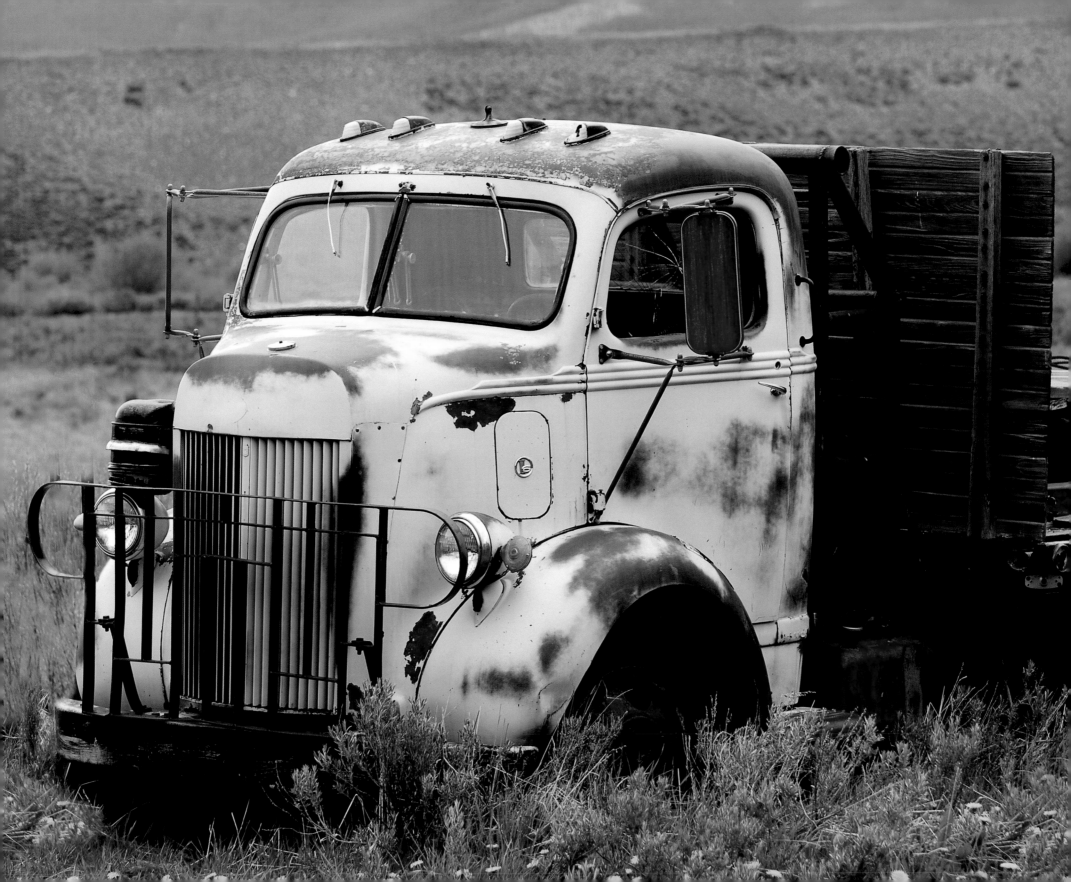

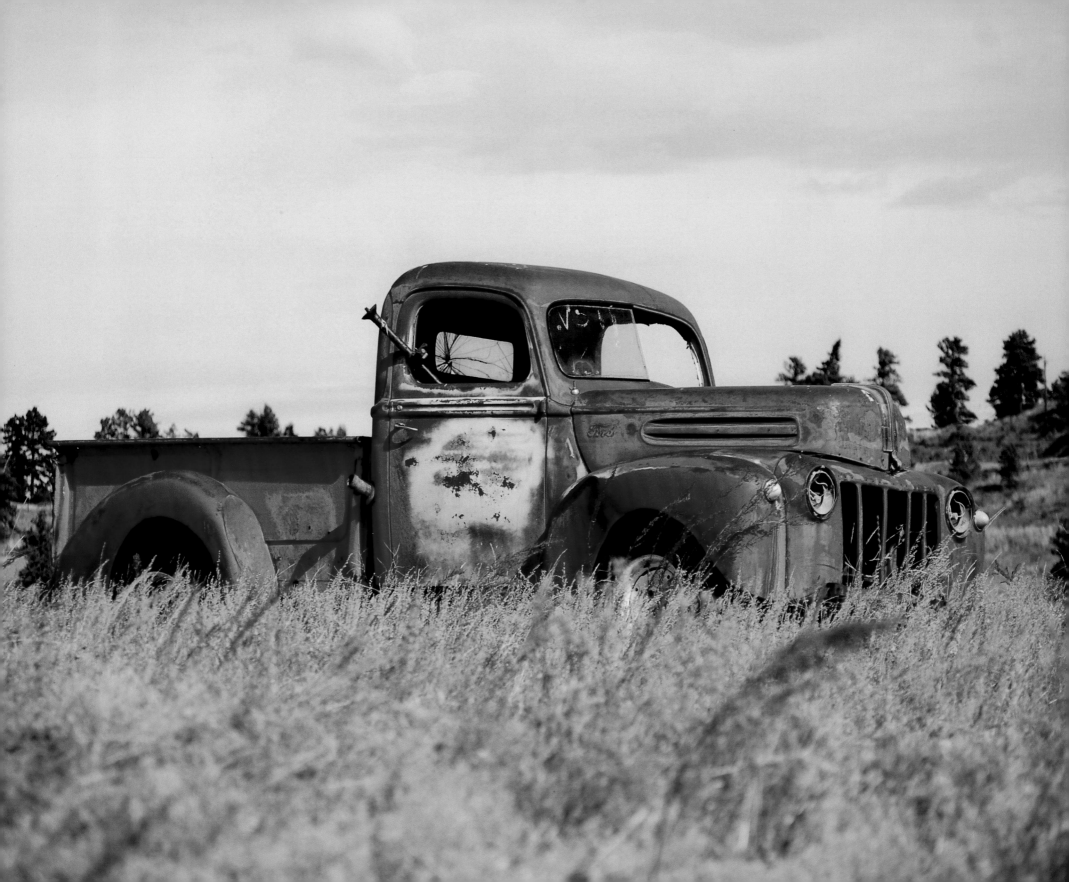

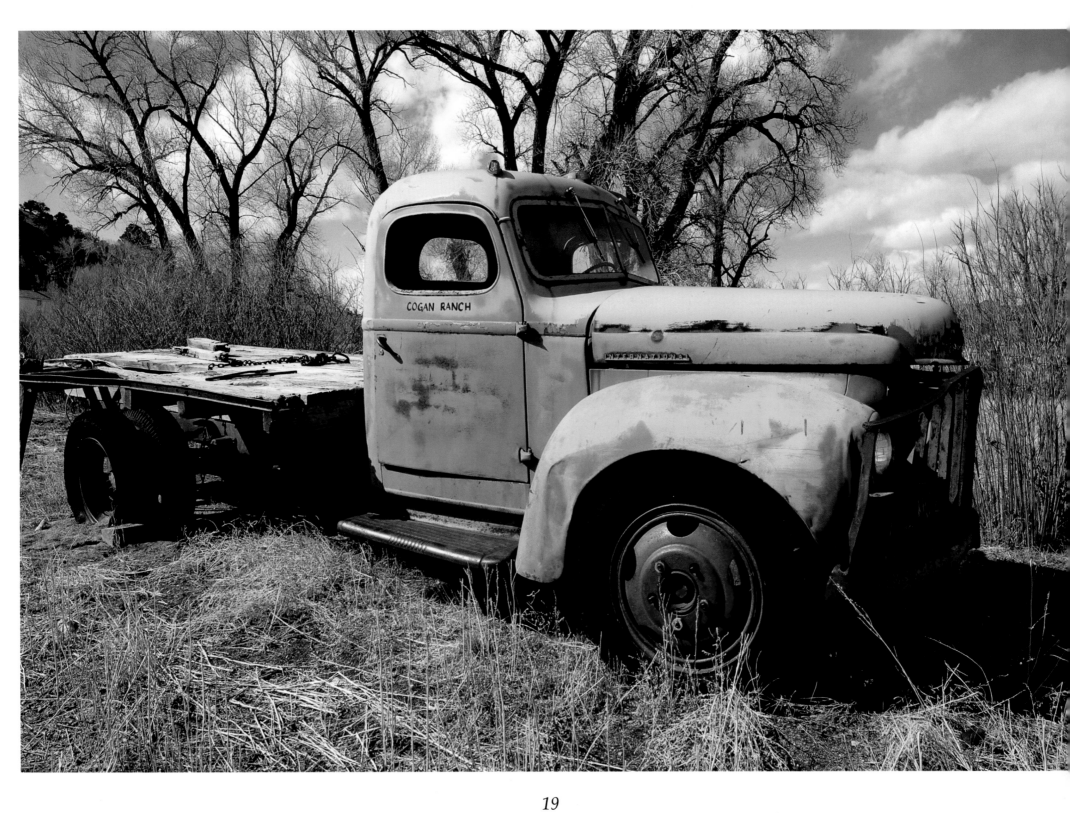

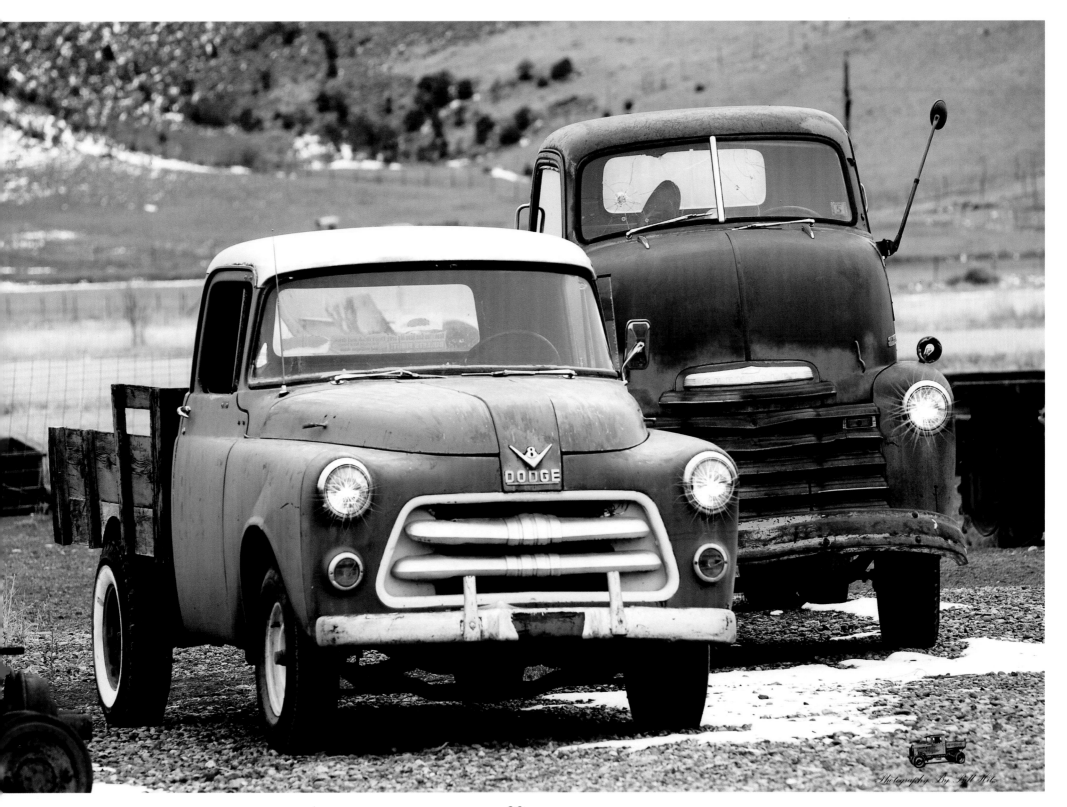

Photography By Bill Hitz

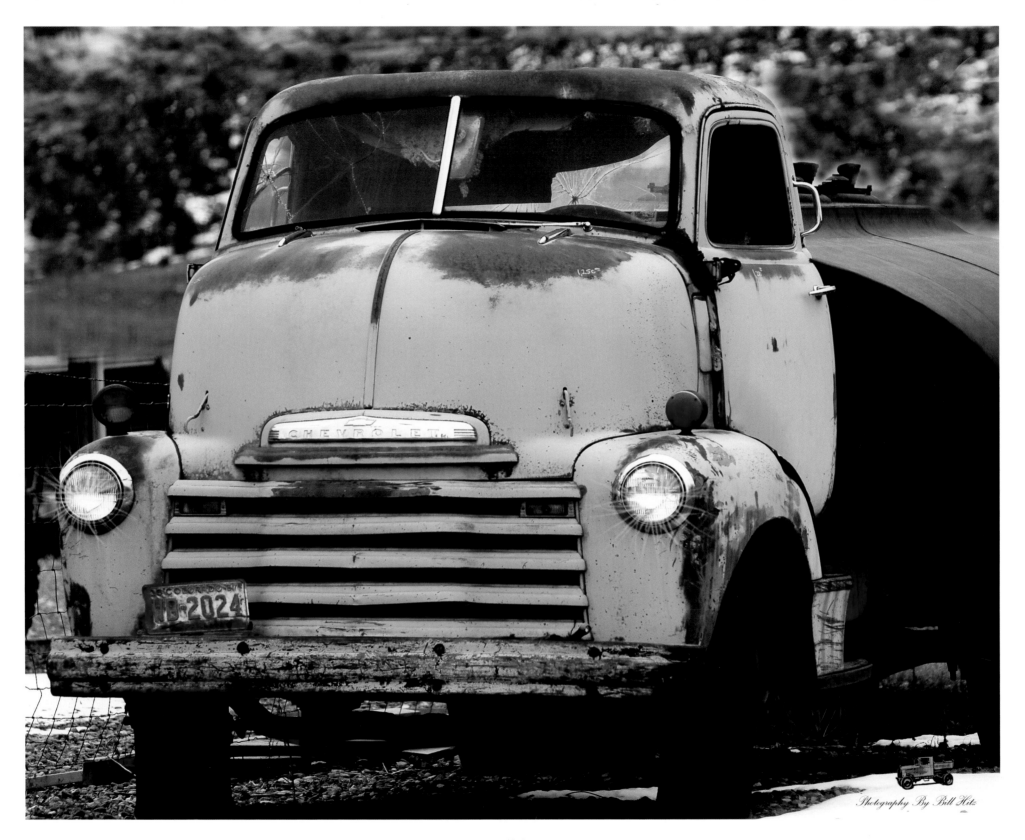

Photography By Bill Hitz

21

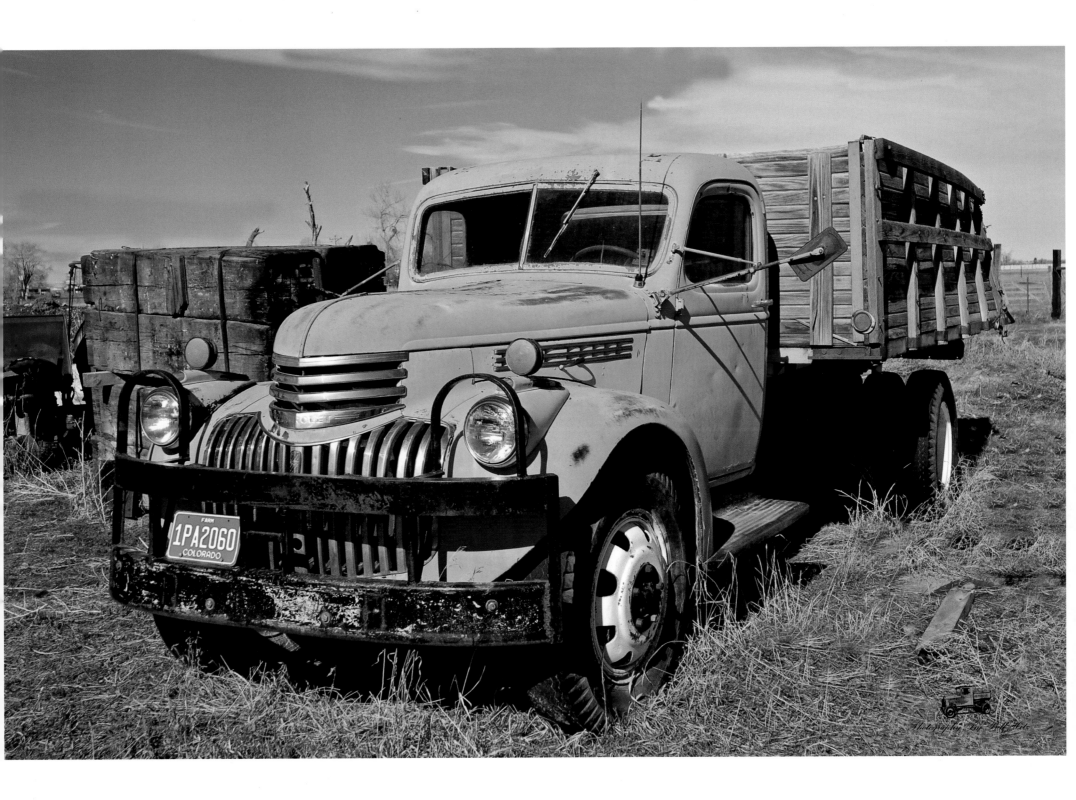

22

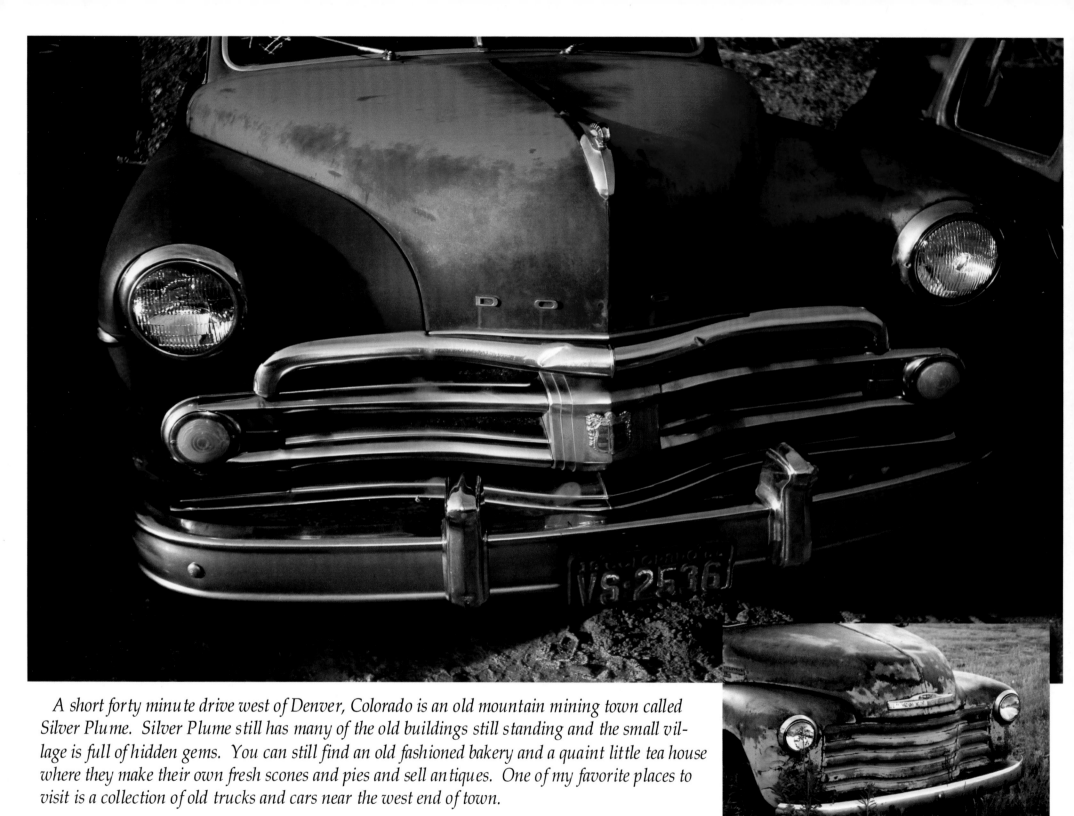

A short forty minute drive west of Denver, Colorado is an old mountain mining town called Silver Plume. Silver Plume still has many of the old buildings still standing and the small village is full of hidden gems. You can still find an old fashioned bakery and a quaint little tea house where they make their own fresh scones and pies and sell antiques. One of my favorite places to visit is a collection of old trucks and cars near the west end of town.

23

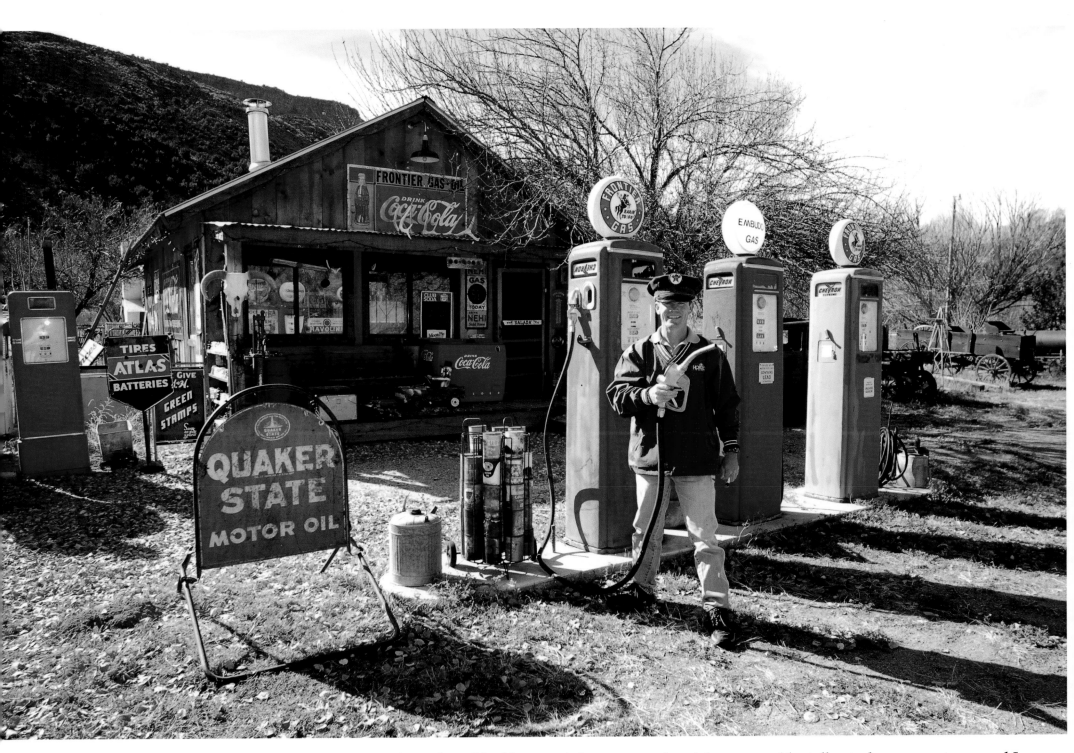

On our way back to Denver from Santa Fe, New Mexico, where I had been training a co-worker, Mac, we accidentally made a wrong turn, and I was glad we did. As we were driving past this junk yard of gold it felt as if we had just passed through a time machine. There were old gas pumps, signs, hats, oil cans and a lot of old vehicles out back. Mac makes a good stand-in prop, too.

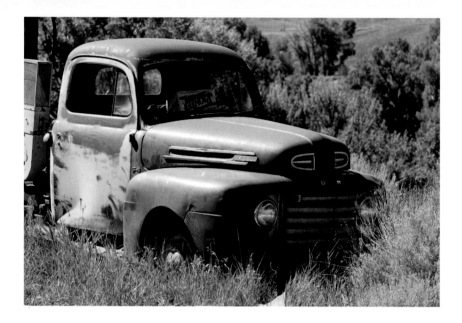

Leadville, Colorado is not only one of Colorado's highest mountain towns; it's also one of the coldest! There are many historic buildings here dating back to the bustling days when it was a busy mining town. I had always wanted to get a photo of the old Tabor Opera House.

I decided to stop one cold winter day on my way through town. Just as I was lining up my shot, this old Checker cab pulled up and stopped just in front of the old hotel, just as if it was there to pick one of her guests. This is the same Checker cab that was used for decades in cities like New York City. Checker Motors built cars from 1922 through 1982; however there are few that still exist from before 1962. I have been told many times that I am at the right place at the right time. This was one of those times.

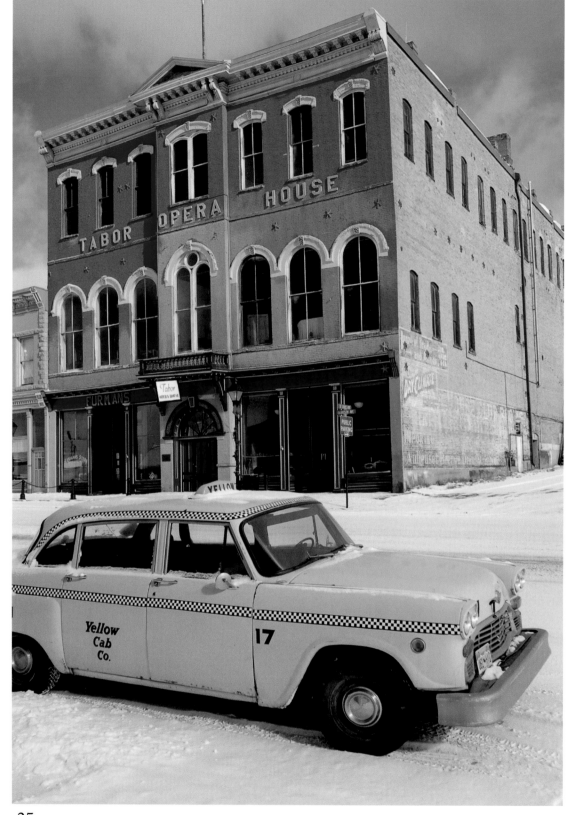

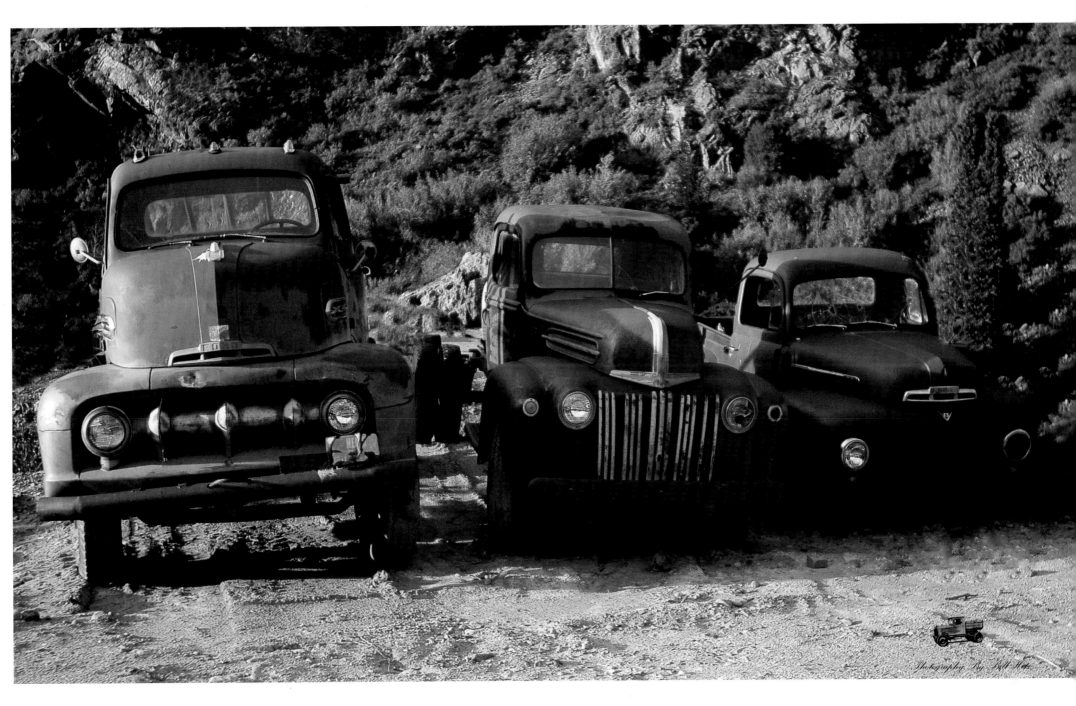

Silver Plume, CO.

26

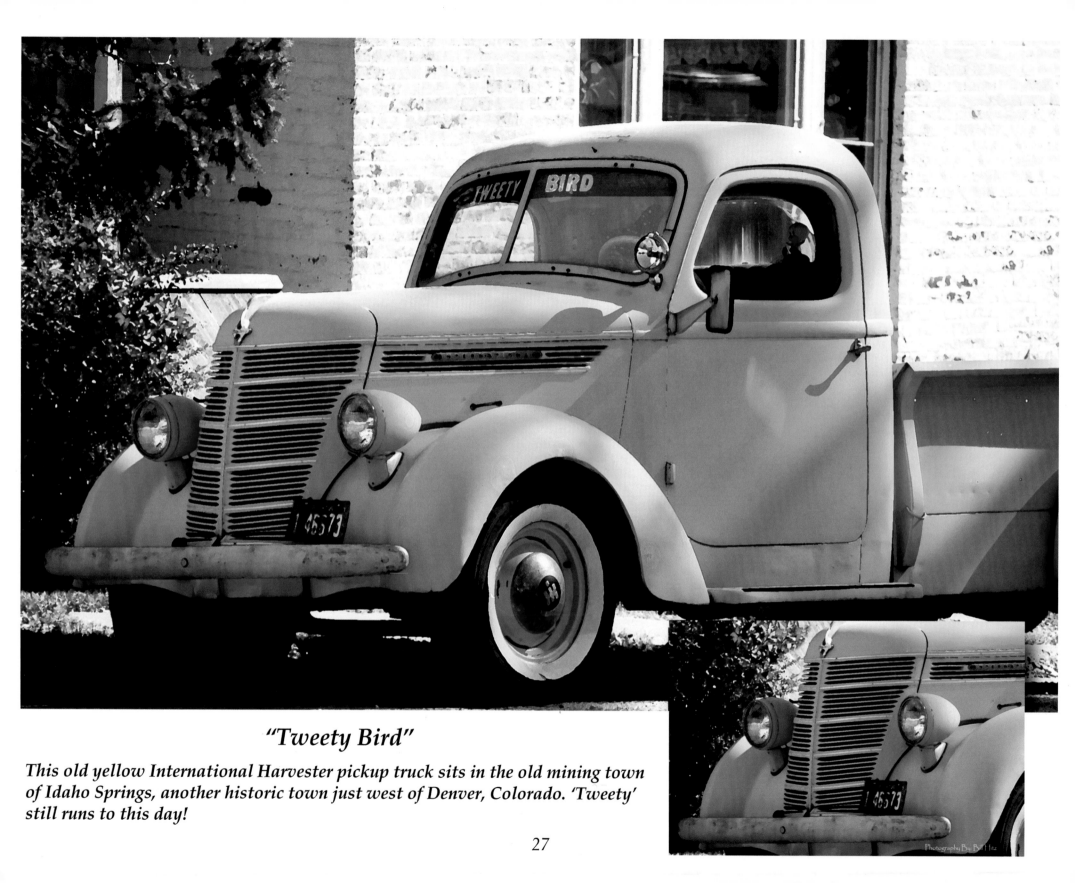

"Tweety Bird"

This old yellow International Harvester pickup truck sits in the old mining town of Idaho Springs, another historic town just west of Denver, Colorado. 'Tweety' still runs to this day!

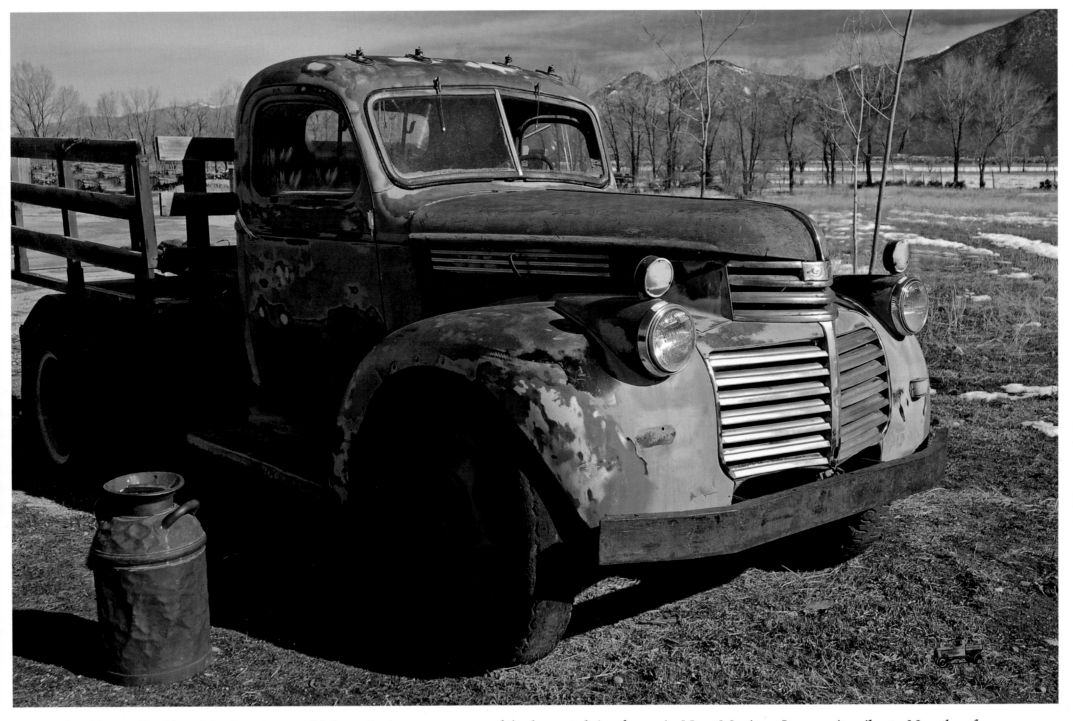

North of Santa Fe, New Mexico sits an old farm that was once one of the largest dairy farms in New Mexico. It now sits silent. No other farms can be seen for miles around. It makes you wonder where all the old farms and farmers have gone.

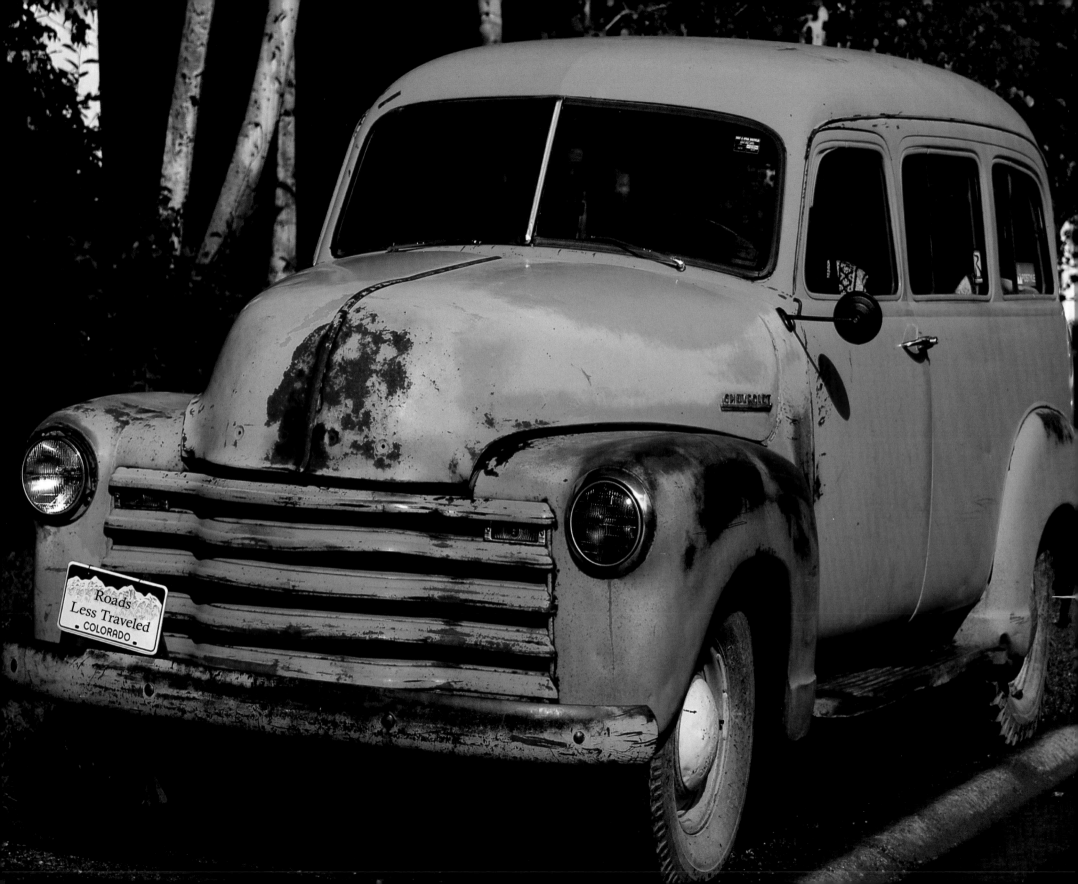

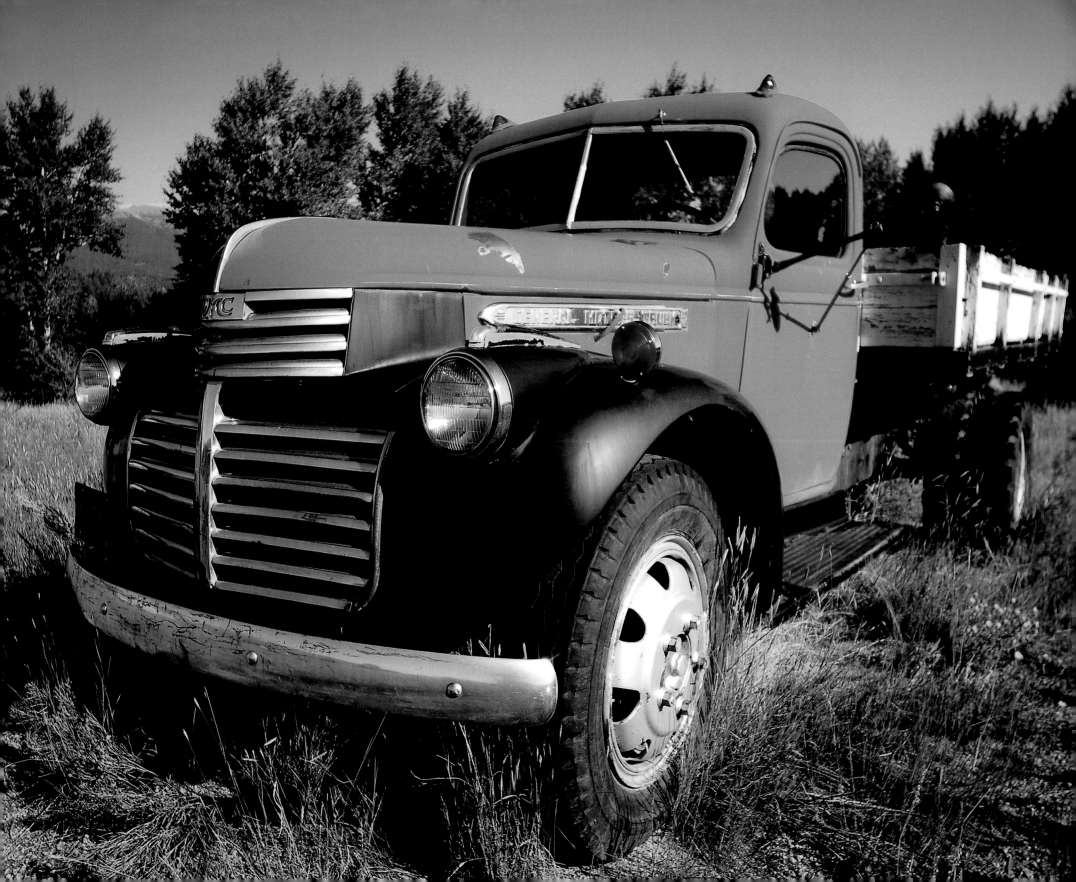

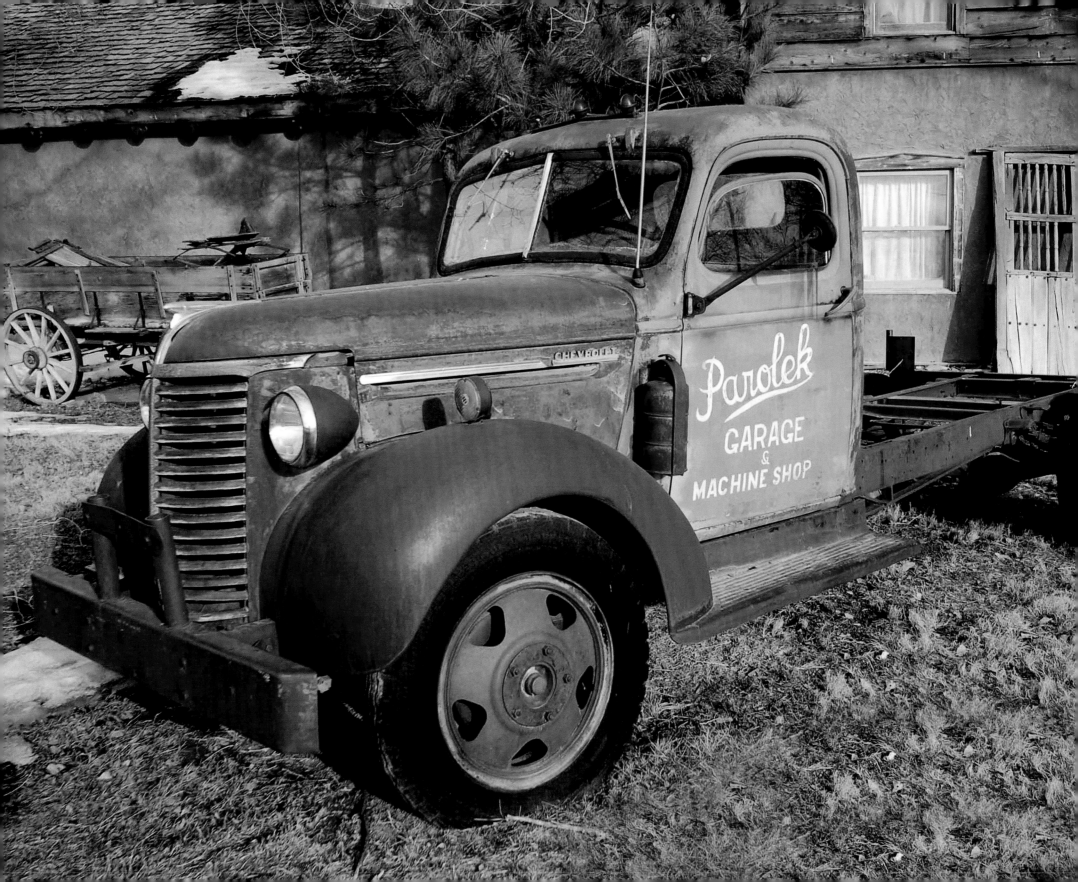

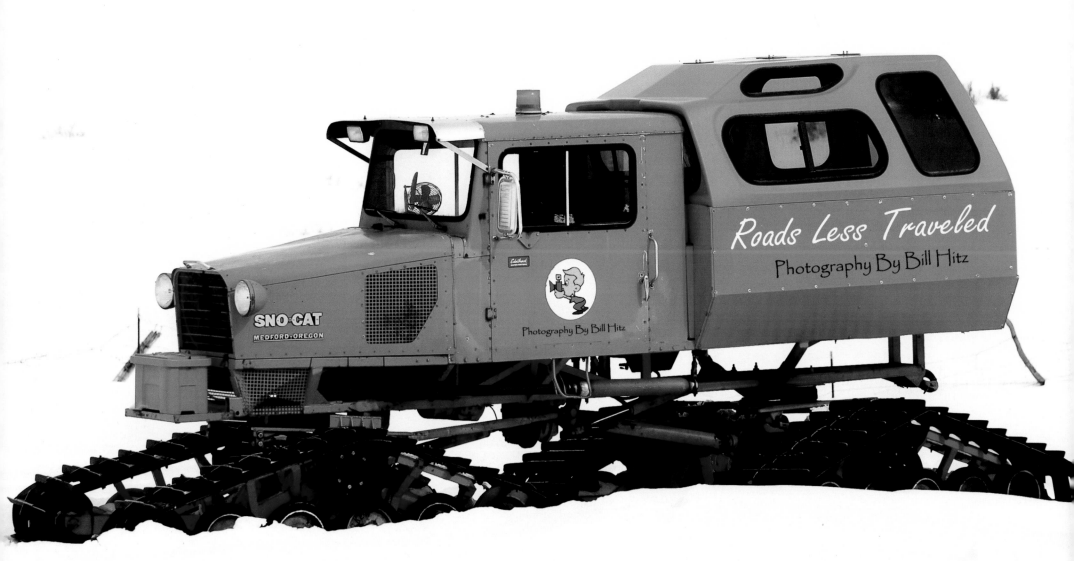

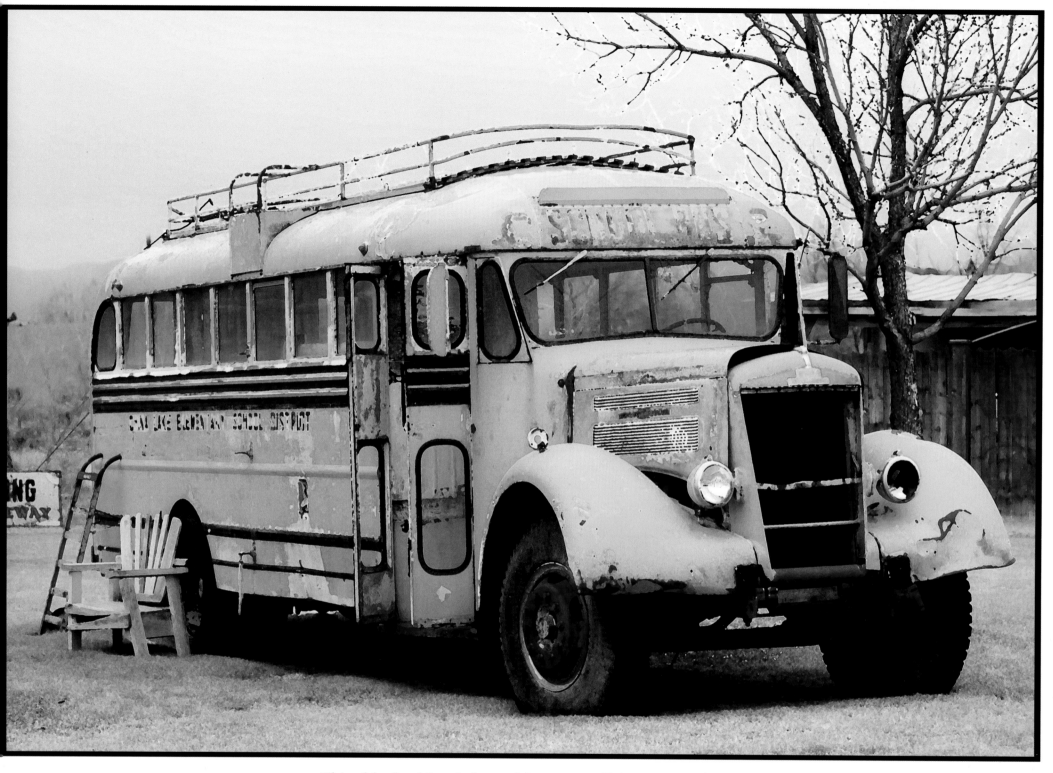

This old school bus is located just west of Montrose, Colorado

33

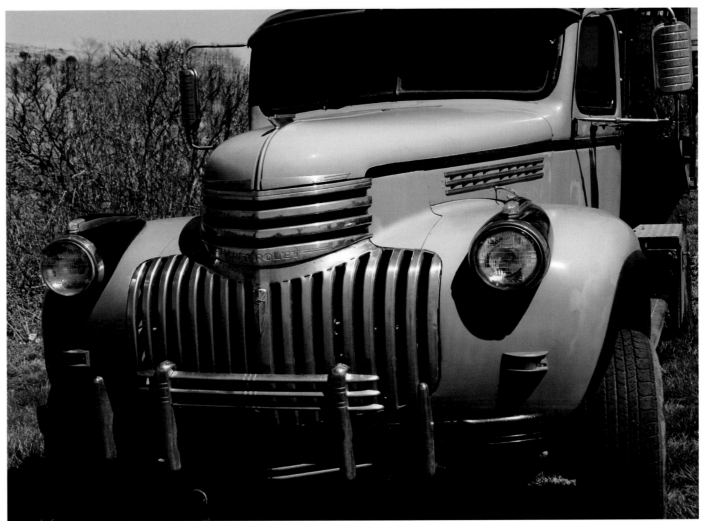

Many of the roads I travel go through farm and ranch lands. Everywhere I look I see a land that is rich in history. I look for old trucks and farm equipment as I drive these lonely roads. They come in all shapes and have so many different colors. It's almost like a rainbow dropped every shade of color, from bright to pastel, creating true works of art along the trail, just waiting to be discovered. The cold, heat, rain, snow and winds create the effects on these old vehicles. I remember my grandfather had some old cars that just sat out in all kinds of weather for year after year. Amazingly enough some of these old trucks can be worth a lot of money. They have truly 'seen their better days.' This is not junk. This is art. You just have to view it in a different way. It makes one reflect on what it was like on the farm back then. The old farm is silent now. The old trucks sit still. Soon they will be gone. So many farms are disappearing. What happened to these families, the crops, and the land? I'm sure those old trucks never had to run on gas made from corn. Most of them are gone now, but the few left behind tell the story of what life was like growing up on the farm, so don't take them all!

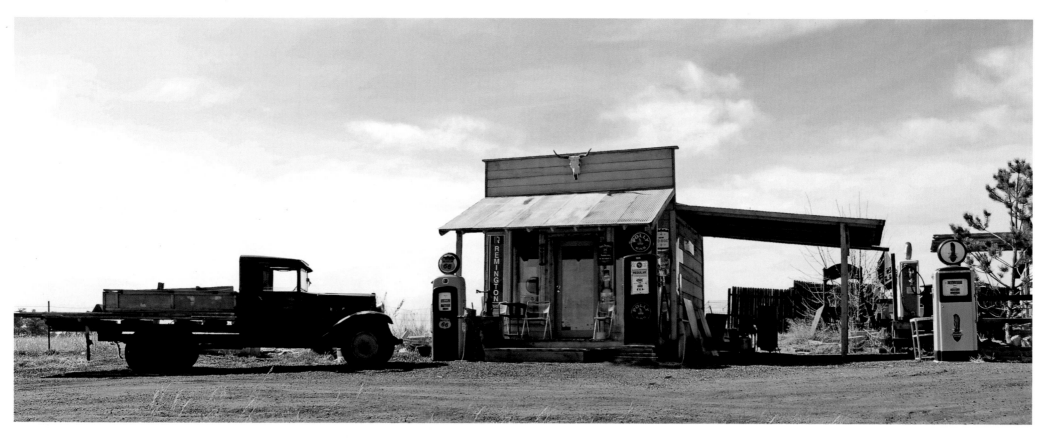

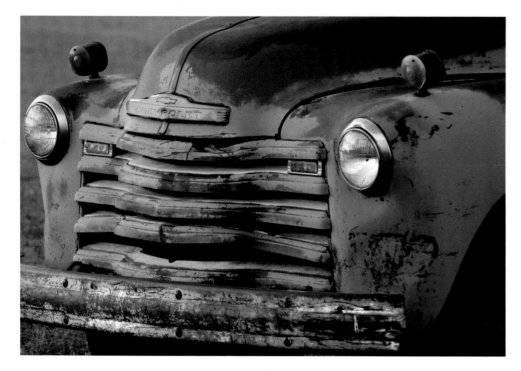

The photo above was taken just the way it sits. I have traveled this road near Franktown, Colorado many times and never noticed this place before. One day I saw the old truck and drove a little closer. I wanted to fill up my tank but the pumps didn't work.

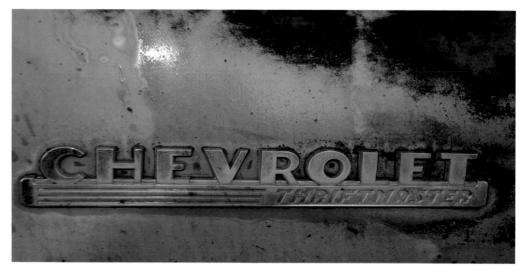

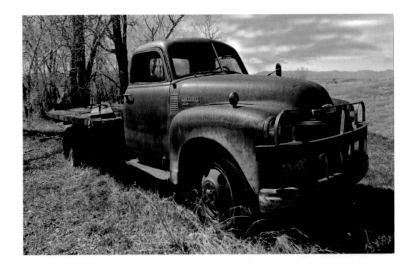

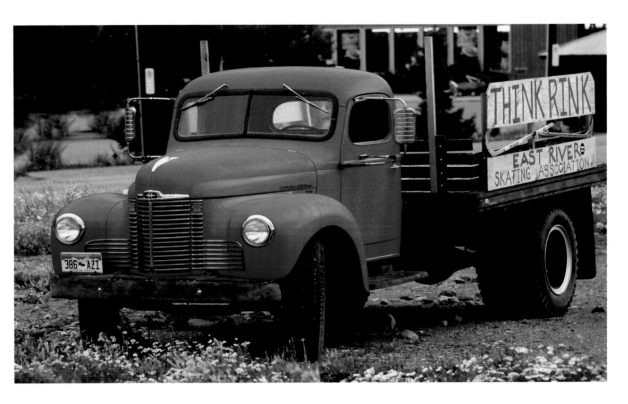

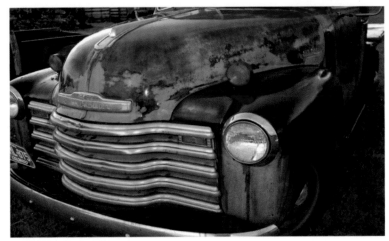

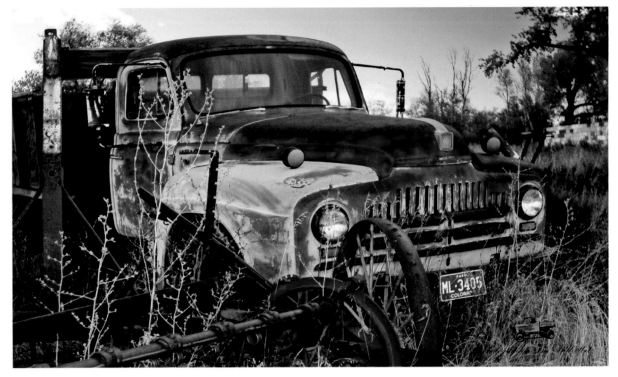

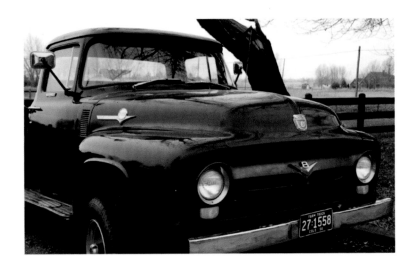

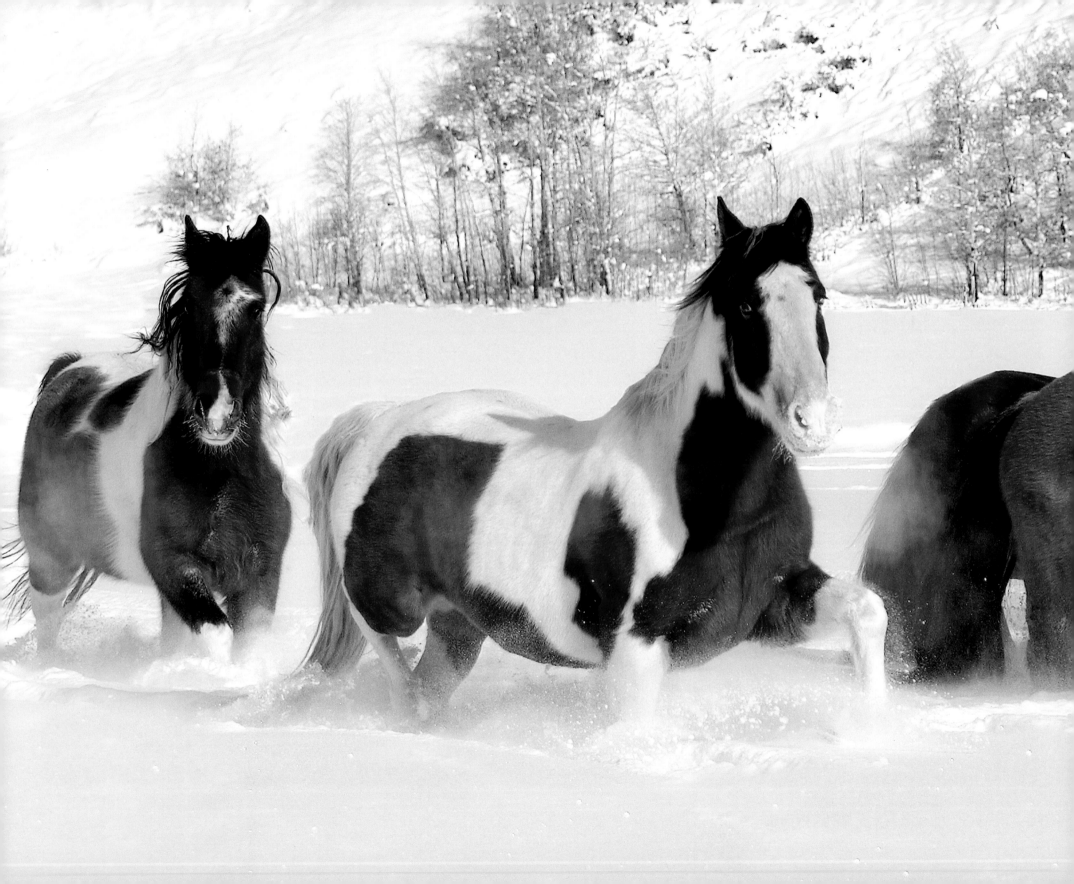

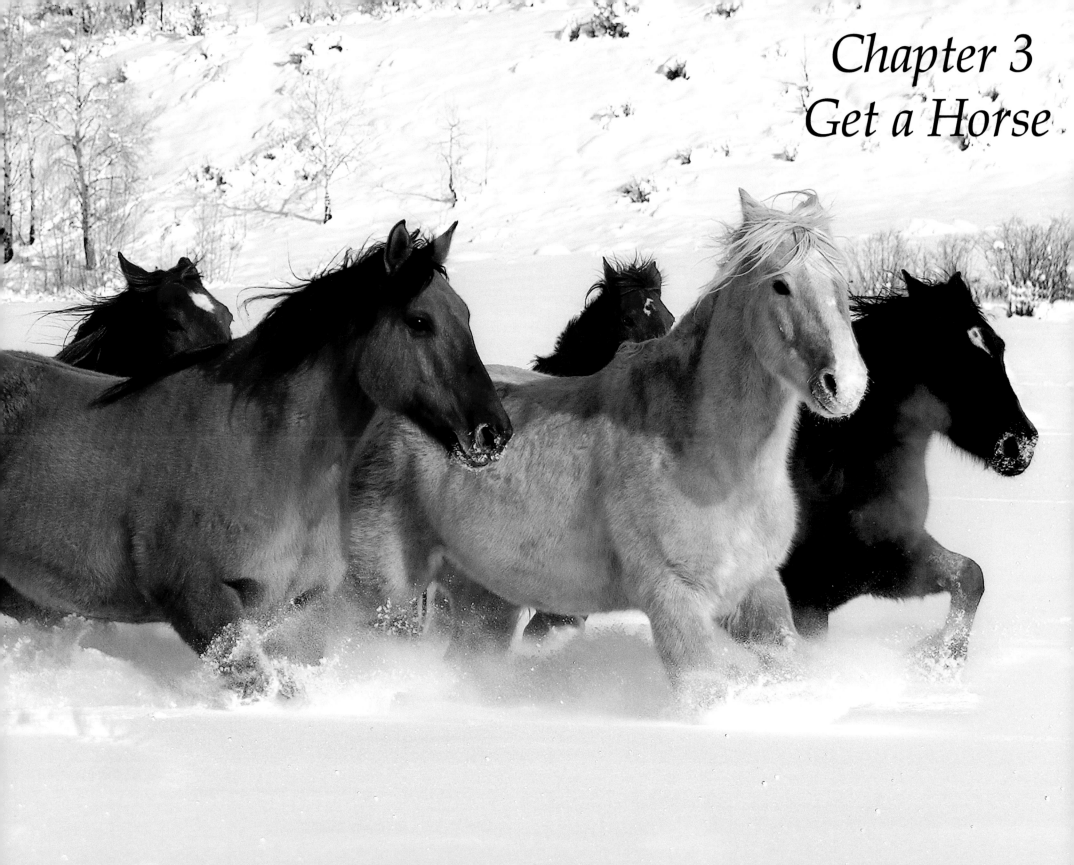

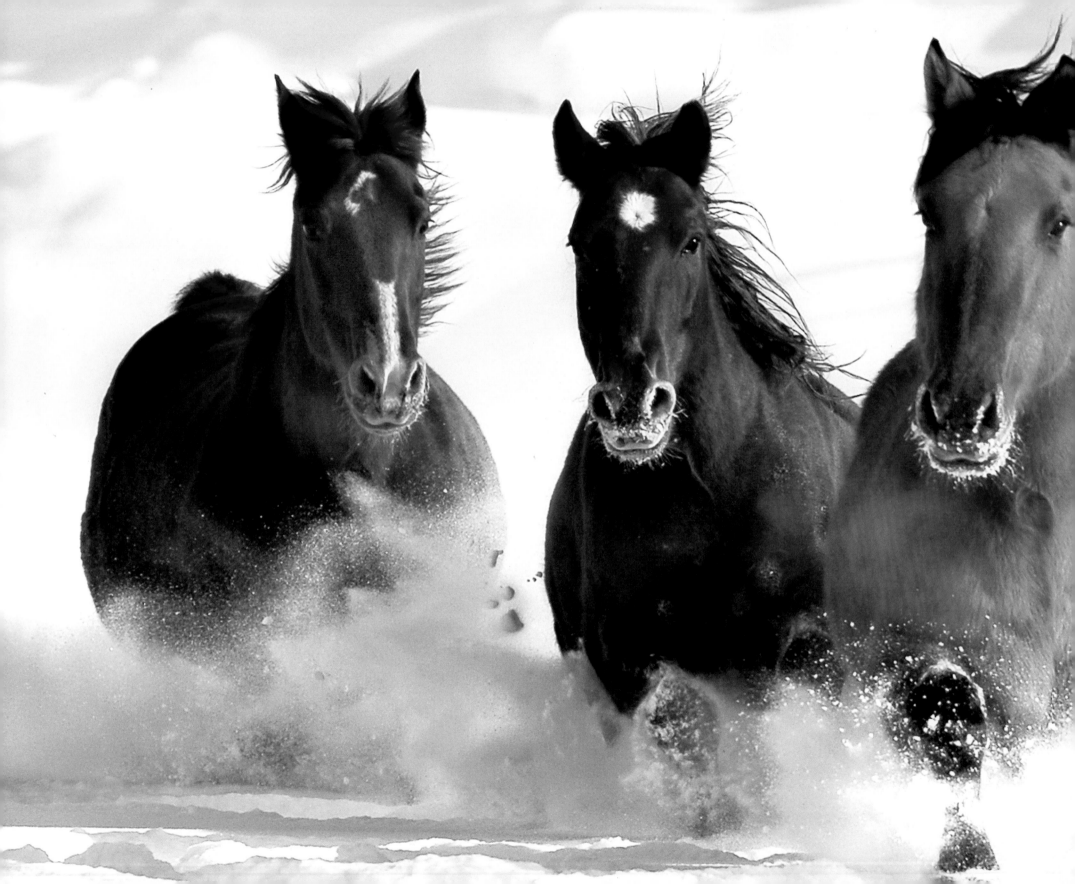

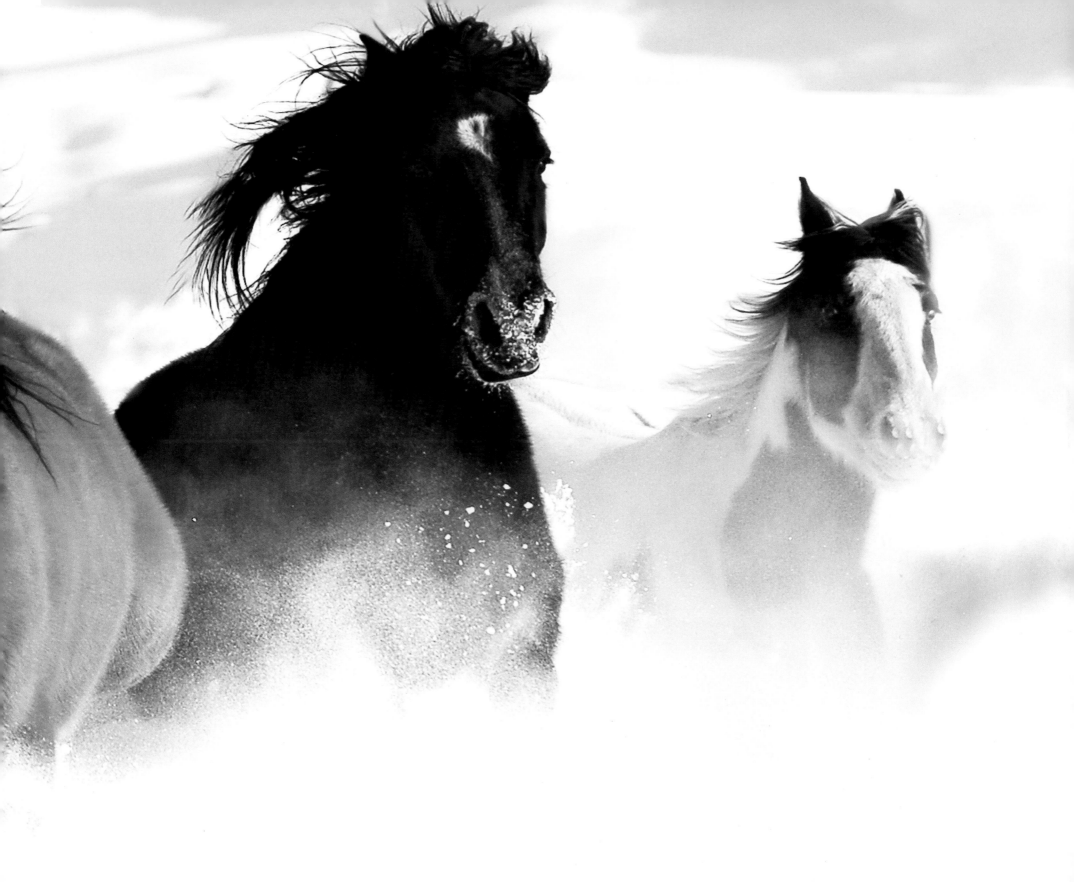

On the roads I travel, horses are everywhere. The key is to be willing to stop and take the time to get the photos when the opportunities present themselves.

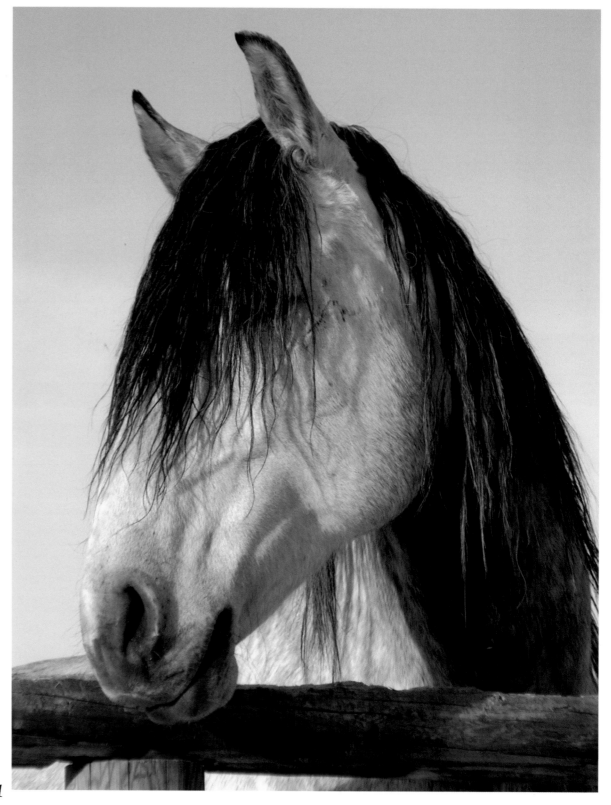

41

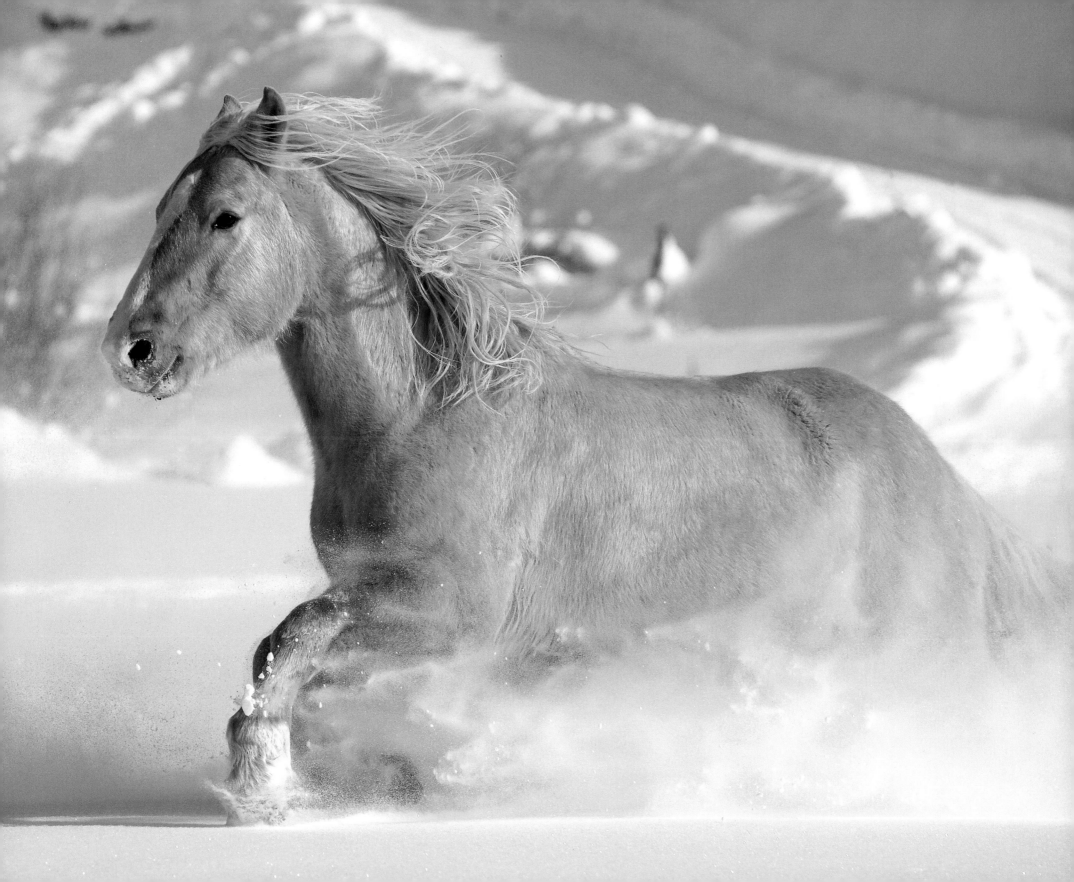

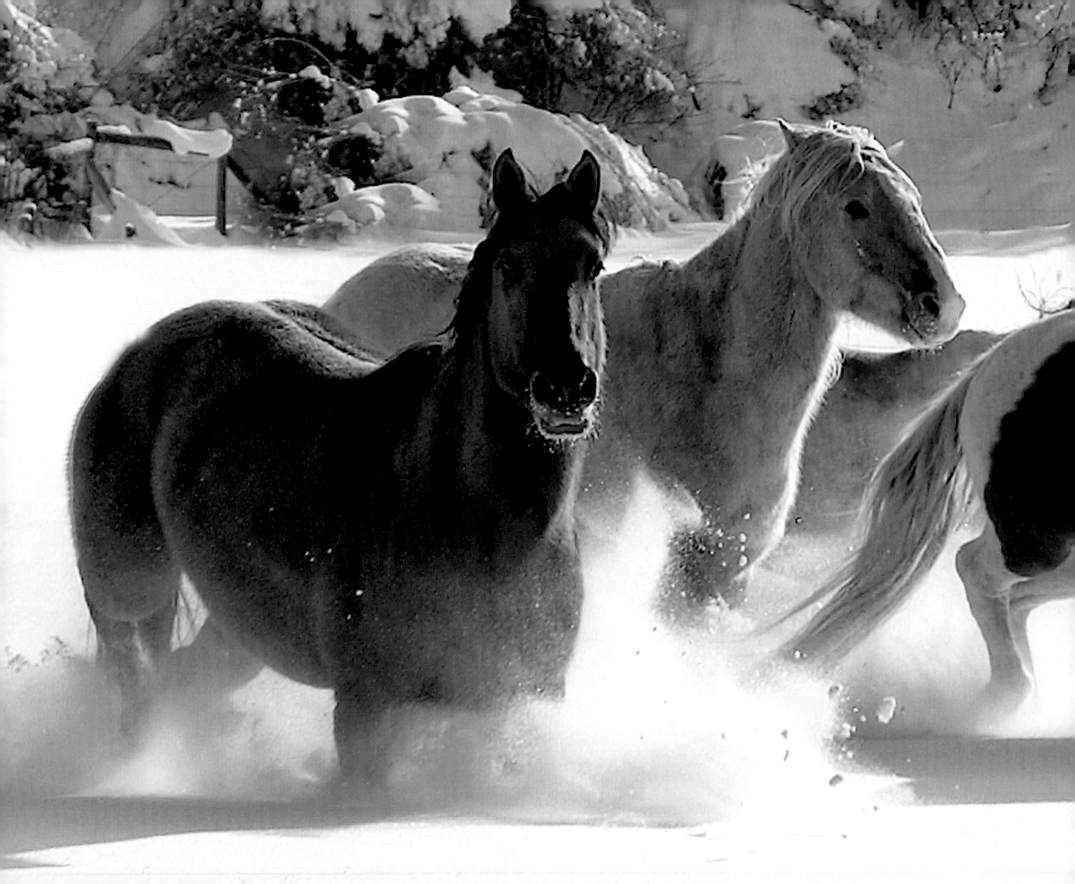

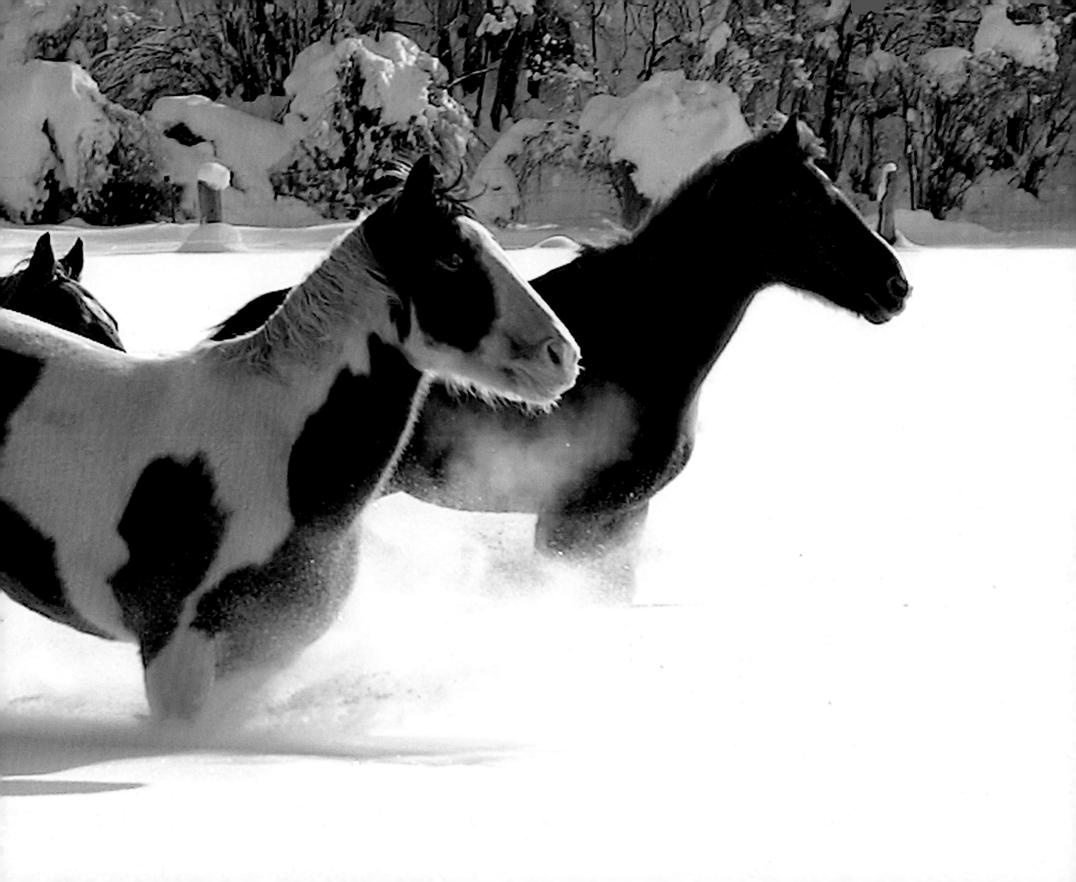

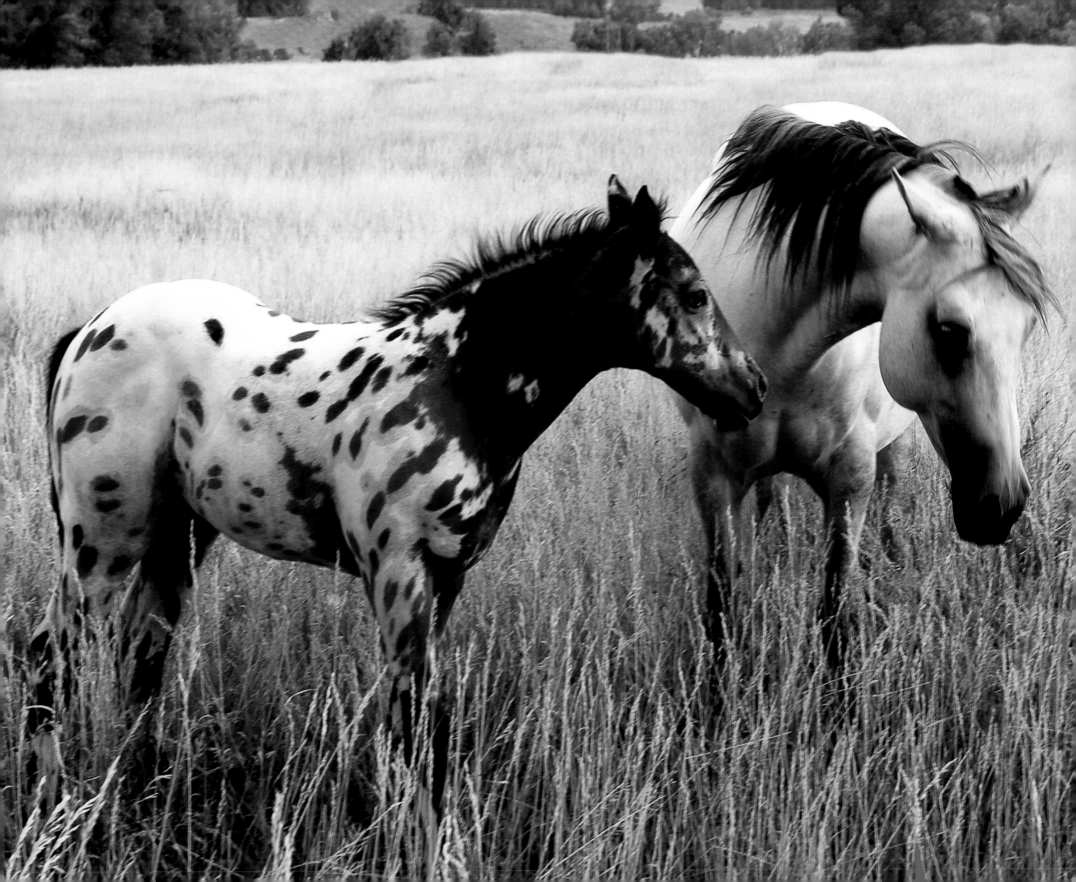

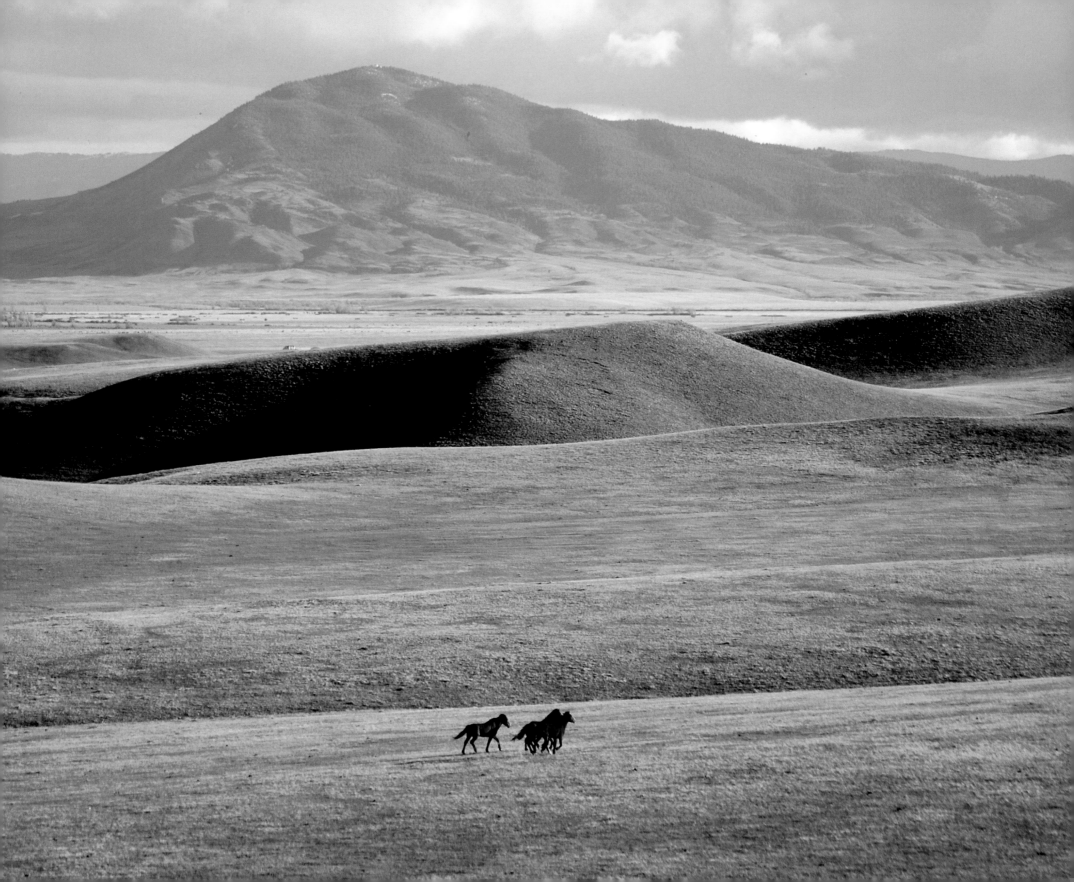

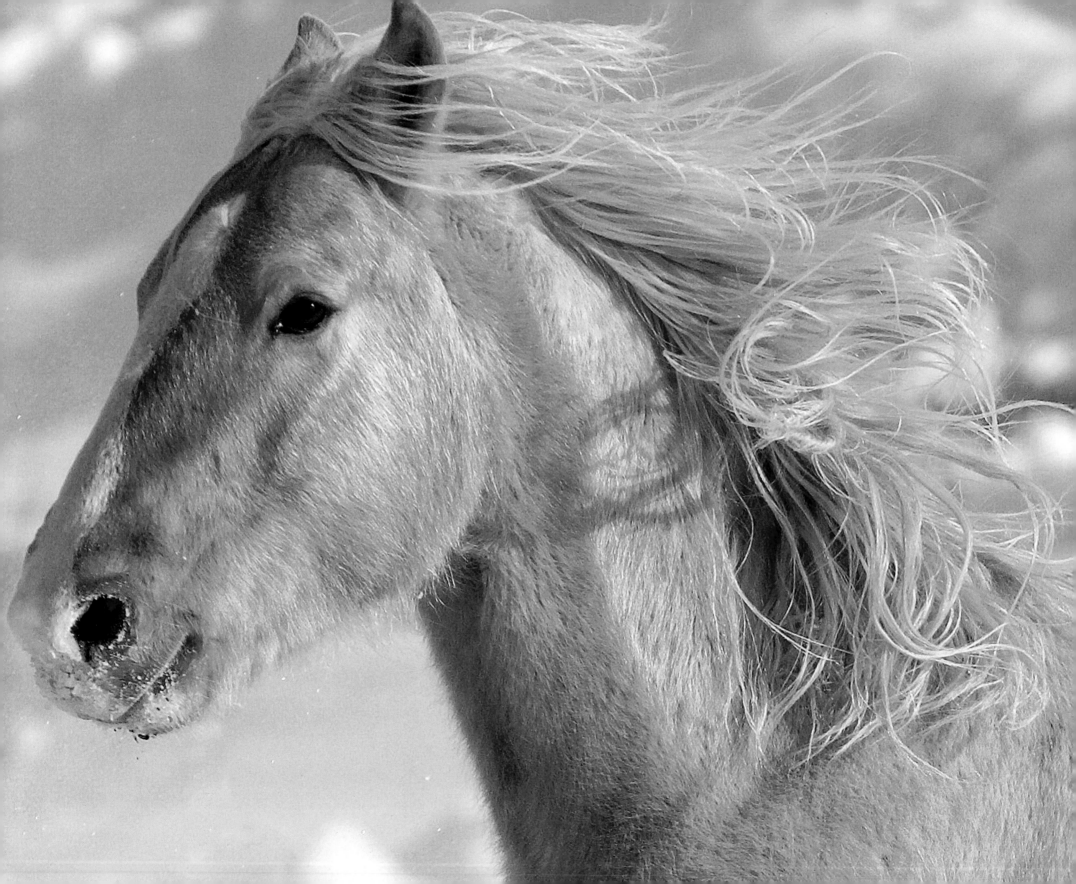

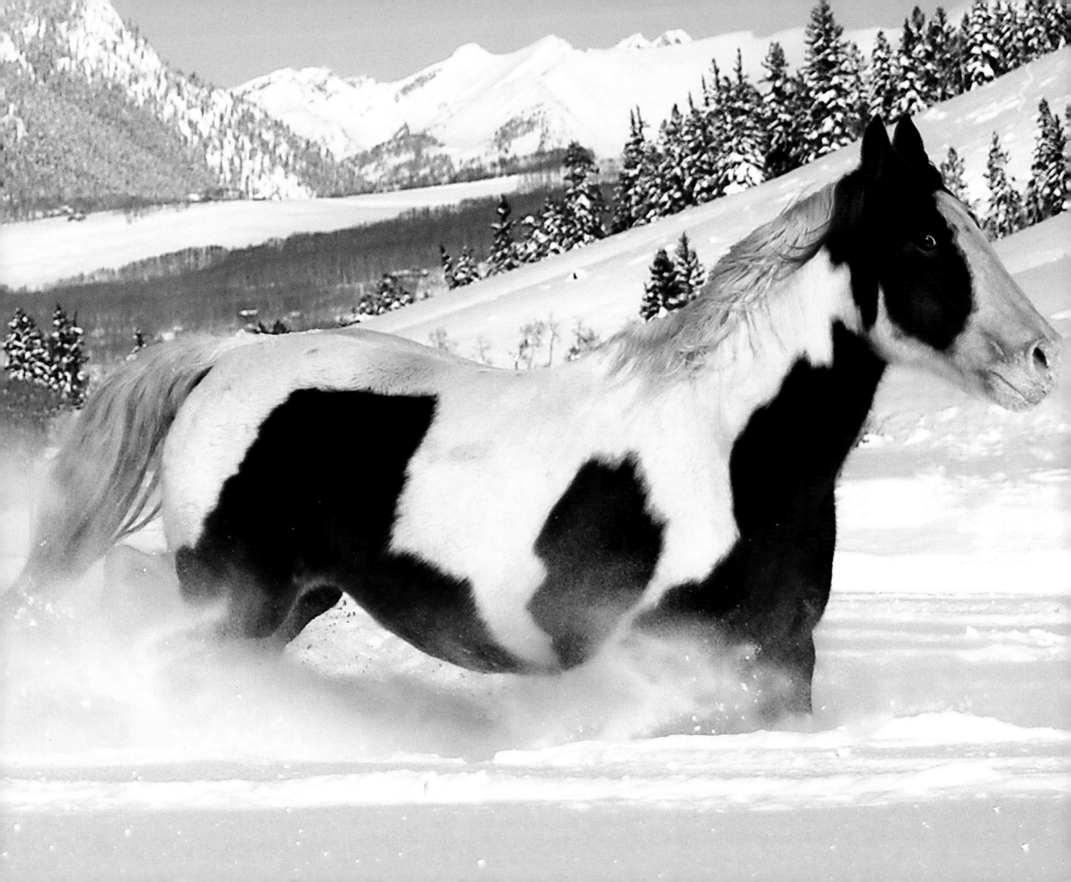

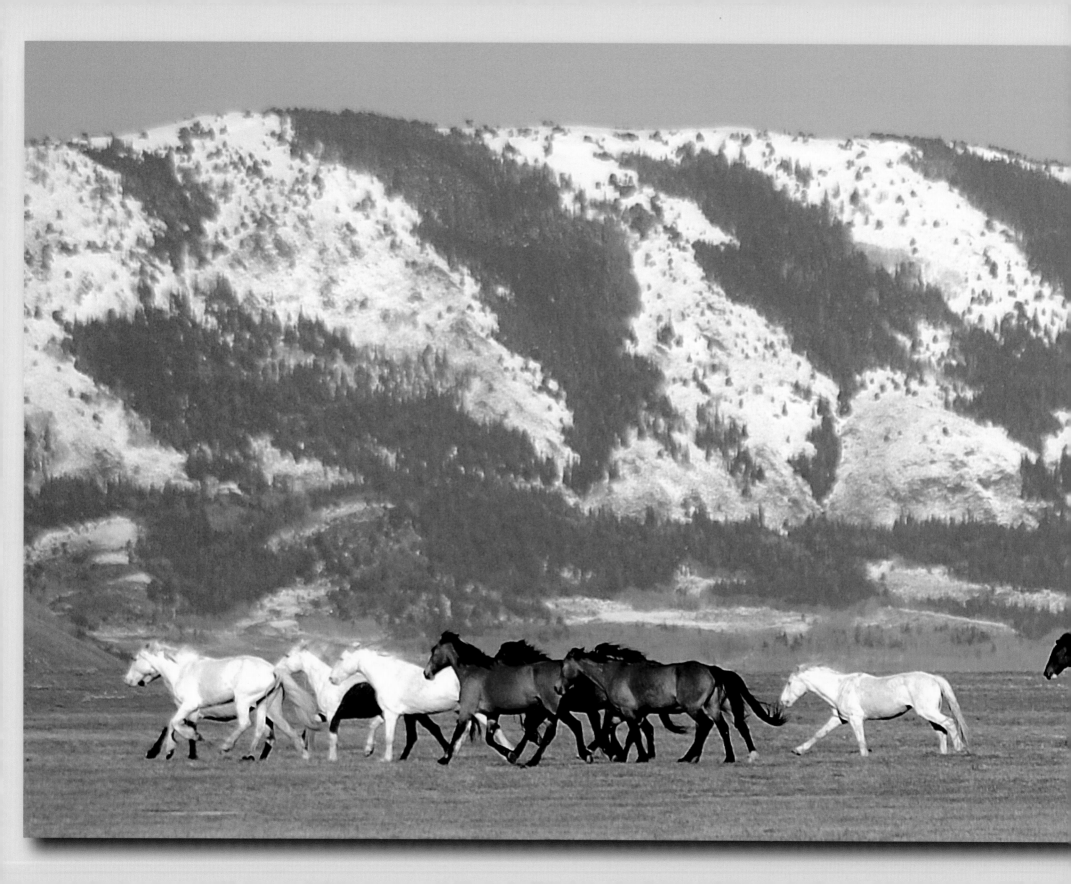

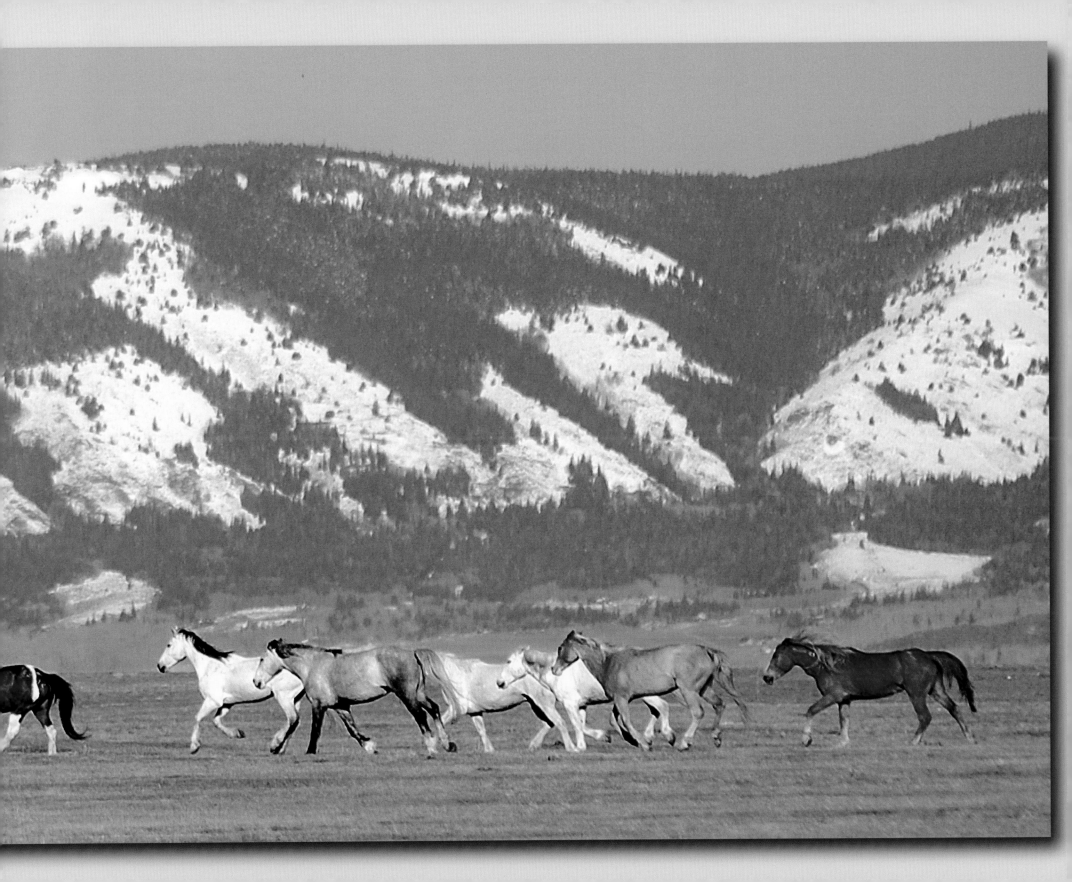

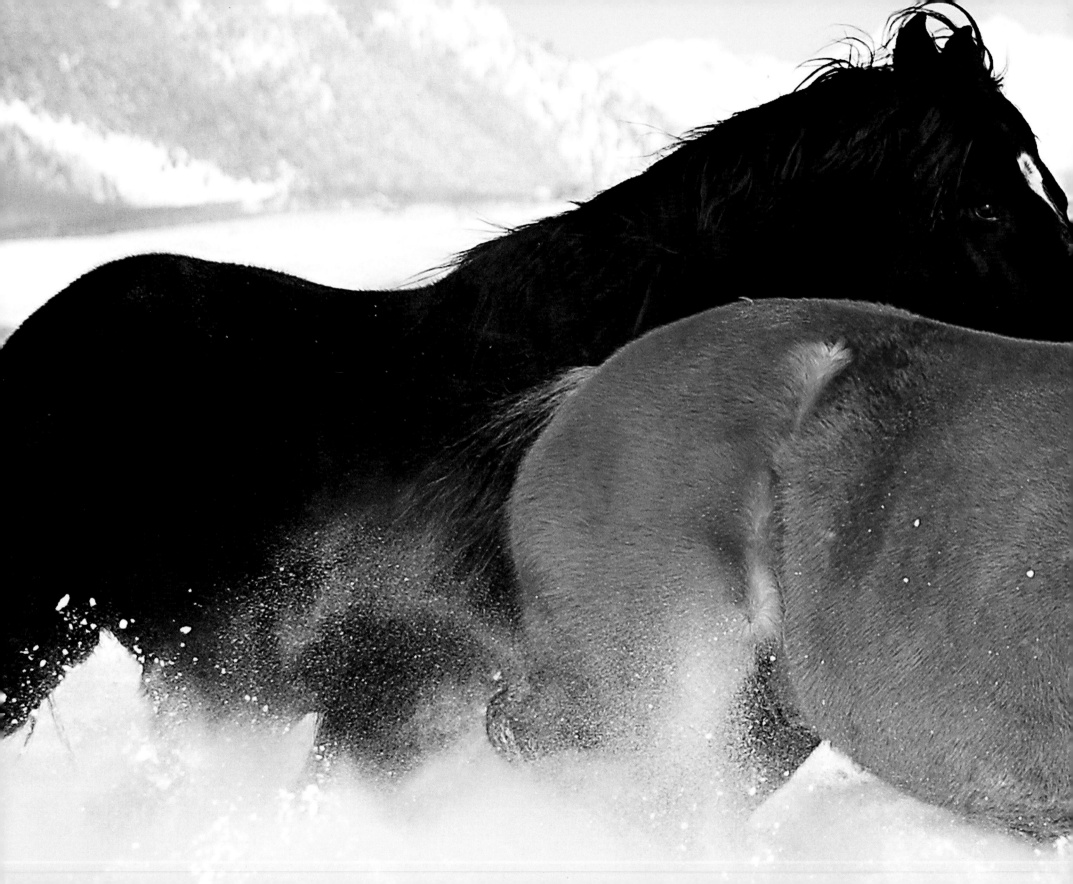

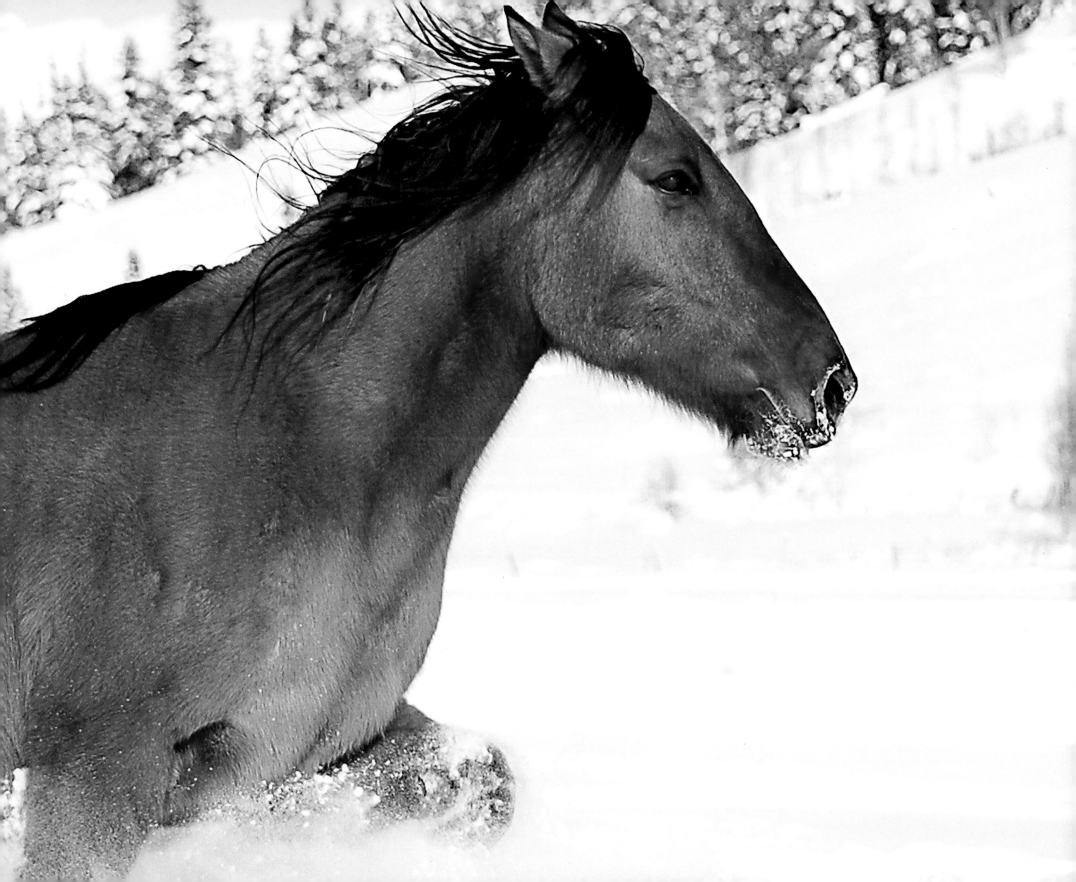

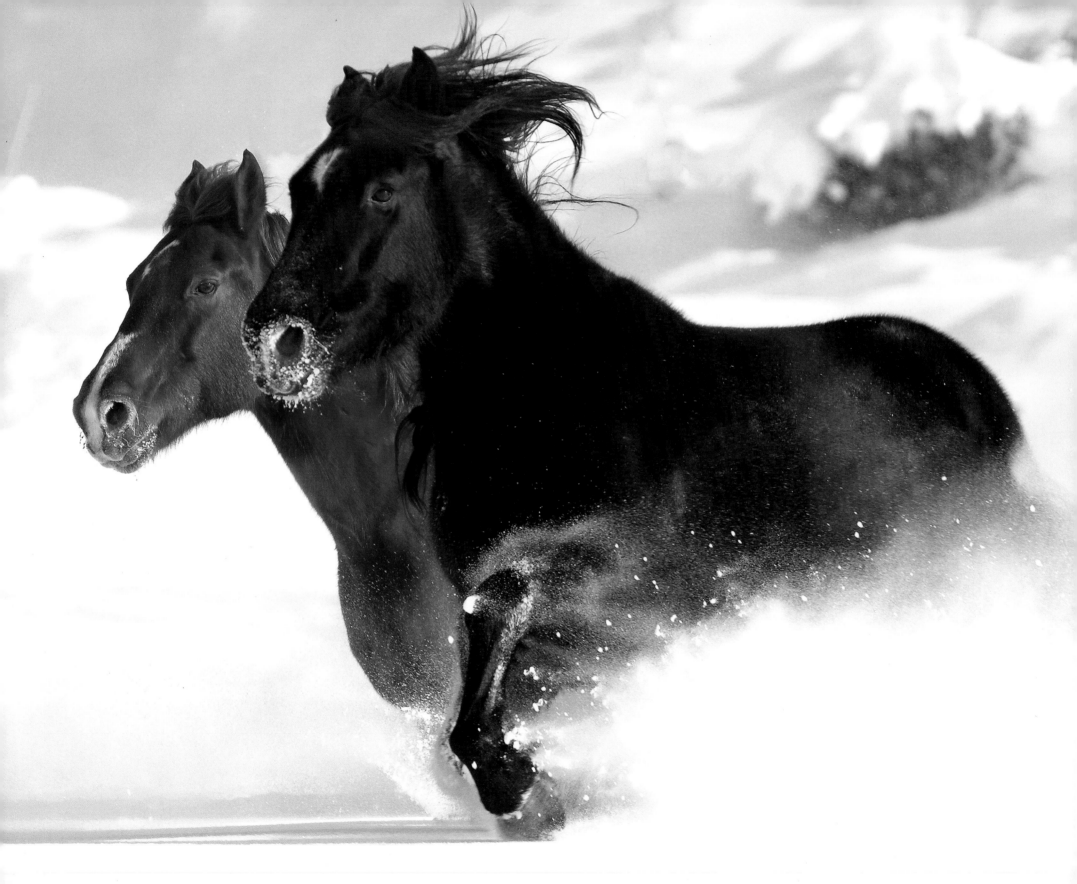

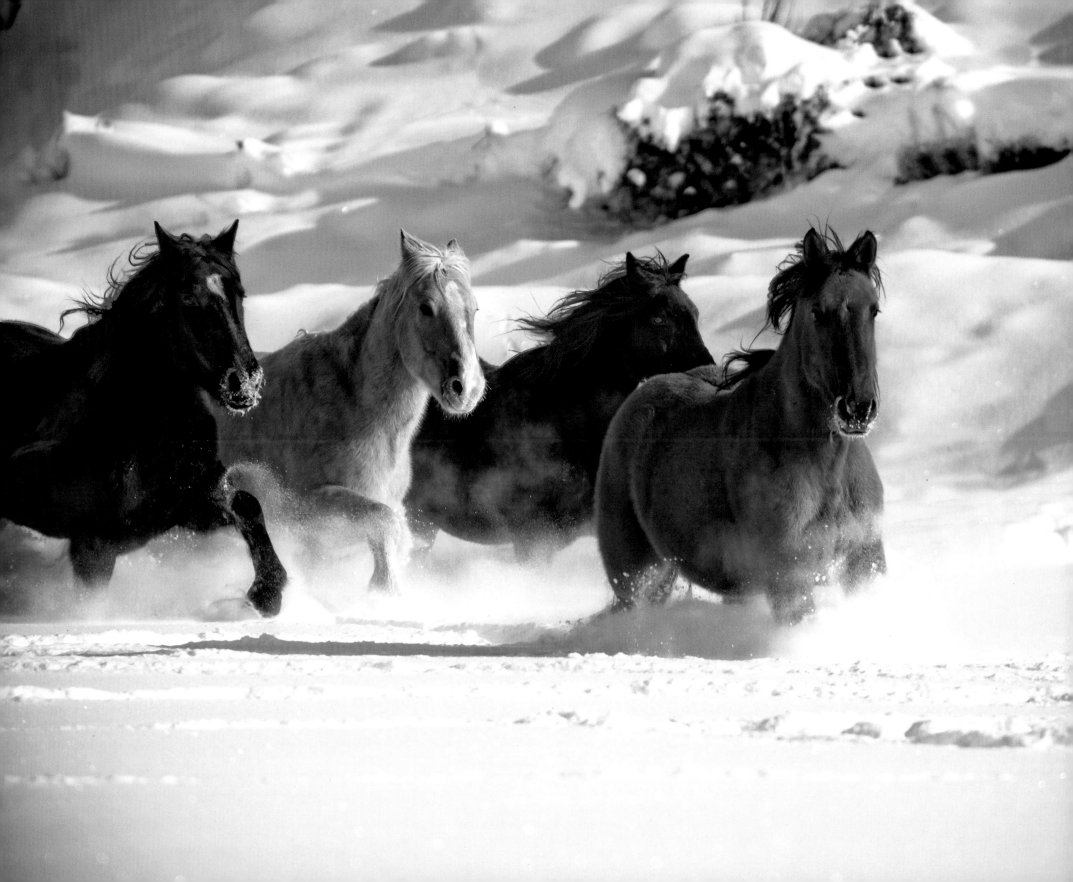

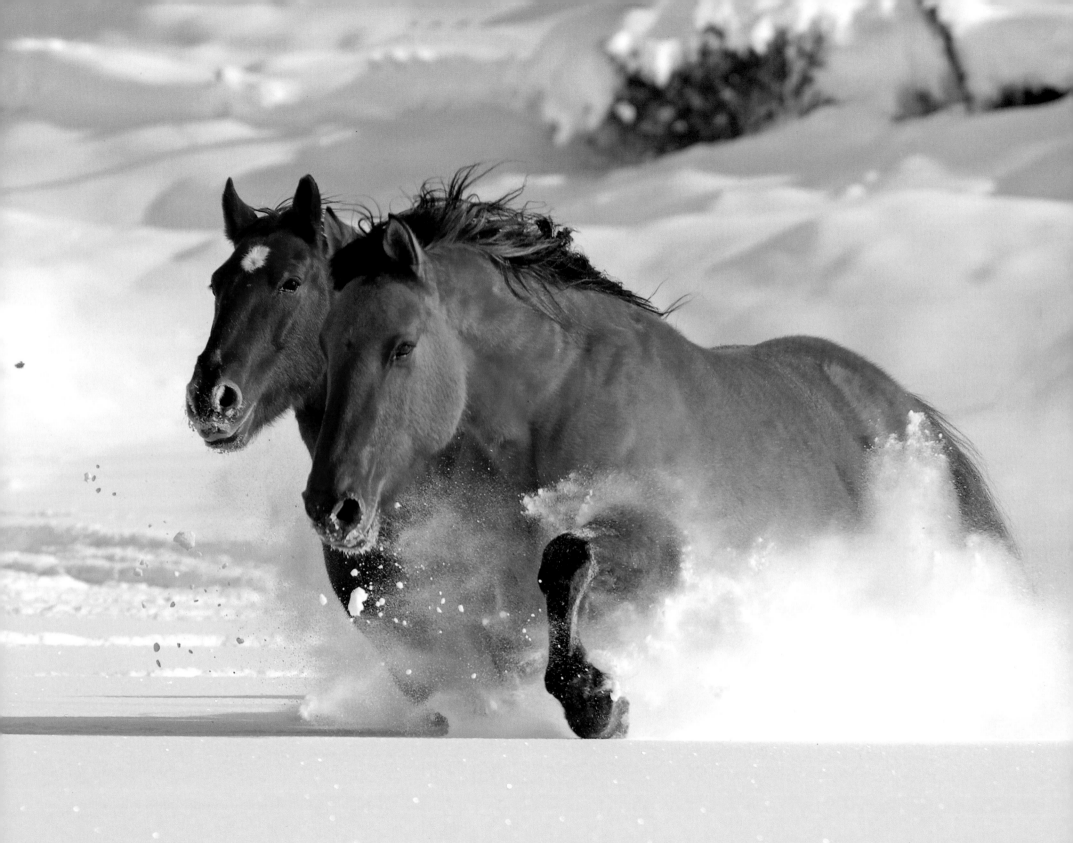

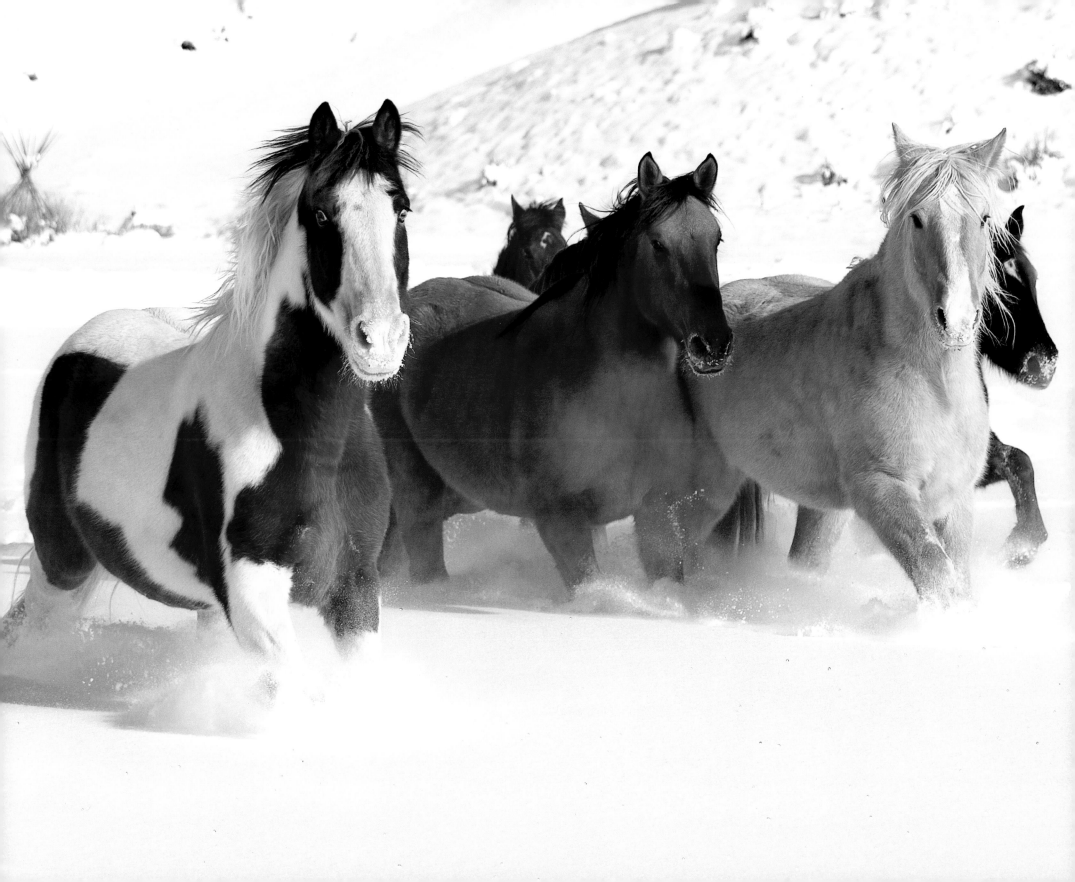

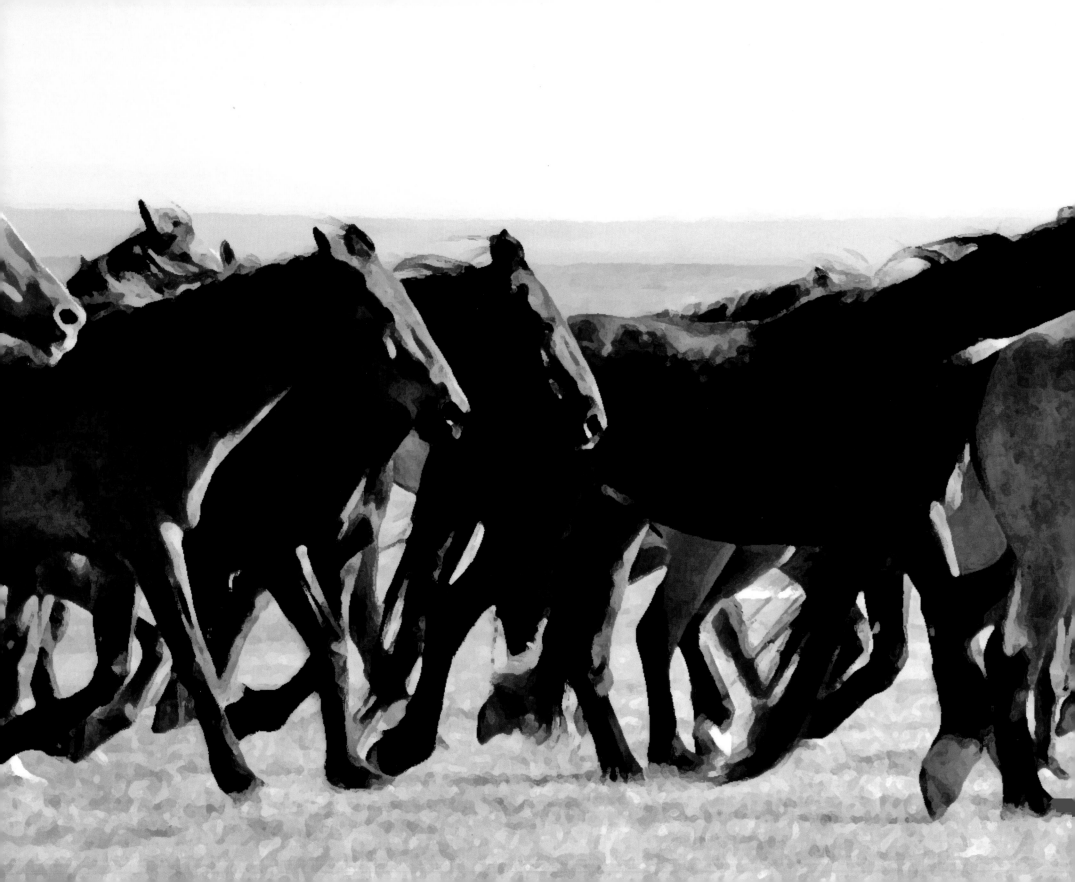

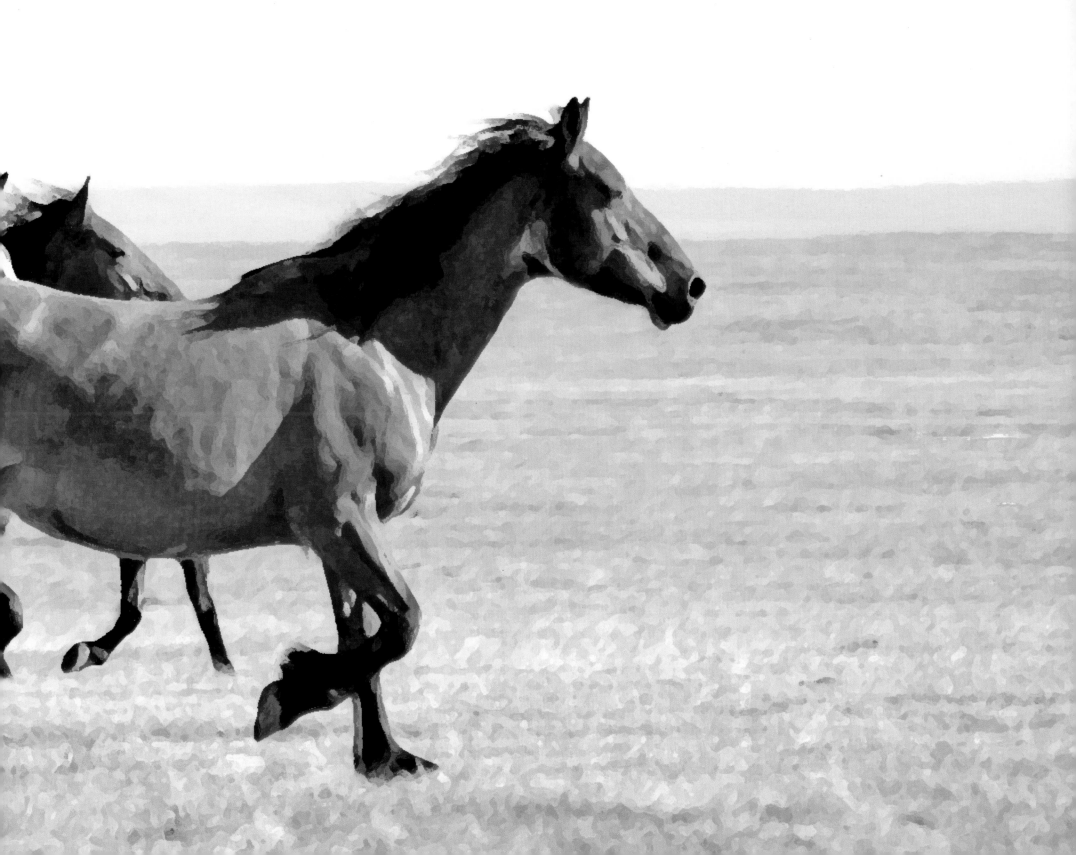

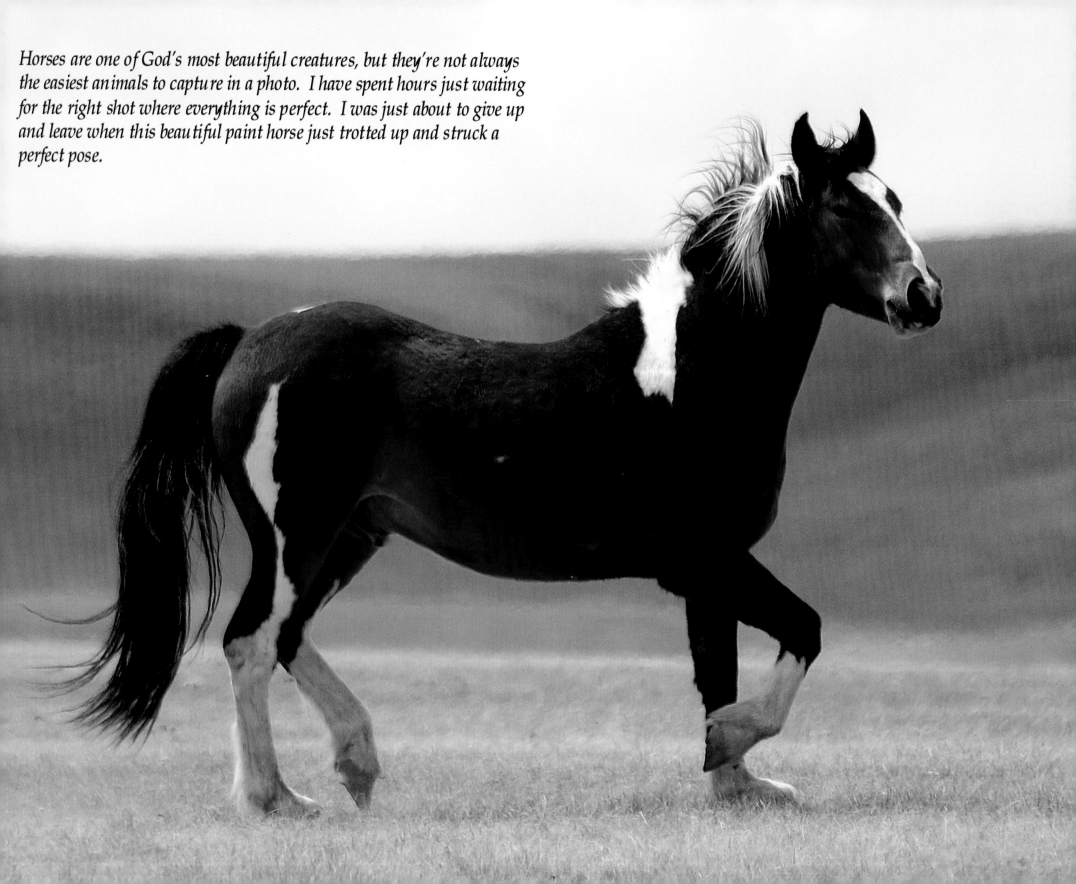

Horses are one of God's most beautiful creatures, but they're not always the easiest animals to capture in a photo. I have spent hours just waiting for the right shot where everything is perfect. I was just about to give up and leave when this beautiful paint horse just trotted up and struck a perfect pose.

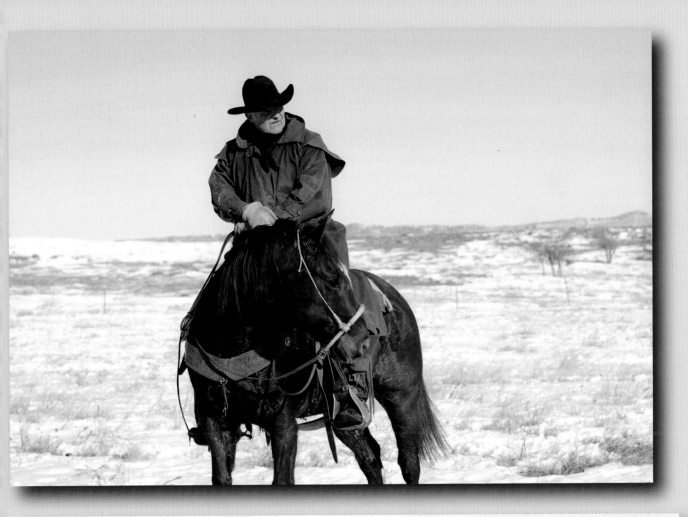

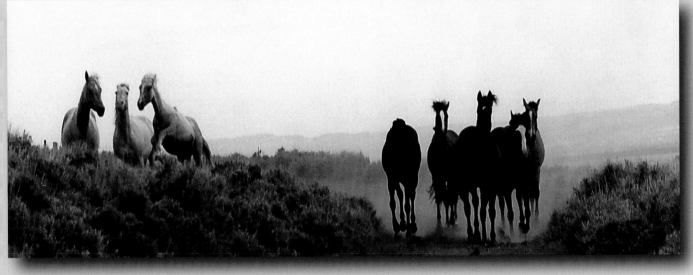

After visiting some customers near Laramie, Wyoming one winter day I pulled into Dick's driveway. When I didn't find anyone at the house I thought I'd try the nearby barn. When I opened the old squeaky door, I could see a tall cowboy working a horse on a lead rope in the center of a large pen. I introduced myself and after showing Dick some of my products, he became what would become a long time customer of mine. As I got to know Dick and his family a little better, they would ask me to stay for coffee or maybe even a meal sometimes. One day Dick told me he was going to be moving some of his horses at another one of his ranches a few hours farther north. I told him that I would love to be able to go along and shoot some photos if he wouldn't mind. He said he would love to have me come along. I met Dick at his ranch and rode with him over to the other ranch. He dropped me and my camera off in a pasture and told me to get set up and he would be back shortly with some horses. I wasn't disappointed. Soon there was what looked like hundreds of wild horses running over the hill toward me. I captured shot after shot of some of the most beautiful animals I could have imagined. Dick has been a rancher his whole life. I am grateful that he allowed me to preserve a part of the history of our great nation as these ranchers and their way of life gradually become a thing of the past.

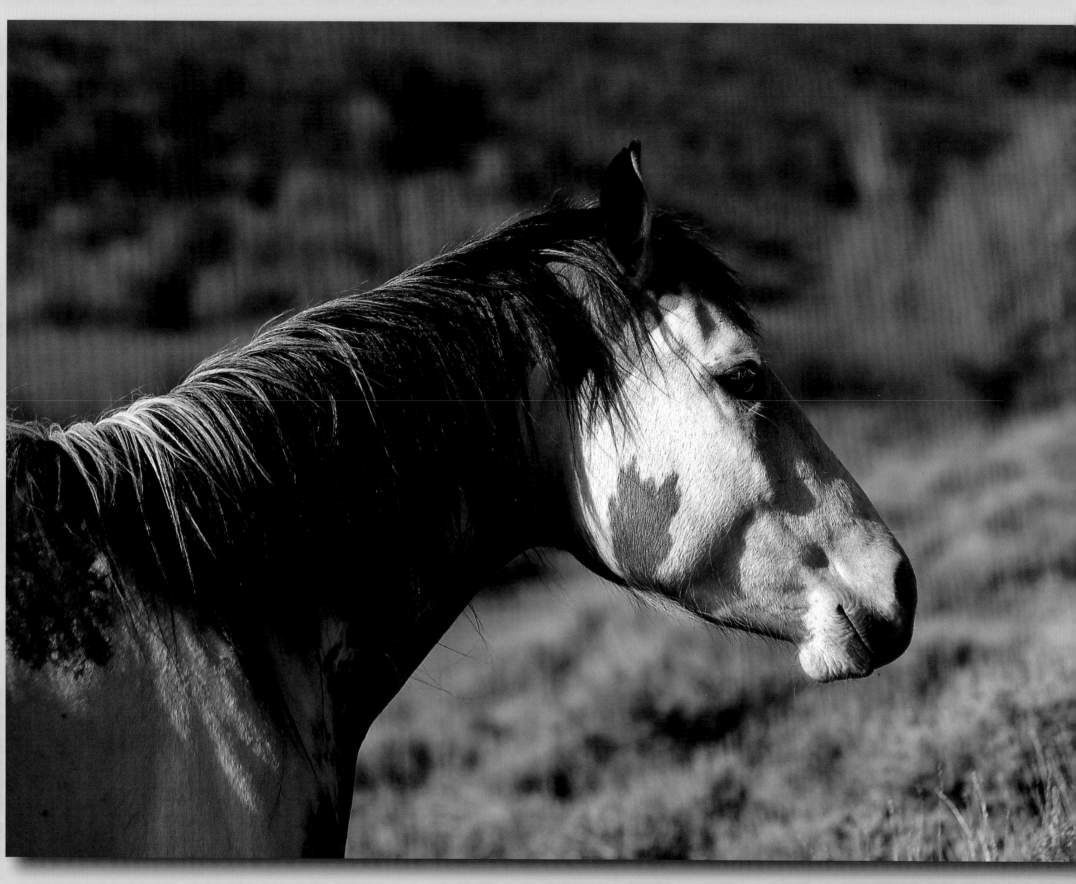

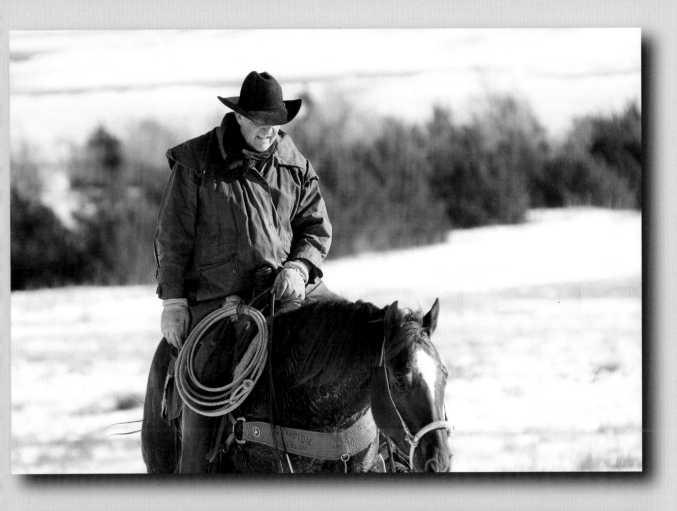
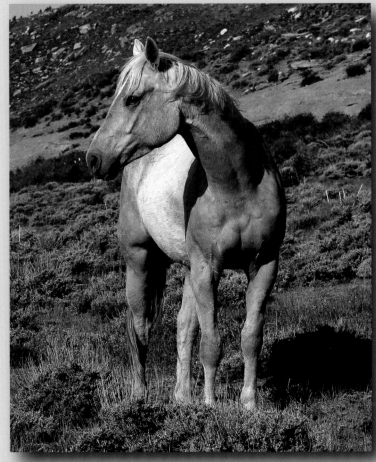
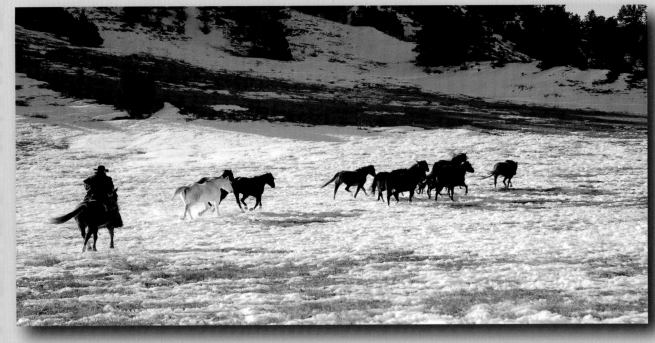

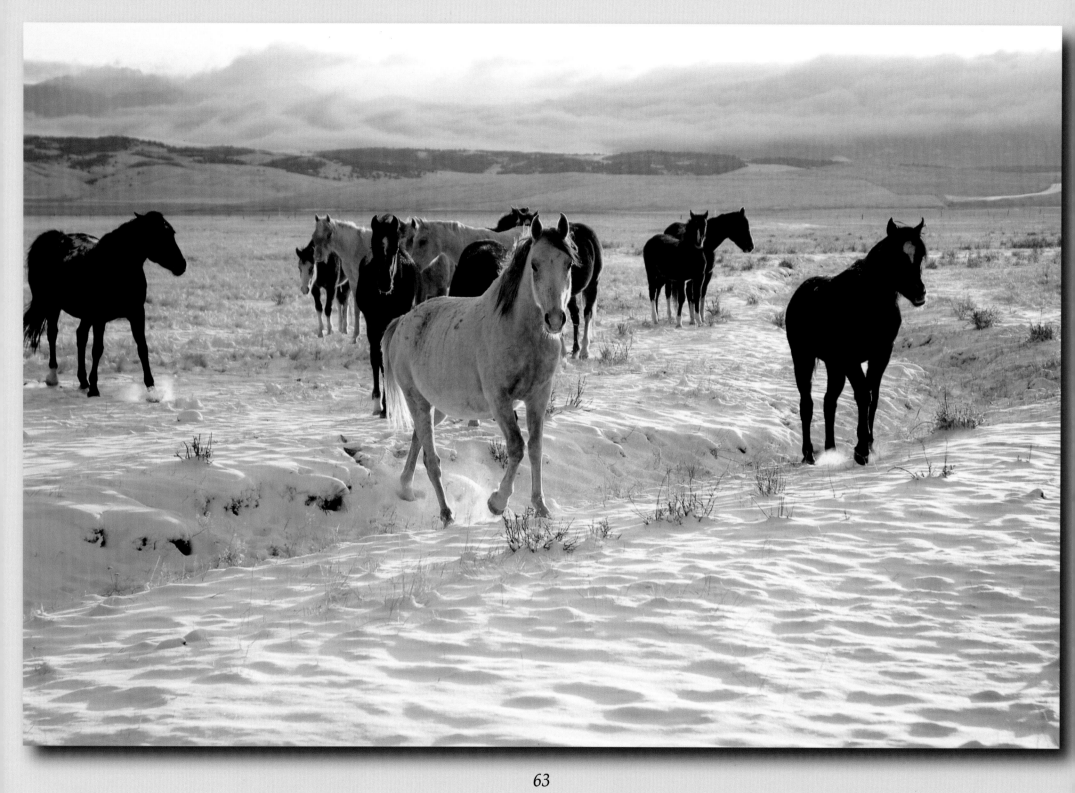

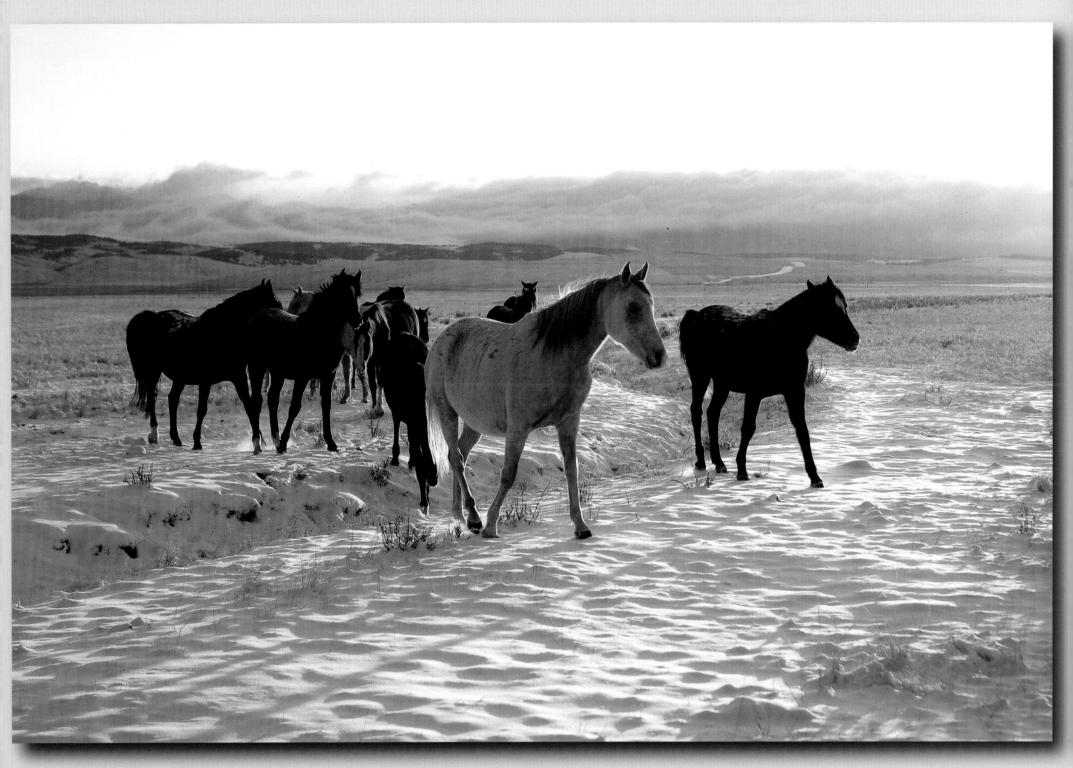

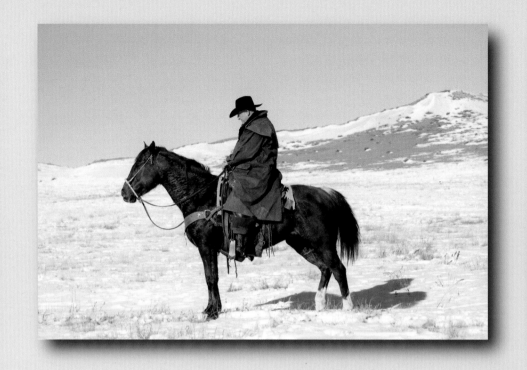

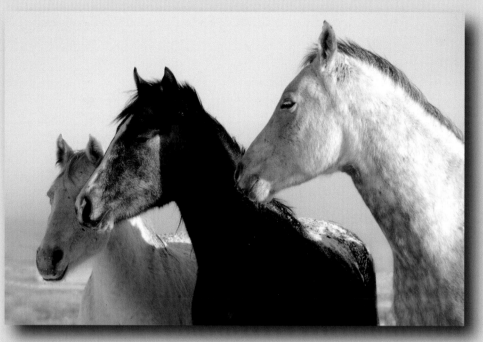

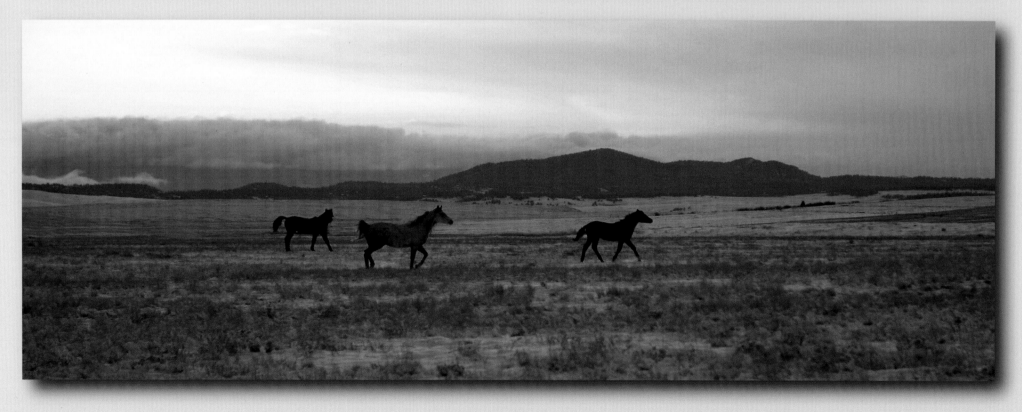

65

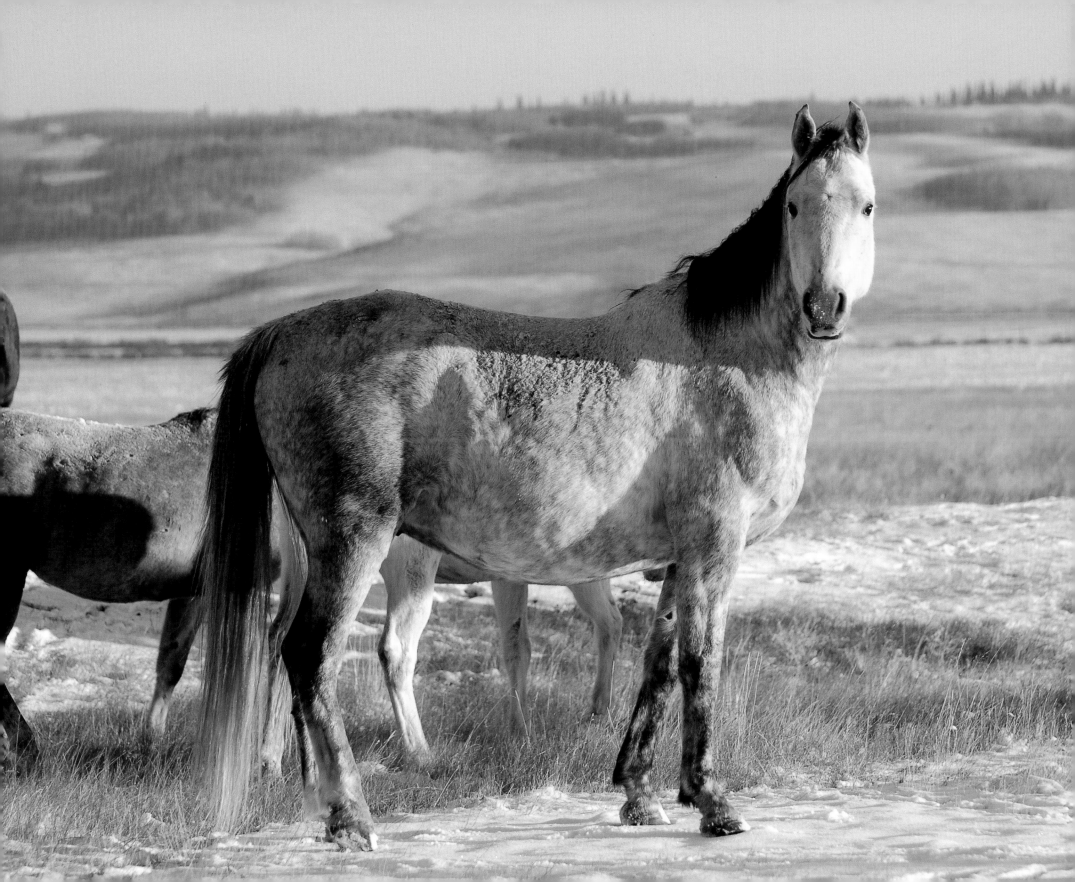

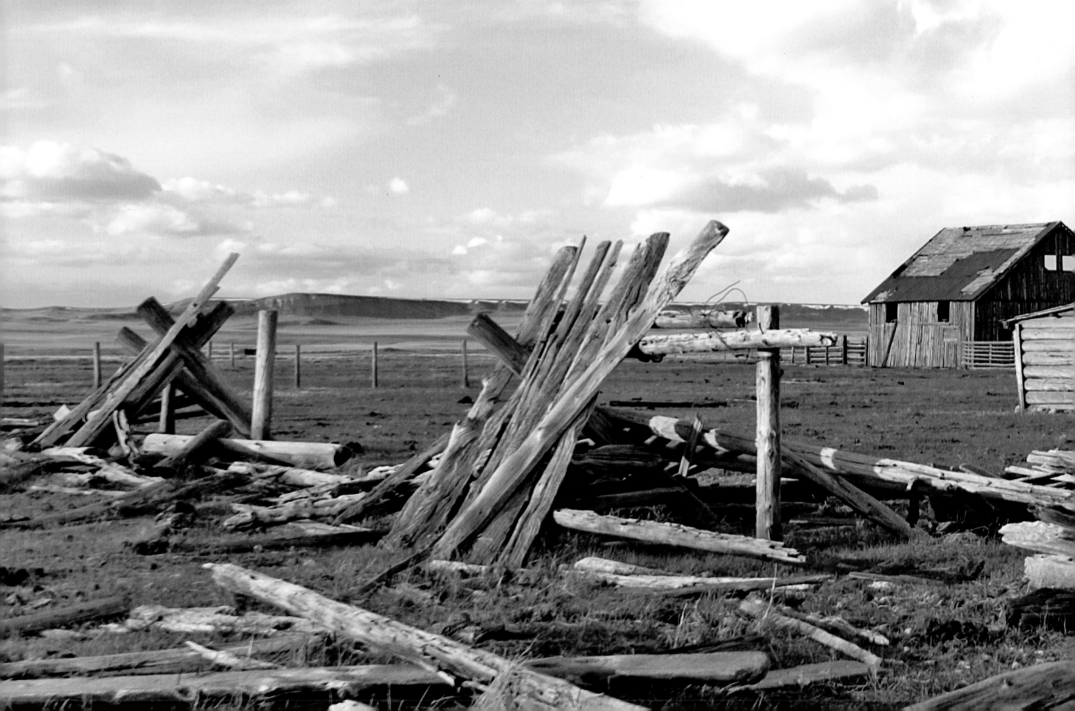

Chapter 4
Old Farms and Ranches

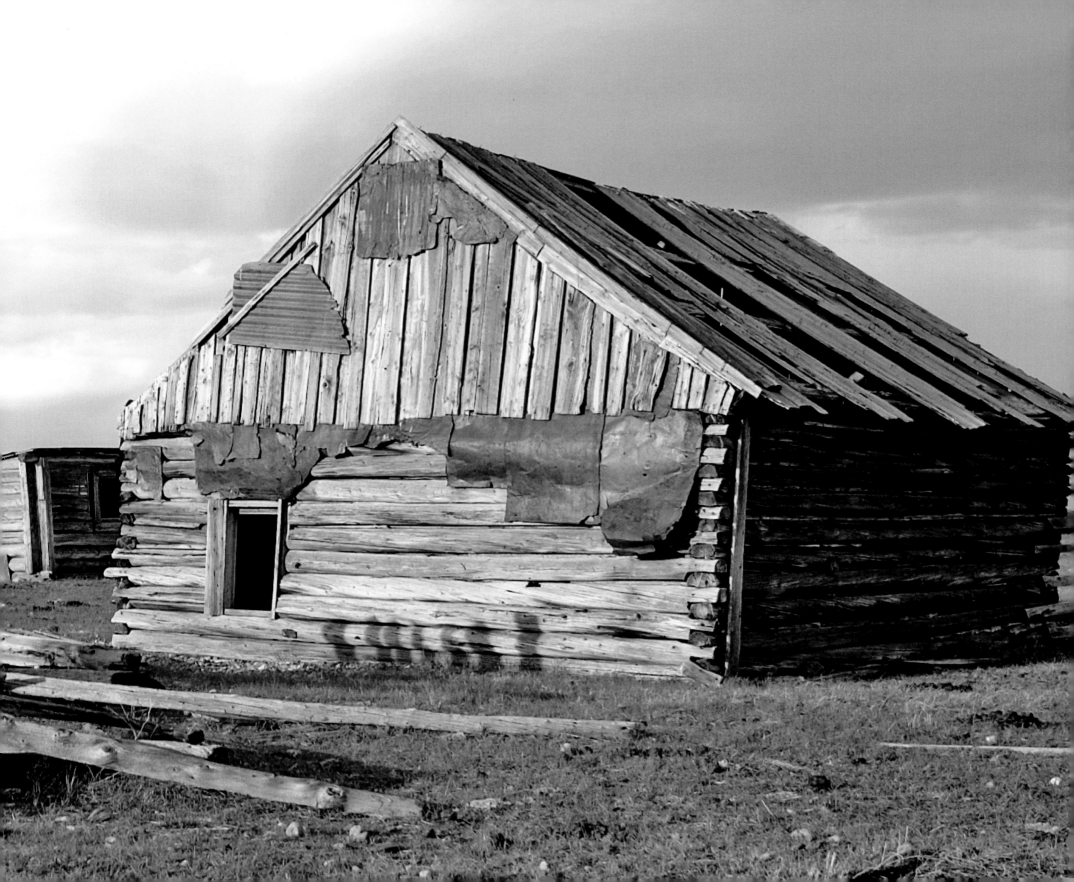

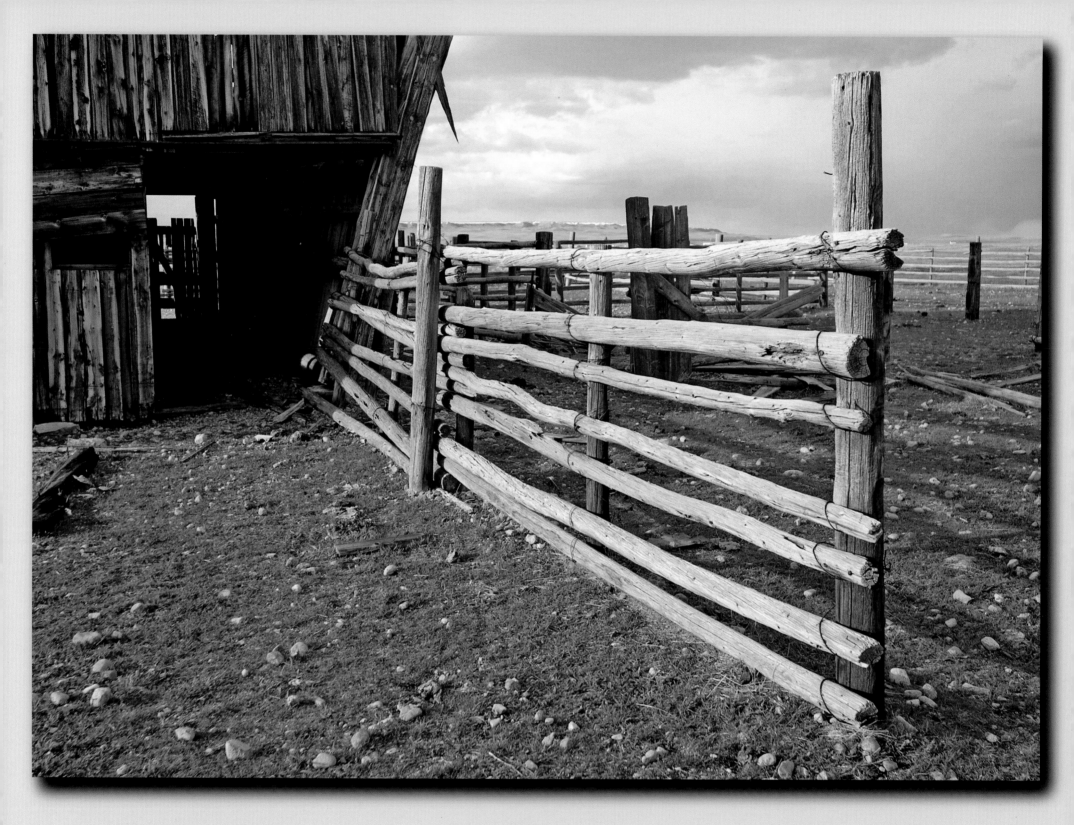

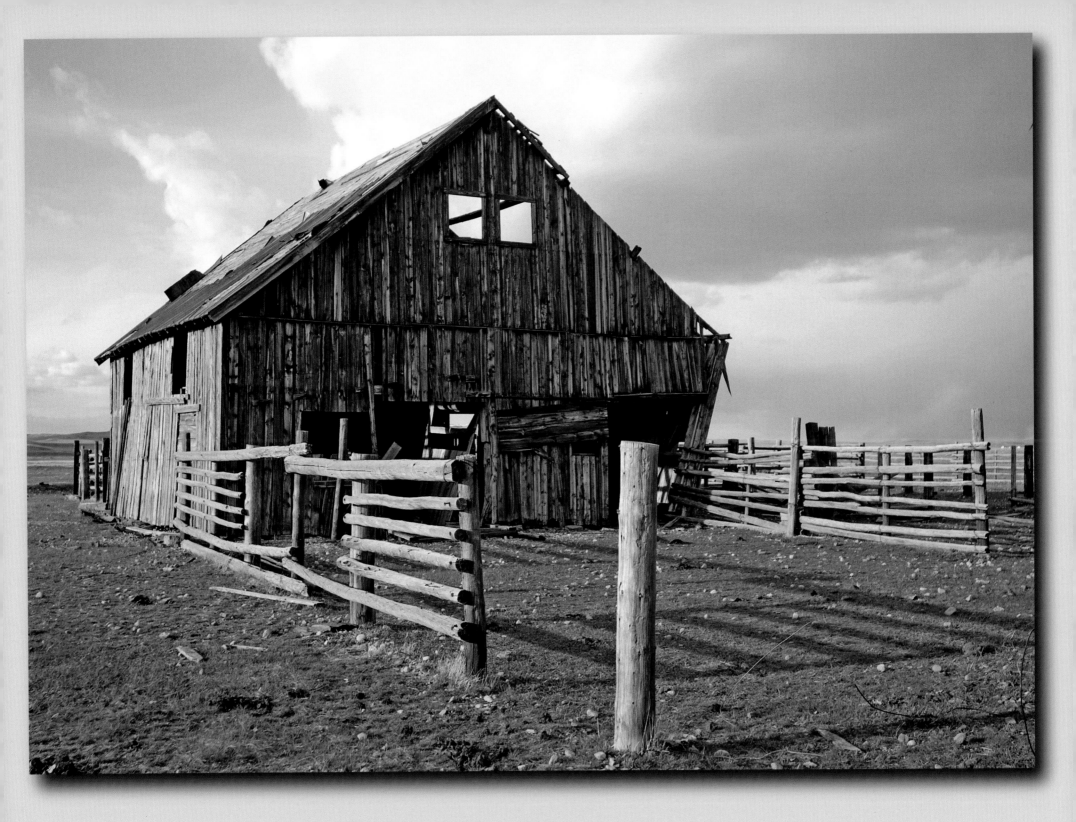

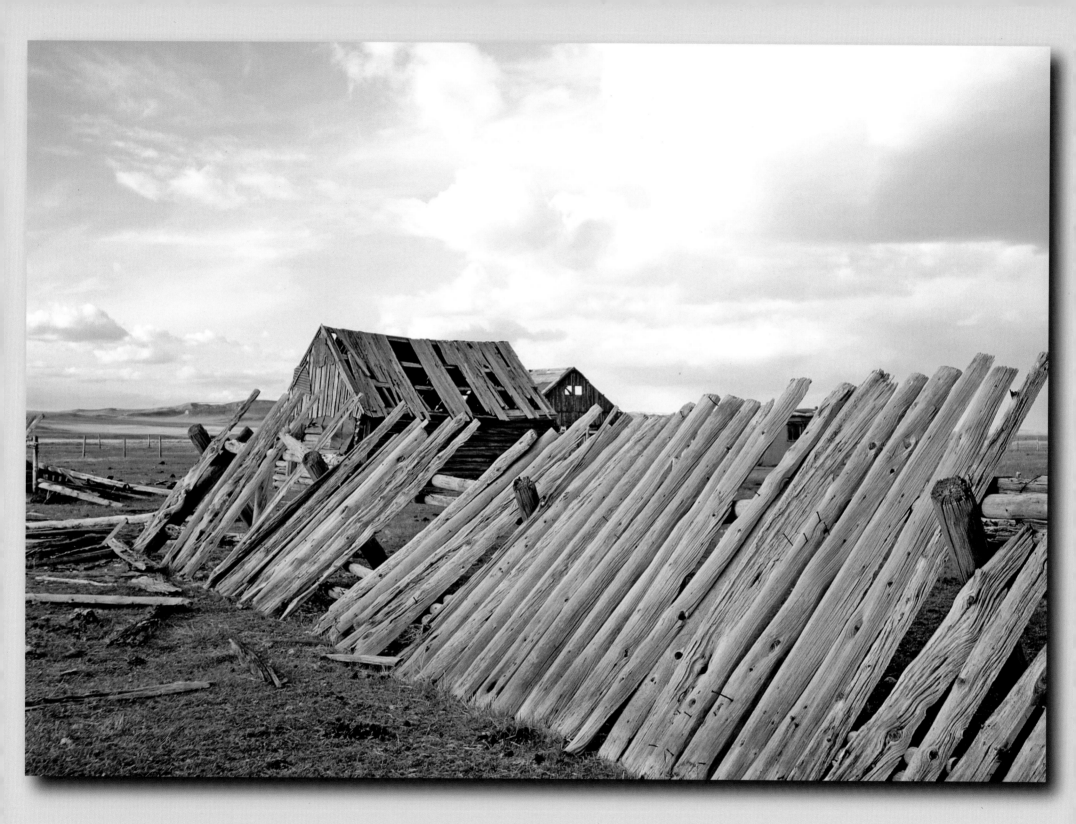

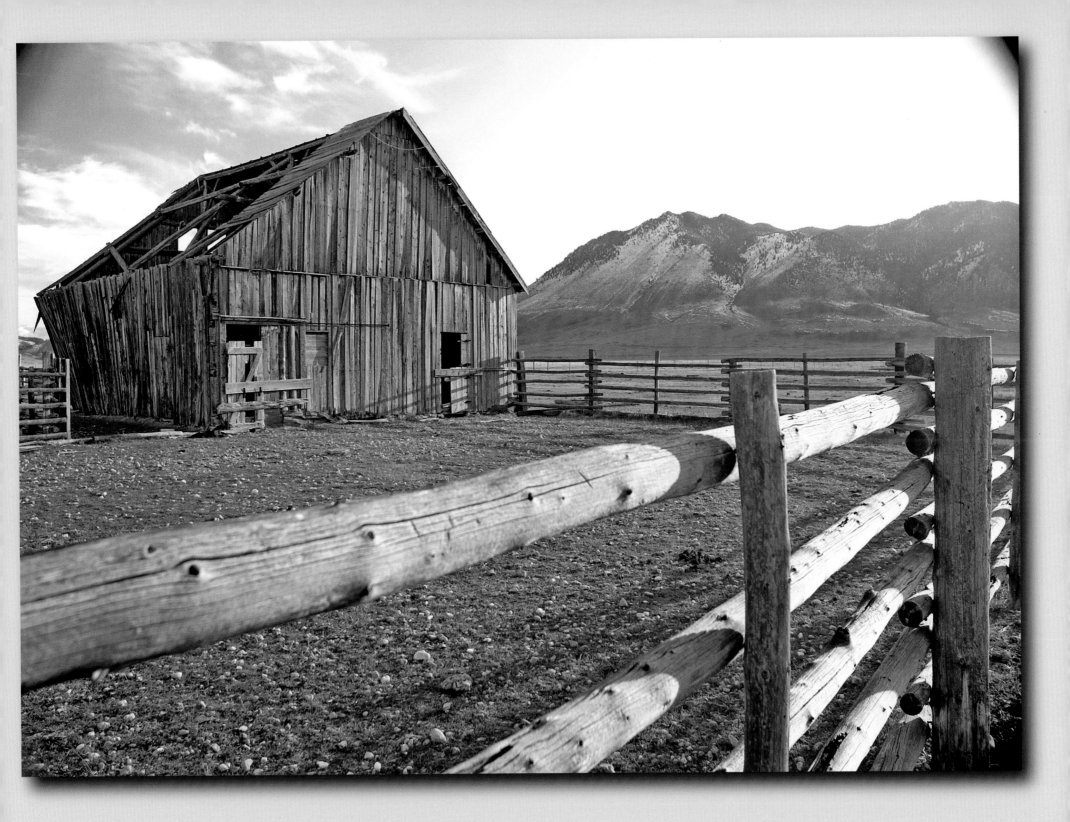

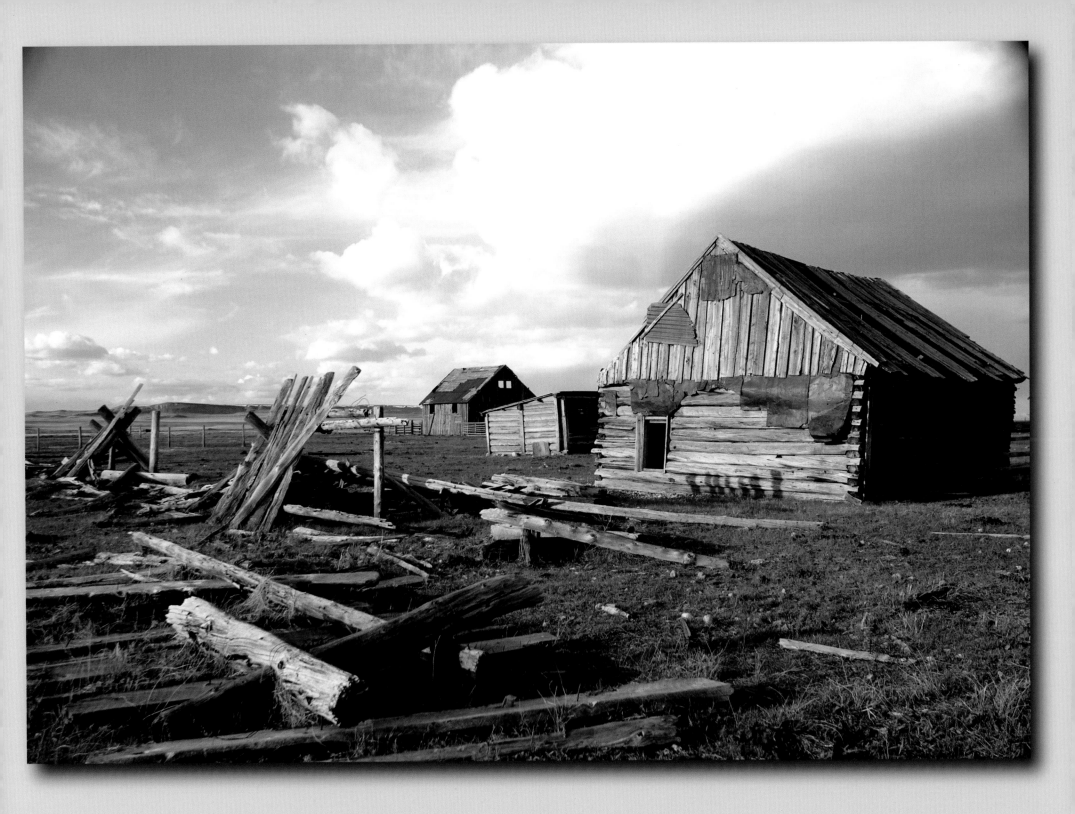

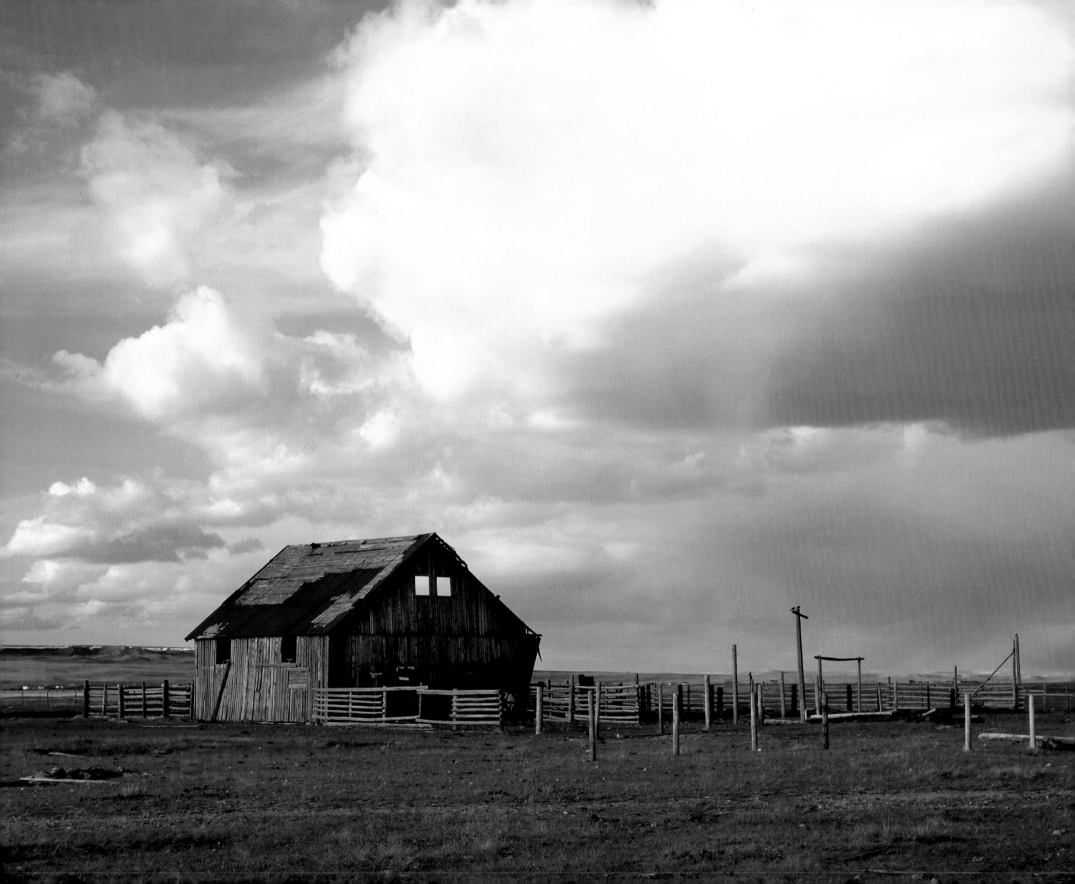

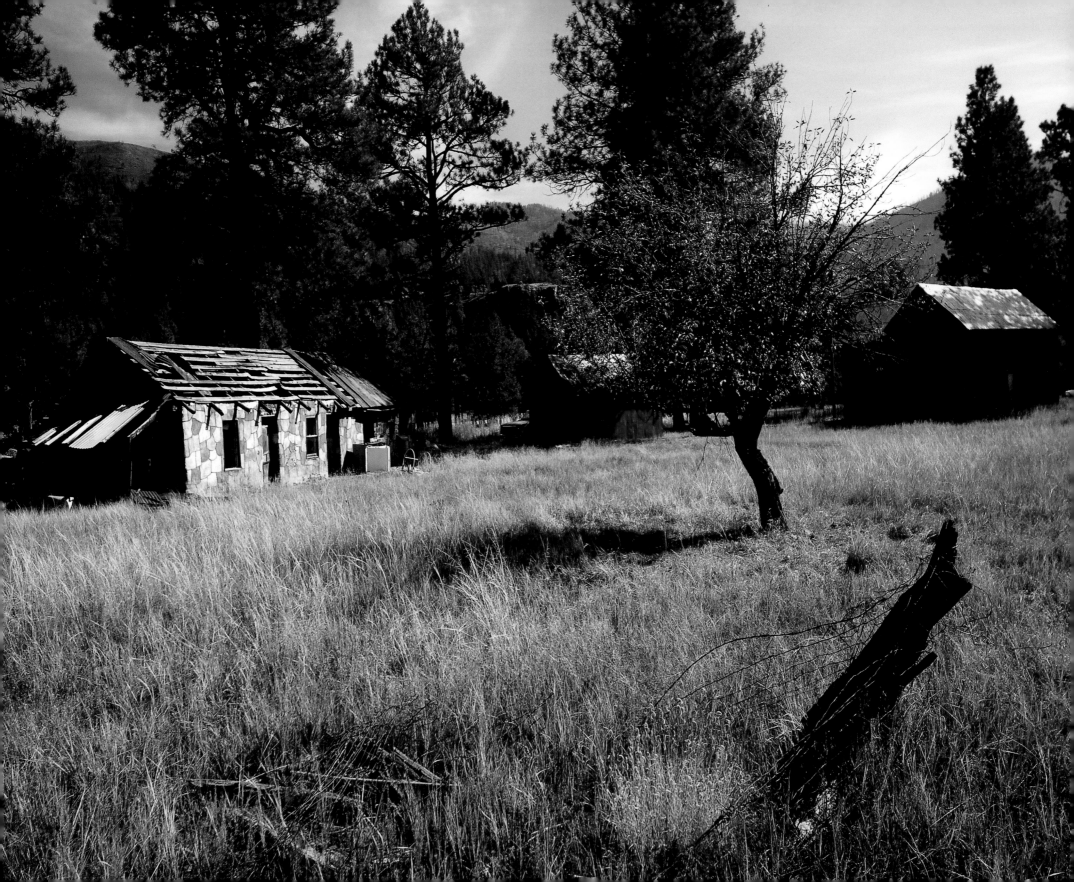

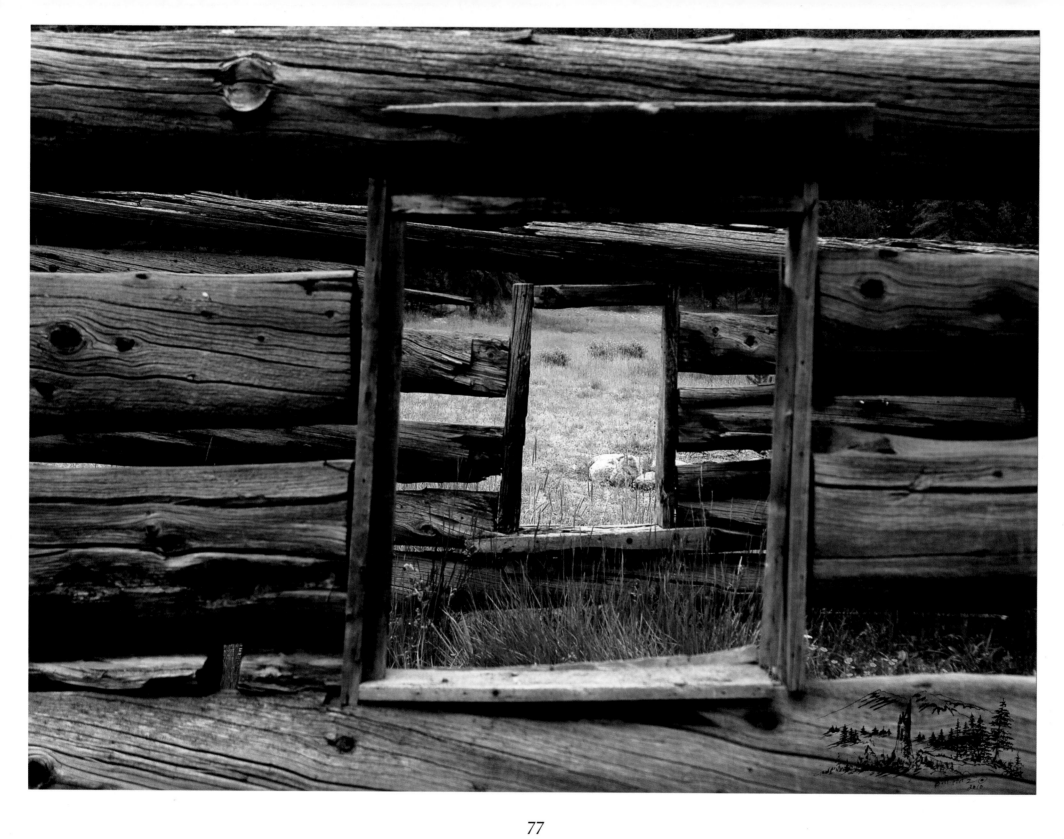

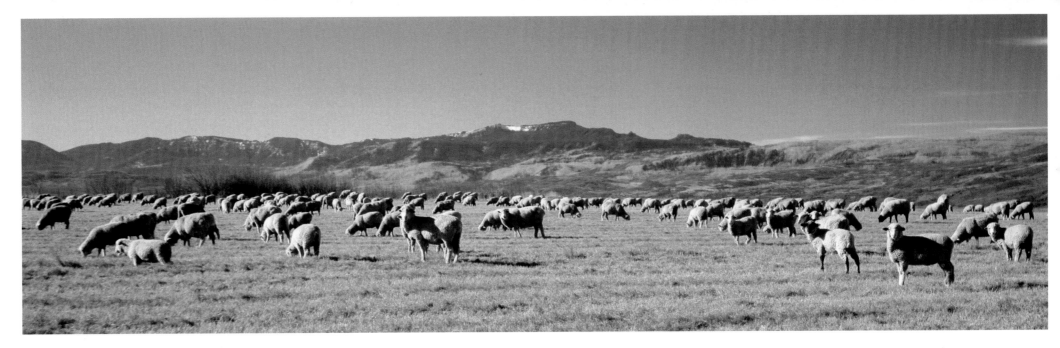

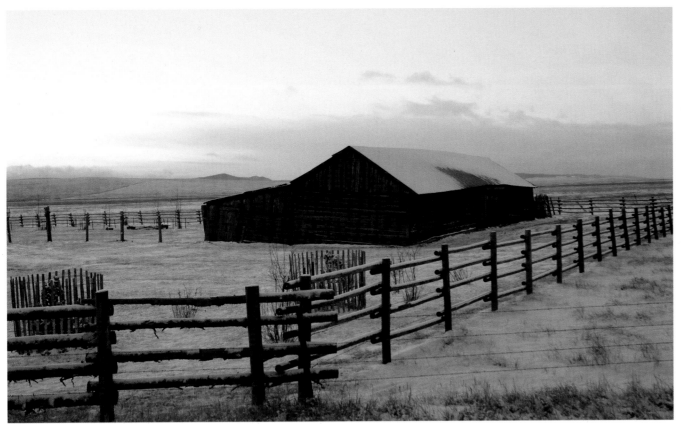

While driving near Cimarron, Colorado I passed one of the largest sheep ranches in the state. For as far as I could see there was nothing but sheep. I almost thought I was back in the Snowy Mountains of Australia.

78

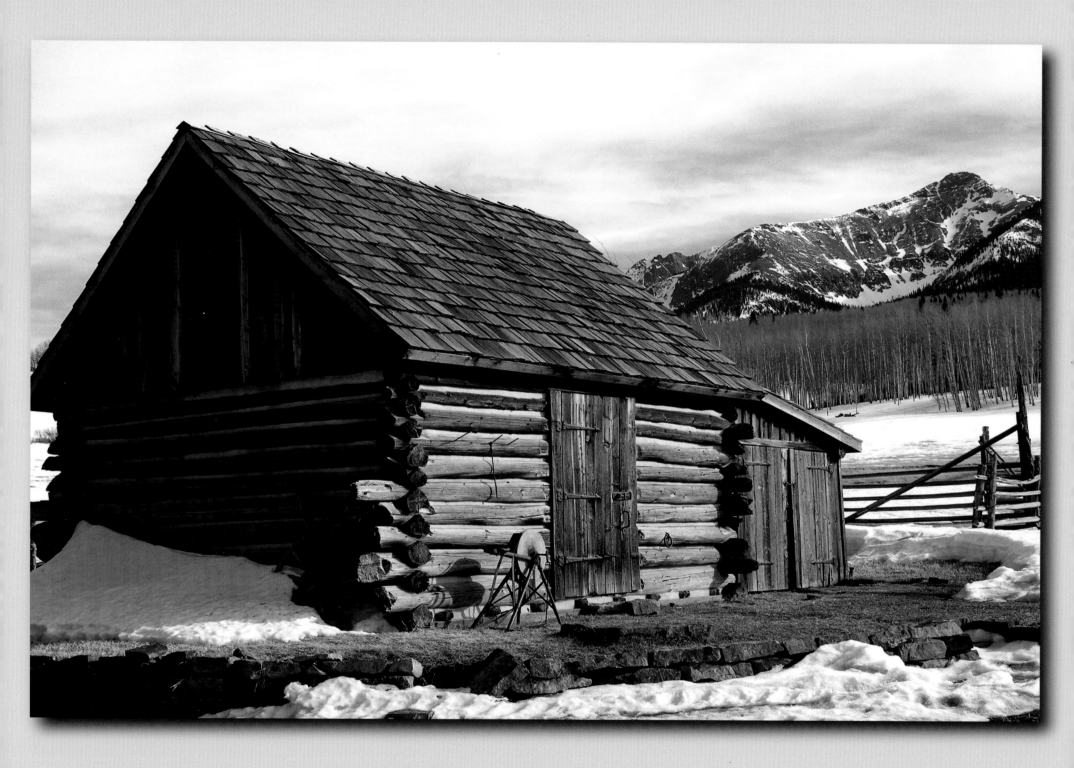

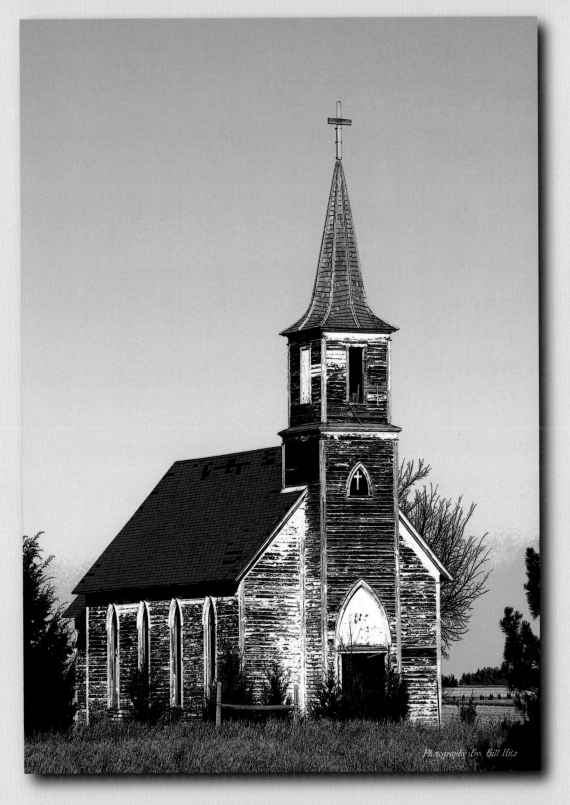

Photography By: Bill Hitz

Sometimes one of the most difficult things to do is finding the right way to get close enough to something that catches my eye as I drive down the road. I spotted this old church from the Interstate as I was driving through Nebraska on my way from Wisconsin back to Colorado one time. After taking the next exit I wound my way down the dirt roads until I got back to the church. One of the things that caught my eye about this old building was the way the small white, almost pristine cross seemed to glow from the dark window above the front doors. I felt as if I was drawn to it. As I stood there in the aura of this old church, I could almost see the people sitting in the pews, the ladies in their long dresses and hats, the farmers trying to shine their boots on the back of their pant leg and little Jimmy hitting his sister in the back row. I felt that a part of the history of this place stayed with me as I went back on my journey, waiting to see what might catch my eye at the top of the next hill.

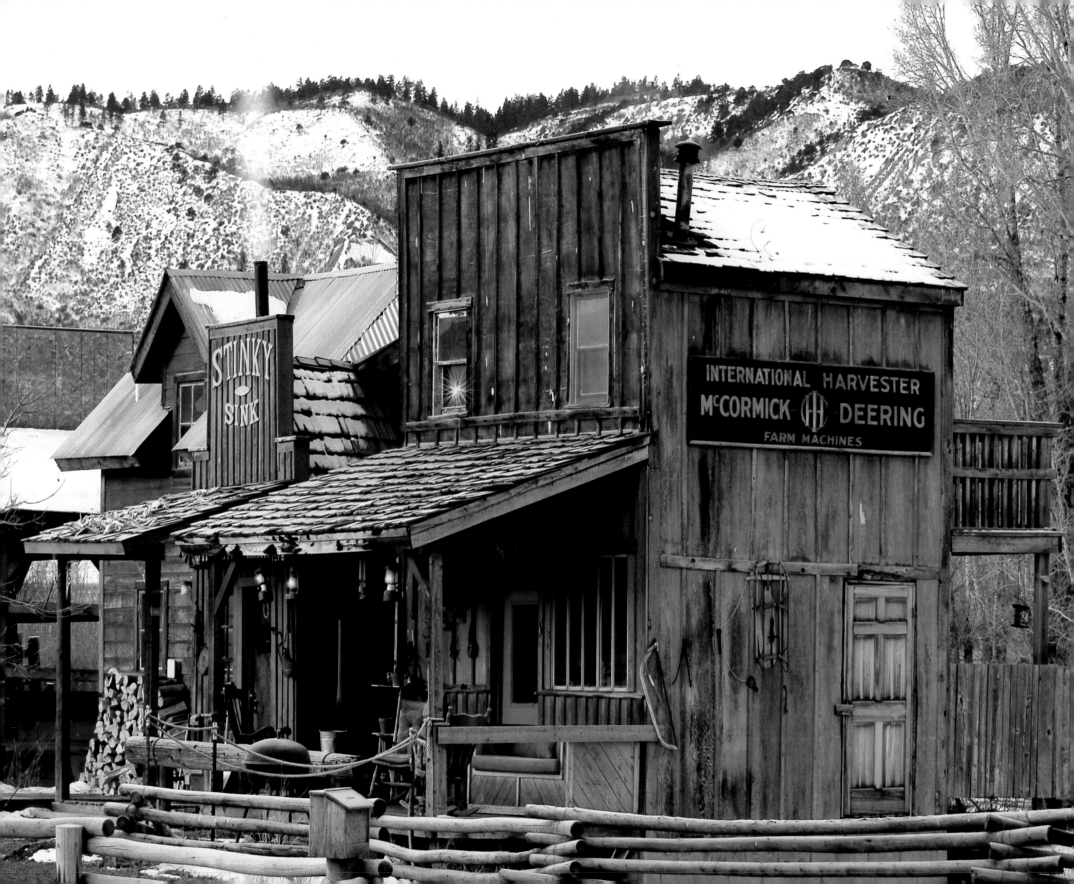

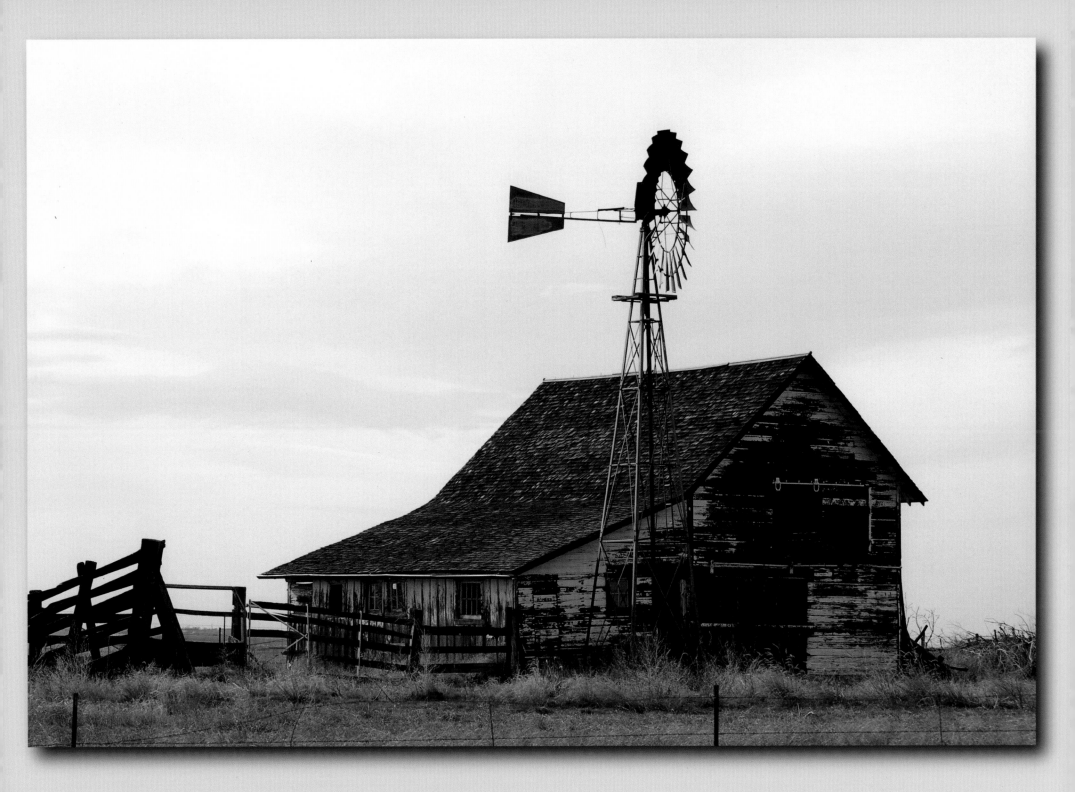

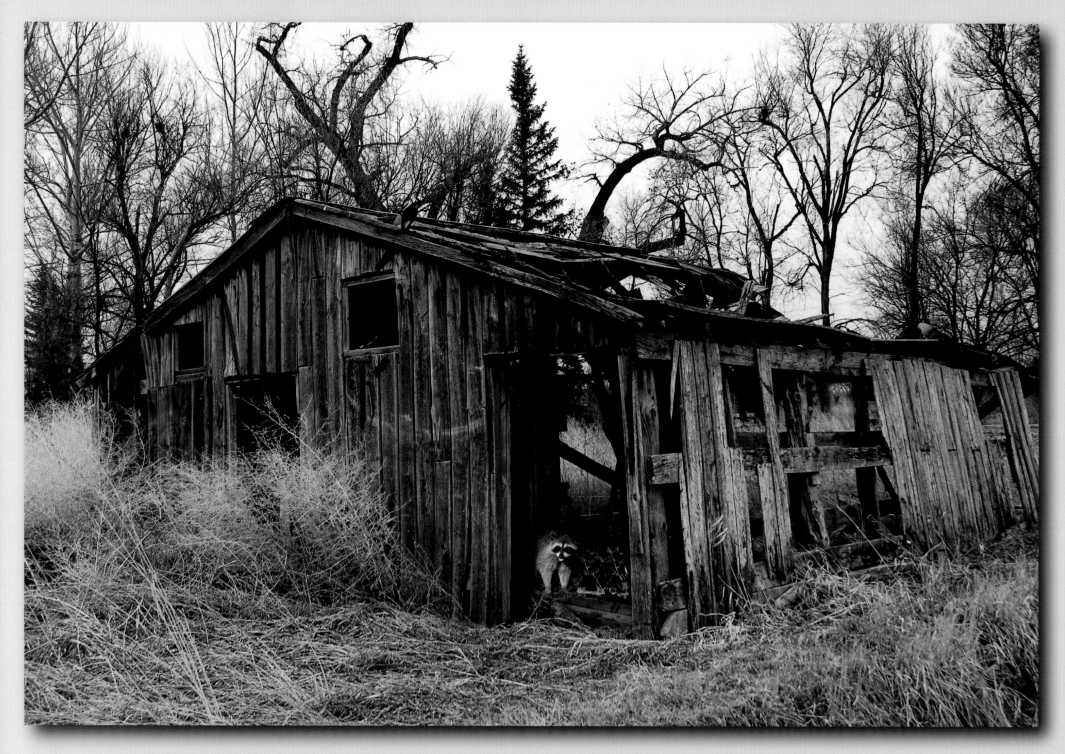

I didn't even notice the little raccoon until I had taken this photo of an old abandoned barn just west of Steamboat Springs, Colorado. I guess it wasn't abandoned after all!

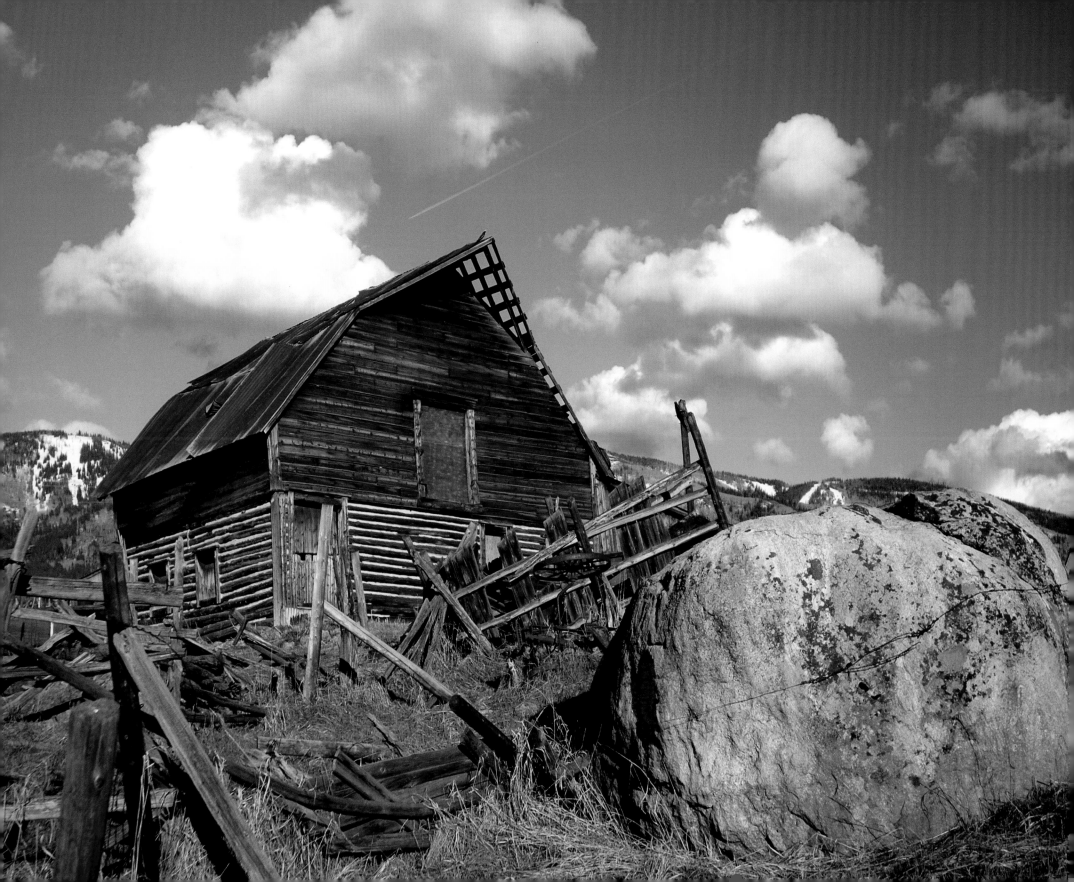

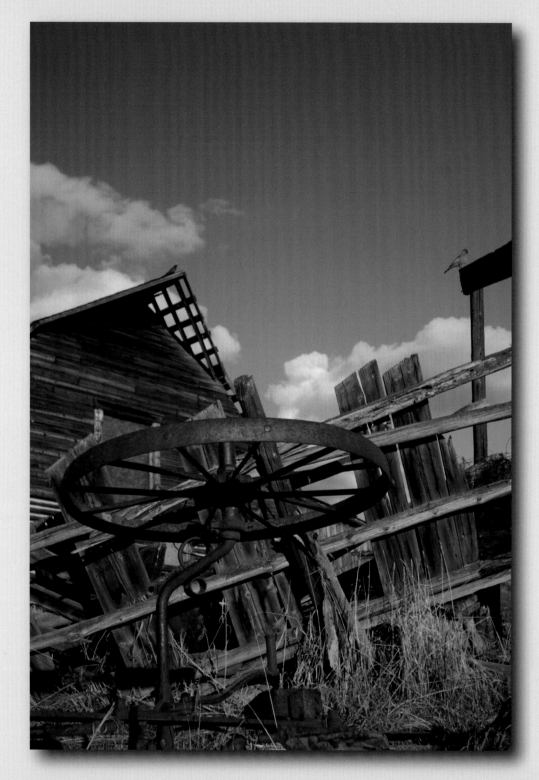

You may have seen this same barn with the Steamboat ski resort in the background. Check out the robin on the gate post.

85

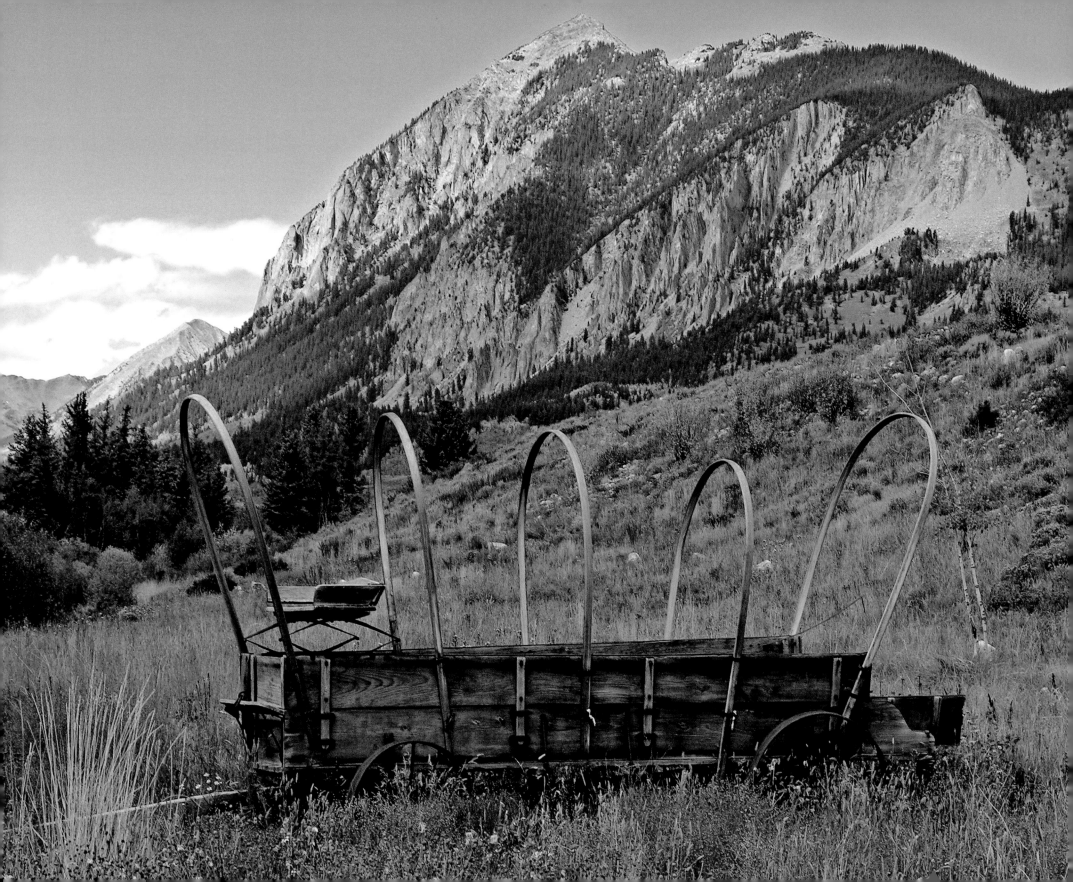

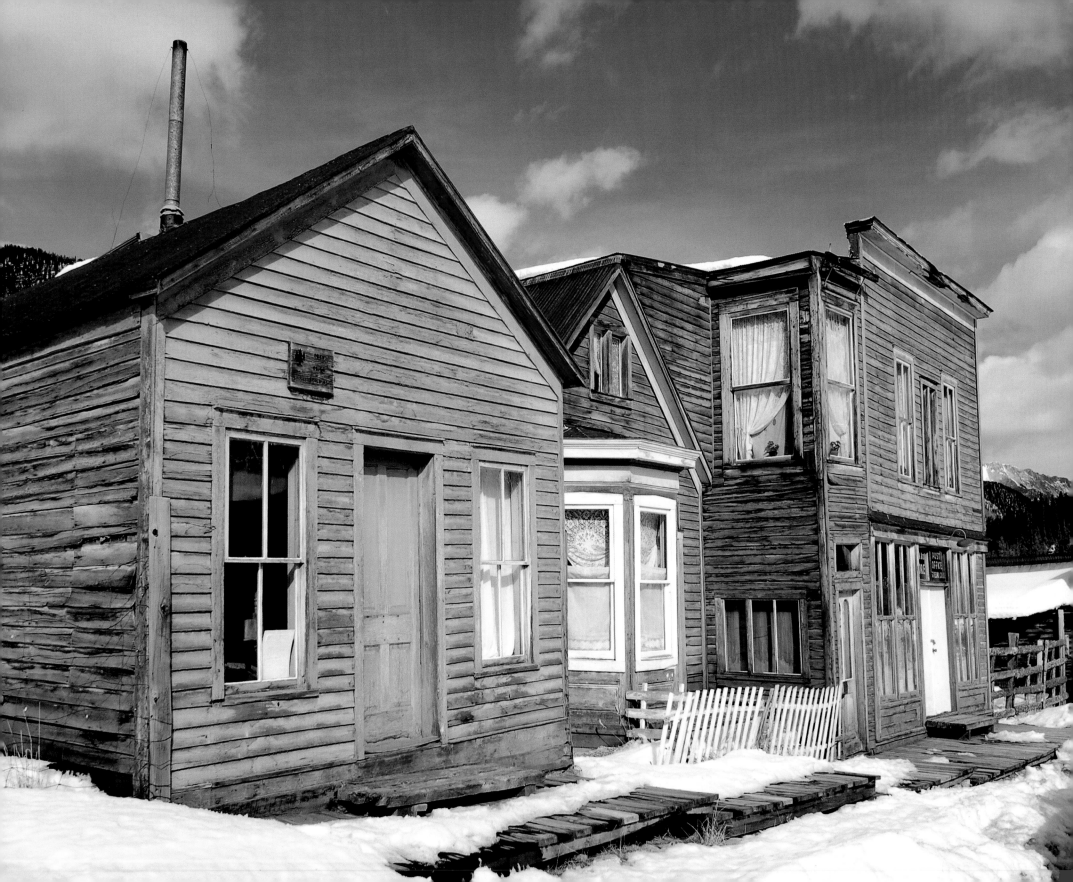

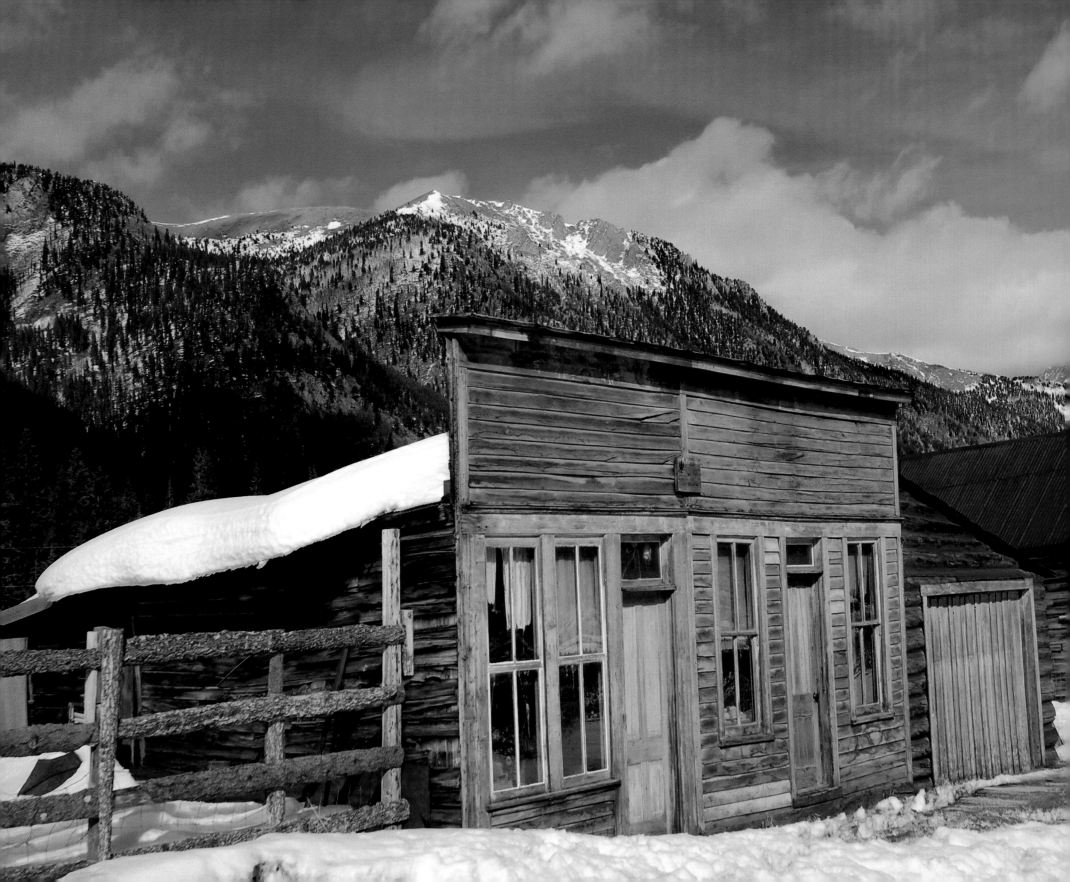

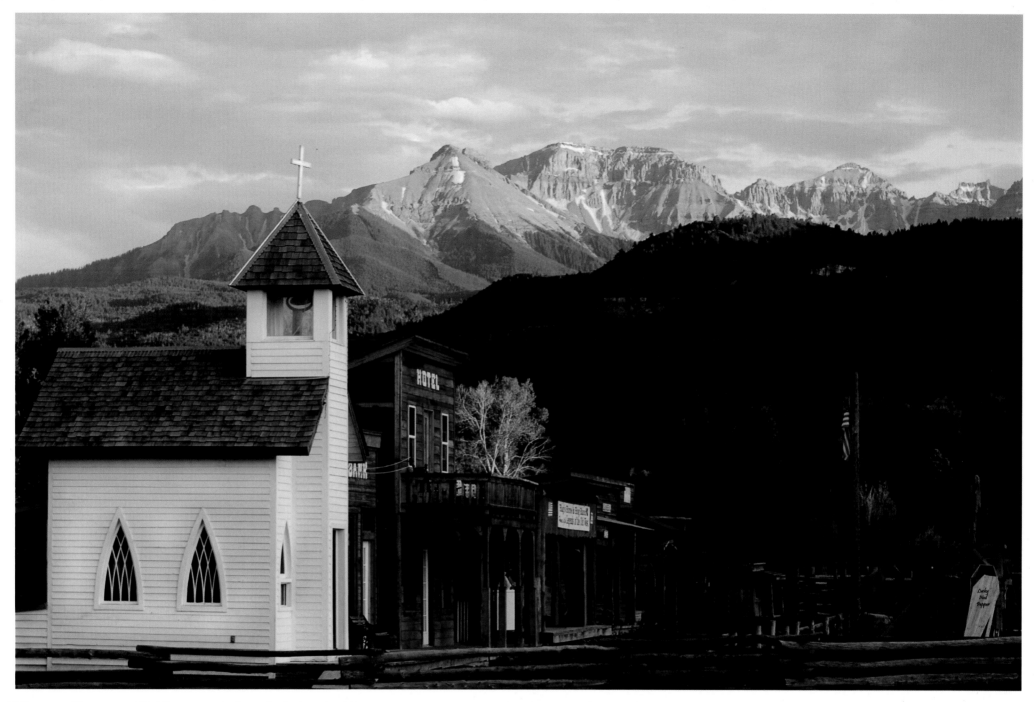

The small town of Ridgway, Colorado is located between Montrose and Ouray, Colorado in the San Juan Mountains. Parts of the movie 'True Grit' with John Wayne were filmed in this historic little mountain town. You can still enjoy a buffalo burger at the True Grit Café in beautiful downtown Ridgway, across from the old city park, which still has some of the old cottonwood trees that were seen in the movie. This view shows some of the old buildings that have been preserved, with the beautiful San Juan Mountains in the background.

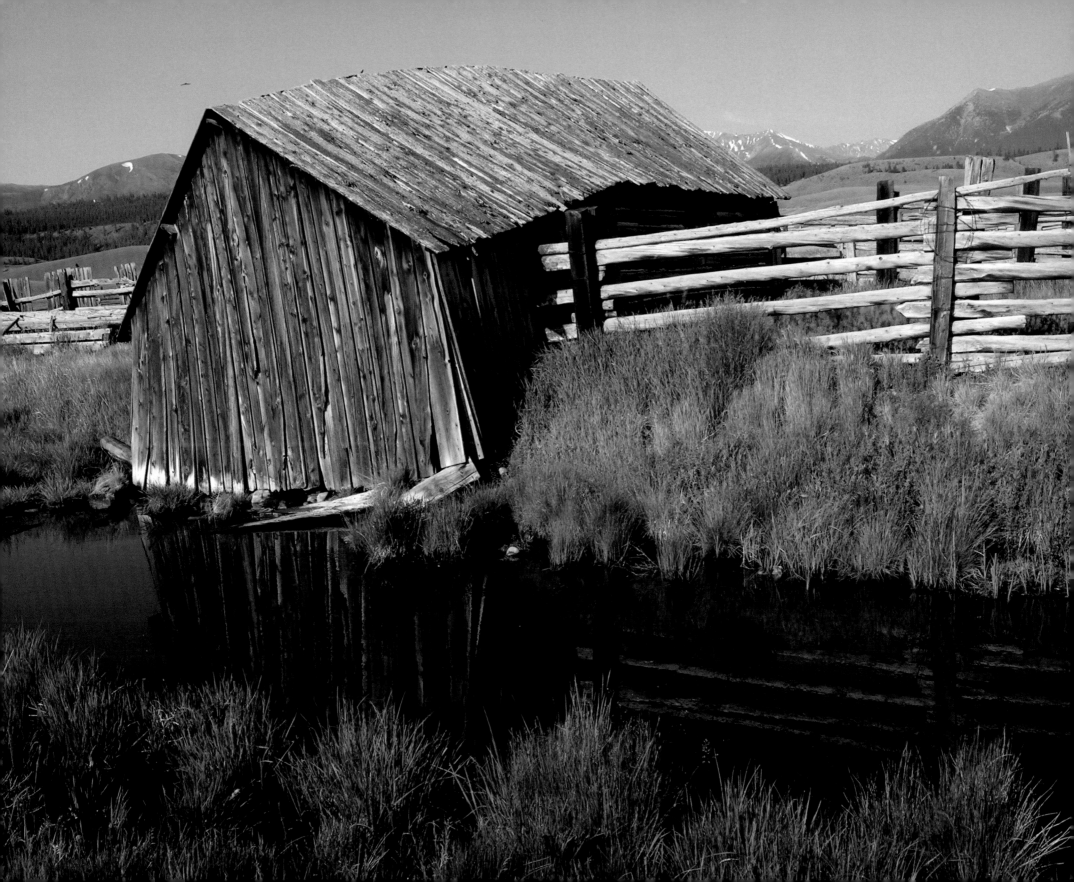

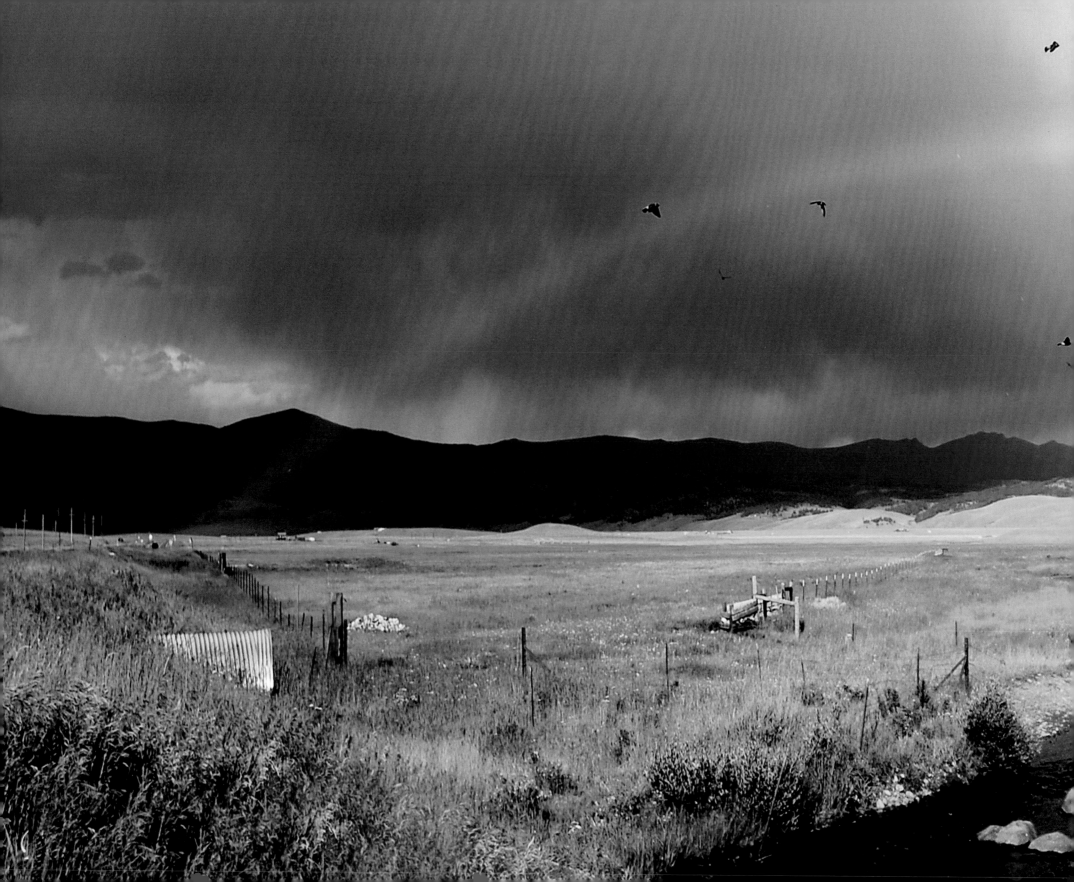

Chapter 5
Scenic Views on my Journeys

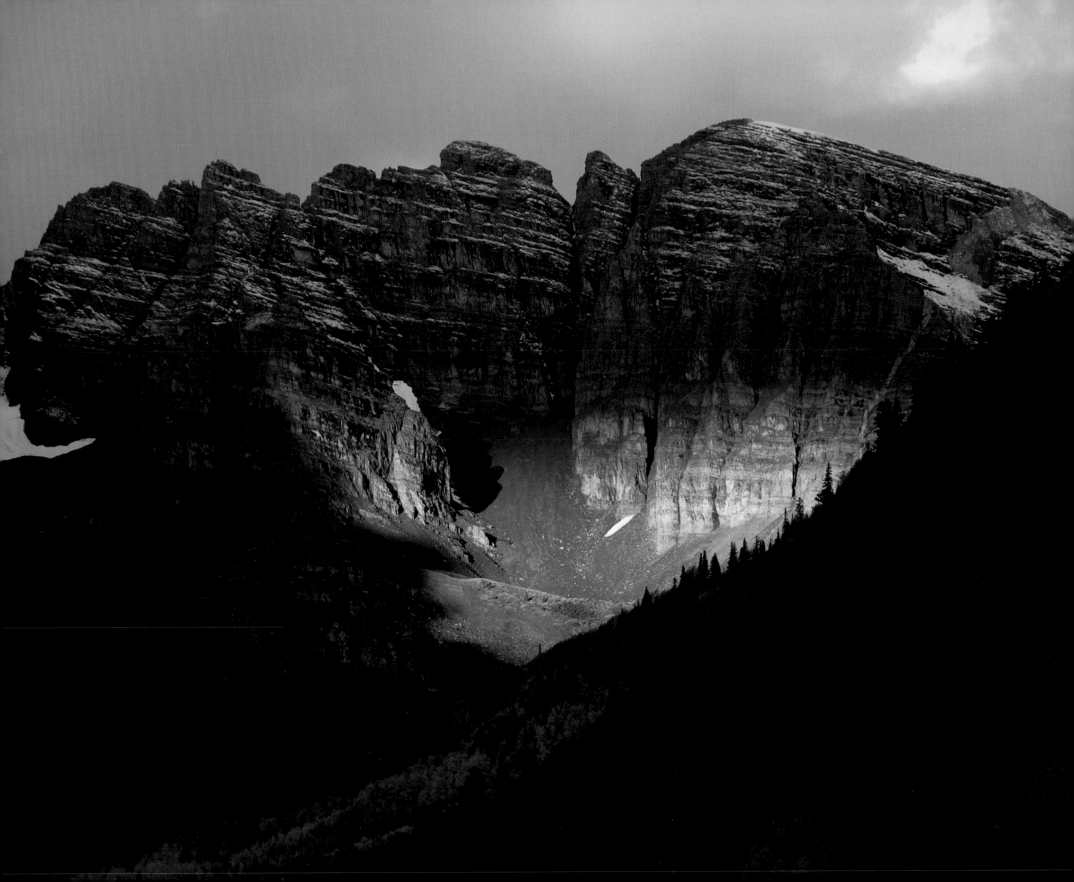

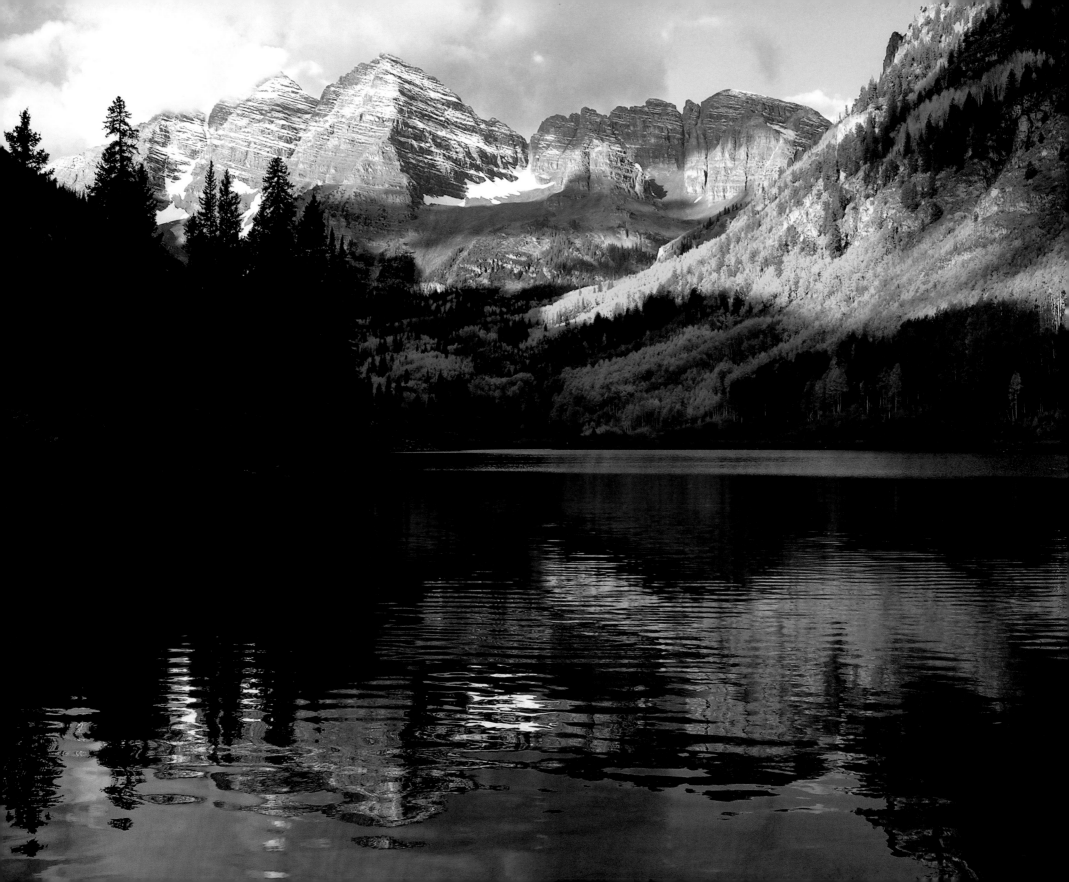

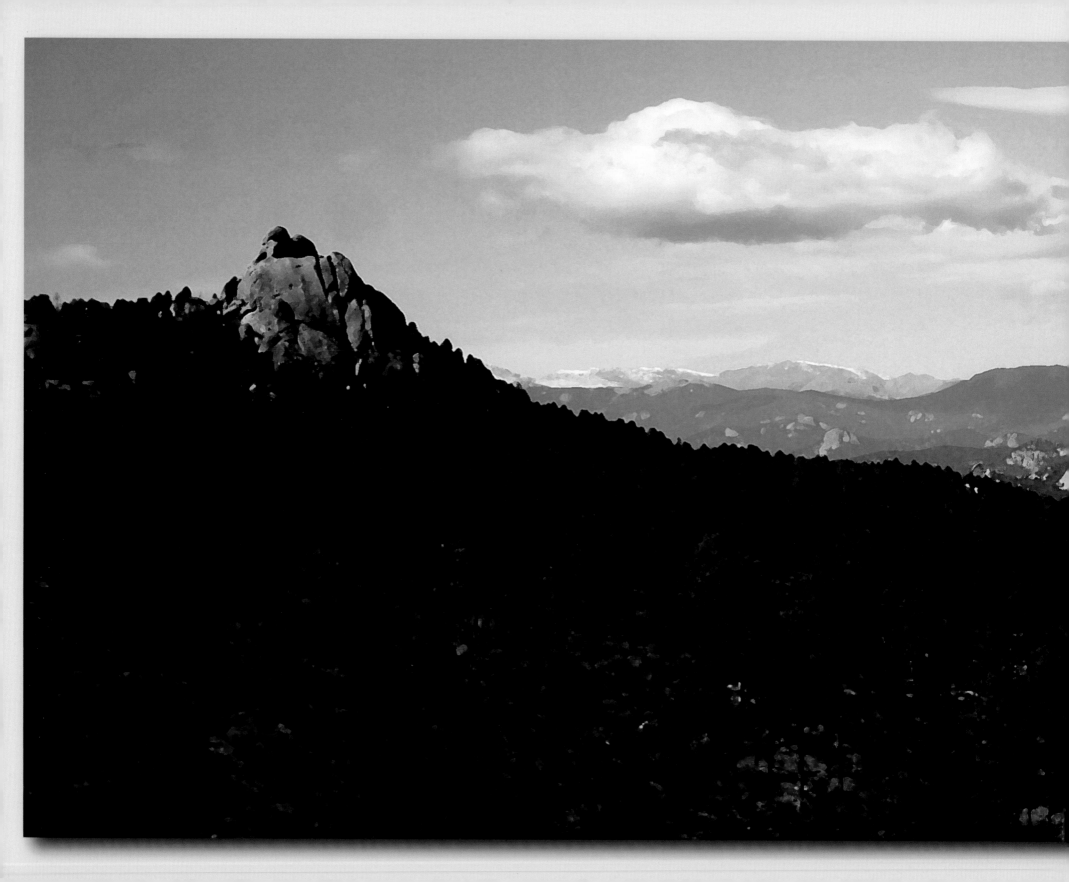

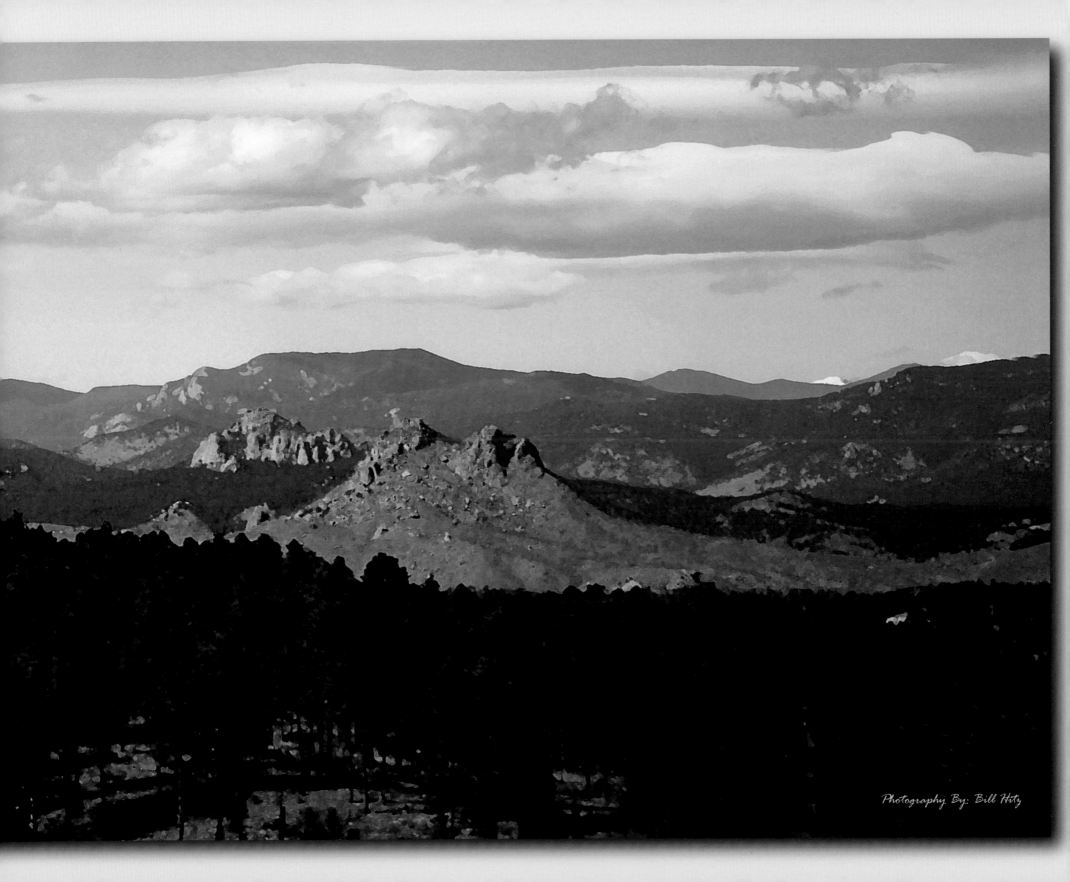

Photography By: Bill Hitz

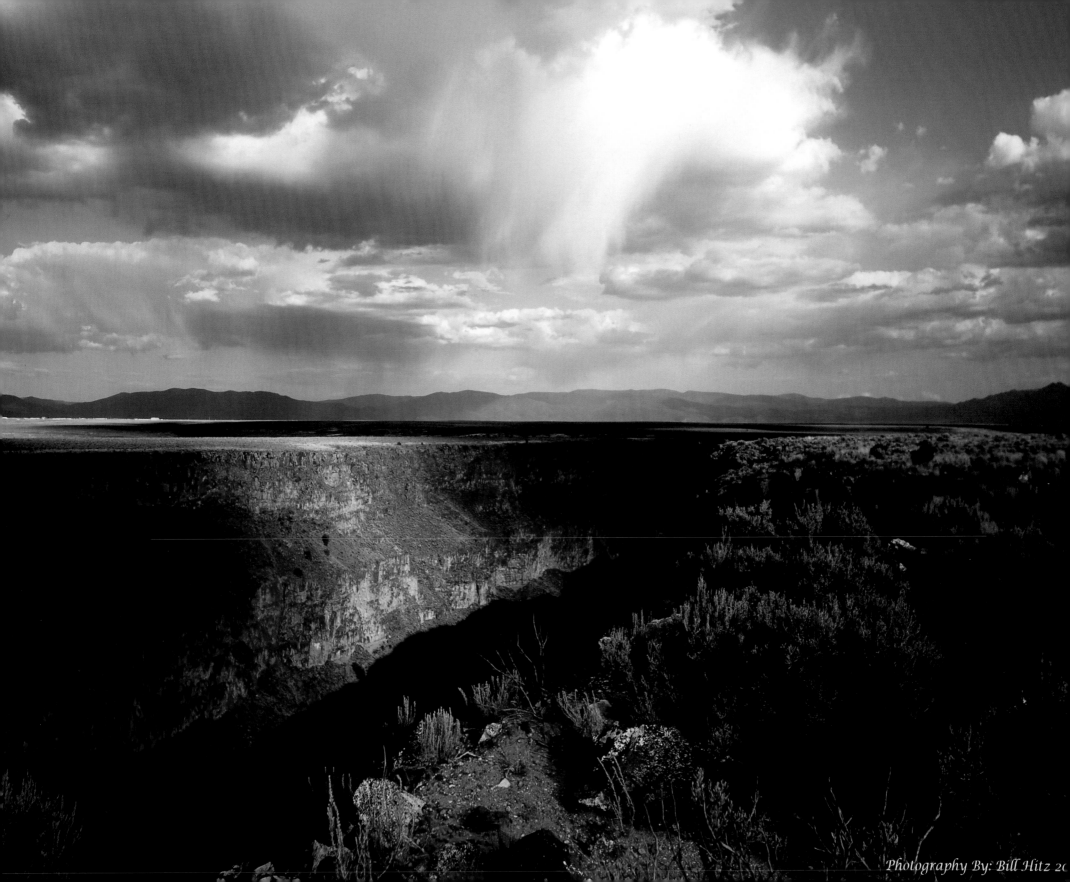

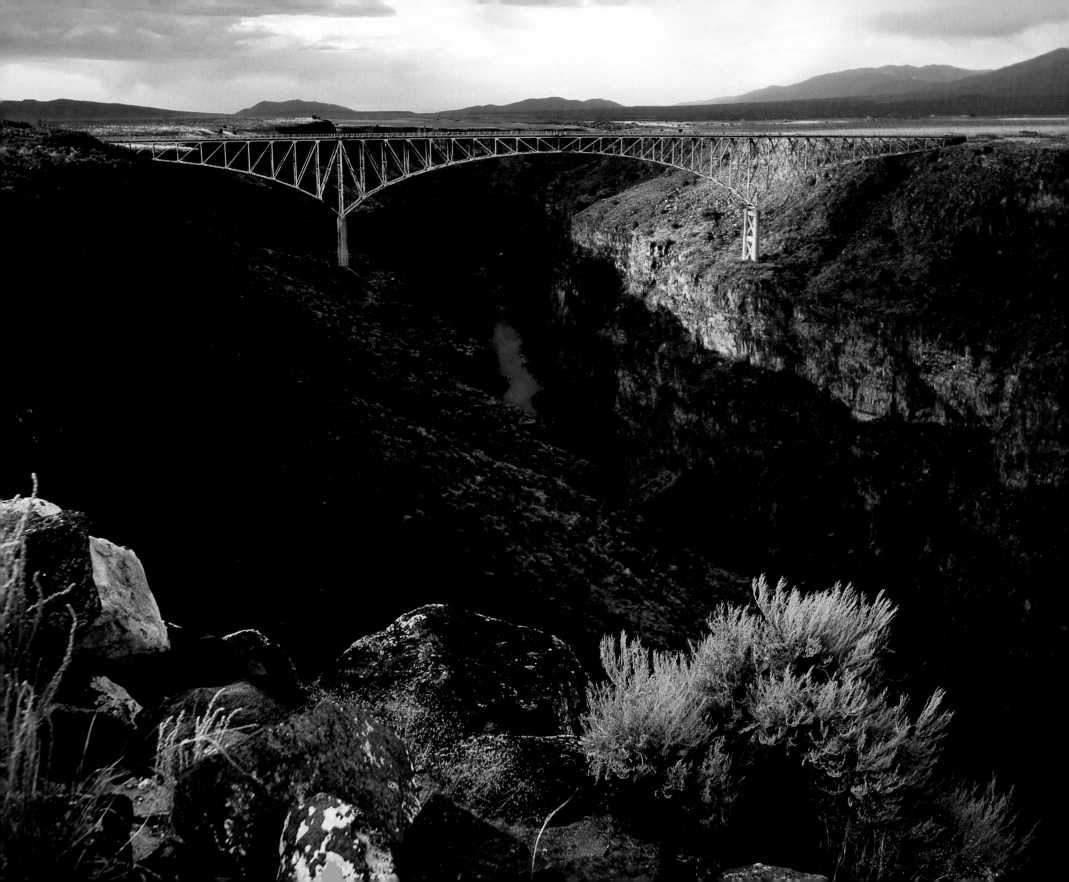

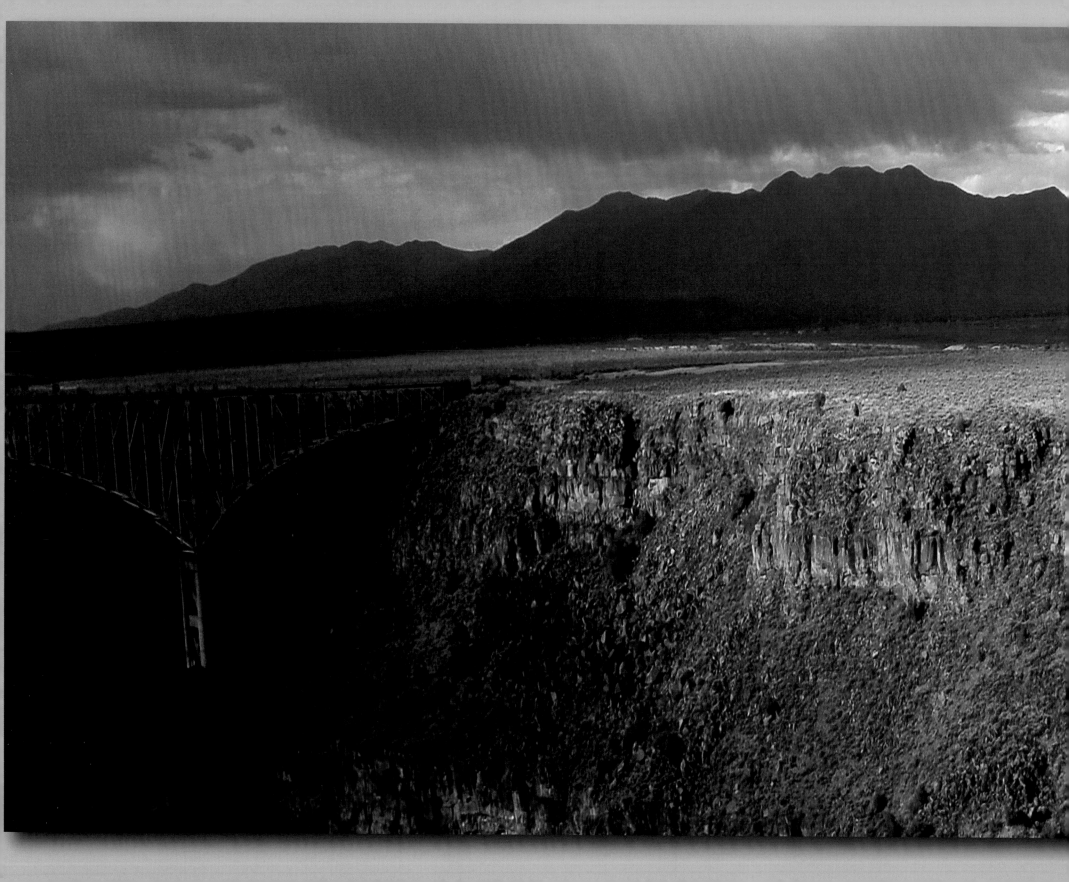

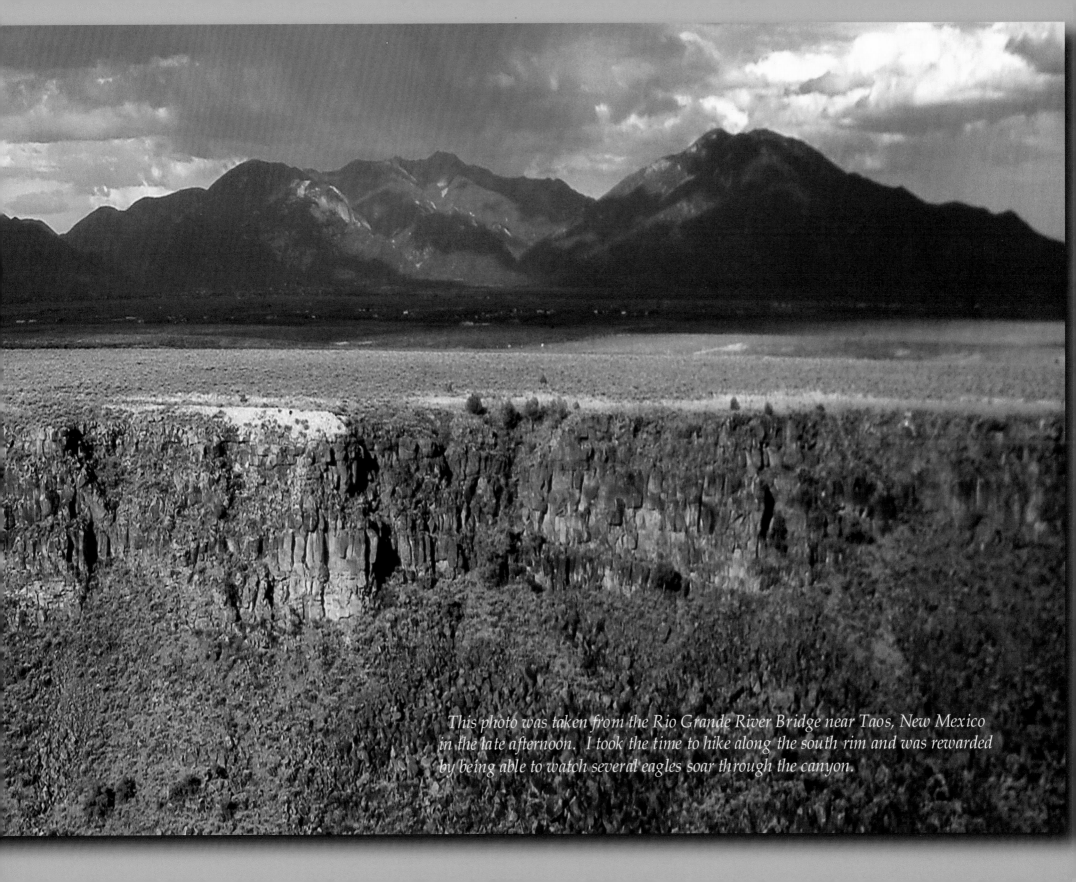

This photo was taken from the Rio Grande River Bridge near Taos, New Mexico in the late afternoon. I took the time to hike along the south rim and was rewarded by being able to watch several eagles soar through the canyon.

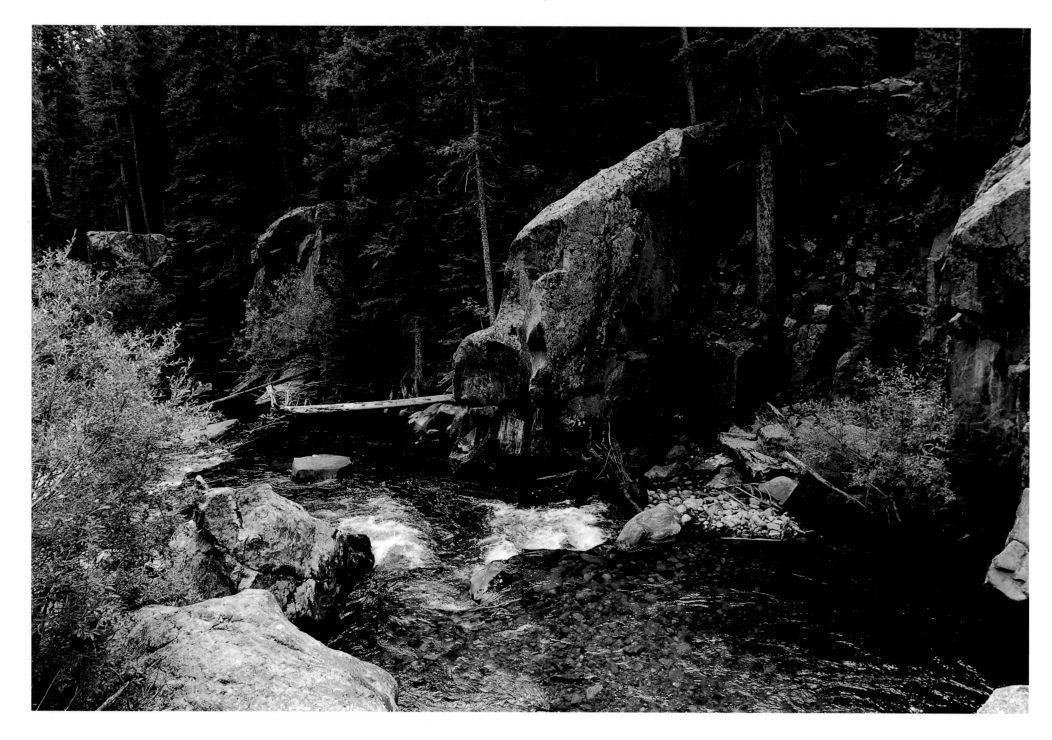

They didn't name this Clear Creek for nothing. The clear water allows the multicolored rocks to show through the swift current. This was taken just off I-70 near Empire, Colorado but if you don't turn off and stop, views like this are easily missed.

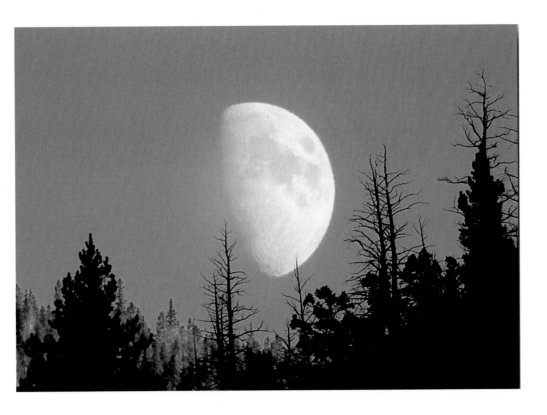

Most old mining towns in Colorado have an old cemetery nearby, if you're willing to search for them. These tend to be a wealth of photographic opportunities. This one, near Empire, is filled with interesting headstones and wrought iron fences. Many of the tombstones are works of art. Some of the grave sites dating back to the 1800s are still being decorated with flowers to this day. A bright moonlit night can add a whole new perspective.

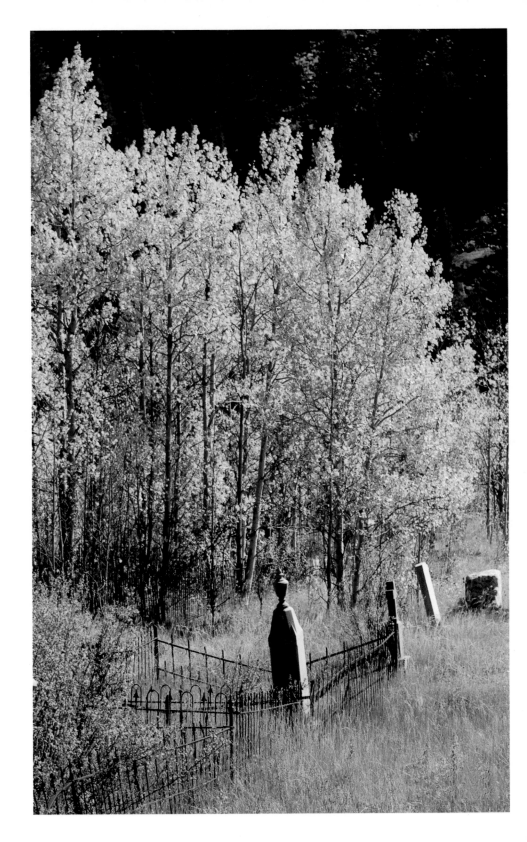

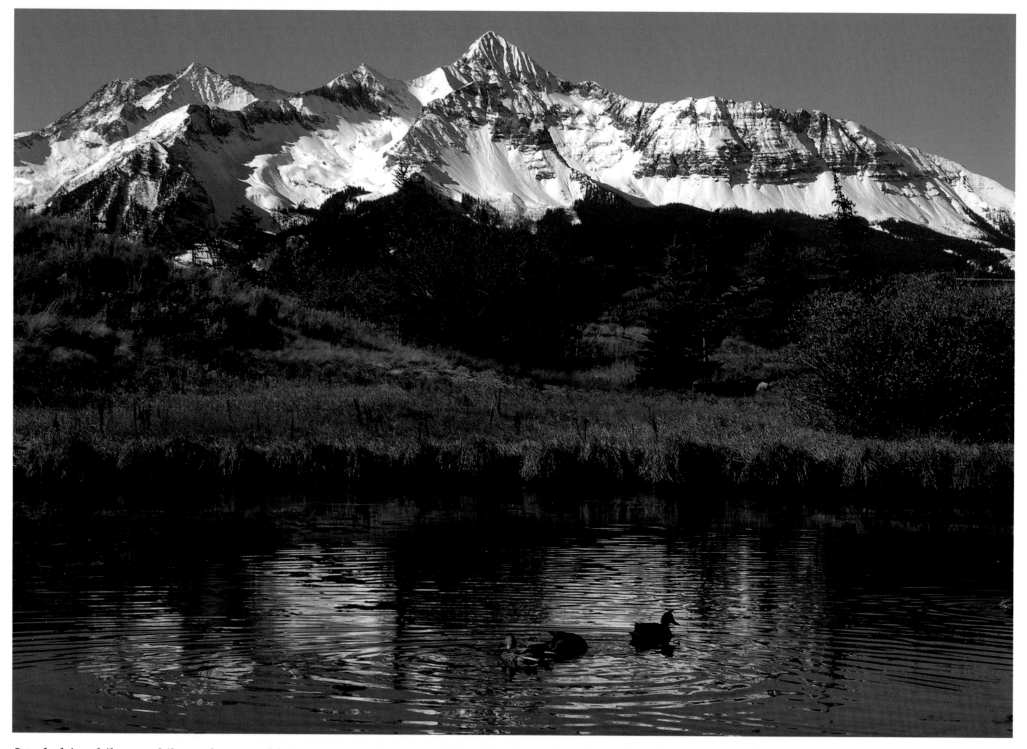

I took this while on a hike early one cold October morning near Telluride, Colorado. That's Mt. Wilson, one of Colorado's many mountain peaks that tower above 14,000 feet, in the background.

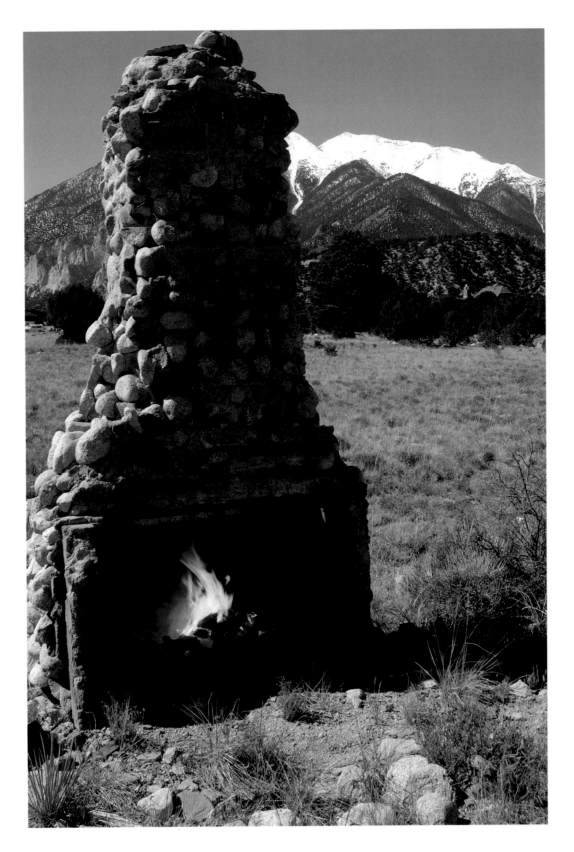

A Special Place

Some of the places I have found as I have driven the back roads of Colorado, searching for that next potential customer, have become very special places that are near and dear to my heart. This lonely old stone fireplace chimney on the road to St. Elmo is one of those places. I stop here nearly every time I drive this road. I have stopped here with friends who have been along for the ride but most times I am alone. I can't help thinking about the people who built this chimney. I'm sure it must have been part of a lonely log cabin, built by hopeful settlers, anxious to build a life for their family in this remote, rugged country. No evidence of the cabin remains, but this chimney still stands, a sentinel of a time gone by. I have spent many hours just sitting on a camp chair with a campfire burning, thinking about the meals that must have been cooked and the coffee that was heated in that very fireplace. Occasionally I will be joined by a small herd of deer or a single eagle or hawk soaring on silent wings overhead, just as they must have done when this cabin was home to a special kind of American, the pioneer. Their spirit lingers here. I know. I have felt it.

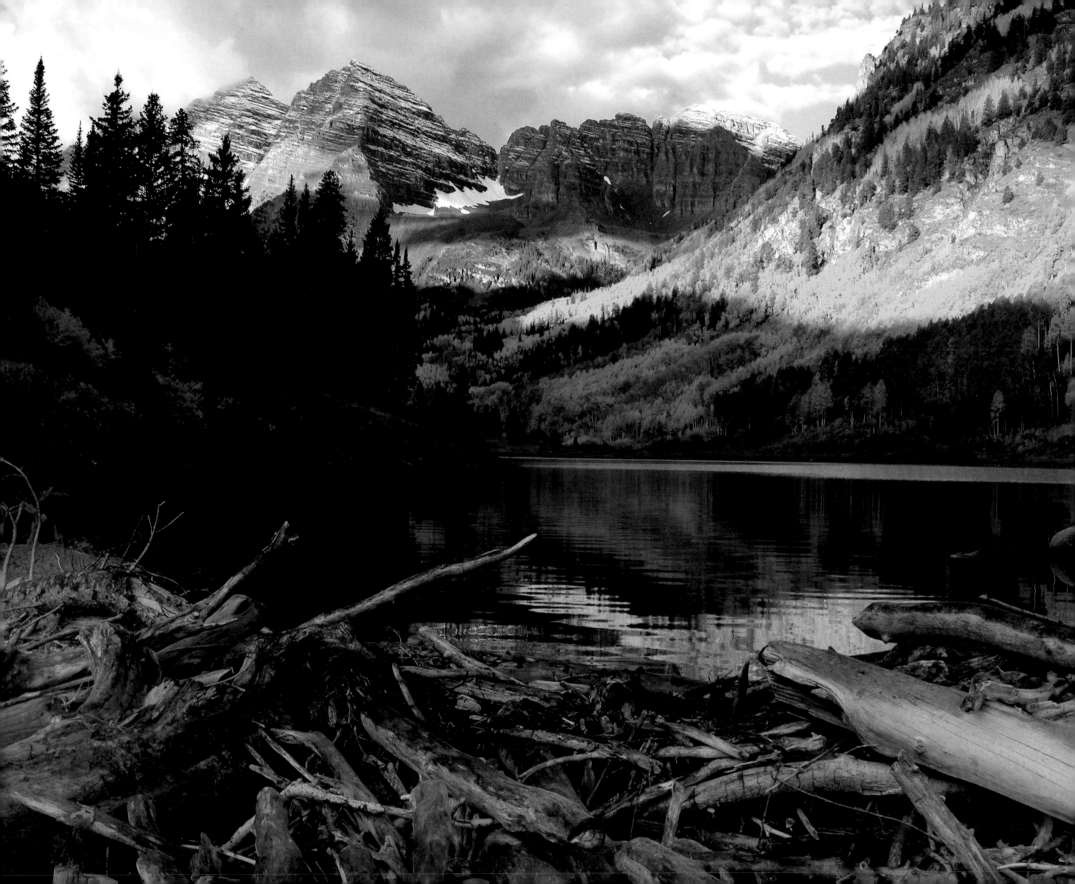

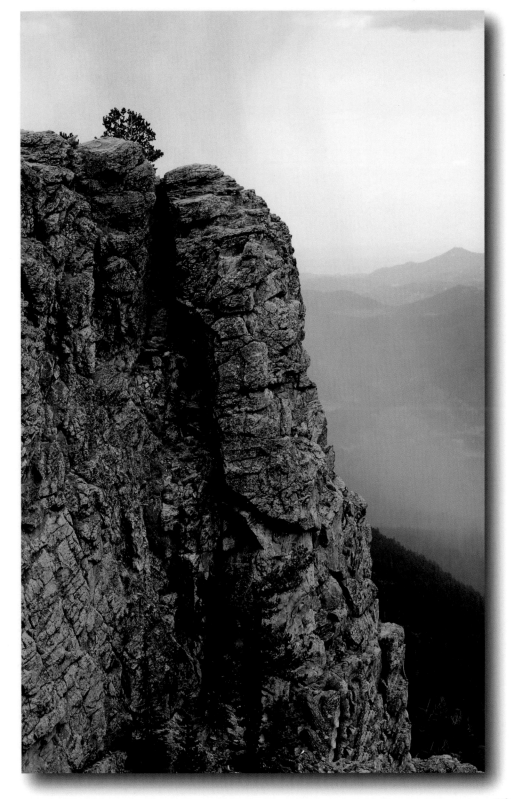

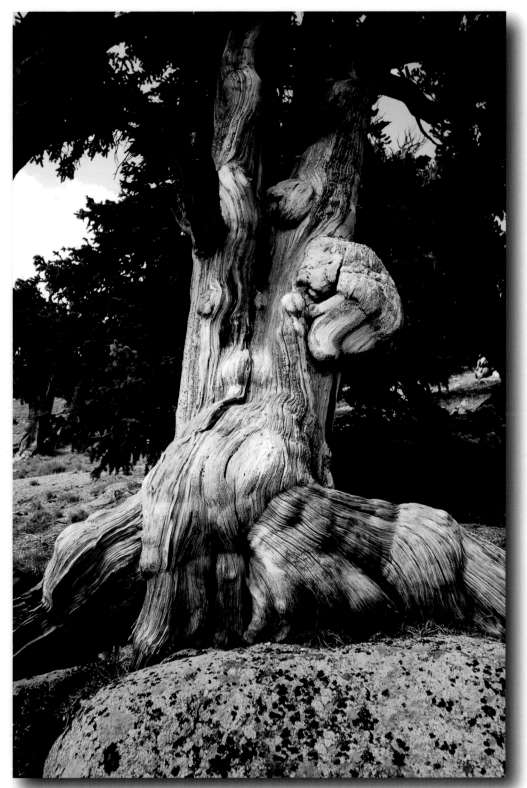

106

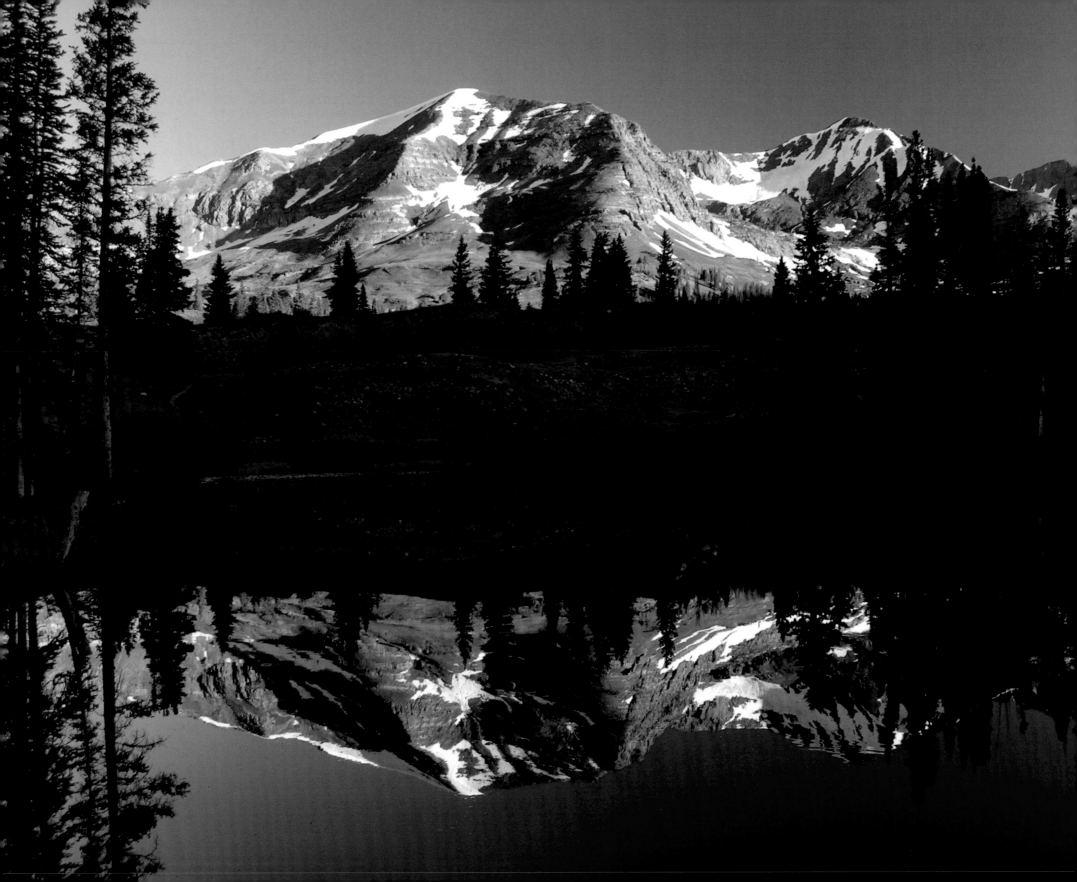

Lake Irwin

One day in late May, I had been visiting some of my clients in Crested Butte, Colorado. It was starting to get late as I began looking for a place to spend the night. I had heard about a campground on Kebler Pass at Lake Irwin. Kebler Pass is where some experts believe the world's largest living organism is located. There is a huge grove of aspen trees there that is believed to be one single unit, interconnected by their common root system, which is how they reproduce. I headed up the winding gravel road as I searched for the campground. When I finally arrived, it was almost dark. The camp host was very friendly and helpful. He told me that he had been hosting there for over fifteen years. I told him that I was hoping to get some good photos of the area. He directed me to what he said was one of the best sites in the campground to get some good photos as the sun was coming up and suggested that I wouldn't be disappointed if I were to get up before the sun came up the next morning. At a little over 10,000 feet above sea level, the next morning dawned crisp and cold, but the view I was greeted by was awe-inspiring. It was one of those moments in time when I have spent hours waiting for the sun, sky and wind to be perfect all at the same time. I almost felt like I was in another world as I captured shot after shot of snow-capped mountains reflected in the glass-smooth water of the lake.

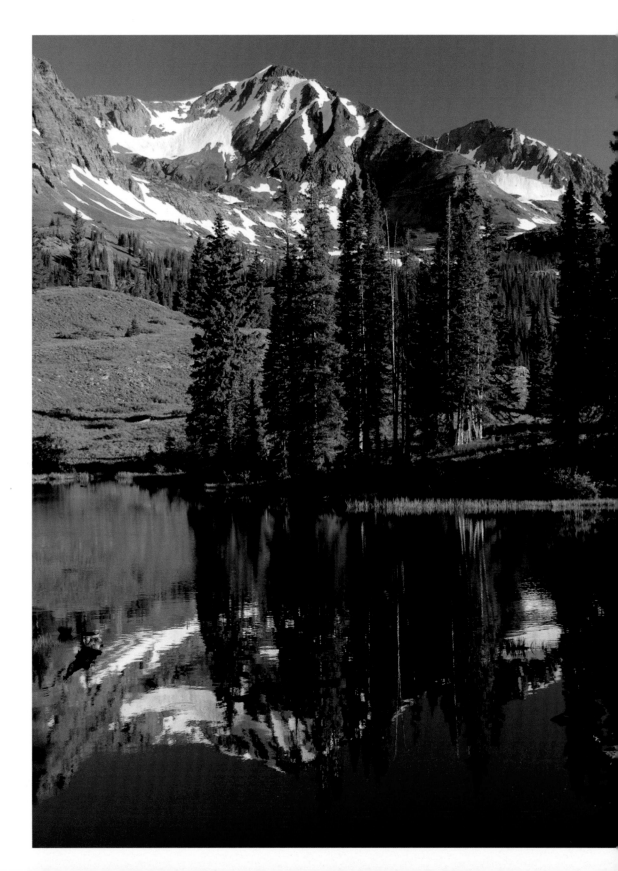

108

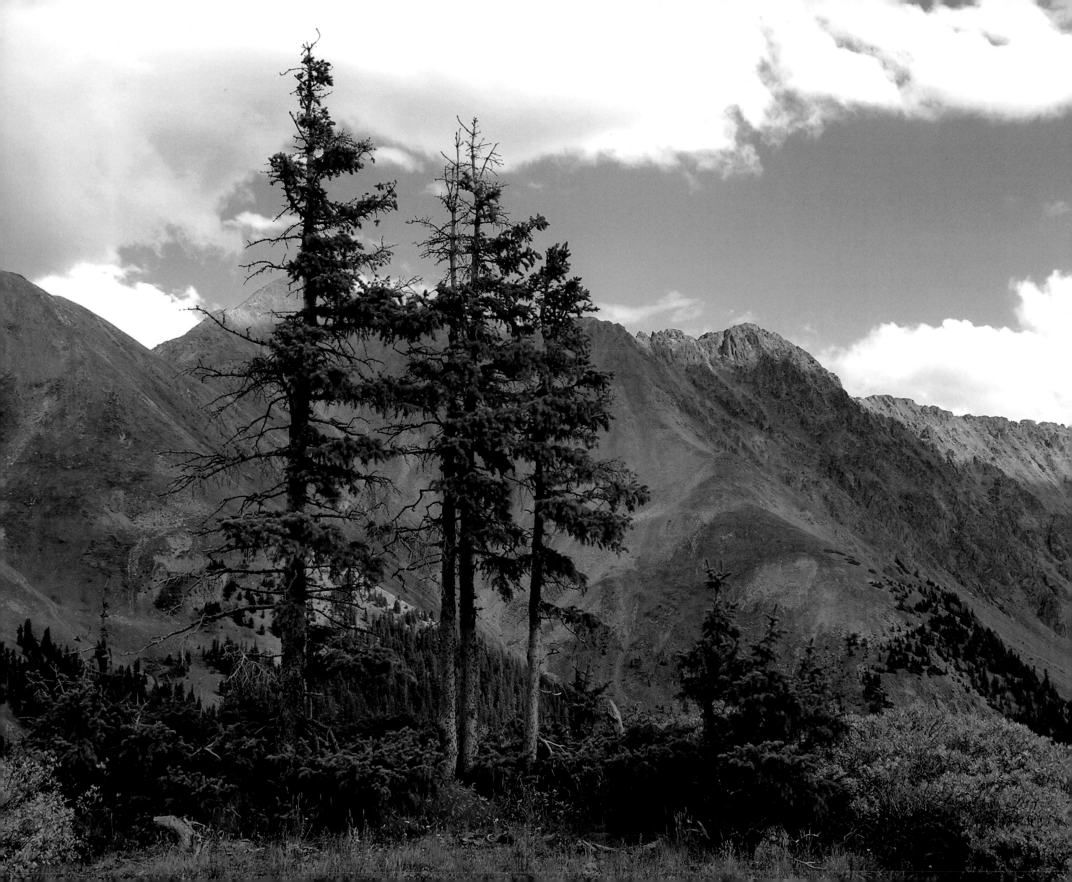

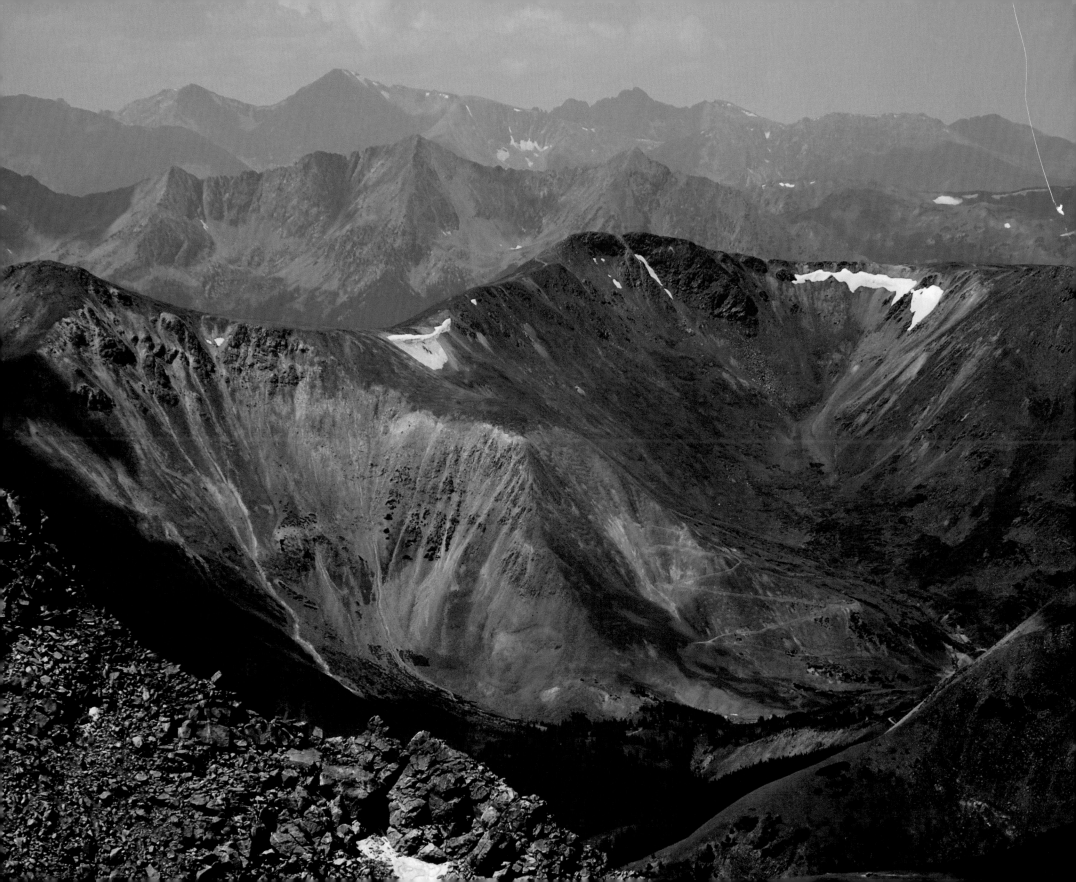

Blue Mesa Reservoir near Gunnison, Colorado
I took this photograph early in the morning while the water was still smooth as glass. It's hard to tell where the land ends and the water begins. If you turn this photo on its side, it looks kind of like a praying monk with a tall pointed hat and a thick robe.

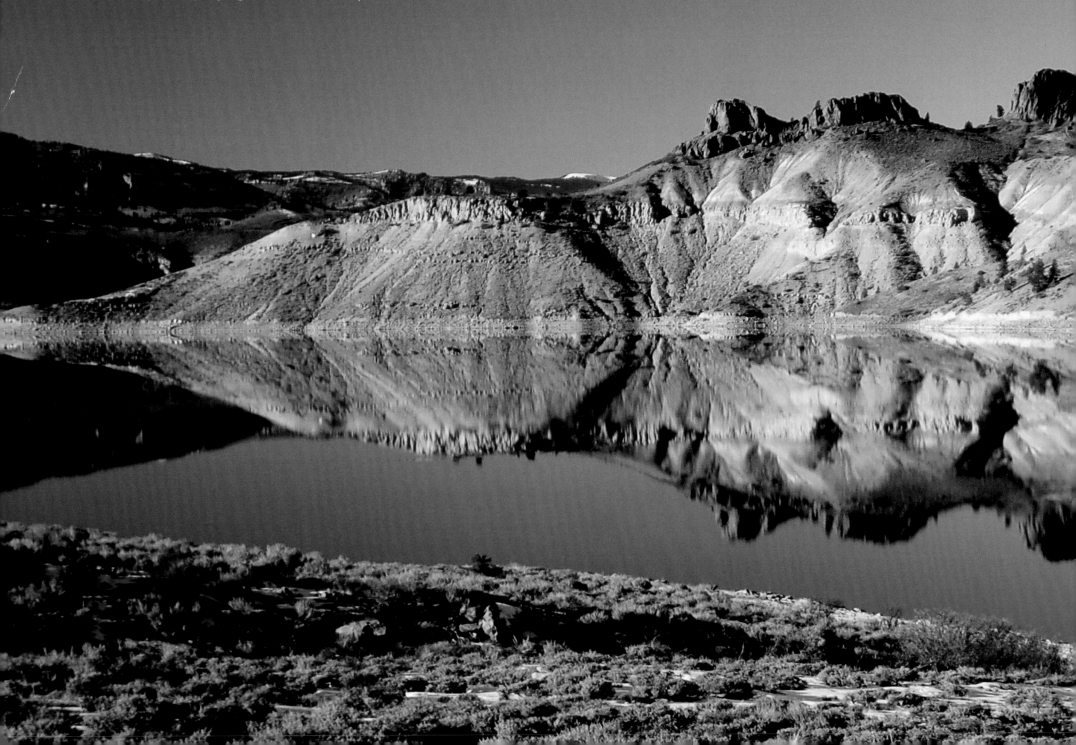

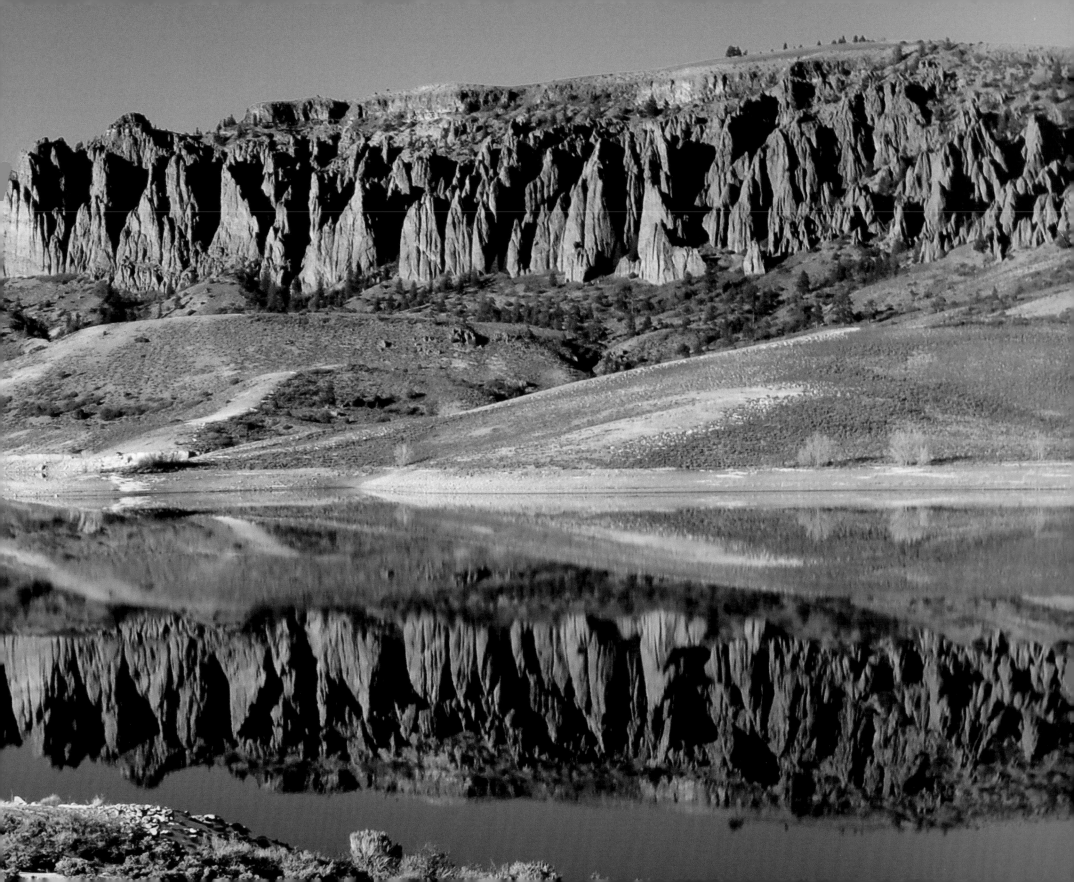

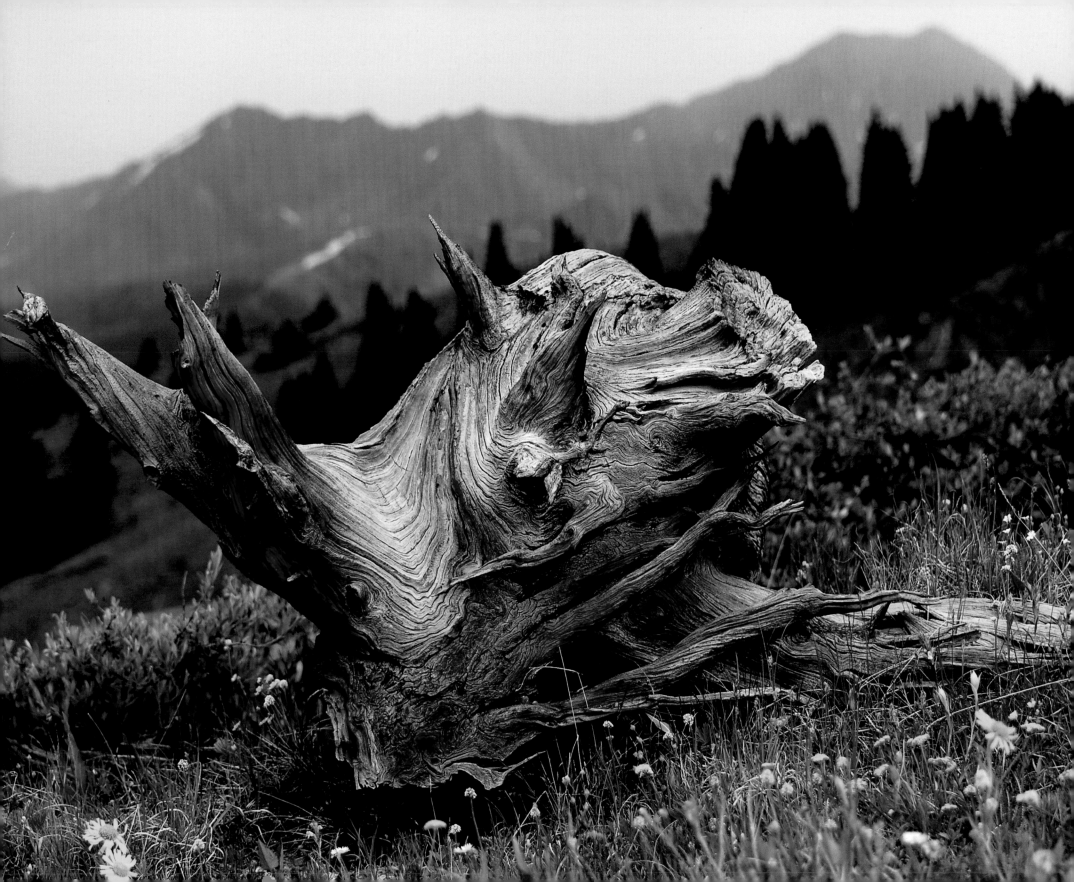

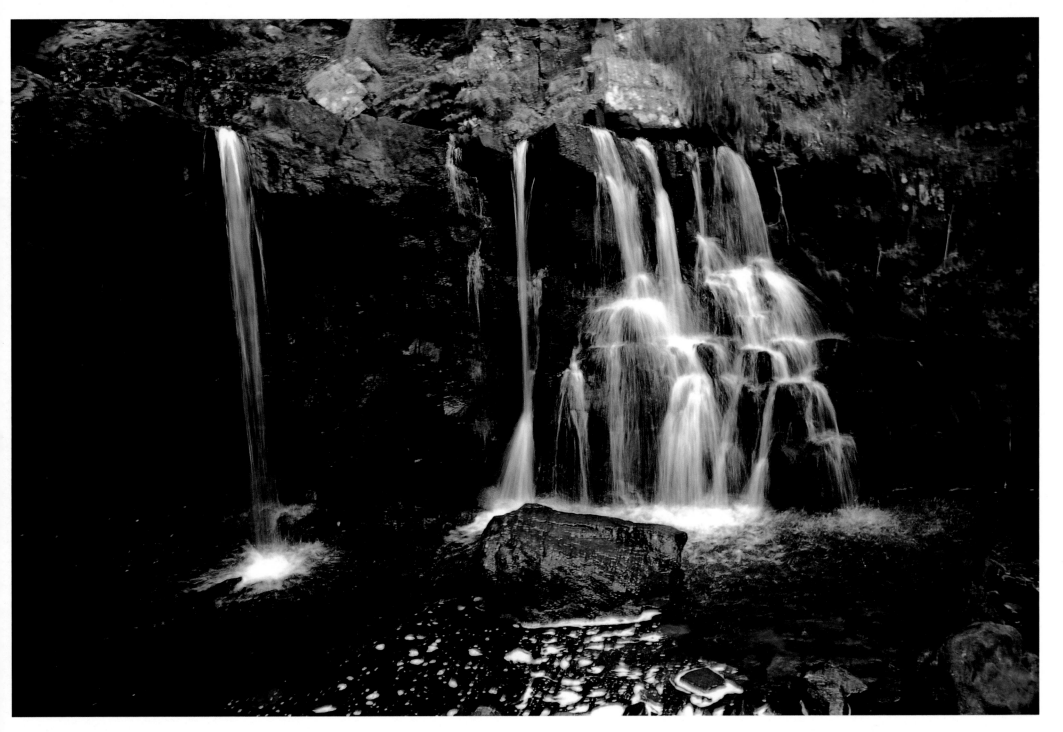

I came across these falls one sunny summer day in late July while hiking near Lake Irwin. The flowers were in full bloom and the sun would make shafts of light as it shone between the tall pine trees and glisten off the wet rocks in the stream. I felt as if I had just walked into a rain forest on a tropical island somewhere. I have visited this site many times. It is one of my favorite places to hike and take photographs. It has never disappointed me.

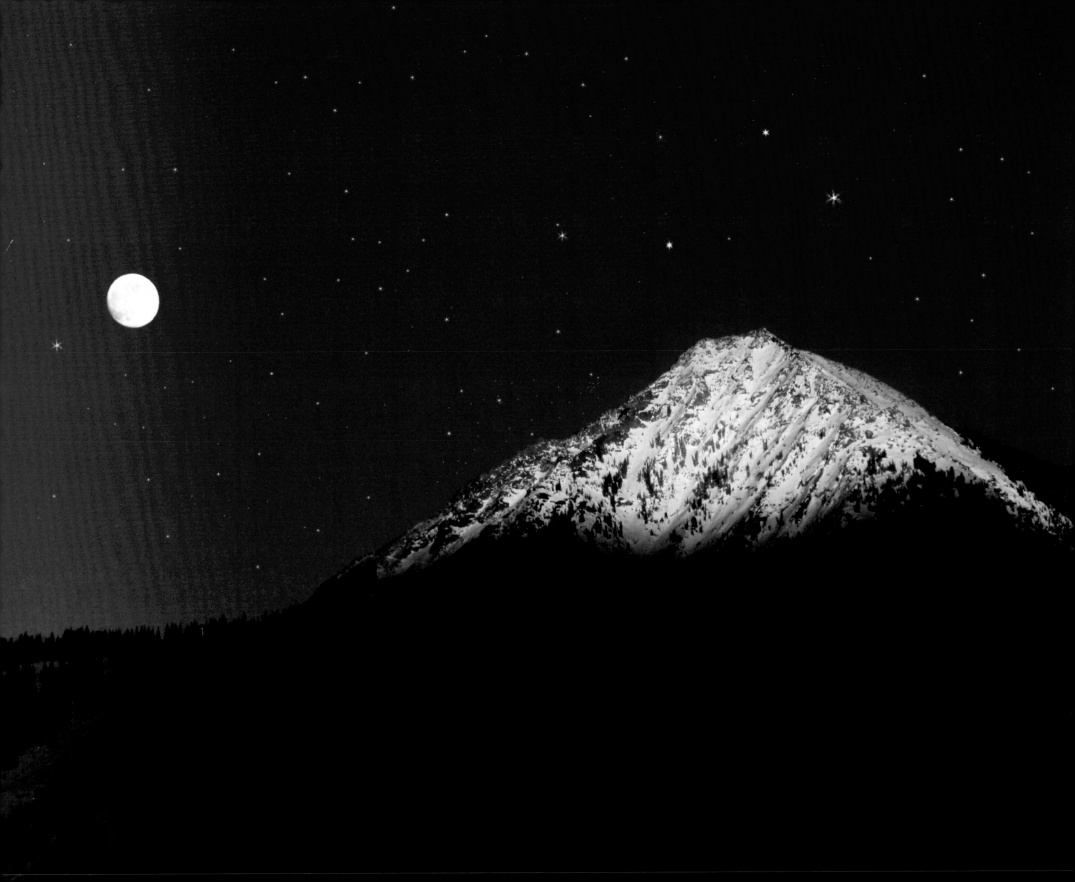

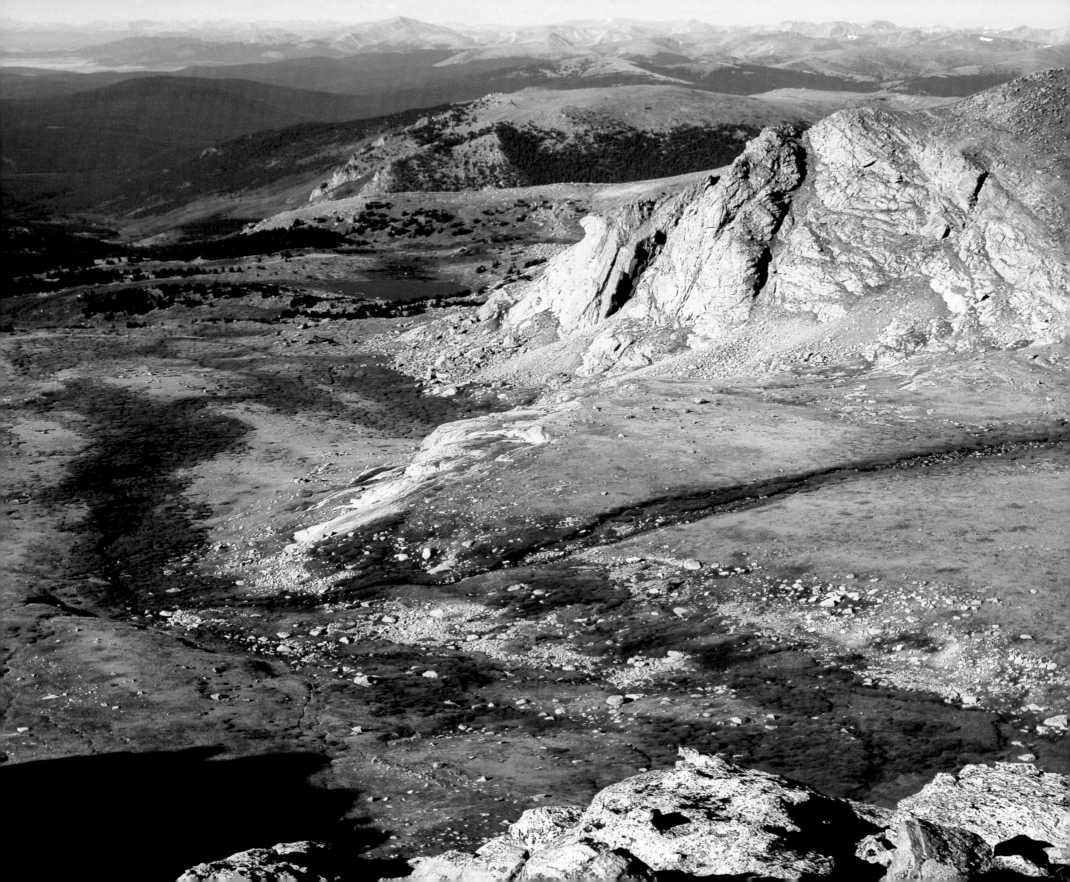

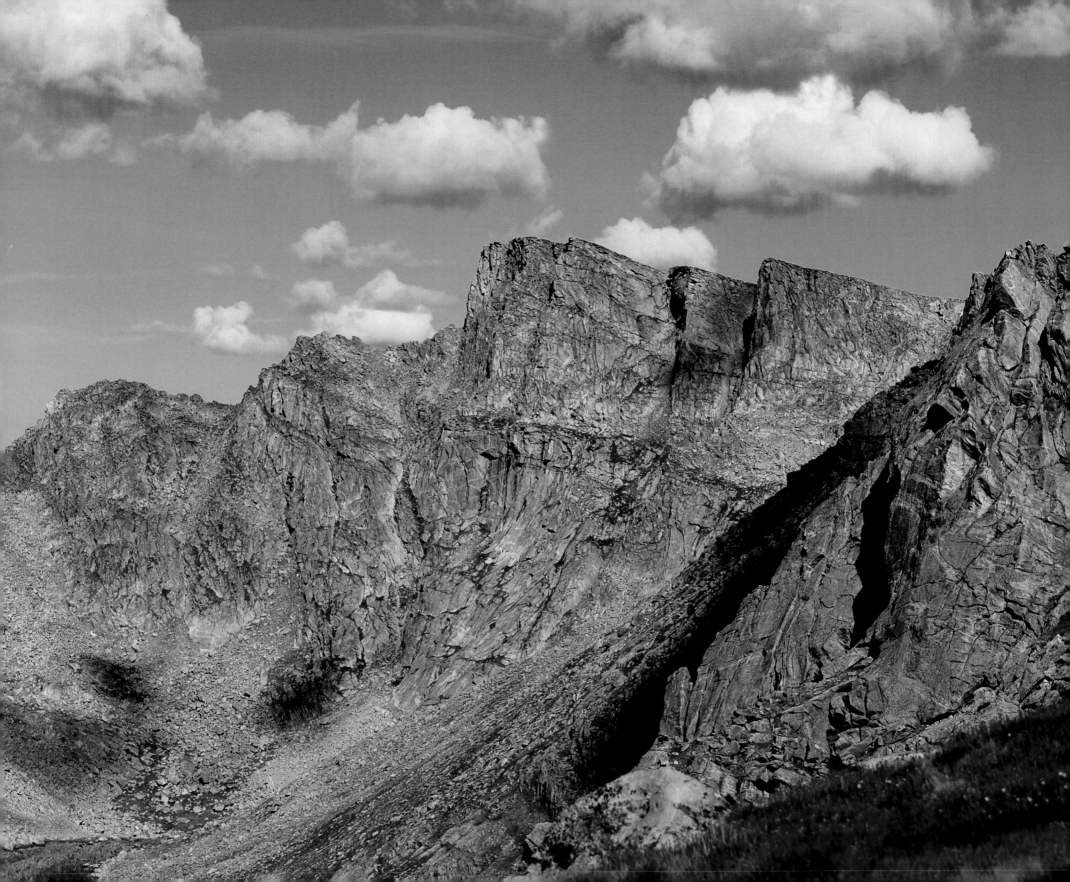

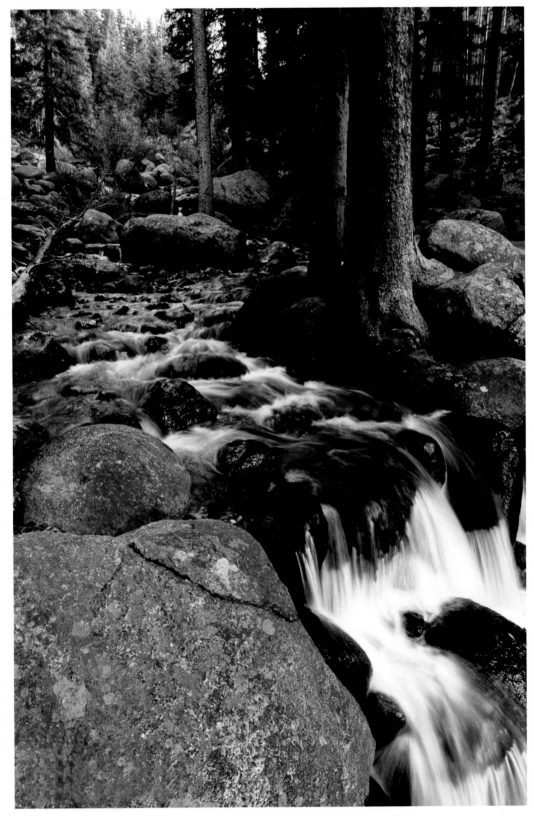

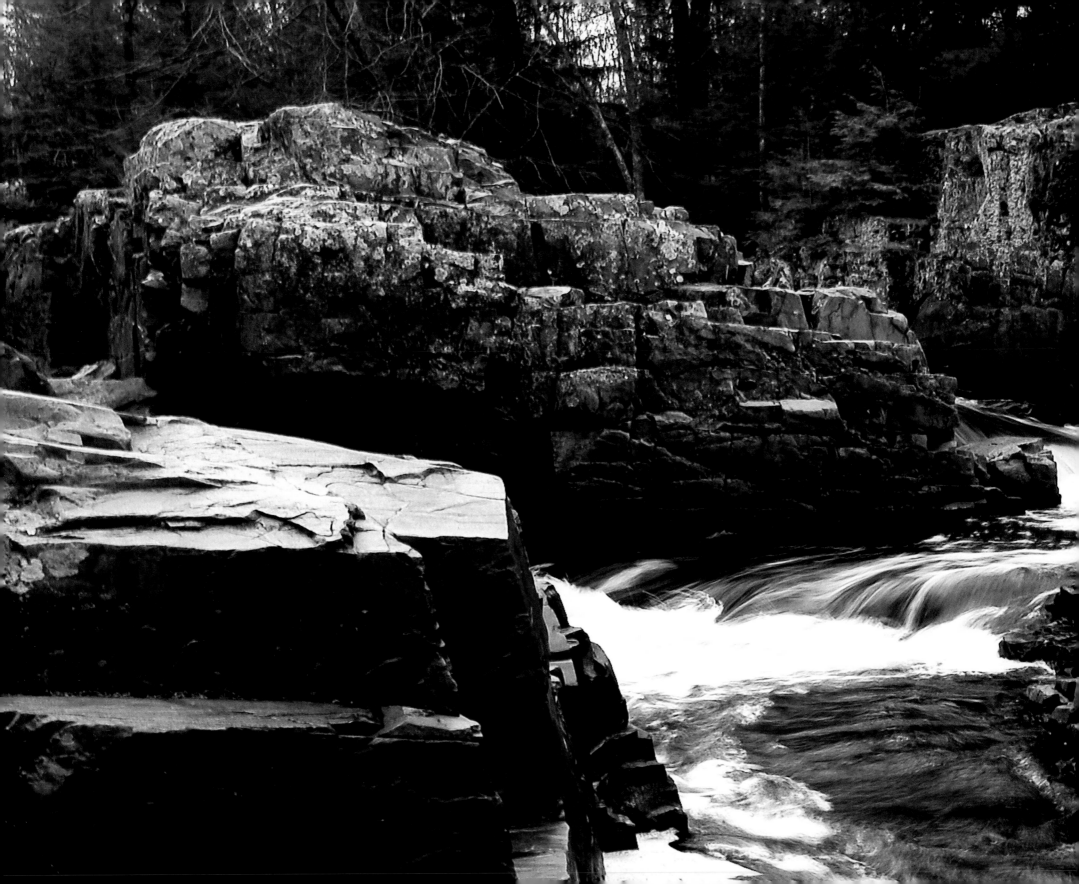

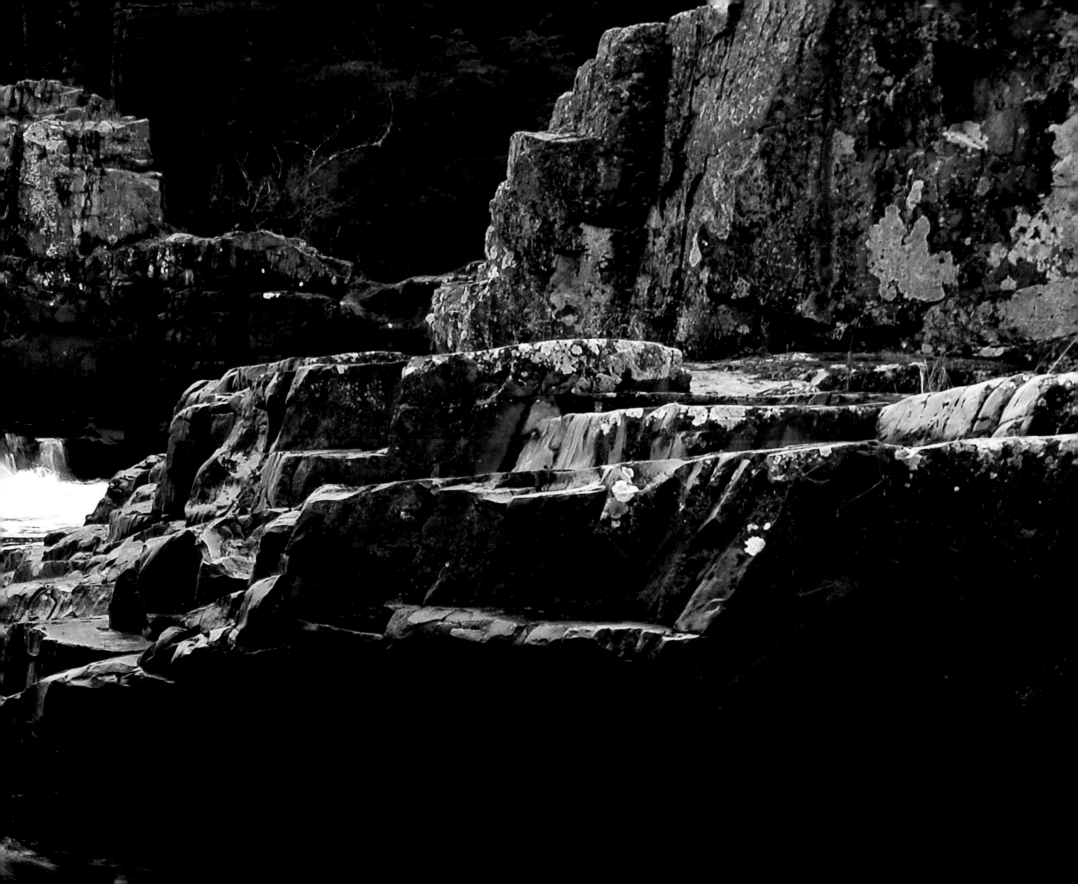

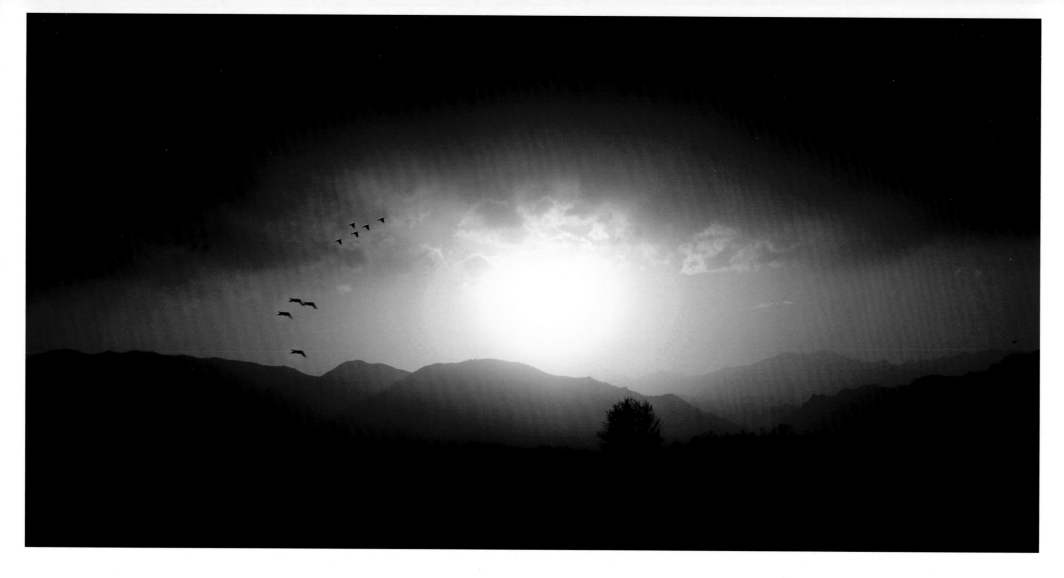

When you talk about the 'Road Less Traveled', it can mean many things. You can travel the same road over and over every day, but if you don't take the time to see the beauty of what is all around you, then your life is going by too fast. I took this photograph from the side of a busy highway during rush hour one afternoon just north of Denver. Most of the people in the cars and trucks around me were just driving to get home from work. It had been a stormy summer day in Denver with rain and thunderstorms. The weather was clearing to the west where the peaks of the majestic Rocky Mountains are visible to those who will take the time to see them. I could see the setting sun beginning to shine through the parting clouds. I stopped at the top of a small rise next to the highway as cars and trucks sped past. I got my camera ready in anticipation of the moment when the sun would be in the perfect position. I started to click my camera. The approaching darkness and the lingering clouds gave the scene a gloomy, almost foreboding feeling. Then the birds flew into my view. You couldn't have asked for anything better than that. The presence of the birds gave the scene a feeling of assurance that everything was going to be alright; that the sun would come up again tomorrow. Like the old saying goes, 'Stop and smell the roses.' There is so much you can do to enjoy nature if you just take the time to do it. A picnic in the mountains can ease the stress level. Take the kids fishing or go for a hike along a mountain trail. You can see so much if you just take your time. Life can be full of joy and wonder if you will let it.

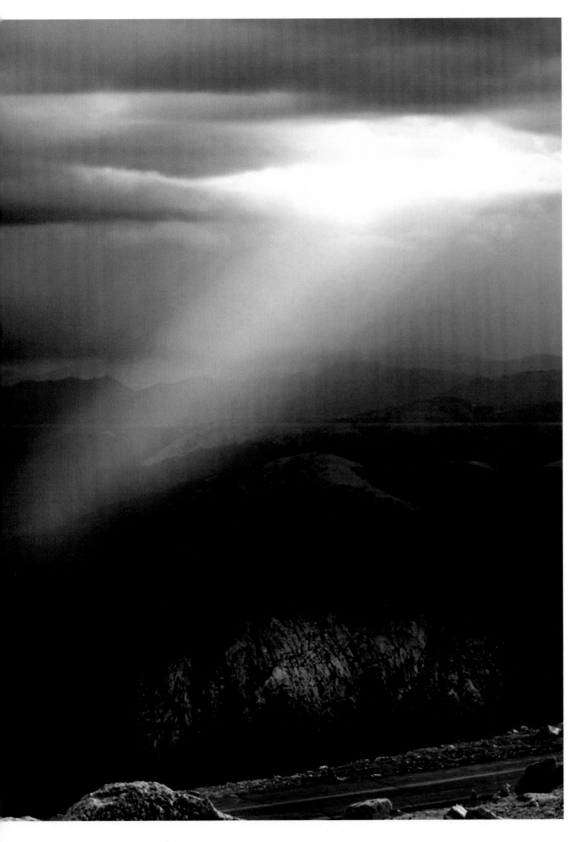

Mt Evans, Colorado

One of the less traveled roads in Colorado is the road to the top of Mt Evans, located about 30 miles west of Denver. This road is the highest paved road in the United States and is only open between Memorial Day and Labor Day each year. The rest of the year it is snowed in and impassible. I like going up here whenever I can because the views are awesome and I always see a lot of wildlife. I have seen elk, deer, mountain goats and marmots. This particular day I was trying to get some photos of the resident herd of mountain goats that live on the peak. This was one of the last days the road would be open before they closed it for the winter. It was cold and the clouds were moving swiftly as the wind pushed them along. The sun was low in the west as it was starting to get dark. Suddenly the clouds just seemed to part and a light from heaven came down through the clouds. I almost expected to hear the voice of God come booming down from above. I am always inspired whenever I am fortunate enough to witness the handiwork of God in the high peaks of the Colorado Rocky Mountains.

122

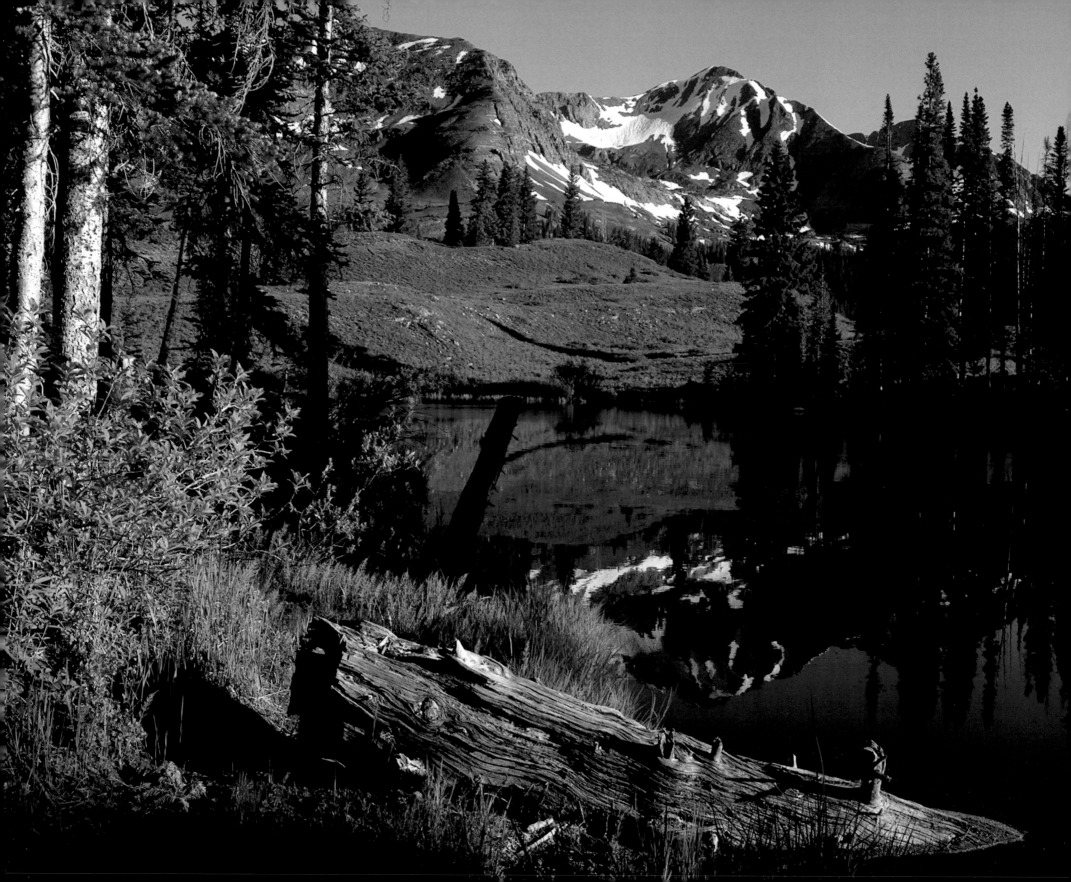

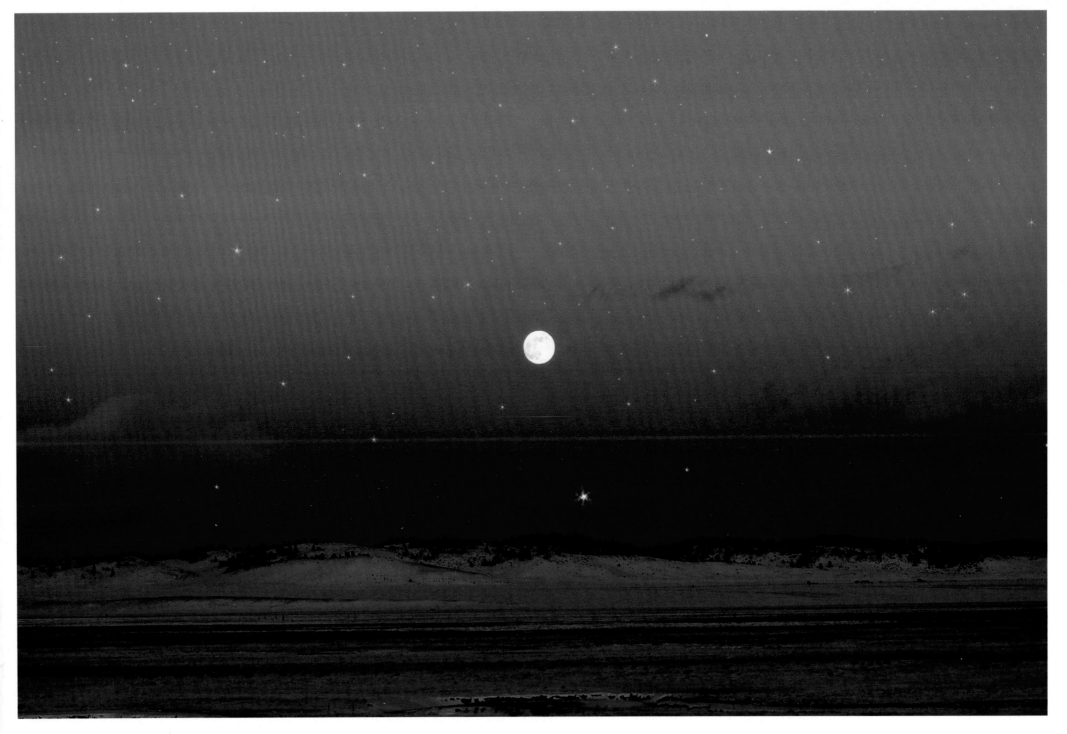

The long drive home after several days on the road selling can be the most difficult part of a trip. It can get very dark in the mountains at night, but when a full moon comes up when there is snow on the ground, you almost don't even need your headlights sometimes. I caught this scene one night in South Park near Fairplay, Colorado. It was a cold December night just before Christmas. The moon and the bright star below it seemed to come up in the east, guiding me safely home for the holidays.

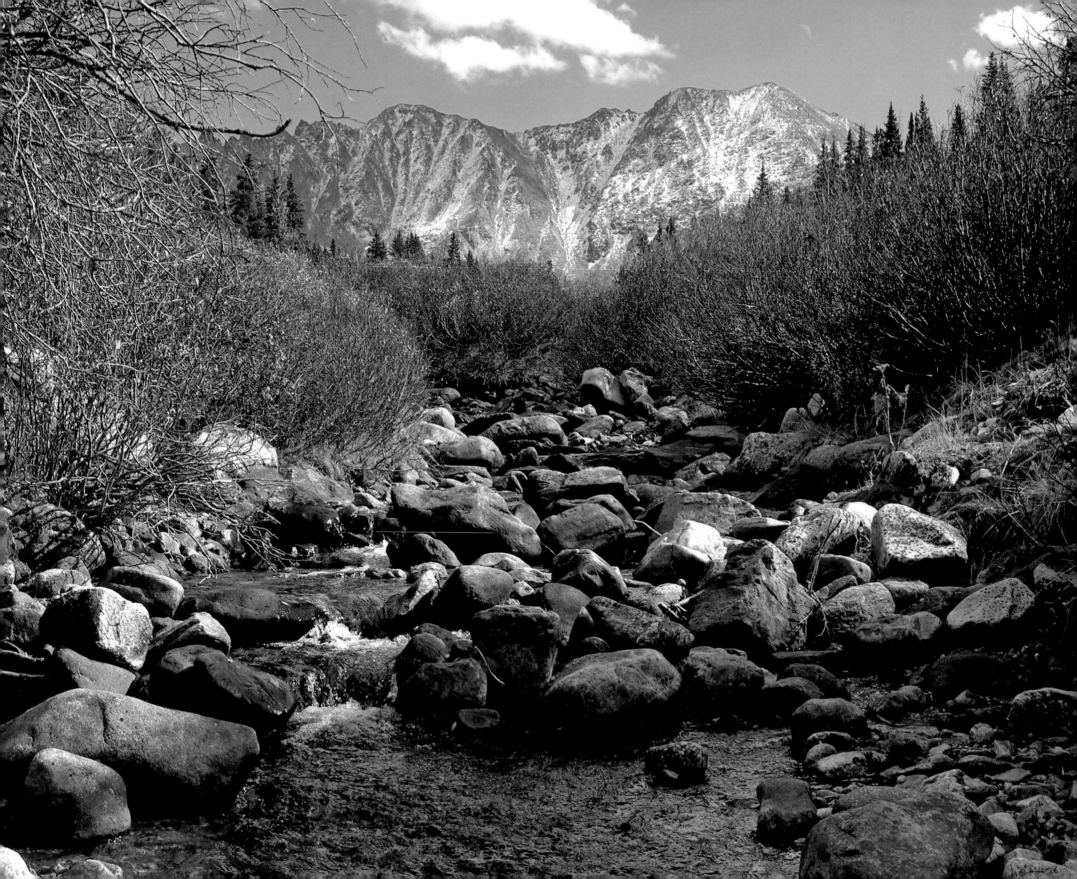

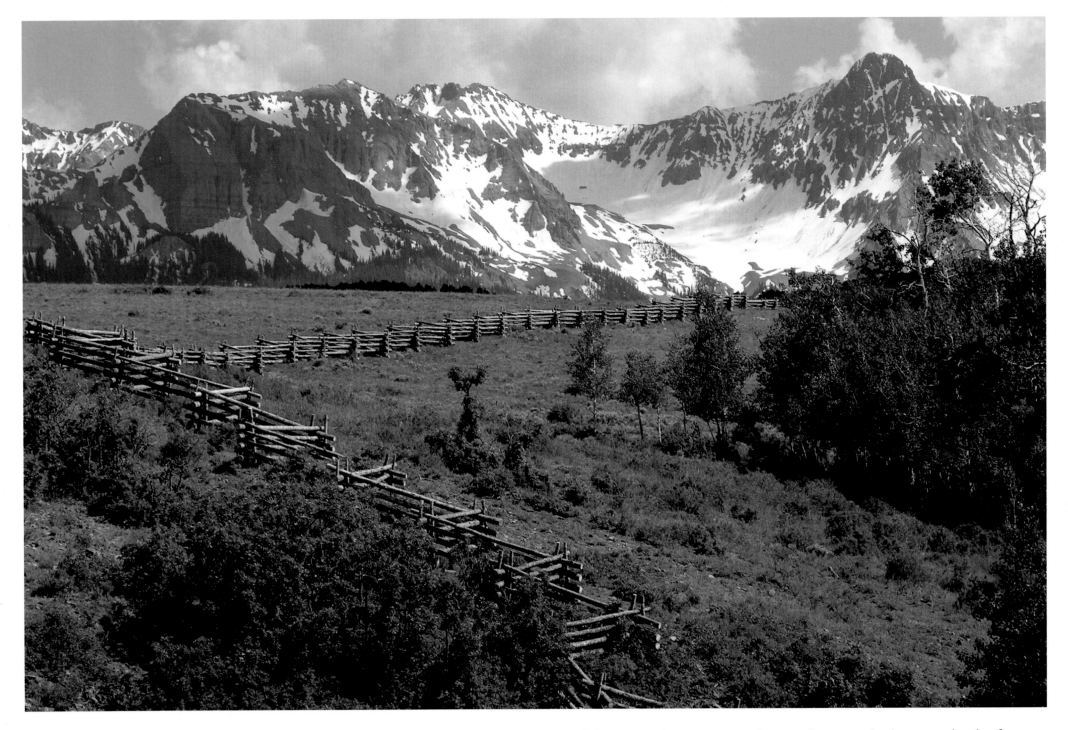

The San Juan Mountains between Ridgway and Telluride, Colorado are some of the most picturesque and most photographed mountains in the country. This area has been featured in numerous movies and advertisements. This photo was taken near Last Dollar Trail. I like to call it the million dollar view.

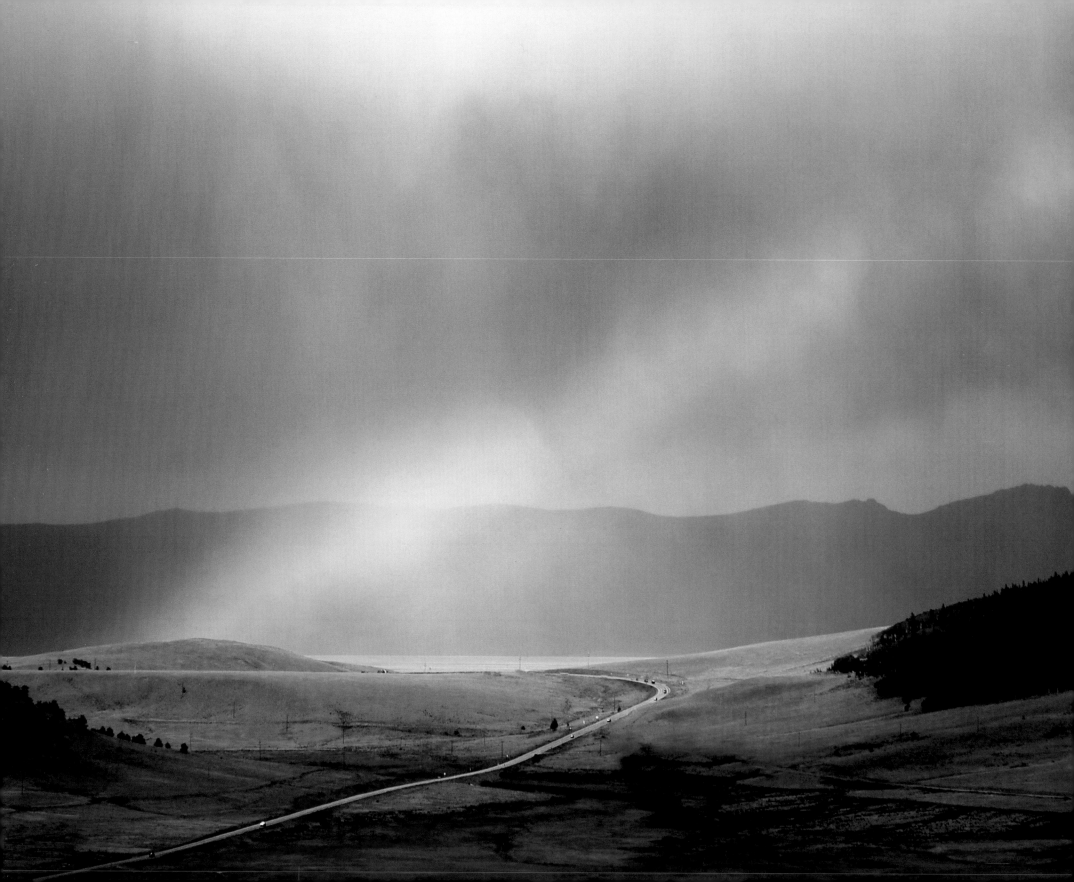

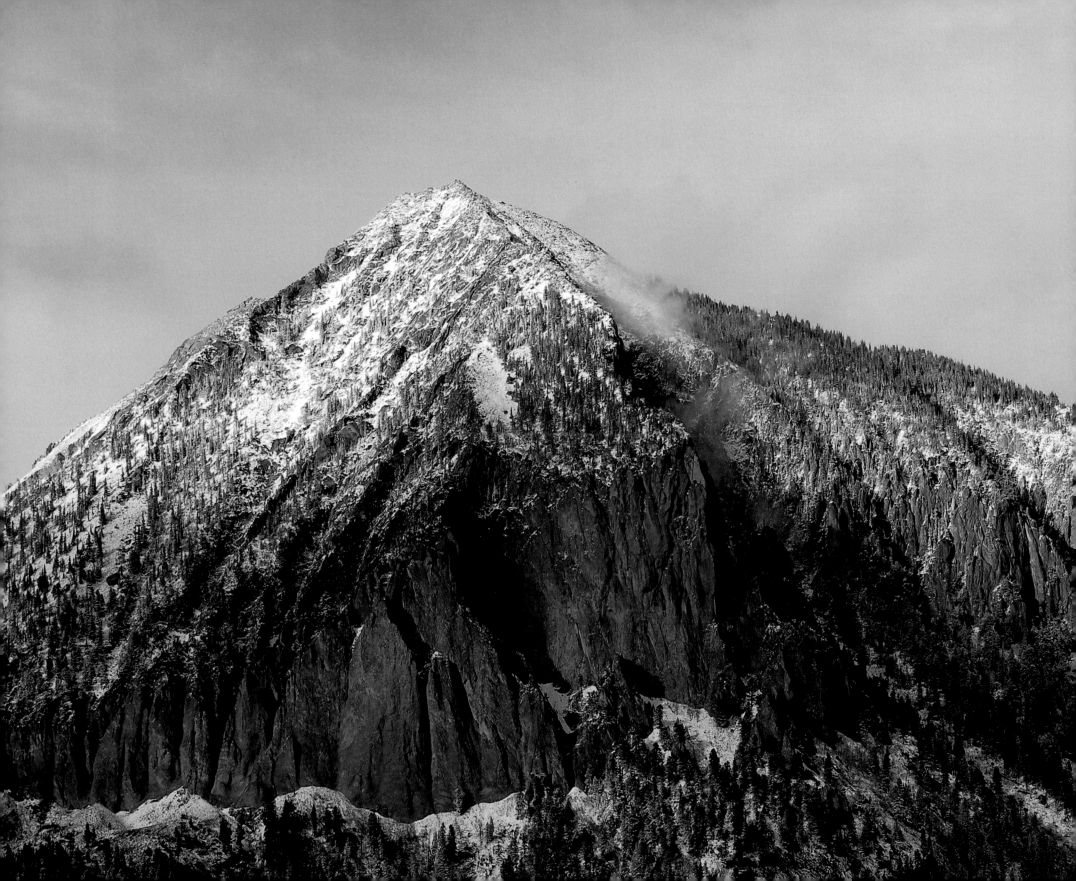

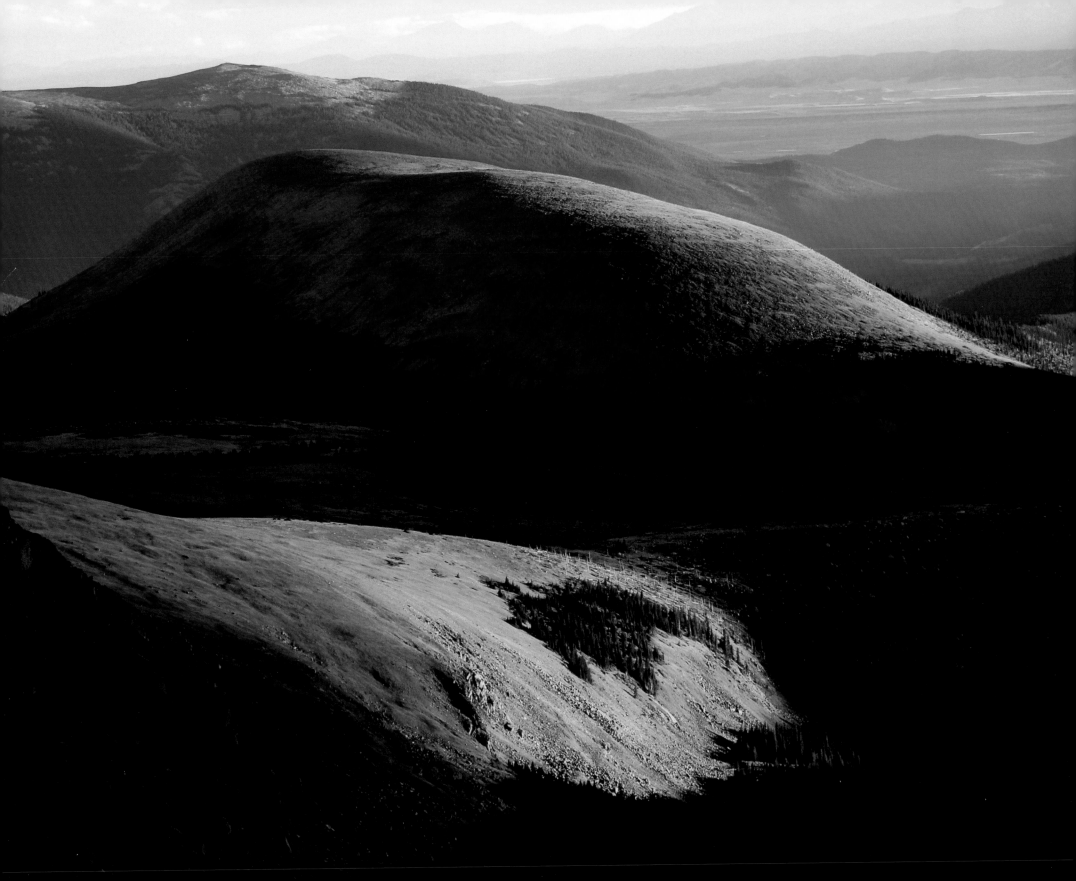

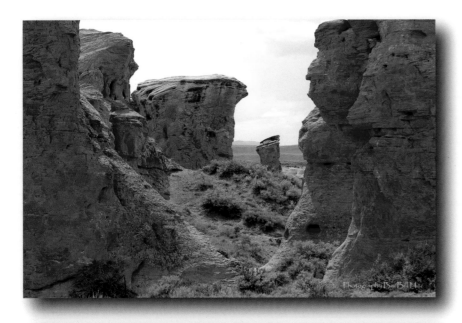

Photography By: Bill Hitz

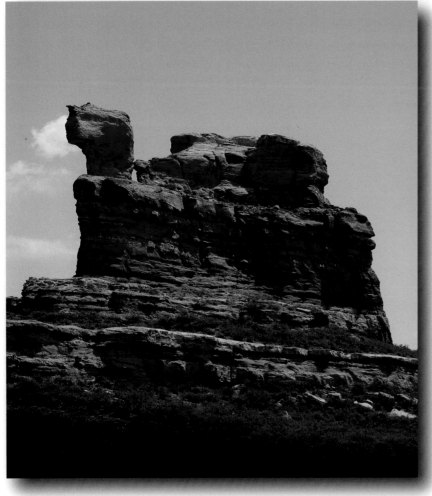

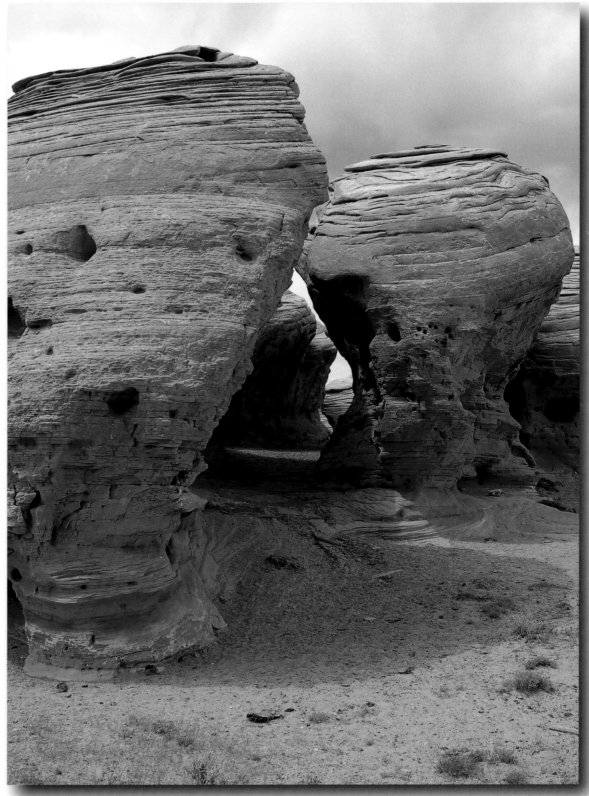

130

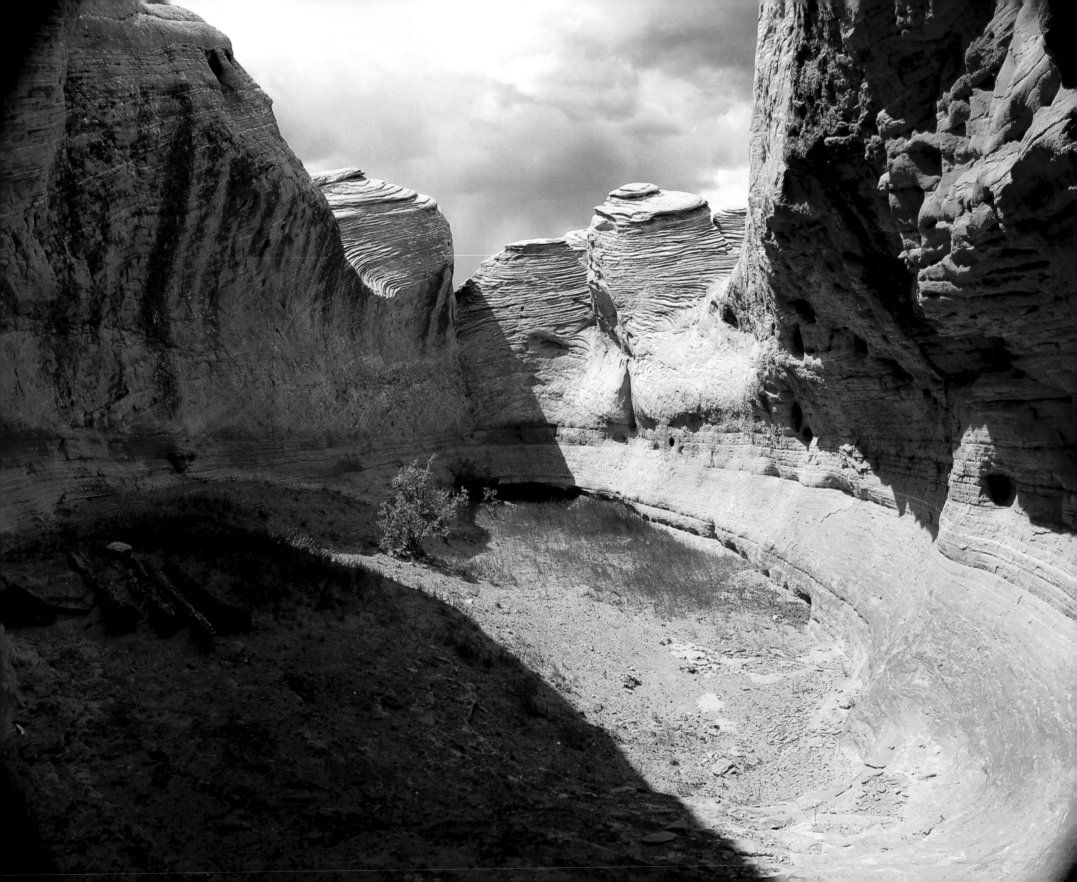

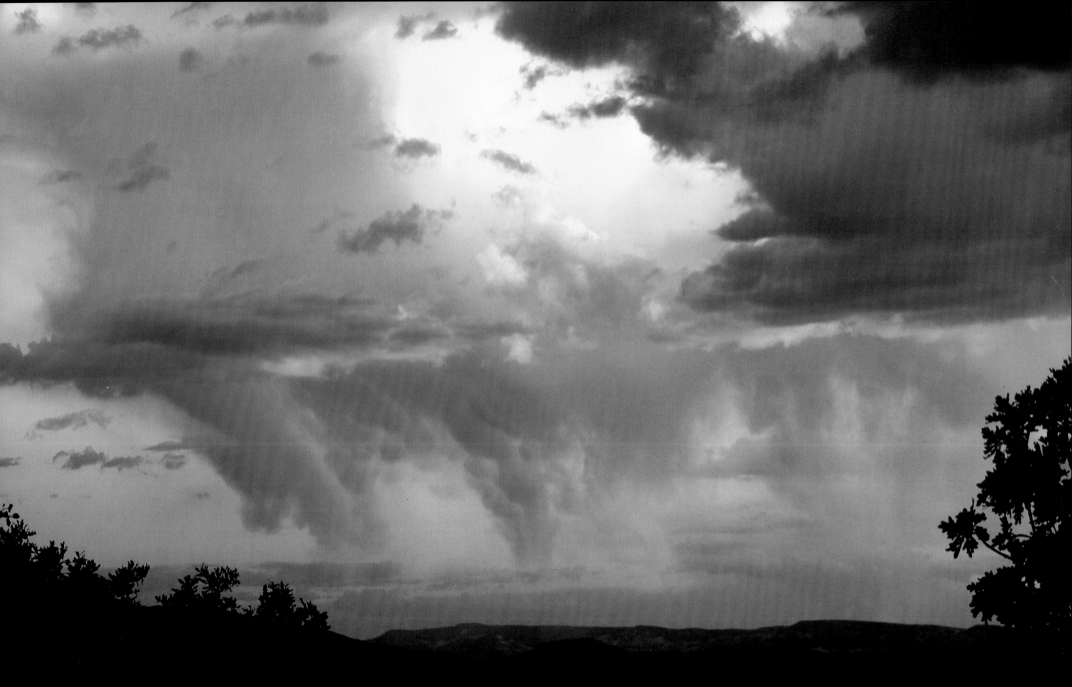

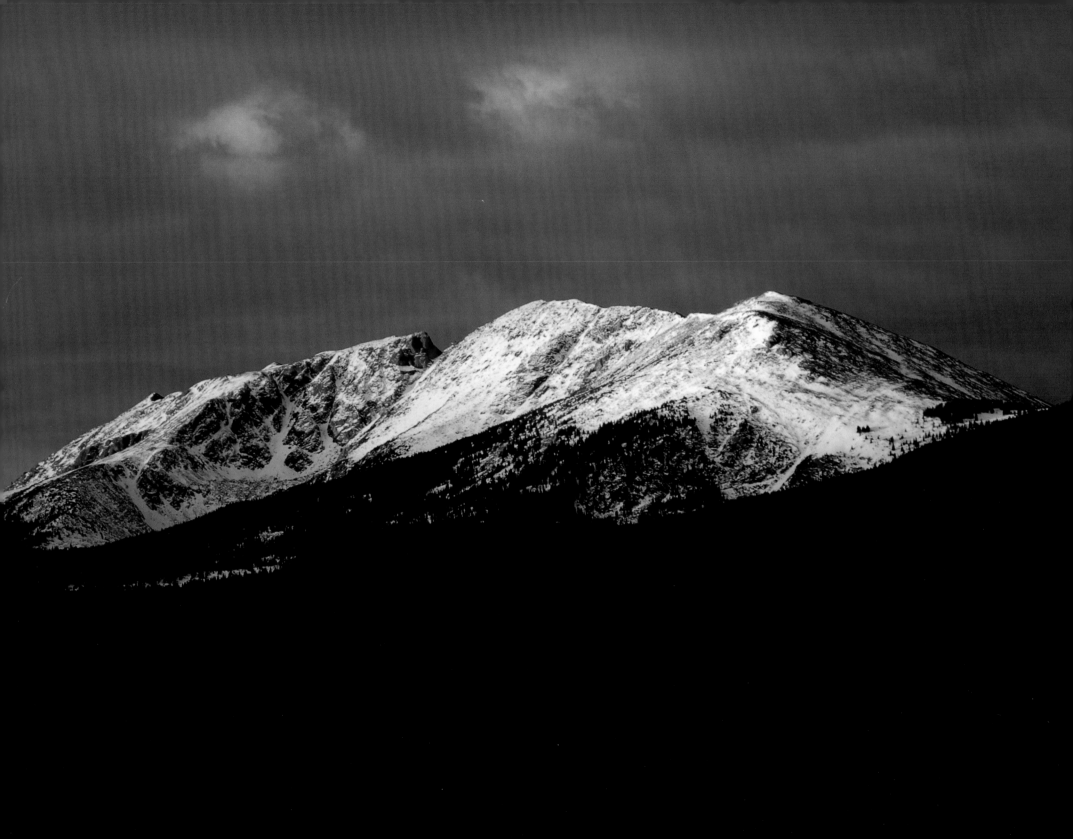

Sunset on Lizard Head Pass near Telluride, Colorado

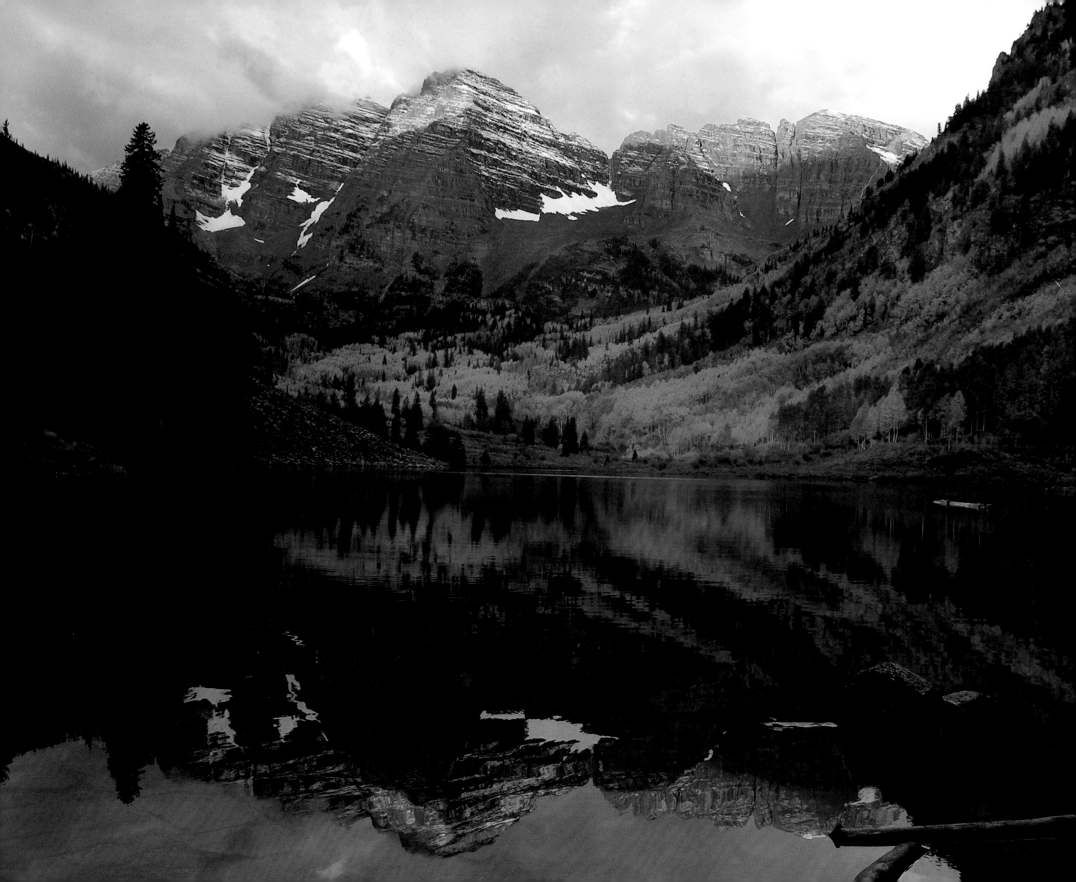

Chapter 6
Colorful Flowers on the Trail

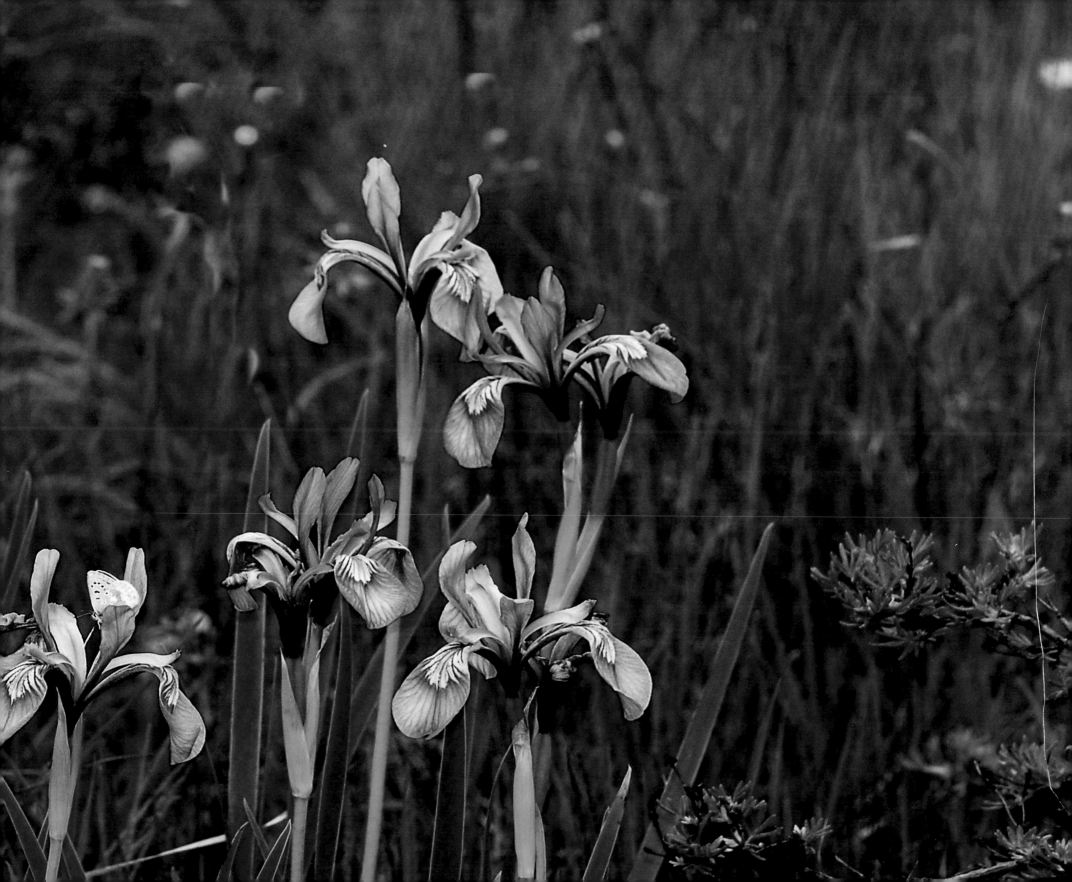

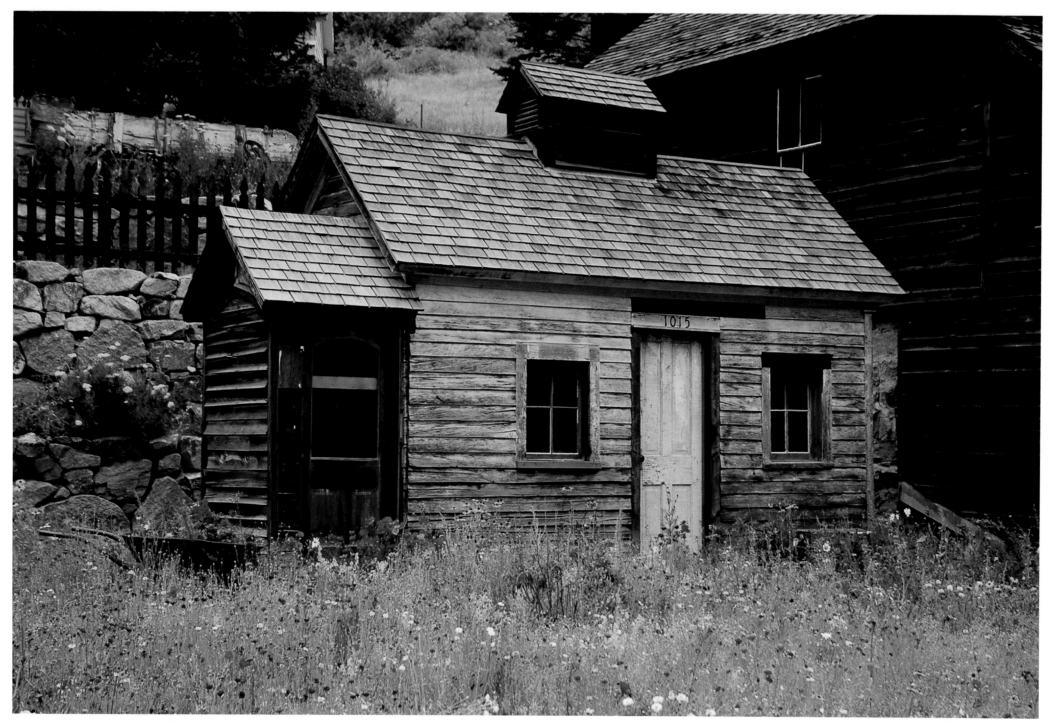

This little cabin is located in the old mining town of Silver Plume, Colorado. It looks as if someone rolled out a carpet of blooming wild flowers. I can imagine how at one time this little historic building was surrounded by muddy streets filled with wagon ruts and miners hurrying to get one more cart full of ore out of them there hills.

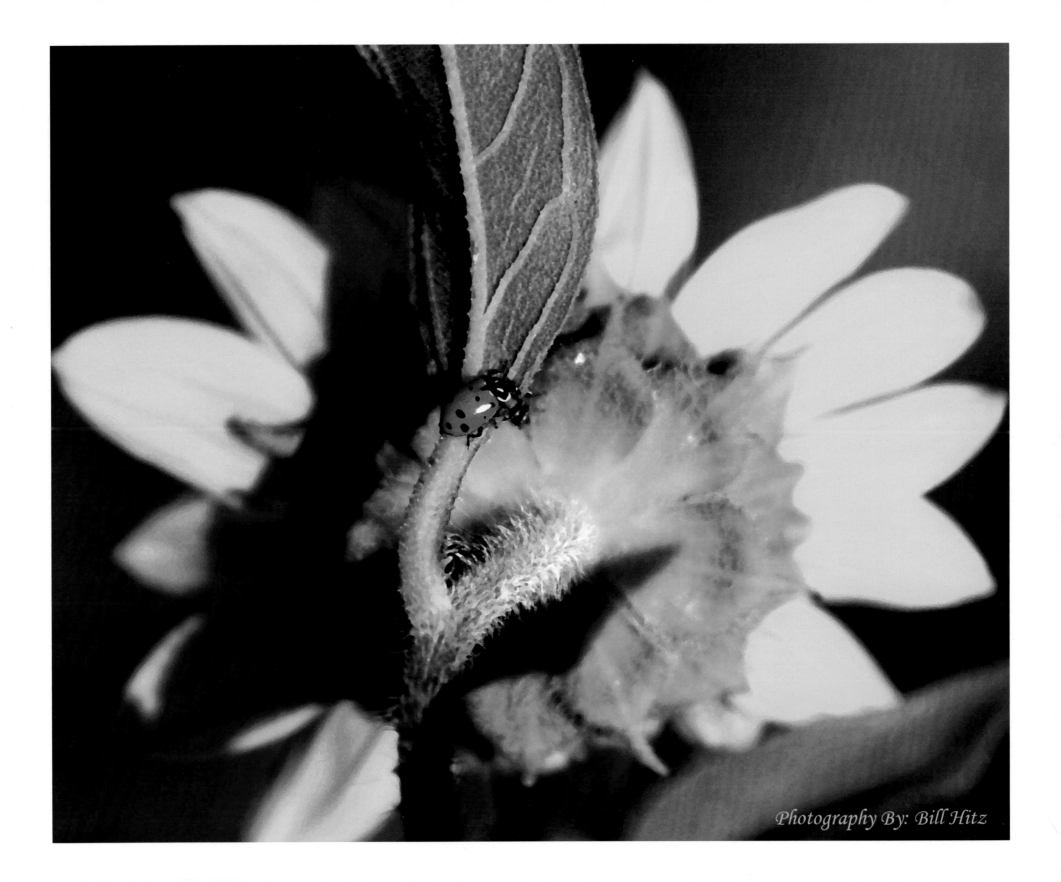

Photography By: Bill Hitz

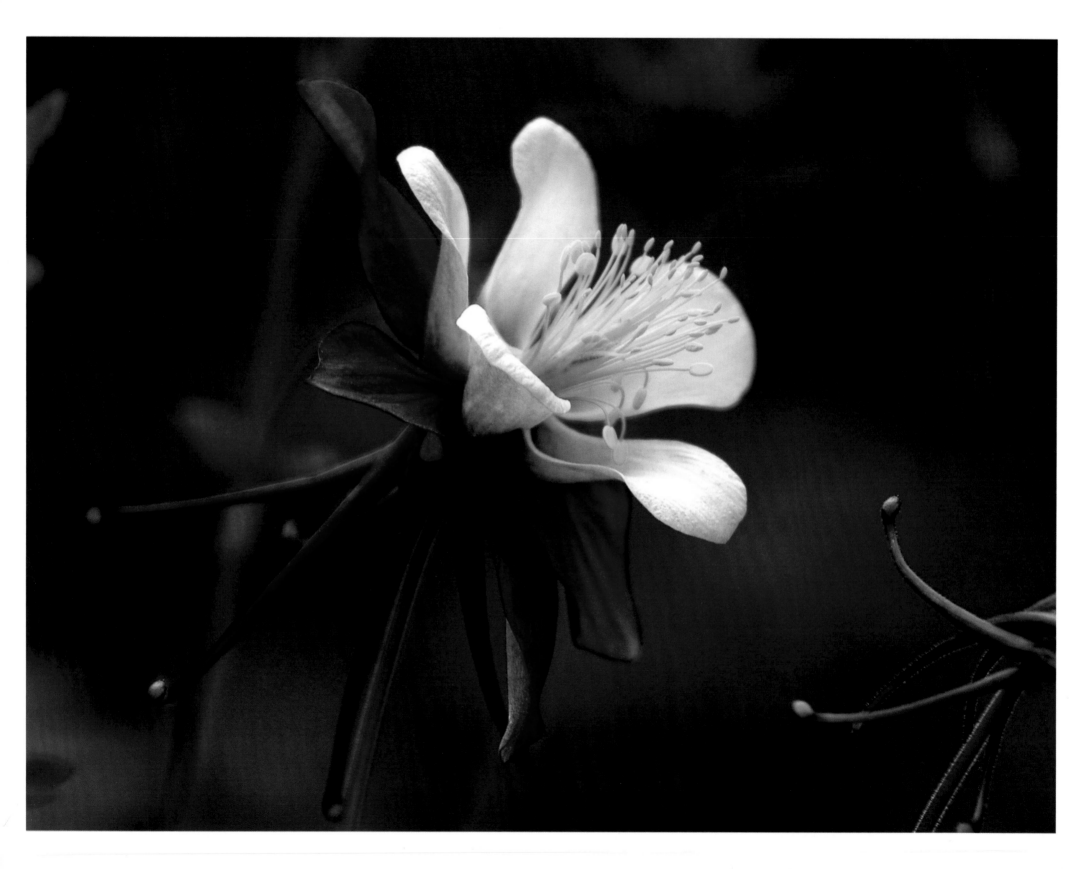

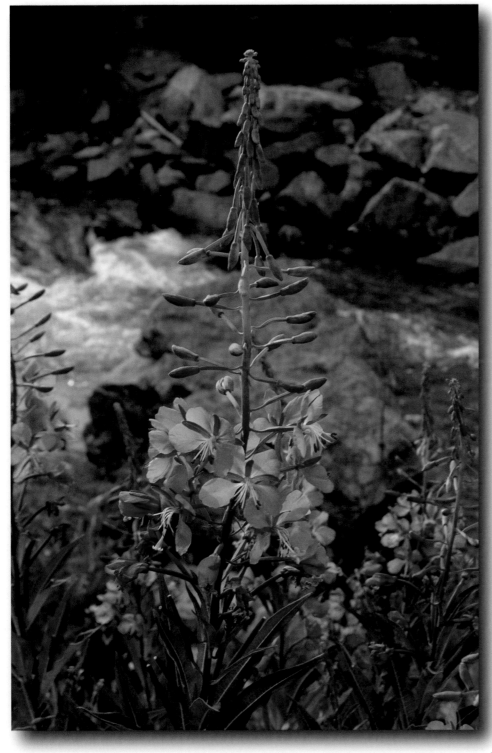
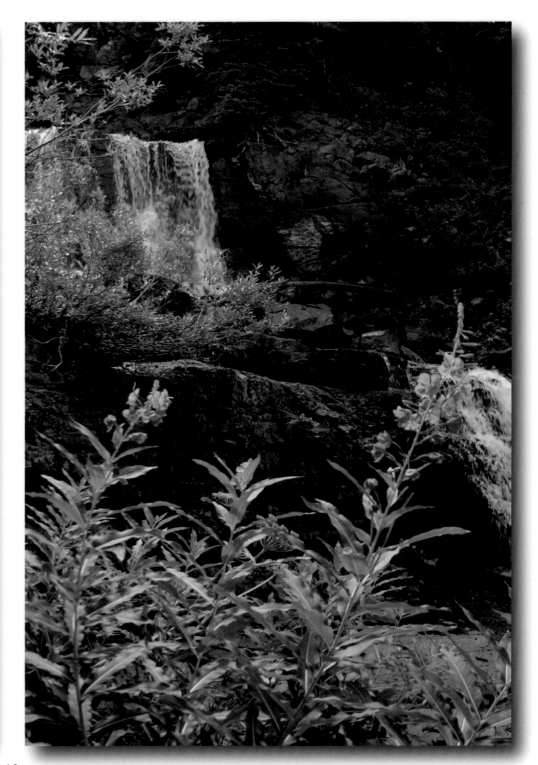

140

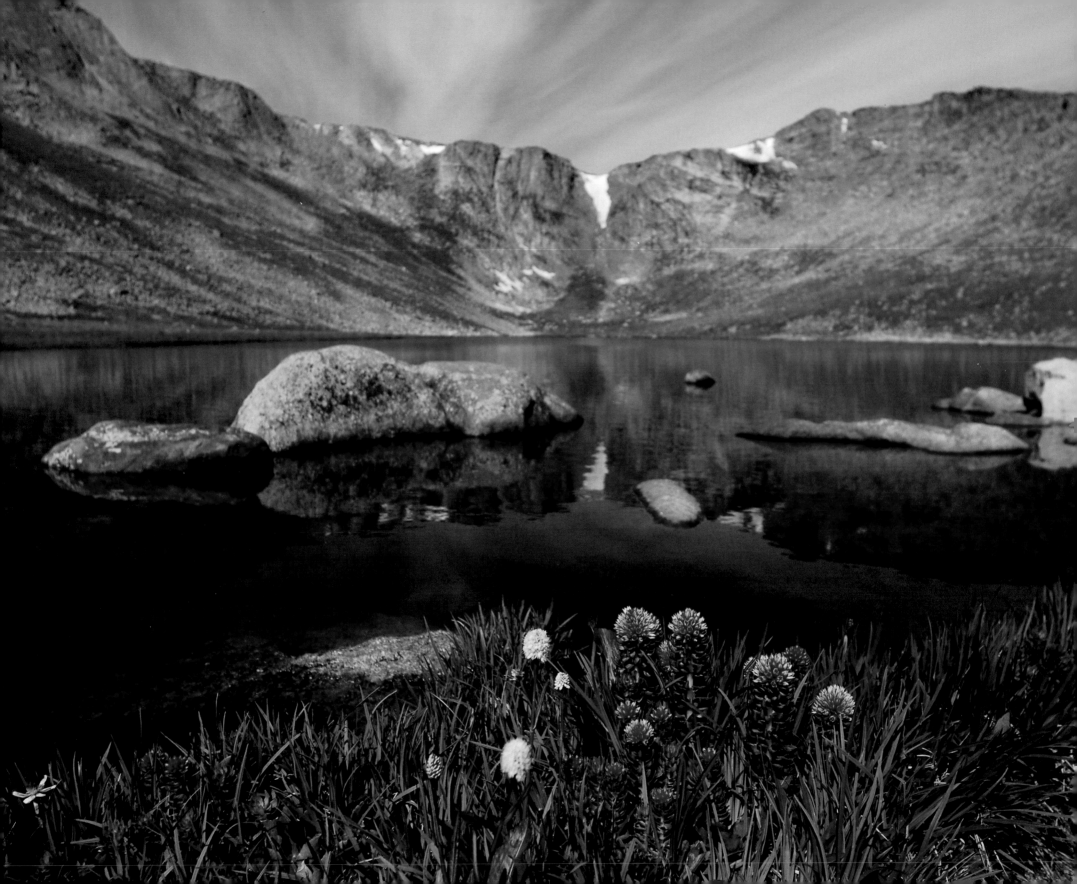

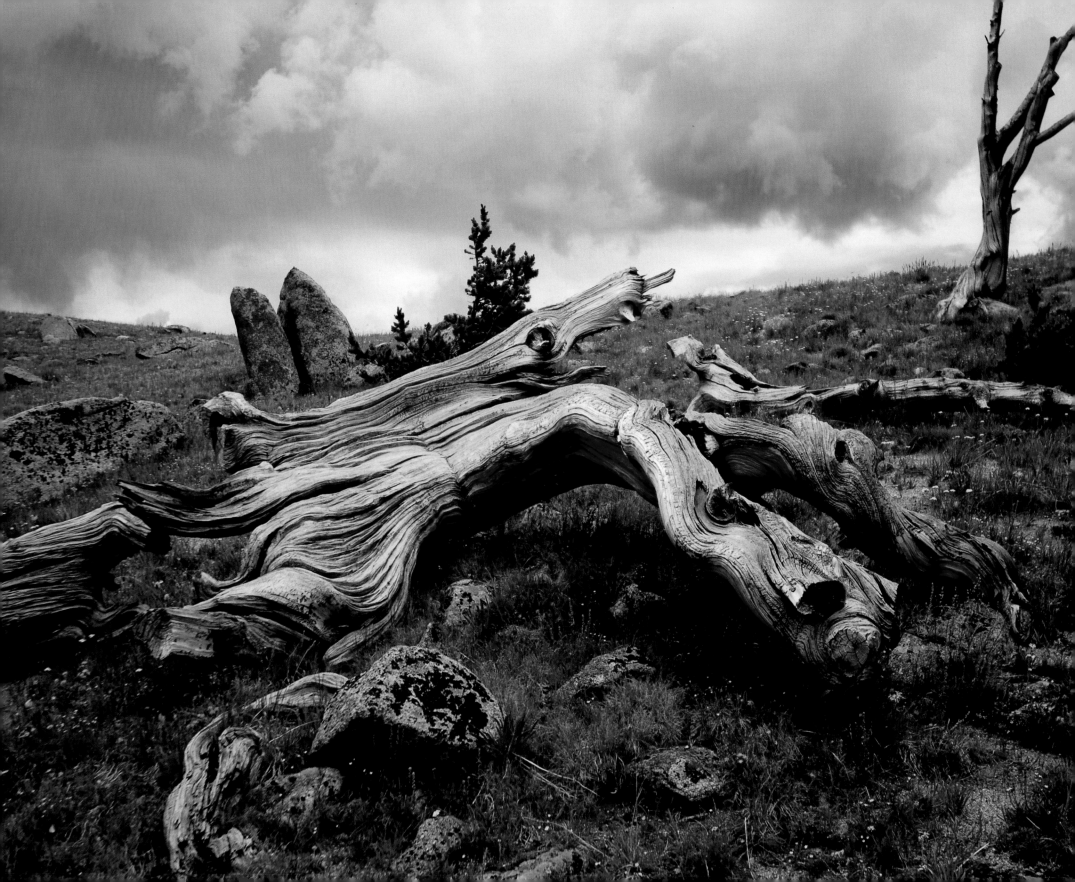

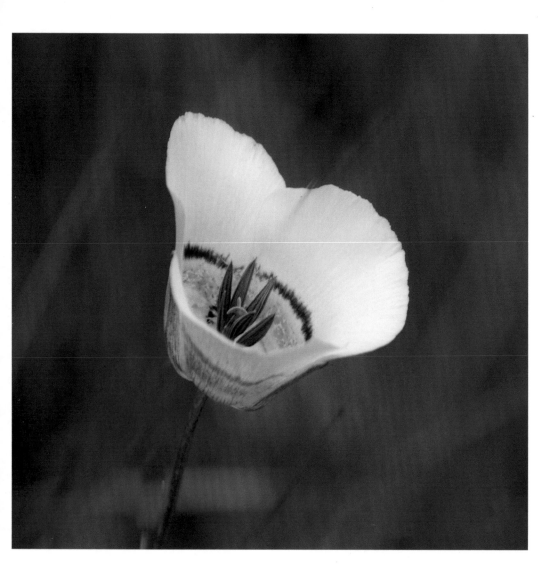

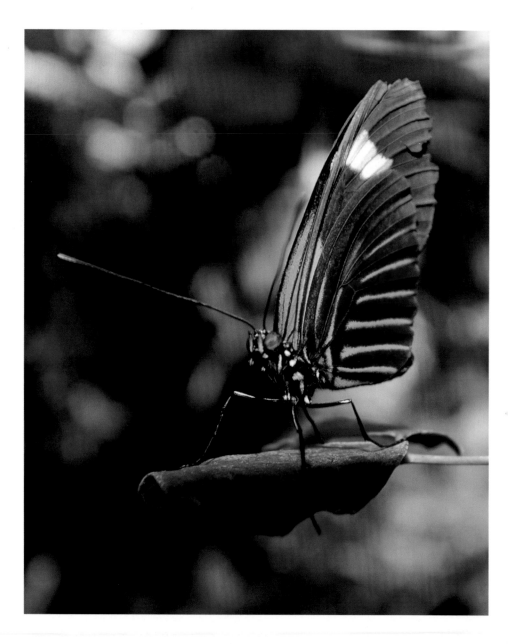

Unlike a delicate flower just waiting for you to come along and take its portrait, this butterfly kept moving from flower to leaf to blade of grass as I chased it around like a little kid trying to pet a frog. It finally sat just long enough for me to catch this perfect portrait as it folded its wings before flying off once more.

It's easy to miss some of nature's most beautiful little works of art if you get in too big a hurry or forget to look down some times. This little forest lily is only about the size of a half dollar and only grows about six inches tall, but is packed with delicate beauty. I had to get down on my elbows in the grass to get this shot.

143

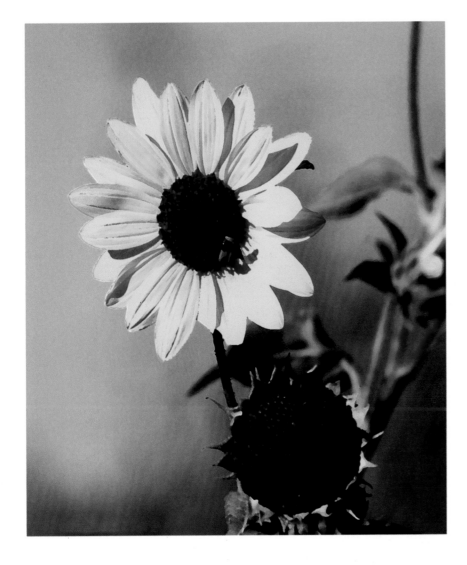

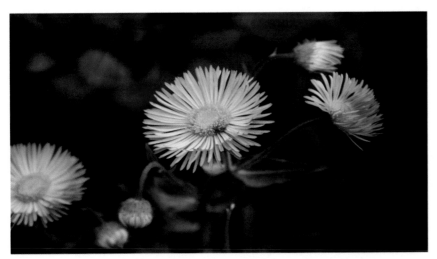

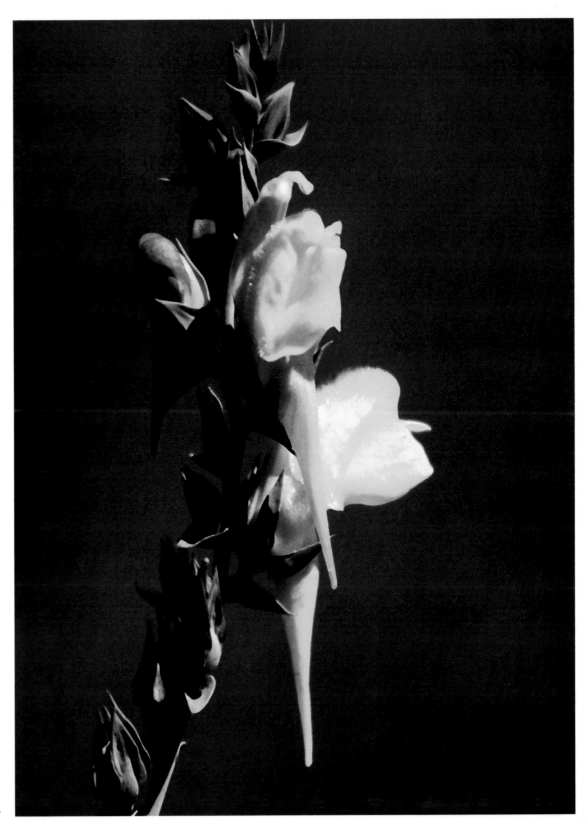

144

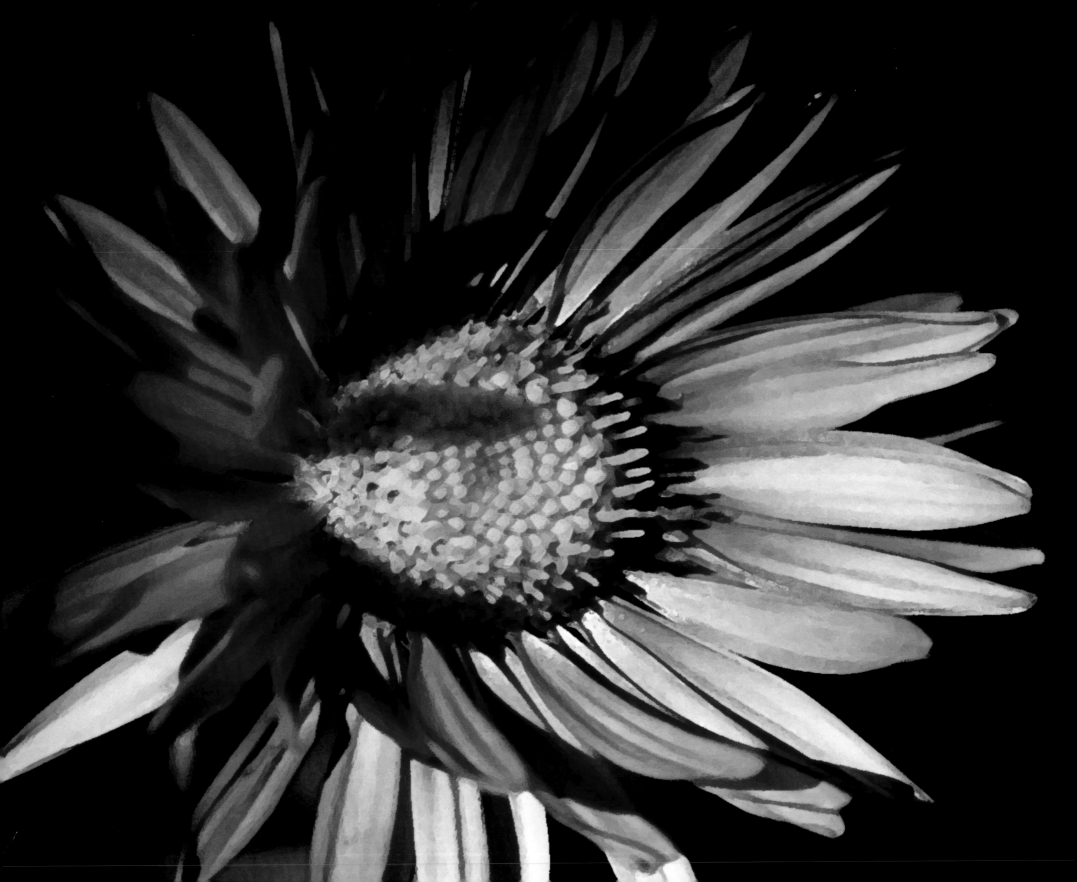

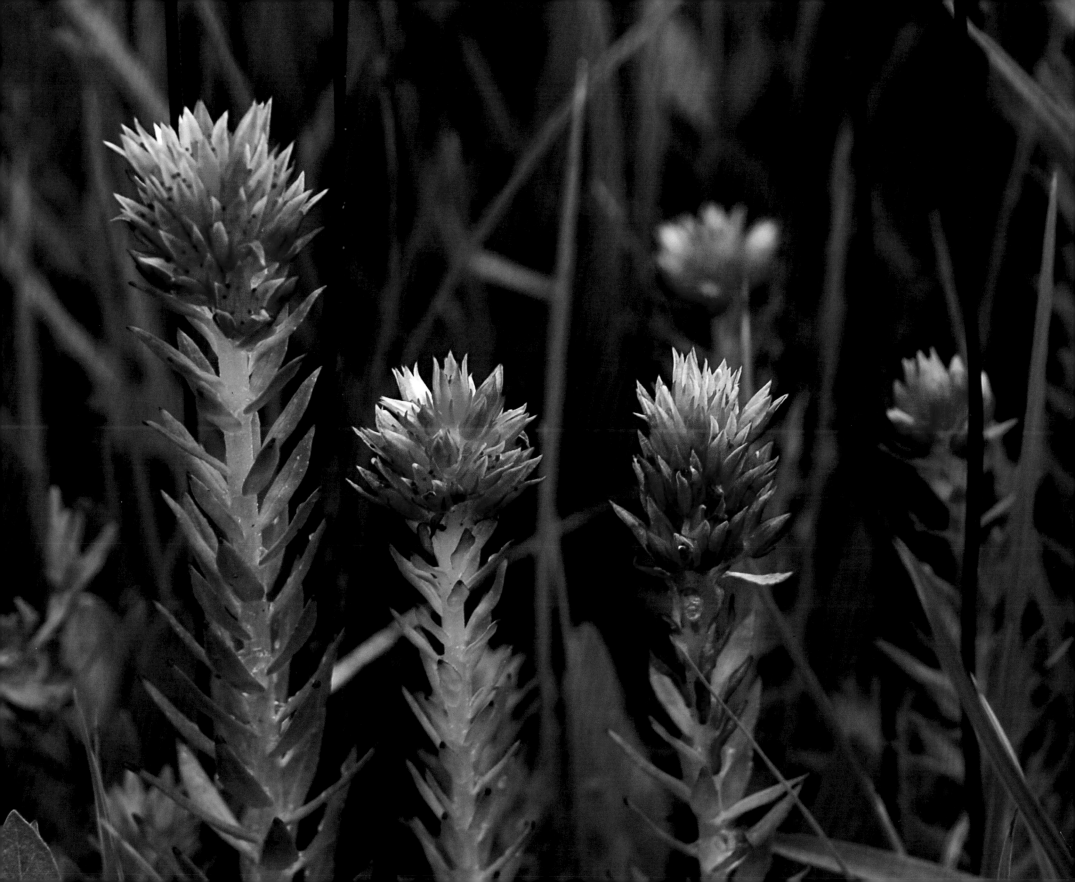

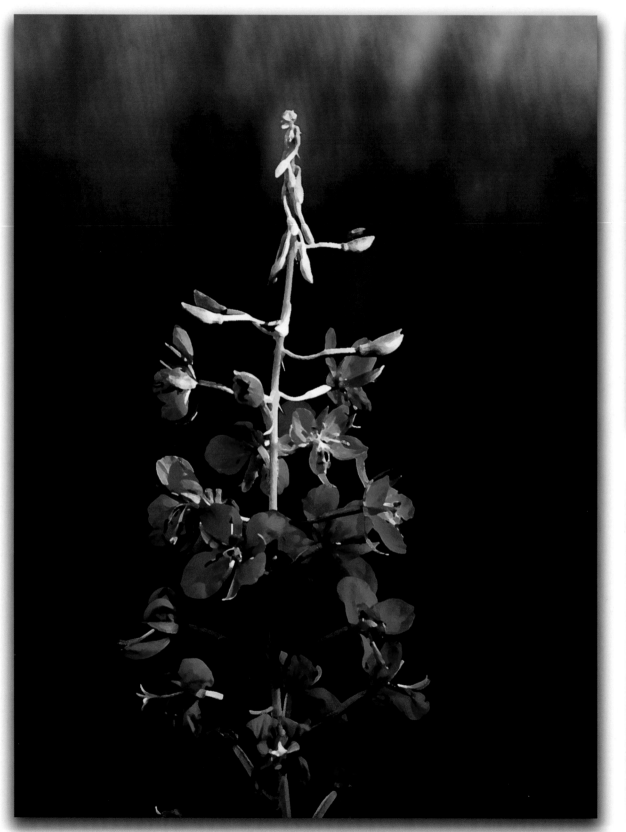
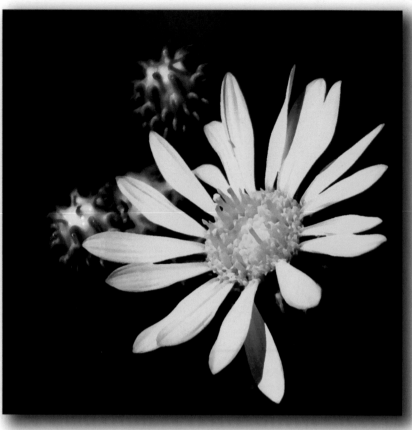
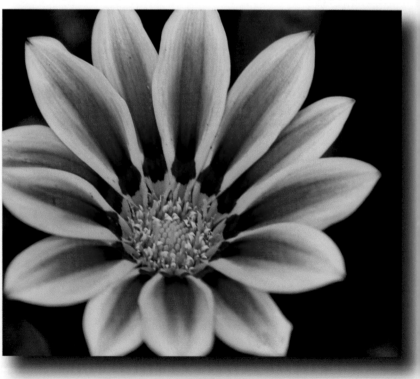

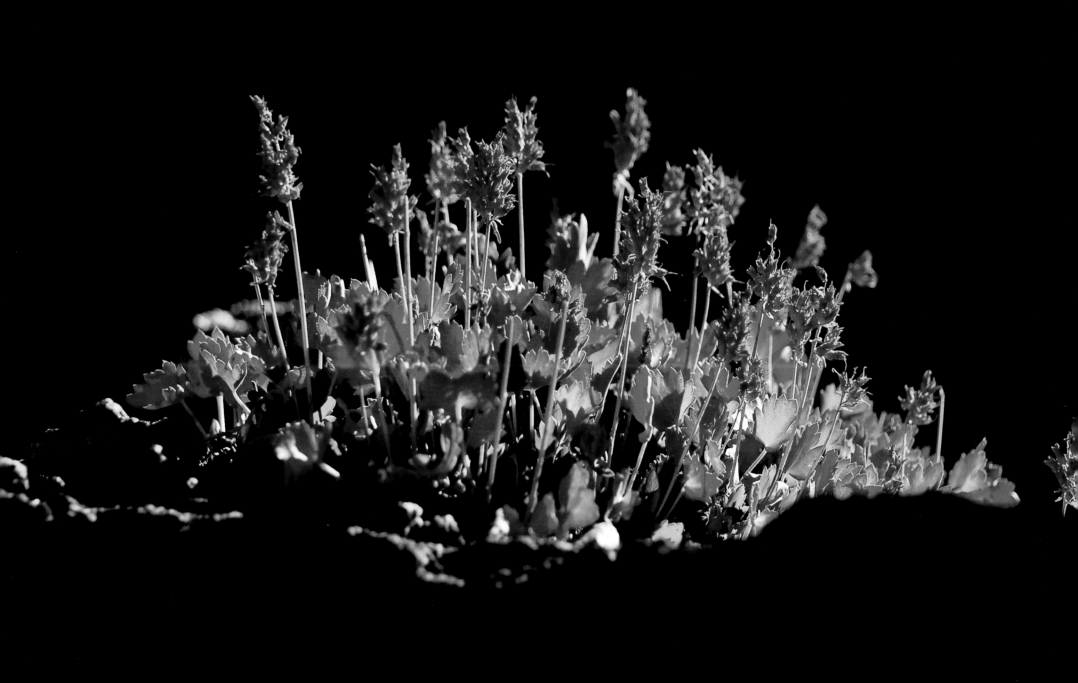

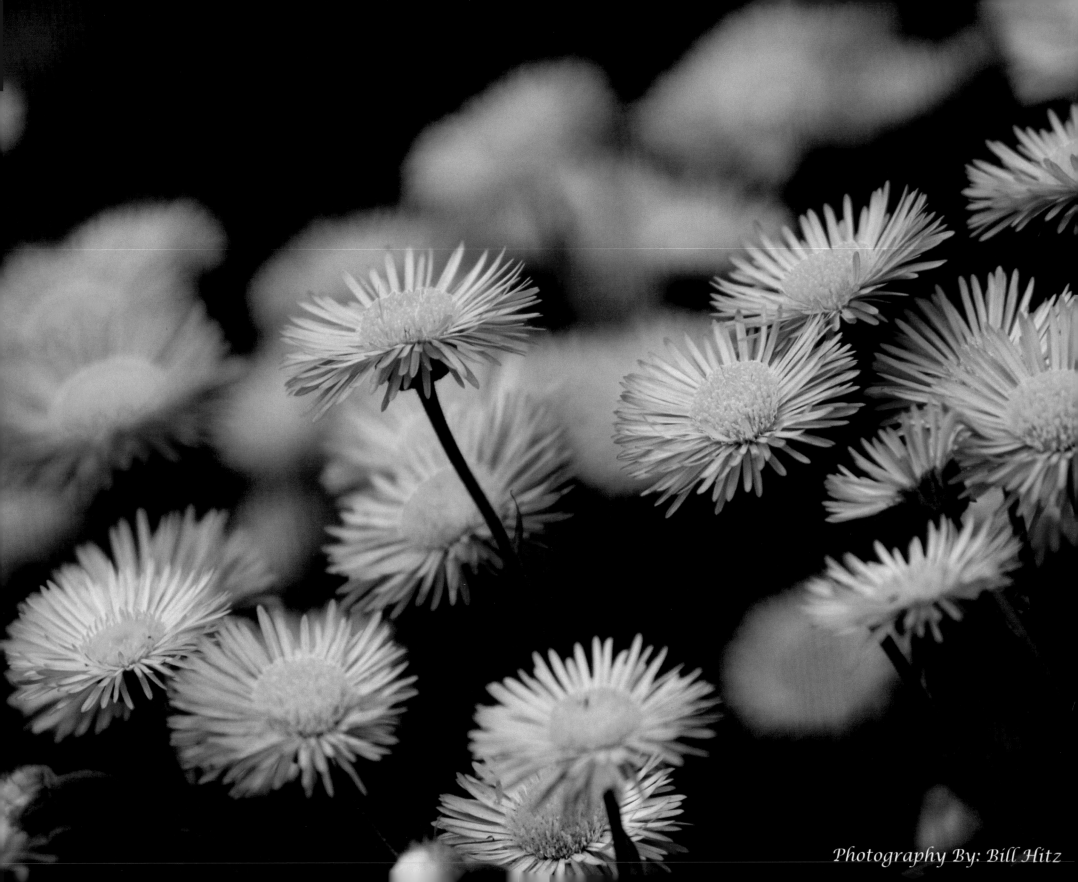

Photography By: Bill Hitz

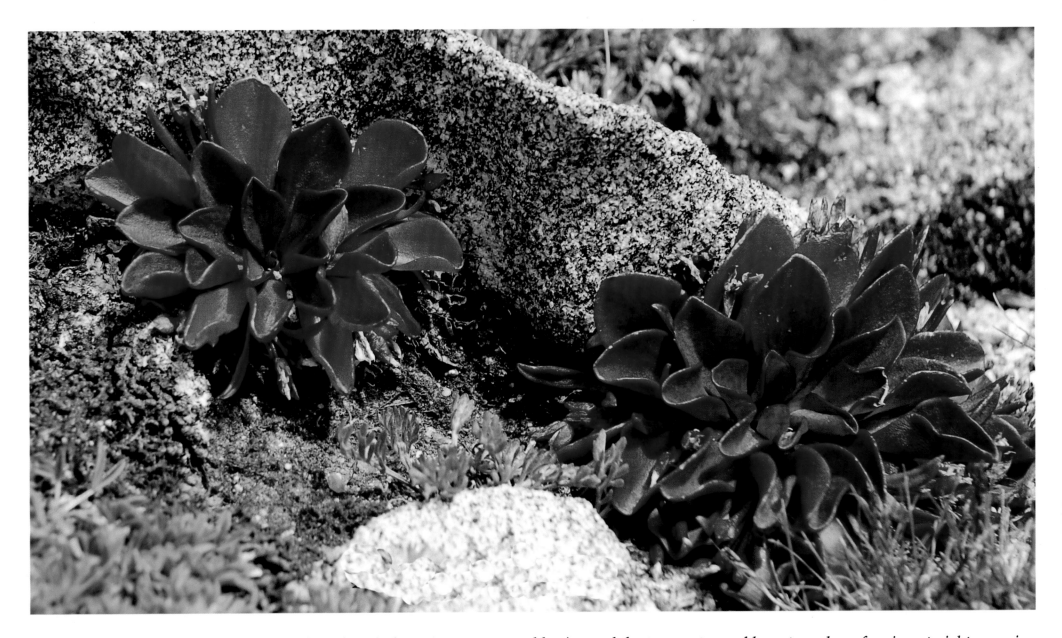

At close to 14,000 feet above sea level, where the wind never seems to stop blowing and the temperature seldom stays above freezing at night, even in the summer time; flowers find it difficult to bloom in this harsh environment. Nevertheless, nature will find a way to add a splash of color wherever and however it can. I noticed these plants growing near the summit of Mt. Evans, just west of Denver, Colorado while I was crawling around on the rocks trying to photograph some mountain goats. These are not blooms but the leaves of these high altitude plants. They almost looked artificial, like they were made of wax. It seems like Mother Nature will do whatever she can to make herself look nice, no matter where you might find her.

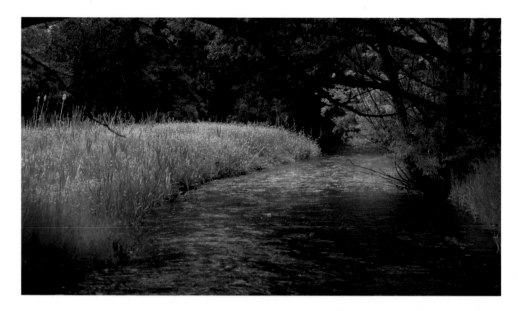

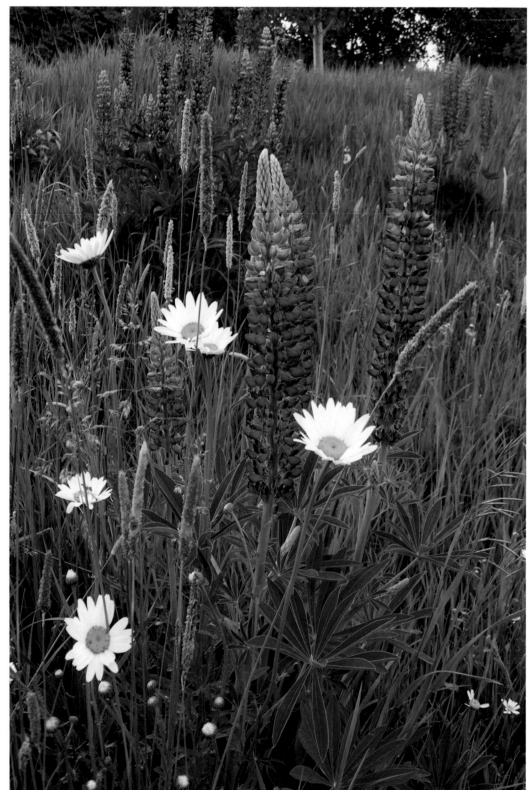

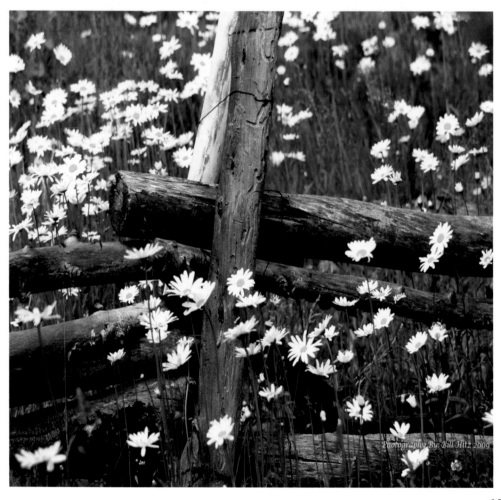

Photography By: Bill Hitz 2009

151

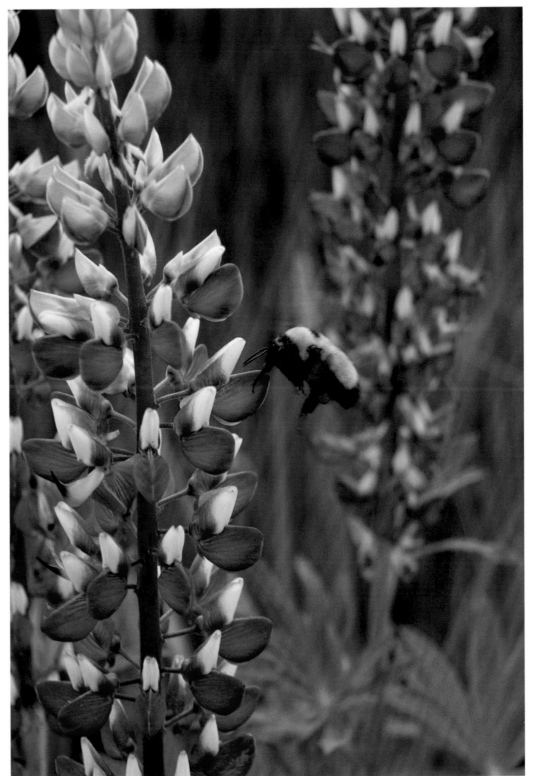

152

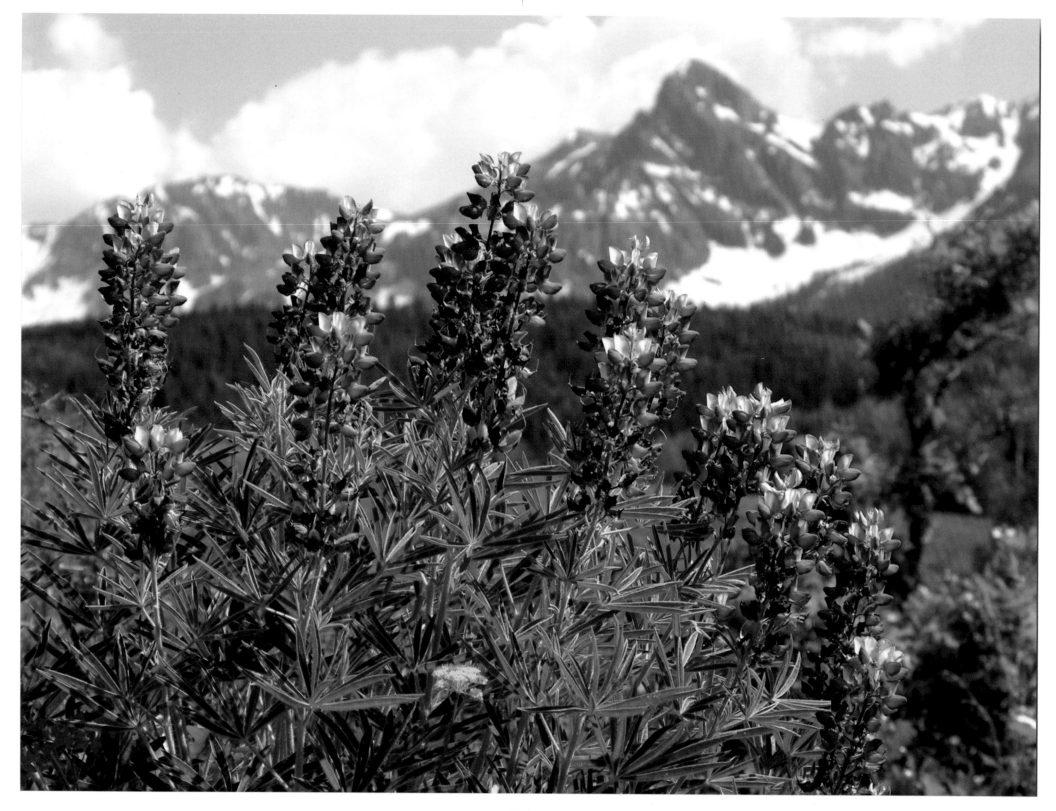

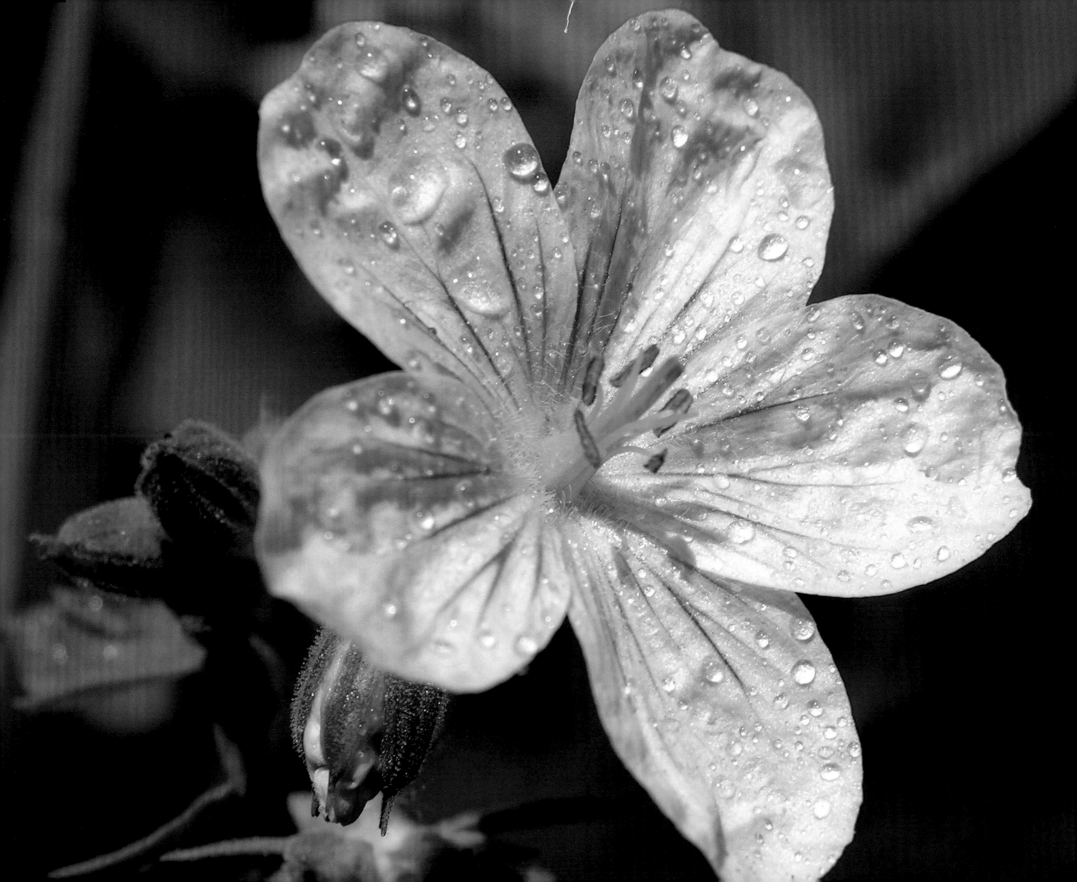

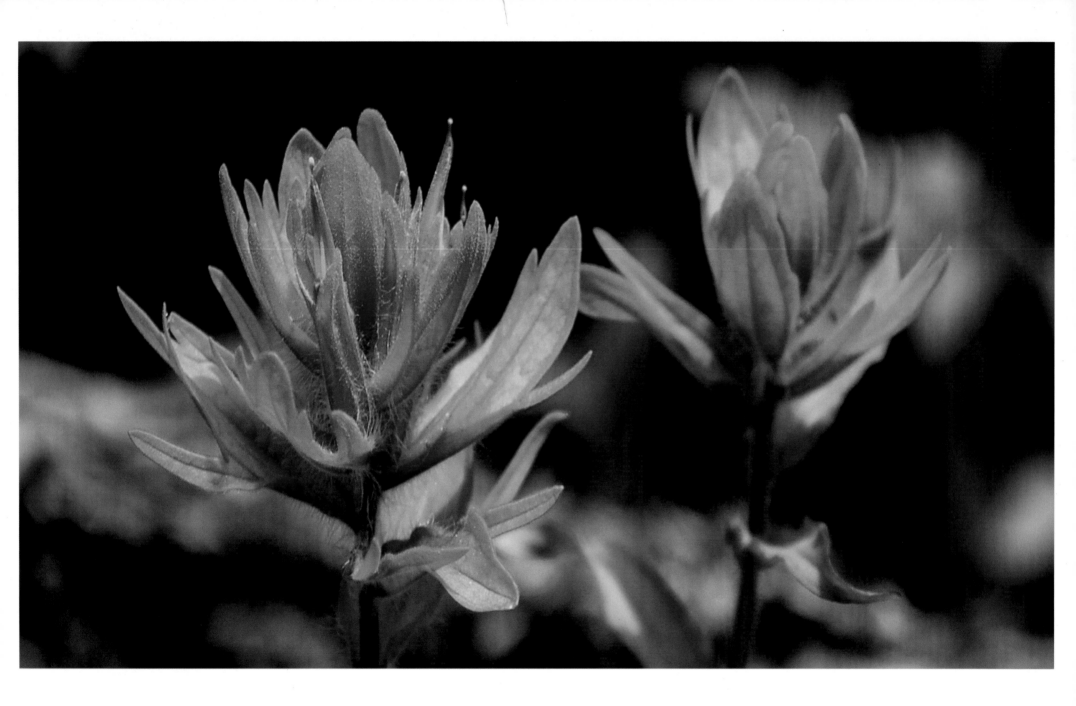

The high pass between Crested Butte, Colorado and Emerald Lake can be covered with all kinds and colors of wild flowers. These little purple blooms seemed to stand out from the sea of yellows, blues, reds, oranges and whites that dominated this lightly traveled mountain trail.

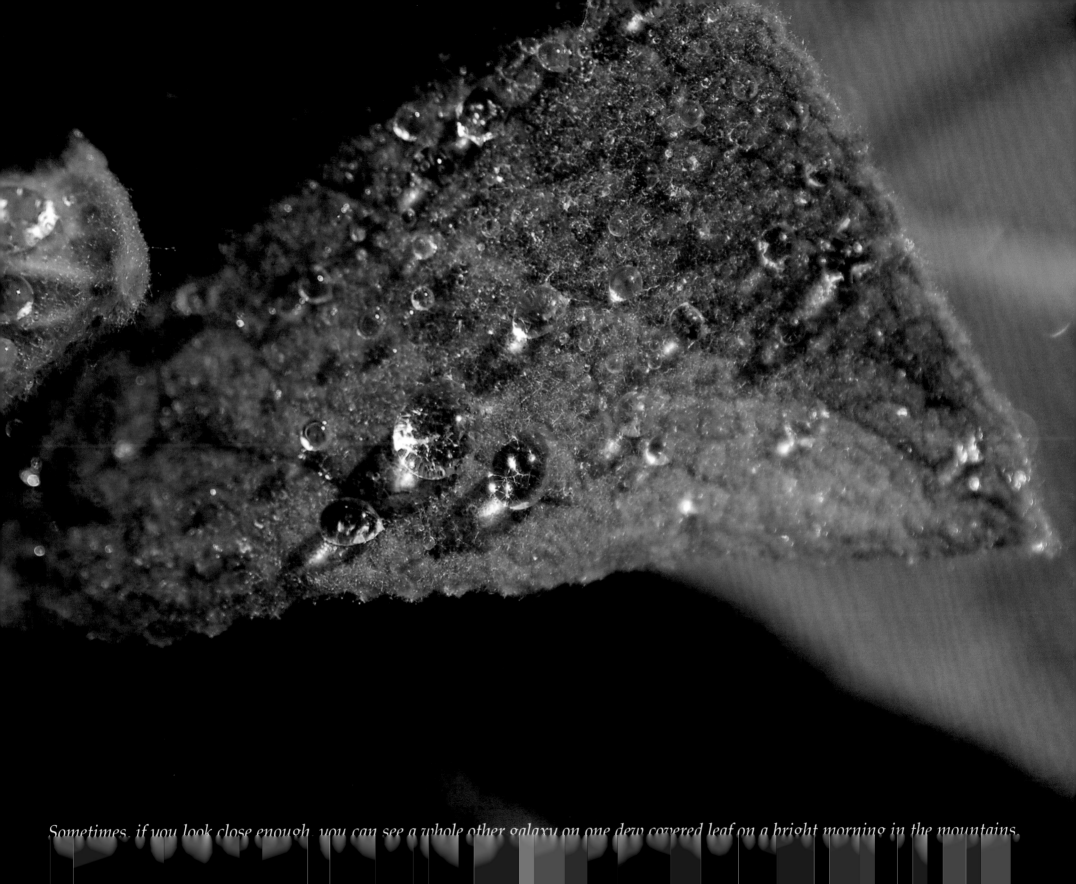

Sometimes, if you look close enough, you can see a whole other galaxy on one dew covered leaf on a bright morning in the mountains.

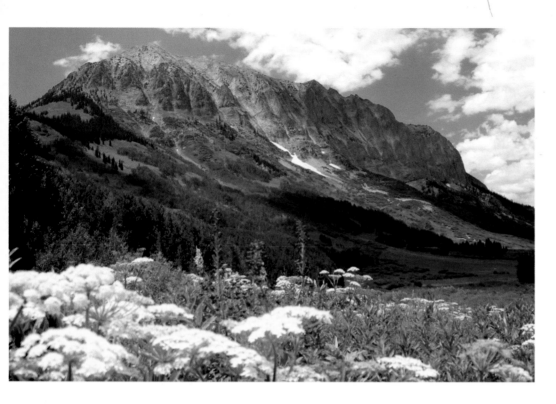

This view of Gothic Mountain was achieved only after getting out of my truck and hiking out into this meadow of wild flowers. Being willing to get off the beaten trail can be rewarded with scenery not available to those not willing to get out and walk. The nearby old mining town of Gothic is known as a local training ground for students of high altitude plant and animal life at the Rocky Mountain Biological Laboratory.

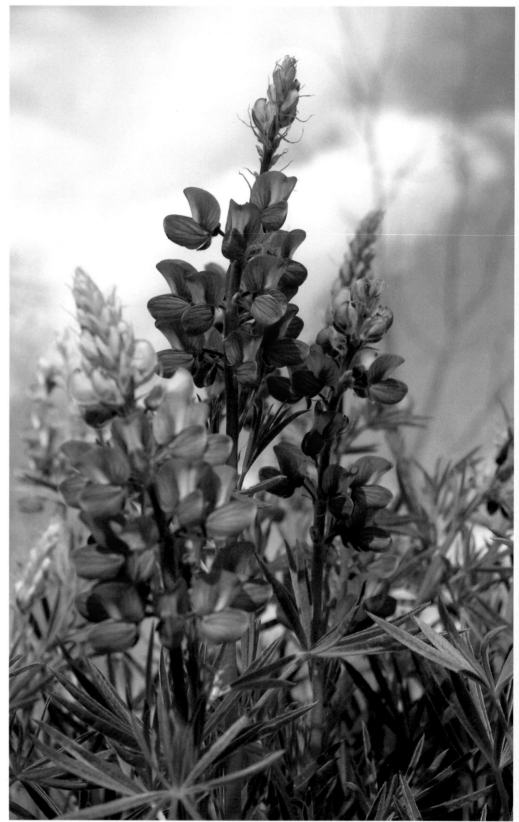

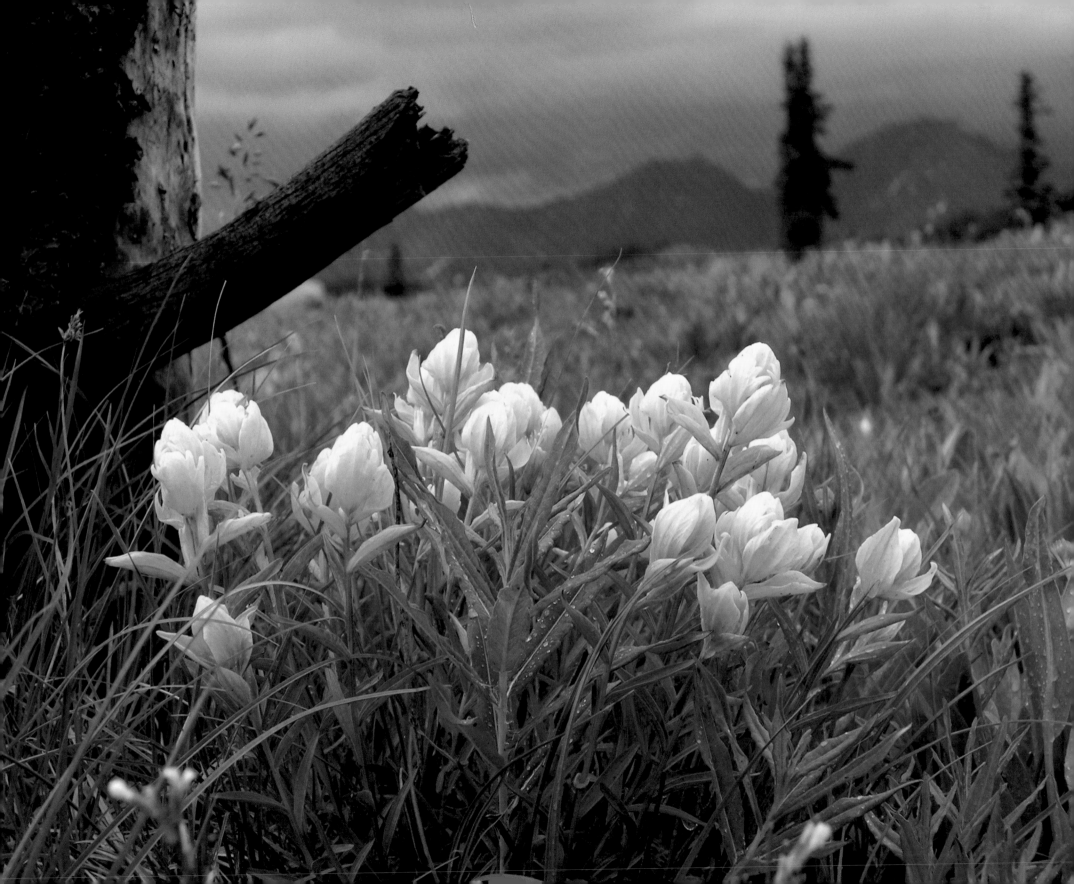

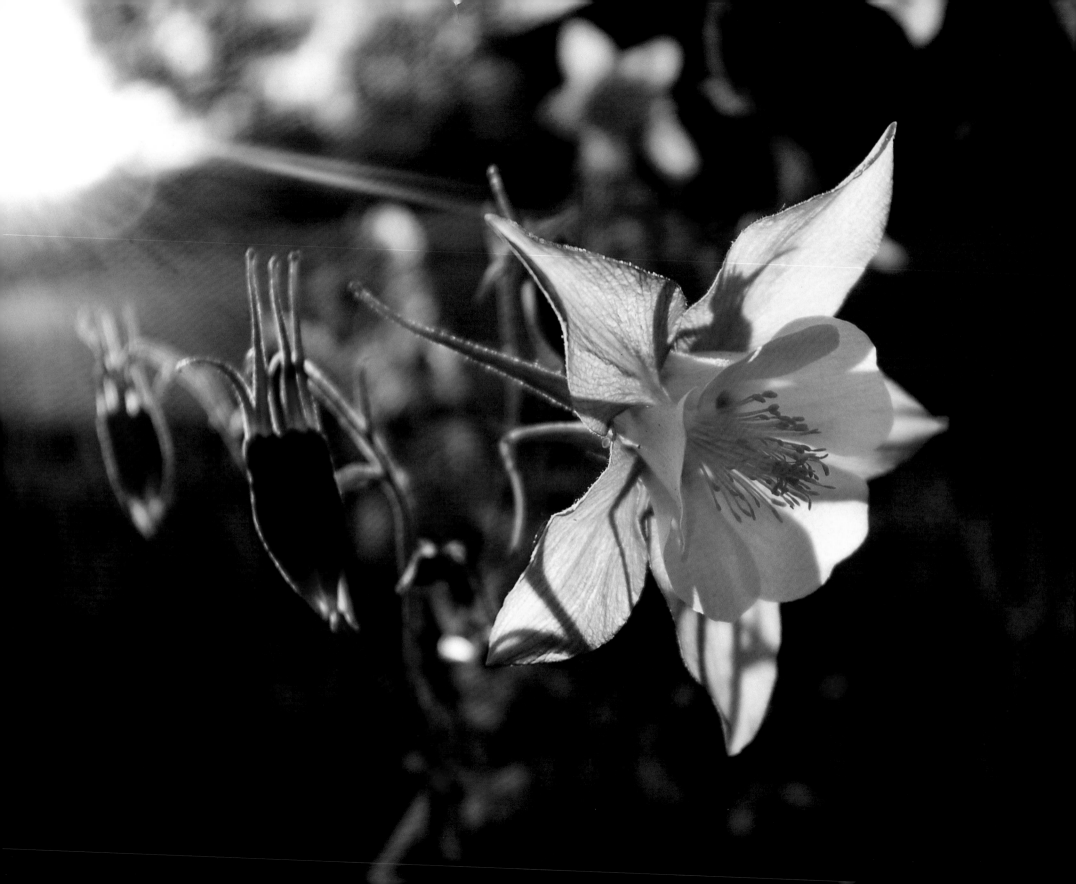

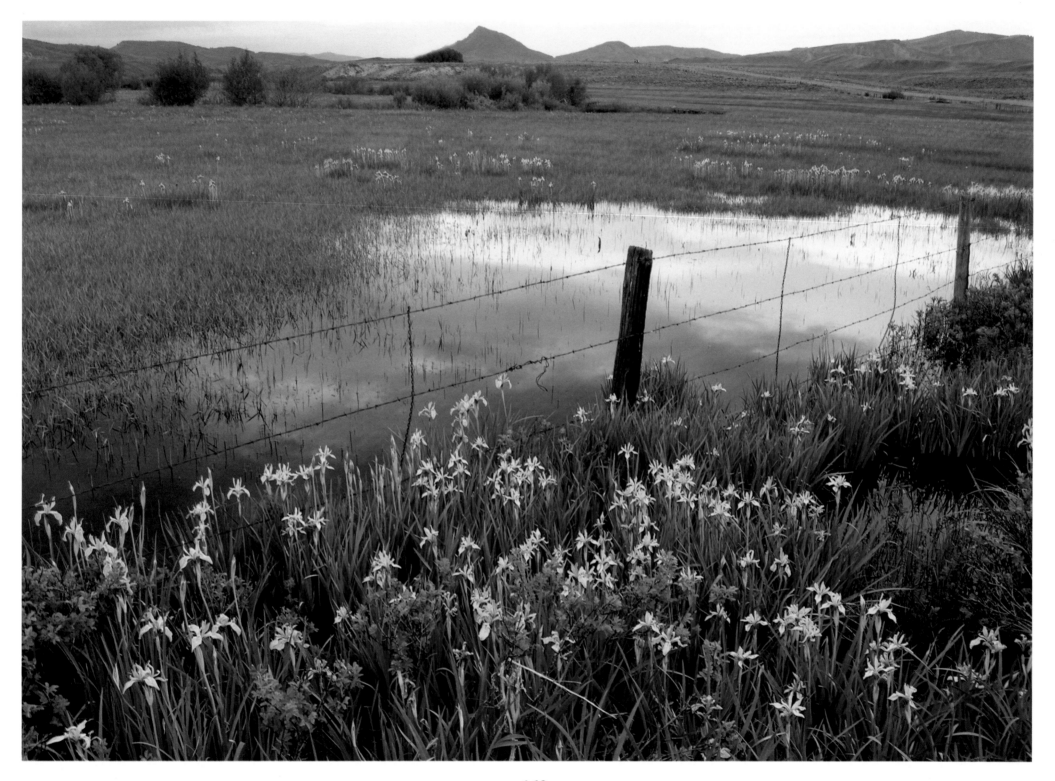

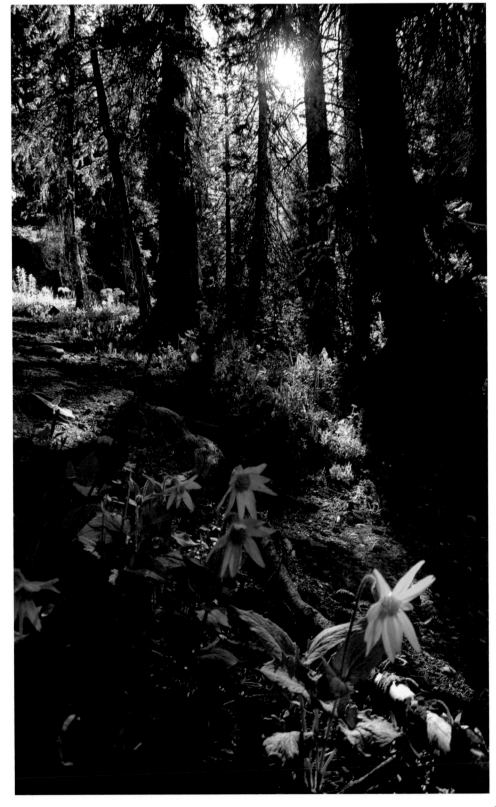
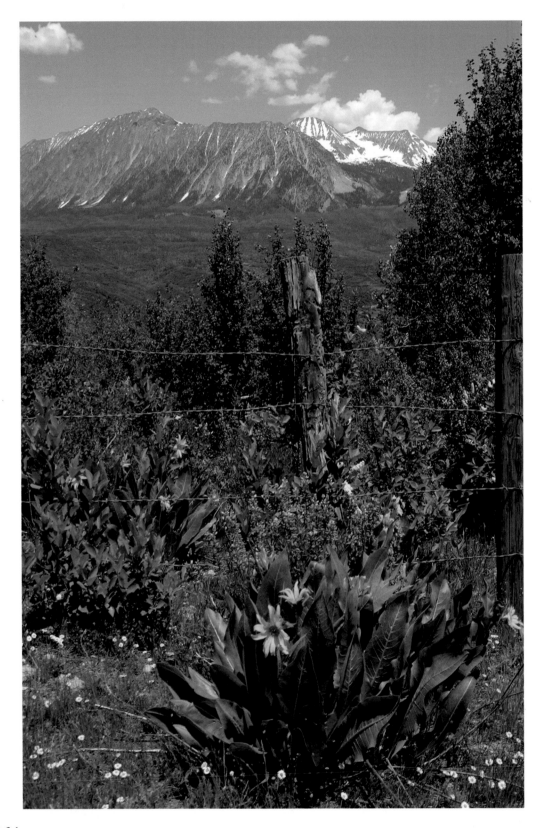

164

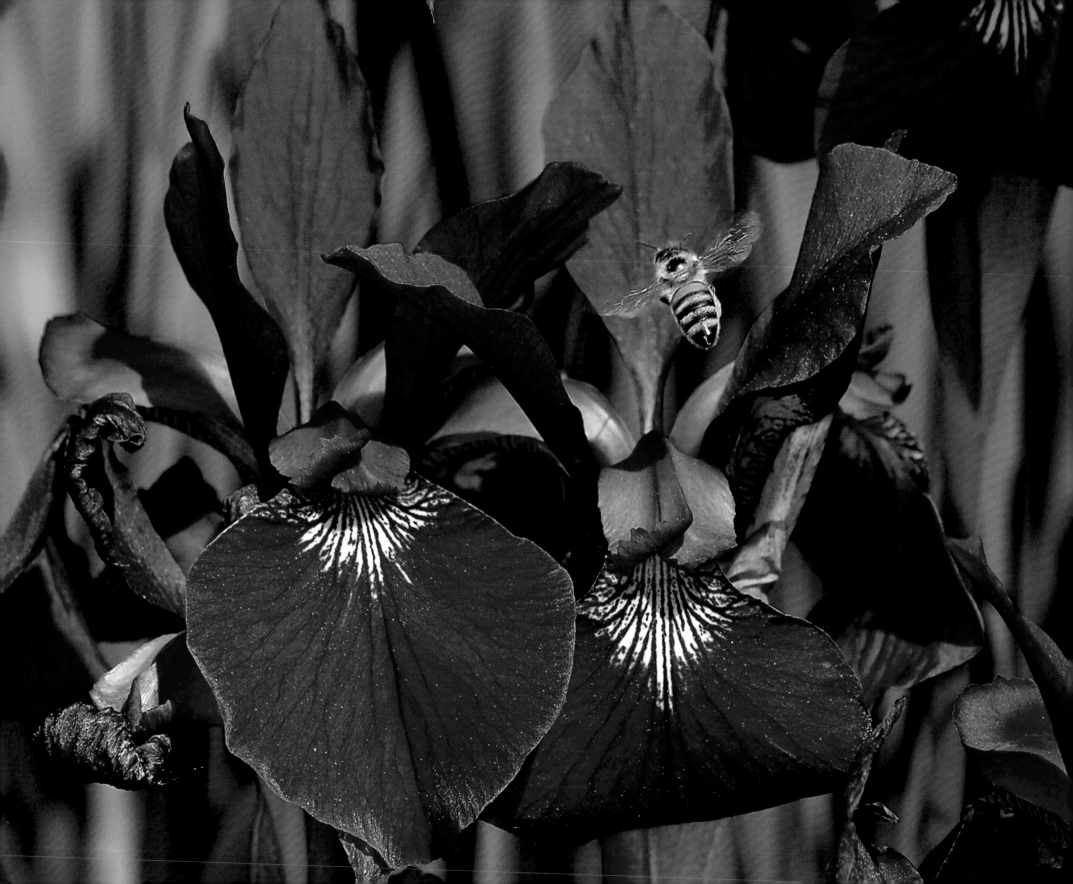

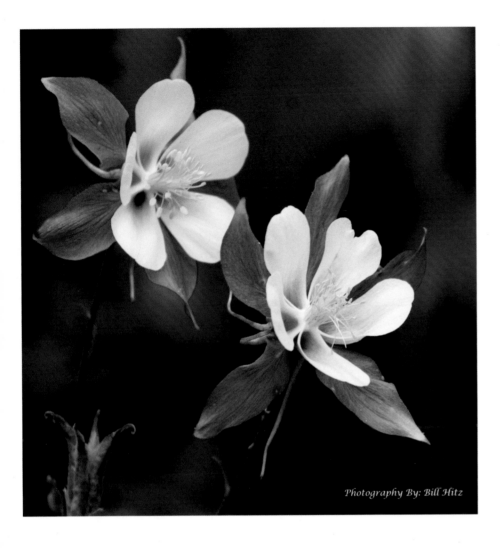

Photography By: Bill Hitz

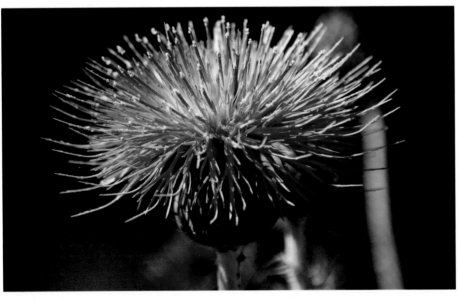

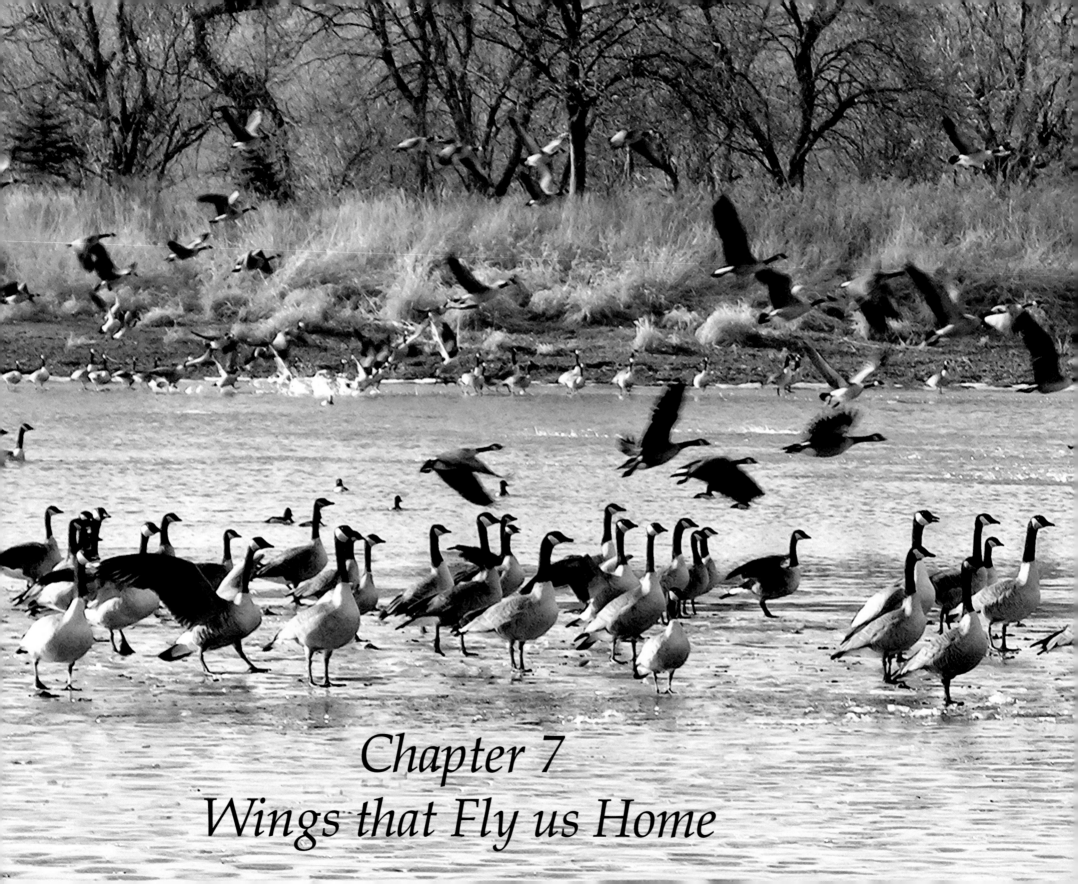

Chapter 7
Wings that Fly us Home

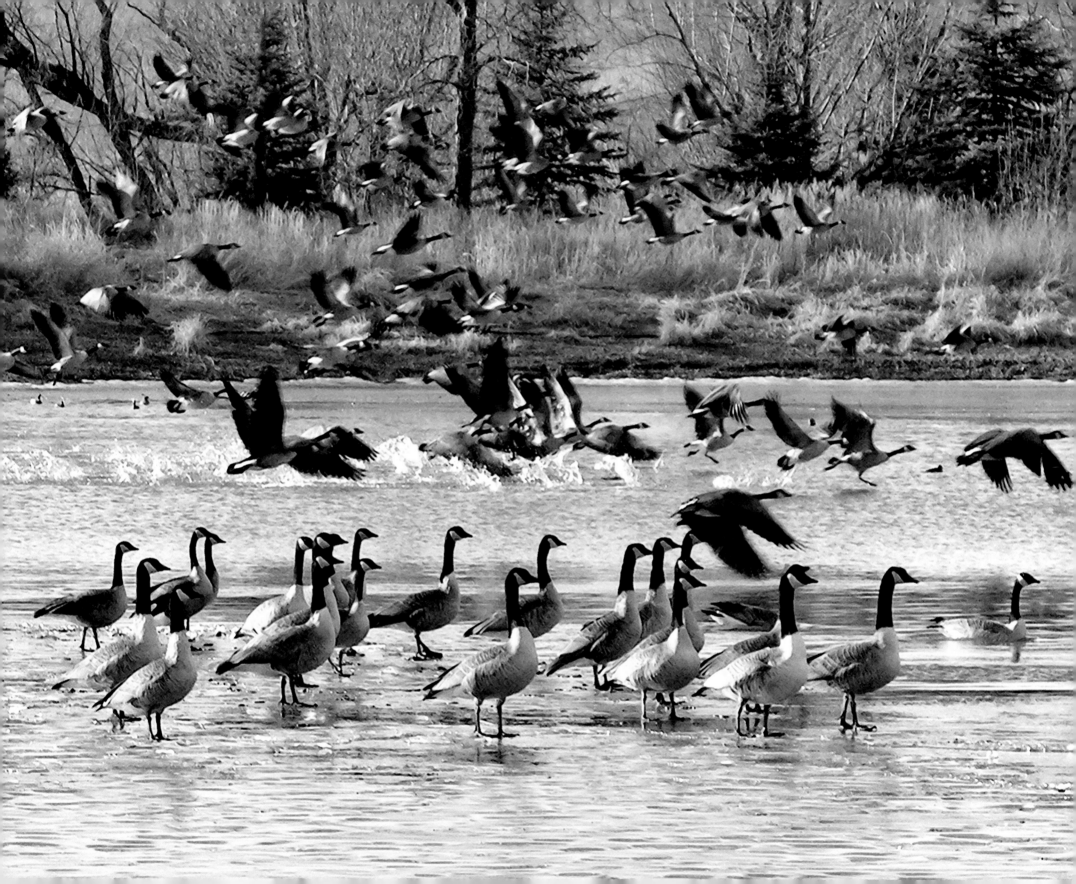

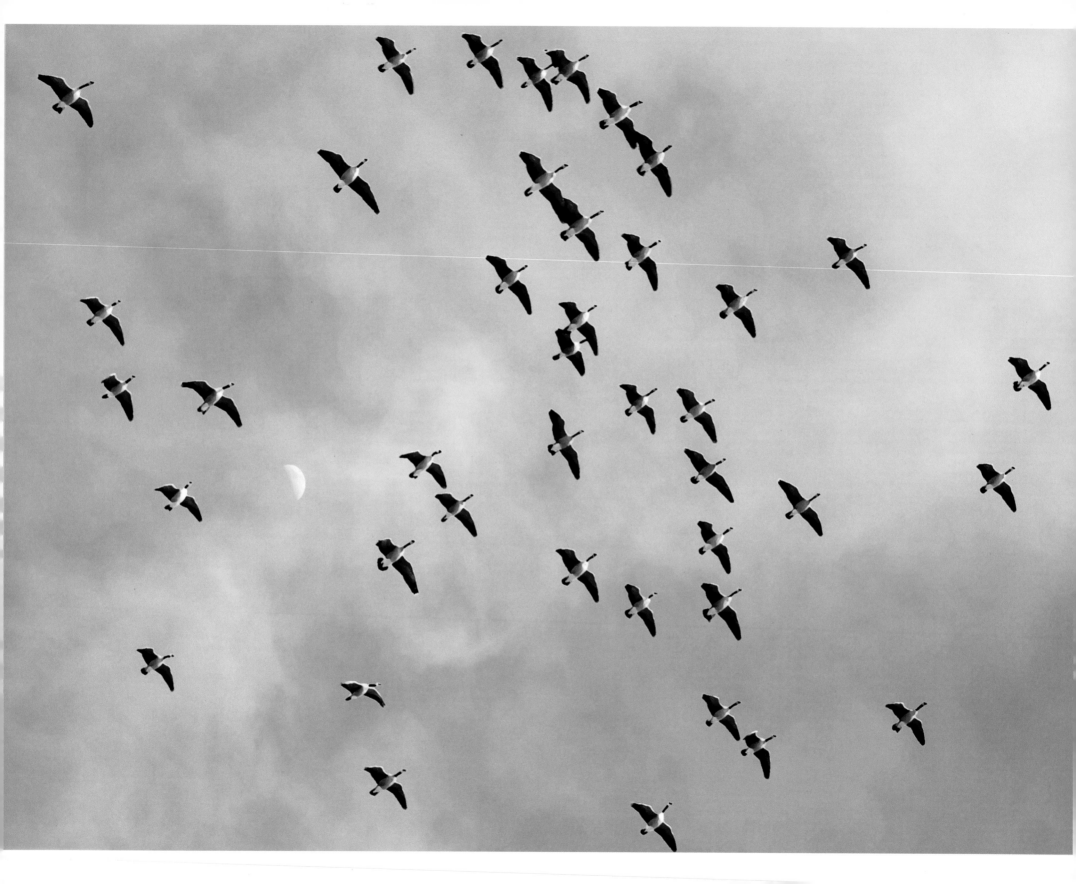

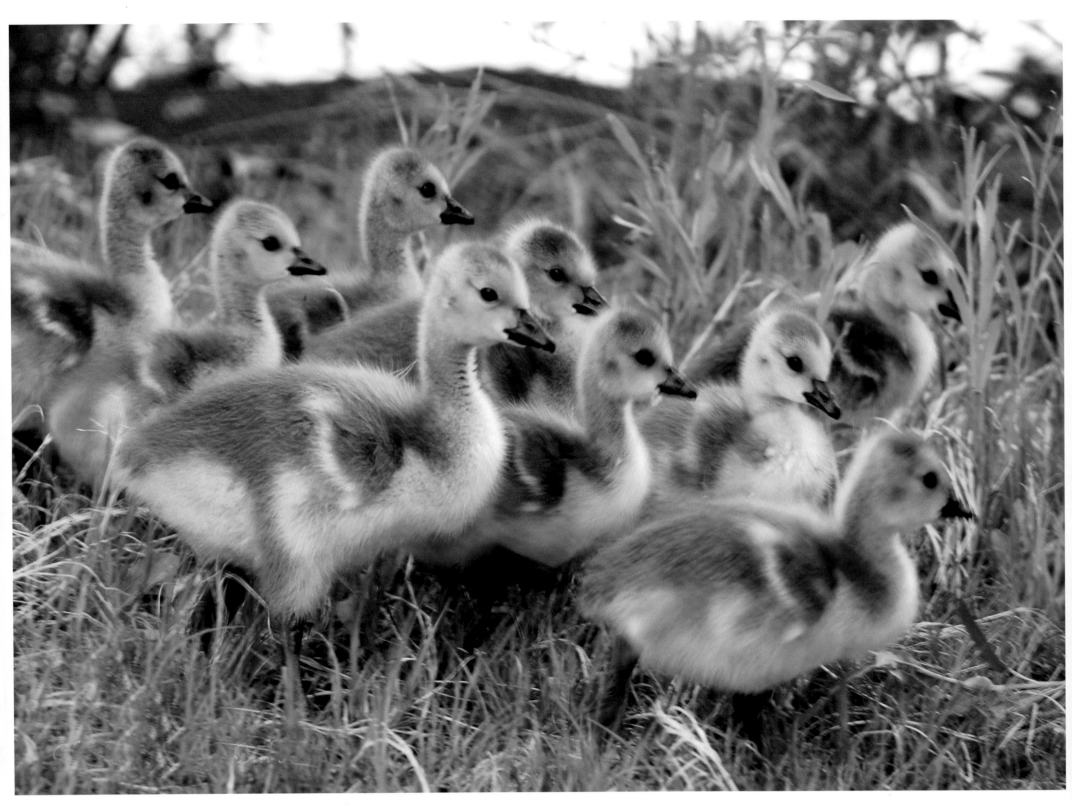

 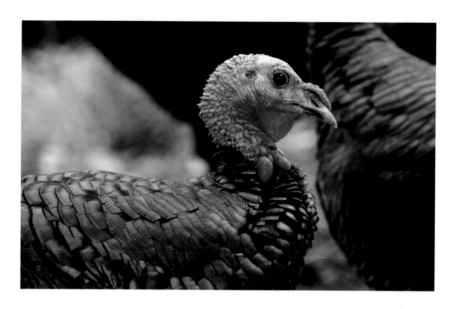

I was on my way to Laramie, Wyoming one early fall day when I decided to drive through Poudre Canyon west of Fort Collins, Colorado. The aspen trees were starting to turn bright yellow, as they do that time of year. I was hoping to catch some good photos of the fall colors along the river. As I rounded a curve, I spotted several wild turkeys next to the road. I pulled my truck to a stop next to the highway and grabbed my camera off the front seat where it always sits, waiting for an opportunity just like this one. As I headed back to where I had seen the birds, I just caught a glimpse of the last one as it disappeared into the trees next to the road. I hurried down a fairly steep slope in hopes of catching just a shot or two before the big birds disappeared into the forest. Soon I came to an abandoned log cabin that was partially fallen down, with no sign of the turkeys anywhere. I decided to take advantage of the opportunity to be in the forest surrounded by trees that were changing to their fall colors. The sky was overcast and the light was perfect. I sat on an old log near the cabin and started to take some photos of the trees and the forest that surrounded me. I was wearing a bright yellow jacket so I was shocked when I looked up and saw several turkeys slowly approaching me from the far side of the cabin. I slowly turned and started to take some photographs of the skittish birds. The more I took their pictures, the closer the turkeys came toward me. It was almost as if they were posing for me. One of the turkeys even pecked my lens while I was trying to take his photograph. I was hoping to catch one of the males as he fanned his tail feathers, so I decided to make a gobbling sound to see if I could get them to fan. Sure enough, after I made like a turkey and gobbled, one of the big male birds fanned his tail feathers for me. I did it again. Two of the males fanned. I probably spent close to half an hour with this flock of birds before I decided I had better get back on the road to Laramie. As I started to walk back toward my truck I noticed the birds were following me. I climbed back up to the highway. I crossed the road to the other side where my vehicle was parked. The turkeys kept on following me, right across the highway. As I got back to my truck, a red pickup pulled up and stopped several yards behind mine. The turkeys were now gathered next to my vehicle, waiting to see what I was going to do next. The driver of the red truck couldn't believe what he was seeing. As he got out of his truck to see what was going on, the turkeys ran back across the road and disappeared into the trees once again. "I can't believe what I just saw," exclaimed the other driver as he approached my truck. "I have been hunting turkeys for over twenty five years and I have never seen anything like that before. Who do you think you are, the Pied Piper? I think I'll start wearing bright yellow instead of camouflage when I hunt turkeys from now on."

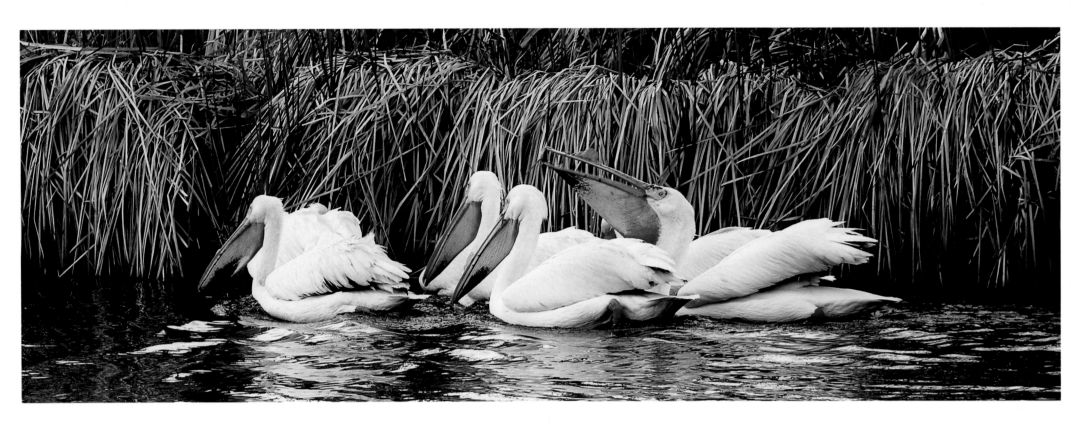

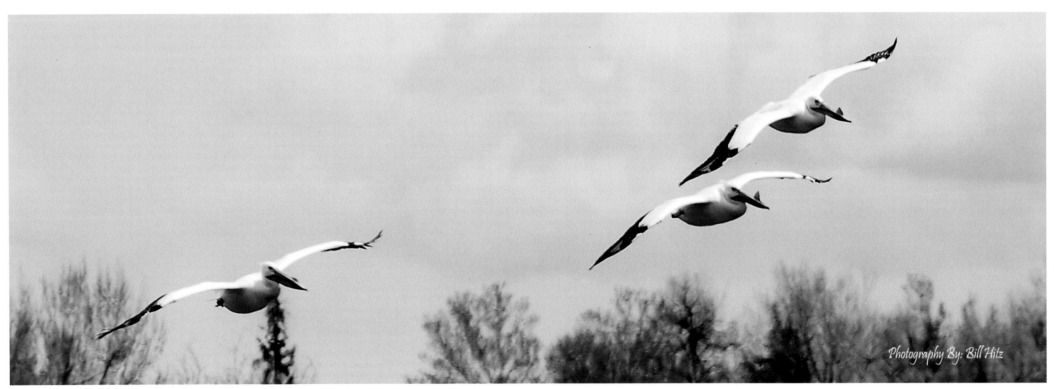

Photography By: Bill Hitz

172

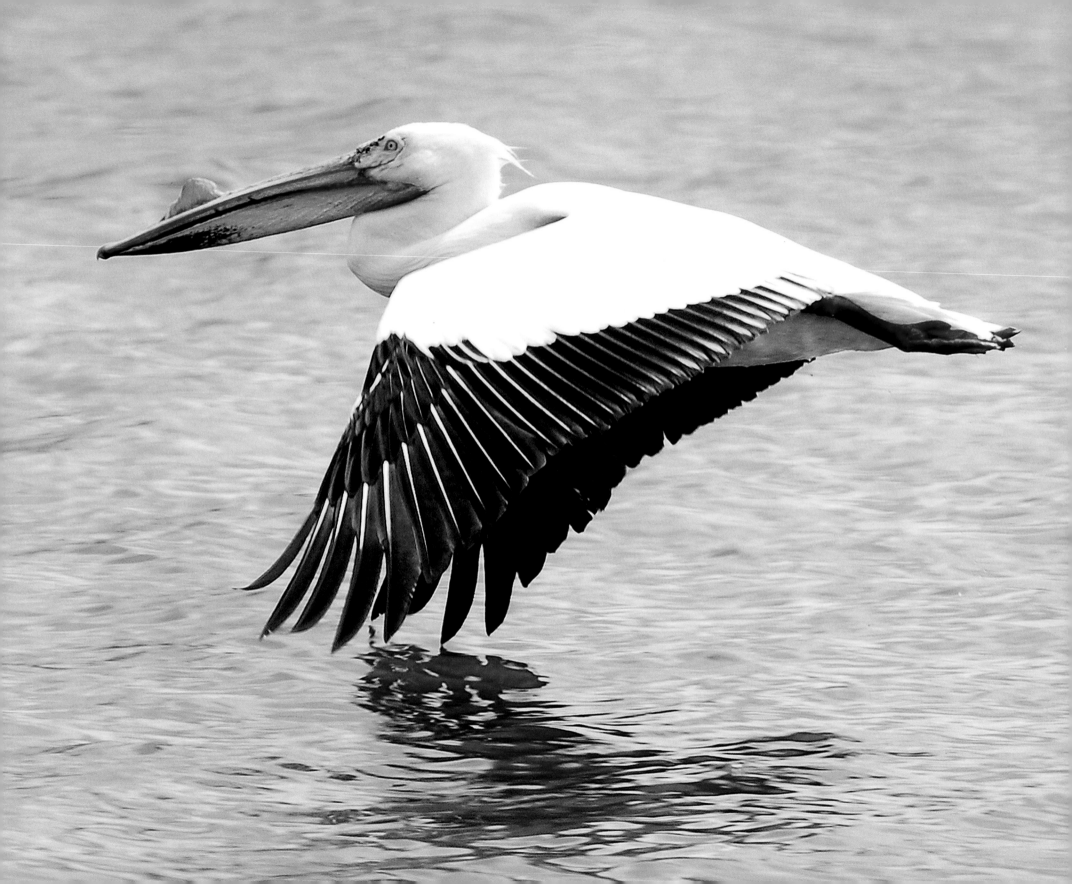

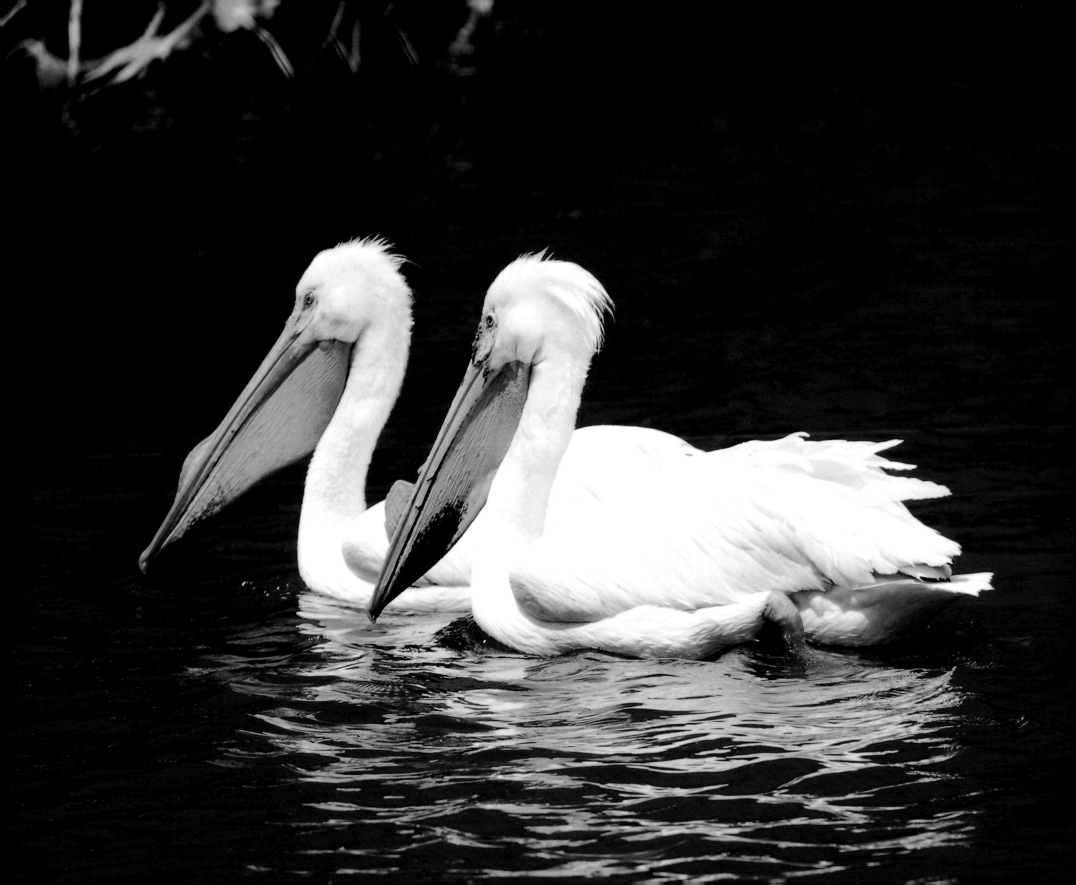

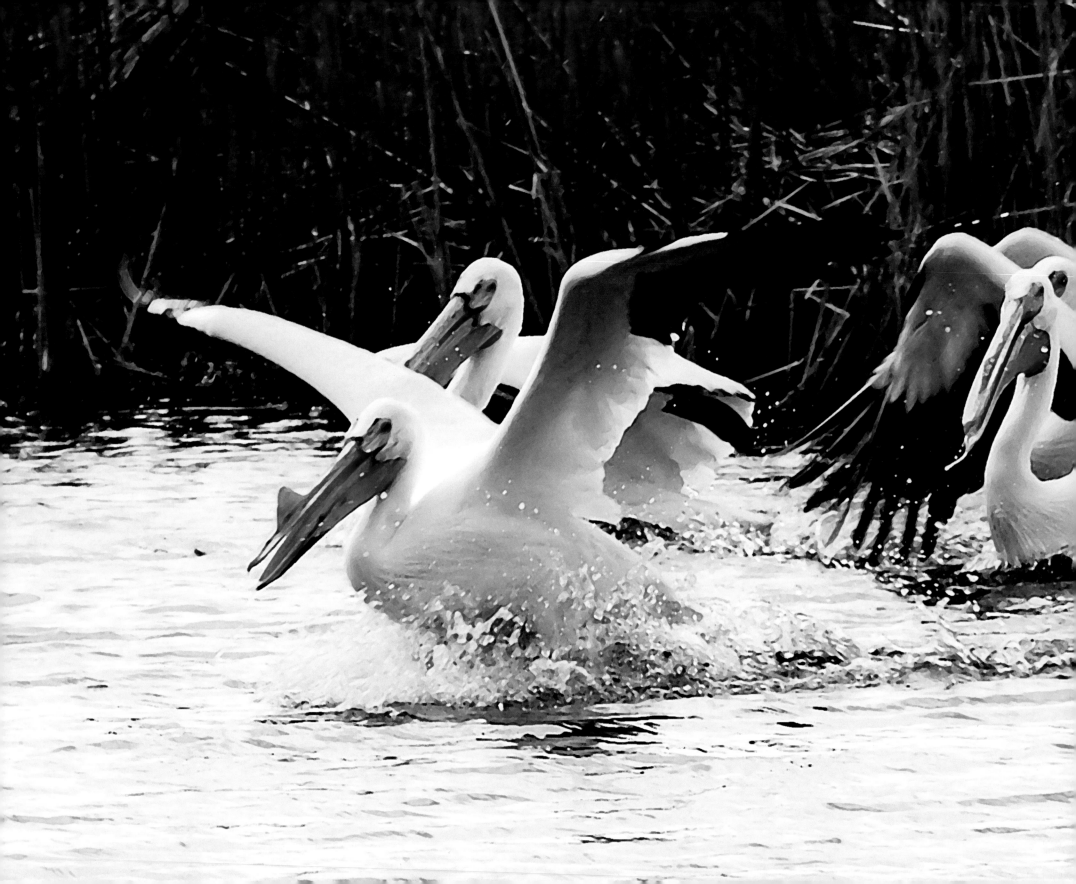

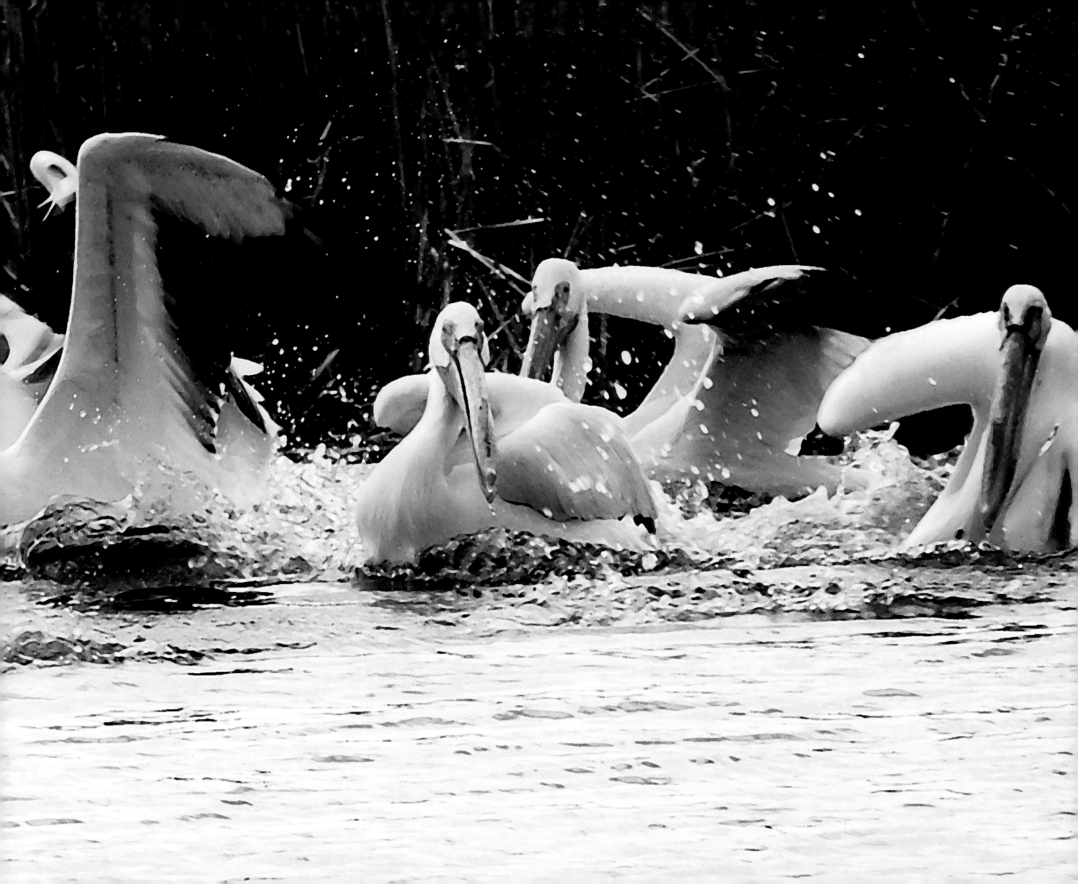

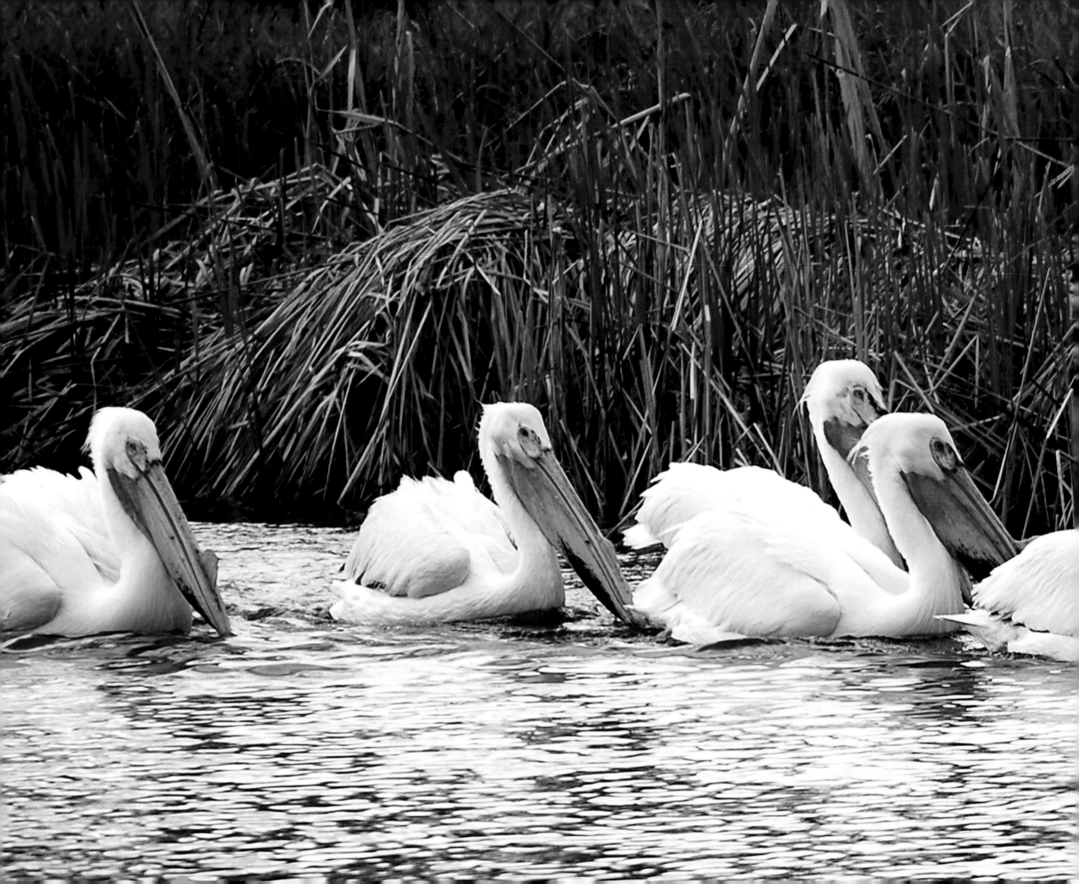

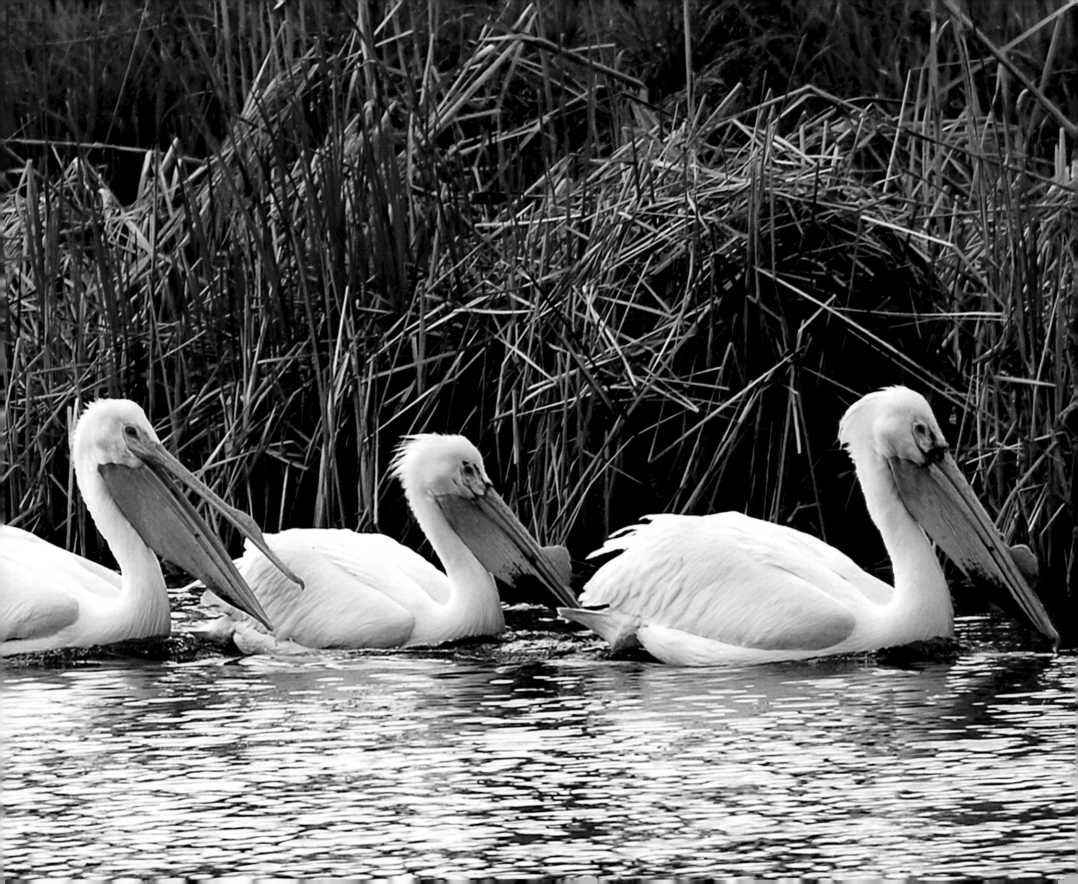

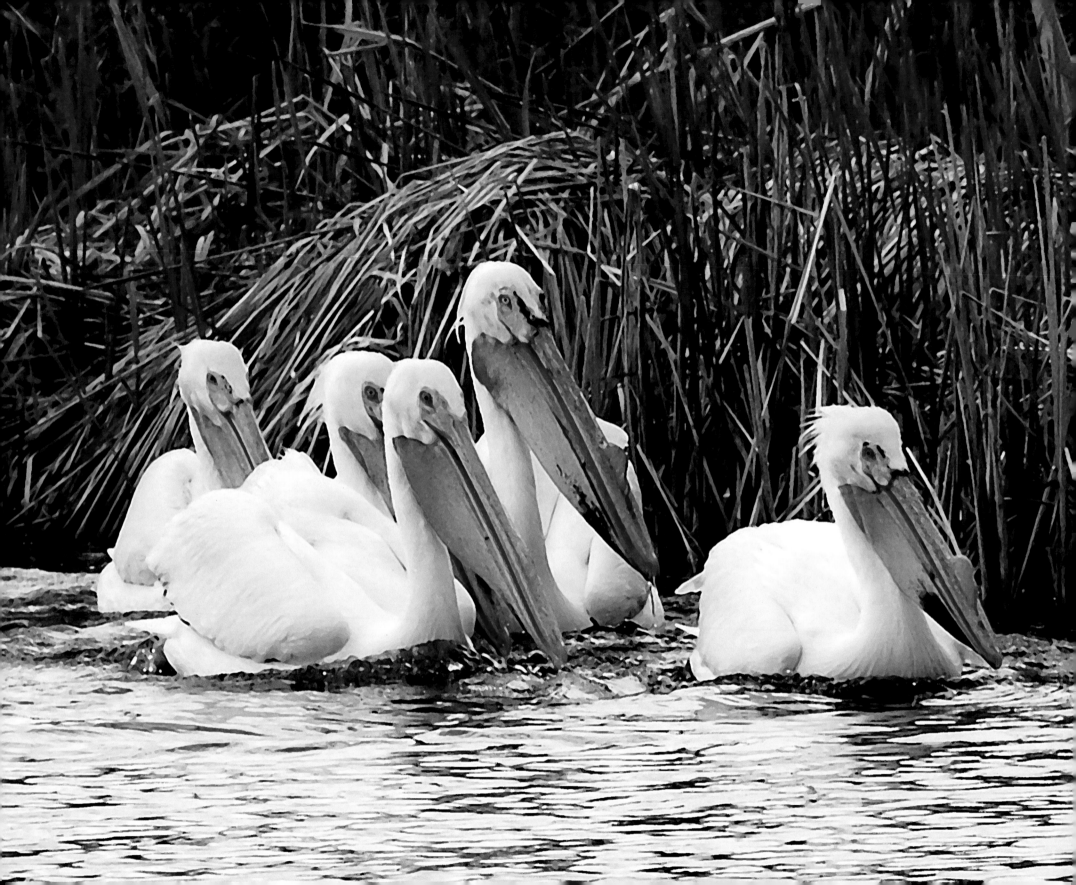

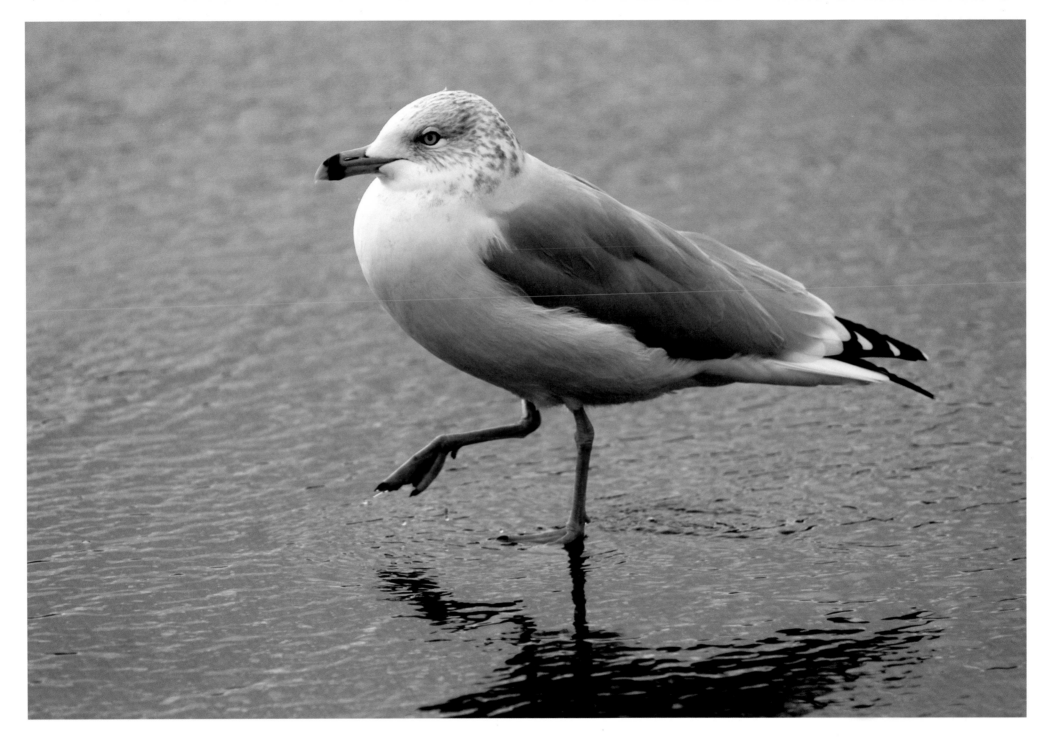

Believe it or not, I took this photo in a Wal-Mart parking lot. I was sitting in my truck eating lunch one afternoon and I started watching some sea gulls flying and splashing in the water that had collected from some melting snow. I was amazed at how graceful and beautiful these birds were as they went about scavenging in the parking lot. Beauty is in the eye of the beholder, if you simply take the time to notice it, regardless of where you might be at the time.

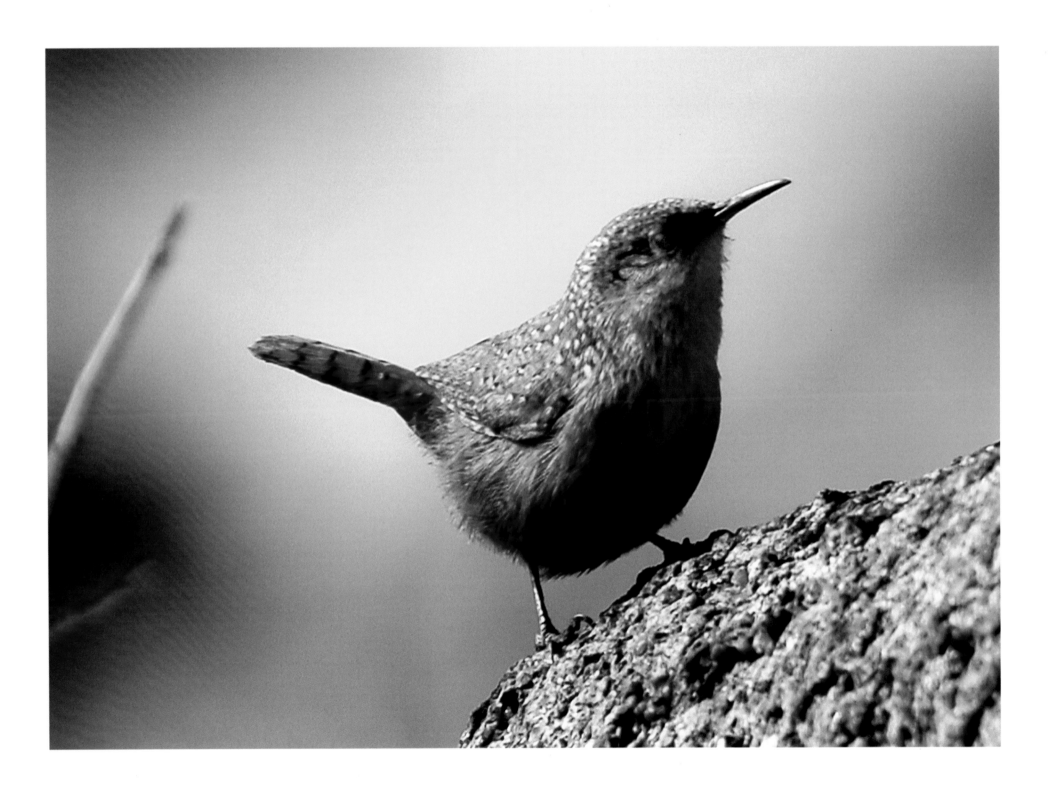

182

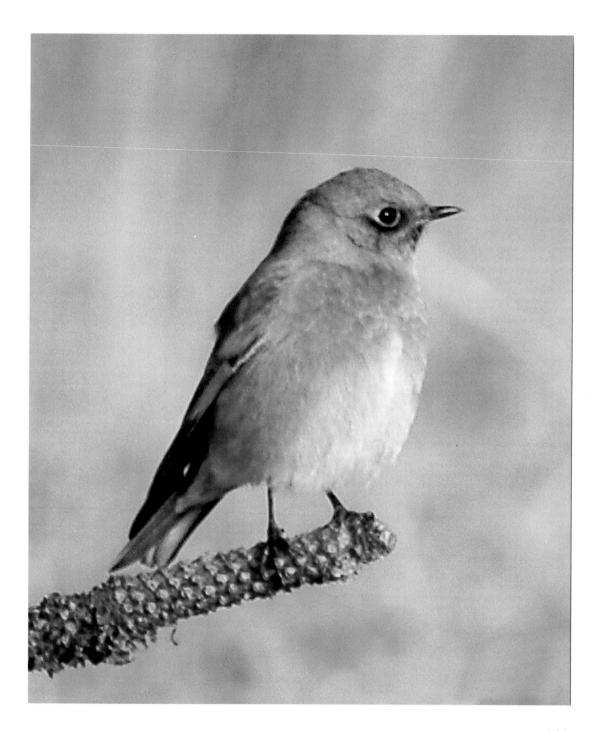

183

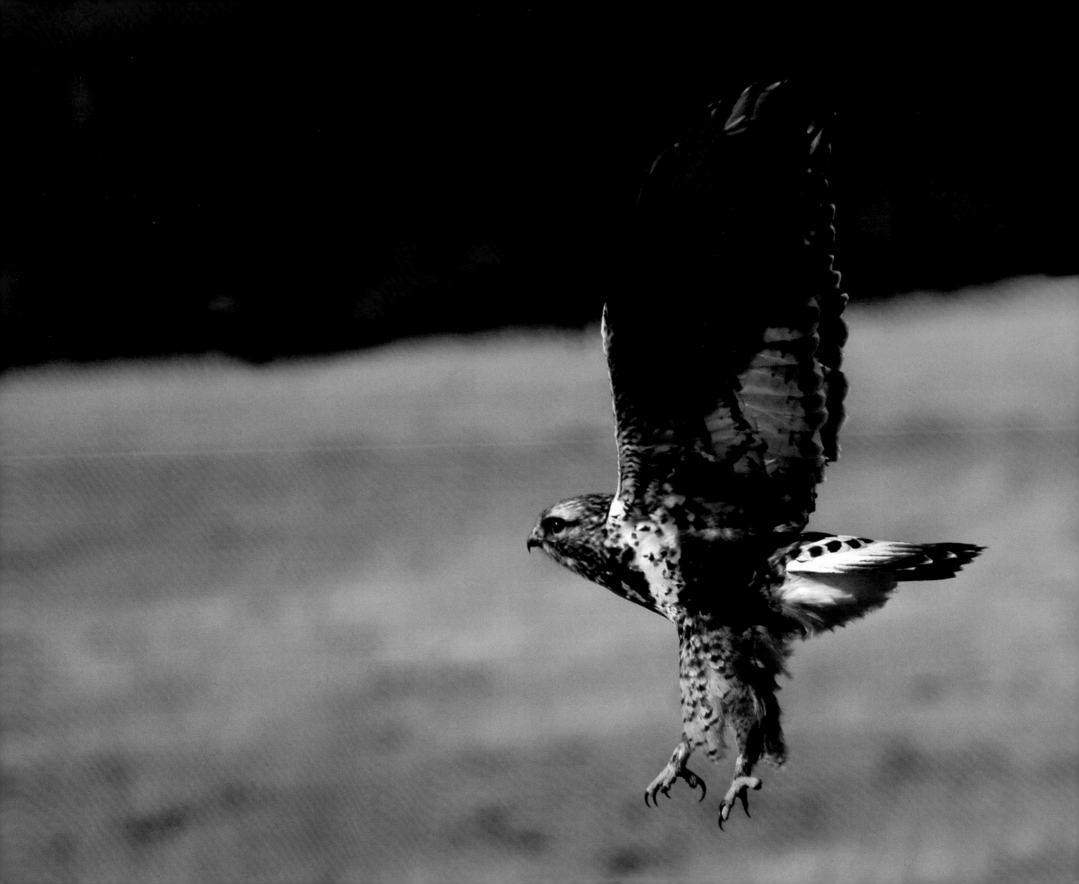

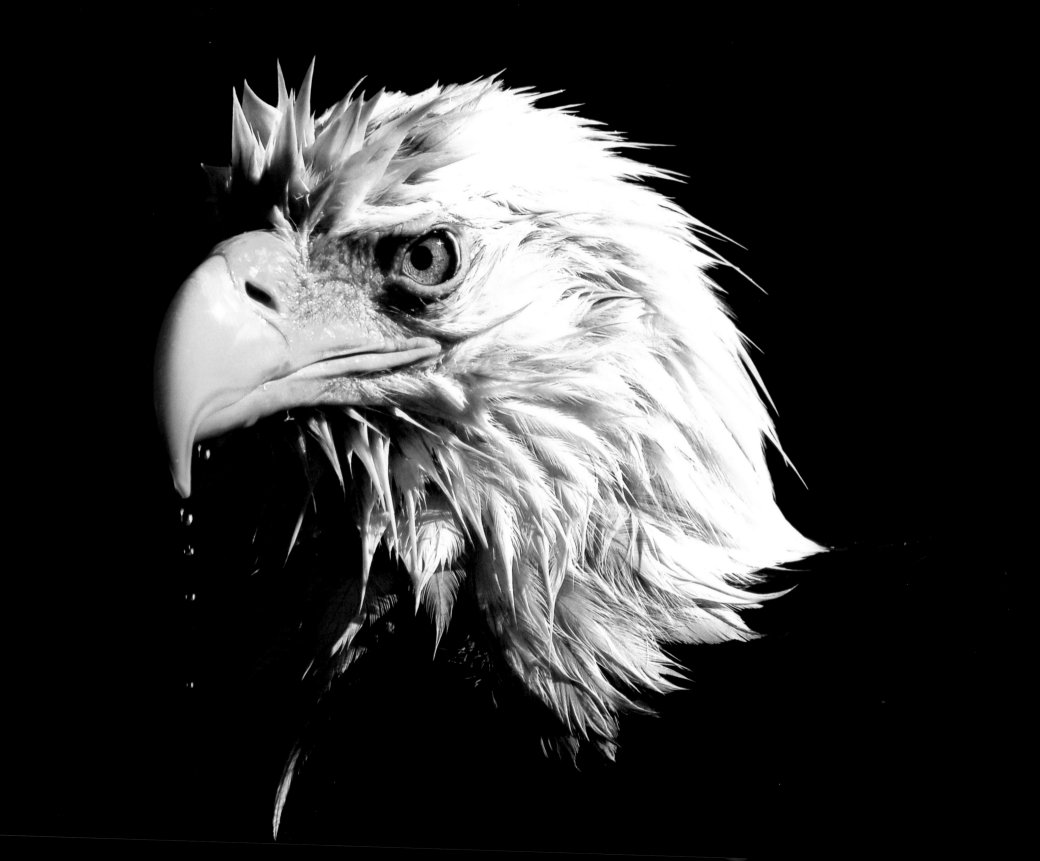

Blue Mesa Reservoir Eagle

Whenever I'm working in the Gunnison, Colorado area, I always make time to stop at Blue Mesa Reservoir with my fly fishing equipment. Not only is the fishing good but the scenery around the lake is some of the most beautiful in the state. I am usually rewarded with several large trout, which I always release, as well as several good photographs. I was returning from a day of selling in Telluride one late afternoon and I was looking forward to a little fishing before it got dark. As I was driving toward the reservoir I noticed a large eagle circling in the air above the water. I parked the truck and started down toward the lake to find a place to fish. I had my camera with me as I usually do when I saw the eagle disappear behind a small hill near the water's edge. I crawled up over the hill on my hands and knees. There was the eagle, washing itself in the water near the shore. It would dip its head down into the water and shake itself. The bright white head feathers were all wet and water would drop off the curved yellow beak. He would stand tall and proud as the gentle breeze slowly dried the feathers. Through my lens I could almost count every feather on his head. The sun was just going down and the bright rays were shining right on the eagle, making it stand out against the dark shaded background. I knew the second I clicked the shutter as I lay on my stomach in the grass that these were going to be some special photographs. I was right. The photo on this page was awarded the National Wildlife Photo of the Year for 2008.

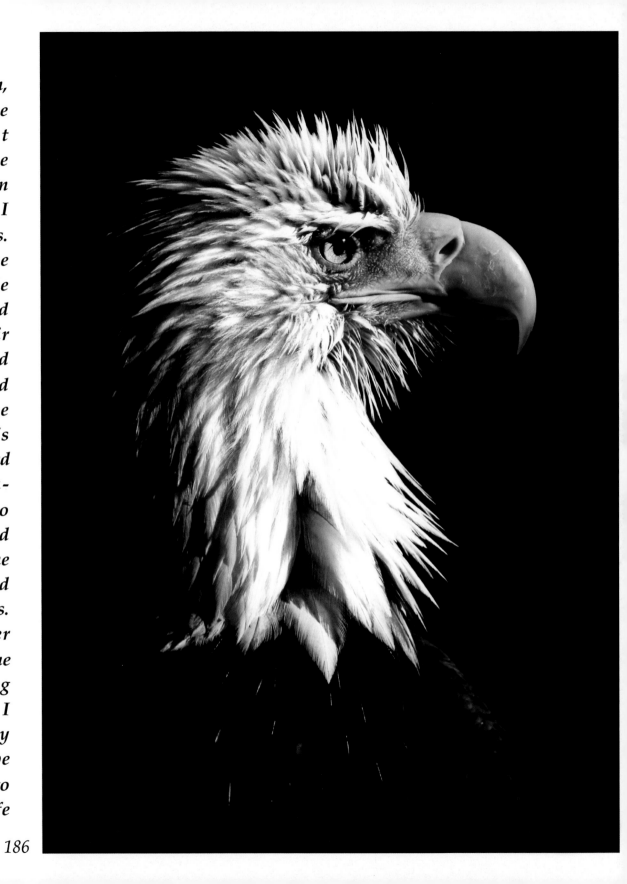

186

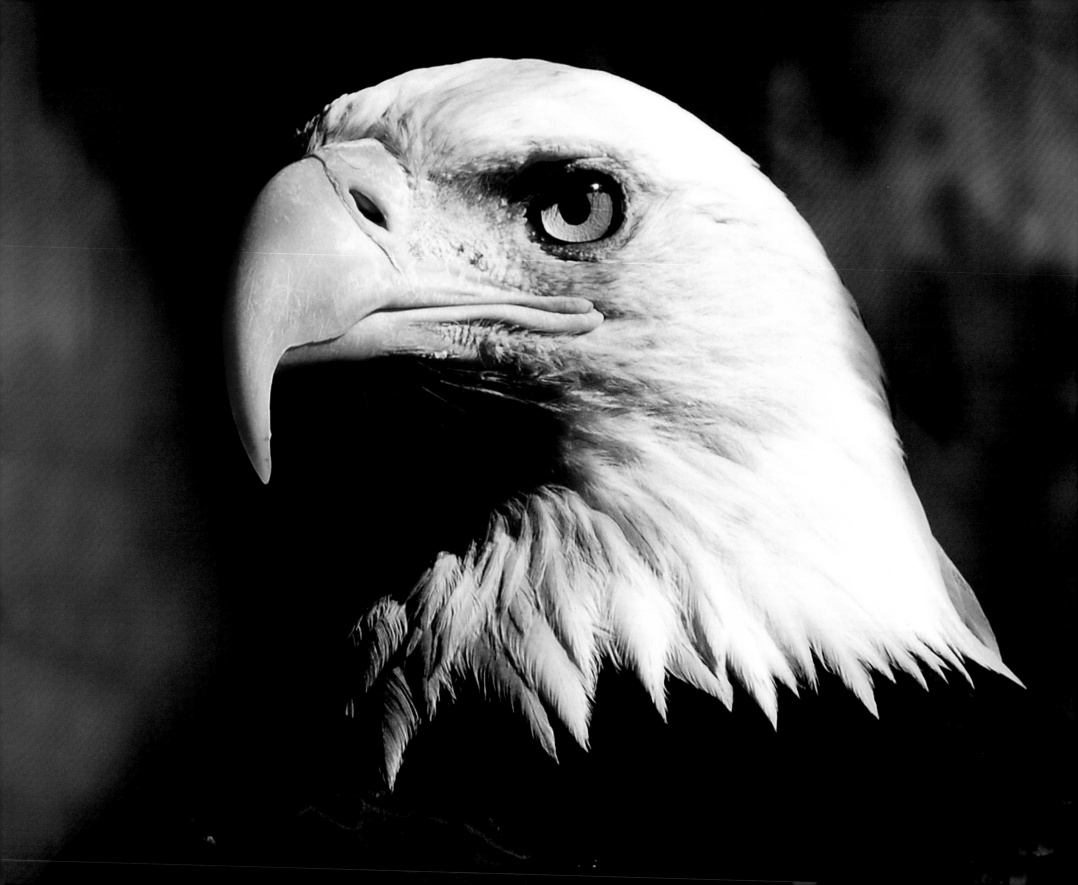

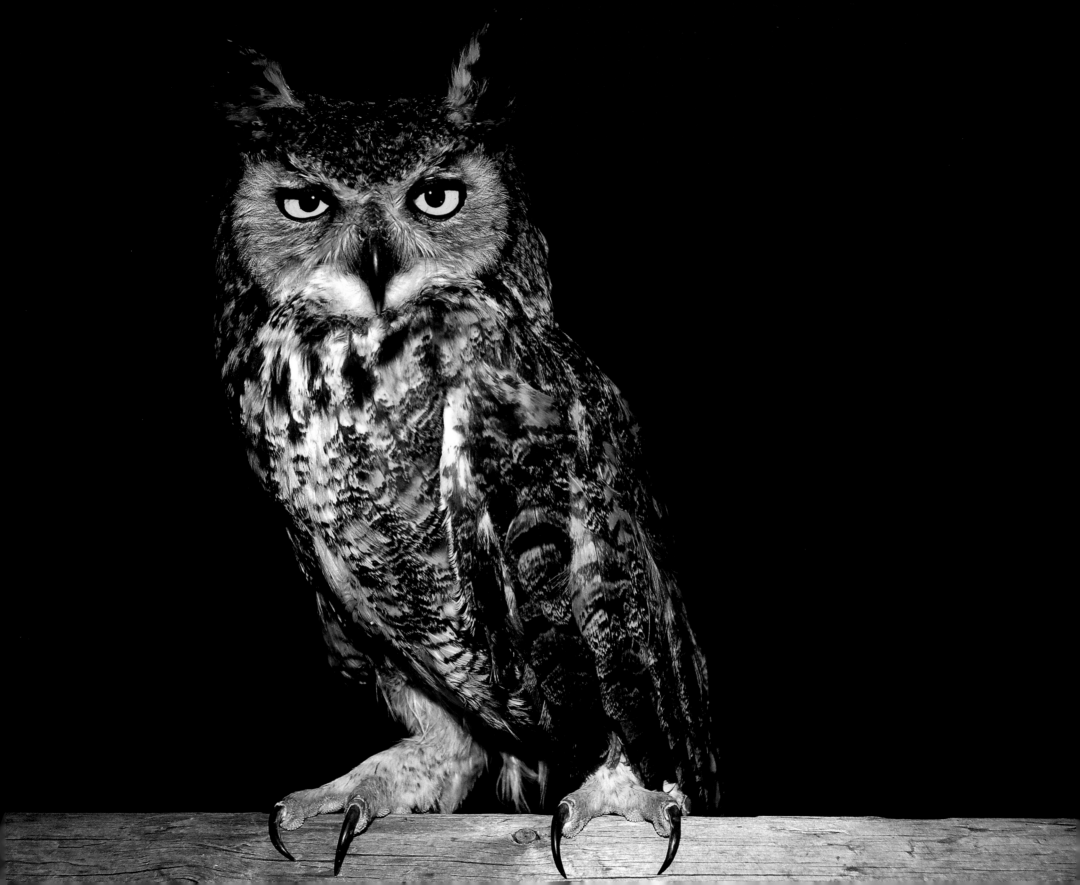

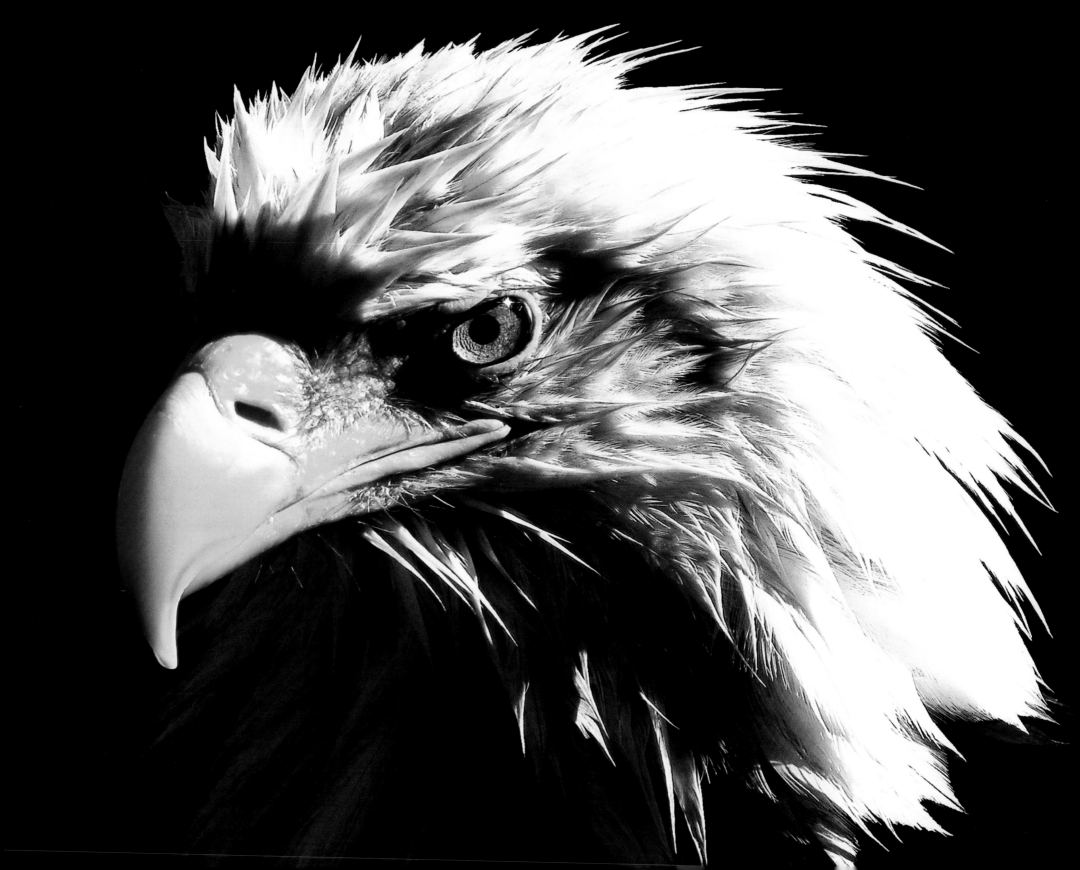

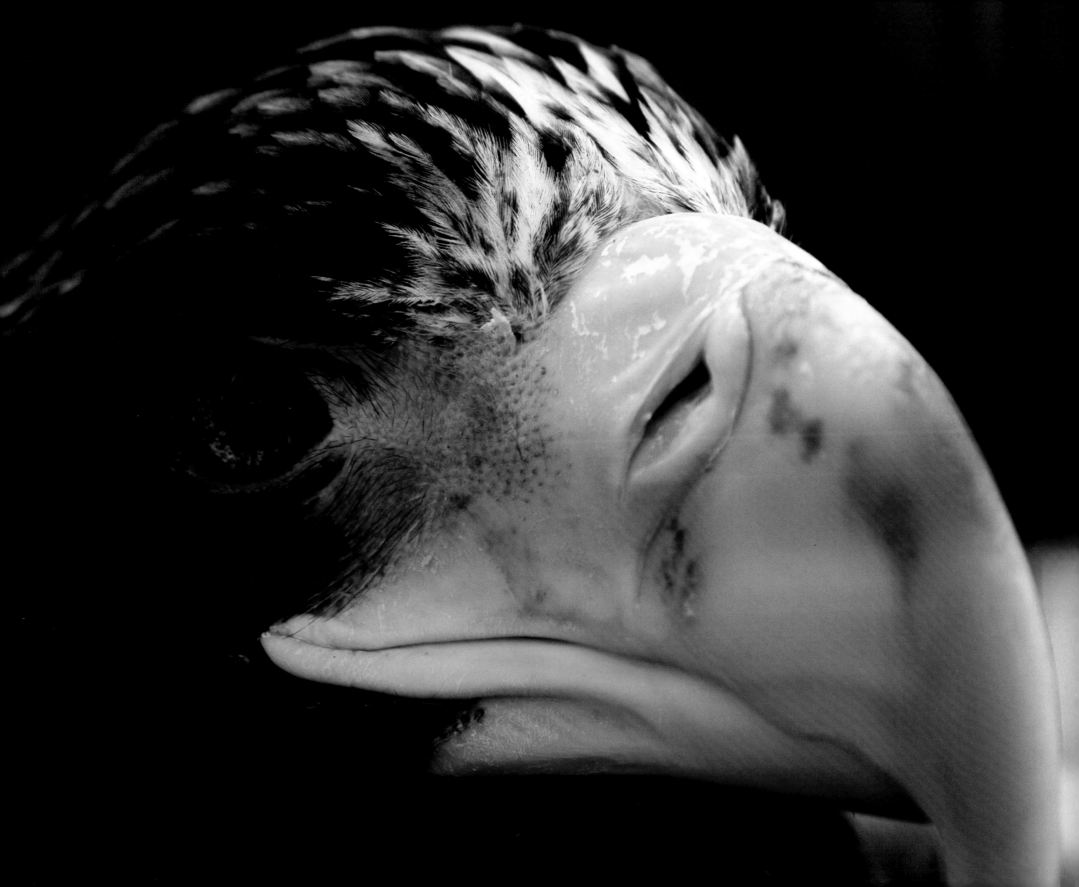

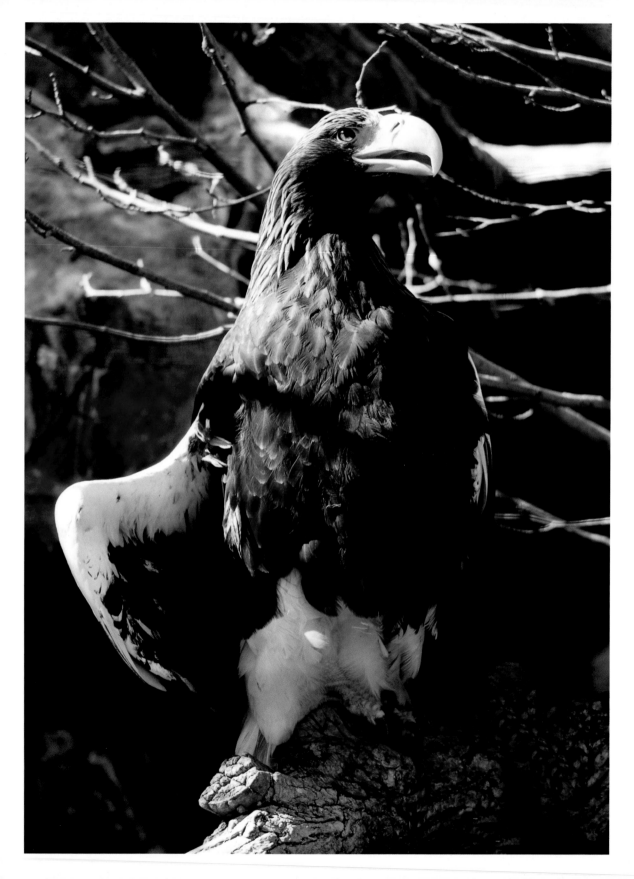

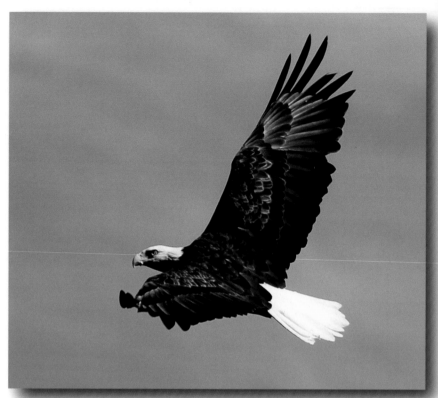

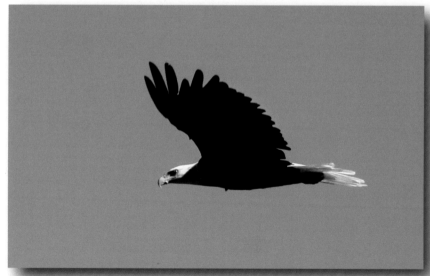

191

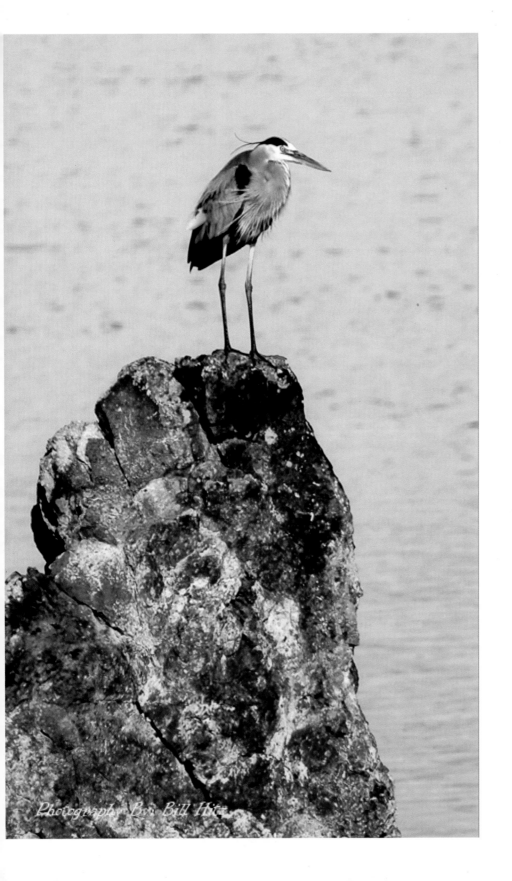

Photography By: Bill Hitz

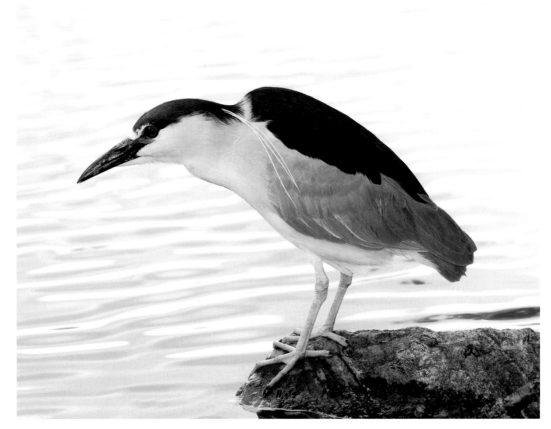

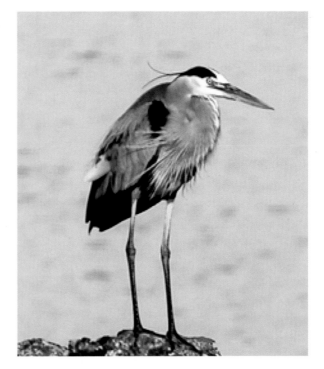

192

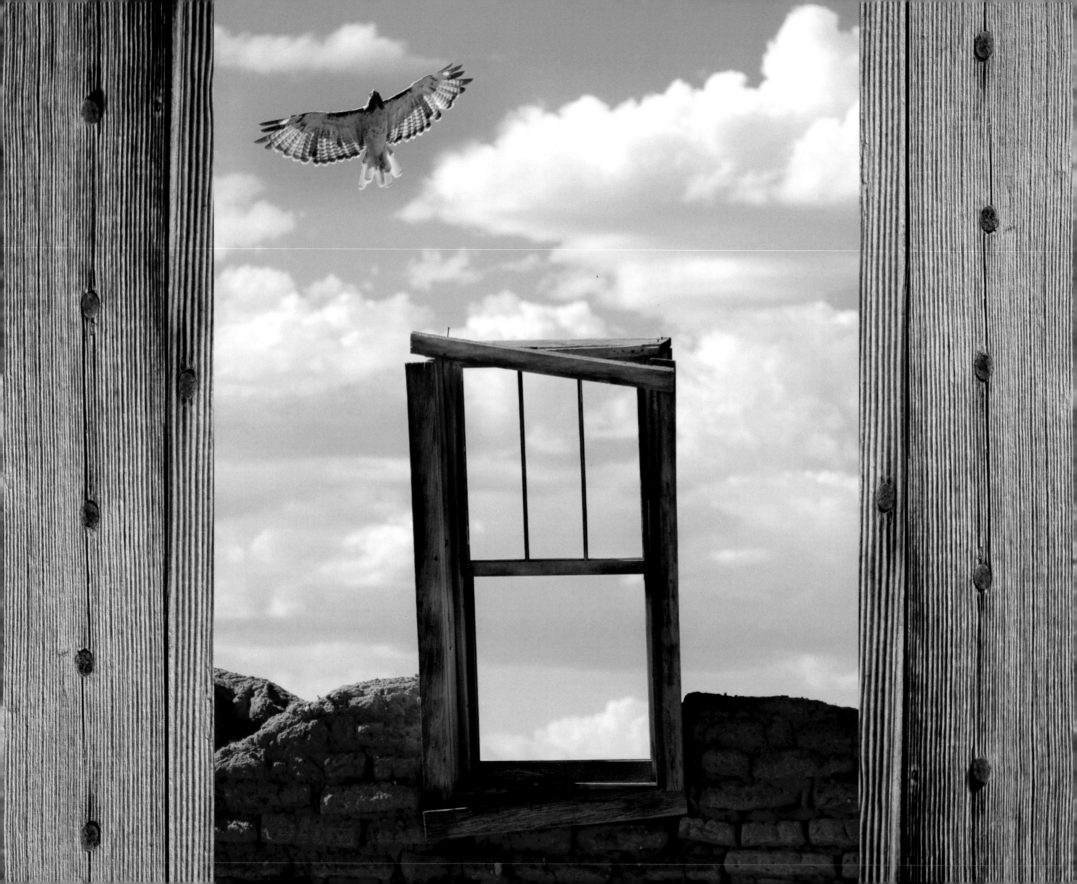

I have a lot of customers in the Santa Fe, New Mexico area, partly because I have a sister that lives there, but also because I enjoy the change in scenery it brings. There is a lot of adobe and southwest style architecture and the land and mountains are more of a high desert than most of Colorado or Wyoming. This particular day I was driving down a dusty dirt road and I could see what looked like an old church and some other adobe buildings, almost like a small ghost town off in the distance. As I got closer, I could see that the buildings and grounds were surrounded by a barbed wire fence. The gate was closed and there was a sign next to it that stated that this had been the location where a small adobe church had burned down and that it was considered sacred or holy ground. The sign continued by stating there was to be no trespassing and no photography. As I stood there with my camera in my hands, disappointed that I wasn't going to be able to capture what I had thought would be some cool photographs, I saw a man dressed in a long black robe approaching from one of the nearby buildings. As he got closer I could see that he was wearing a priest's collar and looked like he was about eighty years old. He told me very politely that I was on sacred ground and that there was no photography allowed. He explained that the church that used to stand here had burned down many years ago, and that tragically, some people had died in the fire. I told him that I was visiting my sister and working in the area. I asked if it would be okay if I just got a few quick photos before I went on my way. He looked me in the eye and said I looked like a nice fellow and that he didn't mind if I took just a few photographs, but I couldn't go inside the fence. He told me that there had been so much vandalism there in the past that they just had to close the grounds to the public. I looked down and got my camera ready to go. When I looked back up, the old priest had disappeared. I started to take a few photos when I noticed a hawk circling around the buildings and a big tree nearby. I thought maybe it had a nest somewhere close in the area. I kept clicking off shots of the old buildings when I noticed the hawk approaching. Just as I was focusing in on the old window frame, the hawk swept in and struck a once in a lifetime pose just above the old ruins, almost as if he were a spirit, guarding the sacred grounds.

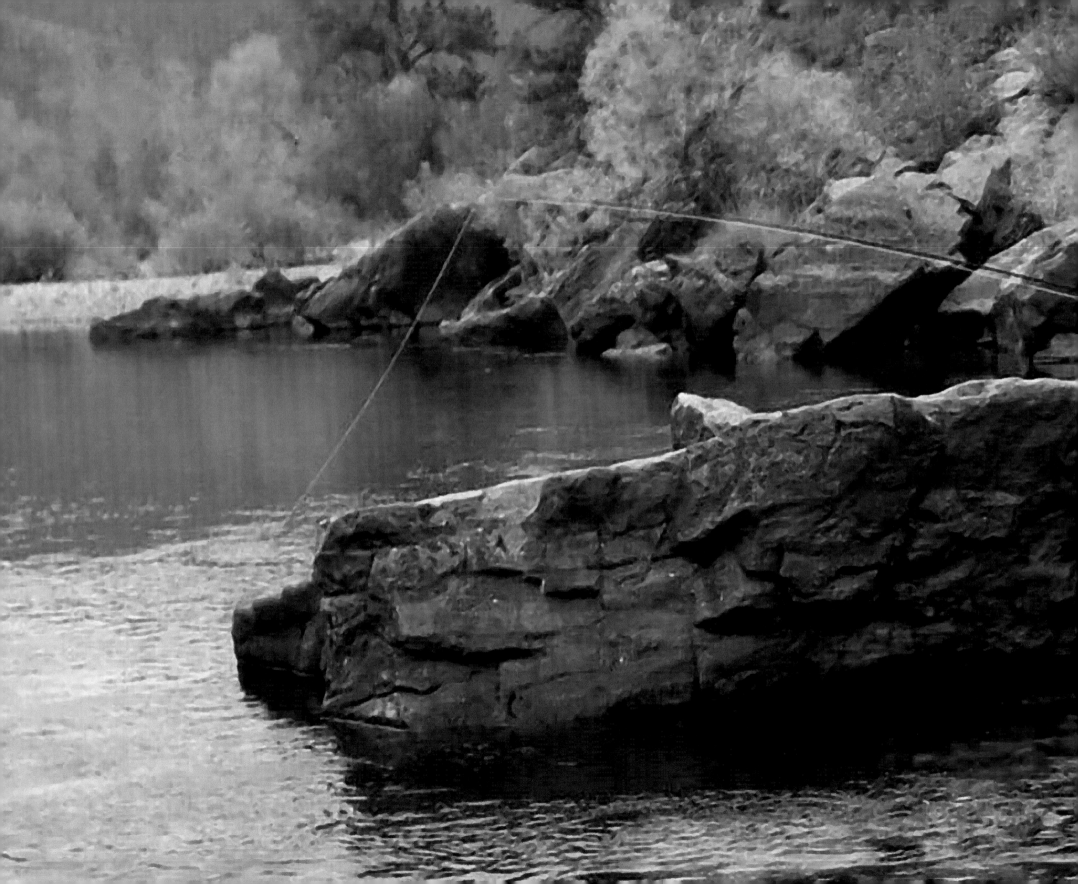

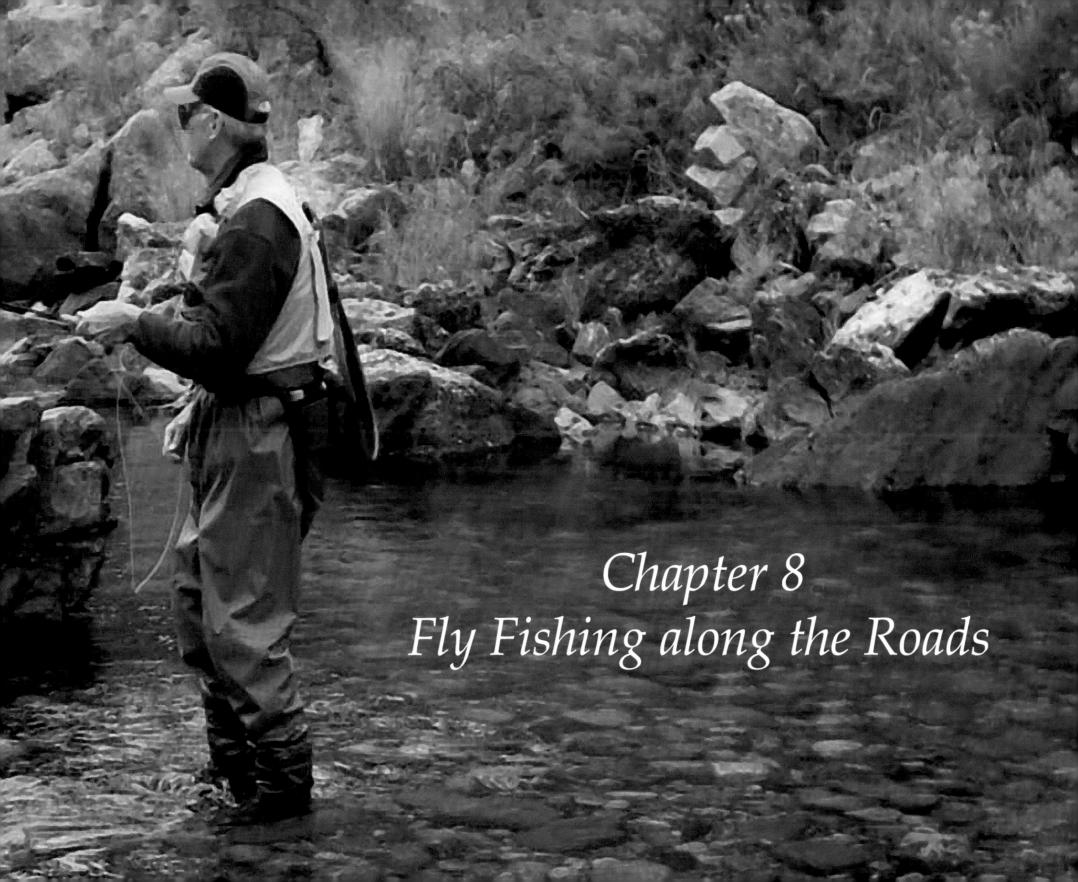

Chapter 8
Fly Fishing along the Roads

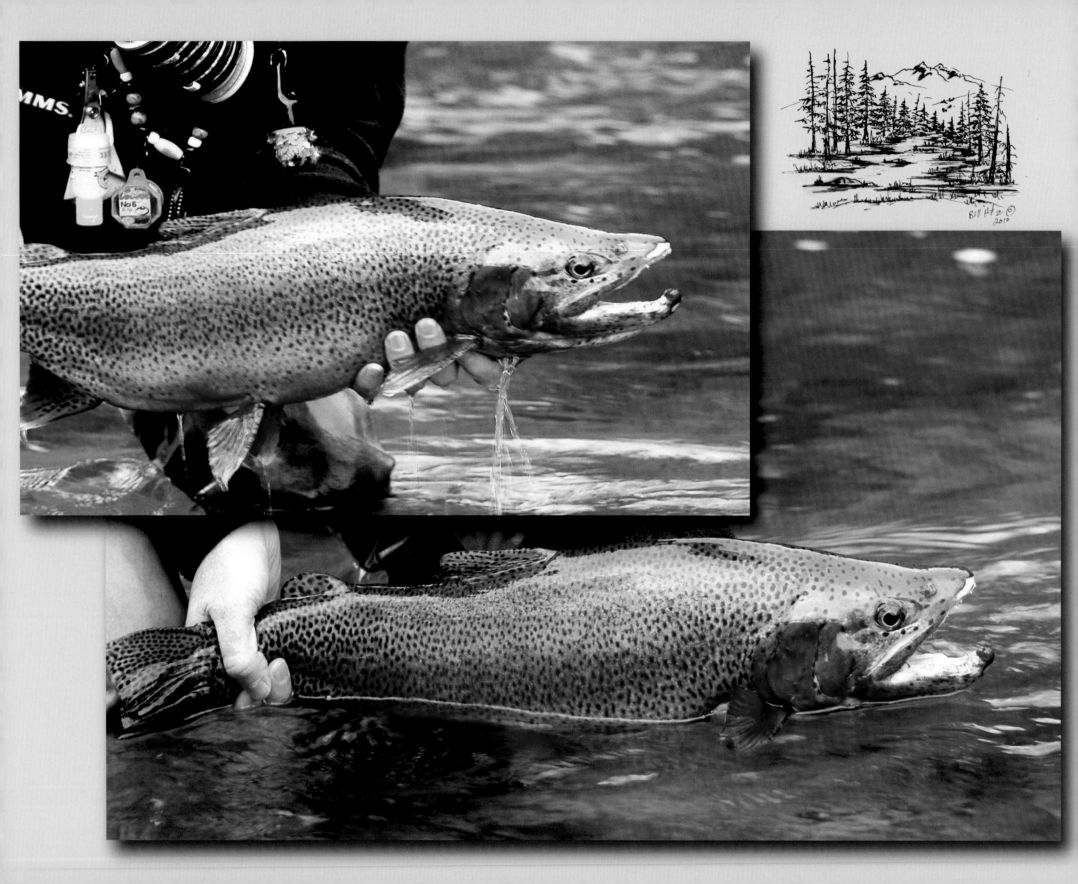

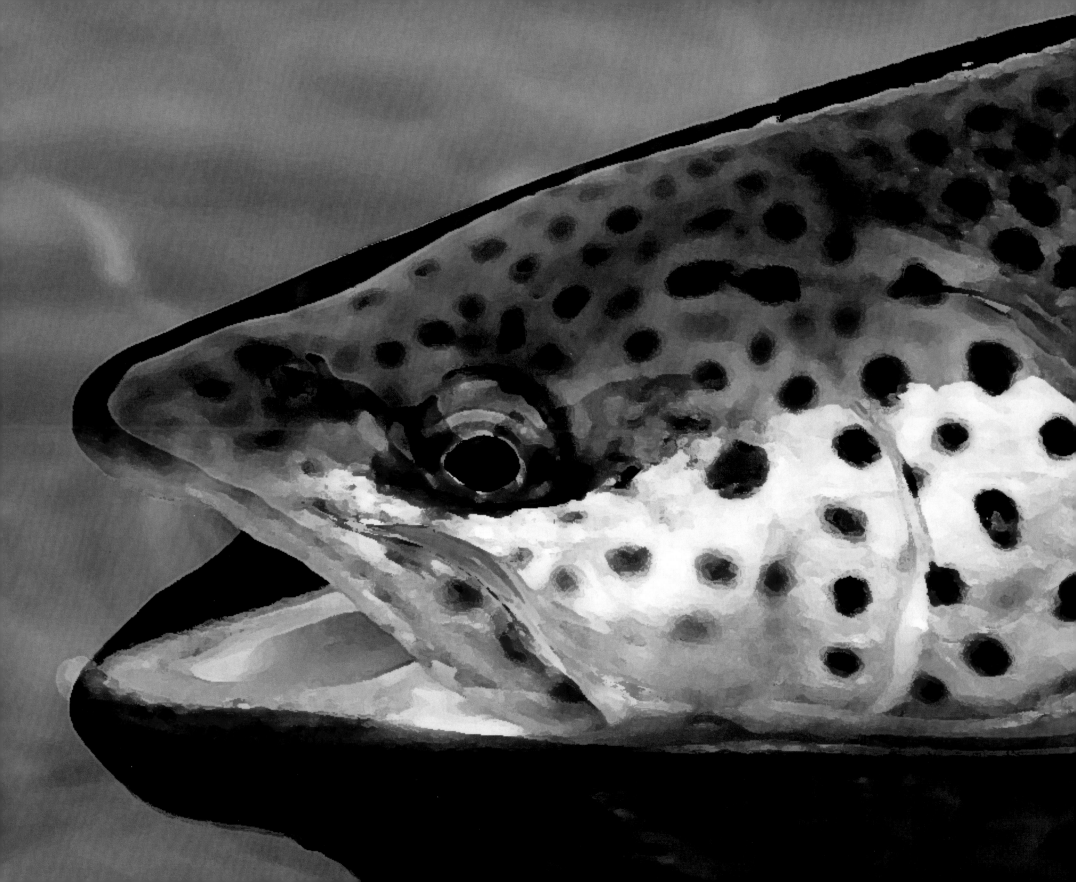

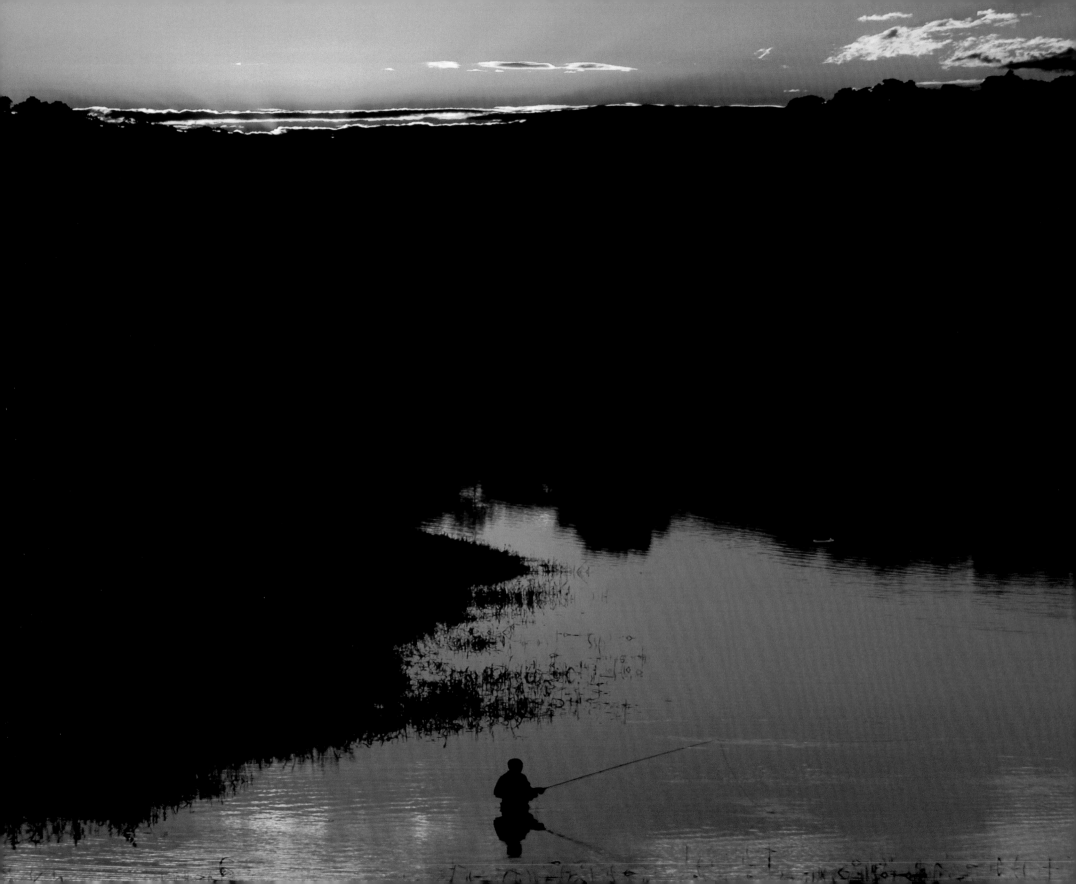

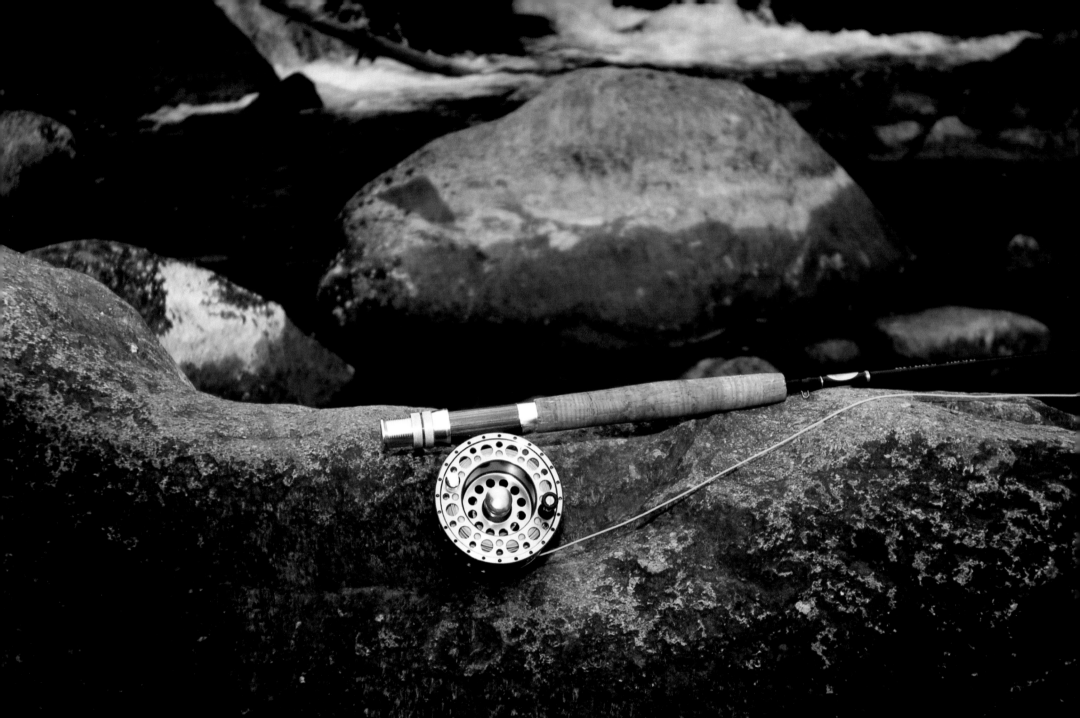

I want to dedicate this page to a dear friend, not only to me but to the entire outdoors and the wildlife of Colorado. Charlie Meyers, a long time sports and outdoor writer for the Denver Post, and one of my favorite people and fly fishing partners passed away after a long battle with cancer in January, 2010. Charlie was an outdoor enthusiast and advocate for wildlife and the environment in Colorado for over forty years. As an outdoor journalist for the Denver Post, Charlie was always looking out for the best interest of Colorado's great outdoors. Charlie's fly rod lies silent now, but the legacy of all Charlie helped to achieve and preserve will remain evident for many years to come.

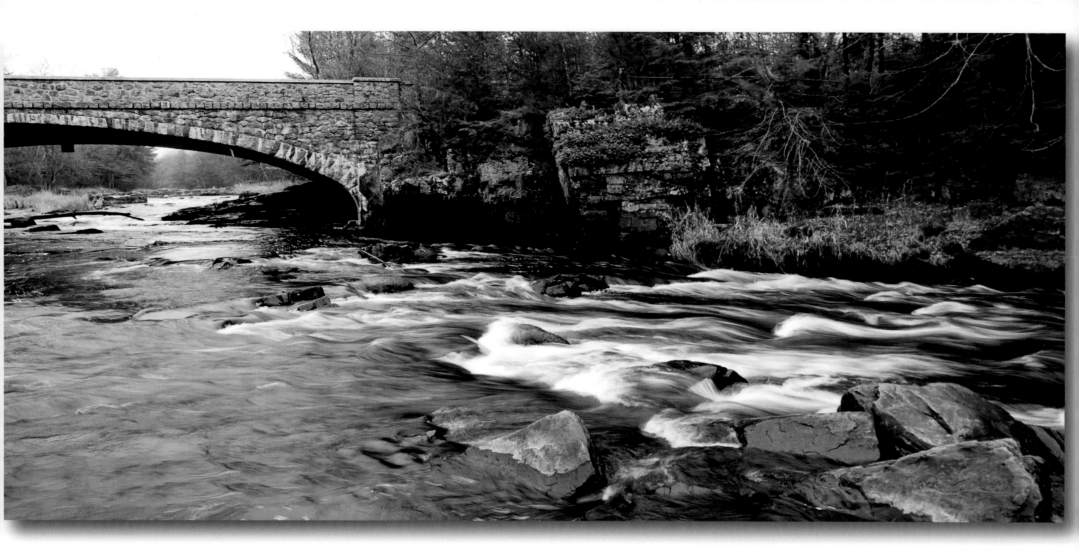

When I was growing up in northern Wisconsin, the first day of trout season was always a day we looked forward to with joyful anticipation. In my large family, fishing was something we learned how to do almost as soon as we could walk and hold a pole at the same time. I remember one year my Dad and three older brothers were going fishing on the first day of trout season. I wanted to go so badly I couldn't stand still, but I was told that I was not big enough yet and they left for the day without me. I was terribly disappointed but I wasn't going to let that ruin my day. I got my pole and my creel and after filling my dad's old Thermos jug with what was left of the coffee in the pot I headed out the door for the nearby creek that ran not far from our back yard. I spent the entire day there catching trout after trout. I still wasn't home by the time my dad and brothers returned. My mother ran outside to tell my father that she hadn't seen me all day and wondered if I was with him. The police were just driving into the yard as I came up over the hill with my creel bulging with several large trout. When my dad saw me and my creel, the first thing he wanted to know wasn't whether I was okay but where I caught so many big fish. I took this photo of the Eau Claire River many years later near the place where I grew up and learned to appreciate the beauty of nature while spending hour after hour fishing rivers like this one.

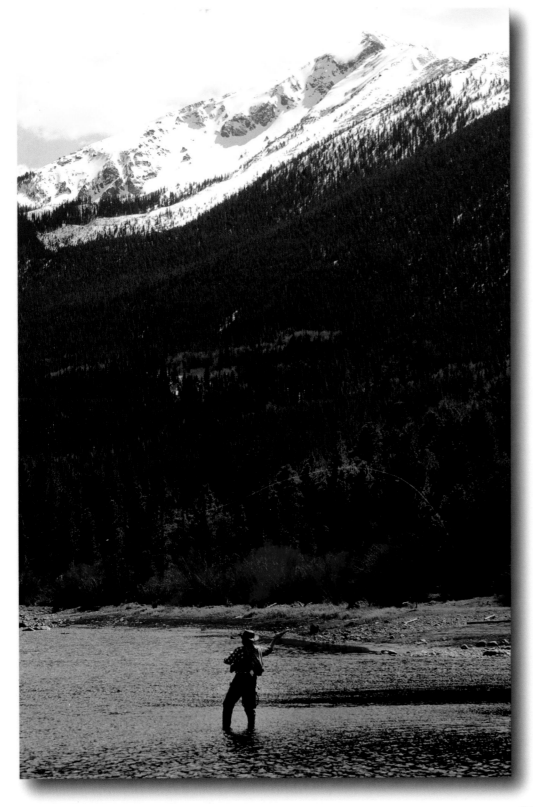

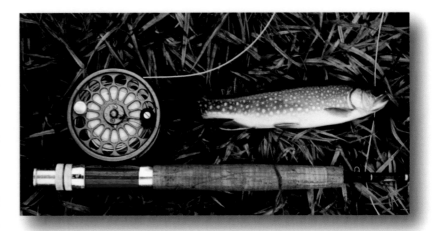

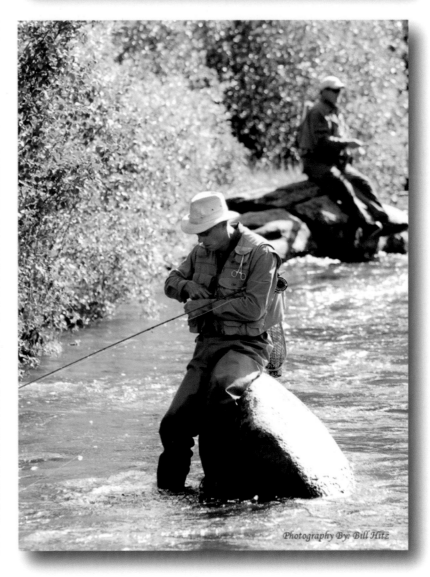

Photography By: Bill Hitz

202

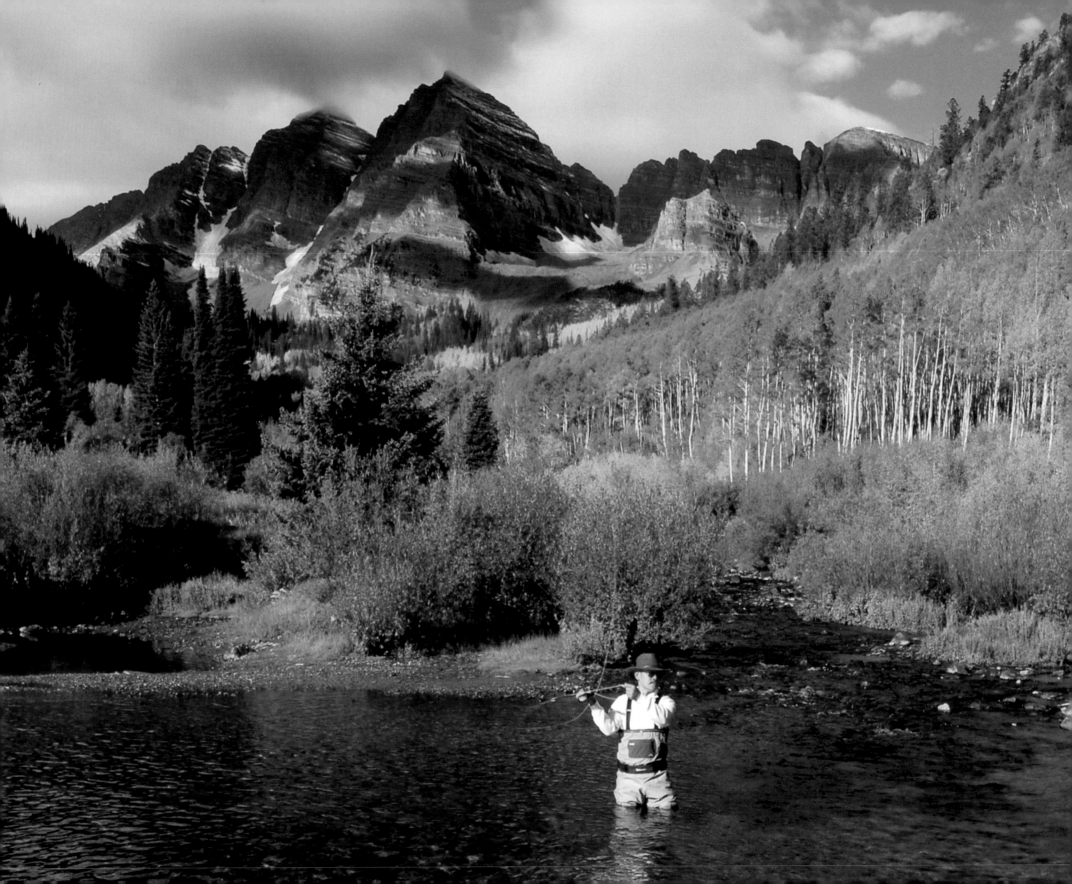

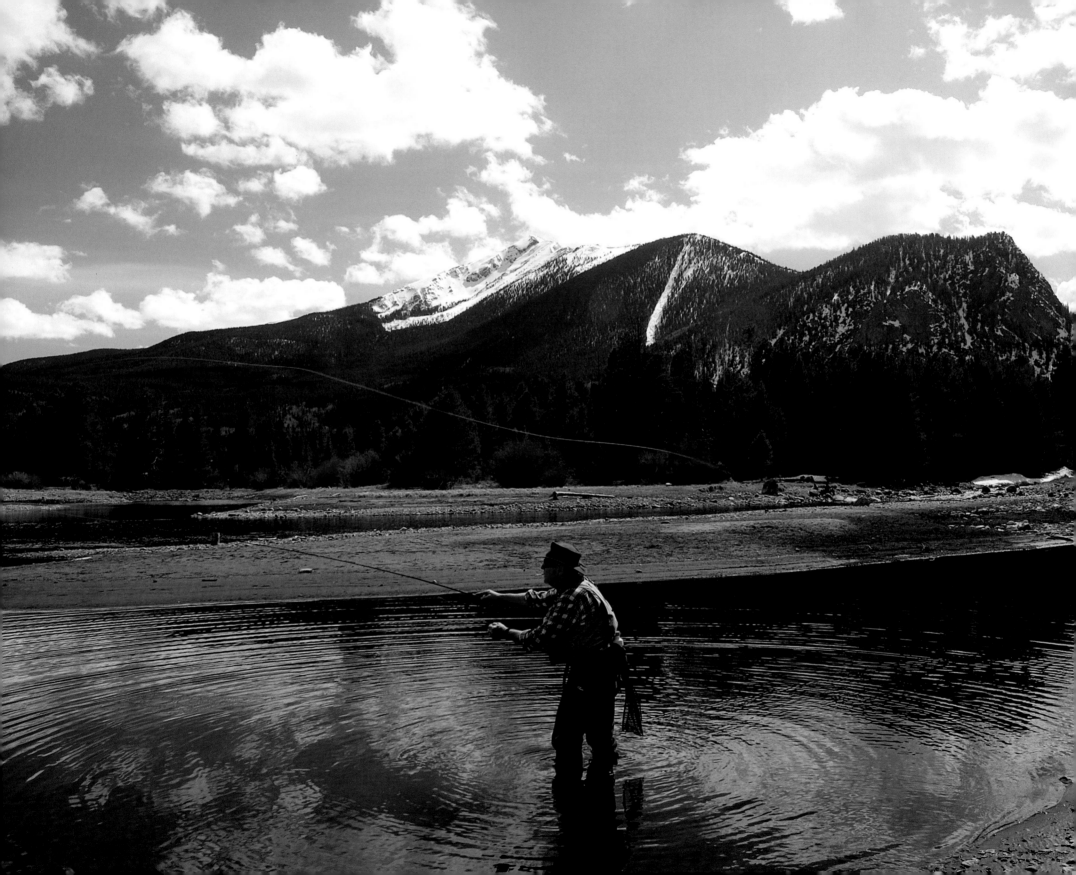

Chapter 9
Inspirational Photos

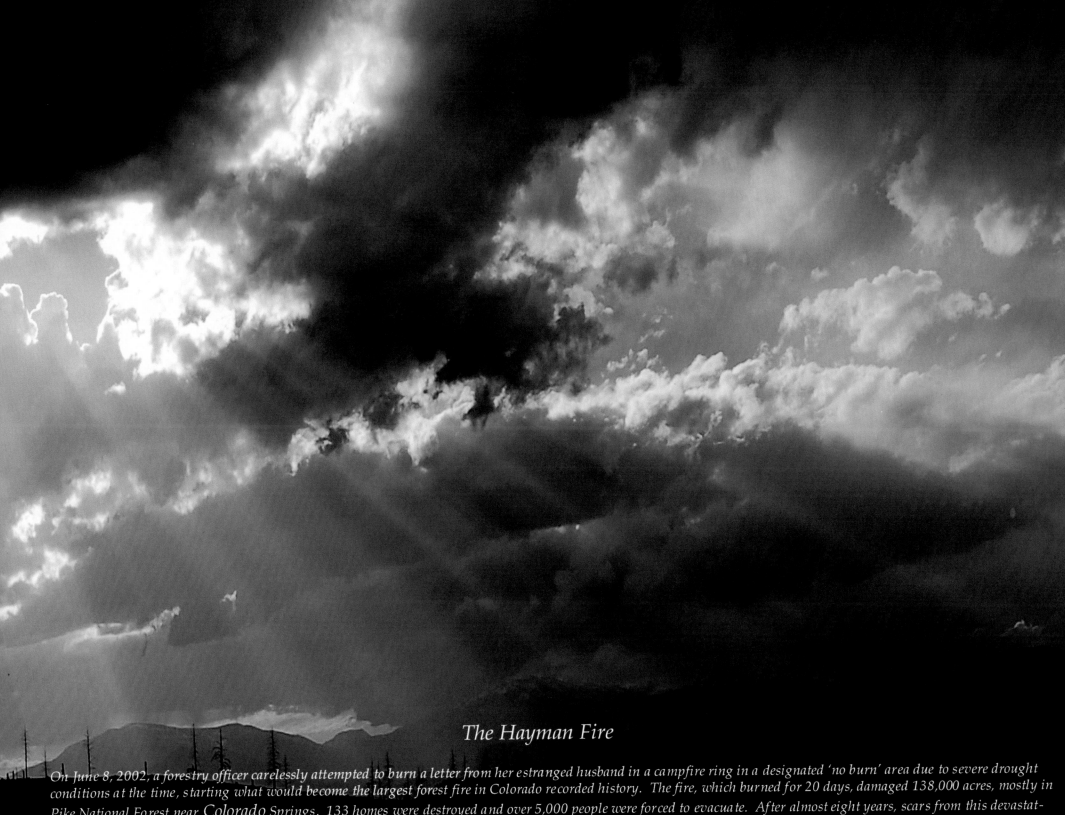

The Hayman Fire

On June 8, 2002, a forestry officer carelessly attempted to burn a letter from her estranged husband in a campfire ring in a designated 'no burn' area due to severe drought conditions at the time, starting what would become the largest forest fire in Colorado recorded history. The fire, which burned for 20 days, damaged 138,000 acres, mostly in Pike National Forest near Colorado Springs. 133 homes were destroyed and over 5,000 people were forced to evacuate. After almost eight years, scars from this devastating fire still remain, and will for many years to come. As I took these photos of that scarred land, I felt as though the glow was coming from the face of God, shining down from above, healing this wound, so that life and beauty will one day abide in these mountains once again.

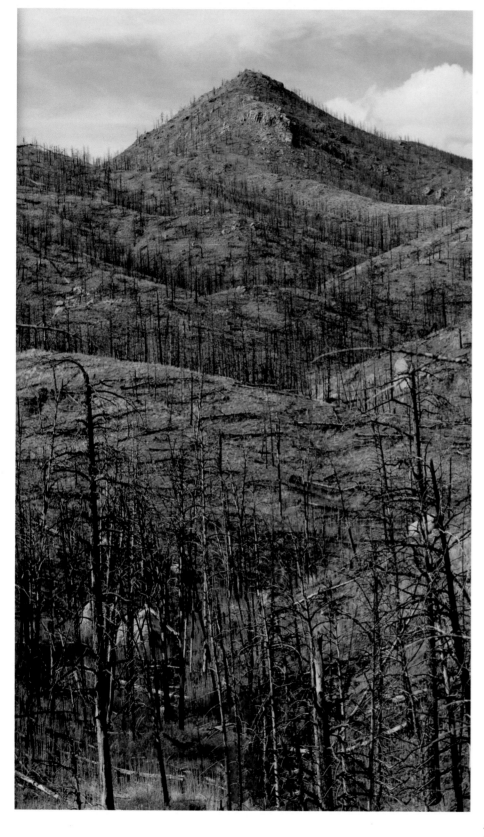
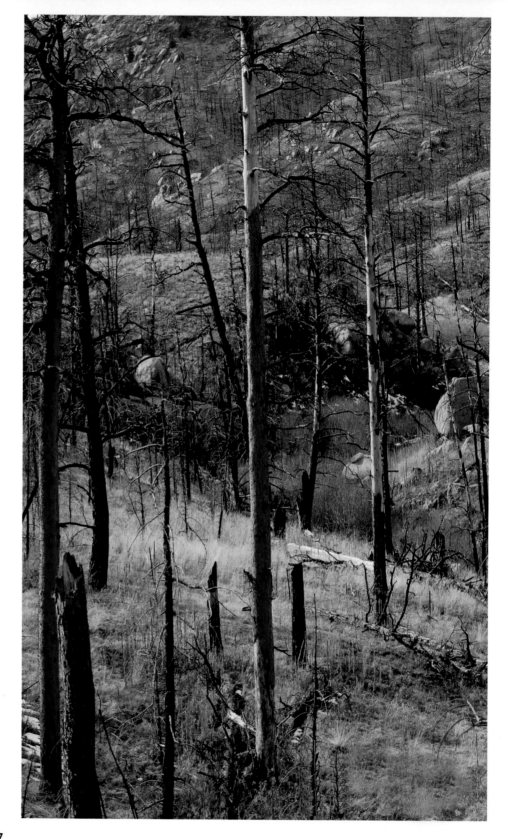

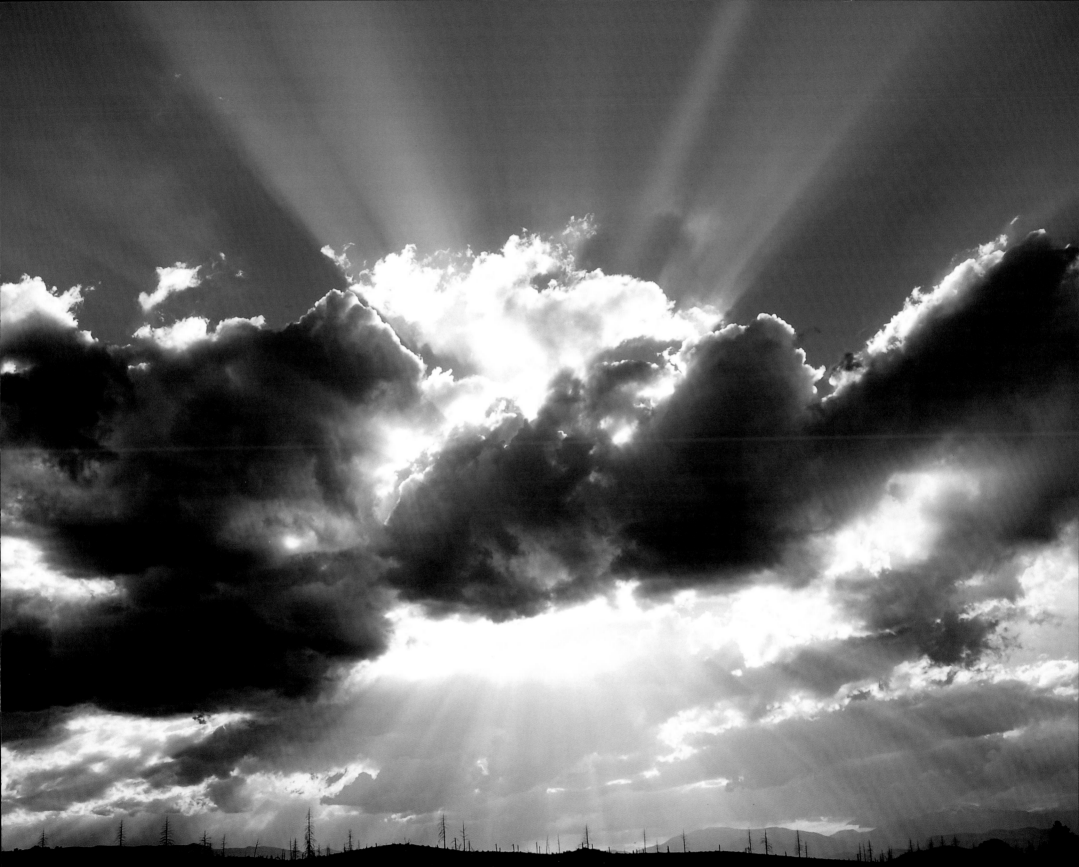

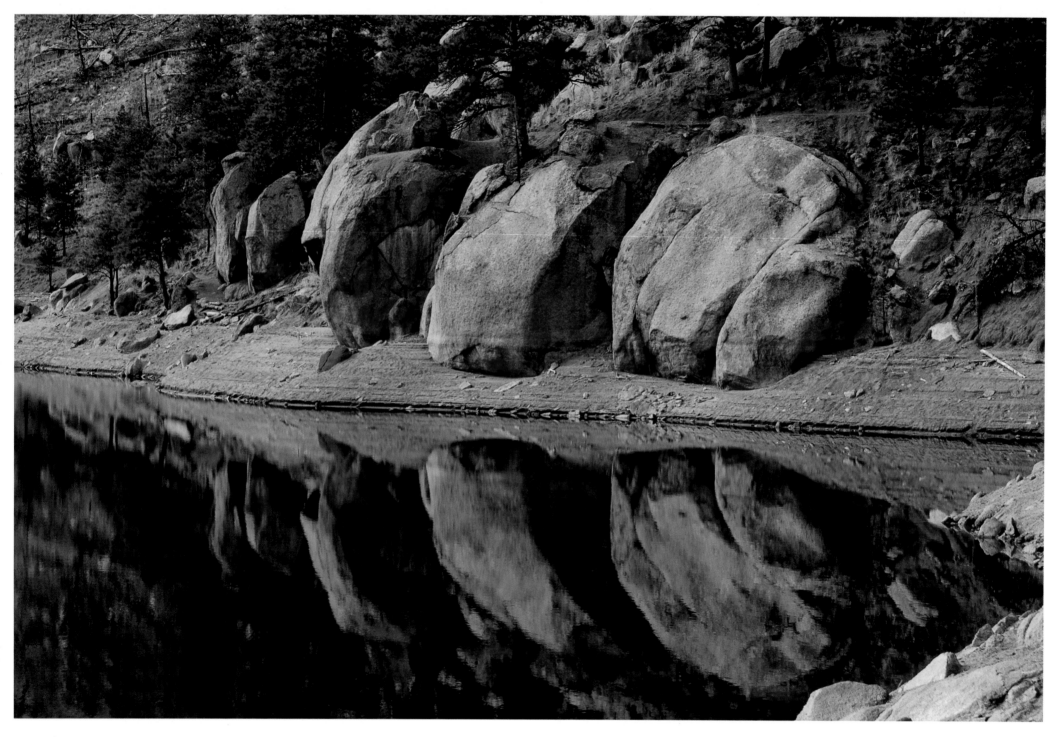

I caught these boulders sunning themselves along the shore of Cheesman Reservoir near Deckers, Colorado early one morning in late fall as they admired their reflections in the calm smooth water.

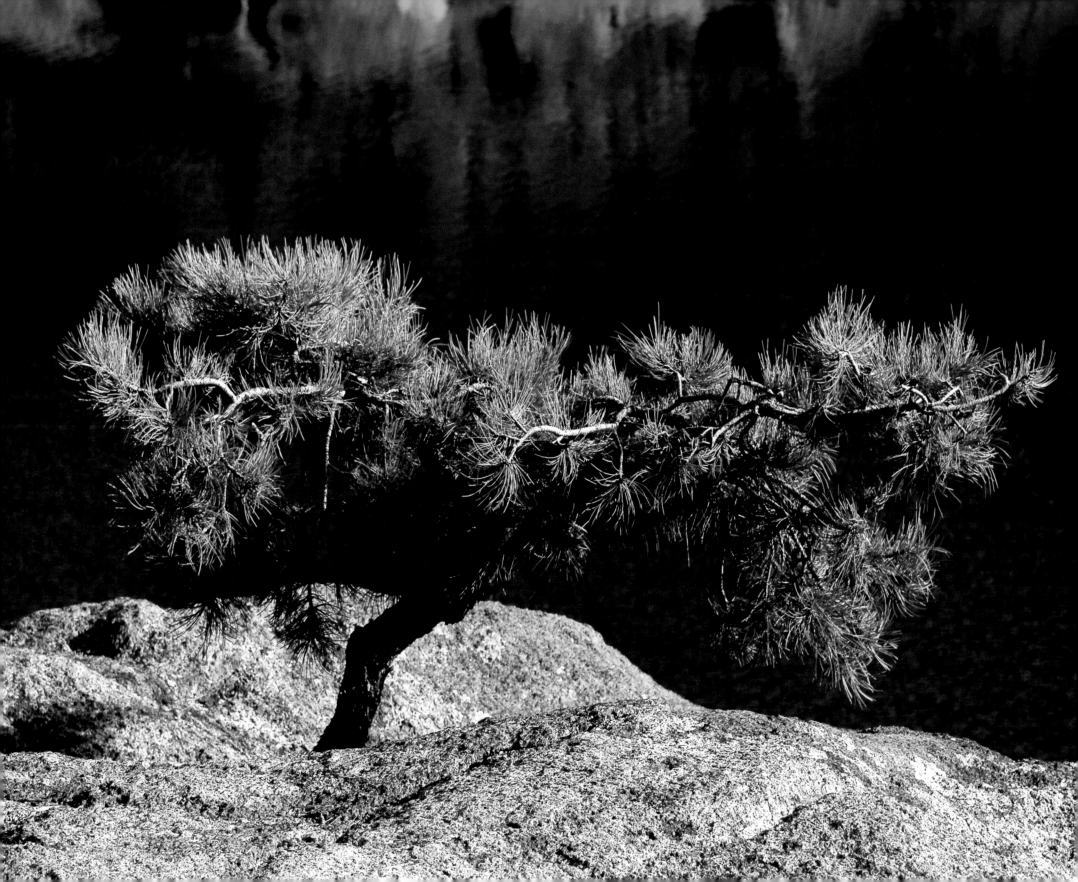

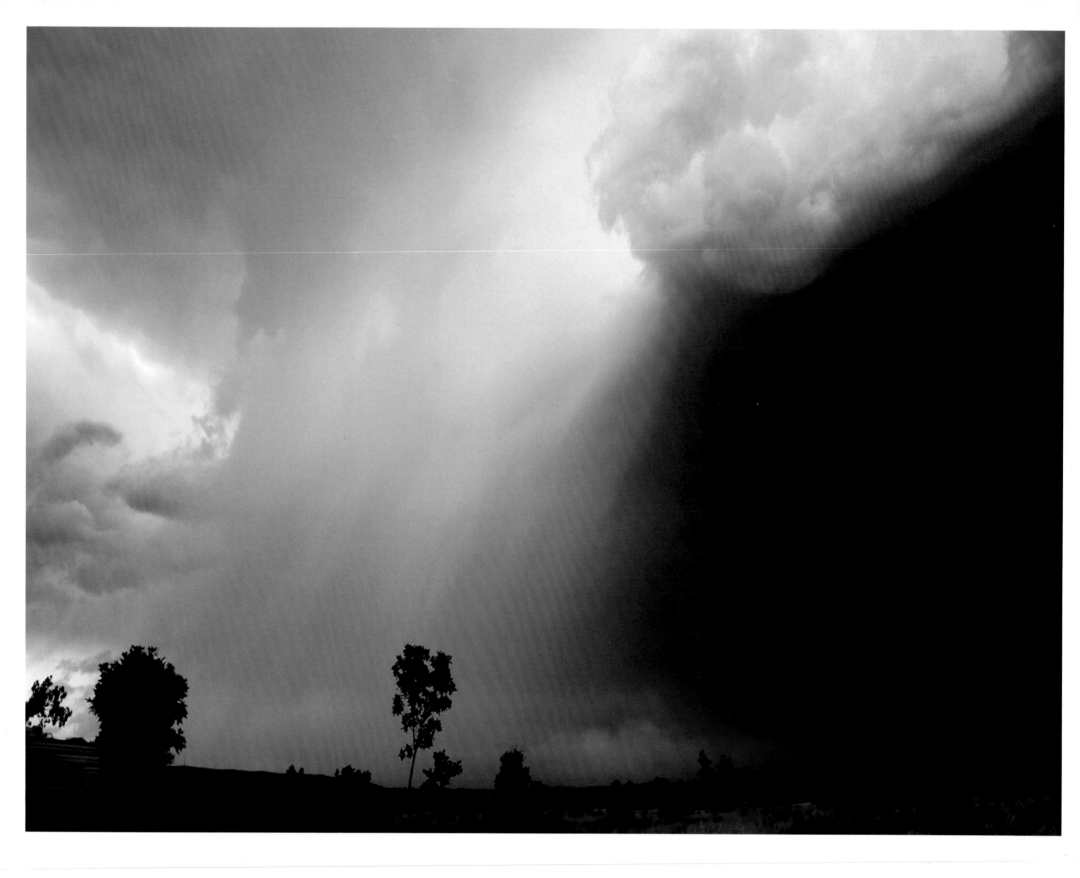

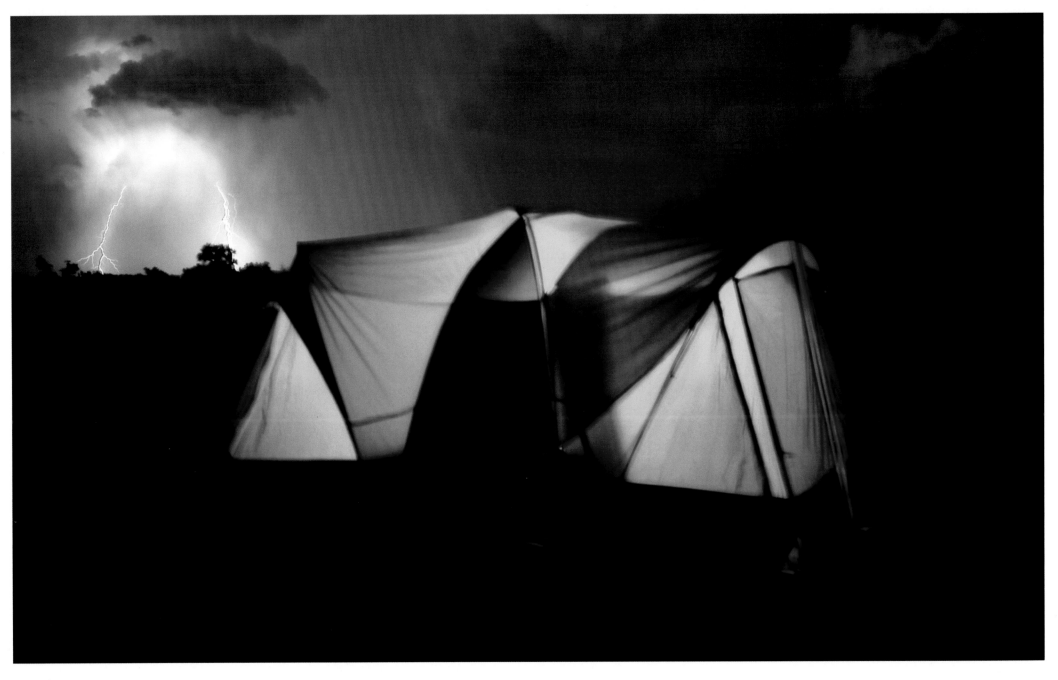

I had my campsite set up at Bear Creek State Park near Morrison, Colorado just southwest of Denver one evening in early June when I noticed a large thunderstorm building to the north and rumbling toward the southeast as it continued to build and grow higher and higher in the sky. I watched as the sky became darker and darker and the lightning was almost nonstop as the storm tracked across the southeast part of the Denver metro area. Luckily, the storm stayed to the east of my campsite, but the photographs I captured were amazing. It wasn't until the next morning when I turned on the radio in my truck that I learned there had been a small tornado and large damaging hail and wind that turned over some cars and damaged a lot of homes and a shopping center in Aurora and Centennial, Colorado that night.

212

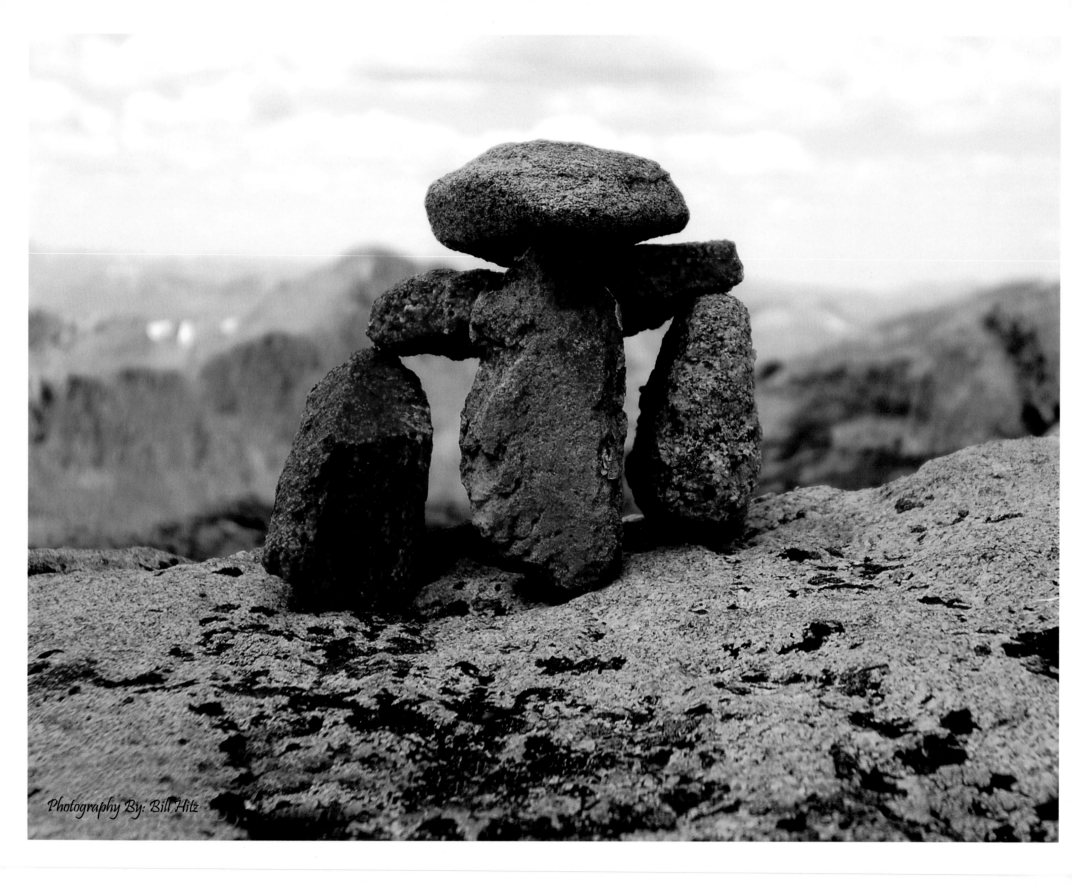

Photography By: Bill Hitz

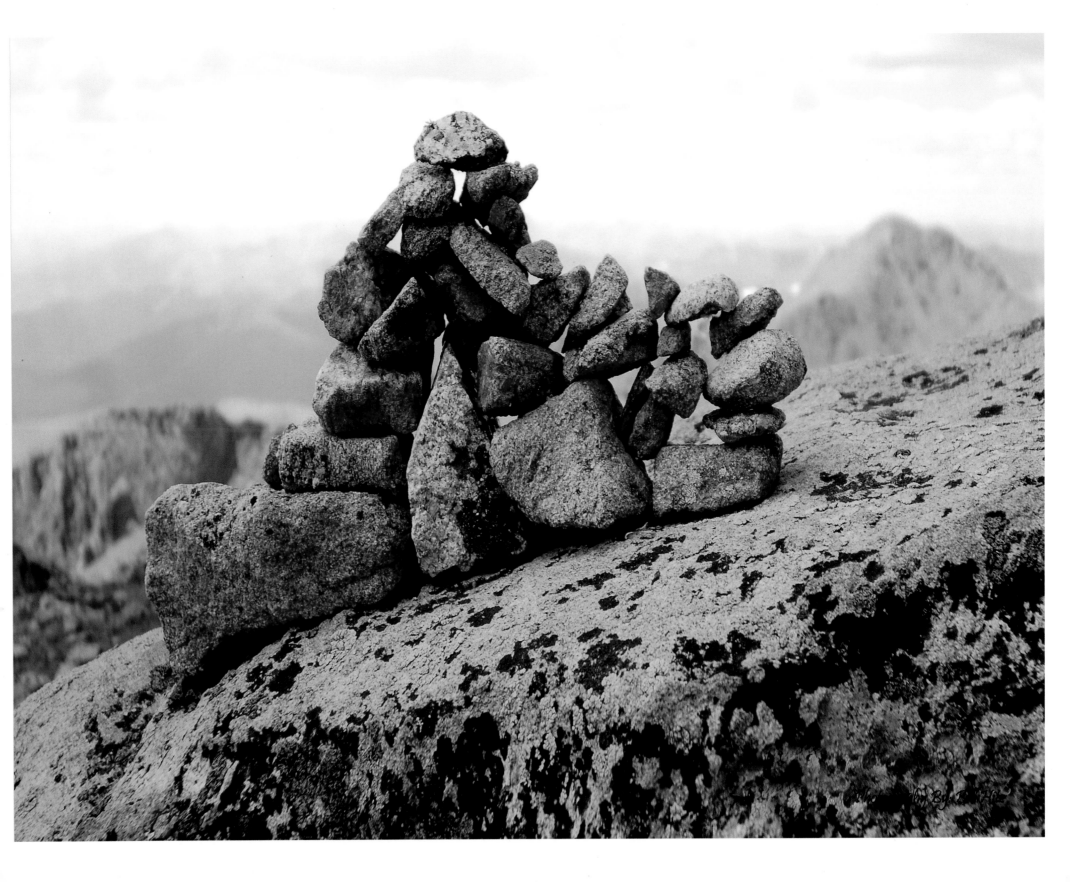

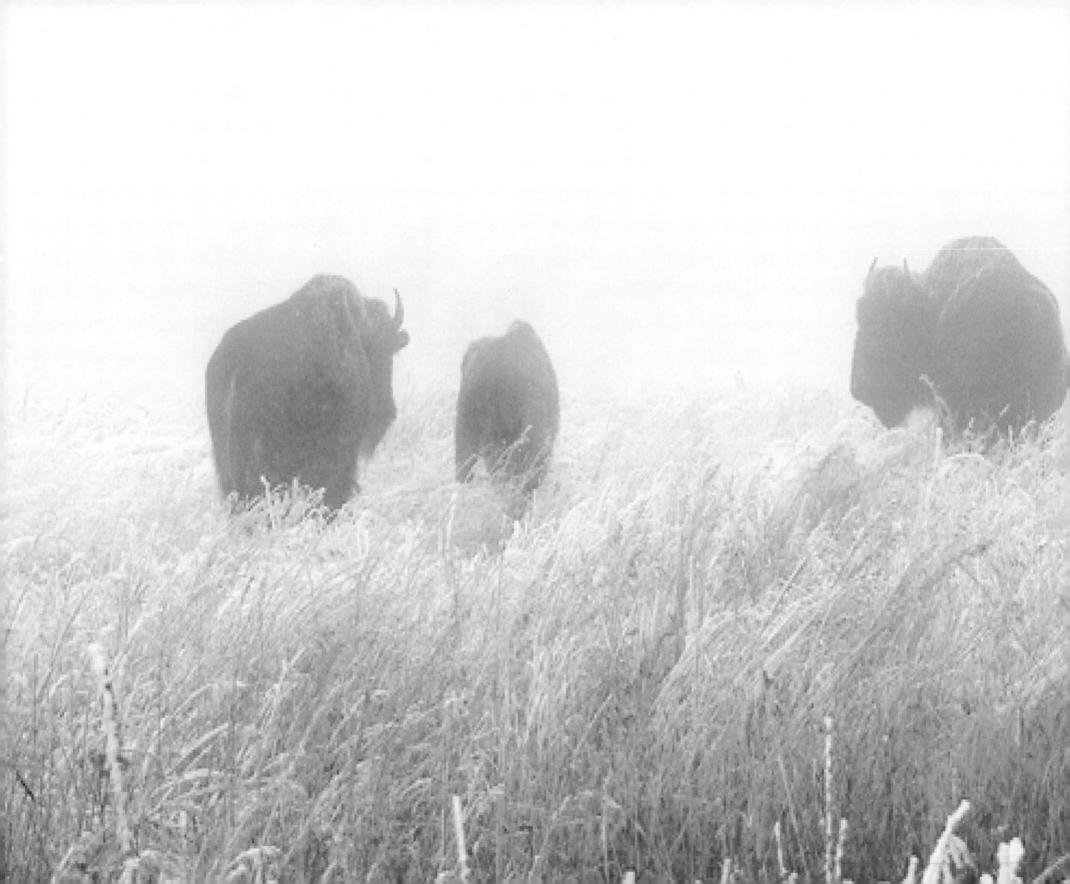

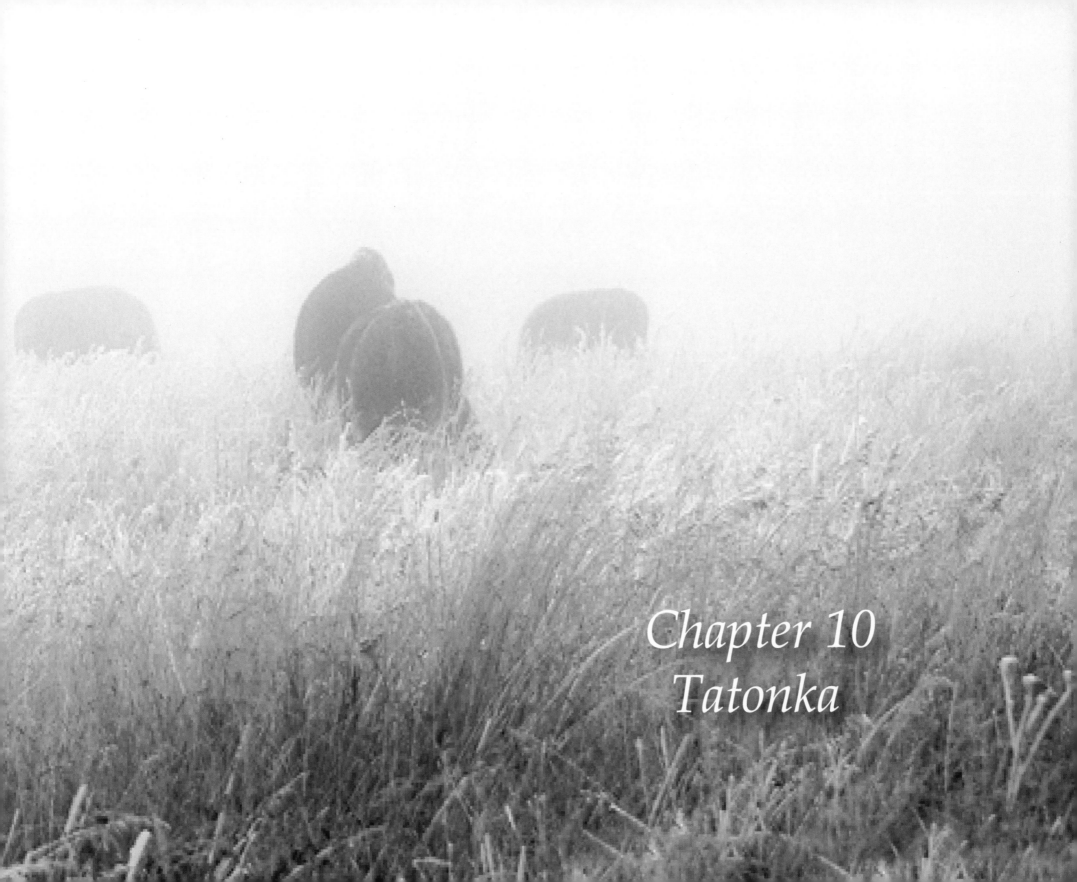

Chapter 10
Tatonka

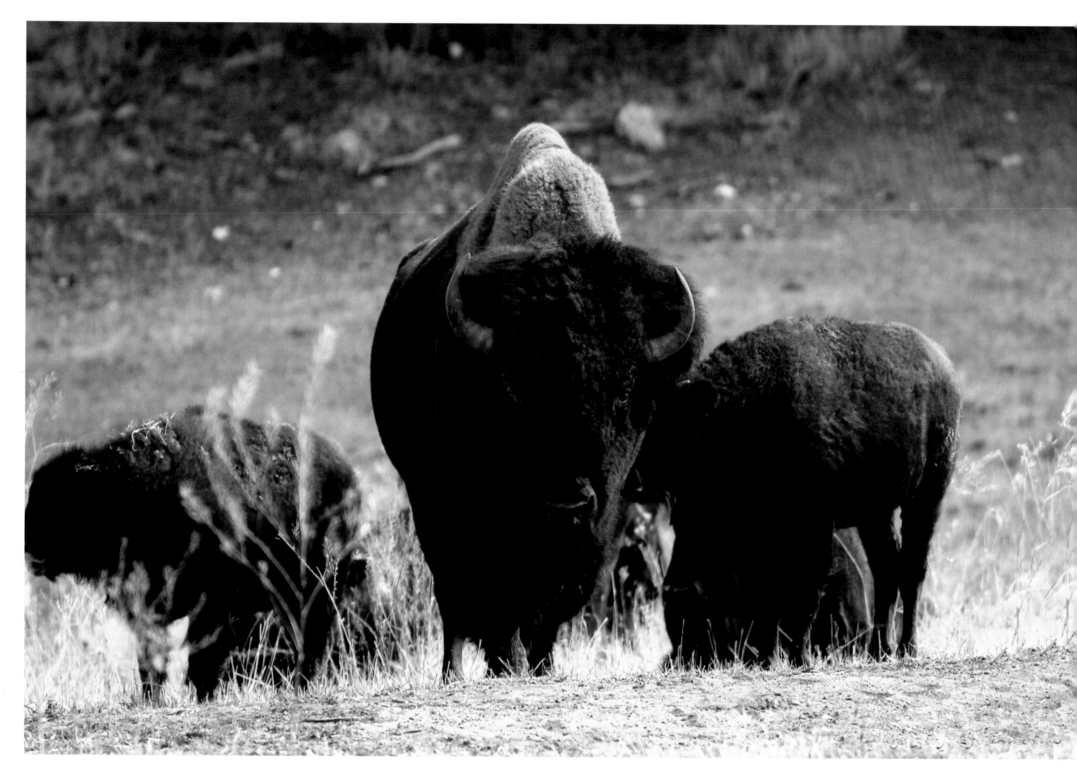

I have learned over many years of traveling the midsection of this beautiful country that I never know when the next person I meet might become a long term close friend or lead me to the next big adventure in my life. This happened once again several years ago when I was making sales calls in the sand hills area of Nebraska. The sand hills of Nebraska is a vast area that covers most of the north-central part of the state and is some of the best natural grasslands for the grazing of cattle and buffalo in the world. While working near Rose, Nebraska, which is a small cattle town surrounded by a sea of prairie grassland I met one of the members of the family that owns the Perfect 10 Bison Ranch. After getting acquainted and learning that I loved to photograph wildlife I was invited to visit the ranch. The ranch house itself was huge and the walls were even made of bales of straw. I learned that all the water on the ranch, even the drinking water came from artesian wells of natural spring water. The buffalo raised on the ranch are all naturally and organically fed, resulting in some of the best certified organic bison meat available. I was taken around the ranch where I was allowed to photograph these proud and regal animals in the most natural of habitats anywhere. These great animals are generally very docile but I learned that you do not want to get between a mother and her calf. Buffalo are very protective of their young. It was interesting to watch how the animals use their massive heads just like a bulldozer to push through deep snow to get to the grass below. I have never seen anything eat as much as an adult bison. They were always eating. I had to be patient to just catch one of the beasts with their head up long enough to get a good photo of their snow-covered faces as they plowed through the deep snow. I certainly learned to have a greater respect for these huge animals of the plains and how they have adapted to living in a harsh and unforgiving environment like the Great Plains of the United States. Now I know why the Native Americans had such a reverence for these special animals, who for them could mean the difference between life and death during a long hard winter on the snowy wind-blown plains.

218

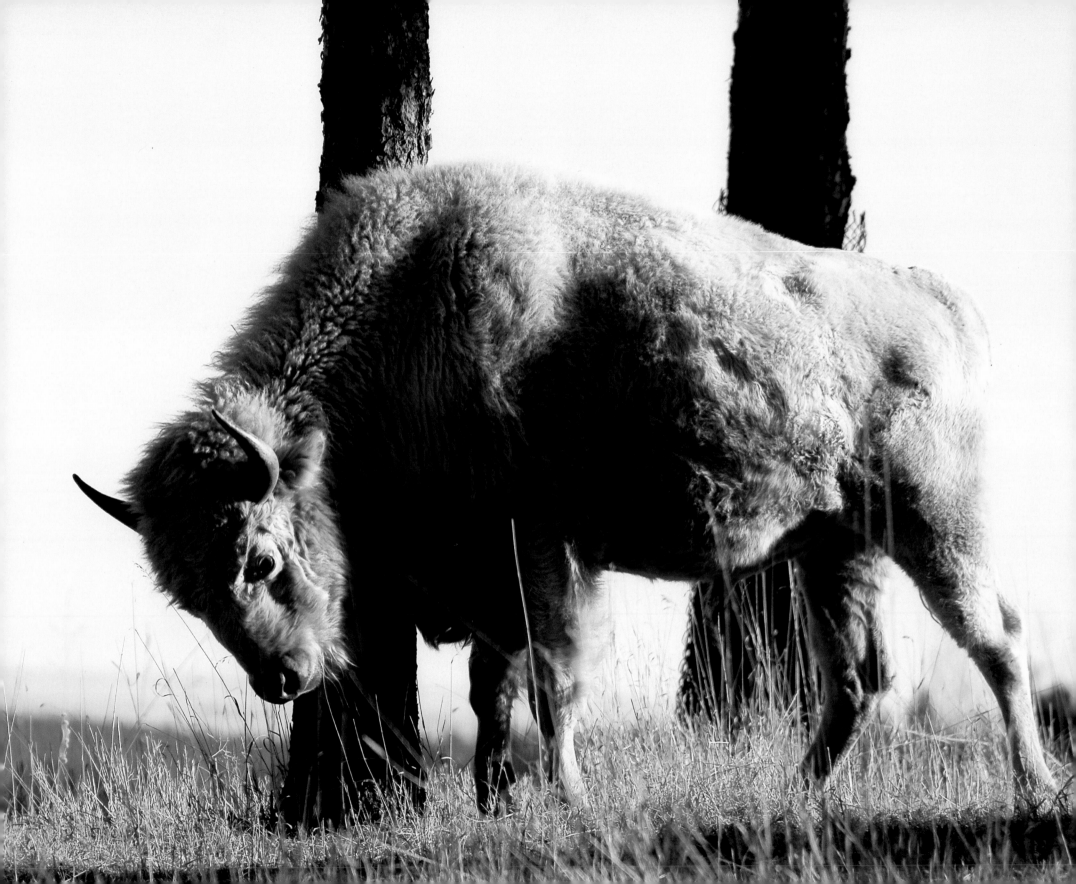

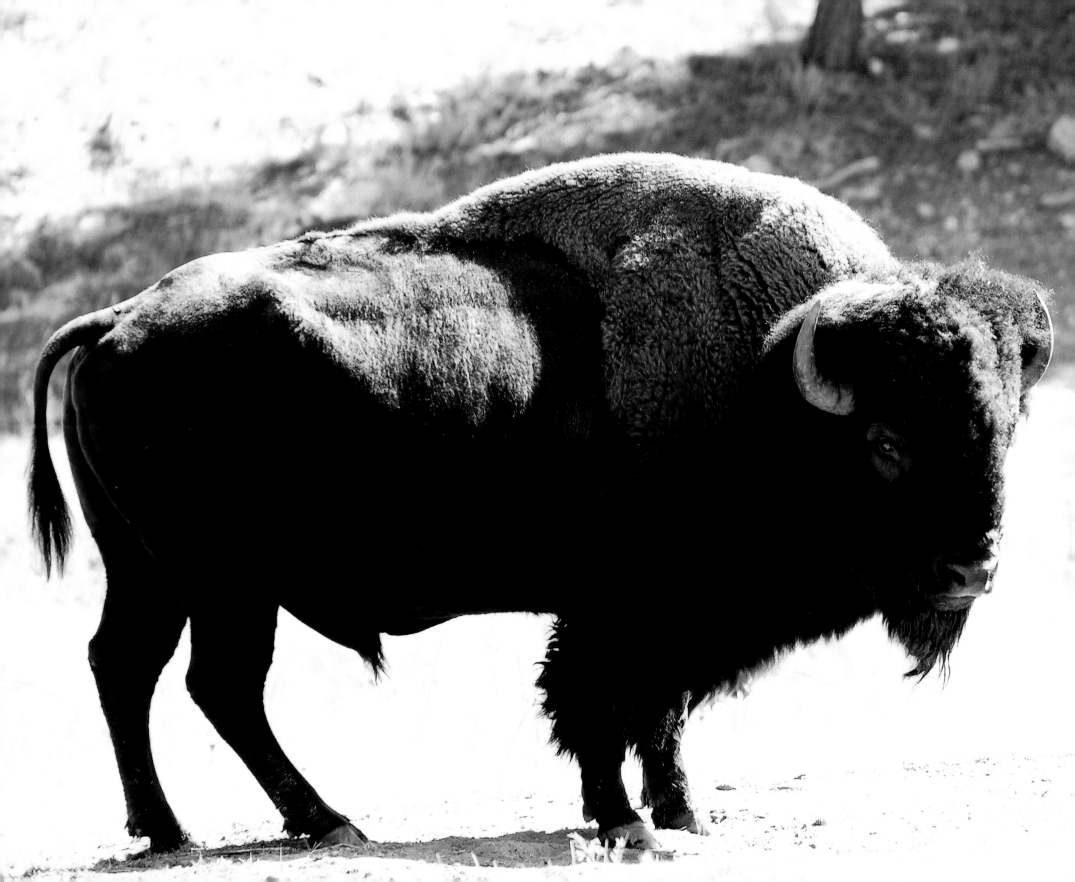

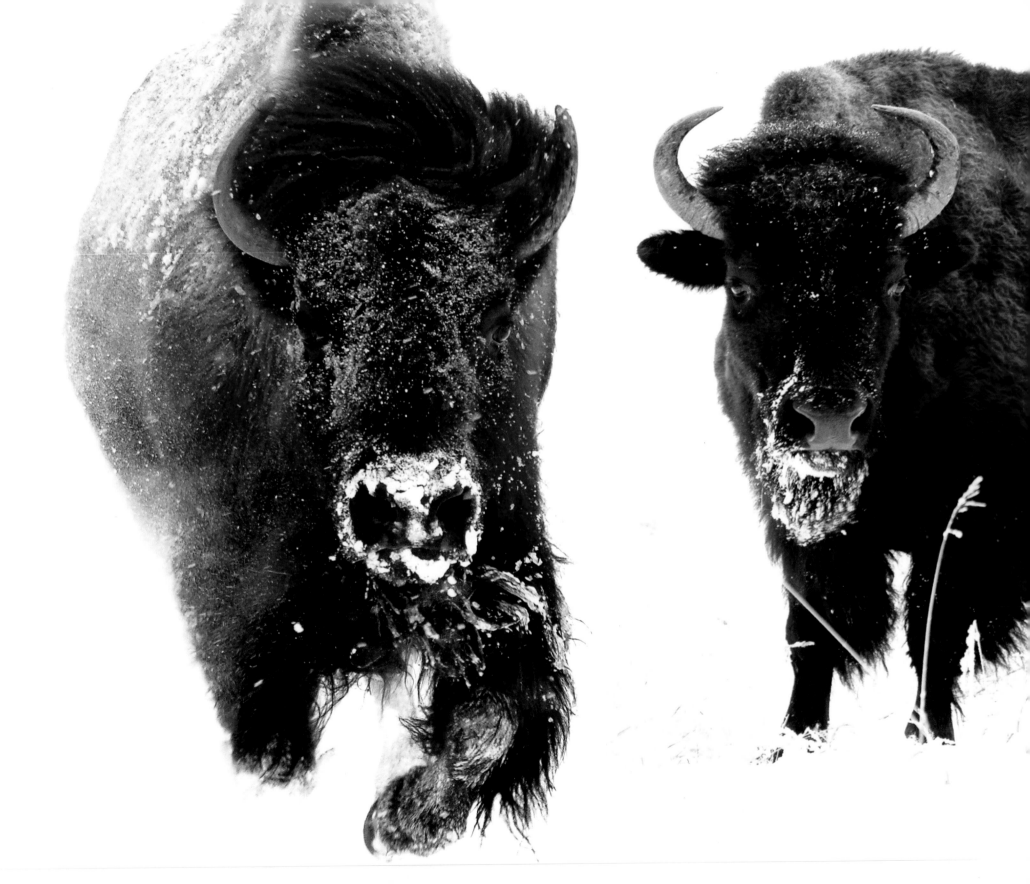

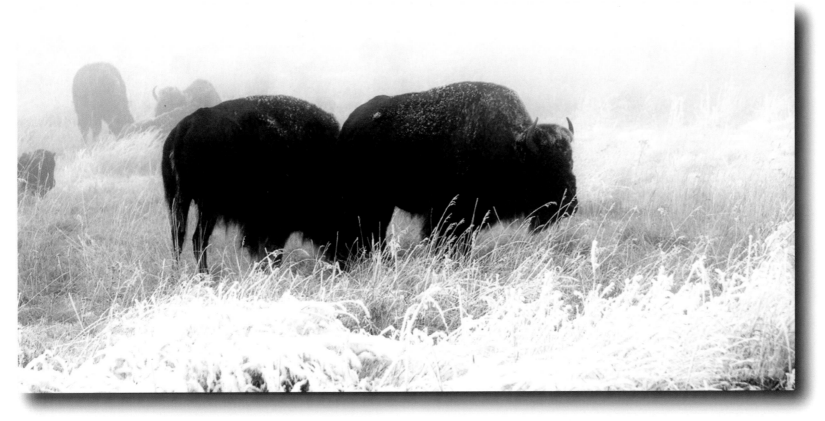

Bill Hitz ©
2010

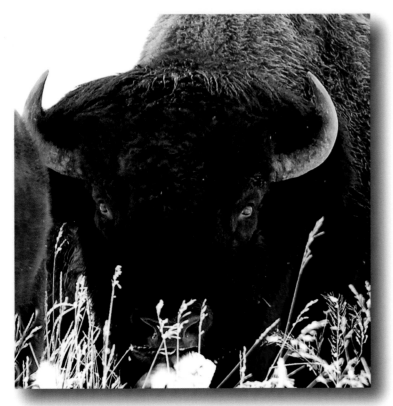

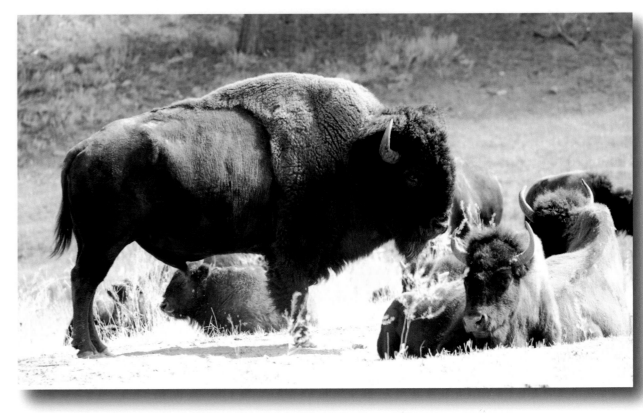

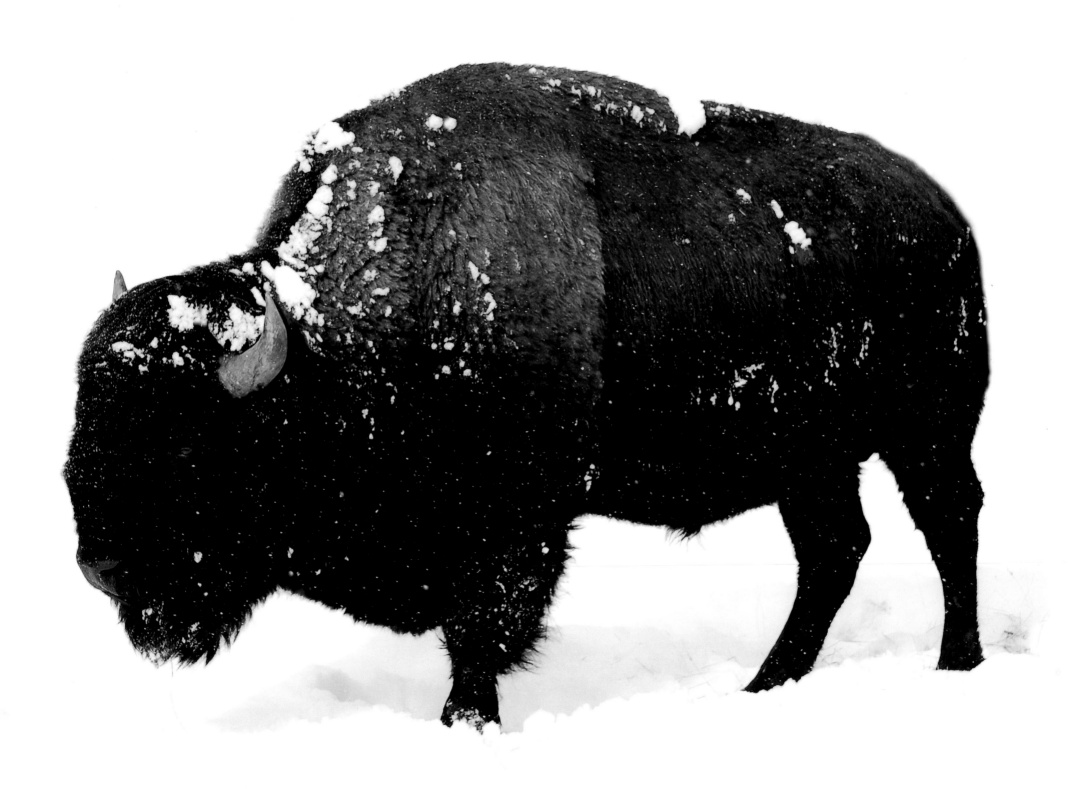

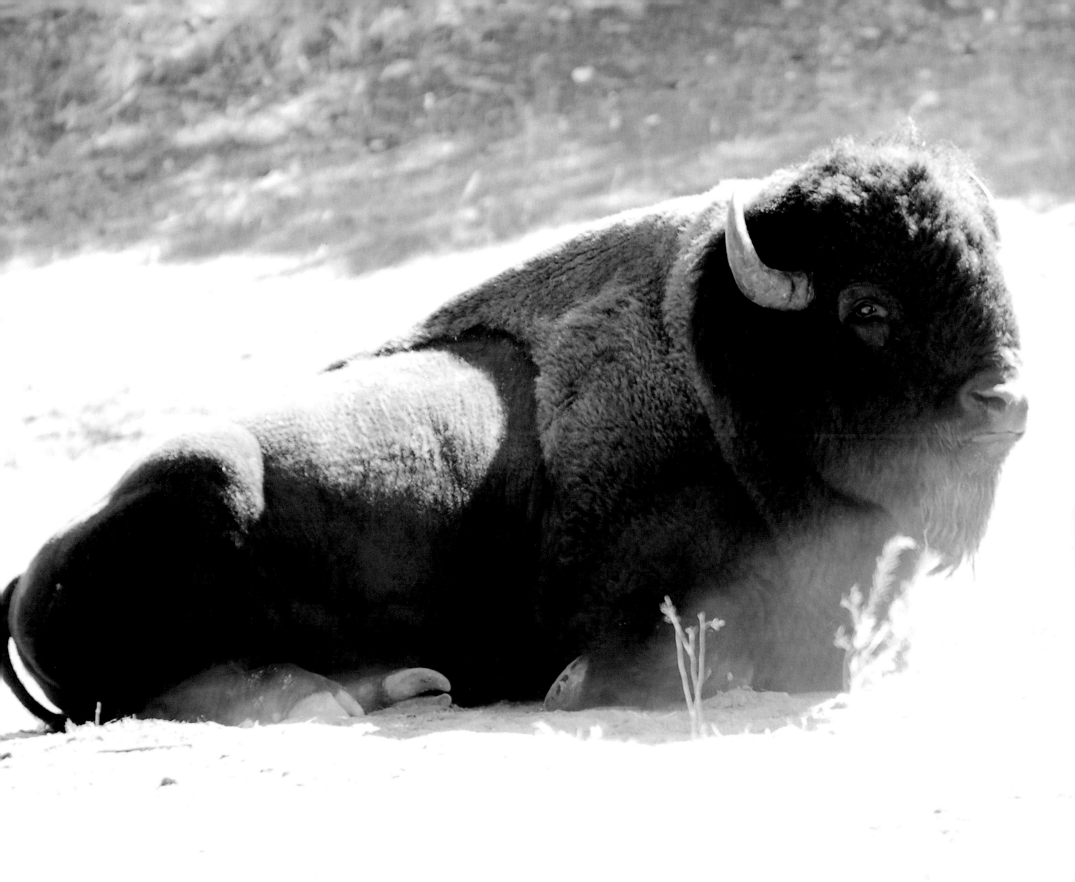

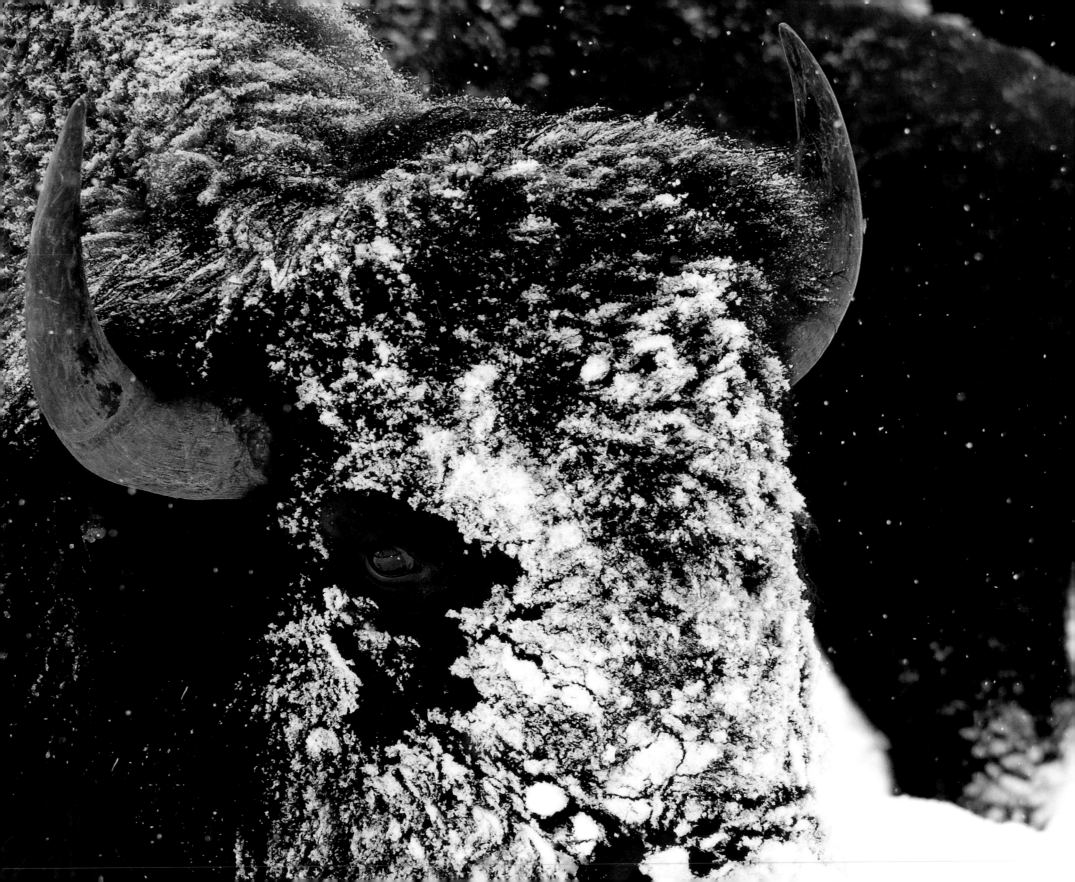

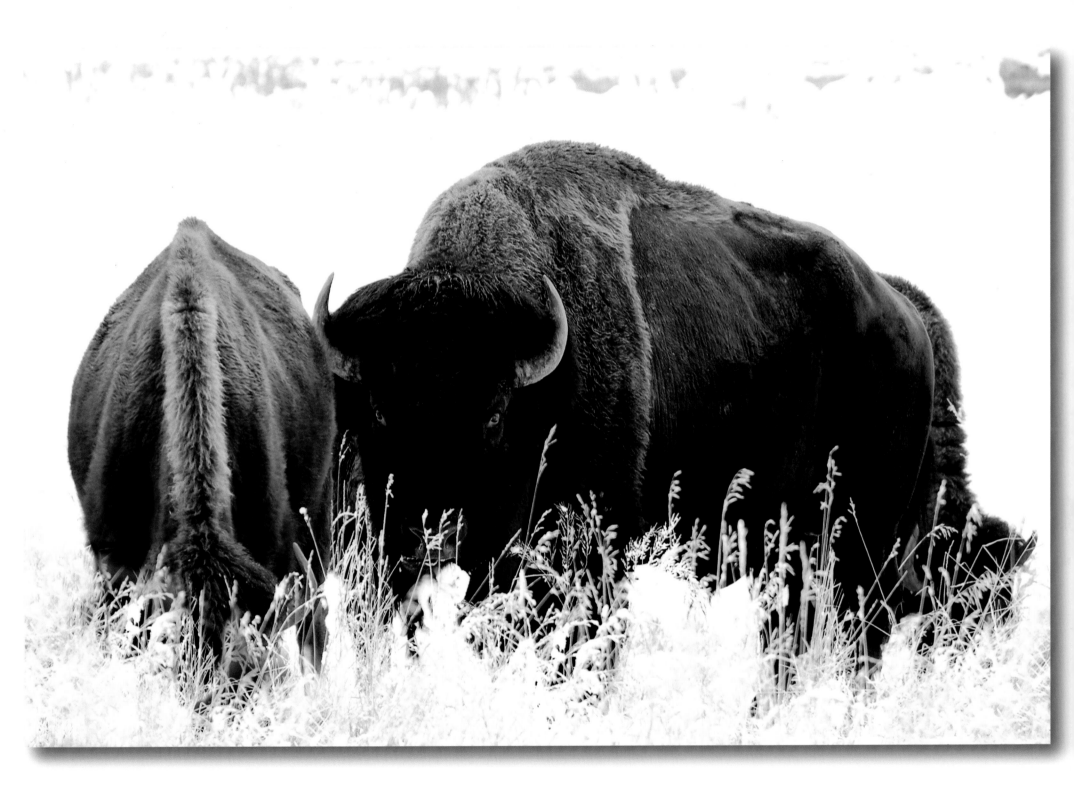

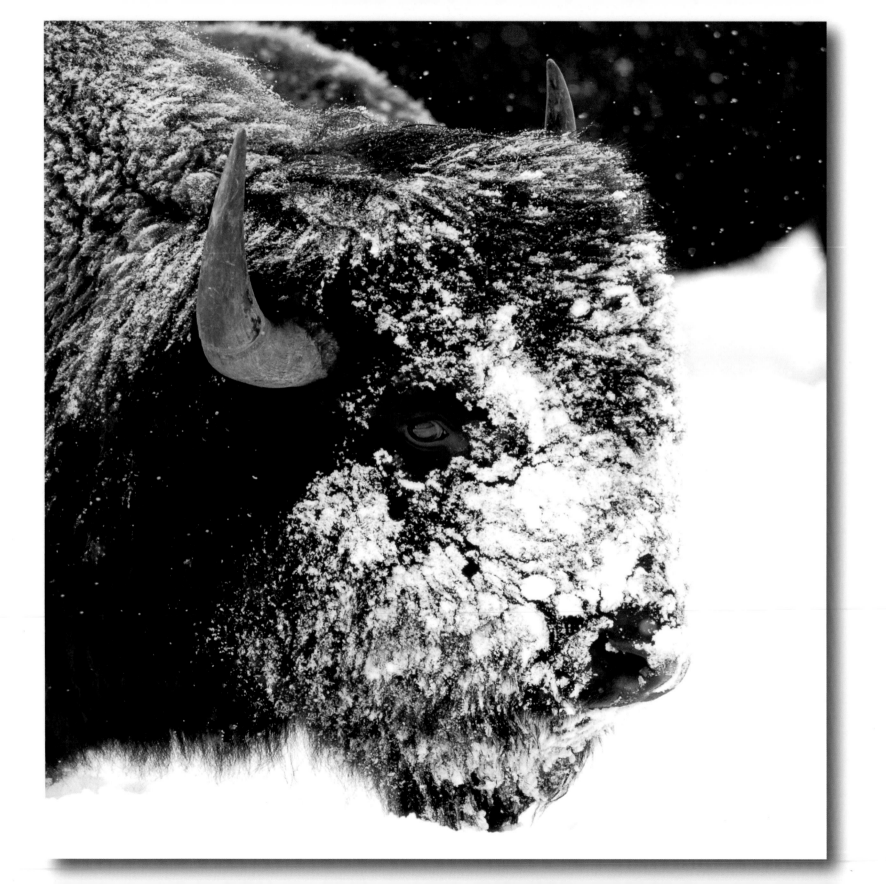

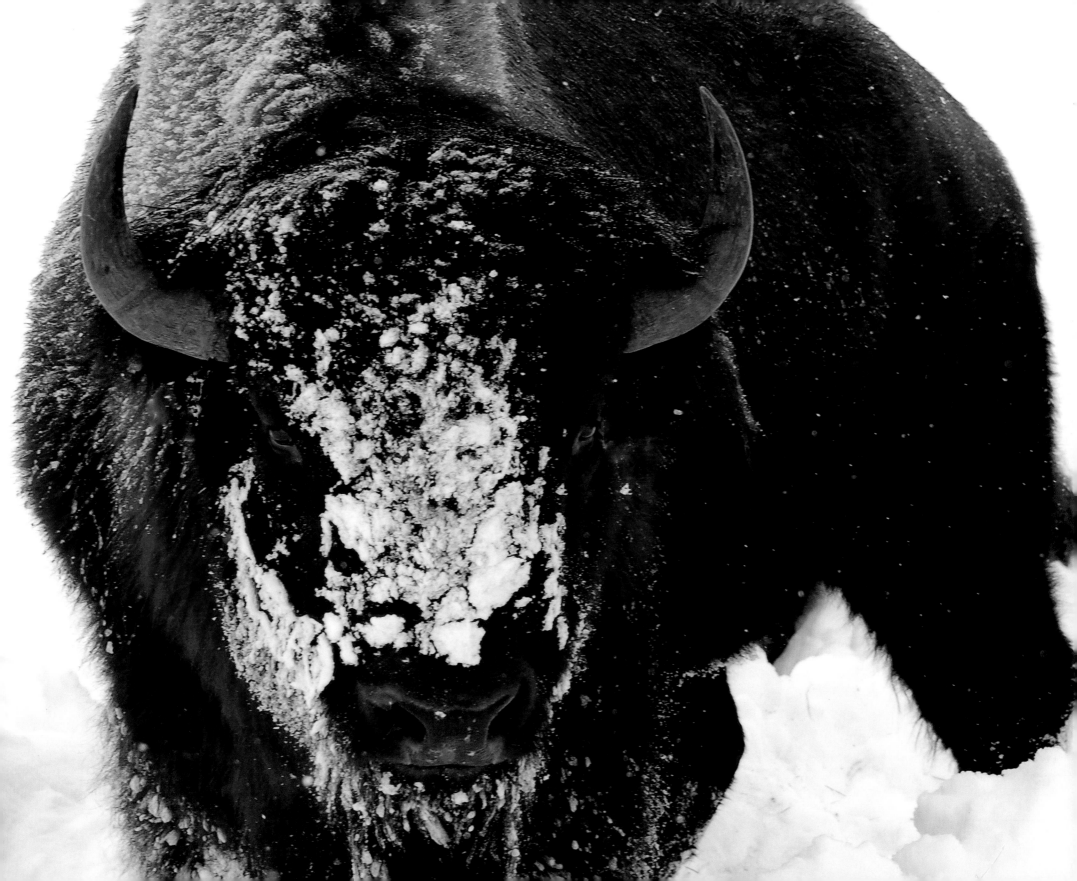

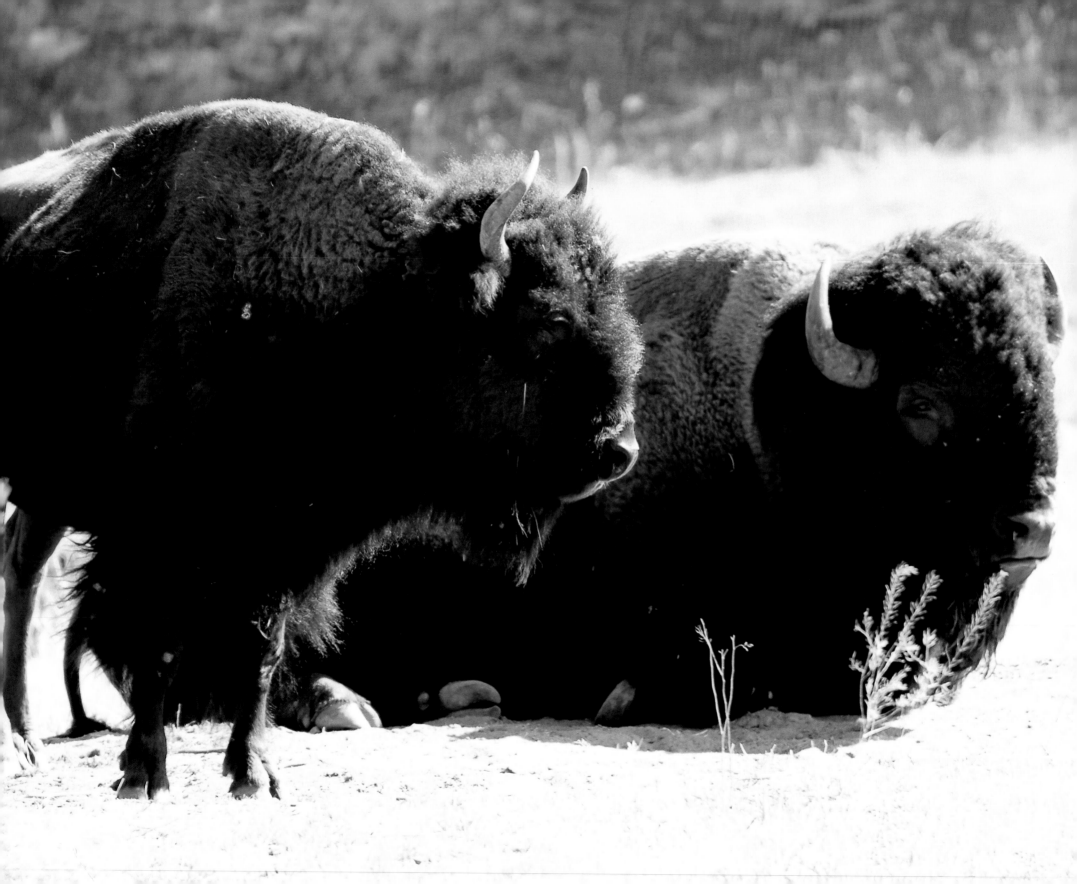

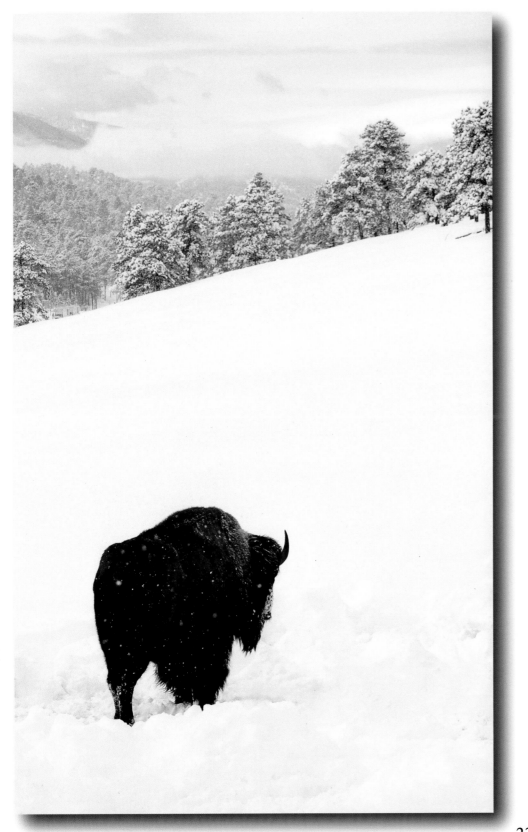
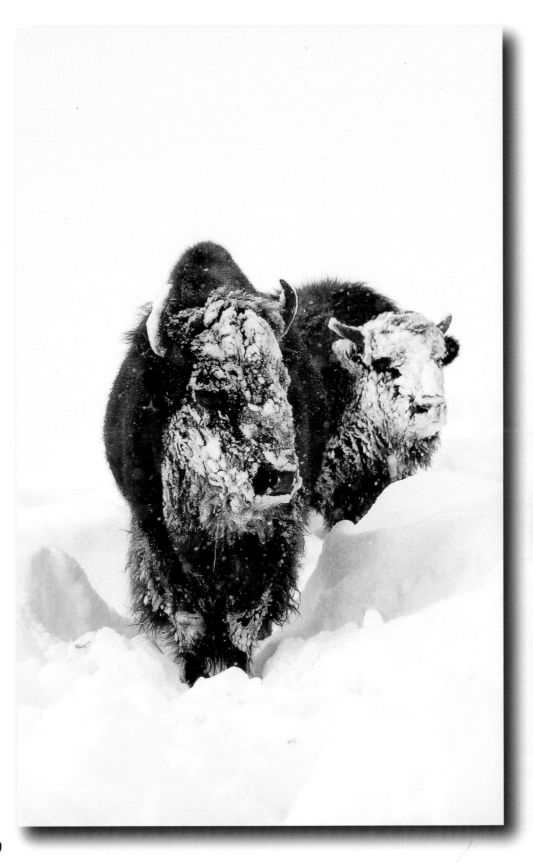

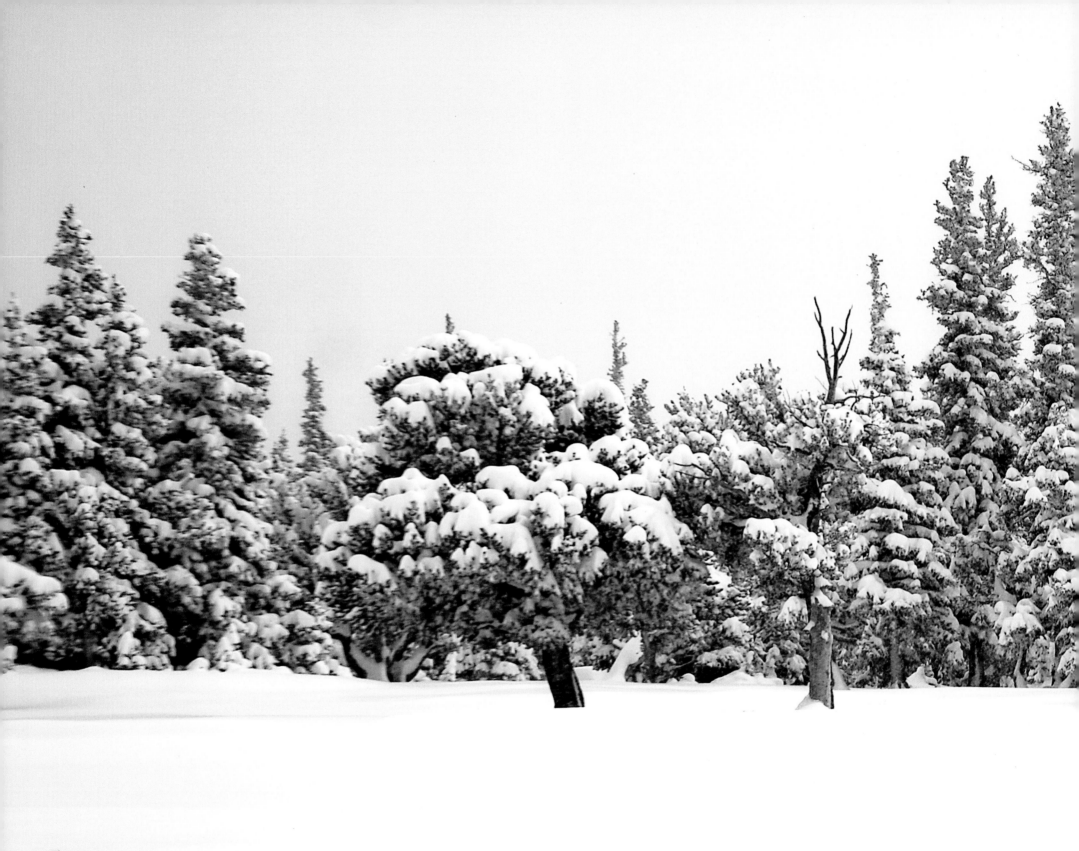

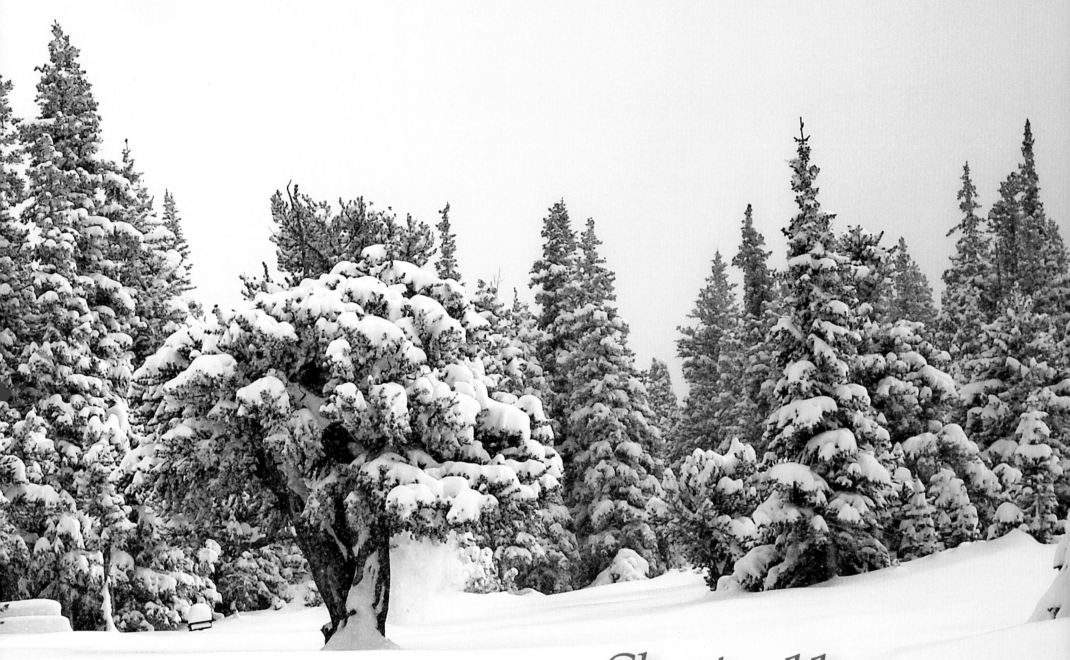

Chapter 11
Snowy Mountains

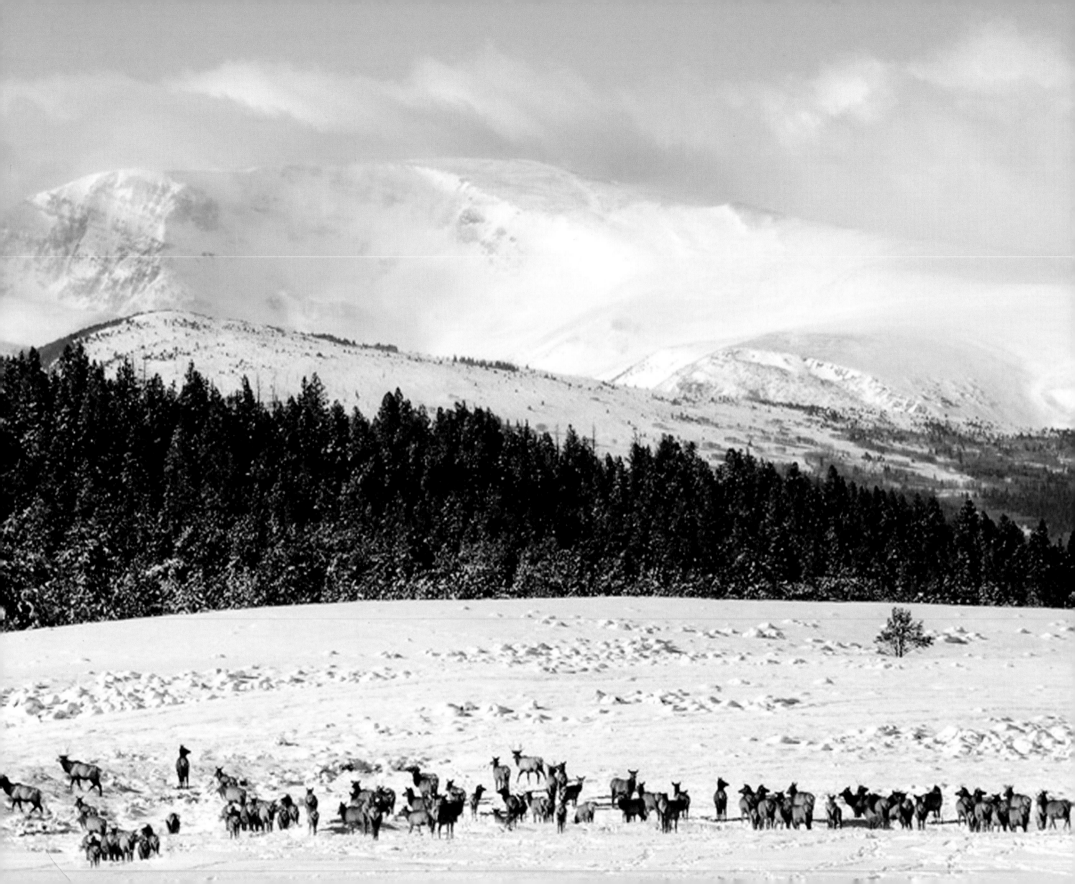

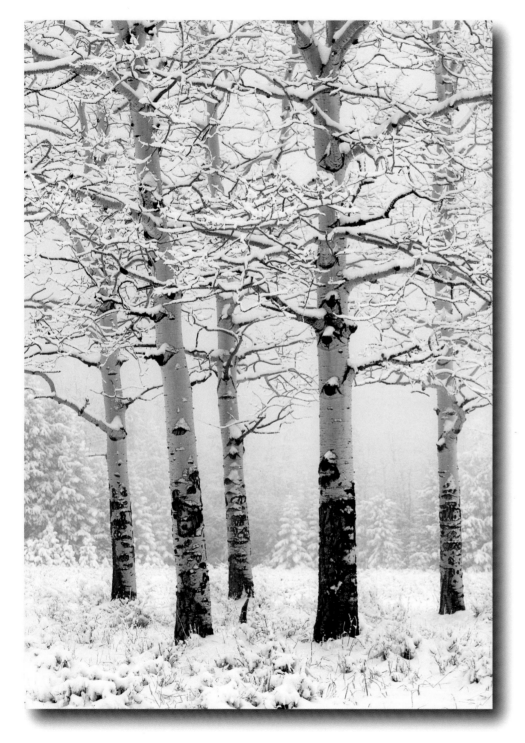

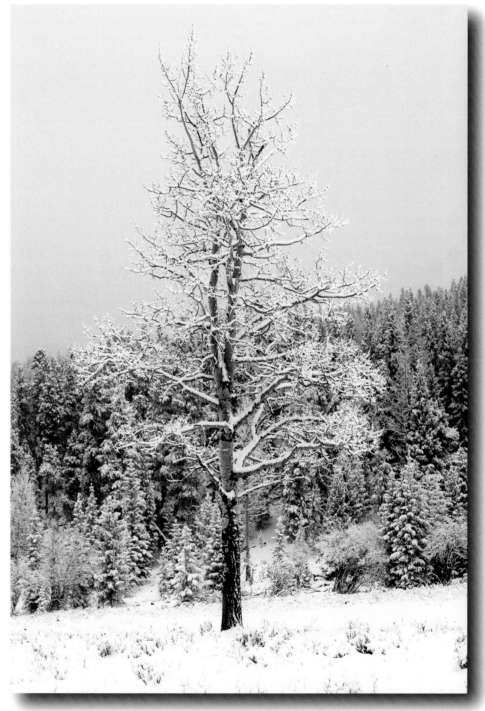

234

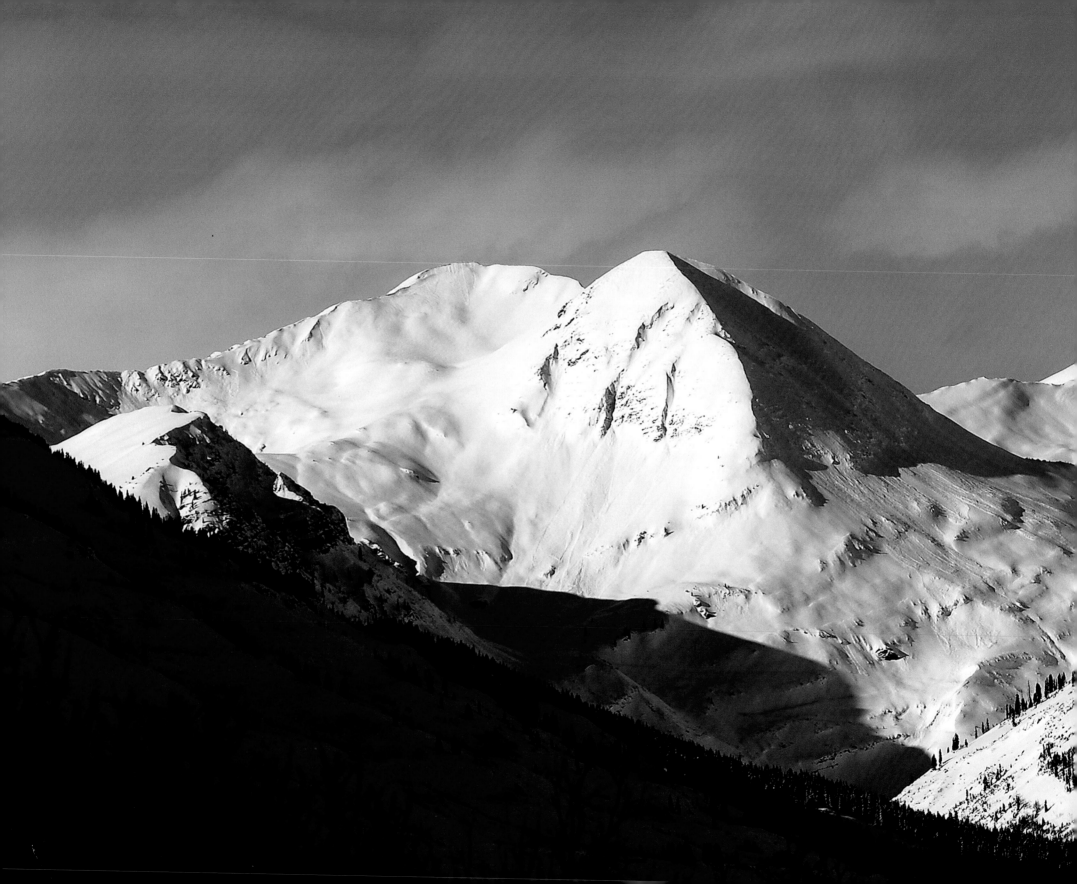

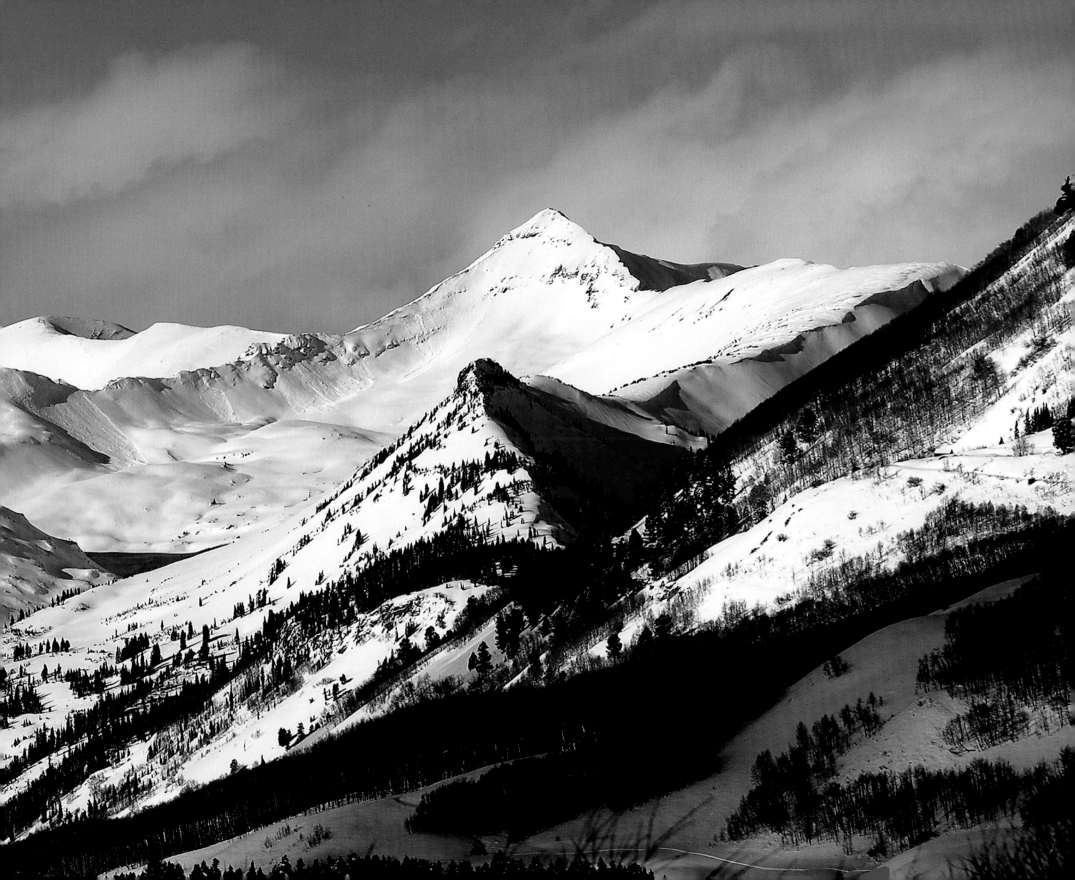

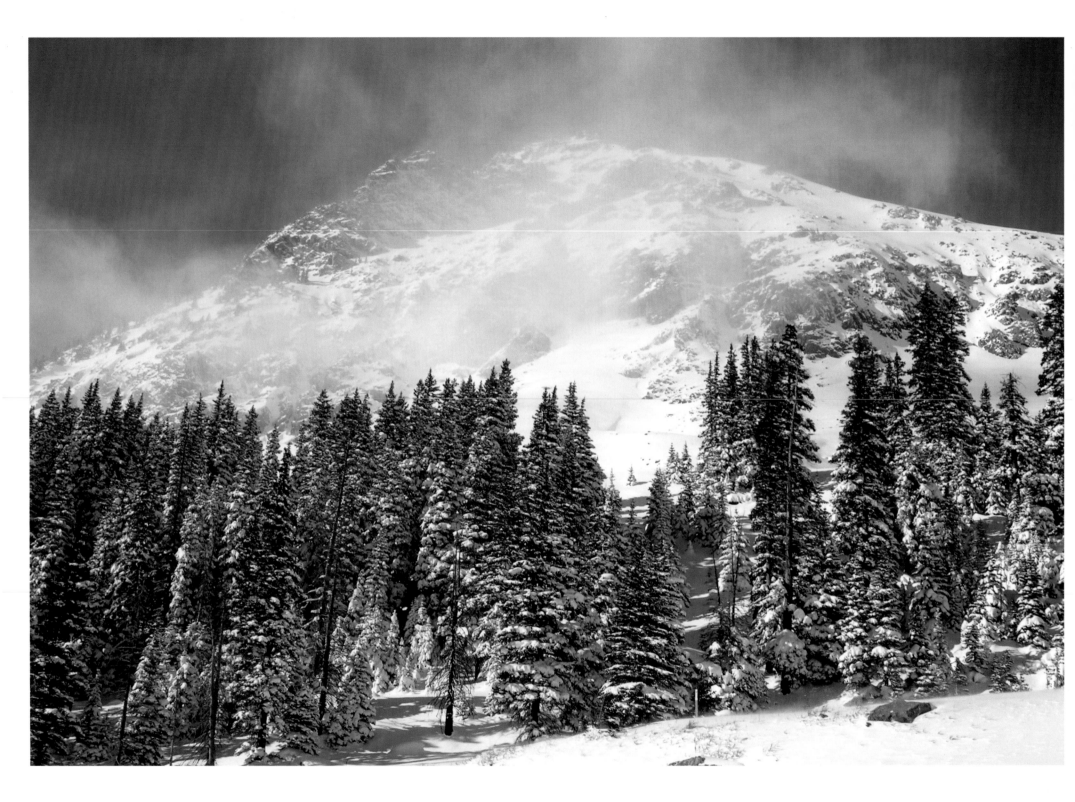

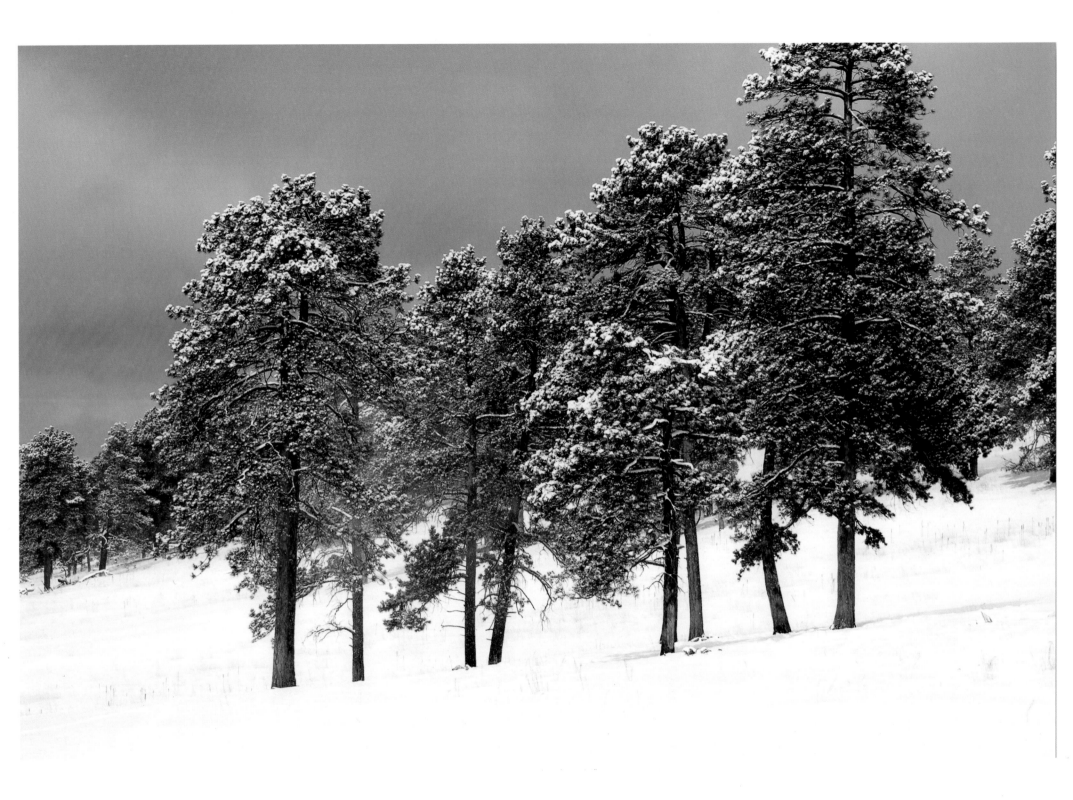

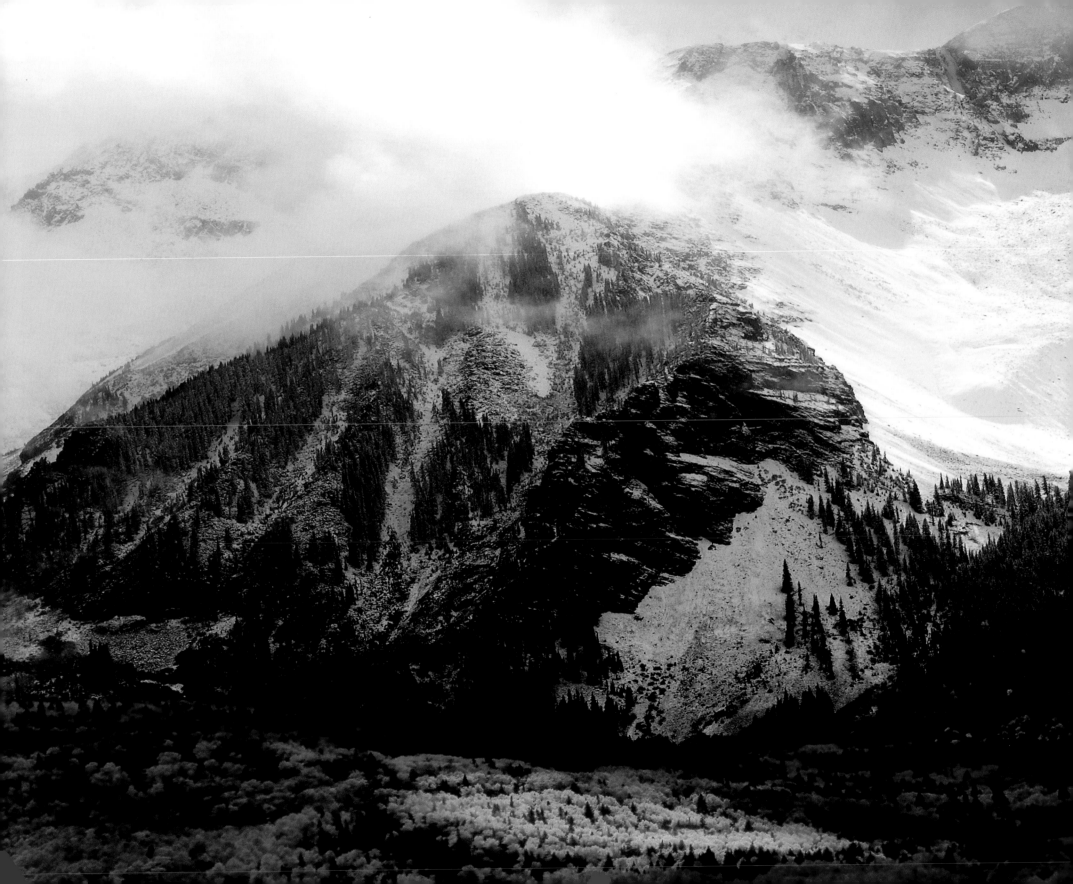

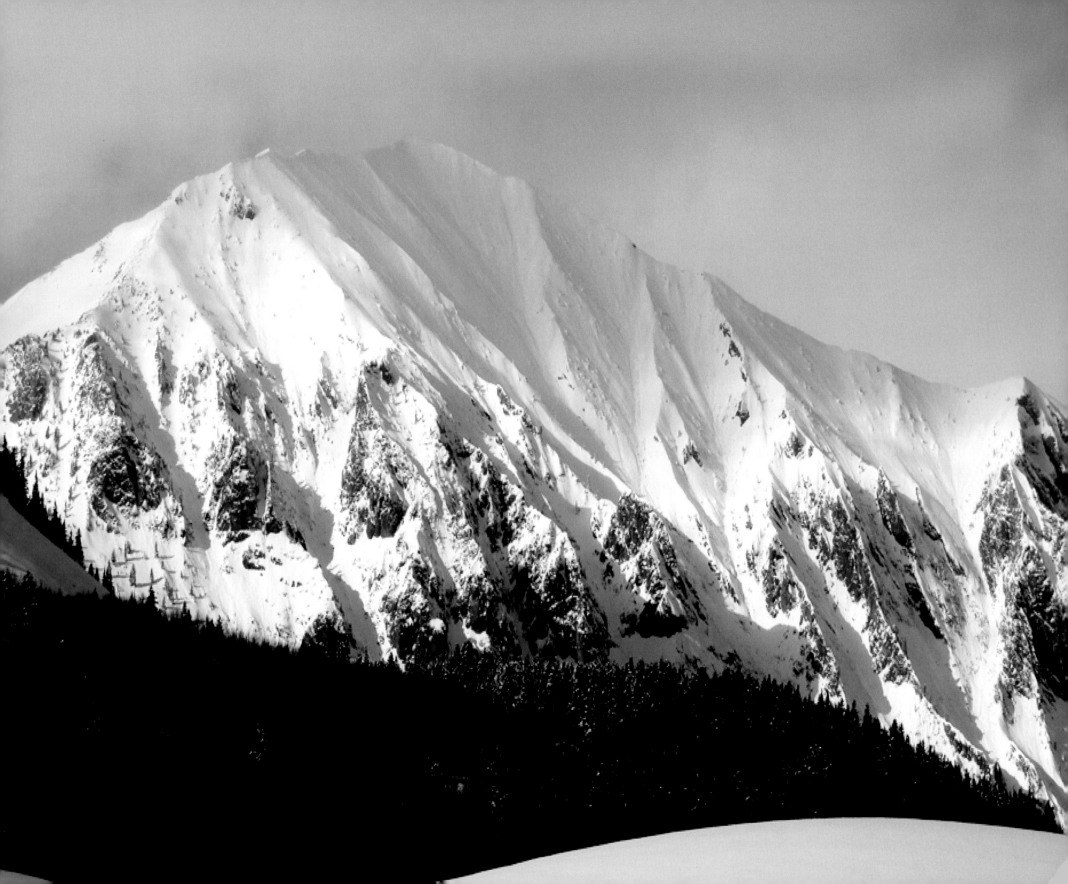

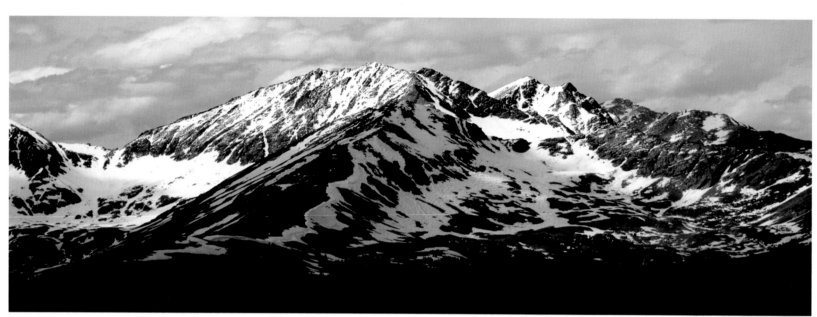

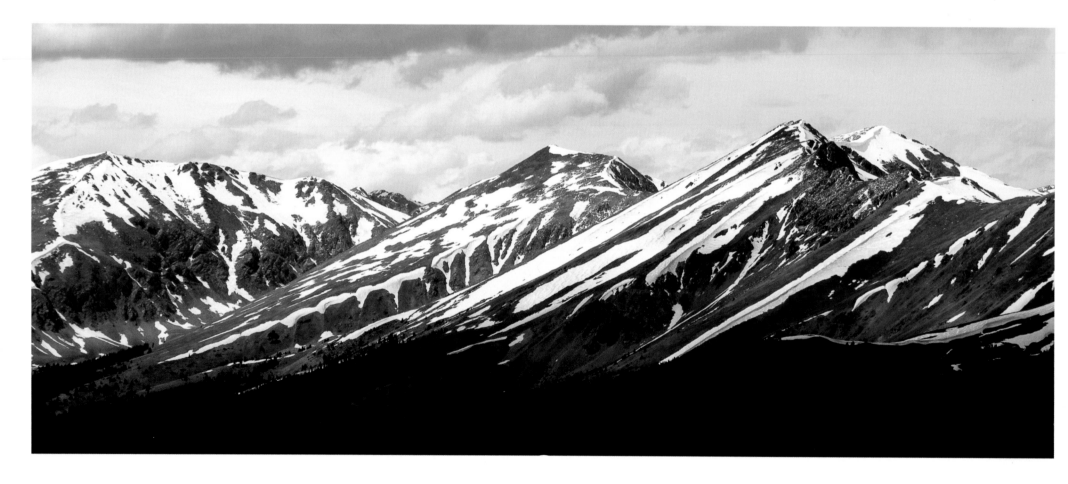

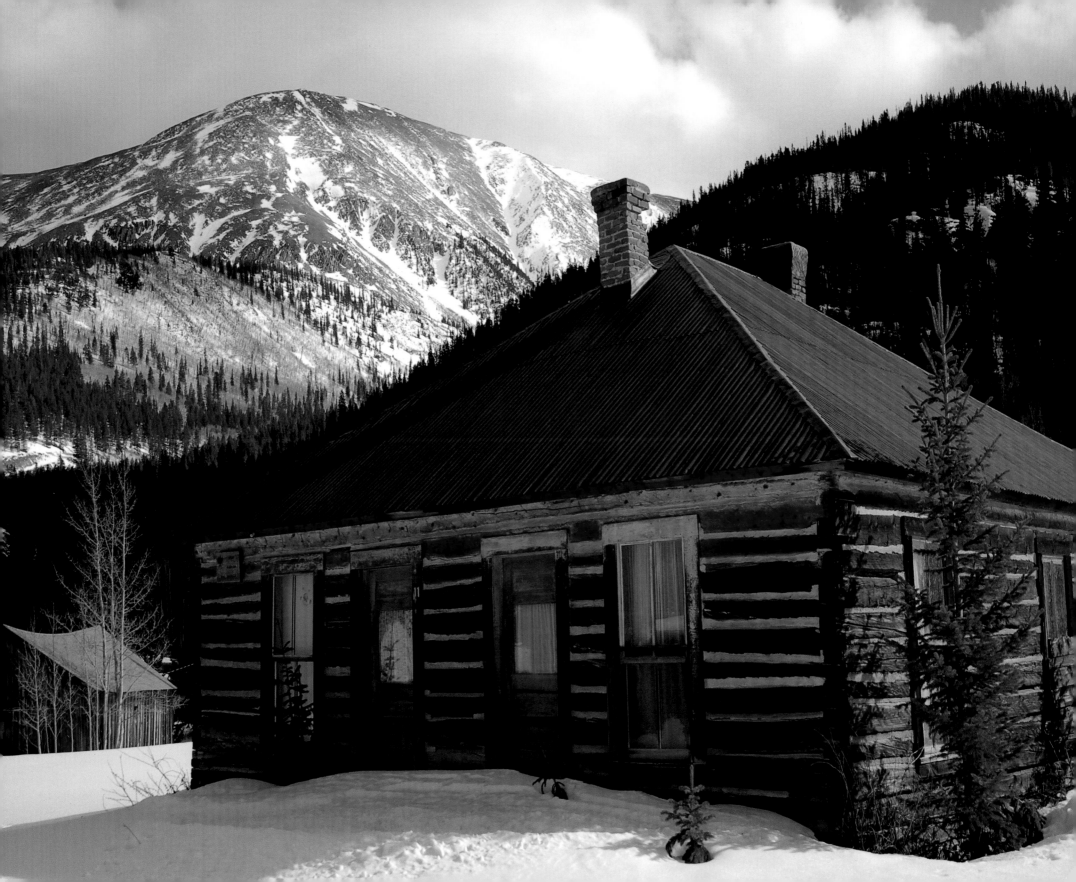

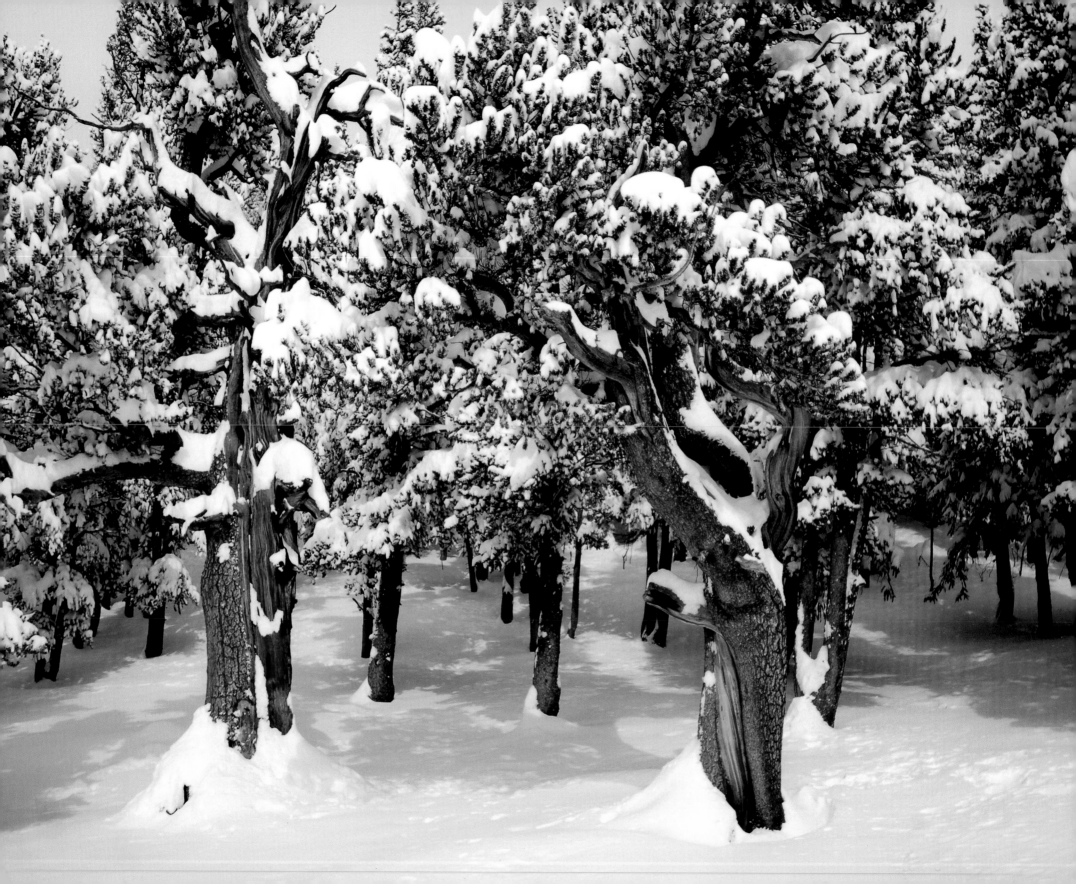

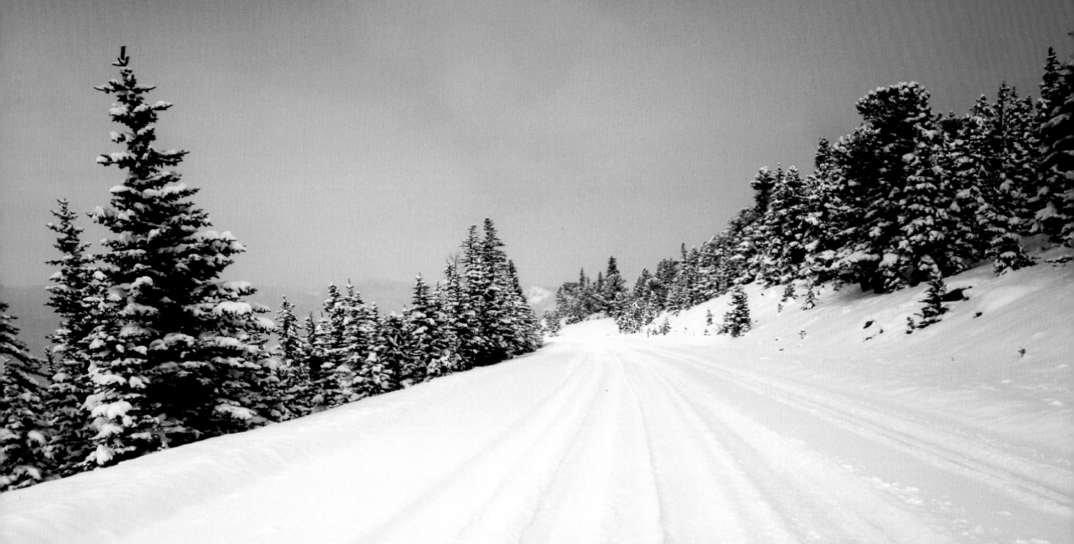

A deep heavy snow fell in Denver overnight one December. The ground, trees and buildings were buried in a heavy white blanket. The beauty was everywhere. The whole world had been transformed while I slept. If it's this pretty here, just think how beautiful it must be in the mountains. I knew I was crazy, but I decided to drive up toward Mt. Evans to try to capture some photographs of the freshly fallen snow on the trees and rocks before a bunch of people get up there and track it all up. I was so early when I got up there; the roads hadn't even been plowed yet. I didn't get stuck or stranded or anything. I had a couple of close calls, but I did get some pretty awesome photos.

Chapter 12
Fire in the Skies

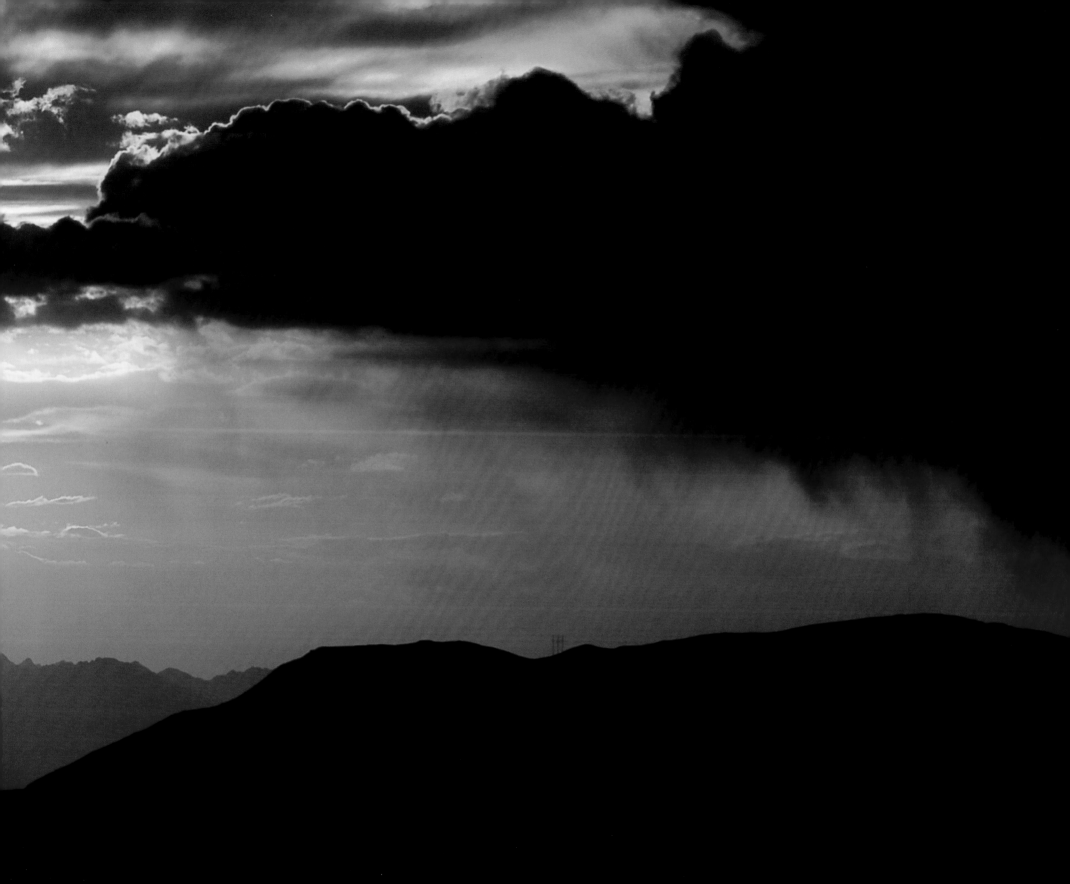

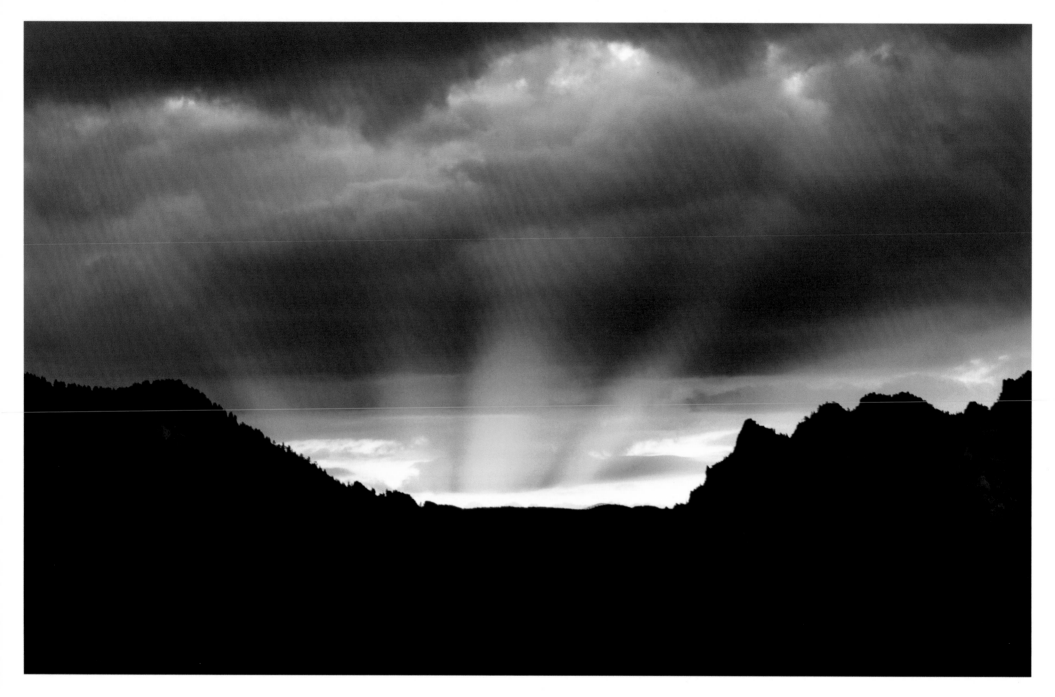

I was approaching Boulder, Colorado one evening from the south on Highway 93 when I noticed the sun setting behind the Flatirons, a range of nearly vertical cliffs that resemble the old flatirons that pioneer women used to iron their clothes with before the electric iron was invented. I pulled off the highway and got my camera ready as I anticipated the coming display as the sun slowly sank below the clouds when I was rewarded with this explosion of color.

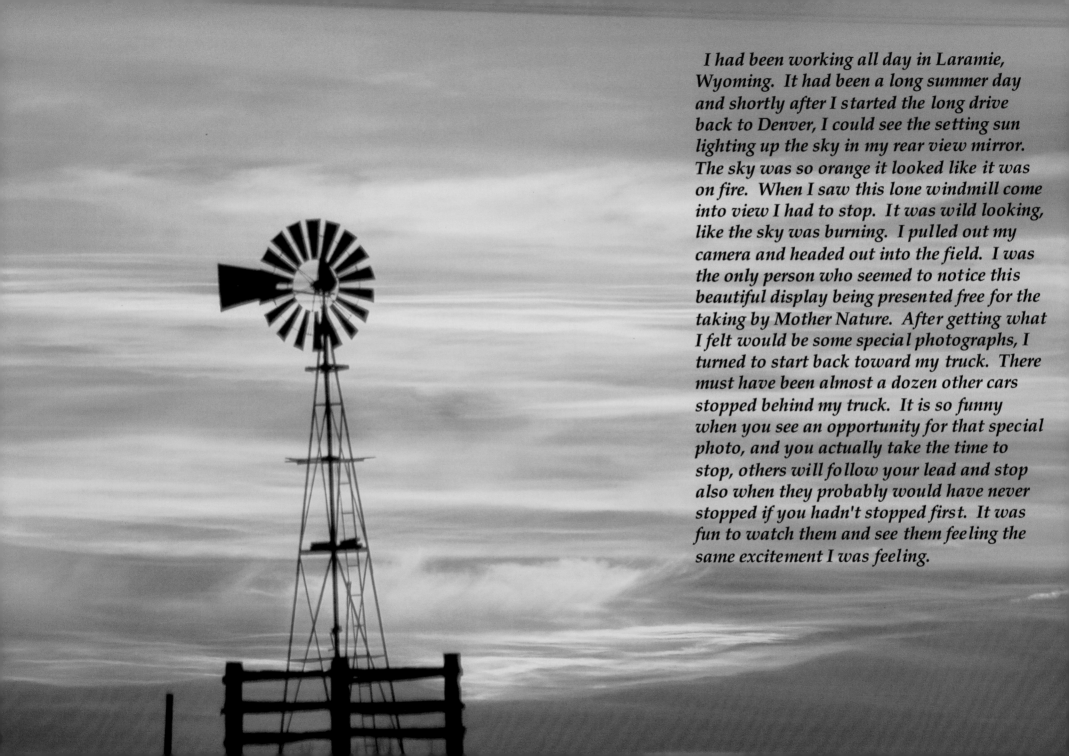

I had been working all day in Laramie, Wyoming. It had been a long summer day and shortly after I started the long drive back to Denver, I could see the setting sun lighting up the sky in my rear view mirror. The sky was so orange it looked like it was on fire. When I saw this lone windmill come into view I had to stop. It was wild looking, like the sky was burning. I pulled out my camera and headed out into the field. I was the only person who seemed to notice this beautiful display being presented free for the taking by Mother Nature. After getting what I felt would be some special photographs, I turned to start back toward my truck. There must have been almost a dozen other cars stopped behind my truck. It is so funny when you see an opportunity for that special photo, and you actually take the time to stop, others will follow your lead and stop also when they probably would have never stopped if you hadn't stopped first. It was fun to watch them and see them feeling the same excitement I was feeling.

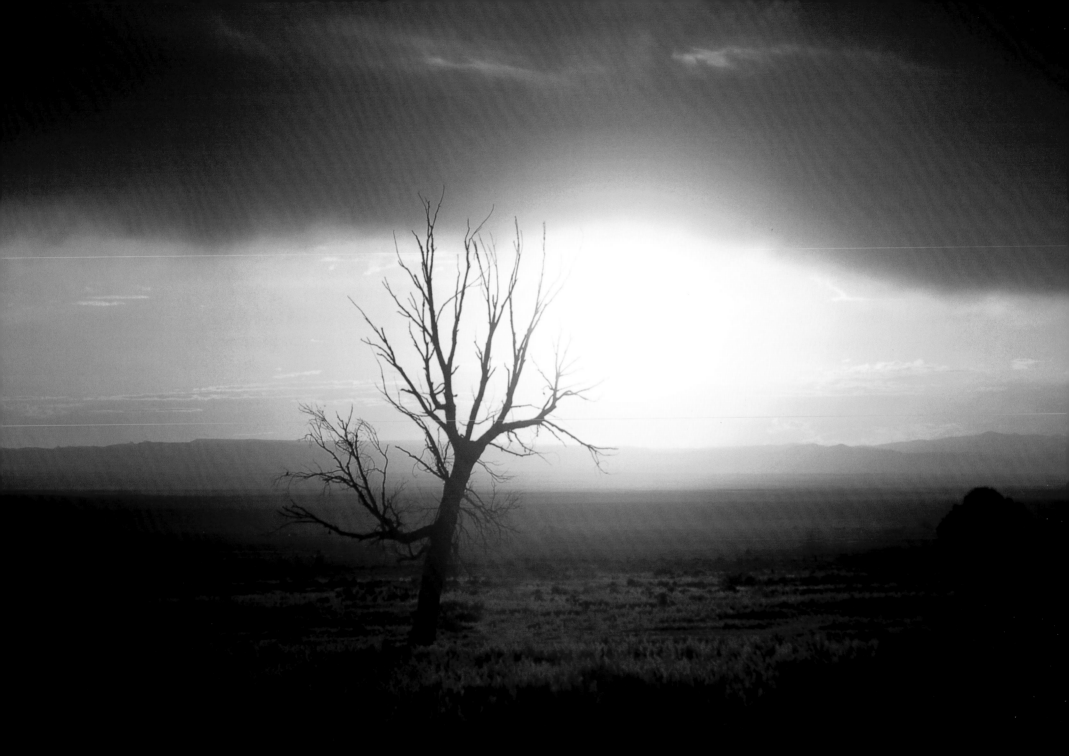

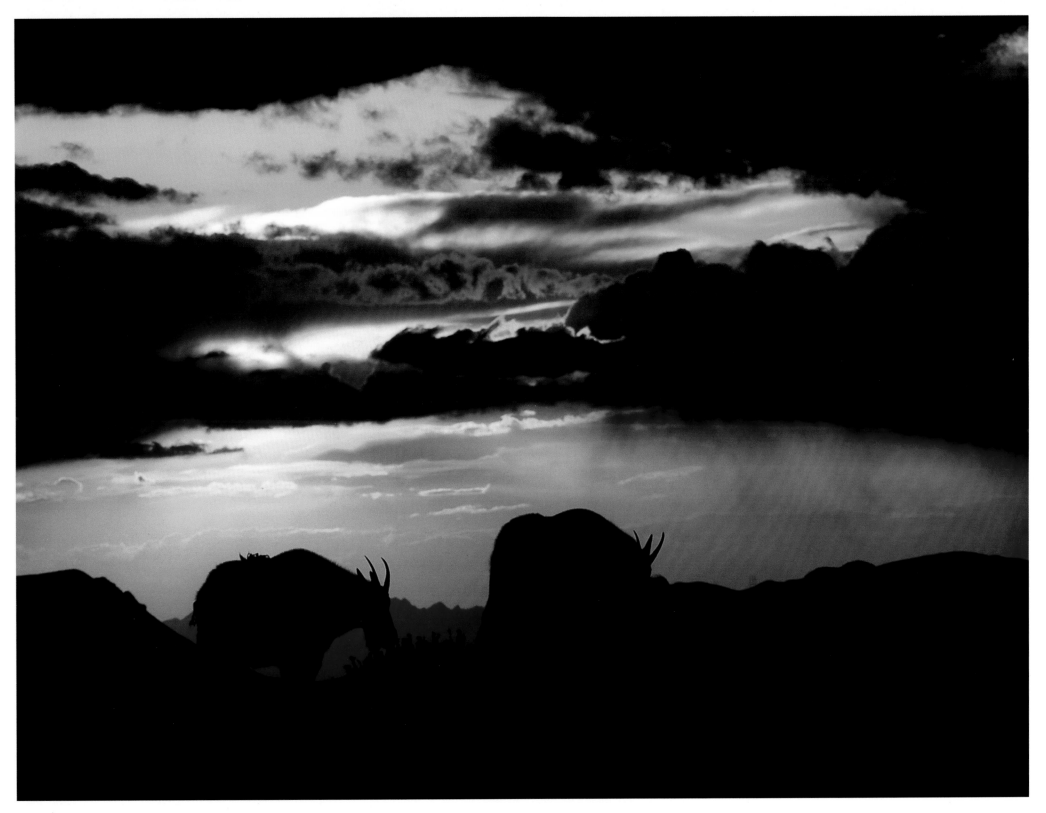

Mt. Evans, Colorado

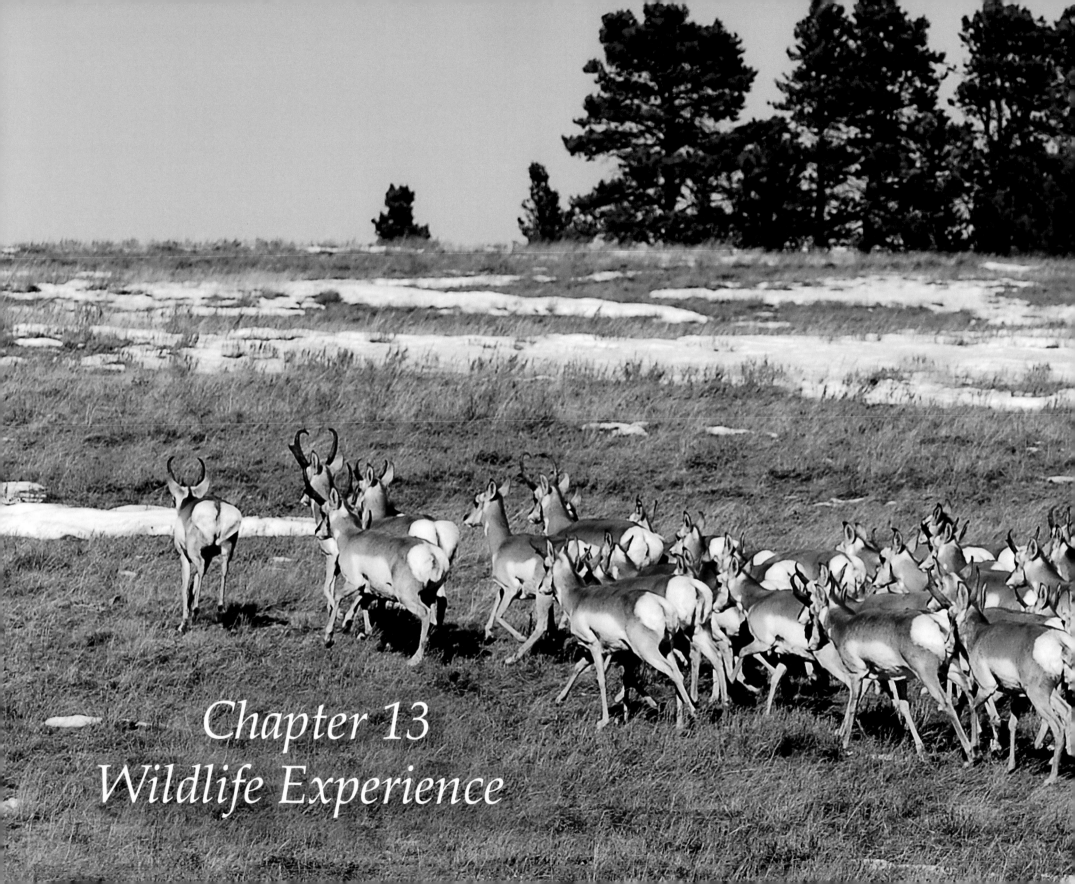

Chapter 13
Wildlife Experience

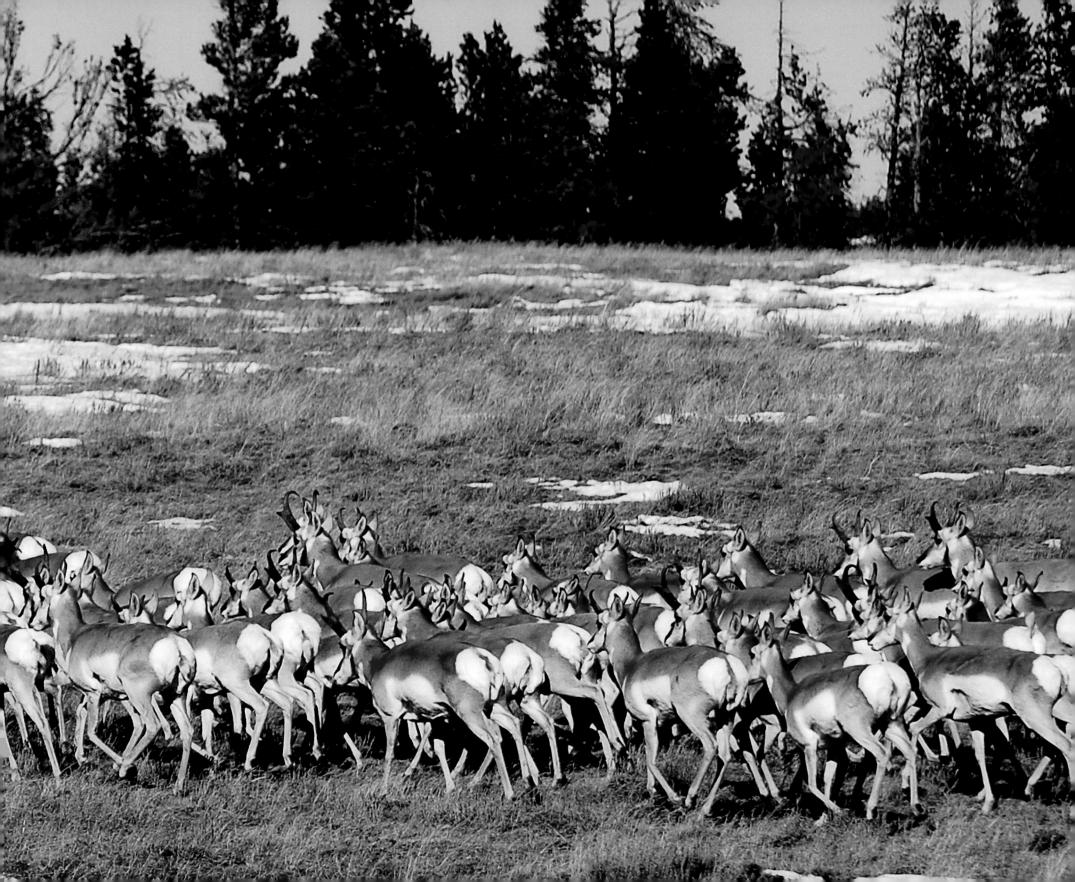

Mt Evans Colorado Rocky Mountains

Elevation 14,270 4349 m Highest Road in North America

During the late summer and early fall of 2009 I spent two weeks camping and hiking on and around Mt. Evans, the highest mountain on the Front Range just west of Denver, Colorado. I spent the cold nights in a tent near Echo Lake, a beautiful high mountain lake located at nearly 11,000 feet above sea level. I would get up before sunrise to capture the sun rising in the cold misty mornings and most days I would drive to the top of Mt. Evans itself to see if I could spot some of the local mountain goats that live there. I saw eagles, elk, deer, birds and numerous colorful flowers and other plants growing out of what appeared to be solid rock. Many evenings I spent waiting near the summit as I tried to capture the beauty of a Colorado sunset at over 14,000 feet above sea level. Sometimes I would be rewarded by catching the silhouette of a mountain goat as the sun went down behind it or the moon as it settled down in the west for the night.

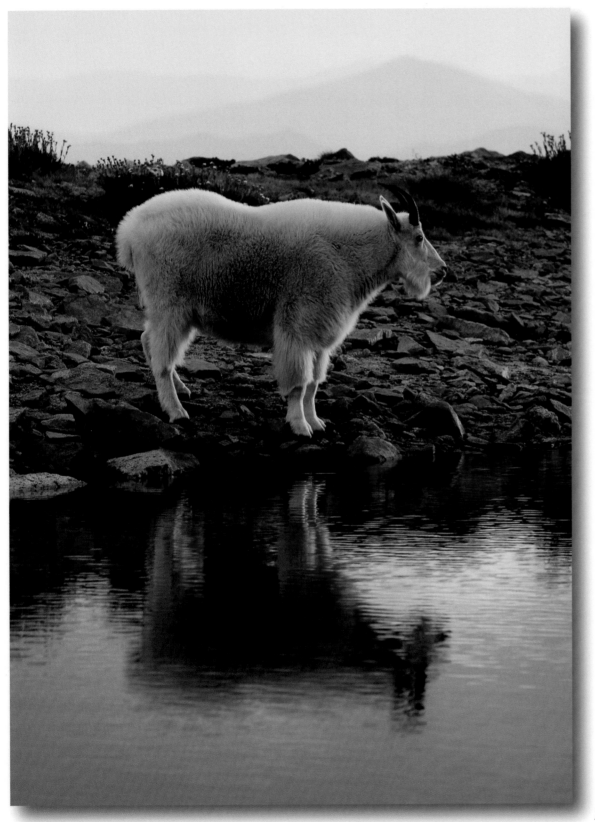

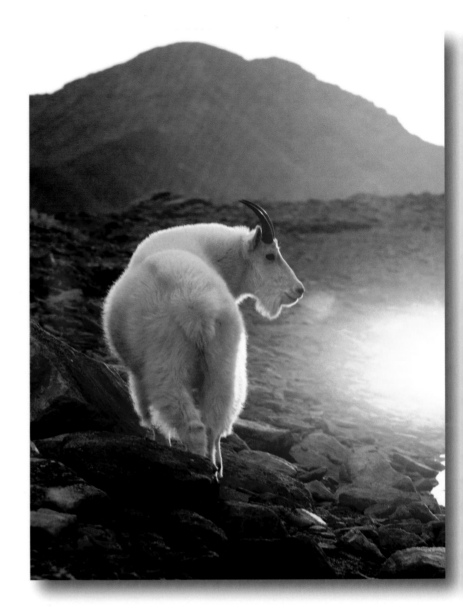

254

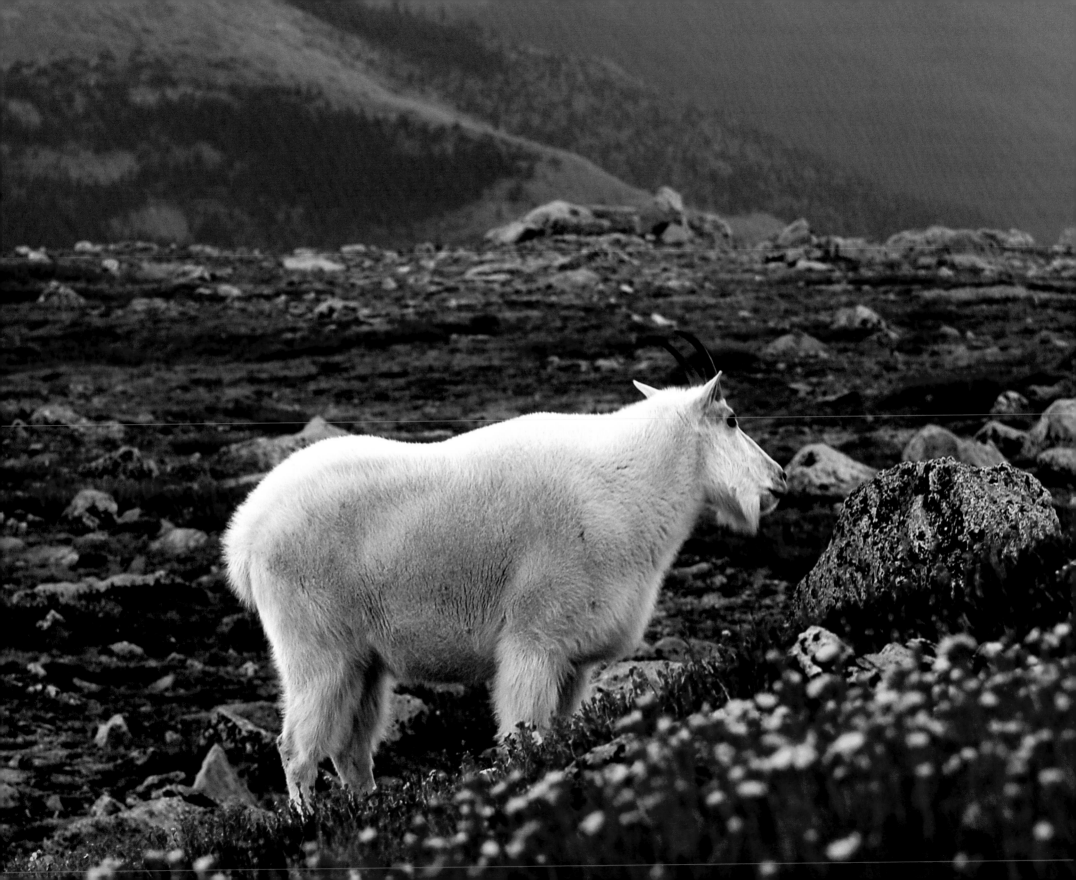

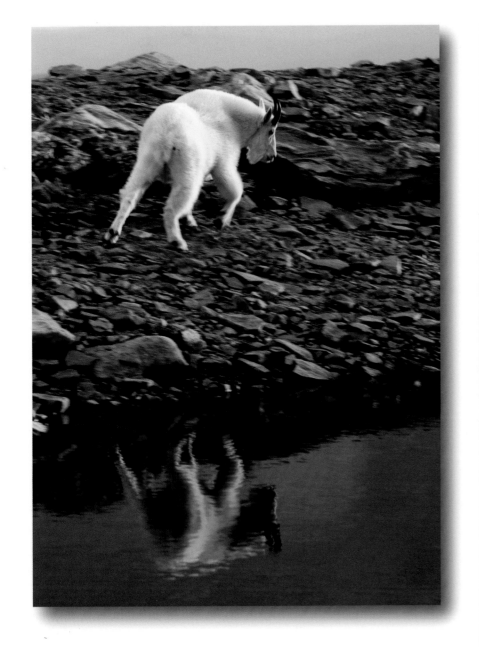

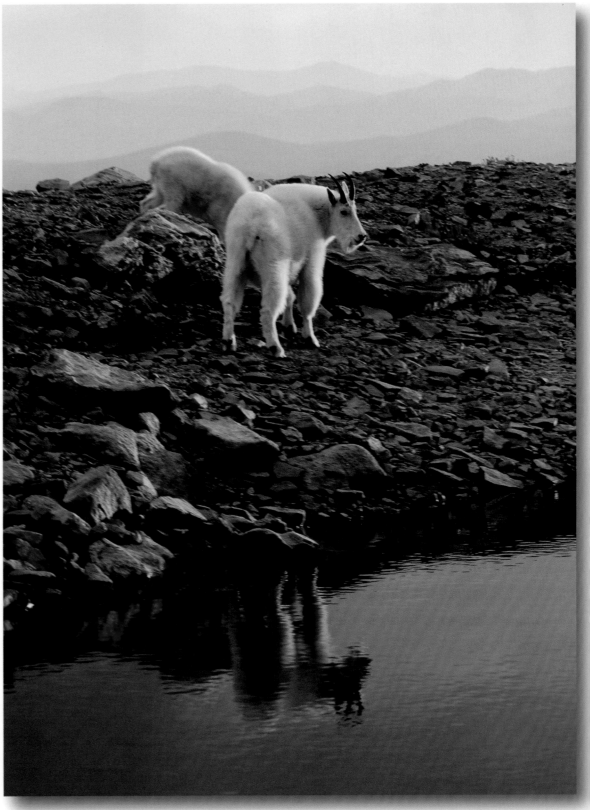

256

Late in the summer of 2009 I spent several evenings near the summit of Mt. Evans, trying to capture some photographs of the amazing sunsets that were made possible, unfortunately, by the numerous wildfires that were burning across the western United States. Smoke from these fires was drifting into Colorado, causing the sunsets here to be enhanced as the sunlight reflected off the smoke hanging in the air with Mounts Bierstadt and Spaulding in the background. This particular evening there were a couple other photographers taking advantage of the opportunity to get some good sunset photos from the top of the mountain. It was cold and getting dark. There was a herd of mountain goats in the vicinity as I crawled down into a low crevice, trying to get the right angle for the shot I anticipated would present itself if I was patient enough. The other two photographers wondered what I was up to, crawling around on the rocks the way I was. Sure enough, one of the goats wandered into my shot, just as the sun was glowing through the smoke-filled air. After the sun had set and I was sharing some of my shots with the other guys, they finally realized why I had been crawling around on the cold hard rocks. Once again I was in the right place at the right time, even though I had to work pretty hard and freeze my toes and fingers to be there.

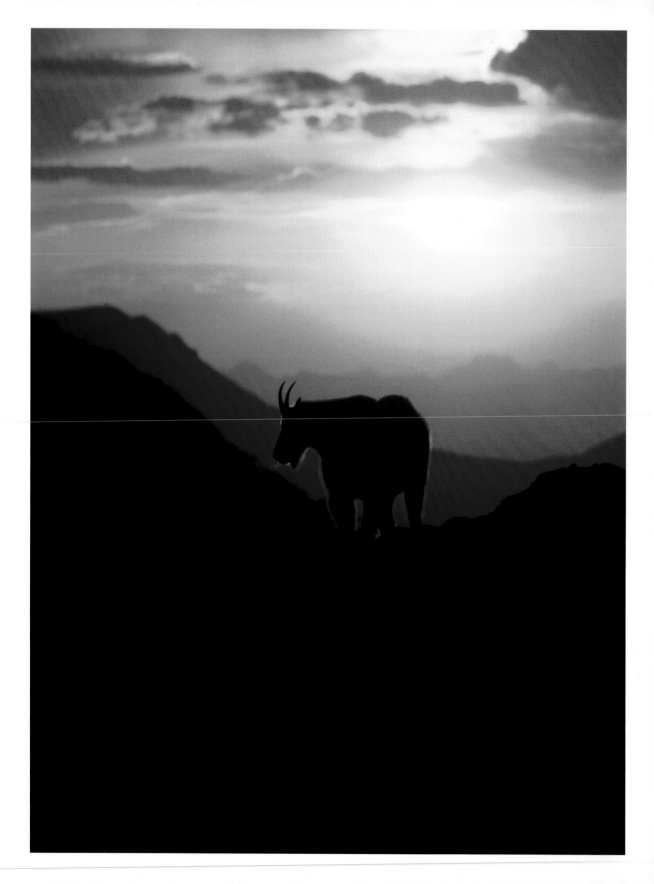

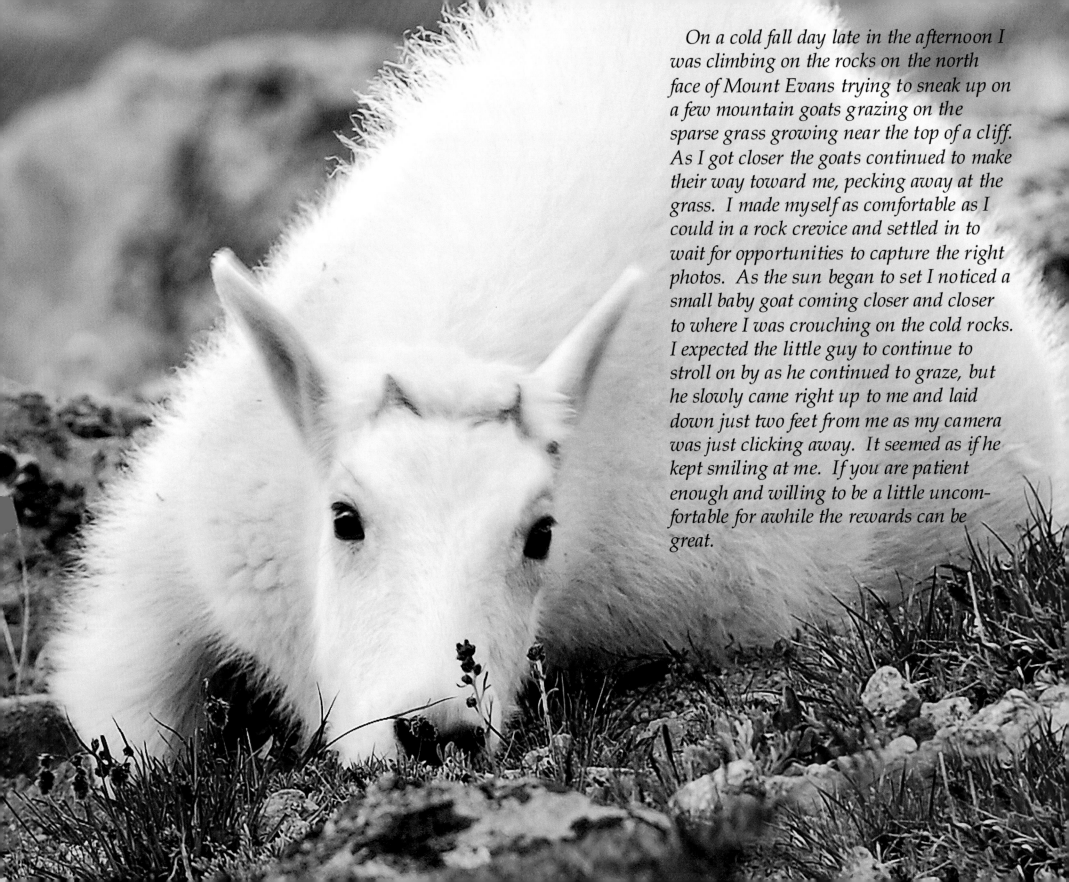

On a cold fall day late in the afternoon I was climbing on the rocks on the north face of Mount Evans trying to sneak up on a few mountain goats grazing on the sparse grass growing near the top of a cliff. As I got closer the goats continued to make their way toward me, pecking away at the grass. I made myself as comfortable as I could in a rock crevice and settled in to wait for opportunities to capture the right photos. As the sun began to set I noticed a small baby goat coming closer and closer to where I was crouching on the cold rocks. I expected the little guy to continue to stroll on by as he continued to graze, but he slowly came right up to me and laid down just two feet from me as my camera was just clicking away. It seemed as if he kept smiling at me. If you are patient enough and willing to be a little uncomfortable for awhile the rewards can be great.

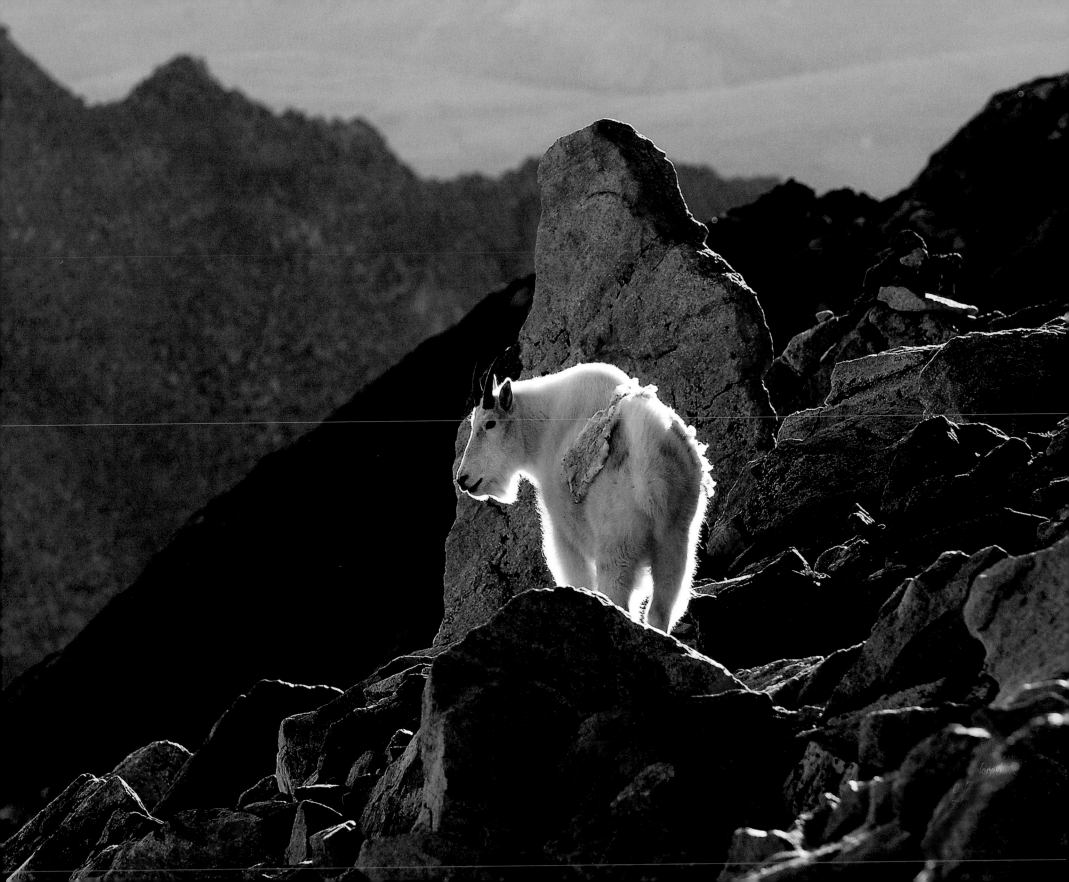

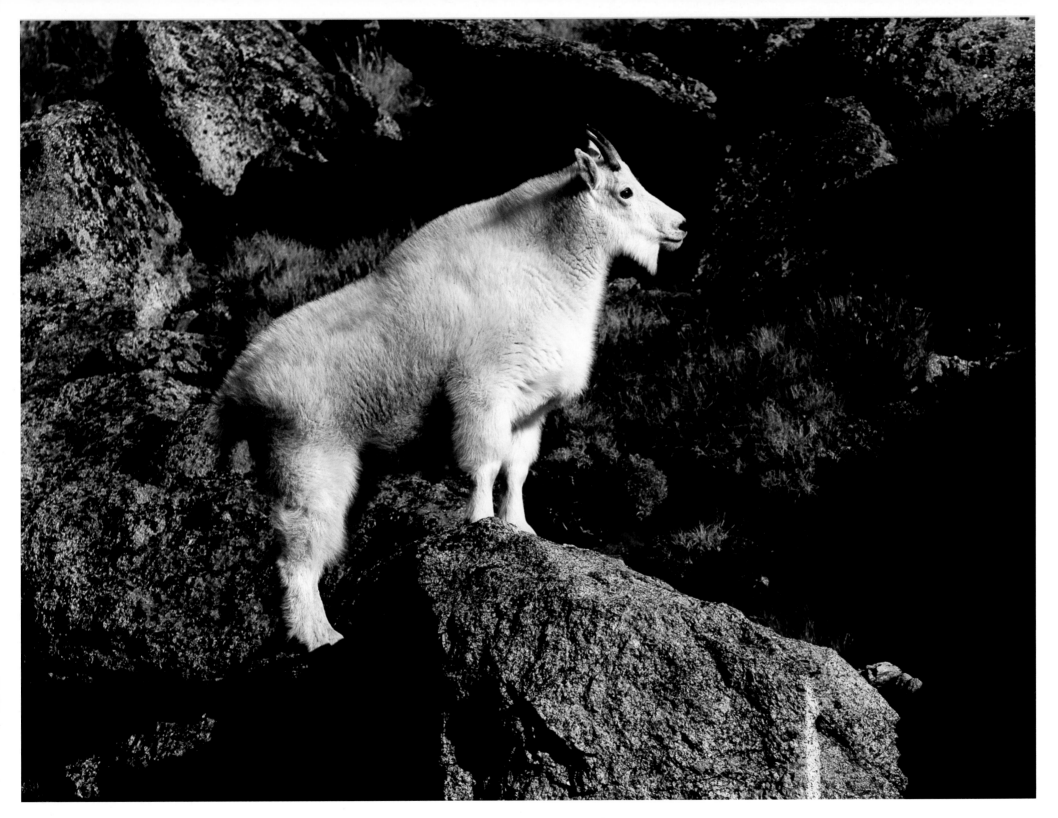

Mt. Evans, Colorado

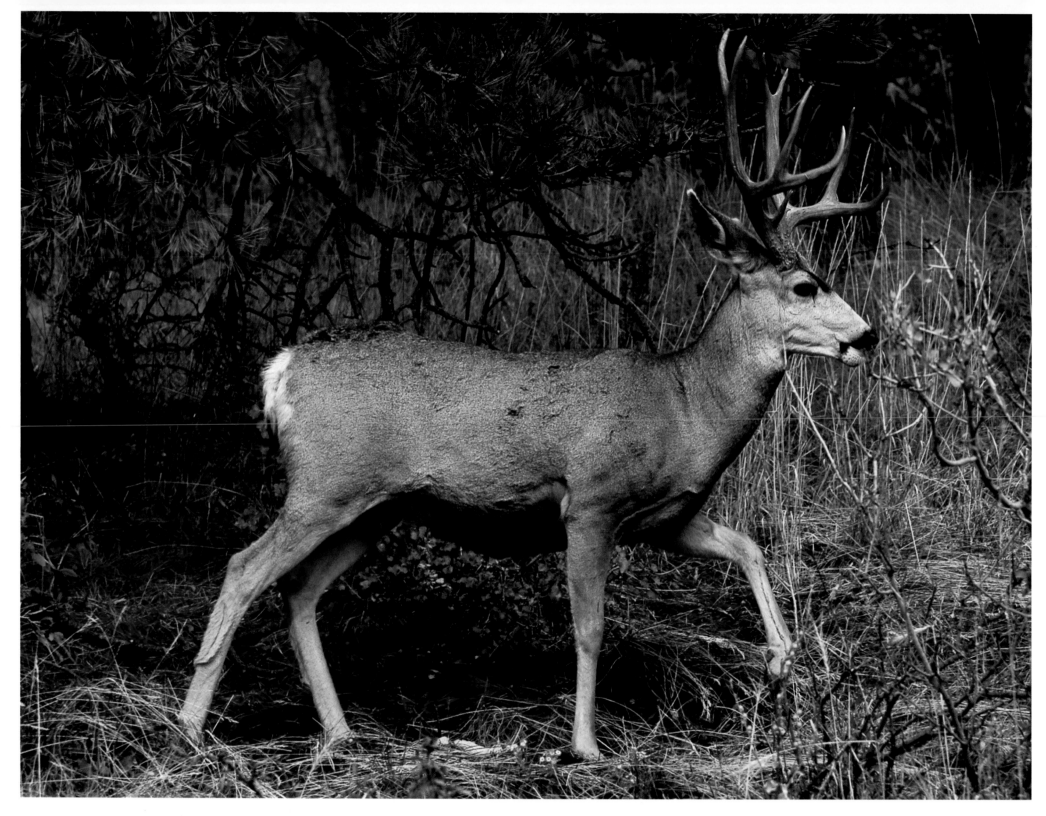

Mule Deer
Green Mountain, Colorado

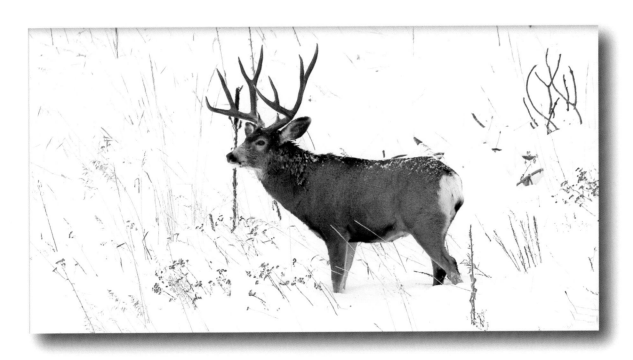

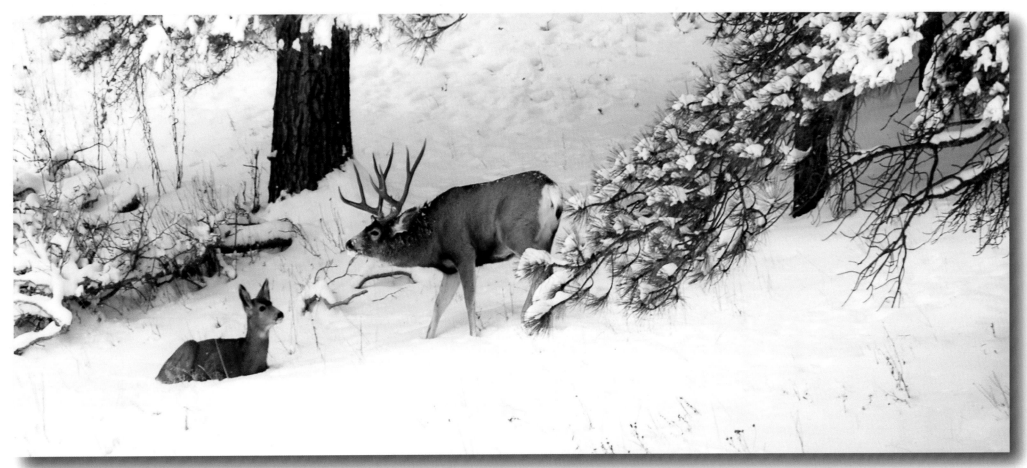

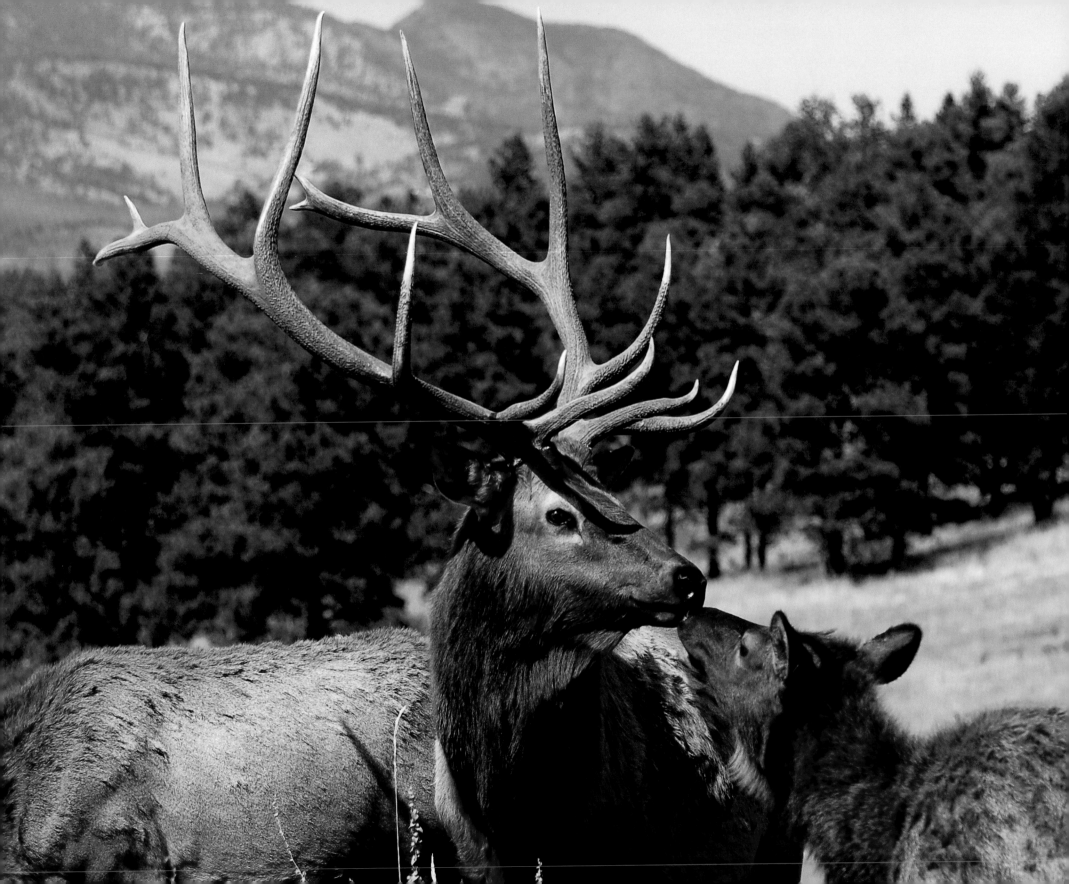

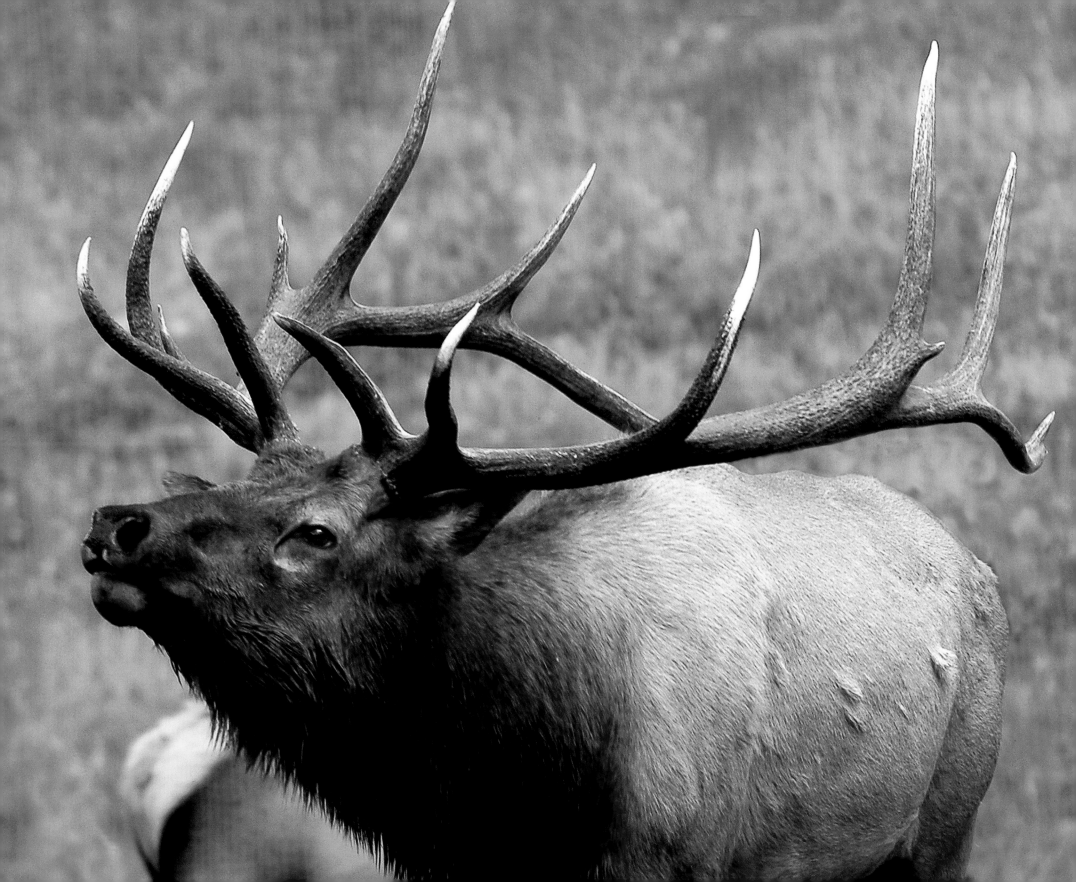

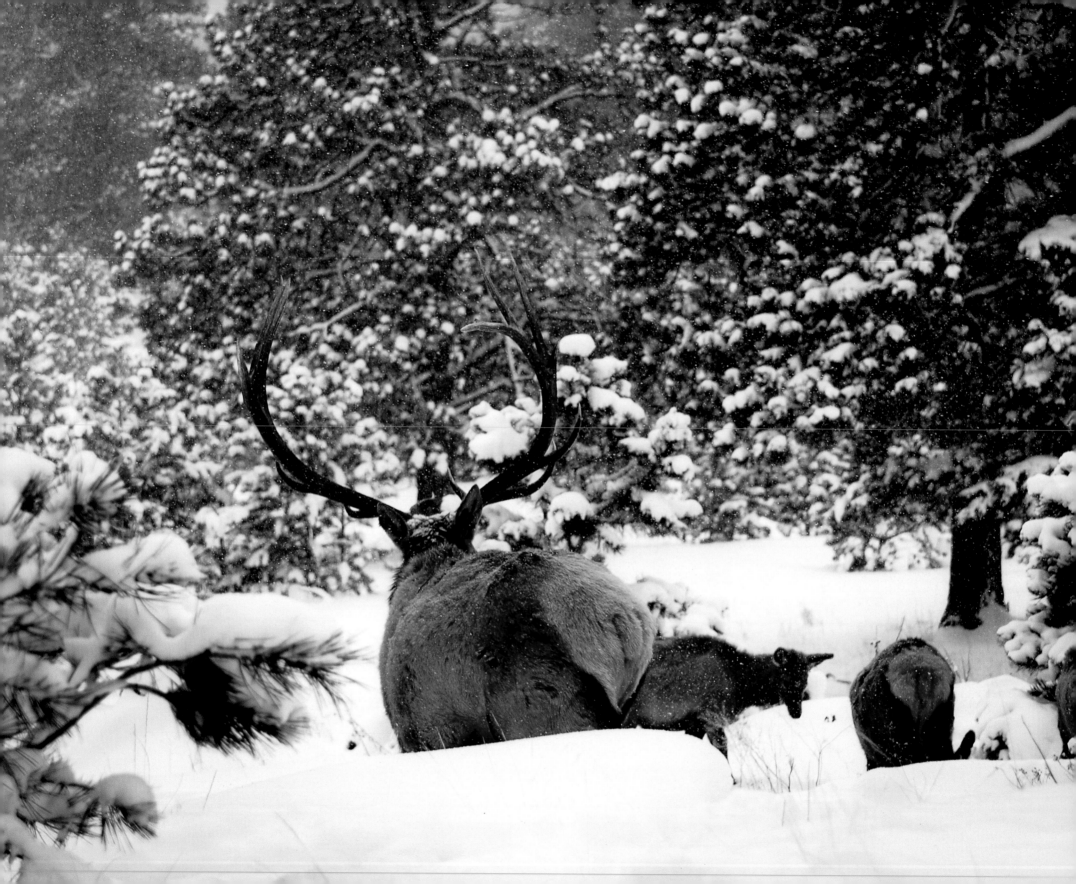

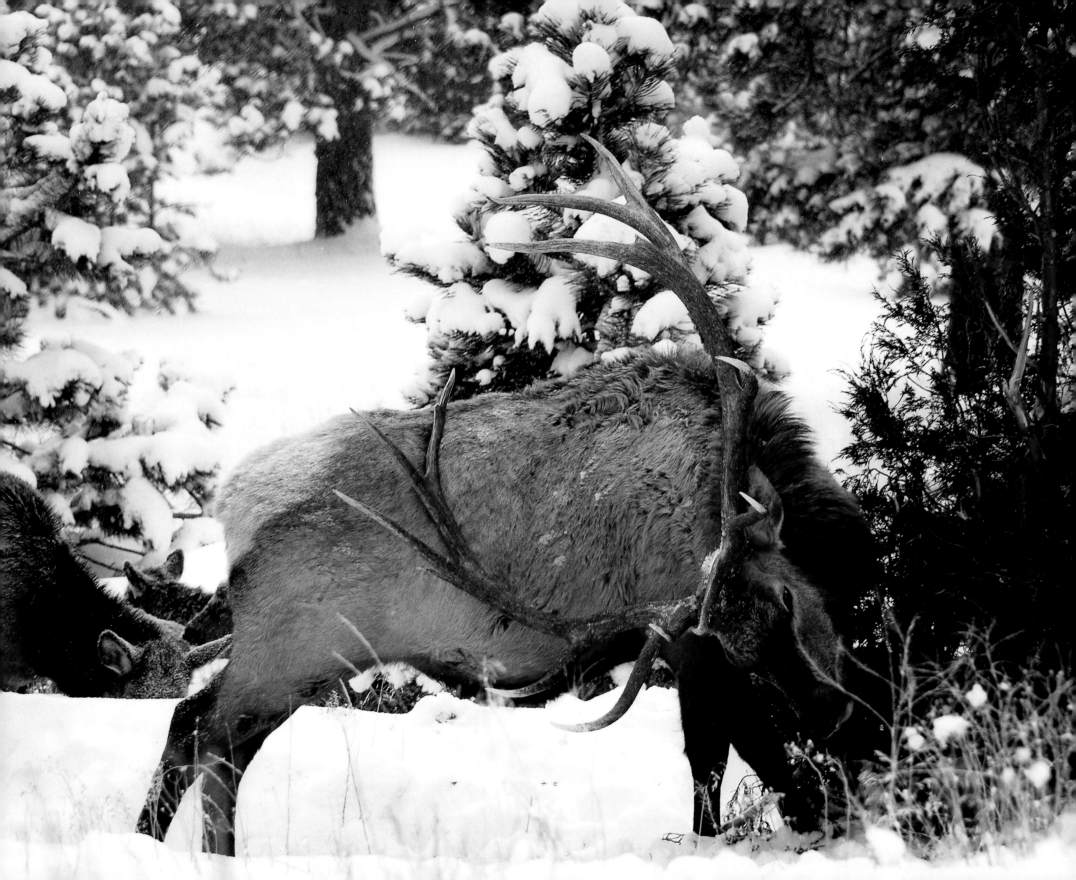

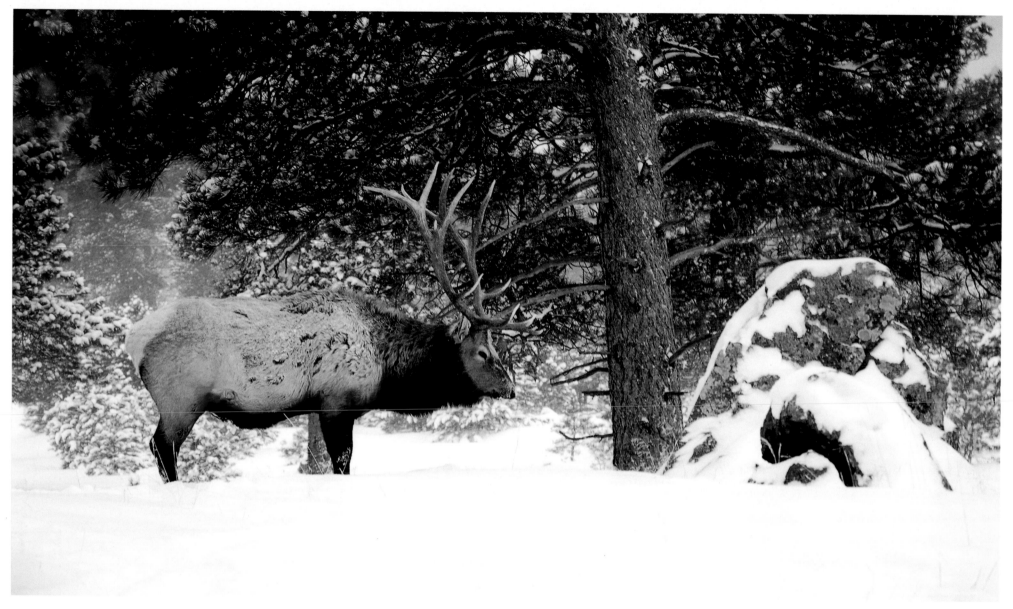

 I was working near Telluride, Colorado on a very cold and snowy winter day. The wind was blowing which made it feel even colder. I wanted to find out if I could catch a glimpse of some wildlife in a valley I always travel through while I'm in this area. As I was getting my camera ready I looked down the valley below and I could see some movement in the deep snow. I hurried down to get set up. I dug out a hole in the snow just big enough for me to hunker down into, my camera ready to go. I sat in that place for a good two hours. It was starting to snow heavier and visibility was poor. I settled in and waited. I closed my eyes for a moment. When I opened them again, it had stopped snowing and this big bull elk walked right in front of me. My patience had paid off. It was like the big guy wanted to pose for me. He stood facing into the wind and gave me a show. In the winter cold elk will feed on young trees when the snow is too deep to find any grass. The next few photographs will show what I was capturing. A bit of frost bite is a part of getting the perfect photo in conditions such as these. I have learned that wildlife photography requires three things if you want to be successful; patience, persistence and perseverance.

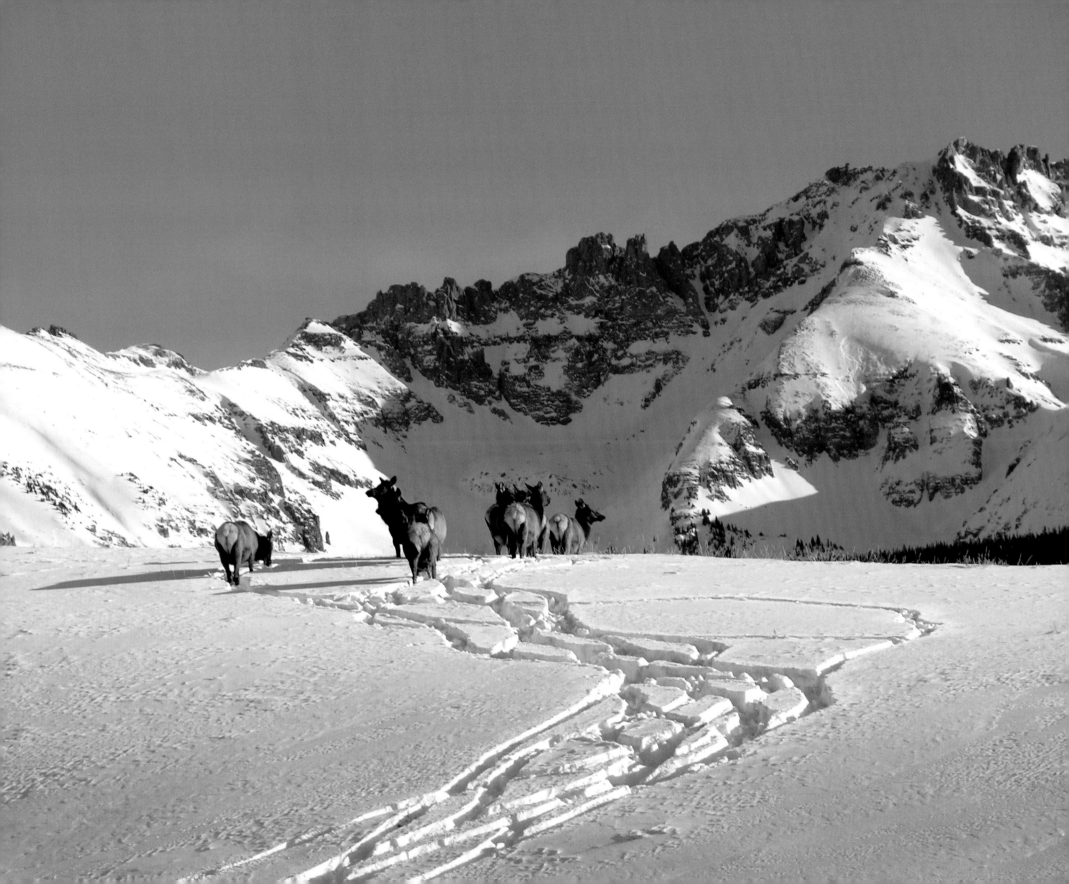

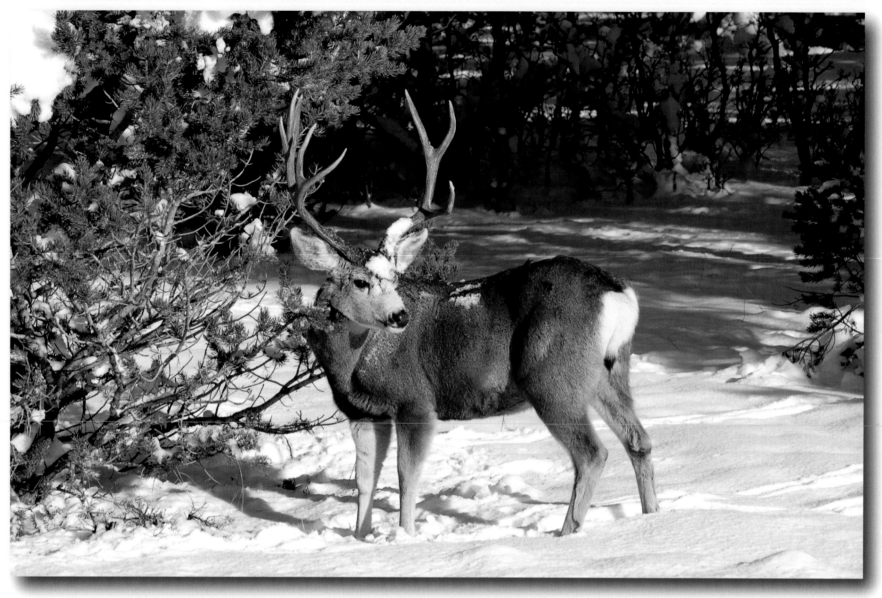

The Truck and the Buck

Occasionally I will work with other salesmen who also have customers in the same area. I was working near Ridgway, Colorado with a co -worker in the same area when I noticed something was shaking the snow off a pine tree a short distance off the road. I parked my truck and walked a short distance through the snow. As I approached the shaking tree, I could see a large buck mule deer vigorously shaking the tree with his antlers, causing the snow in the tree to fall down over his head. I was amazed by how much fun the buck seemed to be having. Just as I was taking this photograph, I heard a loud noise just down the road from where I was. I couldn't believe what I saw when I looked up. My friend's black pickup truck was sliding out of control down a steep snow covered driveway across the road from where I was standing. The truck continued sliding as it skidded across the road and down a steep embankment just missing a huge tree. As I was rushing back toward my truck my cell phone rang. It was my friend. In an upset voice he told me he had just slid off the road and almost hit a tree. I told him I was just down the road and had seen it happen. Luckily the only thing that was damaged was the truck. A local rancher helped us pull the truck out of the ditch. I thanked God it wasn't any worse.

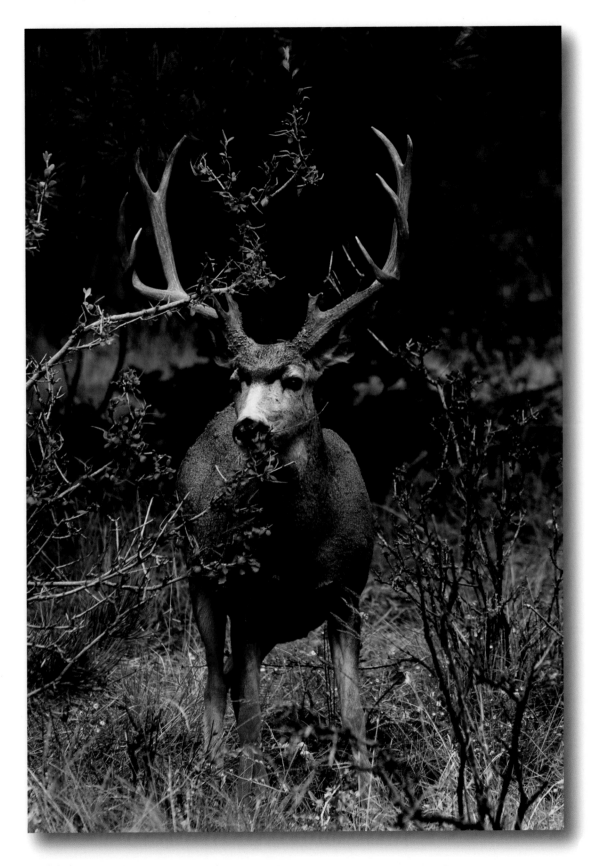

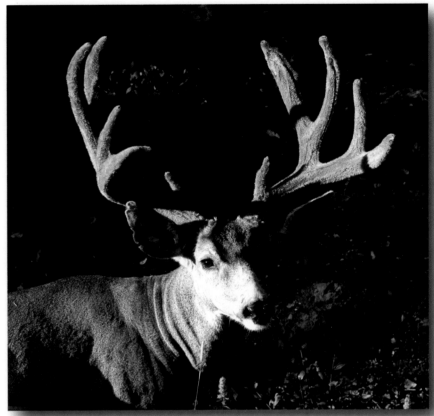

I was out hiking near Mount Democrat along English Creek just north of Leadville, Colorado when I sat down on an old log bridge to rest and enjoy the beauty surrounding me. I had seen many deer in this area before and hoped my patience would be rewarded once again. After resting for about a half hour, I spotted four big mule deer bucks coming toward me out of the trees. I sat still and watched as they continued to stroll slowly toward the creek where I was sitting. Eventually they got to within no more than fifteen or twenty feet away from me. I could tell they knew I was there but they showed no signs of fear. They even laid down for an afternoon rest in the sun, taking turns sleeping while the others kept watch. Eventually I got up to leave. They watched as I slowly walked away, almost as if I were just another wild animal out grazing in the sun. I kid you not. It was one of the most amazing things that ever happened to me on a quiet hike in the Colorado Mountains.

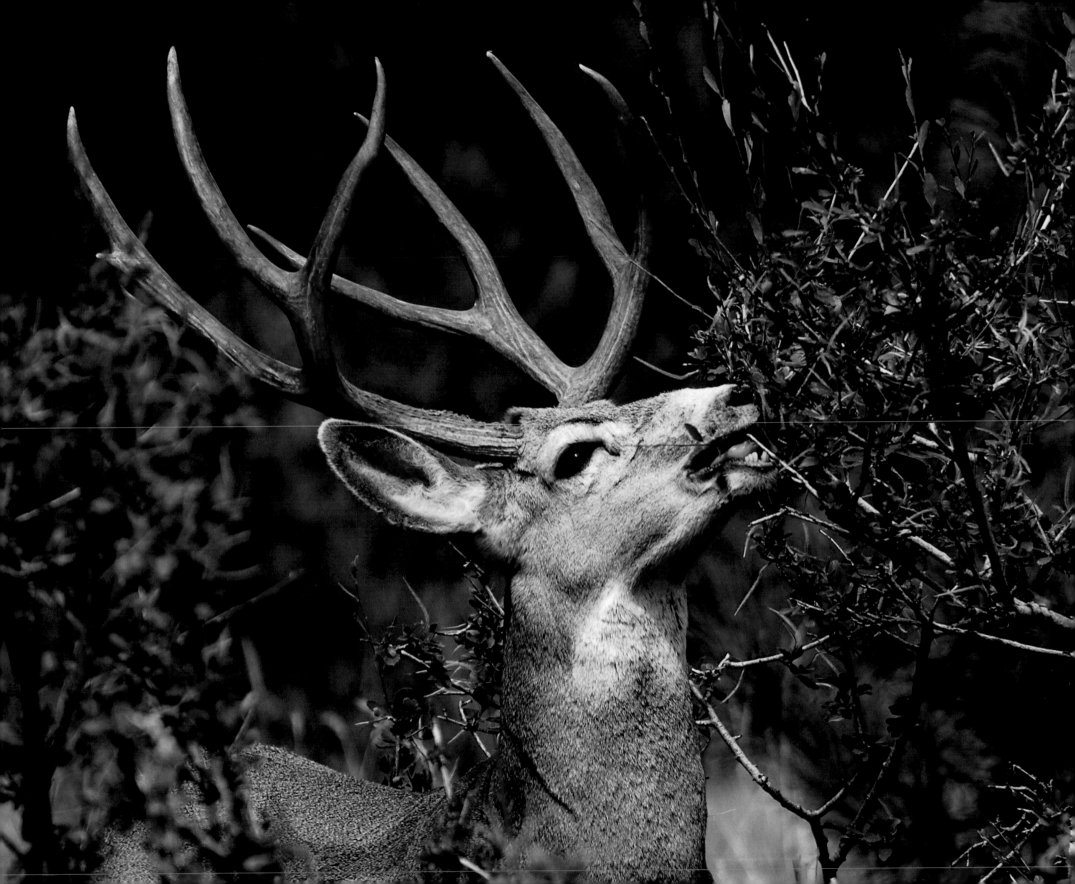

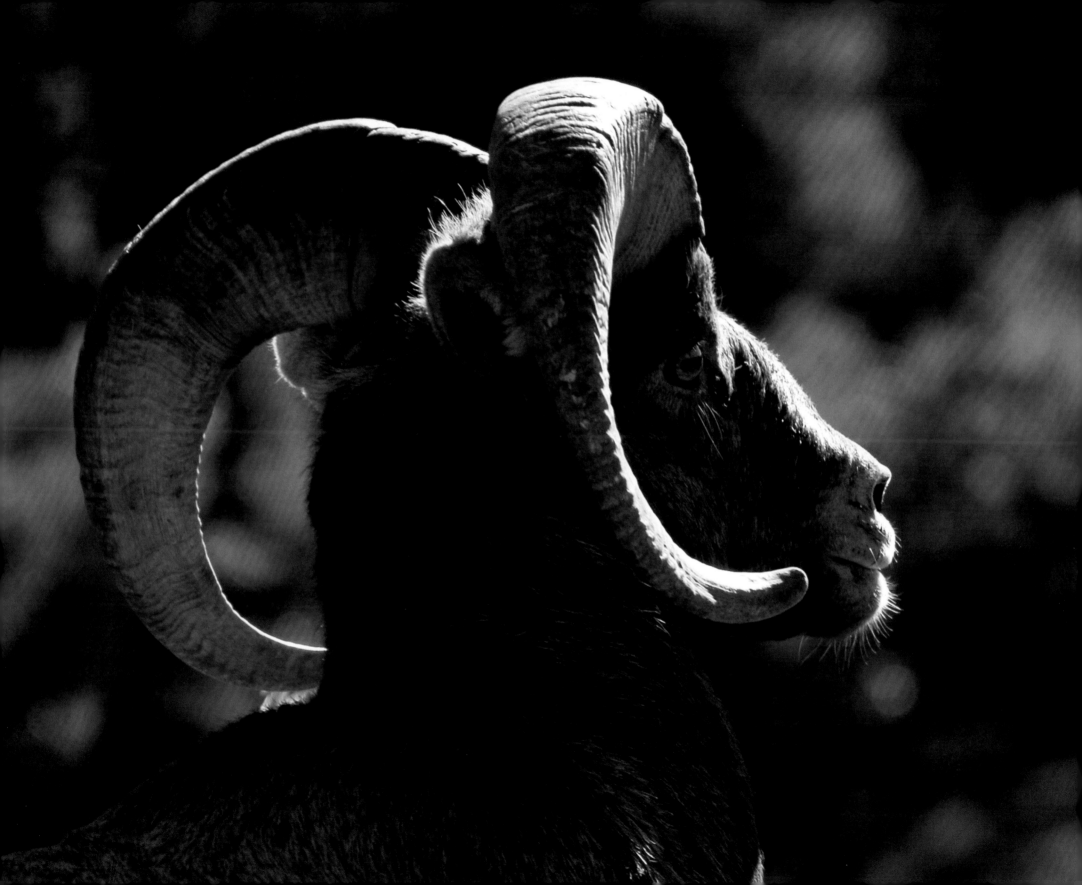

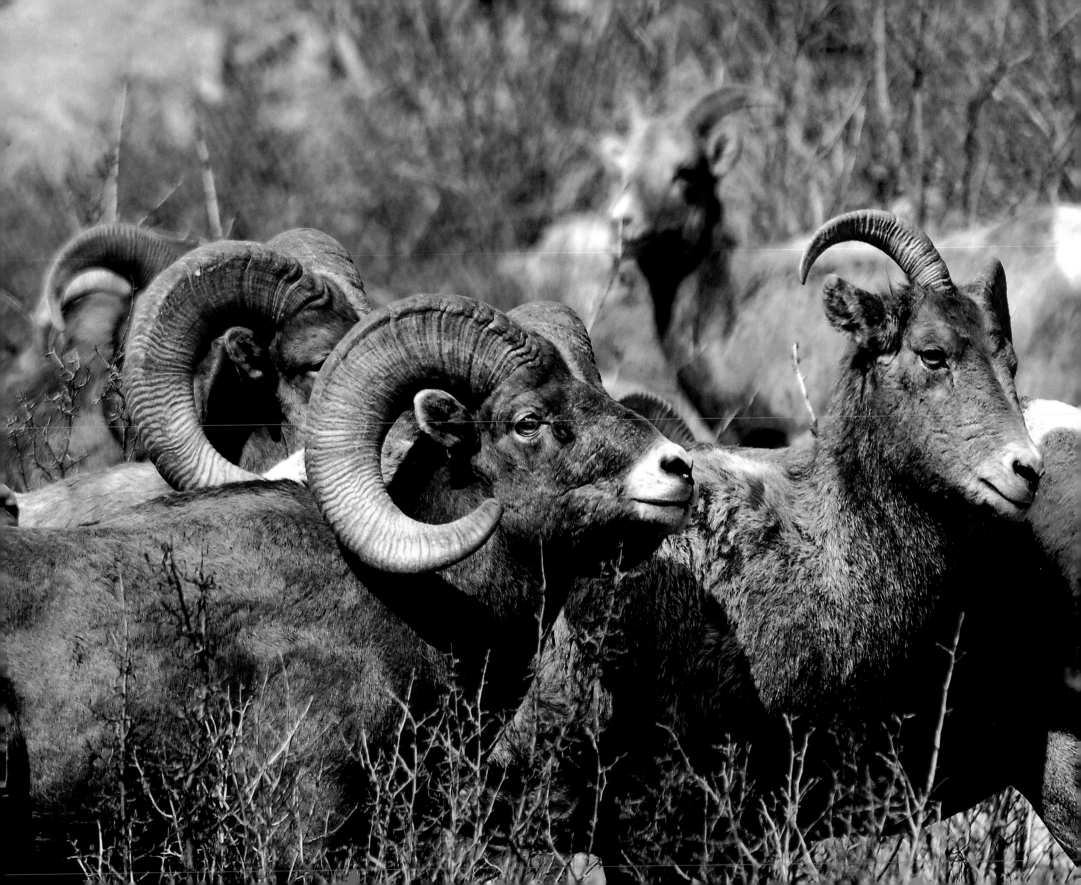

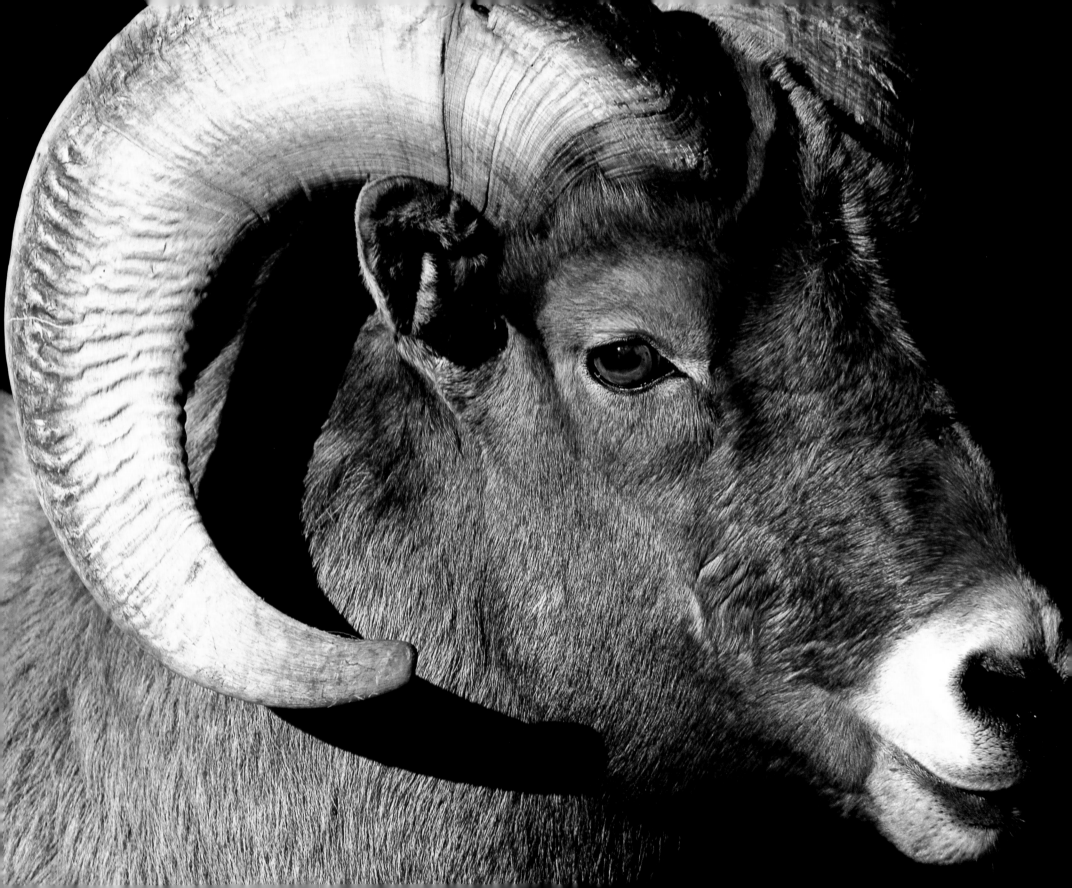

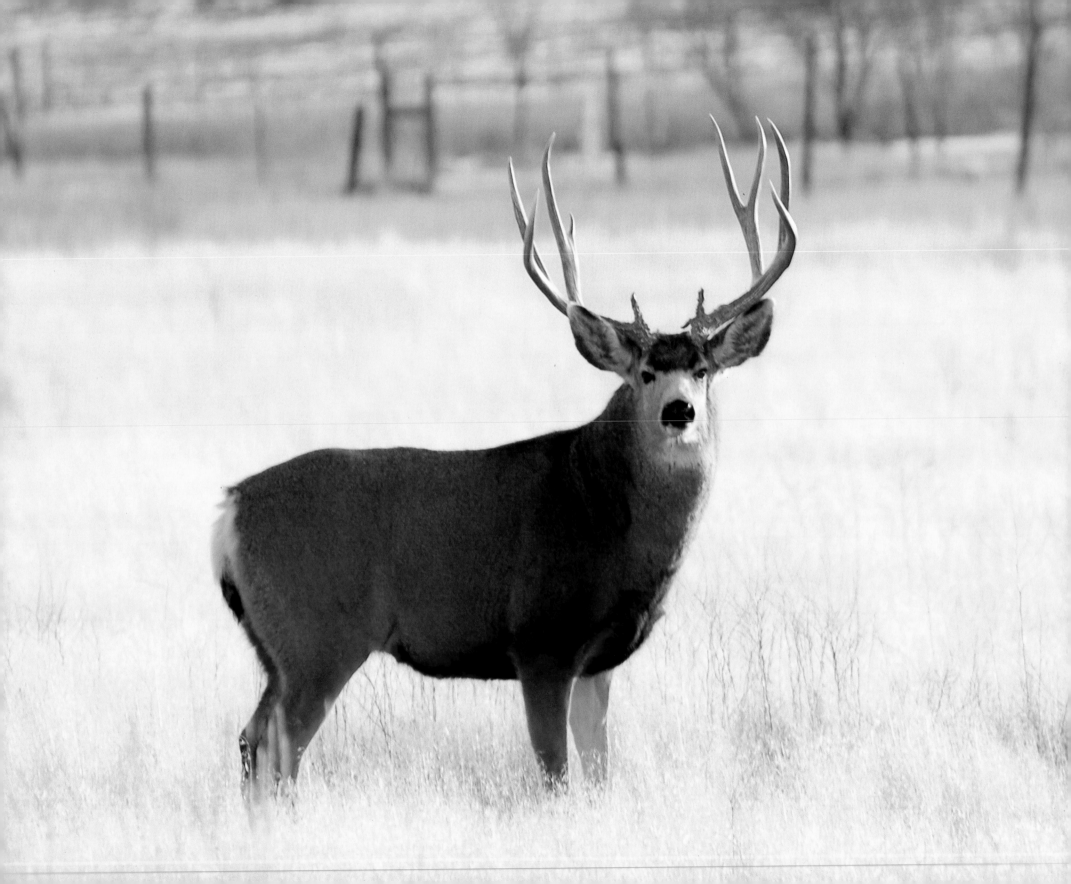

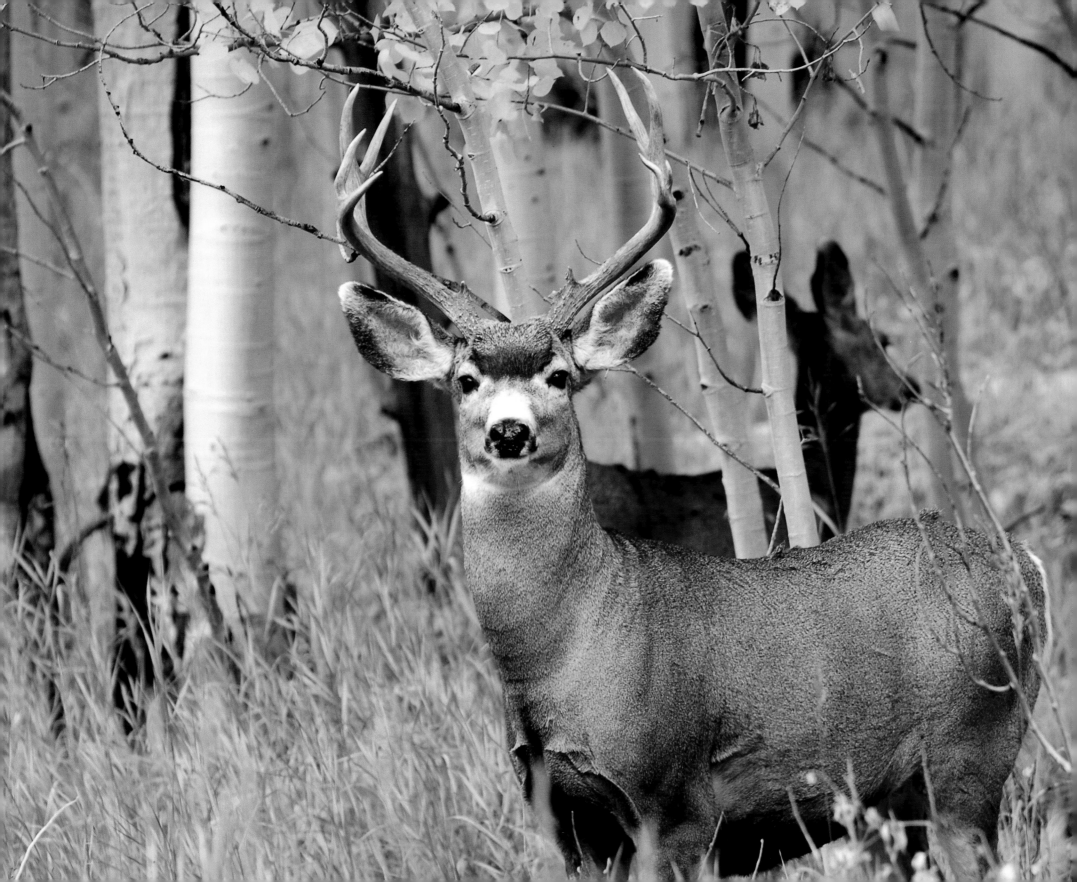

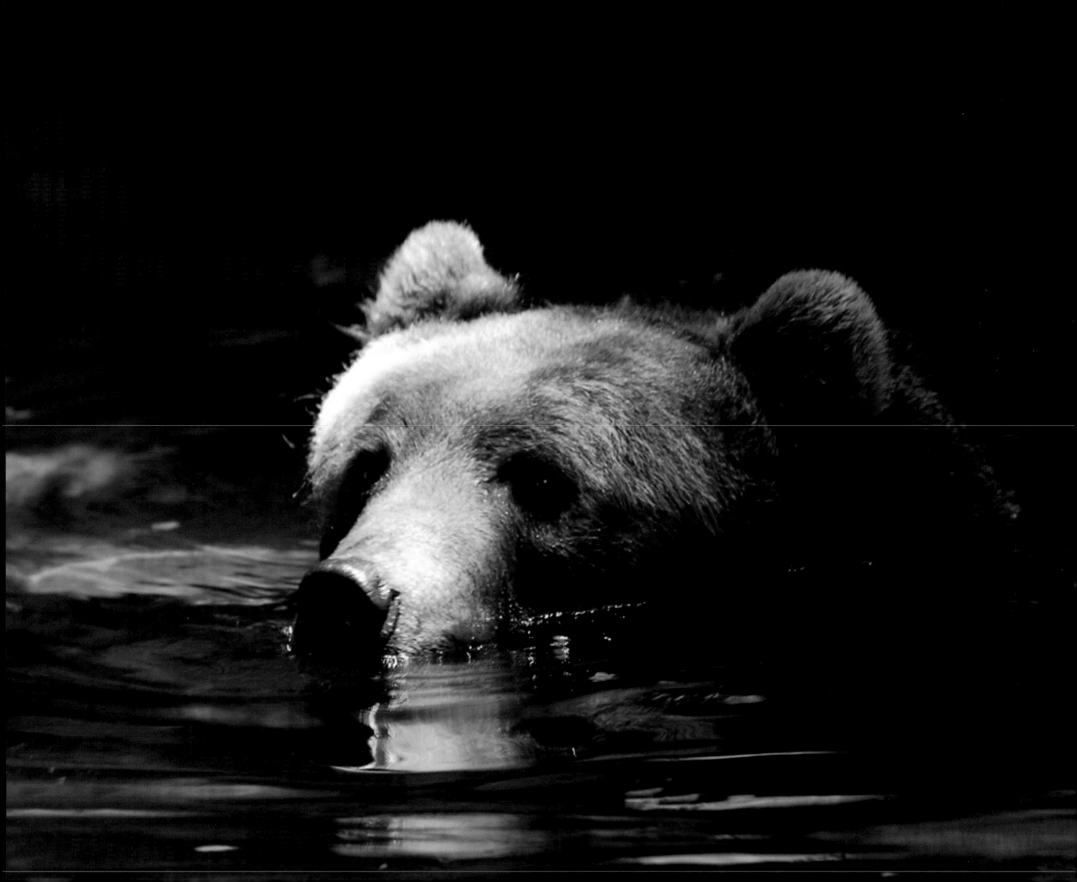

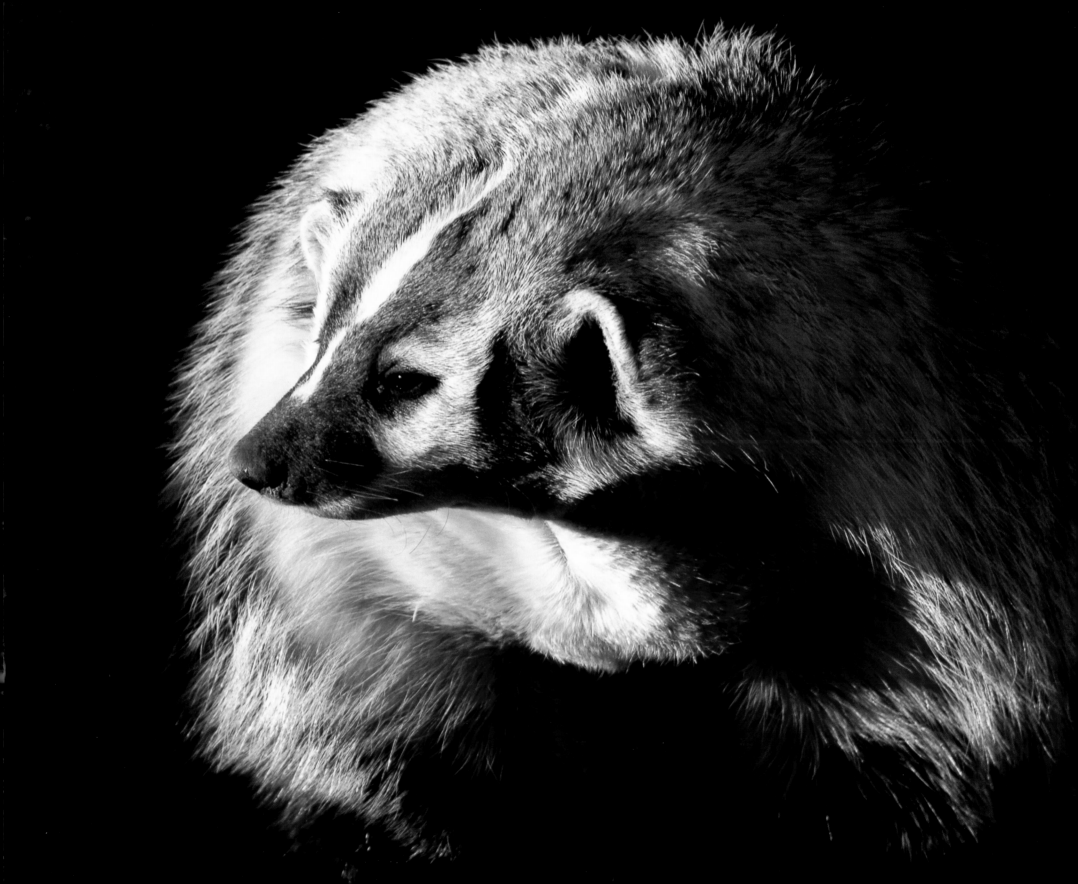

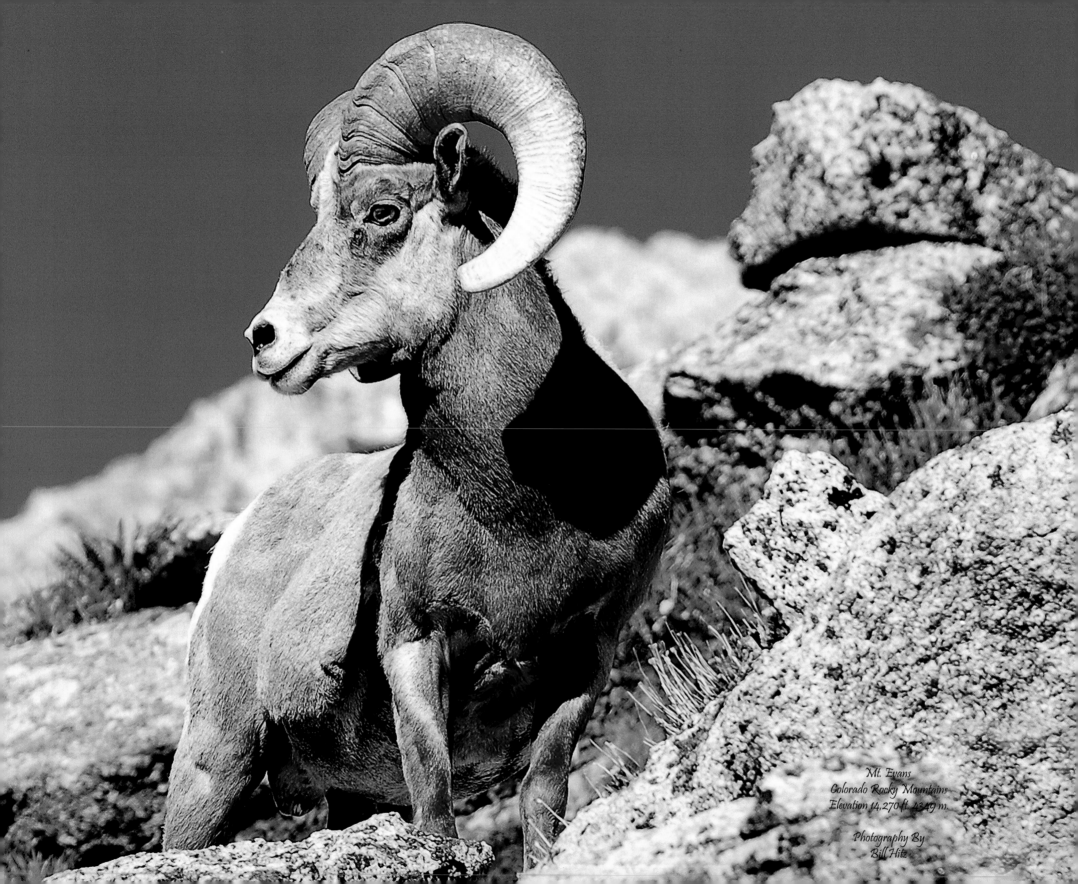

Mt. Evans
Colorado Rocky Mountains
Elevation 14,270 ft. 4349 m.

Photography By
Bill Hitz

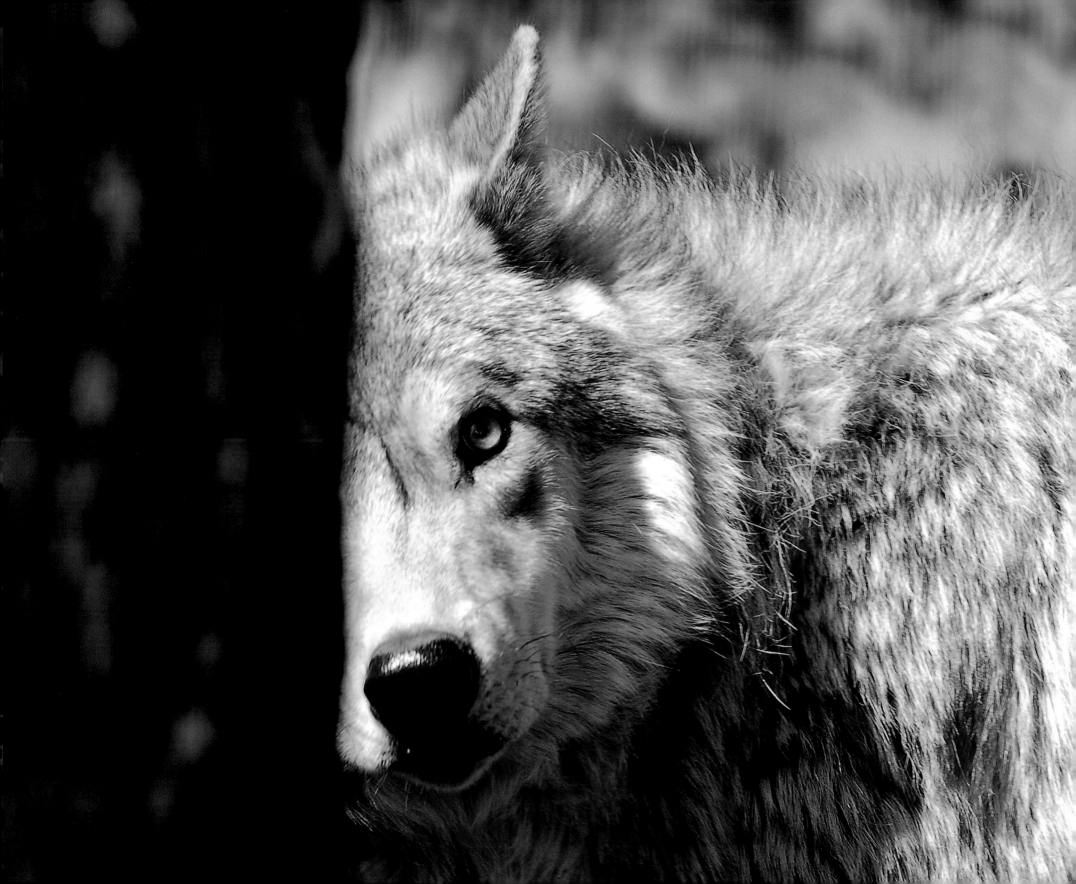

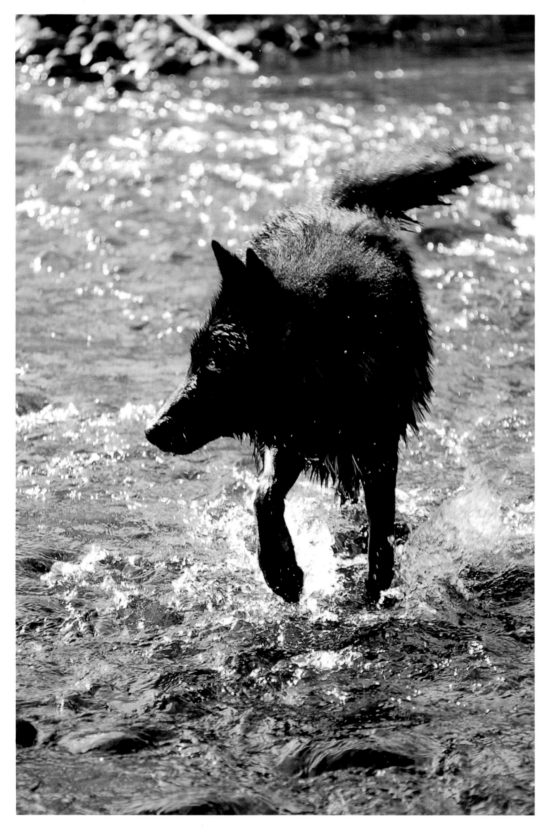

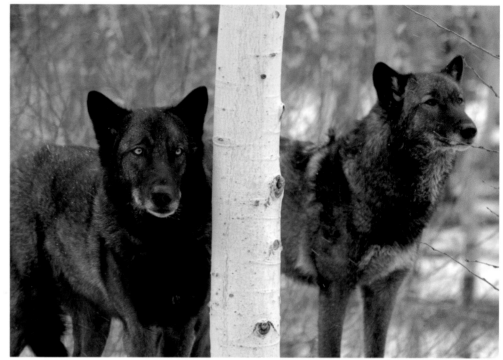

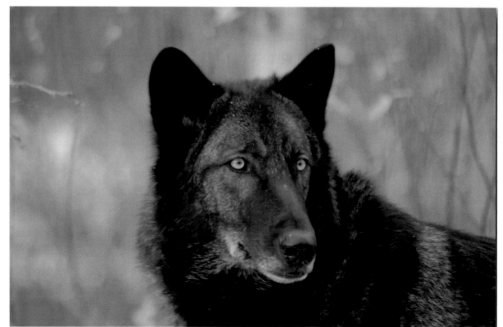

281

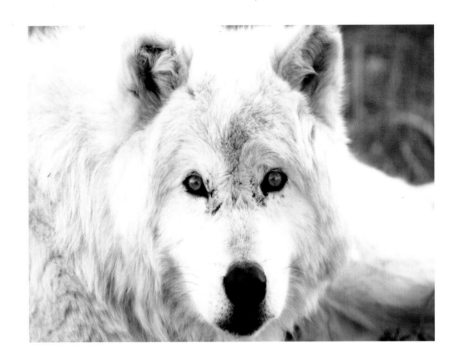

Since the release of wolves back into the wild in Yellowstone National Park in Wyoming, there have been a few sightings of the animals in the wild in Colorado. The timber wolves in these photos actually live in captivity near Georgetown, Colorado on a private reserve. I am fortunate enough to know the people who manage this facility who have allowed me to photograph these beautiful animals in a fairly natural habitat.

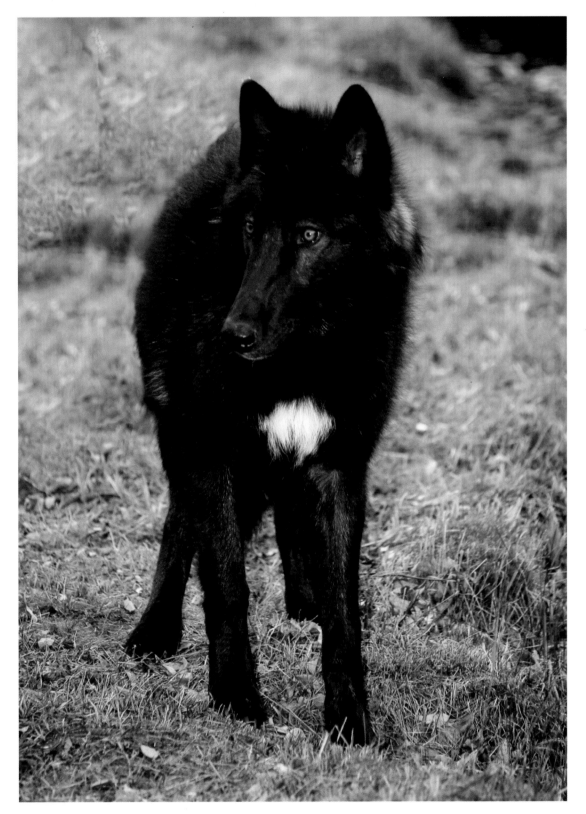

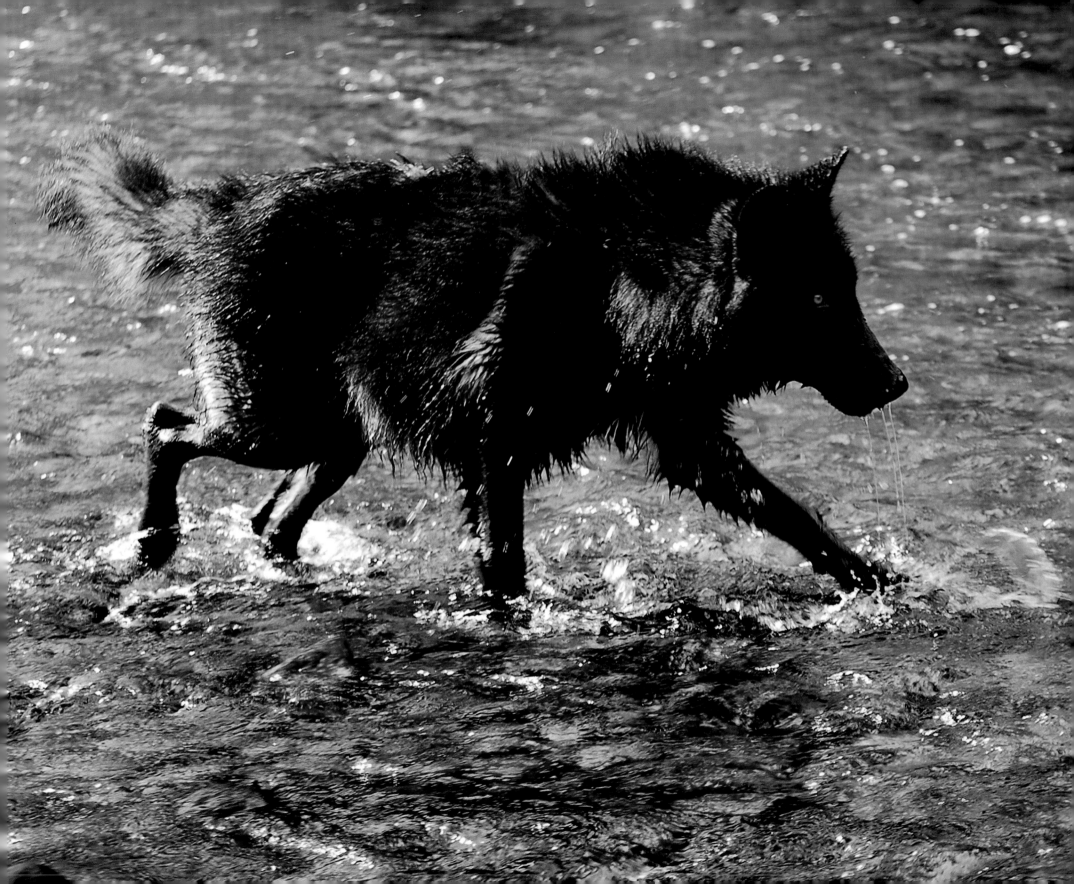

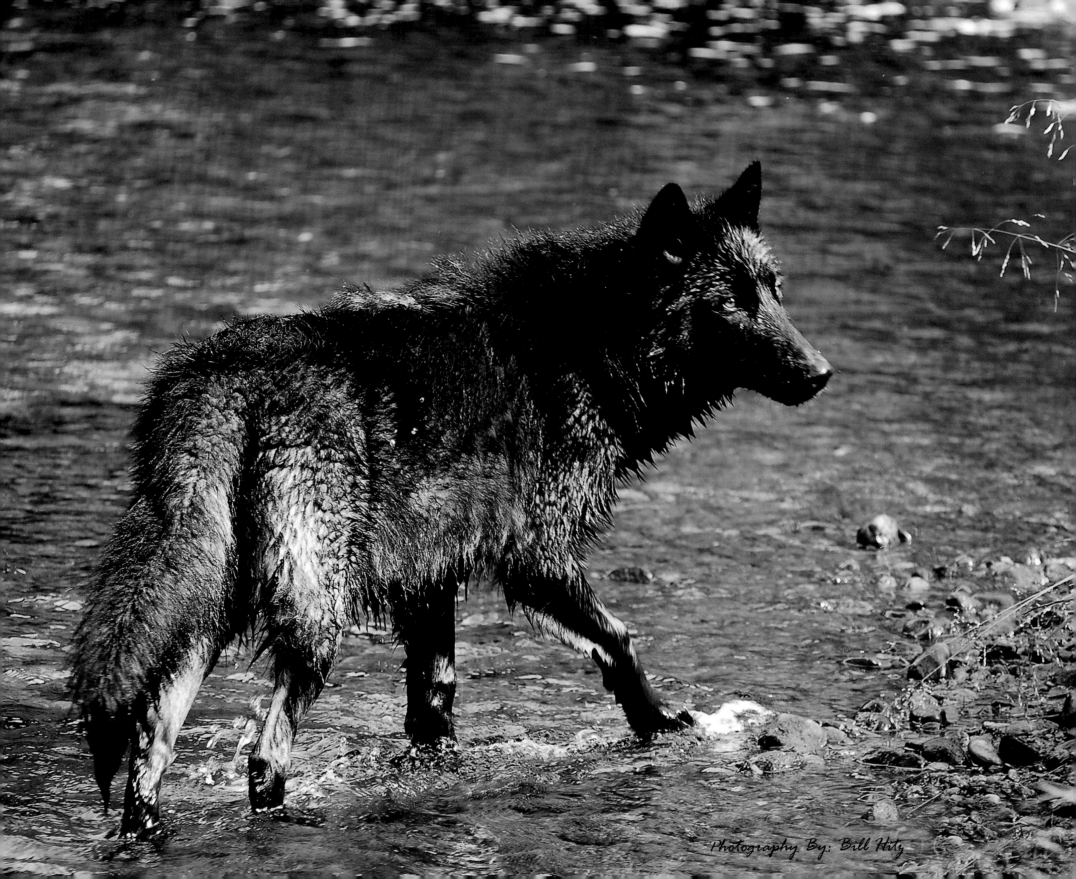
Photography By: Bill Hitz

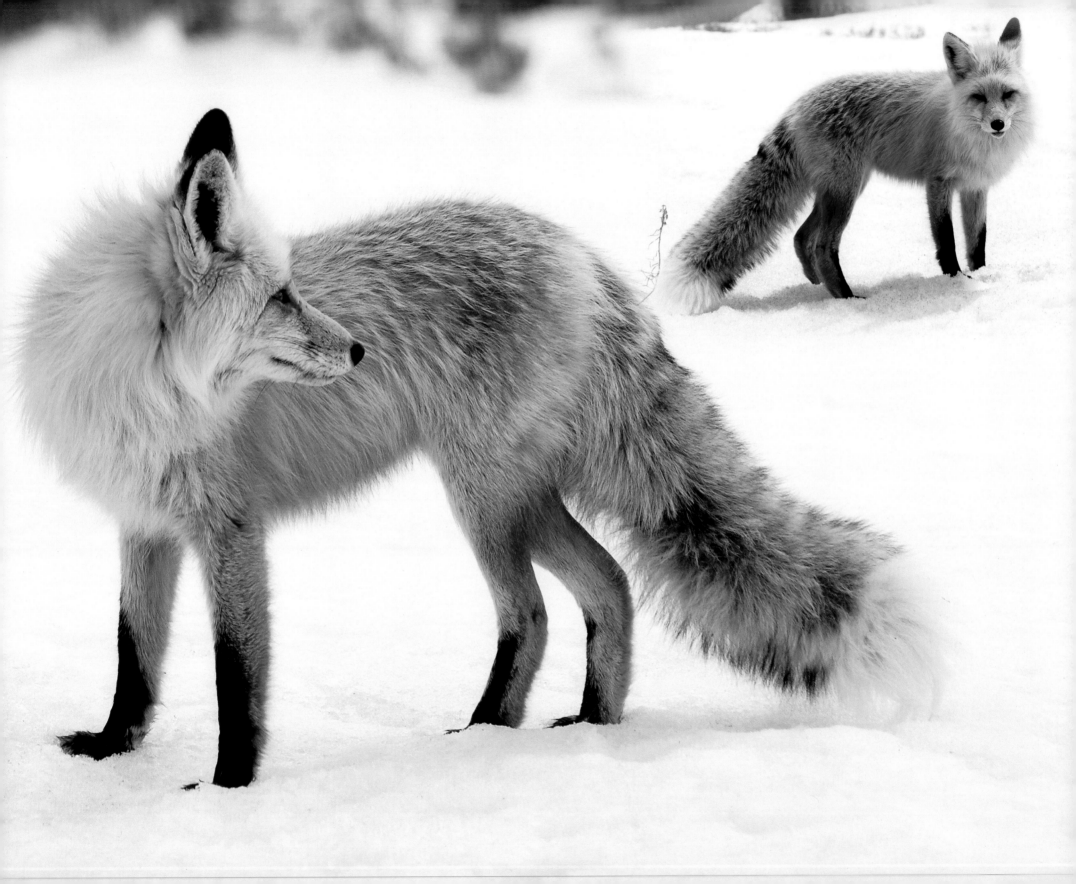

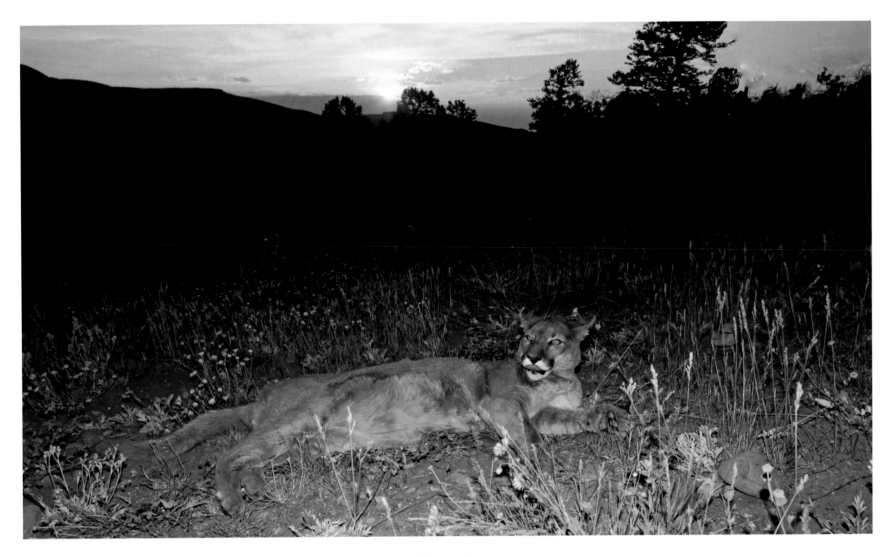

"Ruby"
I Will Never Forget

As a door to door salesman working in some of the most remote areas of the Rocky Mountains, I was constantly coming across little surprises at almost every driveway I entered. When you work an area you try to contact as many people as you can. I was told to always carry some dog biscuits to discourage dogs running up driveways from chewing on me. Boy did they come in handy. I had more than a few close calls. One day while working near Mount Wilson in southwest Colorado I started down a long dusty gravel driveway. As I drove closer to the home I thought they had a large oversized dog. Well, I was never told to carry cat biscuits. This was one big cat. I had been told to watch out for mountain lions but I never expected to encounter one on a sales call. Ruby, as I found out, was her name. Ruby was owned by a lady who had cared for her for many years. She told me that as near as she could determine, Ruby was about 24 years old. I felt very honored to be introduced to such a wonderful animal that God had created. Just to sit with Ruby was a once in a lifetime experience that I will never forget. I will always remember that special day and Ruby will always have a special place in my heart.

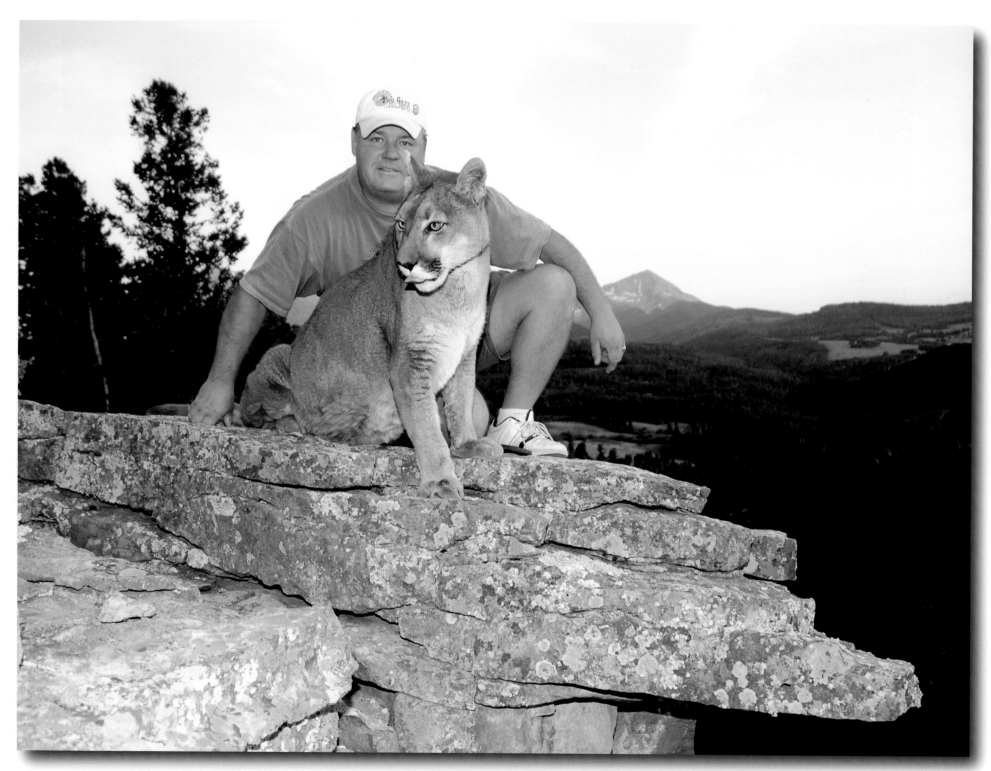

Mount Wilson near Telluride, Colorado

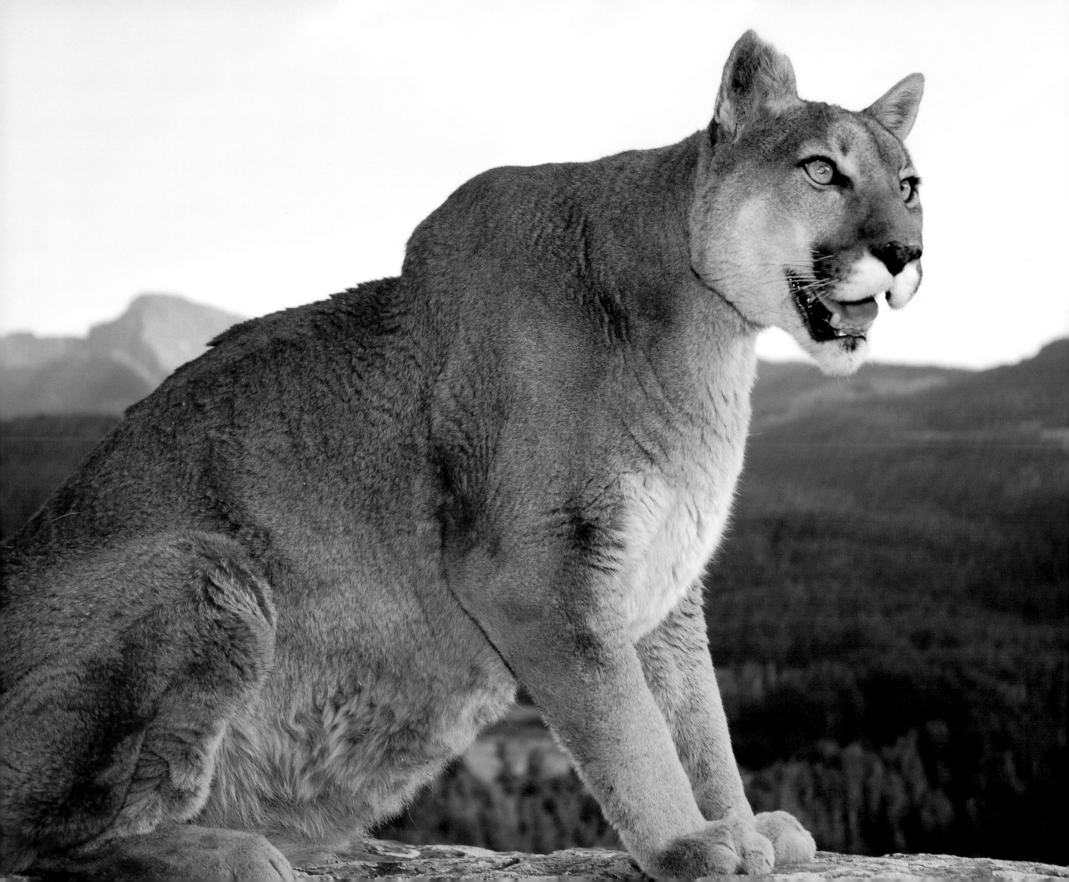

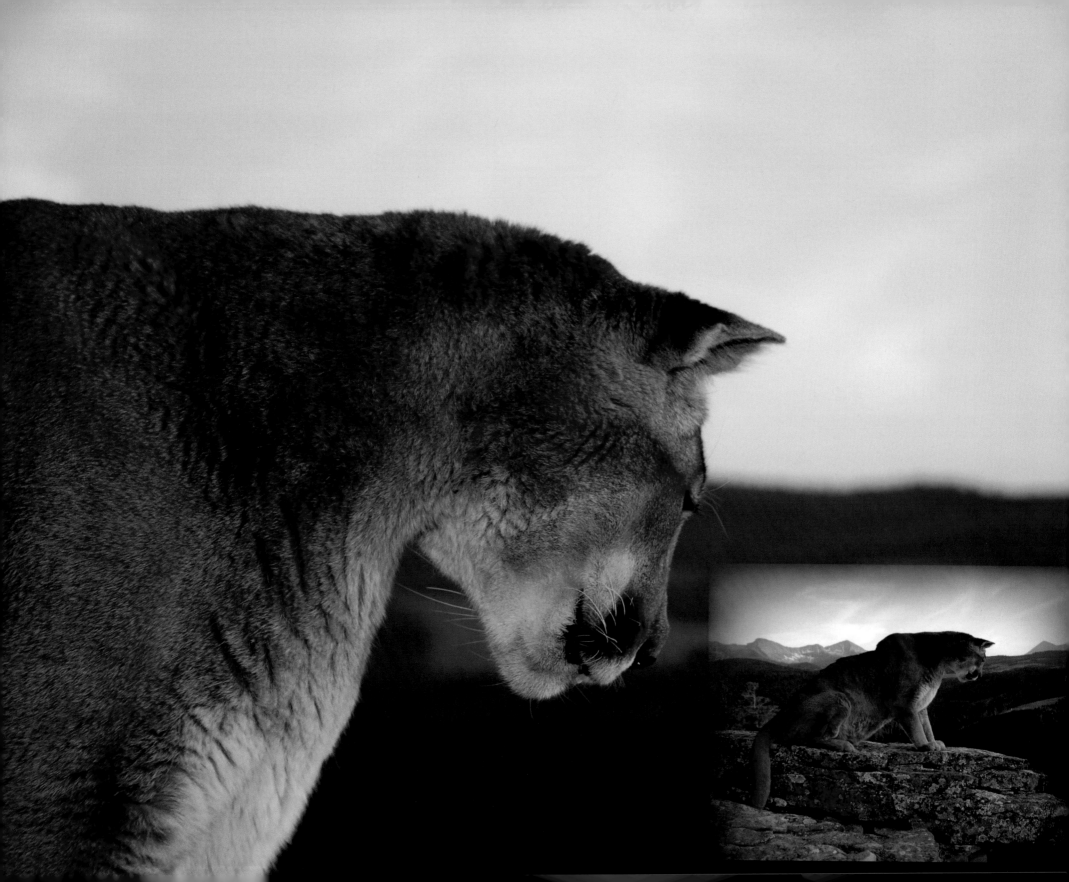

In Loving Memory of 'Ruby', a Friend to All

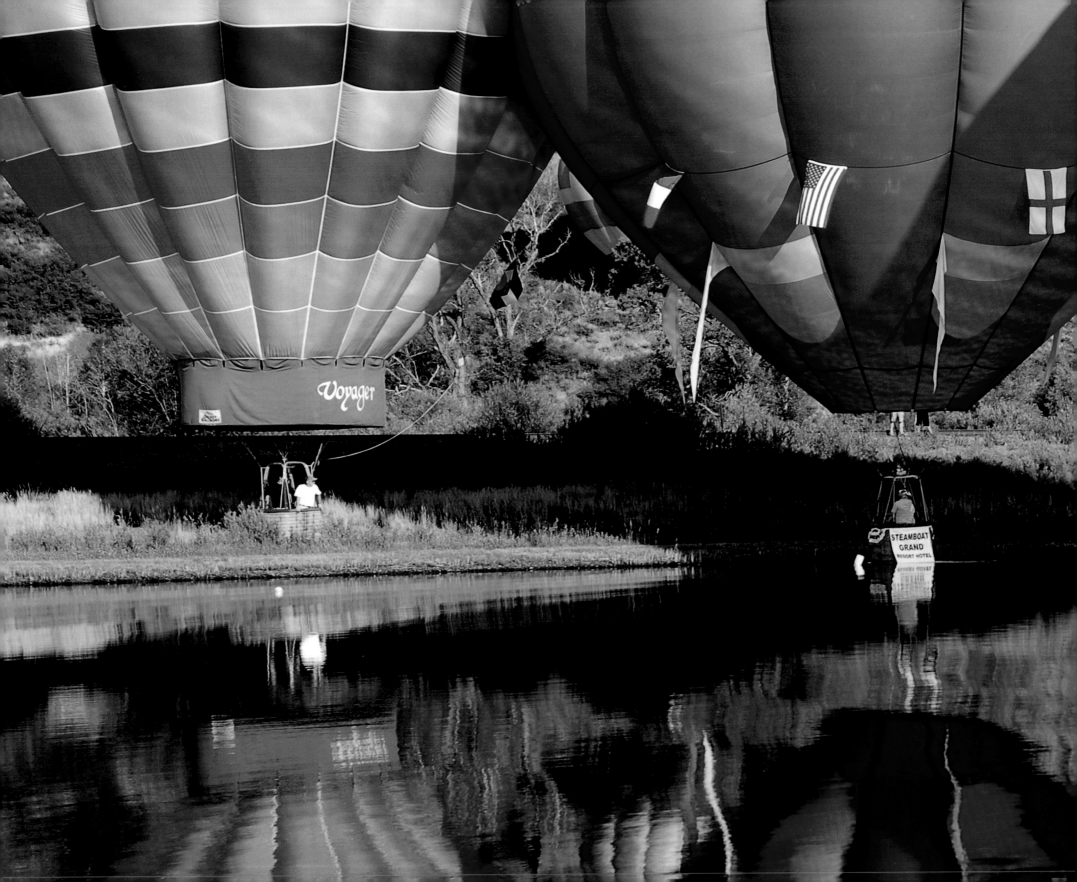

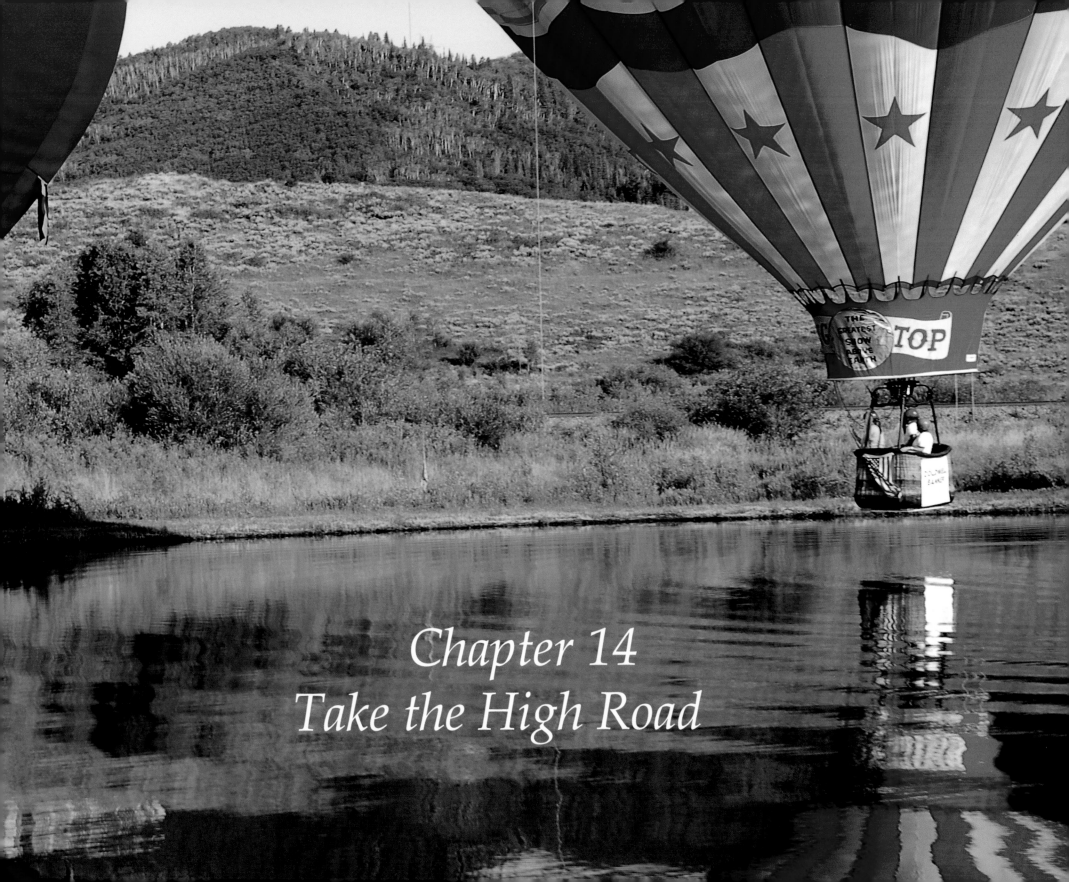

Chapter 14
Take the High Road

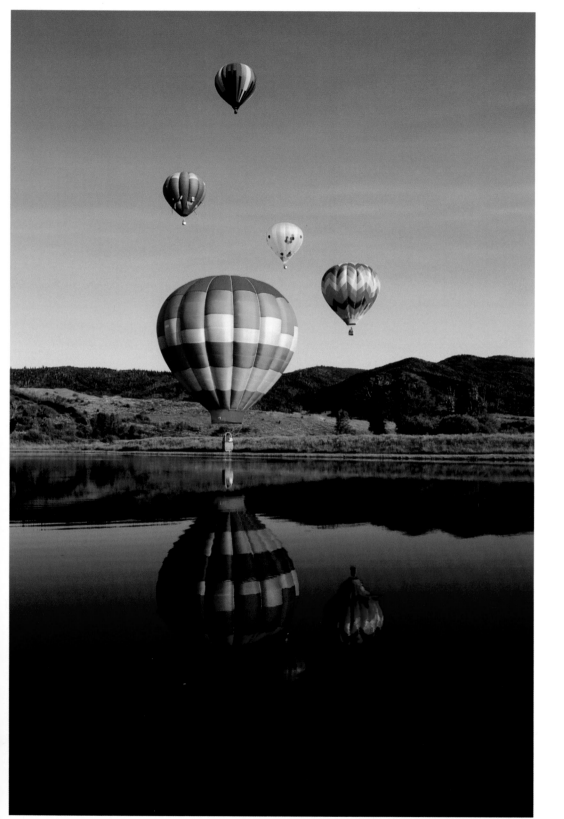
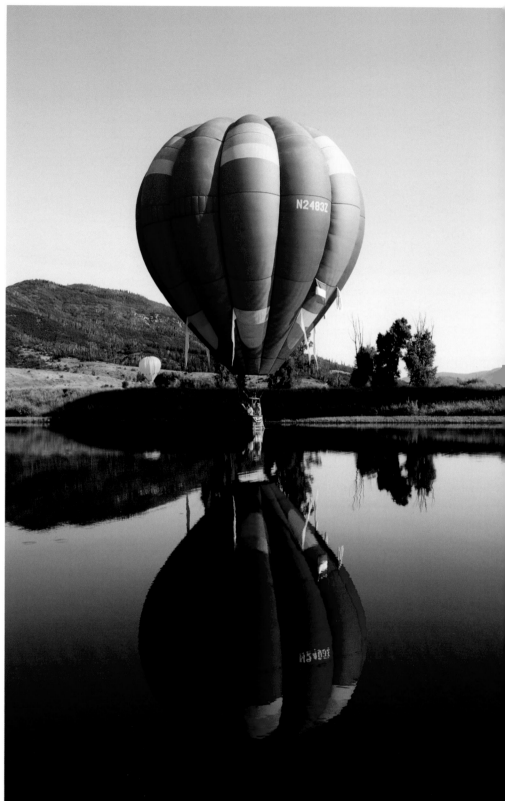

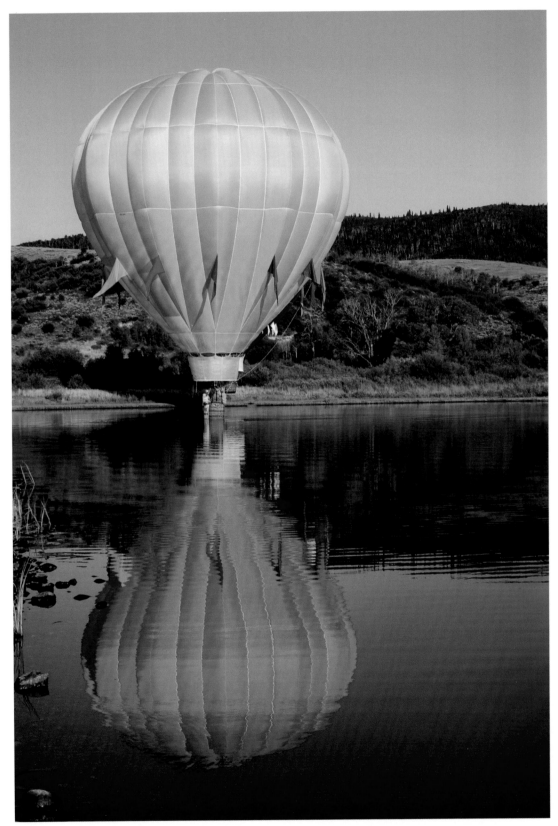

"Hot Air Ballooning above the Boat"

I fell in love with the Steamboat Springs, Colorado area many years ago. There is always so much to do in 'The Boat'. Strawberry Park Hot Springs is a place to dip yourself into and refresh your body in the natural hot spring water. In winter, the skiing and snowboarding at Steamboat ski resort is unmatched. There is always plenty of fresh powder to leave your tracks in. North of Steamboat you can visit Elk River Guest Ranch or take a horseback ride near Steamboat Lake. You will want to be sure to bring your camera. Coming into Steamboat from the south, the drive over Rabbit Ears Pass is grand. Each year around the Fourth of July the Rocky Mountains around Steamboat Springs come alive with color. No, the aspens don't start changing until September. I'm talking about the Steamboat Springs Hot Air Balloon Festival. Balloons come in from all over the United States. If you get up at first light, which comes very early this time of year, you can watch as the crews fill the balloons with hot air. The soft breeze, the cool fresh mountain air and a cup of hot coffee will get you started. If you're lucky and bold enough to ask, you might even catch a ride before the main event. You can capture some of the best photos early when the winds are still and hundreds of balloons are taking off at the same time. Some of the balloons are like works of art. What a grand site to see. In what I call 'A Touch of Class', the balloon pilots challenge each other to skim the smooth mirror-like water of the lake. These pilots are very skilled. A dip in the water and the balloon basket sits still for just a few seconds. Then you hear a blast from the balloon burners. It sounds like a rocket taking off as the hot air rushes into the giant balloon and it rises slowly above the water once again to drift quietly and slowly off into the bright morning sun. When they light up the balloons at night, it looks like Christmas, especially if you are watching from the top of the nearby ski mountain. The balloons look like little glowing Christmas tree ornaments. This is a great event to see.

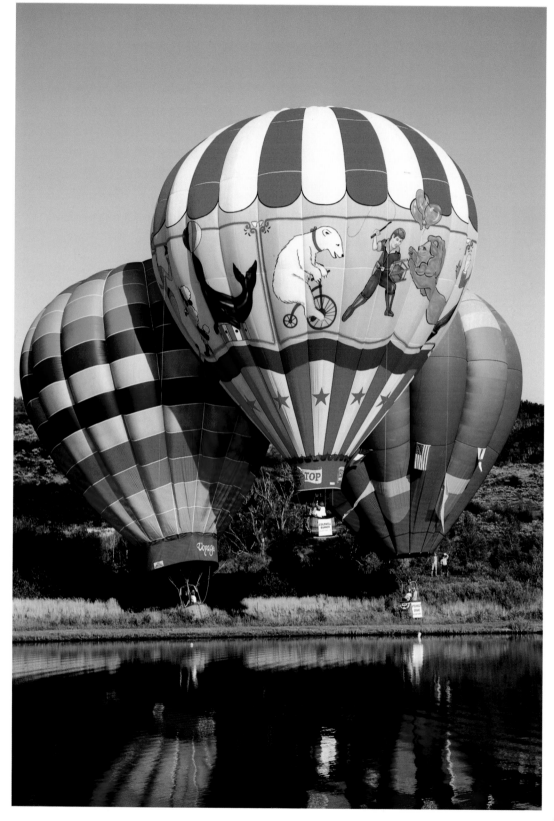

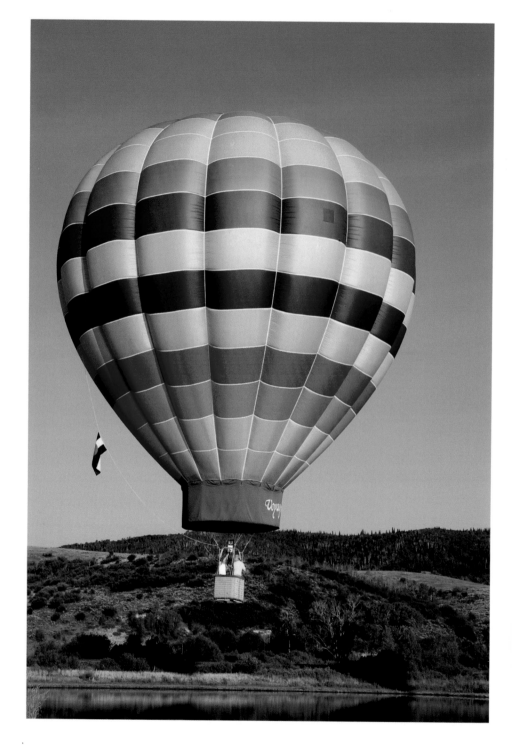

295

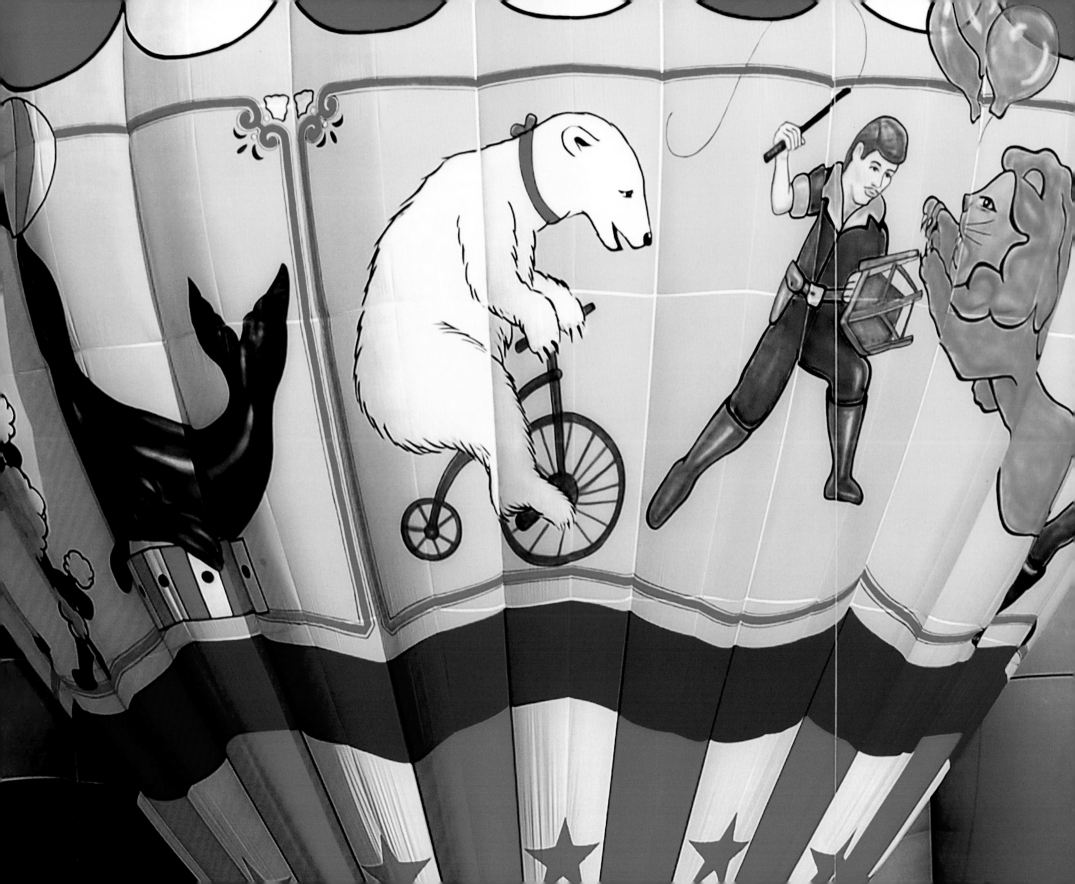

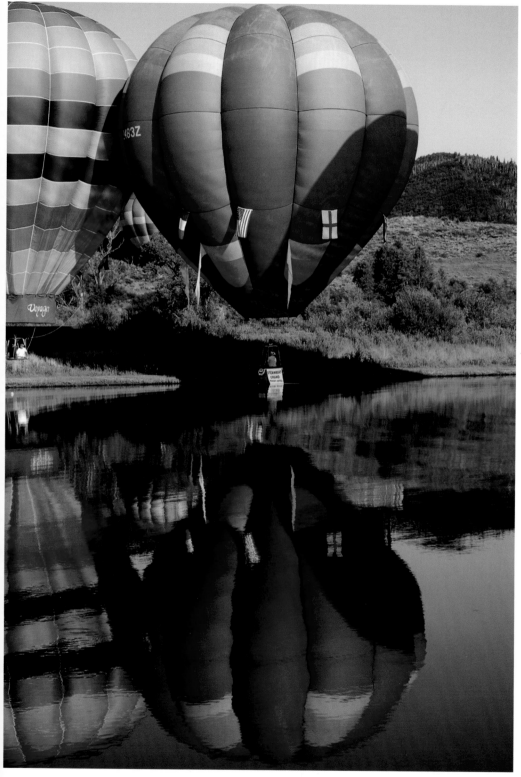
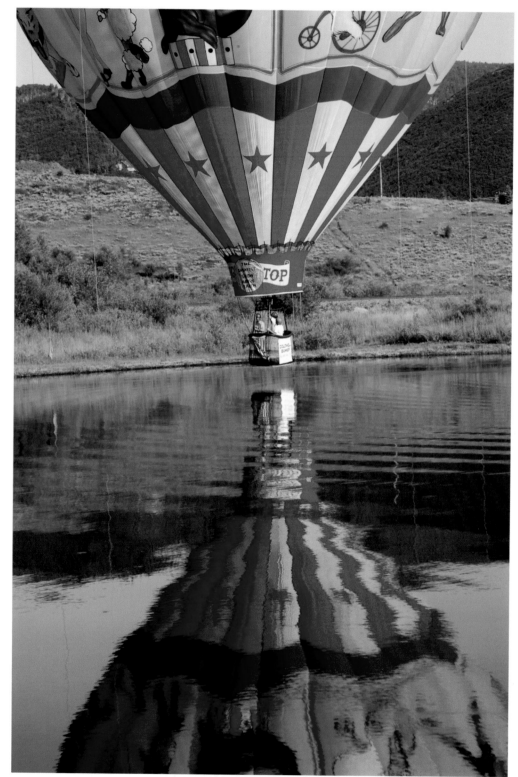

Chapter 15
Magical Fall Colors

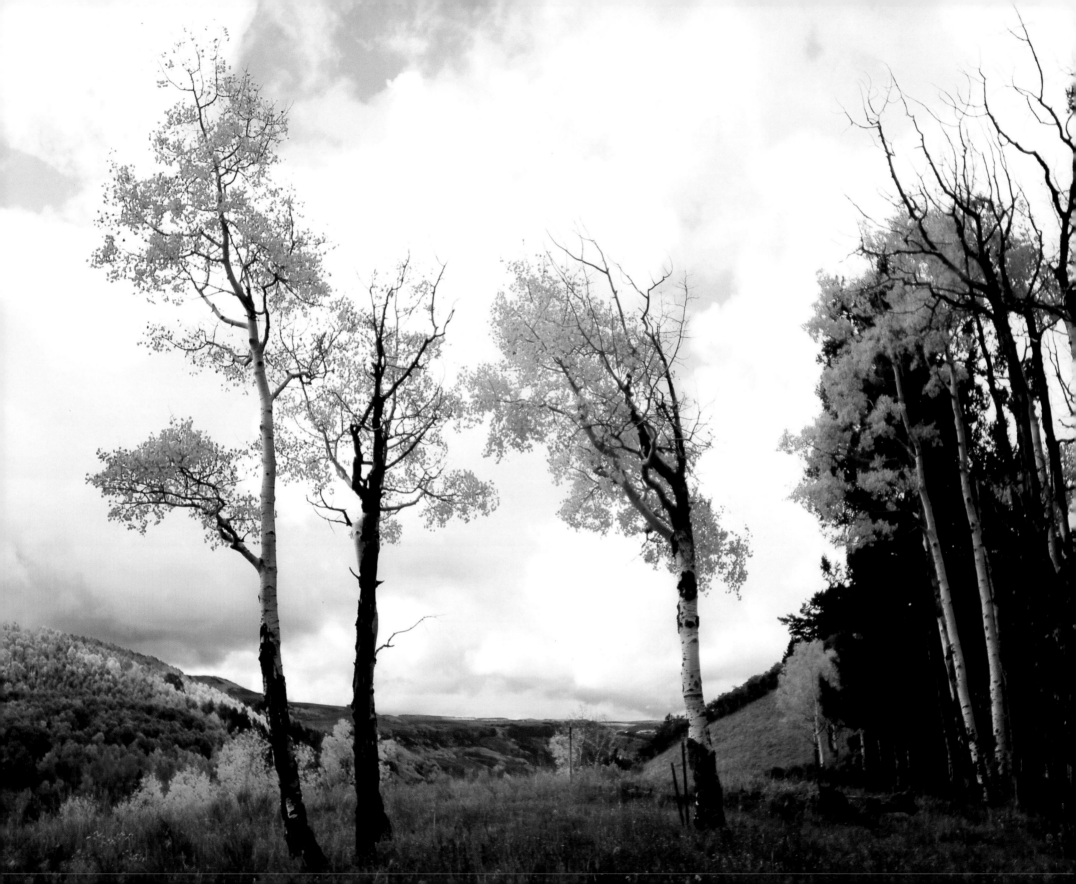

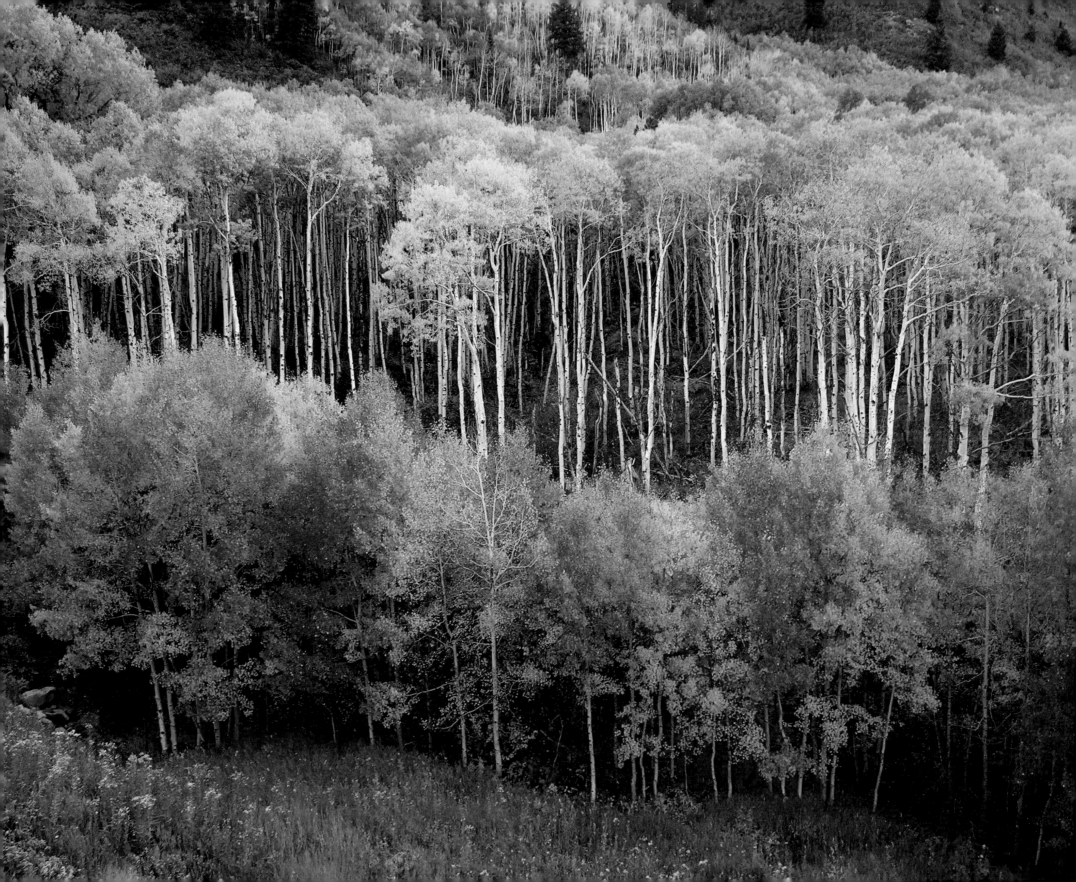

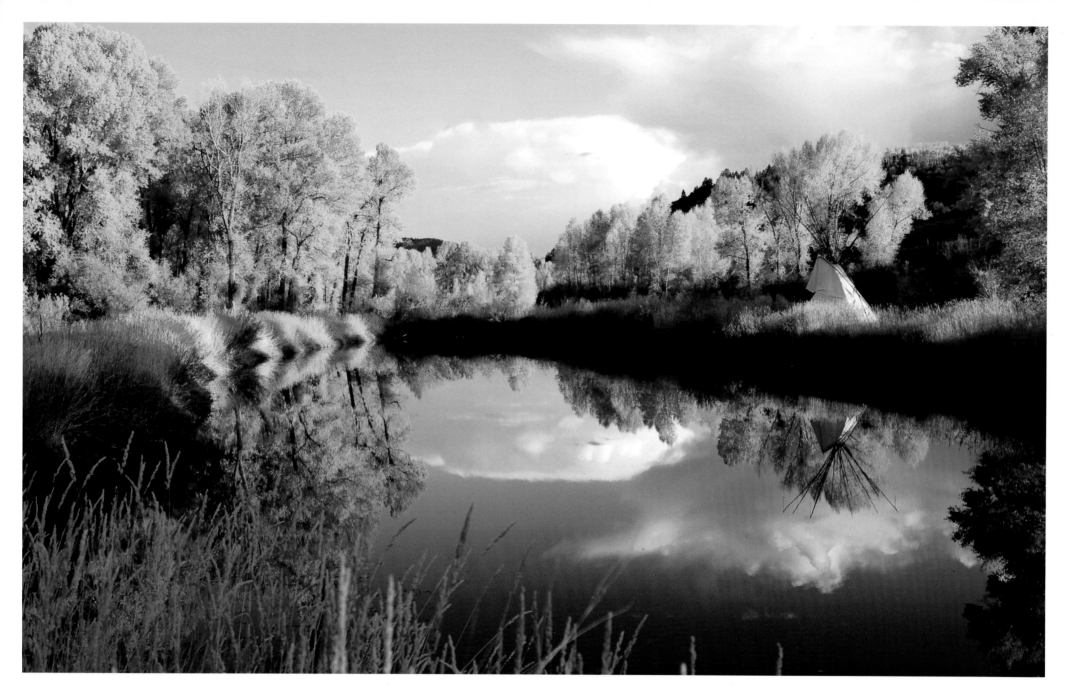

One of my favorite drives is the road between Steamboat Springs, Colorado and Steamboat Lake State Park near the little old mining town of Hahn's Peak. The drive to the lake is beautiful. The road follows the Elk River valley where some of Colorado's grandest cattle ranches stretch through the tall green grass as far as the eye can see. I like to stop at the old country store in the very small cowboy town of Clark for an ice cream or a bag of salted peanuts. When you arrive at the lake you'll want to have your camera ready. I came across this quiet scene on a calm autumn day when the water was as smooth as glass, reflecting the brilliant blue sky and the billowing white clouds. I felt as if I were looking back in time when Native Americans might have actually lived in teepees on the shores of this very lake.

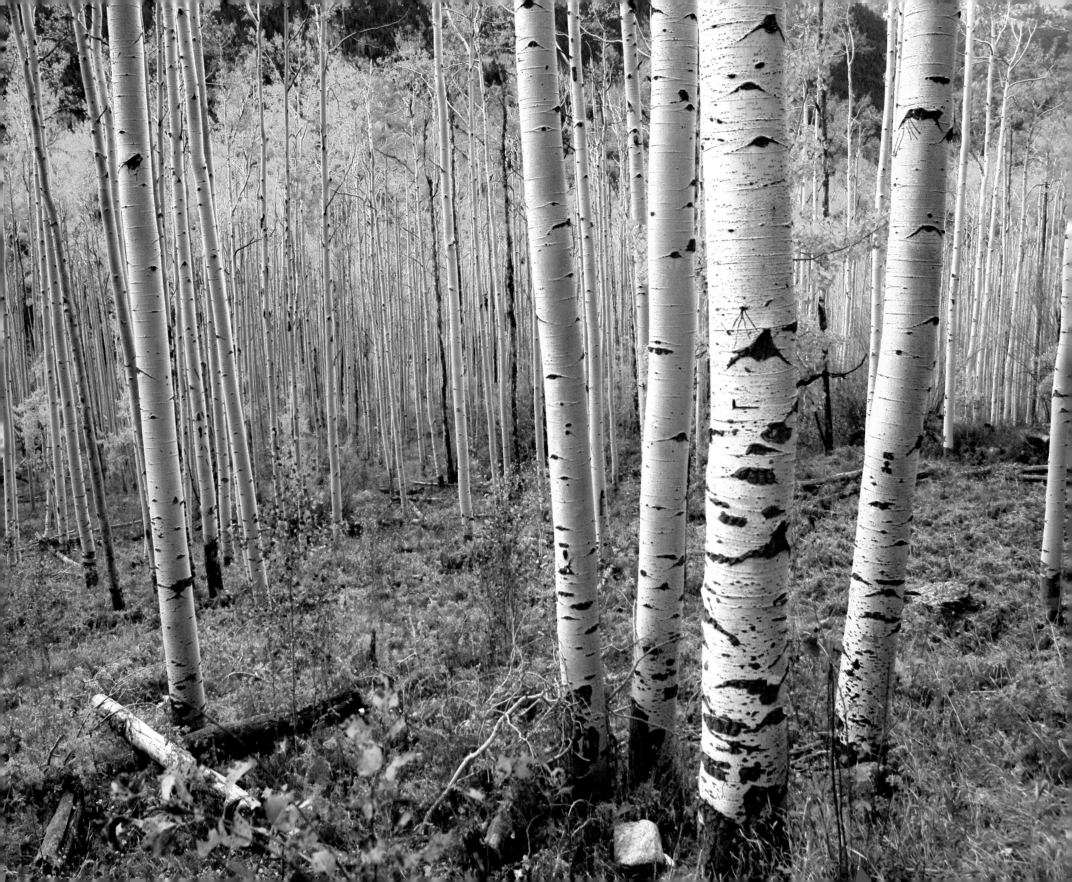

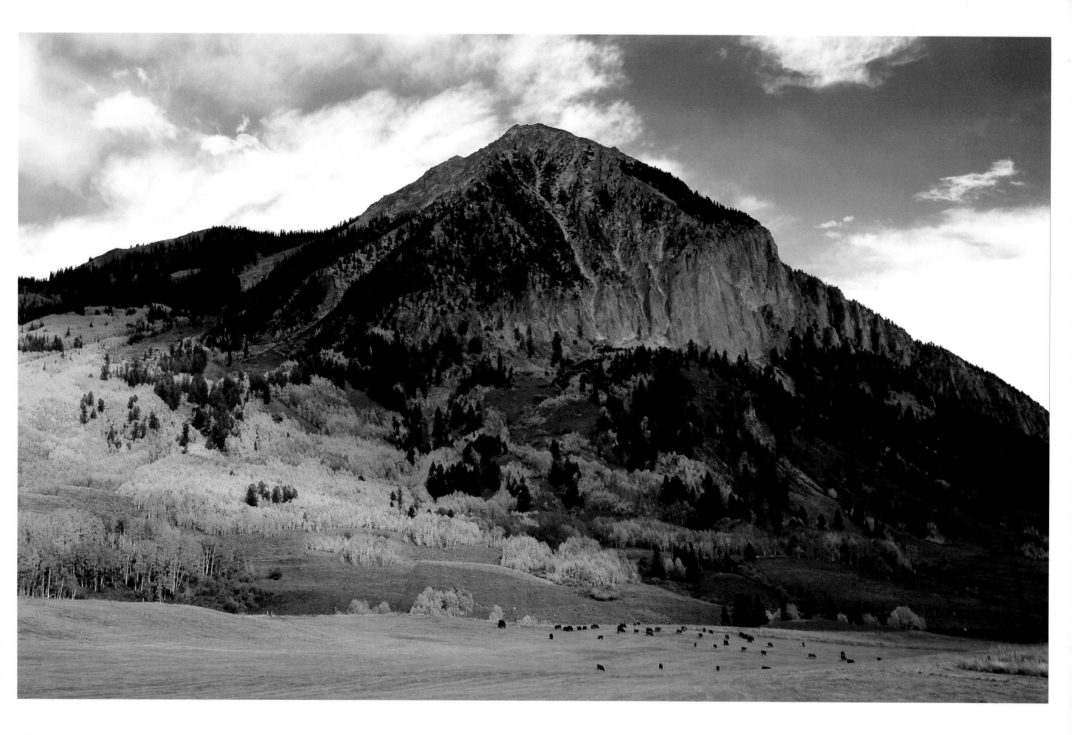

This mountain would be immediately recognizable in the winter from the opposite side of the mountain to many who ski in central Colorado. This is Mount Crested Butte in the summertime as seen from the back side. If you only visit the Colorado Mountains in winter for skiing or snowmobiling, it's hard to visualize the vast pastures and grasslands that burst out from under the heavy winter snow in the spring and summer.

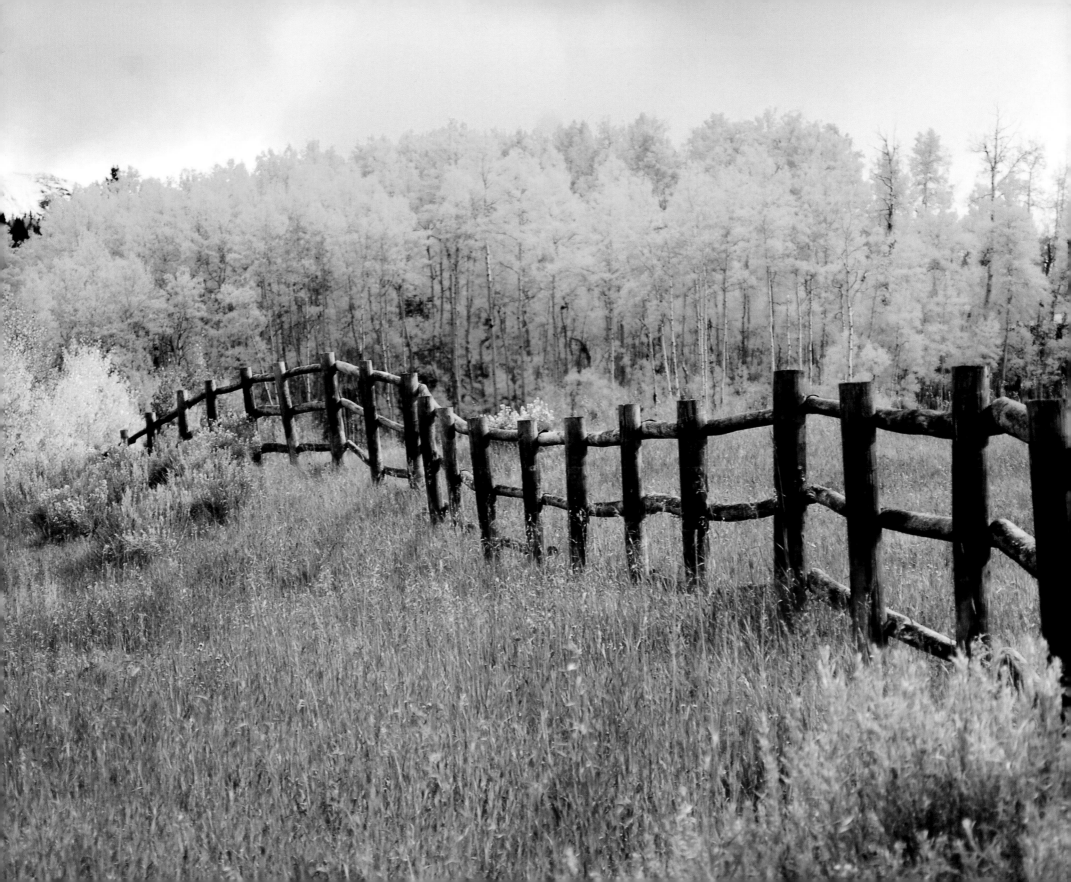

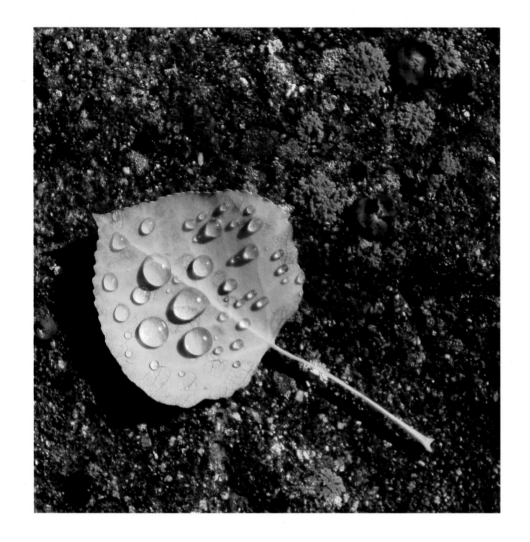

I took these photographs near the top of Independence Pass, around 11,000 feet above sea level, between Twin Lakes and Aspen, Colorado late in the fall color season. Most of the aspen leaves had already turned from bright yellow to brown, and many had already fallen off the trees altogether. What most people don't realize is that after the leaves turn brown is when the plants and grasses that grow on the ground start to turn brilliant shades of red and orange.

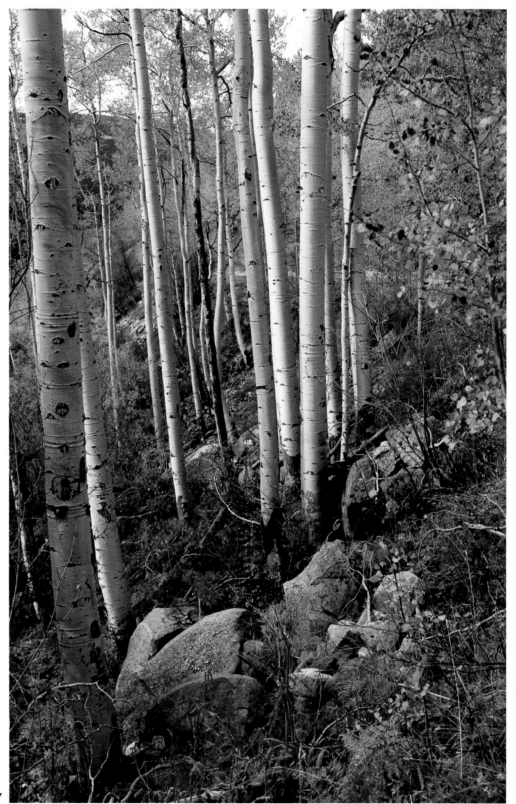

307

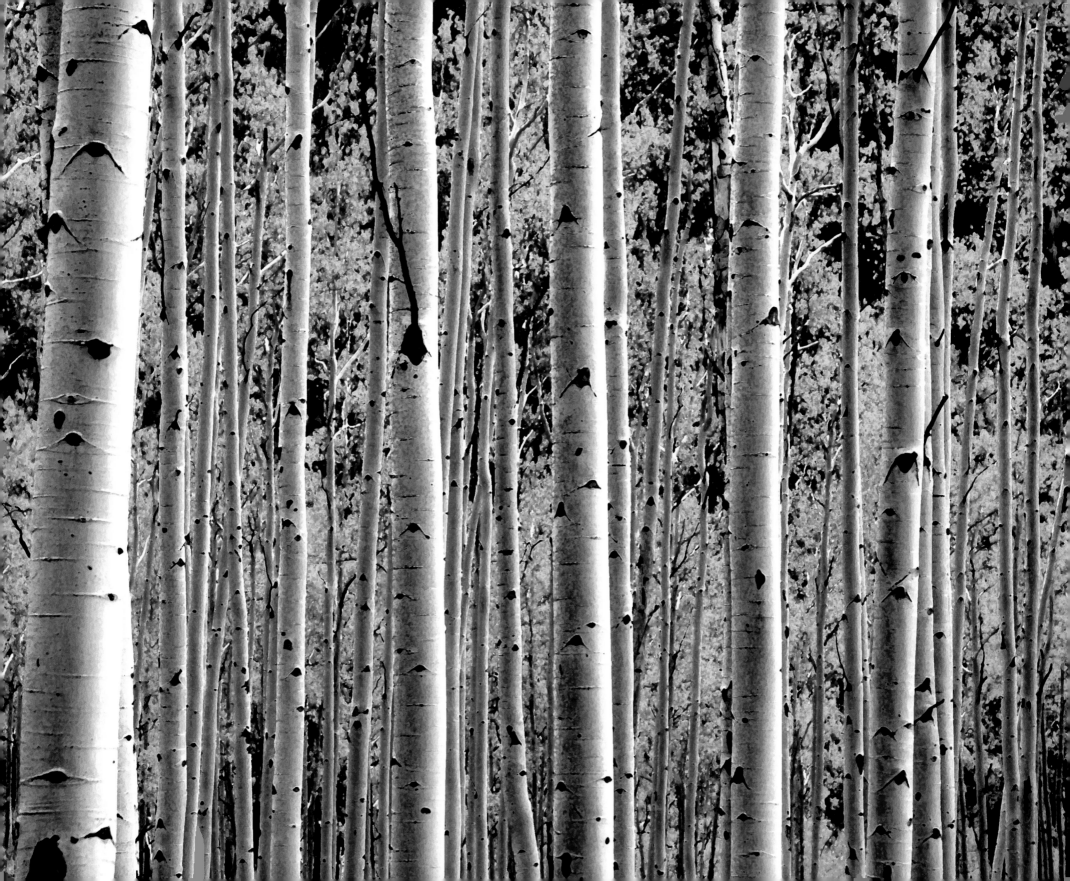

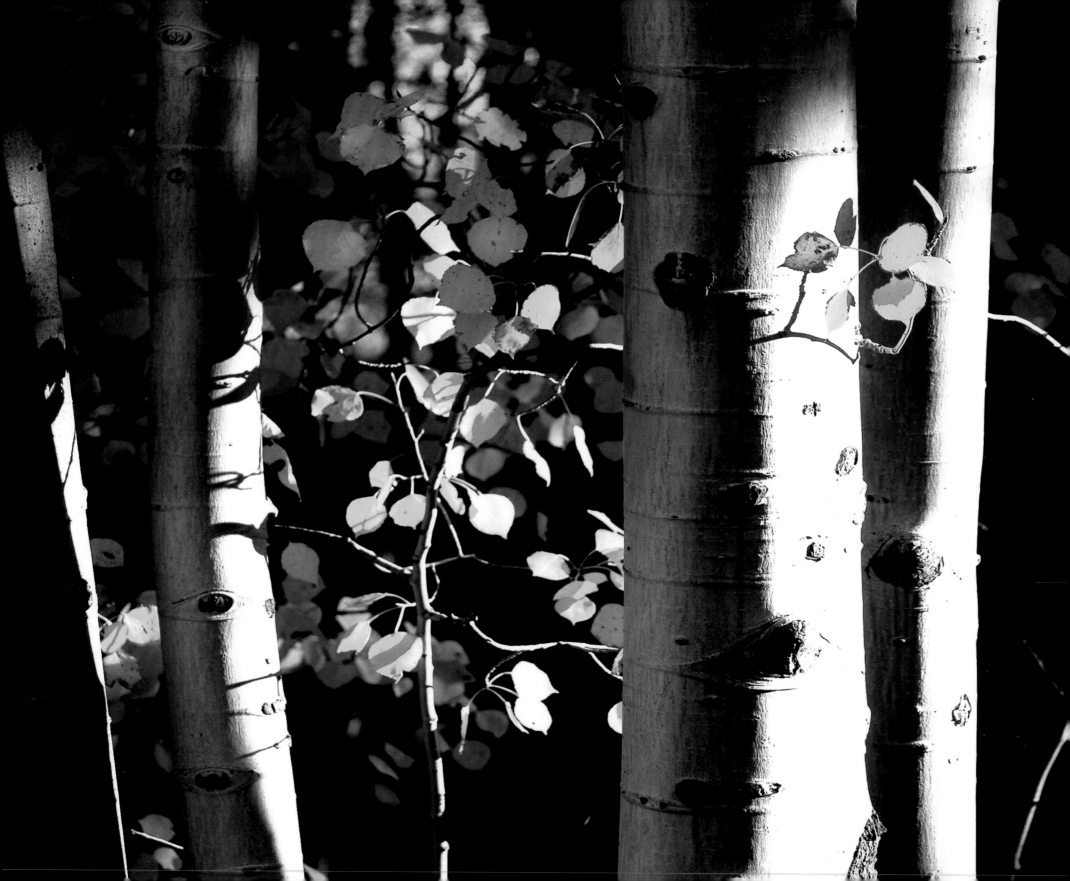

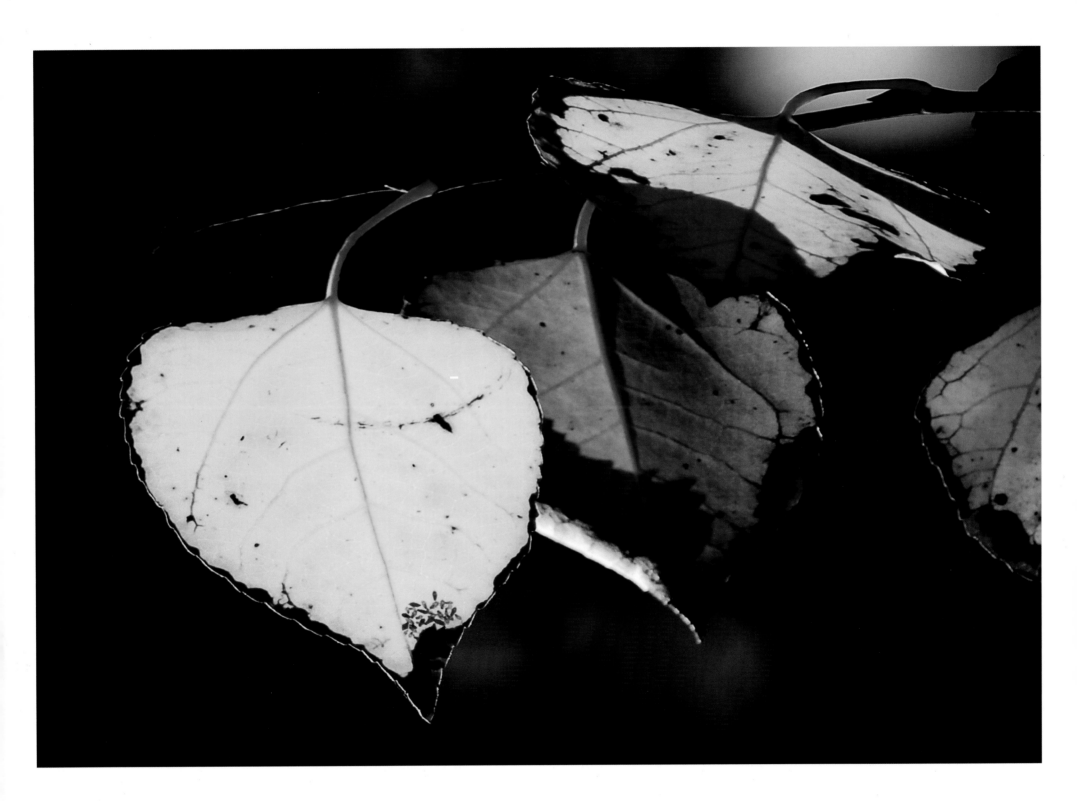

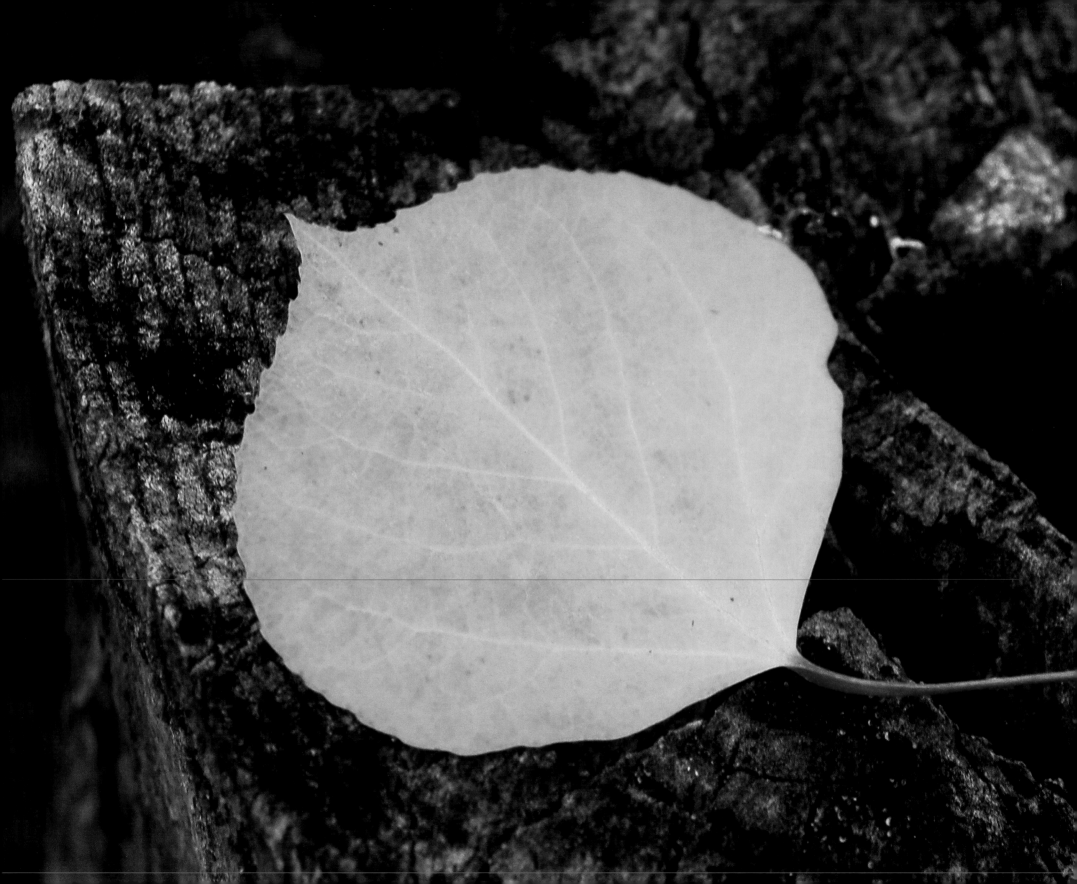

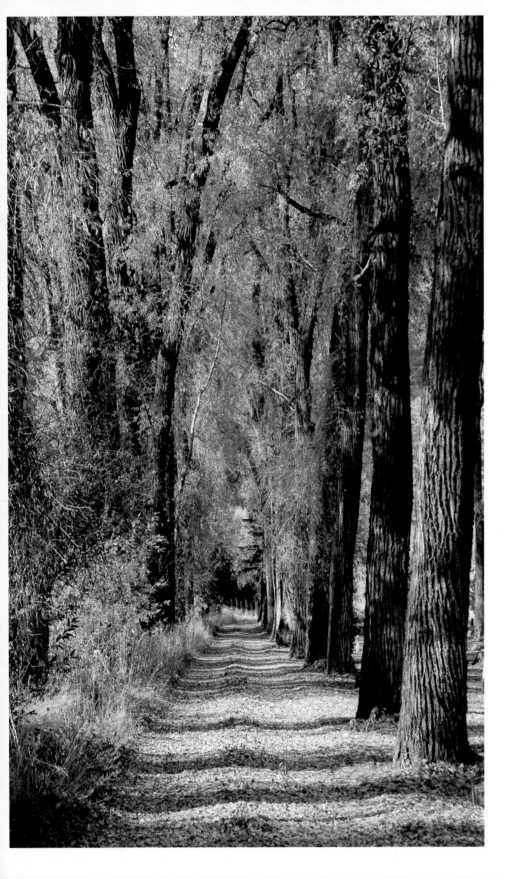

These tall sentinels stand guard along both sides of the path that leads into the cemetery in Aspen, Colorado. It feels almost as if they have prepared a nice soft leaf covered path for those who have traveled over many hard, dusty, dirty muddy roads of life as they make their final journey down this one last road as they travel to their final destination on this road they wish they didn't have to take.

312

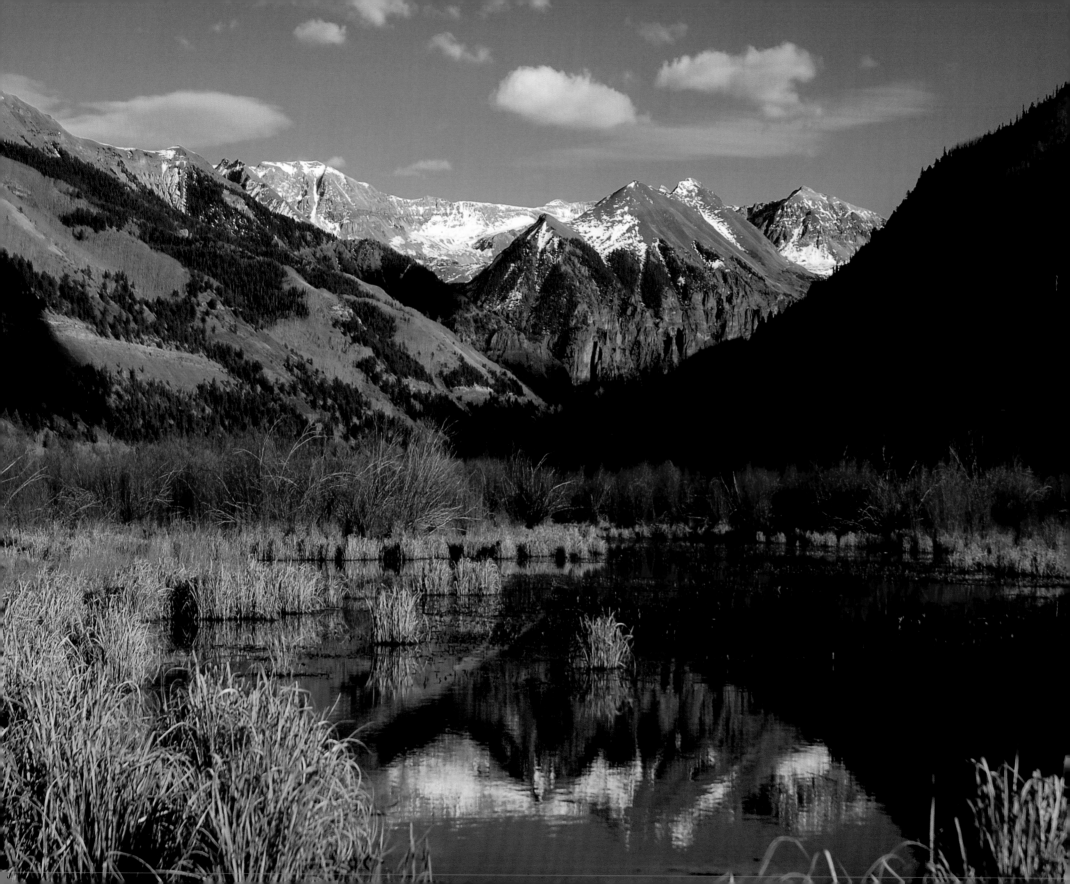

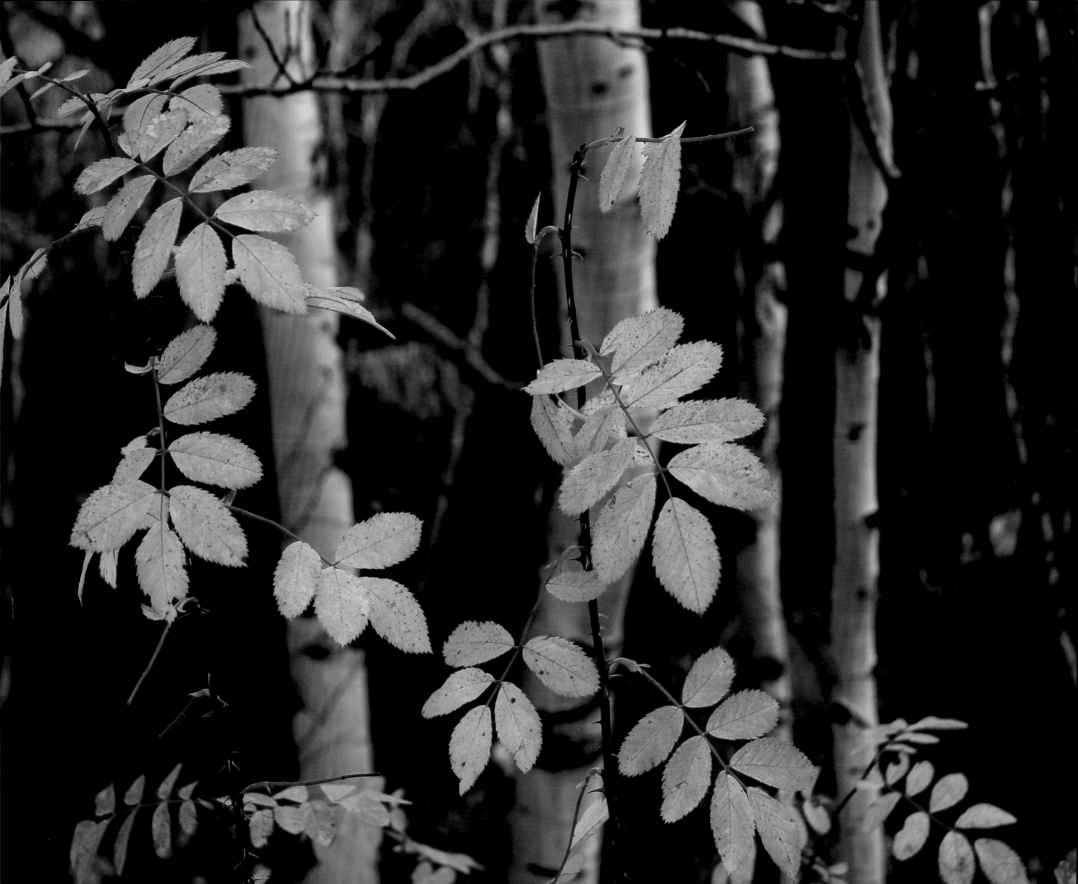

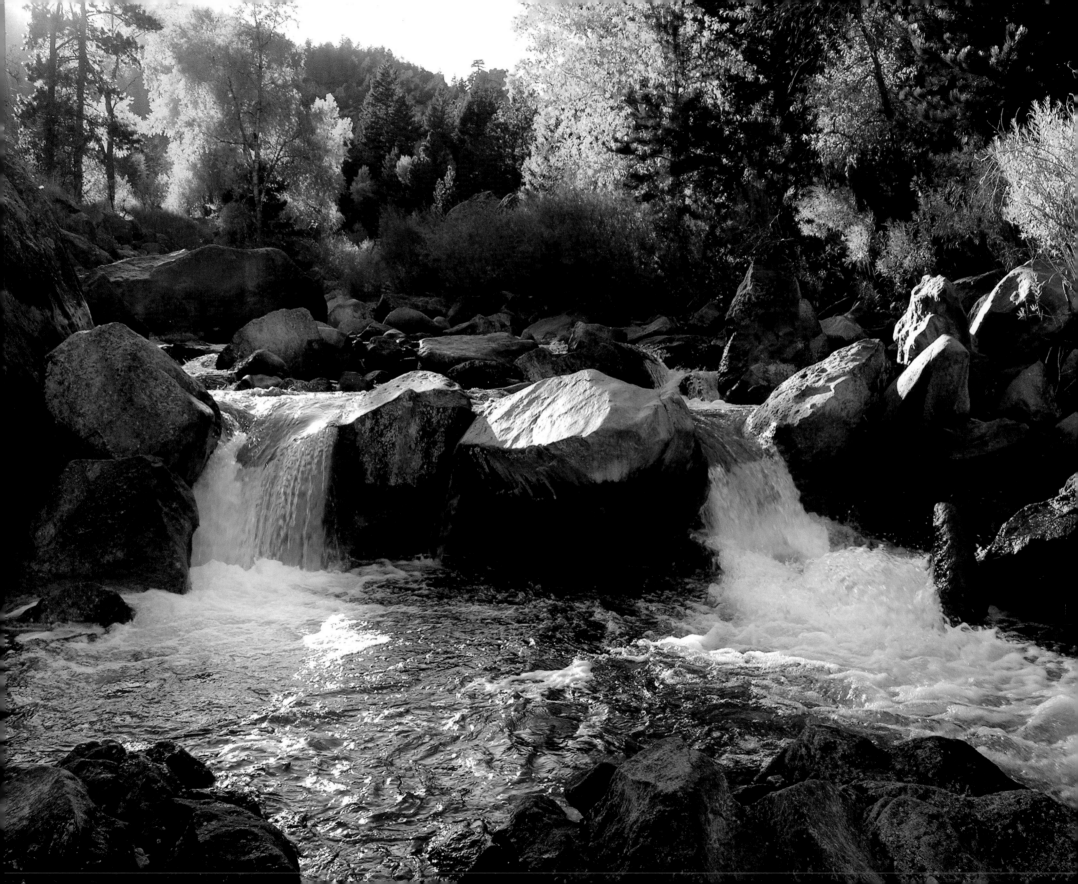

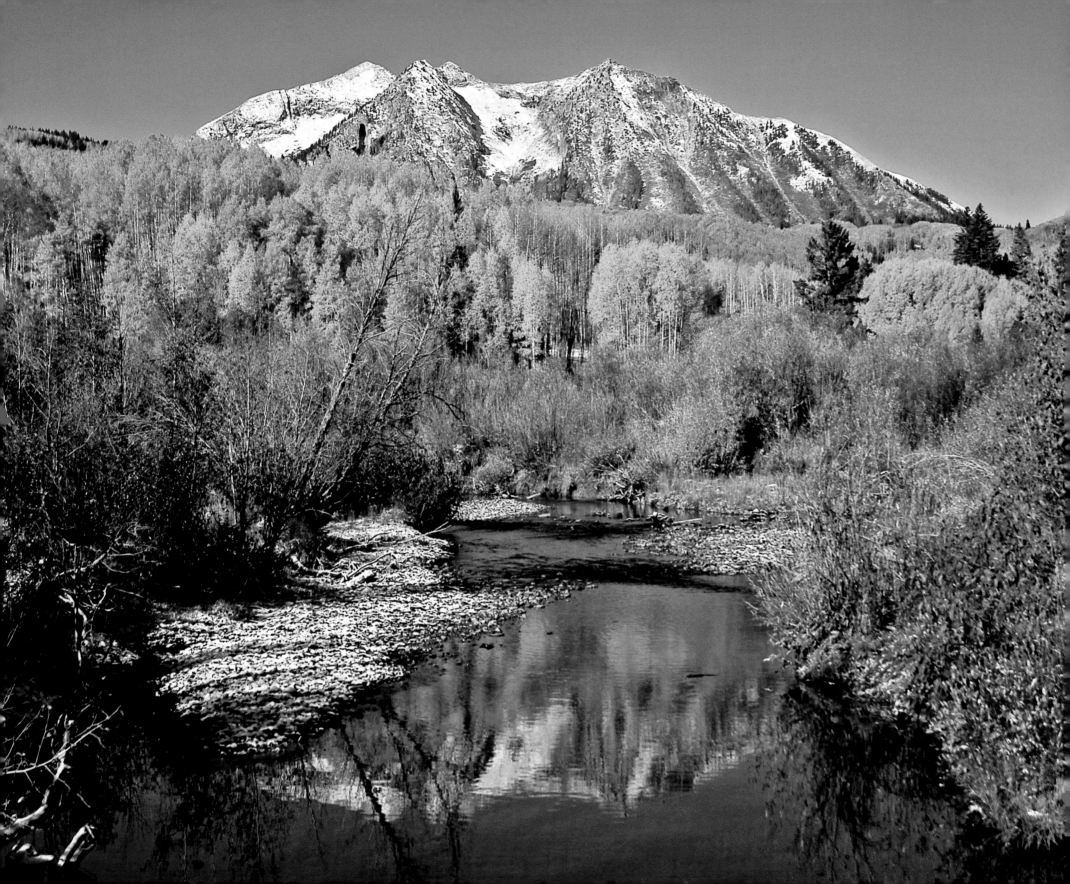

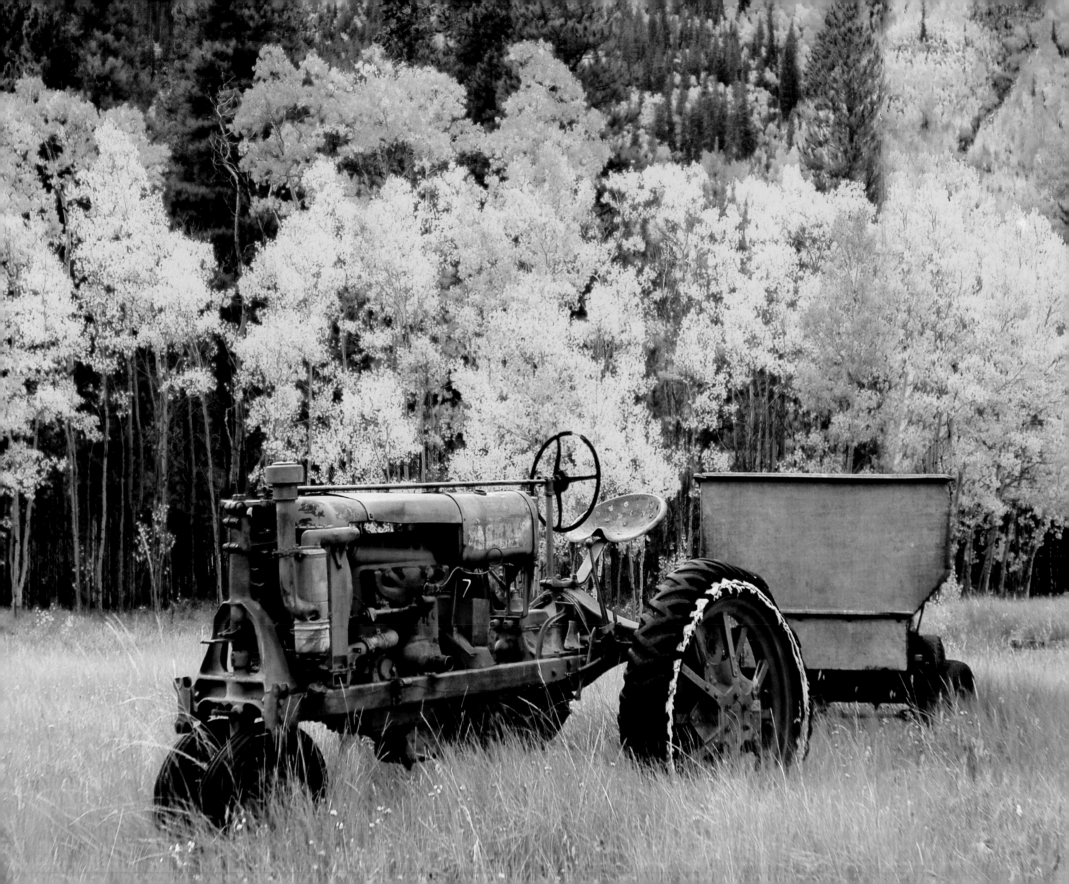

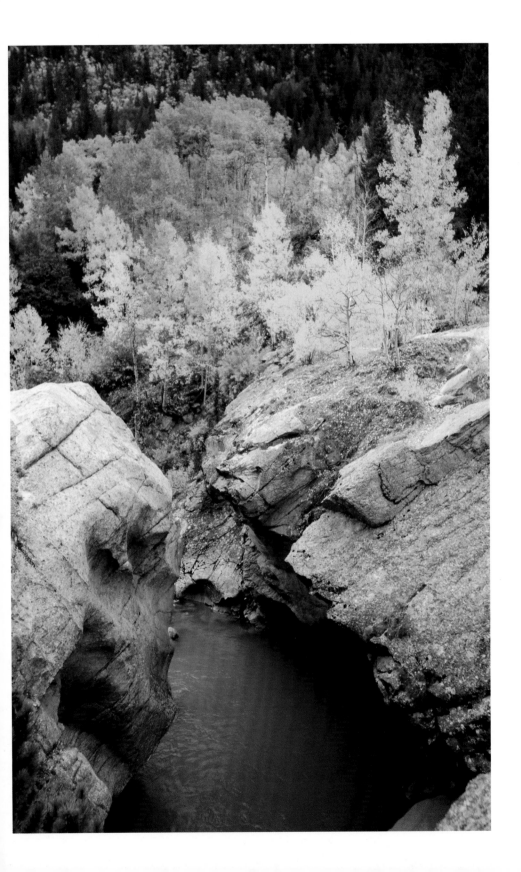

I found these beautiful rock formations while hiking near Willis Gulch toward the west end of Twin Lakes in Lake County in central Colorado. An added feature that made these photographs more striking is the bright greens and blues in the water. The minerals that are dissolved in the water give it this color, which is why you will find many lakes and streams in this area named turquoise, emerald, mineral, copper and blue.

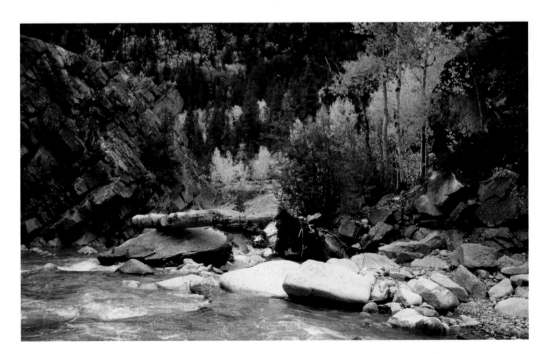

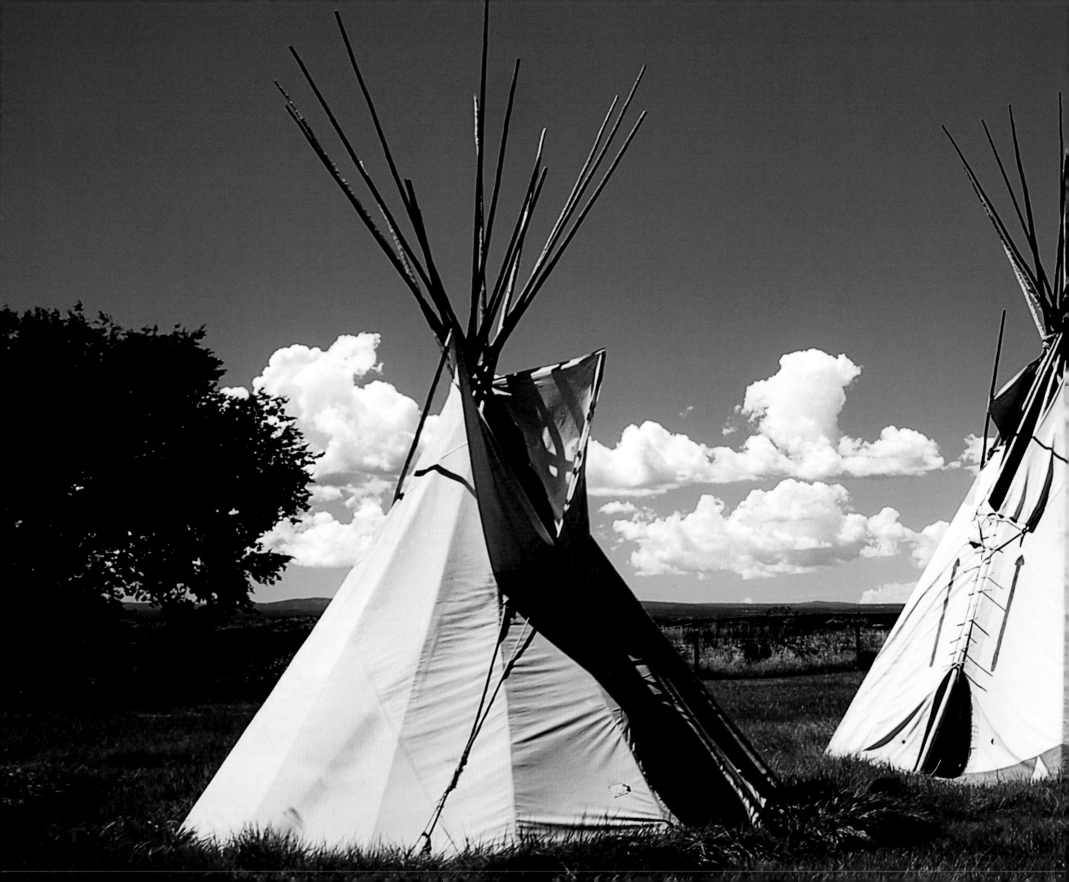

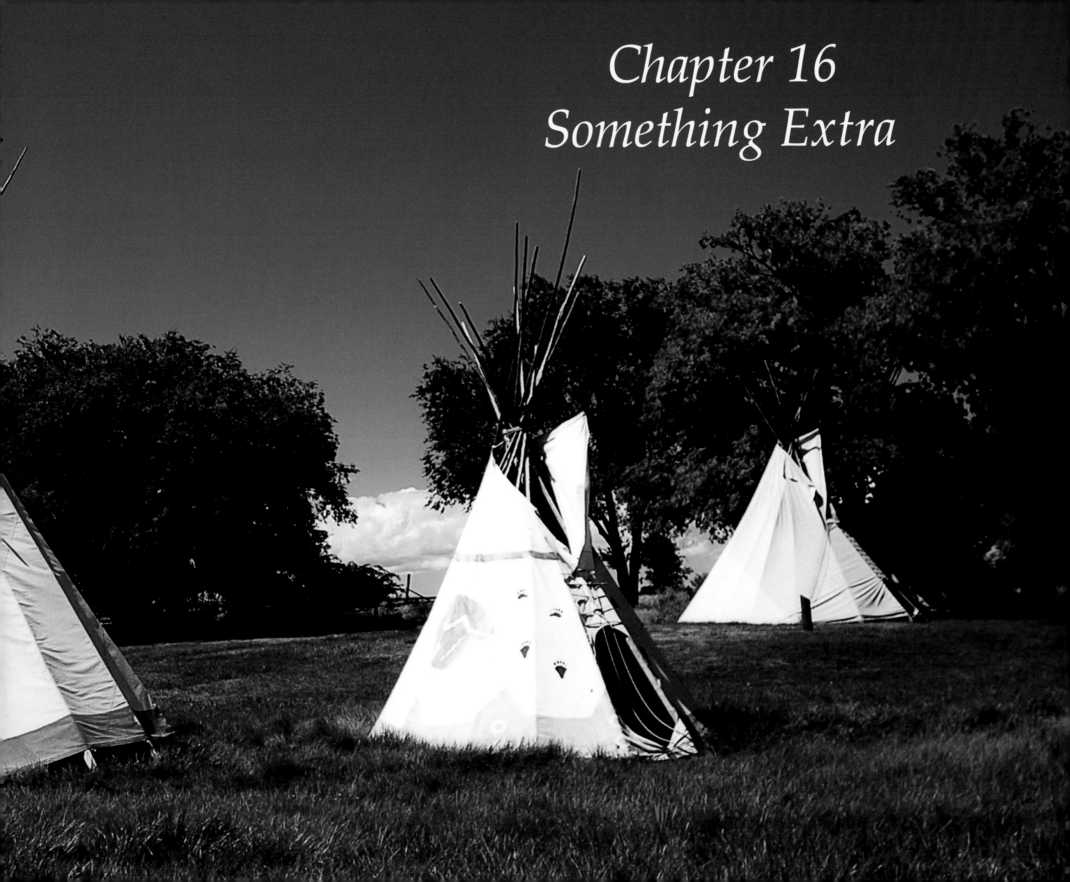

Chapter 16
Something Extra

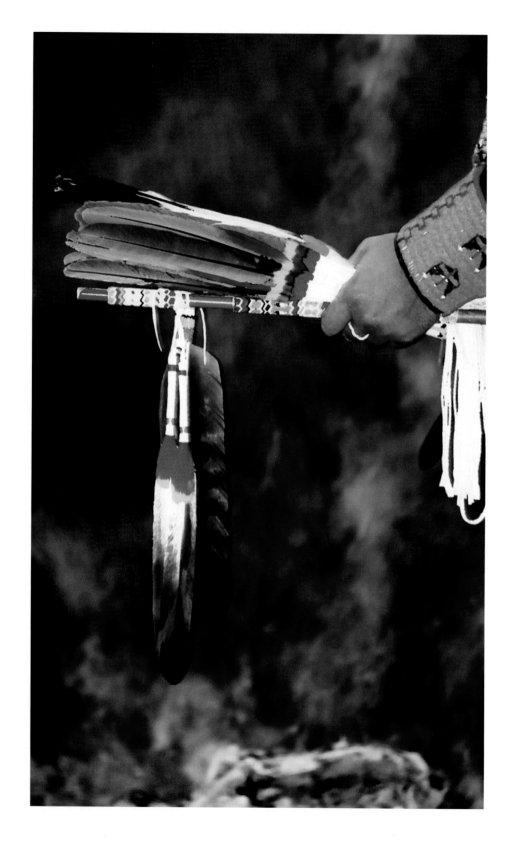
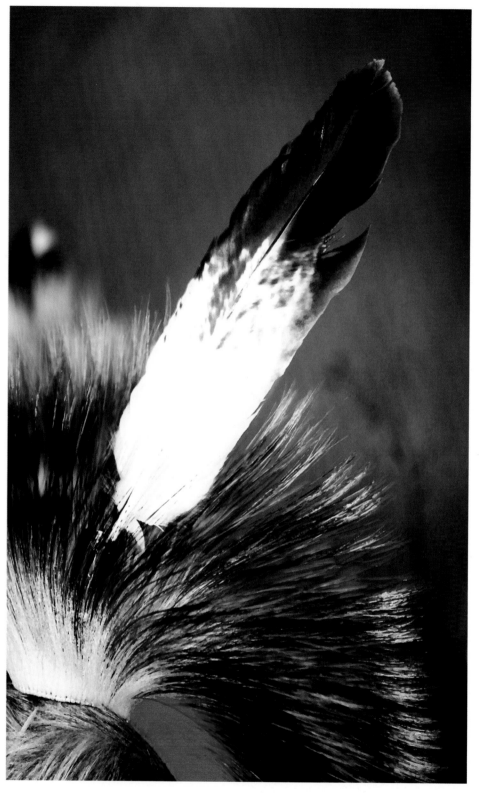

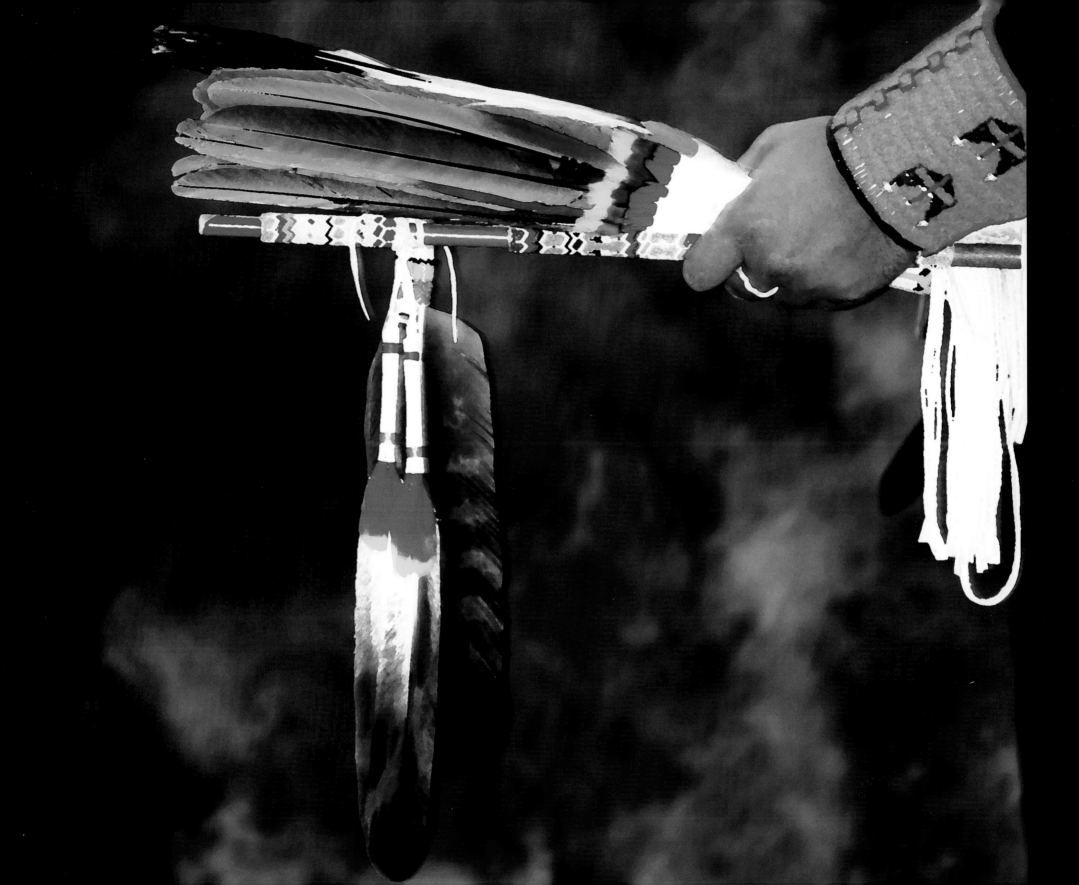

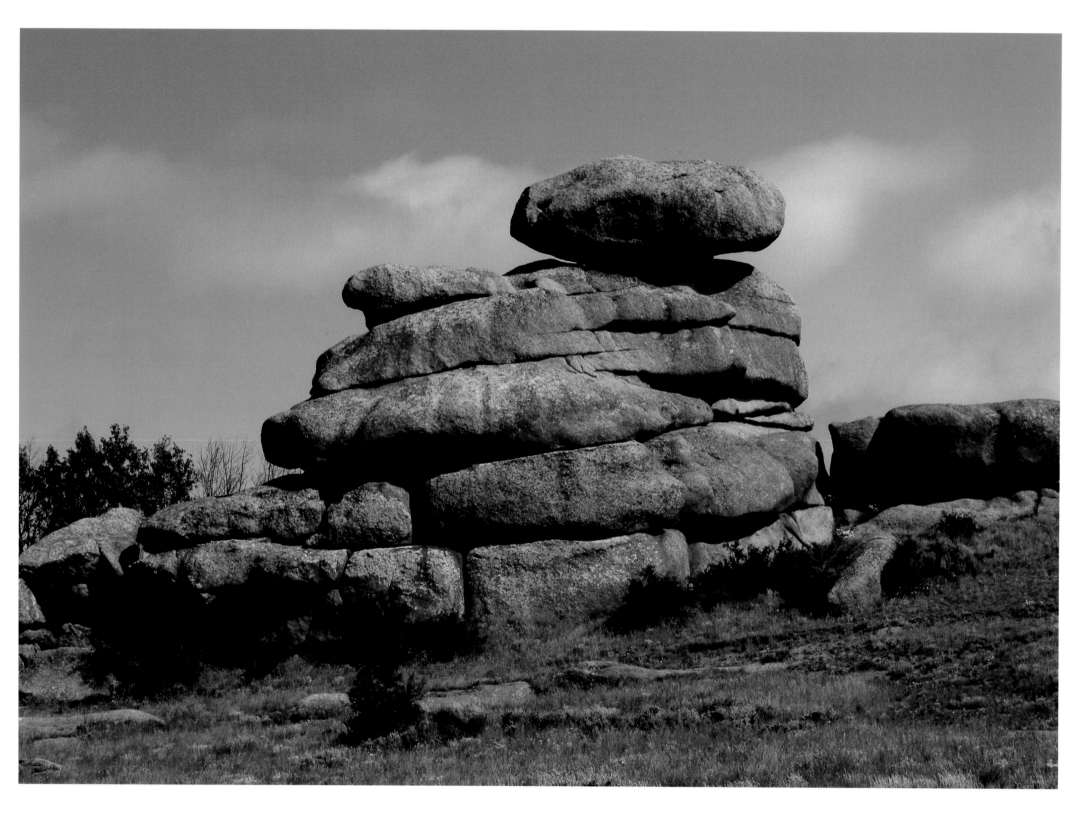

You have to be willing to get off the beaten path if you want to be able to see places like these. You won't see this from the seat of your car traveling at 80 miles per hour down the highway, staring at the taillights of the car in front of you.

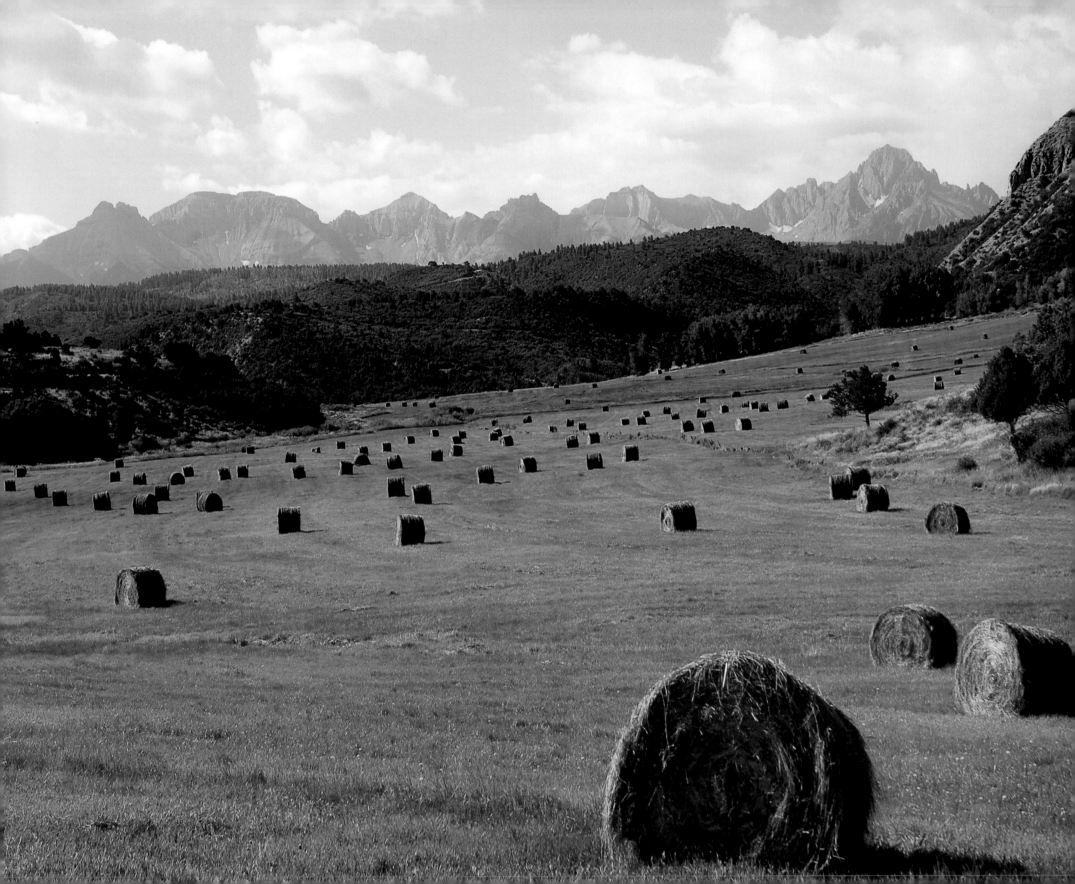

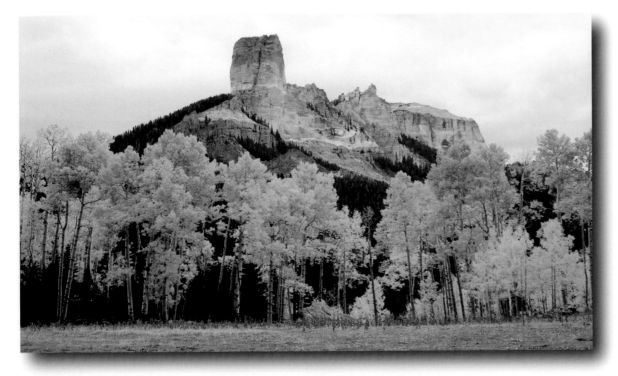

Some of you might recognize this distinctive mountain from scenes in movies such as 'True Grit' and 'How the West Was Won'. Known as Chimney Rock, this peak towers to nearly 12,000 feet above sea level and is located near Owl Creek Pass in southwest Colorado near the small mountain town of Ridgway, which doubled as Fort Smith, Arkansas in the movie 'True Grit' which starred John Wayne. The meadow located at the base of the mountain is known as Deb's Meadow after Debbie Reynolds who starred in 'How the West Was Won'.

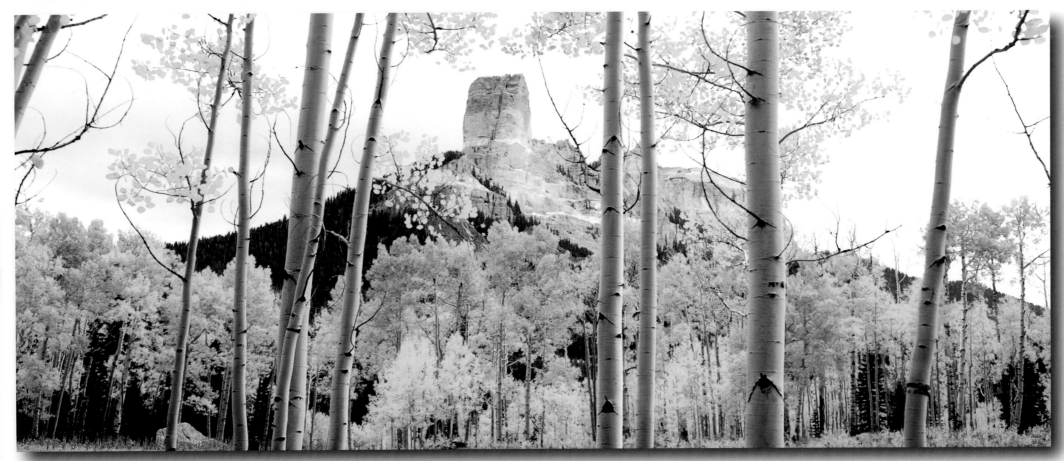

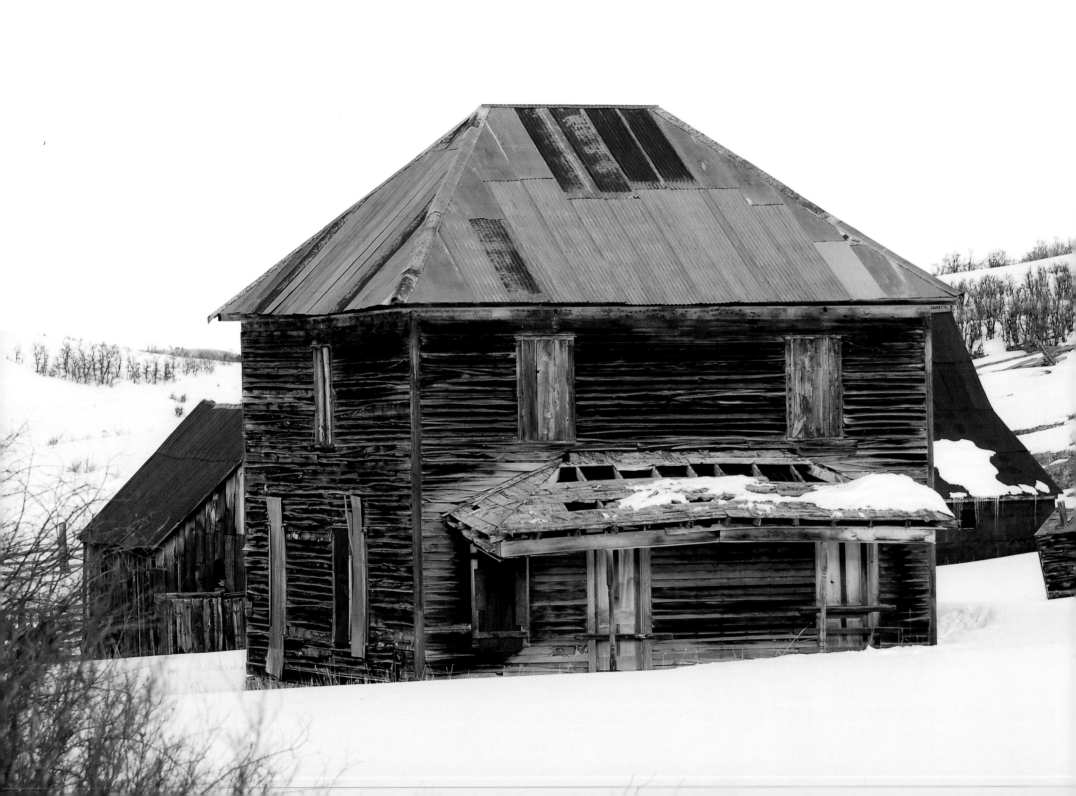

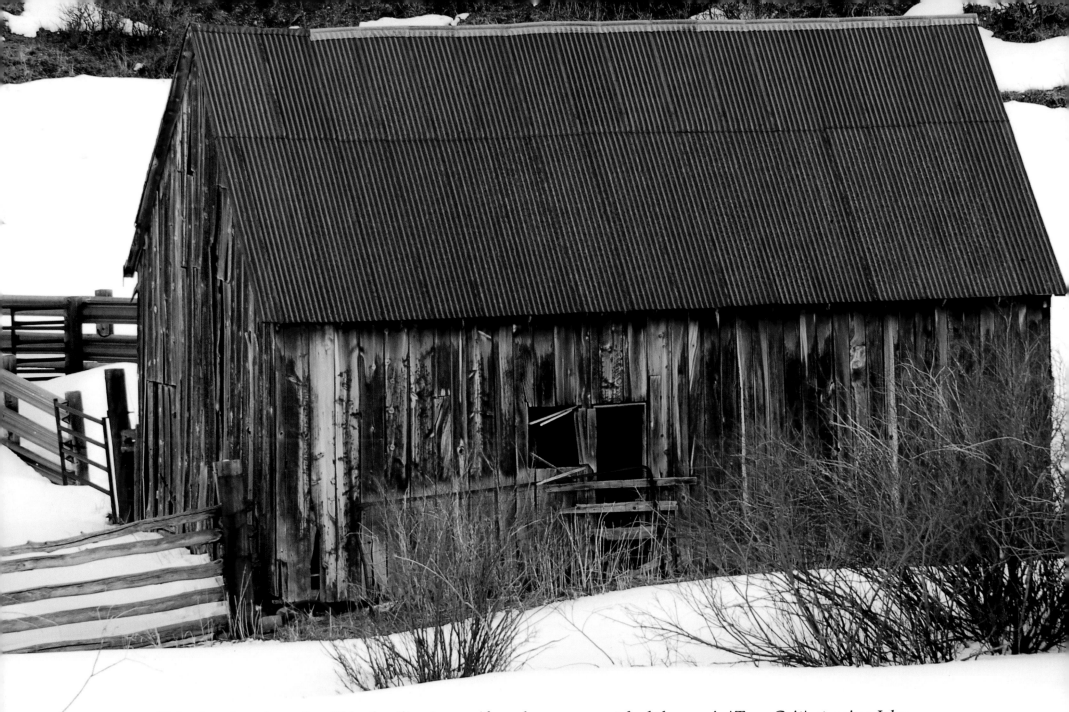

This abandoned ranch will be familiar to you if you have ever watched the movie 'True Grit' starring John Wayne. Located along Last Dollar Road, which runs between Ridgway and Telluride, Colorado, this ranch was used as the Ross Ranch, both at the beginning and the end of that movie. It's difficult for big John Wayne fans, like Rod and myself to see the old ranch fall into disrepair the way it has. If you look closely, you will recognize the house, the big old barn, a shed and even the outhouse that appeared in the movie. The four-rail fence that John Wayne jumped with his new 'tall horse' at the end of the movie is still there, but has since fallen over.

Izzy's

This is one of my favorite places to eat in Crested Butte, Colorado. It's just a little place on a back street. I found it one day and decided to have breakfast there. They have the best potato pancakes I've ever had. I've eaten there many times since, but this particular day there were all these colorful bicycles parked in front. The rainbow of color just caught my eye, with the bright red building in the background and all the bikes stacked in front. This was the only time I have seen it like this. I have actually sold numerous copies of this shot. People just seem to like the mix of bright colors and the quiet mood of a small mountain town on a bright sunny day.

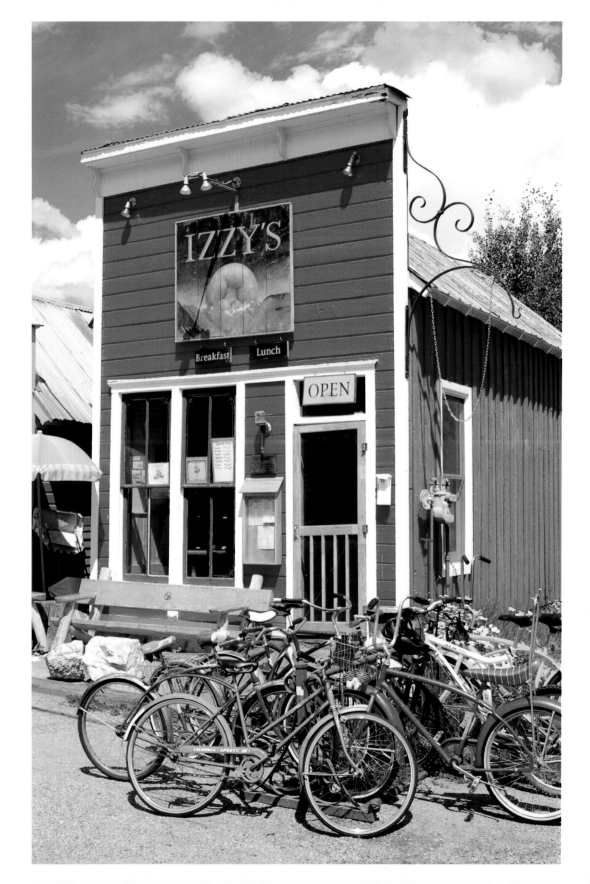

Index

Index

Index

Thank You for taking this Journey with me.
You are always welcome at my campfire.

Photographer
Bill Hitz

Reprints of all photographs included in this book are available for purchase. For more information or to place an order, please visit our website: www.roadslesstraveledbook.com. A portion of the purchase price of this book and any reprints ordered from this book will be donated to support The Children's Hospital in Denver, Colorado. We would like to thank you for your support of this book, which has been a dream in progress for many years. Watch for us as we travel yet 'Another Road Less Traveled'...

Bill Hitz ©
2010

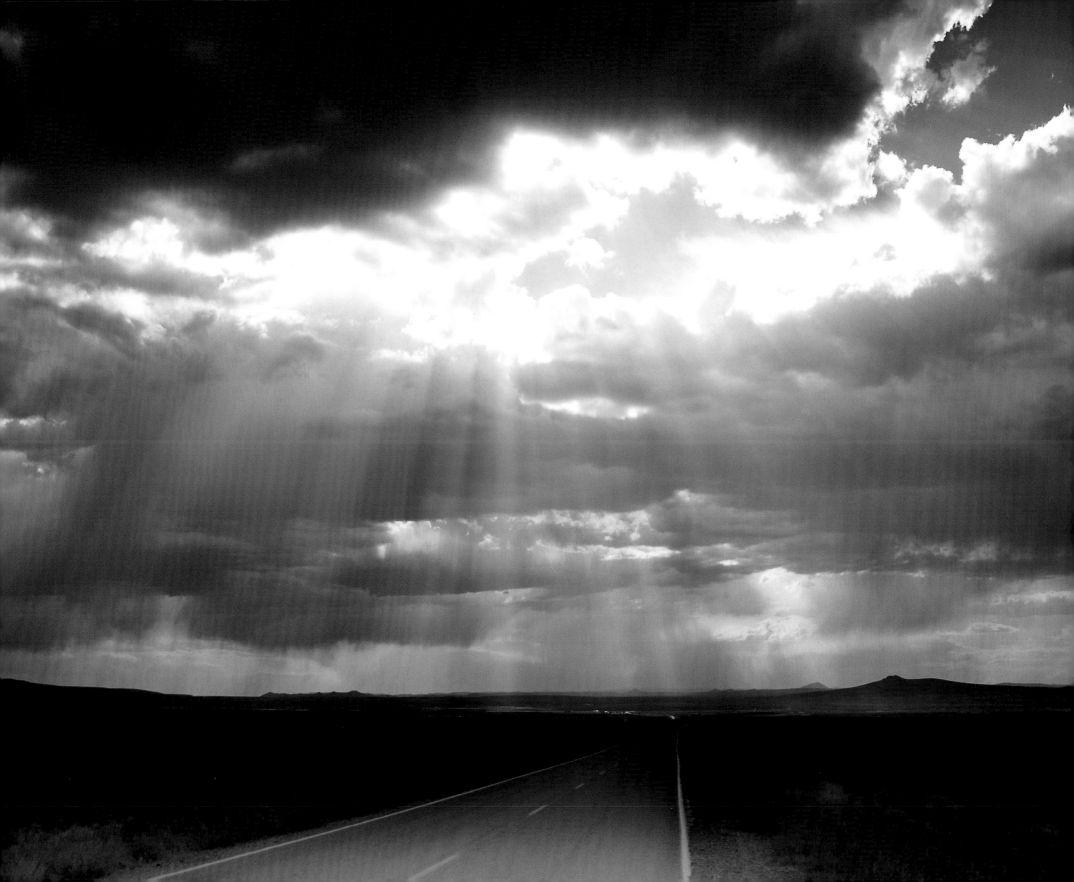

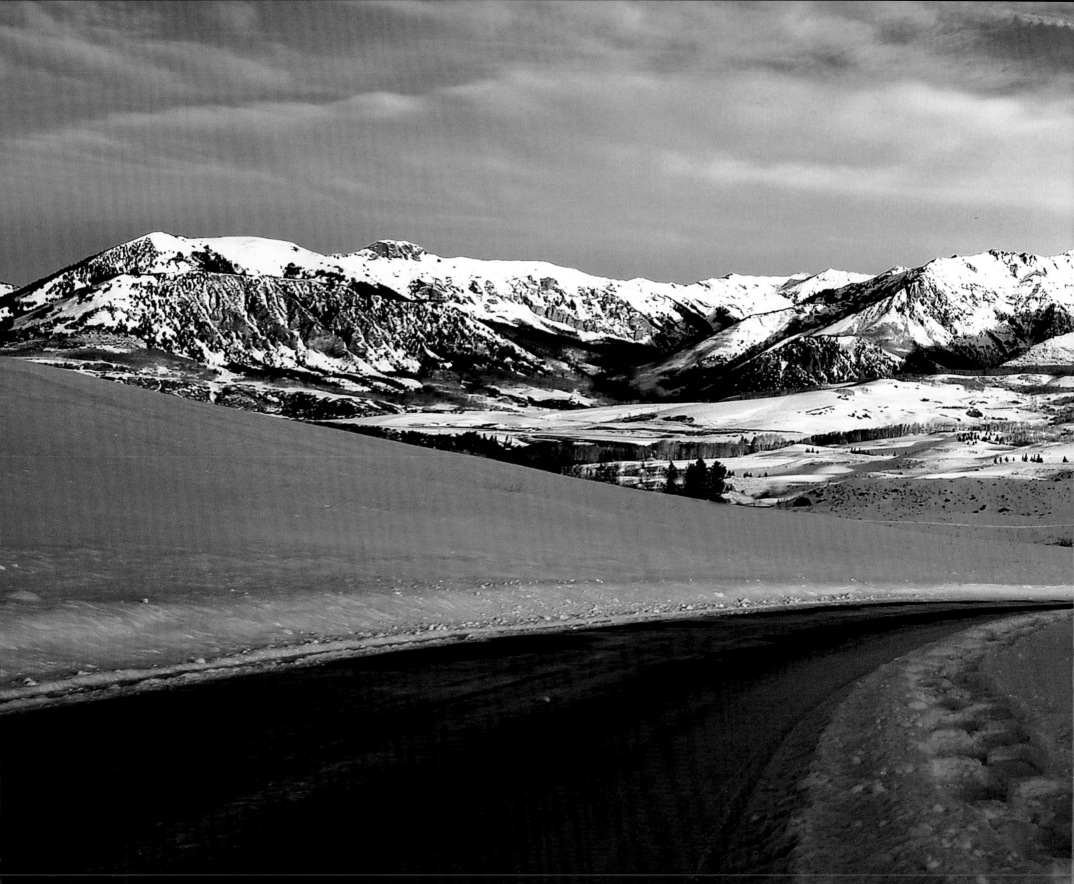

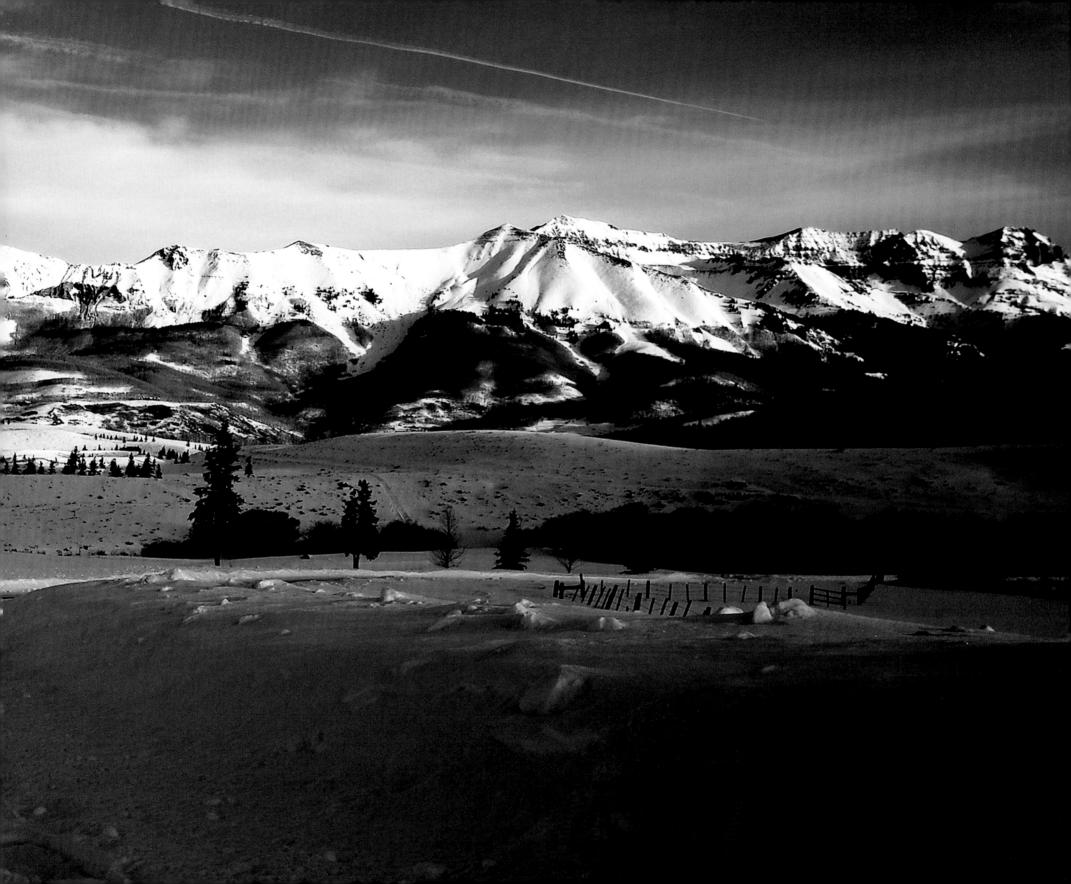

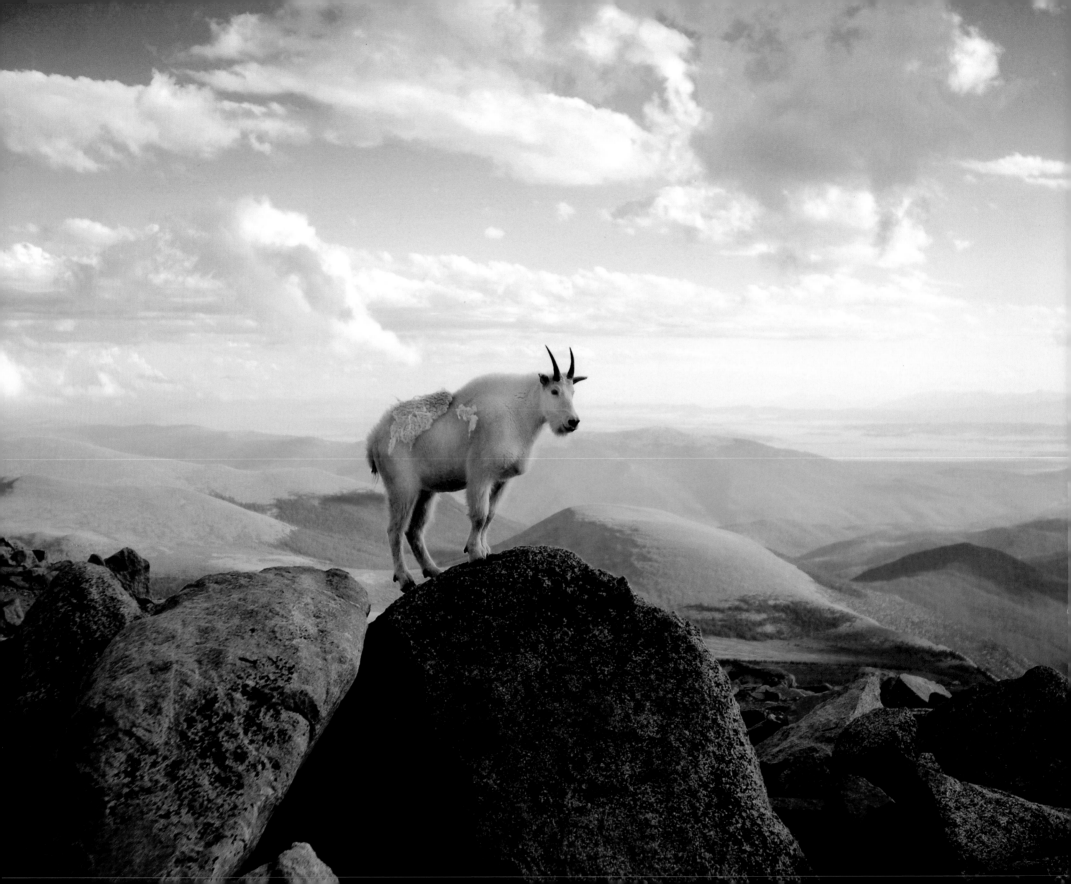

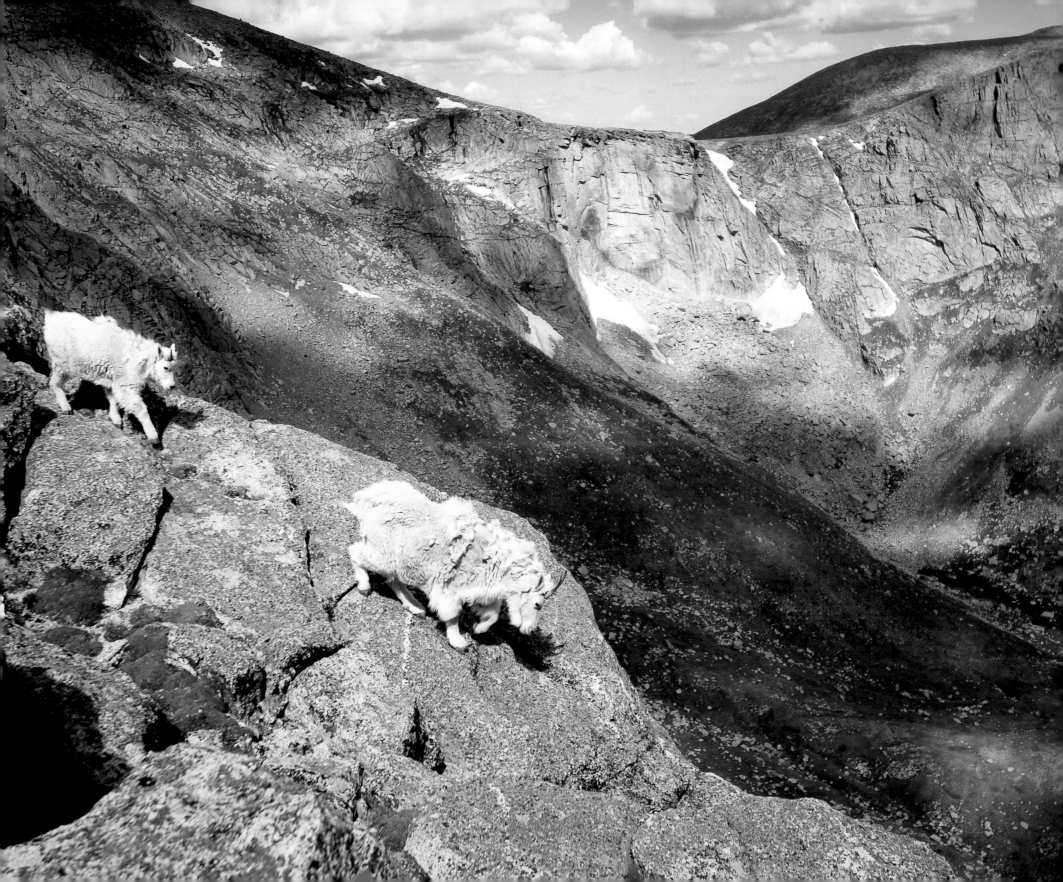

Watch for another
Road Less Traveled